La page contient une illustration pleine page avec une liste de plantes dans la colonne de droite.

L.

H.F. Ligustrum lauri folio fructu Violaceo.

H.F. ...do

H.F. ...re

H.F. ...bus

Candleberry Myrtle with broad leaves.

H.F. Myrtus Brabanticæ similis Carolinensis humilior
Candleberry Myrtle with narrow leaves.
Mespili Novem aut decem Species.

N

H.F. Nux Juglans Nigra Virginiensis.
The black Walnut.
Nux Juglans Virginiana alba.
The White Walnut.
H.F. Nux Juglans Cotice duriore lævi.
The Hickory Nut.
H.F. Nux Juglans minima
The Pignut.

P

G.C. Pavia
Horse Chesnut with scarlet flowers.
G.C. Periclymenum persoliatum Virginianum.
The trumpet Honysuckle.
G.C. Phaseolus frutescens Caroliniana.
Kidney Bean Tree.
H.F. Platanus Occidentalis.
The Plane Tree of America.
H.F. Populus Carolinensis.
The Carolina Poplar.

Q

Quercus semper virens.
Live Oak.
Quercus Alba.
White Oak.
Quercus Nigra.
Black Oak.
H.F. Quercus rubra.
Red Oak.
Quercus Castaneæ folijs.
The Chesnut Oak.
Quercus An-polius Ilex Marilandica &c.
Willow Oak.
Quercus
Scarlet Oak.

R

Rhus Virginianum.
Sumach of Virginia.
Rhus Novæ Angliæ.
New England Sumach.
Rhus.

S

Staphylodindron Virginianum trisoliatum
The three leavd Bladder Nut.
Senecio Carol: arborescens.
Groundsel Tree.
Spirea Opuli folio.
Gelder Rose of Virginia.
Siliquastrum
Judas Tree of America.
H.F. Strax Aceris folio.
Sweet Gum Tree.

T

Toxicodendron rectum.
Poyson Oak erect.
Toxicodendron triphillum.
Poyson Oak trailing.
Toxicodendron folijs alatis fructu Rhomboide
The poison Ash.

Y

Yucca Arborescens.
Yucca Draconis.

Z

H.F. Zanthoxylum Spinosum.

Illuminating Natural History

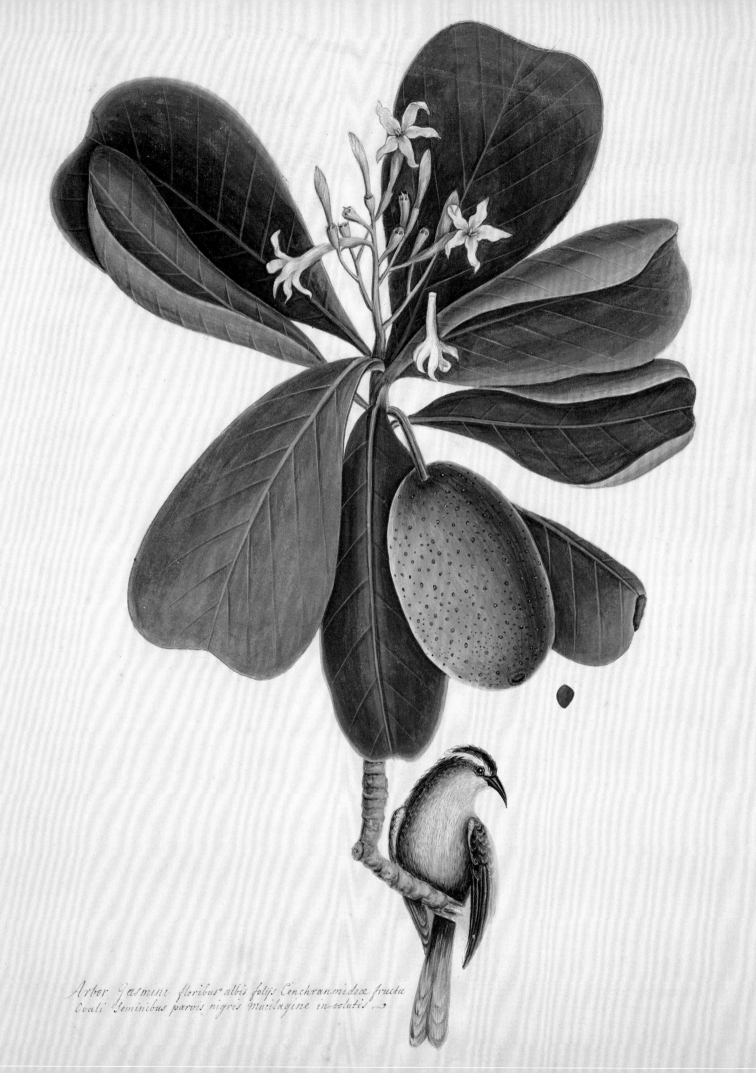

*Arbor Jasmini floribus albis folijs Cenchranmidea fructu
Ovali seminibus parvis nigris mucilagine involutis.*

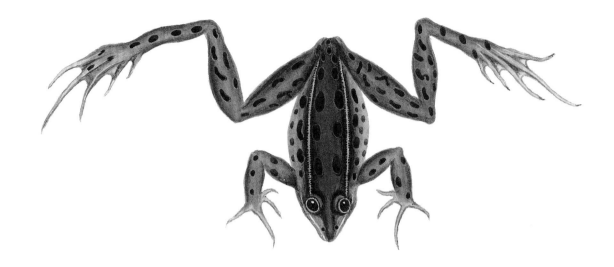

Illuminating Natural History

THE ART AND SCIENCE OF MARK CATESBY

Henrietta McBurney

PAUL MELLON CENTRE FOR STUDIES IN BRITISH ART

DISTRIBUTED BY YALE UNIVERSITY PRESS & NEW HAVEN AND LONDON

FOR CHRISTOPHER

First published in 2021 by the Paul Mellon Centre for Studies in British Art
16 Bedford Square, London, WC1B 3JA
paul-mellon-centre.ac.uk

ISBN 978-1-913107-19-2 HB
Library of Congress Control Number: 2020950214

British Library Cataloguing-in-Publication Data
A catalogue record for this book is available from the British Library

Designed by Emily Lees
Origination by Evergreen Colour Management Ltd
Printed in Wales by Gomer Press

ENDPAPERS Mark Catesby, 'A Catalogue of American Trees and Shrubs that will
endure the Climate of England', c.1742, mounted into Catesby's *Natural History*, II.
Oak Spring Garden Foundation, Upperville, VA (detail of fig. 117)

FRONTISPIECE Mark Catesby, 'The Bahama Titmouse' and 'The Seven Years
Apple', 1722–5. Royal Library, Windsor, RCIN 925894 (see fig. 145)

CONTENTS

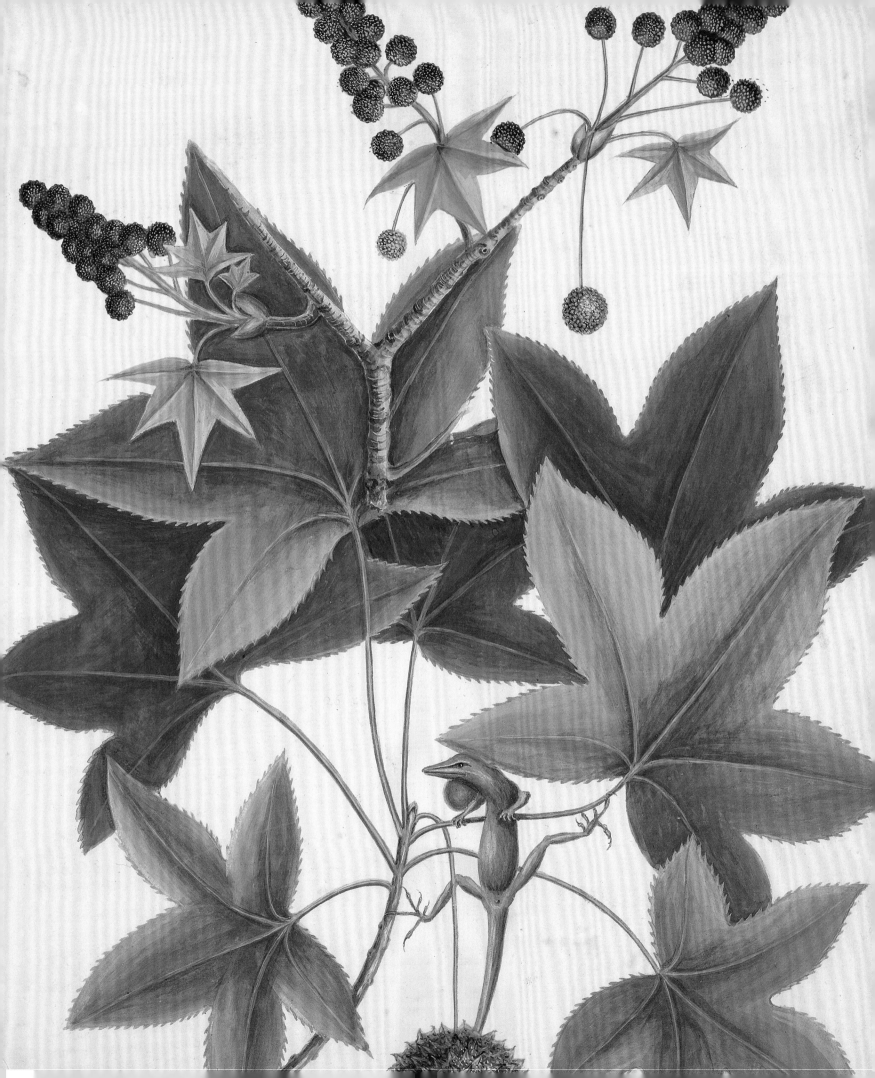

DETAIL OF FIGURE 226

Mark Catesby, 'The Green Lizard of Carolina' and 'The Sweet Gum-Tree', 1722–5.

This book is about a book – specifically it is an examination of the myriad strands that went into the making of Mark Catesby's magnum opus, his *Natural History of Carolina, Florida and the Bahama Islands* (1731–43), with his two later related publications. Writing it has involved many hours of consulting rare books in libraries, examining drawings by Catesby and his contemporaries, turning the pages of his herbaria, and memorable moments such as recognizing the very viperfish in a glass jar that Catesby painted both for himself and for Hans Sloane, and holding shells and a fossil that he picked up three centuries ago during his travels in South Carolina. The opportunity to study these many diverse bodies of material first-hand has been both a unique experience and a great privilege which I owe to an enormous number of colleagues and friends in museums, print rooms, archives and collections in the UK and abroad.

I first encountered the drawings Catesby made and collected in preparation for his book during my work as a curator in the Royal Library at Windsor. I am grateful to past and present colleagues in the Royal Library and Archives for their support and help over the years, including Rea Alexandratos, Andrew Brown, Irene Campden, Julian Clare, Pamela Clark, Martin Clayton, Carly Collier, Jean Cozens, Richard Day, Geoffrey de Bellaigue, Clara de la Peña McTigue, Allison Derrett, Alan Donnithorne, Oliver Everett, Megan Gent, Kate Heard, Sally Korman, Roderick Lane, Anne Lansiaux, Karen Lawson, Marie Leahy, Iona Mackworth-Young, Oliver Millar, Theresa-Mary Morton, Daniel Partridge, Shruti Patel, Lauren Porter, Rosie Razzell, Jane Roberts, Prudence Sutcliffe, Emma Stuart, Olivia Winterton and Bridget Wright. Michael Warnes, formerly chief paper conservator in the Royal Library, was responsible for the exacting process of lifting and conserving the Catesby watercolours between 1994 and 1997. The expert photography of Eva Zielinska-Millar, former senior photographer at the Royal Collection, is evident throughout this volume.

A Senior Fellowship from the Paul Mellon Centre for Studies in British Art in 2013/14, following an earlier Mellon Research Support Grant in autumn 2010, and a Visiting Scholarship from the Yale Center for British Art in 2014, allowed me to focus on turning my previous work towards a catalogue raisonné of Catesby's drawings into a book. I am grateful for the hospitality and support of the PMC staff and its past and present directors, Brian Allen and Mark Hallett. At Yale, I spent many happy hours in the Study Room and Rare Books and Manuscripts department of the YBCA. I am enormously grateful to Amy Meyers, and to her colleagues, especially Katherine Chabla and Elizabeth Fairman, for their welcome, enthusiasm, and help in directing me to different parts of the collections. At Yale I also owe thanks to the staff of the Beinecke Rare Books and Manuscripts library, and to Patrick Sweeney at the Peabody Museum who gave me the opportunity to inspect early herbarium collections, botanical collecting equipment and the Lentz collection of early microscopes.

Thanks to the hospitality of Leslie Overstreet, during spring 2014 I was able to spend time in the

Cullman Library of the Smithsonian Libraries and Archives studying the three editions of Catesby's *Natural History* alongside each other, together with the smaller format volume we now believe is the copy Catesby sent to John Bartram. We visited a number of other North American libraries to inspect first editions of Catesby's work, including Dumbarton Oaks, the Library Company of Philadelphia, the New York Public Library and the Oak Spring Garden Library. I am grateful for the welcome given by the staff of all those institutions. A productive search for Catesby's letters was undertaken at the Historical Society of Pennsylvania and at the Library of Congress. At the Morgan Library & Museums, New York, I thank Jennifer Tonkovich and her staff for their helpfulness during my first visit and for their continuing kindness and support.

In British libraries and collections, I have benefited from the friendship and help of many colleagues. I owe a significant debt of gratitude to the Royal Society, whose staff have been invariably welcoming during my visits over the years and supportive of my research. Amongst them I thank Rupert Baker, Joanna Corden, Ellen Embleton, Louisiane Ferlier, Katherine Marshall, Jo McManus, Virginia Mills, Keith Moore and Karen Peters. At the British Museum, Kim Sloan and Sheila O'Connell in the Department of Prints and Drawings have been unfailingly generous with their time and their knowledge, and Felicity Roberts kindly shared her research on George Edwards's drawings made for Hans Sloane. In the Department of Africa, Oceania and the Americas, I thank James Hamill and Jonathan King for their advice on Sloane's collection of ethnographic artefacts. In the British Library, I am particularly grateful to Arnold Hunt for his identification of two previously uncatalogued letters from Catesby to the Earl of Oxford among the Harleian papers. Thanks are also due to Alexandra Ault and Laura Walker.

At the Natural History Museum, I thank colleagues across many departments for their collaboration and their kindness, including Malcolm Beasley, Mark Carine, Paul Martyn Cooper, Oliver Crimmen, Charlie Jarvis, Fred Rumsey, Andreia Salvador, Consuelo Sendino and Mark Spencer. At the Linnean Society, I thank Will Beharrell, Lynda Brooks, Isabelle Charmantier, Elaine Charwat, Andrea Deneau, Gina Douglas and Liz McGow for their help and hospitality; at the Chelsea Physic Garden, Dawn Kemp and Sue Medway; at the Lind-ley Library of the Royal Horticultural Society, Brent Elliott; and at Badminton House, Elaine Milson. I am grateful to Crispin Powell for sharing his wide knowledge of the collections at Boughton House, and to James Peille for his help during my visits to Goodwood House. I am grateful for the hospitality of the Earl and Countess of Derby and to Stephen Lloyd and Ashleigh Griffin during my visits to study the Collinson volumes previously at Knowsley Hall.

Over many years working in the Munby Rare Books Room, and elsewhere in the University Library, Cambridge, I have received much help, support and friendship from numerous colleagues, including Liam Austin, Stella Clarke, Sophie Connor, Emily Dourish, Agnieszka Drabek-Prime, Suzanne Edgar, Will Hale, Madeleine Harrigan, Helen Hills, Nicola Hudson, Onesimus Ngundu, Ian Pittock, Ed Potten, Liam Sims, Anne Taylor, Michael Taylor and Claire Welford-Elkin. At the Wren Library, Trinity College, I was privileged to have the opportunity to compare the hand-colouring of two first edition copies of Catesby's *Natural History* side by side, with the encouragement of Sachiko Kusukawa and willing assistance of Sandy Paul, Jonathan Smith and Adam Green. Nicolas Bell, current Wren librarian, has been extraordinarily kind in undertaking photography from these two copies for me. I also thank Jane Acred for her help at the Balfour and Newton Zoology Library, and Debbie Hodder, Eve Lacey and Katherine Knight at Newnham College Library.

At the University of Oxford, I am enormously grateful to Stephen Harris and Serena Marner who have been unfailingly generous with their time and expertise during my many visits to the Department of Plant Sciences. Stephen Harris has equally generously taken the photographs of objects in his department for this book himself. I am also grateful to Jo Maddocks for her help in the Bodleian Library.

In Paris I thank the staff in the special collections of the Muséum National d'Histoire Naturelle, the Bibliothèque Sainte-Geneviève, the Bibliothèque François-Mitterrand, and especially Vanessa Selbach for her help at the Bibliothèque Nationale (Richelieu). Colleagues at other institutions who have helped me remotely include John Overholt at the Houghton Library, Harvard University; Jeannette McDevitt and Charlotte Tancin at the Hunt Institute for Botanical Documentation, Carnegie Mellon University, Pittsburgh; Steve Tuttle at the

South Carolina Archives and History, Columbia; and Virginia Ellison, Harlan Green and Molly Inabinett at the South Carolina Historical Society, Charleston.

Special thanks are also due to the following for their significant contributions to the book: Ian Bolton for solving photographic difficulties with his customary willingness and humour; Penny Brading for her expert editing of Catesby's letters; Christopher Dawkin, for help with the Felsted School archives; Robert Harding for advice on costs of early eighteenth-century illustrated books; Jon Harris for advice on labelling maps and plans; Corie Hipp for the photograph of her home at 35 Lower Meeting Street, Charleston; Suzanne Hurley for her advice on aspects of South Carolina history and her generous help with maps and other references; Shephard Krech III for his ornithological expertise; Sachiko Kusukawa for many stimulating conversations in the tea room of the University Library and her invariably prompt replies to random queries; Patricia McGuire and Mike Good for their joint palaeographic skills in helping to transcribe parts of Nicholas Jekyll's almost illegible letters; Margaret Riley for sharing her knowledge of the Sherard brothers and for the loan of a copy of her PhD thesis; Xander Ryan for his expert advice and constructive suggestions for the appendix of Catesby's letters; Edward Speyer for on-hand IT assistance; Pieter van der Merwe for advice on eighteenth-century shipping routes; Jane Waring for the loan of her copy of Mortier's *Carte de la Caroline* and her continuing enthusiasm; and Alice Williams for her efficient help with image requests.

The book went into production during the coronavirus pandemic in summer 2020. This meant that images needed to be collected from numerous institutions in full or partial lockdown and with the majority of their staff on furlough. I was only able to assemble the images because of the great kindness of many individuals: Hans Mulder (Artis Library, Amsterdam); Nigel Frith and Lucie Hey (Addison Publications); Ian Bolton (Audio Visual Media Group, University of Cambridge); Vanessa Selbach (Bibliothèque Nationale de France); Rob Lloyd and Sian Phillips (Bridgeman Images); Elizabeth Bray (British Museum Imaging Services); Jennifer McCormick and Grahame Long (Charleston Museum); Nicholas Lambourne and Lara L'vov-Basirov (Christie's Images); Carolyn Wilson (College of William and Mary); David Lewes and Marianne Martin (Colonial Williamsburg Foundation); Brian Gratwicke (Cornell University); Vanda Jeffrey and Andy Morgan (Essex Record Office); Amanda Breen (Gibbes Museum, Charleston); James Peille and Jonathan Wilson (Goodwood House); Mark Bills and Trudy Pickerin (Gainsborough's House, Sudbury); Andrea Deneau (Linnean Society of London); Christopher Kintzel (Maryland State Archives); Steph Eeles (London Metropolitan Archives); Nadine Orenstein and Julie Zeftel (Metropolitan Museum of Art); Peter Elliot (Mill Hill School); Jennifer Tonkovich and Sal Robinson (Morgan Library & Museum); Lisa Olrichs (National Portrait Gallery); Stephen Atkinson, Lucie Goodayle, Jonathan Jackson and Aimee McArdle (Natural History Museum); Megan Evans (National Trust Images); Tony Willis and Max Smith (Oak Spring Garden Foundation); Stephen Harris (Oxford Department of Plant Sciences); Daniel Partridge and Eva Zielinska-Millar (Royal Collection Trust); Ellen Embleton (Royal Society); Erin Rushing (Smithsonian Libraries and Archives); McKenzie Lemhouse (University of South Carolina, Columbia); Dustin Frazier Wood (Spalding Gentleman's Society); David Burnett (Sudbury Museum Trust); Jane Ingle, Adam Phillips and Desmond Crone (Suffolk Archives, Bury St Edmund's); Nicolas Bell (Trinity College, Cambridge); Johanna Ward and Domniki Papadimitriou (University Library, Cambridge); and Claire Hope and Andrew Foster (Virginia Museum of History and Culture).

Two chapters in this book began as collaborative exercises with other Catesby scholars: Chapter 3, 'Catesby's Publications', with Leslie Overstreet, Curator of Natural-History Rare Books at the Smithsonian Libraries and Archives, and Chapter 6, 'Catesby as Naturalist', with Professor Stephen Harris, Druce Curator of Oxford University Herbaria, Department of Plant Sciences, University of Oxford. Each of them subsequently published their research in E. Charles Nelson and David J. Elliott (eds), *The Curious Mister Catesby: A 'Truly Ingenious' Naturalist Explores New Worlds* (Athens, GA, & London, 2015), the publication that grew out of the proceedings of a Catesby tercentennial conference in 2012. The present book owes an enormous amount to the stimulating conversations I have had with both Leslie and Stephen over many years, to their generous time in looking over drafts, and for

many invaluable corrections and suggestions. Roger Gaskell has also given generously of his time and expertise; his close reading, constructive comments and suggestions have added immeasurably to the chapter on Catesby's publications.

Attempting a multi-disciplinary study of this kind has its challenges. My readers, including Charles Nelson and Mark Laird, each offered comments from very different perspectives. I thank them for their positive recommendations as well as for their critical input and helpful suggestions. David Alexander, Aaron Bauer, Roger Gaskell, Charlie Jarvis, Stephen Harris, Leslie Overstreet, Arthur MacGregor, Xander Ryan, Christopher Stray and Gillian Sutherland have each read, and sometimes re-read, parts or all of the text. I am very grateful for their willingness and their excellent and stimulating comments. Needless to say, I am responsible for all errors that remain.

At the Paul Mellon Centre, I thank Emily Lees for steering the book forwards through three periods of lockdown, and for her sensitive and elegant design. I am also very grateful to Nancy Marten for her expert copy-editing skills and for her interest, energy, and patience; and to Jane Horton for her careful and thorough index.

I have received friendship, help and encouragement in many forms from innumerable friends, family members and others, including Rajani Adam, Michael Alcock, David Alexander, Victoria Avery, Susanna Avery-Quash, Ian Bolton, Alice Briggs, Christl Bruell, Lucilla Burn, Ed Capstick, Emily J. Clark, Tiemen Cocquyt, Brendan Cole, Lizzie Collingham, Peter Crane, David Dallas, Peter Davies, Simon Dormandy, Gabrielle Downie, Gina Douglas, Kay Etheridge, David Elliott, Angela Farmer, Charmian Farmer, David Farmer, Alan Feduccia, Celina Fox, Joel Fry, Jill Gage, Zachary Giuliano, Dawn Golten, Jean Gooder, Patricia Griffin, Lydia Hamlett, J. B. Heiser, Andrew Hewson, Denise Hayles, Caroline Higginbottom, Carter Hudgins, Jack Hurley, Peter Ingle, Ian Jenkins, Kristian Jensen, Peter Jones, Margaret Kenna, Andrea Kirkham, Michael Korey Nicholas Lambourn, Marie Leahy, Karen Limper-Herz, Emma Lloyd-Jones, Arthur MacGregor, Alison McBurney, Anne McBurney, Charlotte McBurney, Gerard McBurney, Helena McBurney, Simon McBurney, Patrick McMillan, Ken McNamara, Fiona Maddocks, Matts Marm, Anne Marshall, Craig Muldrew, Felicity Myrone, Stephen Ortiger OSB, Lynn Parker, John Parmenter, Robert Peck, Francisca Perrett, Florence Pieters, Claire Phillips, Julian Prideaux, Margaret Pritchard, Judy Quinn, Ross Robertson, Barley Roscoe, Christopher Rowell, Lynn Sanders, Tom Schreck, Anthea Secker, Adrian Sek, Elaine Shaughnessy, Molly Silliman, Timothy Simmons, William T. Stearn, Michael Suarez SJ, Anne Summers, Luke Syson, John Townroe, Melissa Trahan, Ginette Vagenheim, Victor van Kooten, Carlo Violani, William Waldegrave, Michael Walters, Francis Ware, Lilah Wayment, Mark Westneat, Keith Wilkinson, Tony Willis, Lucy Wood, Jonny Yarker, Cassie Yukawa-McBurney and Axel Zeitler. Above all, I owe heartfelt thanks to Gill Sutherland and Chris Stray for their encouragement when my energy flagged, and for their extreme generosity and care in more ways than I can say. Without them this book would not have come to completion.

Finally, I thank my family – my children, Francesca, Xander and Edmund, whose good humour, loyalty and support have been unfailing, and my husband, Christopher, who from the beginning believed in a book on Catesby, and whose faith has continued to sustain me through its vicissitudes. I dedicate this book to him.

1627	birth of John Ray
c.1642	birth of John Catesby, Mark's father
c.1652	birth of Elizabeth Jekyll, Mark's mother
1659	birth of Samuel Dale; birth of William Sherard
1660	foundation of Royal Society; birth of Hans Sloane
1670	16 May, licence for marriage of John Catesby and Elizabeth Jekyll in St Andrew's Holborn, Gray's Inn, or Charter House Chapel, London
1683	24 March, birth of Mark Catesby; 30 March, baptism in St Nicholas Church, Castle Hedingham
1694	birth of Peter Collinson; birth of George Edwards
1697	birth of Catesby's younger brother, John
1703	death of John Catesby, senior
1705	death of Ray
1707	publication of Sloane's *Natural History of Jamaica*, Volume I
1708	death of Elizabeth Jekyll Catesby
1712	22 April, Catesby and his sister, Elizabeth Cocke, arrive in Williamsburg, Virginia

1714	Catesby travels to West Indies and Bermuda
1717	death of his surviving older brother, Jekyll Catesby
1719	probably summer, sails for England; 15 October, return to East Anglia reported by Dale; visits Chelsea Physic Garden and Thomas Fairchild's Hoxton garden
1720	May, meets Sherard for first time with letter of introduction from Dale; acquires *Aesop's Fables*
1721	in discussion with Duke of Chandos about going to Africa
1722	first week of February, sails for Charleston, South Carolina; arrives 3 May; September, falls ill with 'swelling in the cheek' and confined indoors for three months; major hurricane in South Carolina
1722–5	explores and collects in Low Country, and travels to foothills of Appalachians and into (present-day) Georgia
1724	April, hurricane in South Carolina; expedition to Mexico with Dr Cooper discussed with his sponsors
1725	January, leaves Charleston for Providence Island; collects in Bahama Islands; publication of Sloane's *Natural History of Jamaica*, Volume II

1726 spring, returns to London; settles in Hoxton and is involved in horticultural activities in Fairchild's nursery

1728 probable publication of 'Proposals'; death of Sherard

1729 May, audience with Queen Caroline; *NH*, Part 1 presented to Royal Society; October, death of Fairchild and Hoxton nursery taken over by his nephew, Stephen Bacon; probable publication of second edition of 'Proposals'

1730 Catesby living in parish of St Giles, Cripplegate; probably meets Mrs Elizabeth Rowland

1731 birth of first son, Mark, with Elizabeth Rowland

1732 completion of *NH*, Volume I (containing Parts 1–5, with date of 1731 on title page); birth and death of second son, John

1733 26 April, elected fellow of Royal Society; summer, travels to the Netherlands; birth and death of first daughter, Caroline; probable death of Bacon and move of Catesby's horticultural activities to Christopher Gray's nursery in Fulham

1736 July/August, Carl Linnaeus visits London and meets Catesby

1737 birth of Catesby's second daughter, Ann

1738 publication of Linnaeus's *Systema naturae*

1739 death of Dale

1740 birth of third son, Mark (indicates first son Mark had died before this date)

1742 probable publication of 'A Catalogue of American Trees and Shrubs'

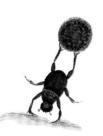

1743 audience with Augusta, Princess of Wales; completion of *NH*, Volume II (Parts 6–10); 29 December, elected member of Spalding Gentlemen's Society; publication of Edwards's *A Natural History of Uncommon Birds*, Part 1 (of 4, 1743–51)

1747 publication of Appendix to *NH*; publication of 'Of Birds of Passage' in *Philosophical Transactions*; 8 October, marries Elizabeth Rowland in St George's Chapel, Mayfair

1748 May, Pehr Kalm visits London and meets Catesby; reports 'poor Mr Catesby's legs swell, and he looks badly'

1749 23 December, death of Catesby and burial in St Luke's Church, Old Street

1753 4 January, Elizabeth Catesby makes will; 18 February, dies; publication of Linnaeus's *Species plantarum*; death of Sloane

1753 'Proposals' for second edition of *NH*

1754 publication of second edition of *NH*, overseen by Edwards

1763 publication of *Hortus Britanno-Americanus*

1758 publication of Edwards's *Gleanings of Natural History*, Part 1 (of 3 Parts, 1758–64); publication of Linnaeus's *Systema naturae* (tenth edition)

1767 *Hortus Britanno-Americanus* re-issued as *Hortus Europae-Americanus*

1768 death of Collinson; purchase by George III of three-volume set of *NH* containing 263 watercolours by Catesby and others

1769 death of Catesby's younger brother, John

1771 publication of third edition of *NH*, with index of Linnean names

1773 death of Edwards

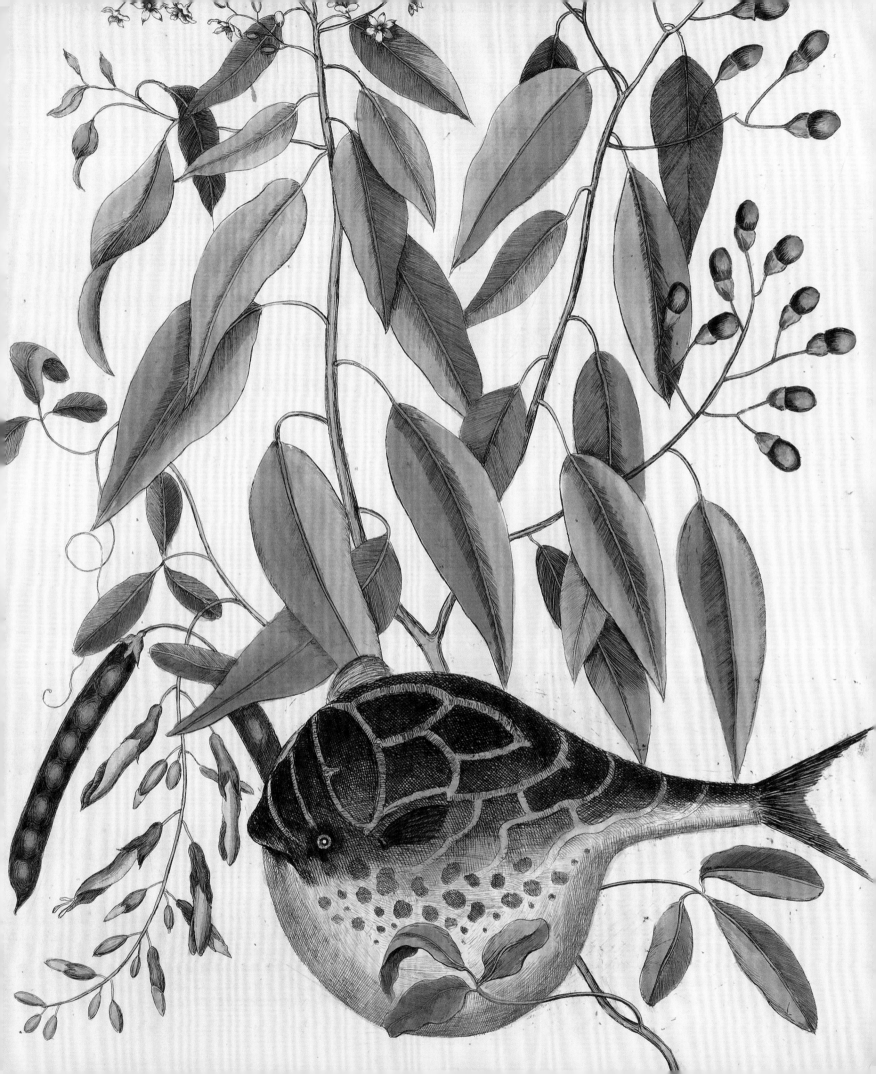

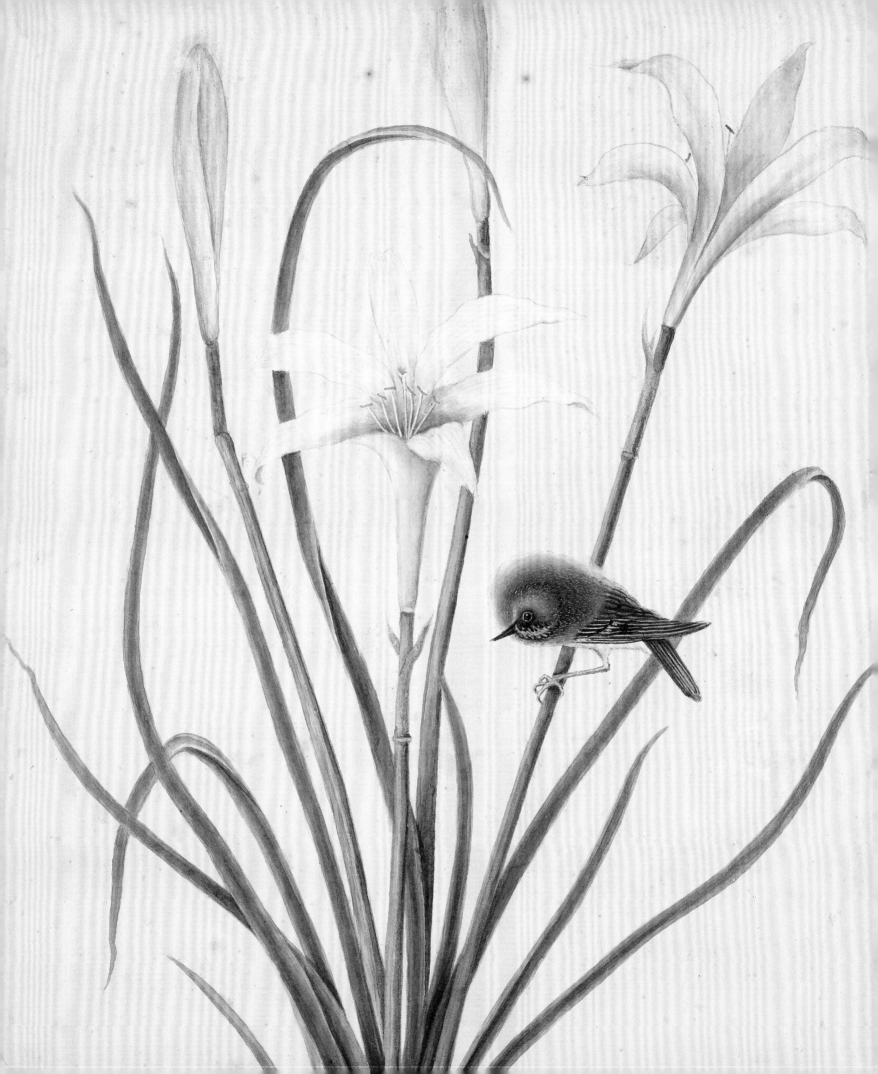

'An understanding of the natural world and what's in it is a source
of not only a great curiosity but great fulfilment.'
(David Attenborough, 2017)[1]

Mark Catesby begins and ends his *Natural History of Carolina, Florida and the Bahama Islands* (1731–43)[2] with expressions of curiosity and pleasure not dissimilar to those articulated by Sir David Attenborough nearly three hundred years later. Noting 'my Curiosity was such, that … I soon imbibed a passionate Desire of viewing as well the Animal as Vegetable productions in their native countries,' Catesby further states that '[I] gratified my inclination in observing and admiring the various Productions of those Countries.'[3] At the end of his book he speaks of the many years he spent collecting these 'materials … from the living subjects themselves, and in their native abodes' and of 'the strong inclination I had to these kinds of subjects, joined to the love of truth, that were my constant attendants and influencers'. For both these naturalists, curiosity, passion, gratification and fulfilment are inseparably connected with observing, studying and describing the natural world. Both too were and are committed to capturing that world in images.

Catesby has been described by a biographer as 'a shadowy, half-known figure'.[4] It is true that we know very little about his early years, and many details of his later life were not recorded. While a not insignificant number of his letters were kept by his correspondents, the majority of these date from the three to four years that Catesby spent in South Carolina; they are concerned almost exclusively with his collecting activities there, and say practically nothing of his activities as an artist.[5] No letters survive from his earlier stay in Virginia, and very few of the letters written to him are extant.[6] Nevertheless,

from a study of the letters that survive, together with the texts of his books, the plants he preserved, the images he created, and what was recorded by his friends and associates, we gain a vivid impression of Catesby's personality. Far from being 'shadowy' or 'half-known', we come to know a man who was utterly dedicated to and passionate about his life's work, who was both reserved and witty, private but not above expressing his emotions, and who was simultaneously a lover of scientific 'truth' and of the beauty in nature and art.[7]

History of Catesby's drawings

Of all the material remains of his work and life, Catesby's drawings are the most compelling document of his creative vision and imagination. At his death, these included not only a number of copies of the *Natural History* and the copper plates, but around three hundred of the original drawings for his book. From a memorandum made by Catesby's friend Peter Collinson, we learn that Catesby's widow Elizabeth was able to '[subsist] on the sale [of copies of the *Natural History*] for about 2 years. Then the Work, Plates, &c. sold for 400£ and about 200£ more left by the Widow was divided between the two Children – a son and a daughter.'[8] But while Collinson makes no specific mention of the drawings in the sale, George Edwards refers to them in a letter written around twelve years after Catesby's death: '[Catesby's] whole fortune: his household Stuff, Coppy of his histor[y], original drawings, and Copper plates did not amount in the whole to 700£.'[9]

FIGURE I

Mark Catesby, 'The Attamusco Lily' and 'Regulus cristatus'. Detail, see fig. 6.

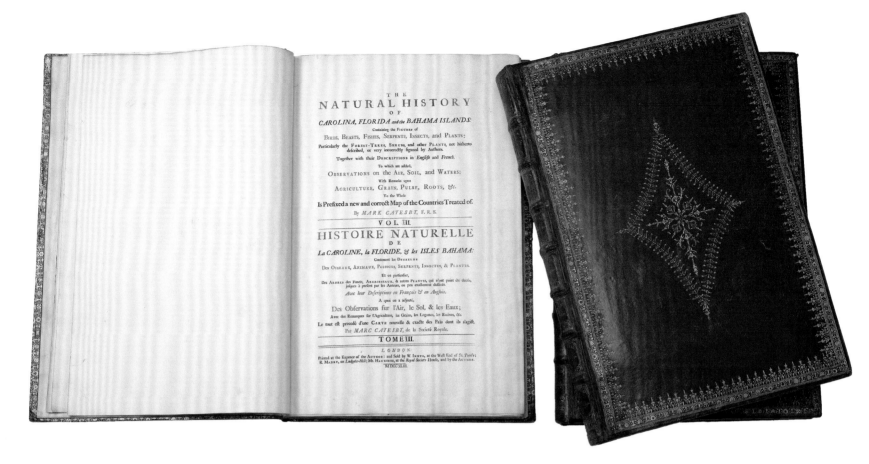

Elizabeth Catesby died on 18 February 1753, just over three years after her husband.[10] It would seem that the contents of Catesby's studio were retained by her until funds from the book sales ran out, when the 'Work' (remaining stocks of letterpress and plates for the book), the 'Plates' (the copper plates) and the original drawings (implied in '&c') were sold – realizing the sum of £400.[11] Mrs Catesby may have sold the drawings and copper plates to the booksellers Marsh, Wilcox and Stichall, who are mentioned as 'the Proprietors' in possession of the drawings in October 1753, eight months after her death.[12]

In an advertisement for the second edition of the *Natural History* it was noted that George Edwards will 'in regard to his [Catesby's] Memory, ... inspect every colour'd Plate that shall be exhib'ted to the Publick'.[13] The naturalist and artist George Edwards had been both friend and colleague of Catesby. They had worked closely together, and Edwards, who would have been familiar with the contents of Catesby's studio, may have been the intermediary between Mrs Catesby and the booksellers after Catesby's death.[14] It would seem likely that it was Edwards who initiated the publication of the second

edition of Catesby's book; he was clearly closely involved in its extended publication between 1753 and 1757, the book was cited on its title pages as 'revised' by him, and as we have seen, he was responsible for checking the colouring of the plates against the original drawings.[15] Edwards's particular interest in the colouring of Catesby's plates is evident from the fact that he borrowed Catesby's drawings to use as a guide when colouring his own copy of the *Natural History*, which he later described as 'equal to the author's original work'.[16]

It would also seem likely that it was Edwards who advised the 'Proprietors' on the compilation of a unique three-volume copy of Catesby's *Natural History* in order to preserve the corpus of original drawings for the book intact (fig. 2). Probably put together after 1755, the compilation involved arranging 263 of Catesby's original drawings so that they approximated the order of the 220 corresponding texts and etched plates.[17] For example, when there was more than one study for a single subject, the individual watercolours were bound on successive folios or, in the case of two magnolia studies, facing each other (fig. 3). Where there were

FIGURE 2

George III's three-volume set of Catesby's *Natural History*, 1731–43, 54 × 38 cm.

Royal Library, Windsor, RCIN 1085716-18

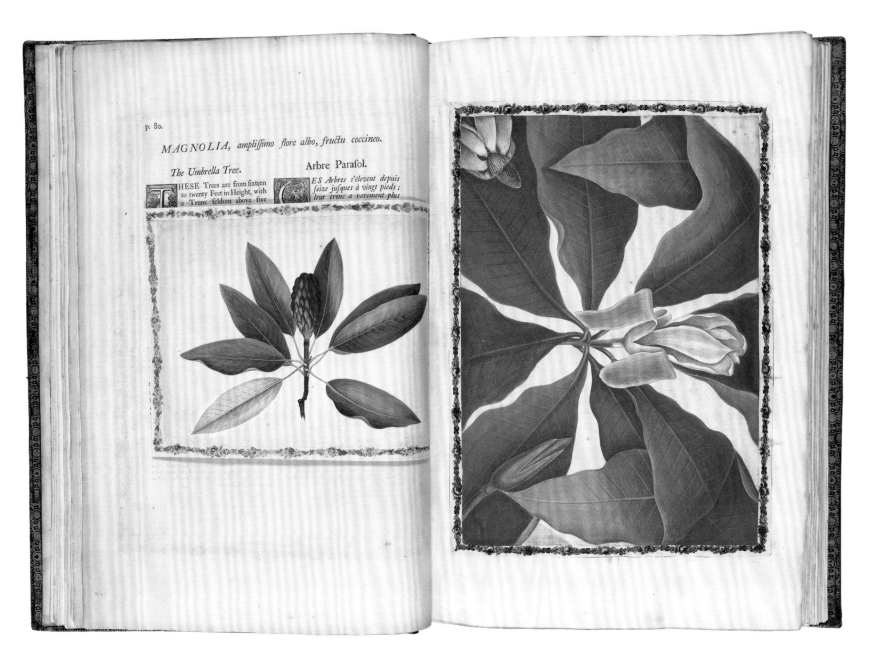

FIGURE 3

George III's copy of the *Natural History* showing eighteenth-century arrangement of 'The Sweet Flowring Bay' and 'The Umbrella Tree'.

Royal Library, Windsor, RCIN 926040, 926041

separate plant and animal studies which Catesby had later combined in a single composition, the compiler pasted them together on a mount sheet: a folio bearing Catesby's separate studies for the 'Indian Pink', *Spigelia marilandica*, and 'Gray Fox', *Urocyon cinereoargenteus*, also indicates the process Catesby himself had been involved in in arranging and adapting the material for his plates (figs 4 and 5; see Chapters 3 and 4). But more complicated decisions were needed when it came to placing drawings whose subjects Catesby had later split up and incorporated into separate plates in different parts of the book. Edwards's distinctive handwritten notes

made in graphite on some of the drawing sheets provide indications to where the related plates are found in the finished book (fig. 6).[18] The binding of the three volumes in gilt morocco may have been done shortly after the arrangement of the drawings.[19] A specially adapted title page for Volume III was made by the addition of an extra printed 'I' to a Volume II title page (see fig. 2).[20]

The *fortuna* of the three volumes containing Catesby's original drawings between their arrangement *c*.1755 and the next record of them in 1768 is unknown. It was possibly during this period, however, that hand-painted etched floral borders were

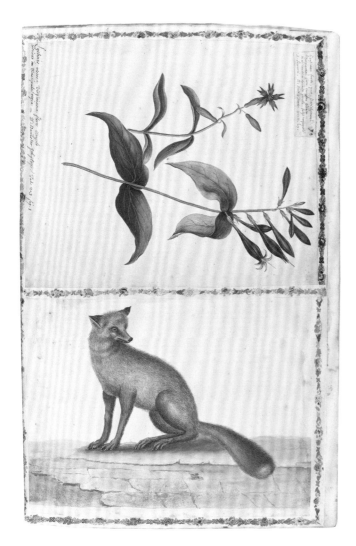

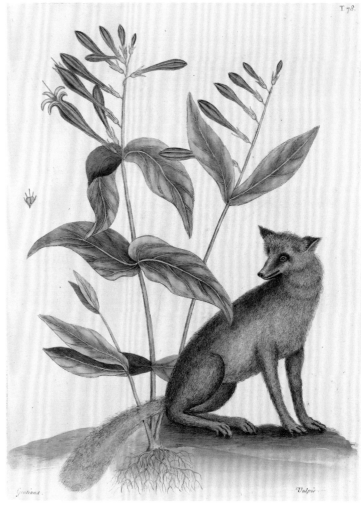

pasted around the edges of the drawings. These borders, composed of a repeated pattern of flowers, foliage and ribbons, are typical of mid- to late eighteenth-century decorative motifs used for the framing of prints for print rooms (see figs 3, 4 and 9). It was common at this period for printed borders of this type to be bought in rolls so that they could be hand coloured, and used to 'frame' landscape, genre and other scenes either to decorate walls or for similar 'fancy work' such as decoupage.[21] From the evidence of a few watercolour splashes on the mounting sheets, it would seem that the floral borders were painted after they had been pasted around the drawings.[22] Both the handling and the incongruous juxtaposition with Catesby's bold compositions suggest the borders were added in the spirit of ladies' amusement rather than by any of Catesby's associates.[23]

At some stage after *c.*1755 the volumes were sold to the London bookseller and publisher Thomas Cadell, who ran his successful business from the Strand.[24] They were bought from him in 1768 by Lord Bute, acting on behalf of King George III. A nineteenth-century inscription facing the title page of Volume I records, 'Purchased in 1768 of Mr Cadell for £120 pounds' (fig. 7).[25] John Stuart, 3rd Earl of Bute, who was one of Catesby's subscribers, had been a friend and mentor of the prince, later king, since the early 1750s, and was instrumental in acquiring natural history drawings and books on his behalf.[26] The large amount of money paid by George III would seem to indicate either a real interest in the drawings themselves or a more general interest in building up a collection of natural history drawings and books.[27] The volumes joined the rest of the king's growing collection of natural history drawings and books in the Royal Library at Buckingham House in London. In 1833, together with the rest of the royal collection of drawings, they were moved

FIGURE 6

Mark Catesby, 'The Attamusco Lily' and 'Regulus cristatus' (detail), with annotations by George Edwards. Watercolour with inscriptions in graphite, 37.5 × 26.6 cm.

Royal Library, Windsor, RCIN 926081

FIGURE 7

Inscription by John Glover (Royal Librarian, 1837–60), probably made during the late 1830s or 1840s, on the inside board of Volume I of George III's copy of the *Natural History* (see fig. 2).

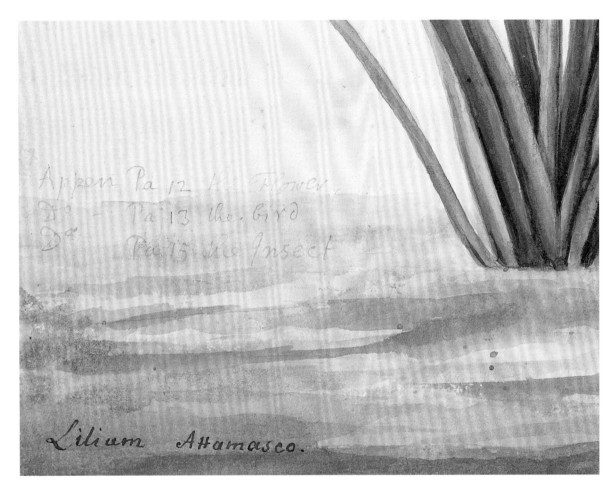

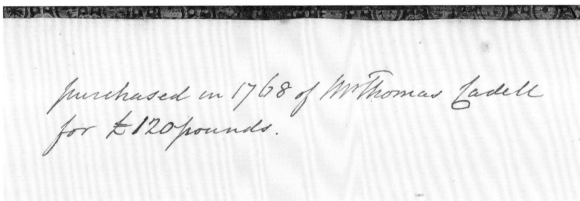

from Buckingham House to King William IV's new Royal Library at Windsor (fig. 8). There the drawings remained in the three bound volumes until 1994, when, thanks to a generous benefaction, they were lifted, conserved and mounted individually (fig. 9).[28] It was during this process that Catesby's sketches for a number of the finished watercolours were discovered on the versos of the sheets.[29] These preliminary drawings revealed a whole further dimension to our understanding of the way in which Catesby created his watercolours.[30]

Origins and scope of the present book

This book arose originally from a projected Royal Collection catalogue raisonné of Catesby's drawings at Windsor and elsewhere.[31] Research into the drawings led to a second source of primary data, the

body of original plant material collected and preserved by Catesby, together with his comments attached to many of the specimens, which now survive in the Sherard, Du Bois and Dillenian herbaria in Oxford, and the Sloane, Dale and Petiver herbaria in London (Chapters 5 and 6).[32] While the Catesby material in the Sloane herbarium was relatively well known, the other herbaria had until recent research by Stephen Harris received very little scholarly attention.[33] A comprehensive catalogue of Catesby's plant specimens and the manuscript notes that accompany them, together with the related drawings, aims to demonstrate the close connections between his illustrations and his plant material.[34] A search for zoological specimens revealed that apart from eight shells, one fish in spirits, and one fossil fish specimen, neither these nor their labels have survived.[35] A search for Catesby's letters was also undertaken in the belief that they constitute a third, vital source of primary data complementing his drawings and natural history collections; all those identified to date are published here for the first time in their entirety (Appendix 3). Contextual material such as contemporary collections and correspondence – of, for example, Hans Sloane and George Edwards – has also been examined for comparative sources of information to help throw further light on Catesby and his milieu.

Over the past two decades or so the close relationship between botany and empire in the early modern period has attracted significant scholarly attention. Many of the studies produced have treated the material from vantage points such as empire, colonial politics, economics, slavery, gender and more recently ecology and environment. Meyers and Pritchard in *Empire's Nature: Mark Catesby's New World Vision* (1998) pioneered this type of study of Catesby's work.[36] Noting that his 'activities and productions [had] not [previously] been addressed in relation to the broader social, economic, and cultural contexts of which he was a part', their anthology presents Catesby's work within the context of colonization, with specific discussions of Newtonian natural philosophy; eighteenth-century landscaping, gardens and plant introductions; patronage; and 'changing relationships among peoples as well as among animals and plants … resulting from the highly complicated processes of colonial expansion'. They hope that their focus on Catesby from these particular vantage points will stimulate 'further investigation

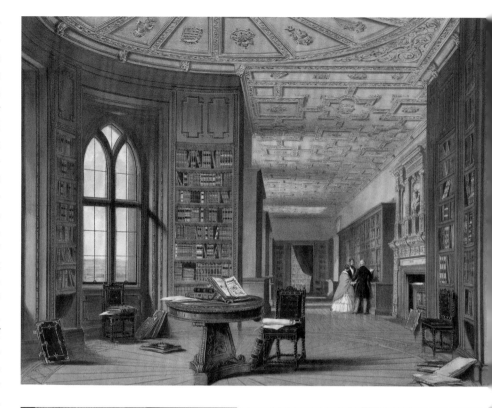

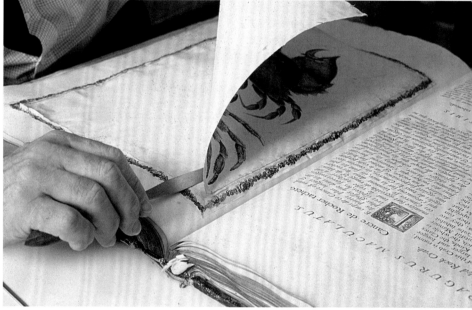

of Catesby's life and work as they illuminated the links between the study of nature and the building of empire'.[37]

Schiebinger and Swan take up the theme in *Colonial Botany: Science, Commerce, and Politics in the Early Modern World* (2005), which presents a wide range of case studies relating to European botany that 'together chart the shifting relationship between bot-

any, commerce and state politics in the early modern period'.[38] The editors challenge 'the historiography of early modern botany', specifying the need to 'bring the science of botany from its perceived isolation as the history of taxonomy into its widest context of the culture, politics and economics of the early modern world'.[39] The anthology *Visions of Empire: Voyages, Botany and Representations of Nature* (2010), edited by Miller and Reill, explores the relationship between the pursuit of botany and the spread of empire during the second half of the eighteenth century. Noting the 'transformation of the collecting mentality from that of gentlemanly virtuoso to an ordering of collections following systematic lines', they focus on two key figures of botanical science, Joseph Banks and Carl Linnaeus, both of whom are seen as 'agents of empire'.[40]

The Botany of Empire in the Long Eighteenth Century (2016), edited by Batsaki, Cahalan and Tchikine, grew out of a symposium on botanical art and illustrations held at Dumbarton Oaks in 2013. This study 'puts botany at center stage at the time when the knowledge and exploitation of plants becomes a fundamental instrument of imperial expansion and government control'. By encompassing the broad timespan of the 'long eighteenth century', the editors are able to survey 'widespread exploration, increase in traffic in botanical specimens, taxonomic breakthroughs, and horticultural experimentation', while their similarly broad geographical scope encompasses powers without overseas colonial possessions, such as the Russian and Ottoman empires.[41] Looking at the material through a number of different case studies, they emphasize the theme that 'the impulse to survey, map and collect are closely linked to the imperial ambition.' The studies include the story of the transglobal movement of the ancient Chinese drug, ginseng (a plant Catesby included in the Appendix to his *Natural History*, see fig. 114), and an analysis of the first comprehensive flora of the Russian empire written by Catesby's friend, the Swiss doctor Johann Amman. In his *Stirpium rariorum in Imperio Rutheno* (1739), Amman, who had been appointed to the first chair in botany at the Saint Petersburg Academy of Sciences in 1733, created 'a lasting image of imperial Russian flora'.[42]

The editors of this book reflect on the use of the 'convenient and seemingly self-evident' category of 'empire' and scrutinize the portrayal of eighteenth-century naturalists as 'agents of empire' through the

different case studies of botanists who were 'both connected to European networks and resistant to their strategies of control'. The editors rightly point out that 'time and again, botanical narratives also convey the lingering romance of discovery, the enduring hold of curiosity and surprise, and the possibility of scientific and aesthetic distinterestedness, even as botany becomes enmeshed with economic profit and imperialist schemes.'

In *Visible Empire: Botanical Expeditions and Visual Culture in the Hispanic Enlightenment* (2012), Bleichmar brings the discussion to bear on botanical images created specifically for the Spanish empire. She employs the term 'visual epistemology' to refer to 'a way of knowing based on visuality encompassing both observation and representation'.[43] She provides detailed analysis of the labour-intensive stages involved in producing each image, including 'multiple observations, decisions, negotiations, and types of expertise', processes which often took place in difficult physical conditions. These efforts on the part of investigators, botanists and artists 'converged to make empire not only viable but visible'. Furthermore, 'images were used to communicate and convince, to help the memory, to make a point more vividly or clearly, and to delight and entertain.'

The present book, while acknowledging these debates and overlapping with some of their areas of focus, is written from a different vantage point. While Catesby's collecting expeditions in the New World were made against the backdrop of early eighteenth-century colonial exploration and expansion, and were thus inextricably bound up with the scientific interests and economic and political attitudes of his time, he represents a botanist who was 'both connected to European networks and resistant to their strategies of control'.[44] As we have seen, he states clearly in the preface to his book that his first trip to Virginia (1712–19) was motivated by his 'Curiosity', indeed his 'passionate Desire', to explore the natural history of the New World: 'my Curiosity was such, that … I … imbibed a passionate Desire of viewing as well the Animal as Vegetable productions in their native countries.' Self-financed, he remained in Virginia seven years, although 'viewing' became collecting, painting, gardening and sending plants to his friends in England (Chapters 2 and 5). His responses to the untamed nature he found in Virginia – an 'active engagement with the land and personal experience in the

field'[45] – were unimpeded by political motives or the requirements of wealthy individuals and institutions at home. This trip was in marked contrast to his second visit to America (1722–6) made on behalf of a group of twelve sponsors, amongst whom was Francis Nicholson, Governor of South Carolina, who provided him with a pension of £20 a year 'to observe the Rarities of [South Carolina] for the uses and purposes of the [Royal] Society'. Yet even if, on this second expedition, Catesby can be described as an 'agent of empire', his personal objective – to write and illustrate a book on the natural history of the area – was pursued in parallel with, or at times in spite of, the need to fulfil his obligations to his sponsors. On several occasions he speaks of the conflict of interest between his own project and the demands of his sponsors – or between 'scientific or aesthetic disinterestedness' and 'economic profit and imperialist schemes' (Chapter 6).

The remarkable survival of the different sources of primary material connected with Catesby allows us to attempt to reconstruct his working life and his aims as a naturalist and artist. While an examination of the broader social, economic and cultural contexts of which he was a part is likewise critical to a proper understanding of his work, theoretical claims must be grounded in the available evidence. Without such a base, broader claims necessarily remain at least partly hypothetical. While not ignoring the wider perspectives, the vantage point of this book, therefore, is based on close examination of the three main sources of primary material outlined above: Catesby's drawings, plant specimens and writings. Until now, the scattered nature of these bodies of material has made it hard for scholars to access them. In assembling them together, this book aims not only to provide a source – or resource – for future studies of Catesby, but to present a case study of the material culture out of which Catesby created his book.[46]

Examination has led to reflections on the diverse strands of enquiry that make up the content of Catesby's *Natural History* – a work described by his eighteenth-century biographer, the physician and botanist Richard Pulteney (1730–1801), as 'the most splendid of its kind that England had ever produced'.[47] The flora and fauna Catesby collected served not only as the models for his images but as specimens for academic botanists and collectors at home (Chapter 6). The images he made and assembled for use in his book functioned both to convey visual and scientific information and as works of art. Observing and recording from life, 'truthfully and accurately', went side by side for Catesby with a constant urge to explore and invent as well as a delight in the beauty and novelty of the natural world. These twin impulses are reflected in his prose as well as his visual imagery: in his writing he conveys factual information, but he also shares with the reader his emotional responses. As a field naturalist he had to train himself to remember the details of form, shape and colour, in addition to morphological configurations, but these visual qualities were equally important to him as an artist (Chapter 4).

The equal importance Catesby accorded to artistic and scientific impulses would have been rare by the end of the century. In Catesby's day, however, there was no clear-cut demarcation between science and art; as one recent scholar has put it, concepts of art and science were 'distinguishable but inseparable in the period'.[48] Movement towards such categorization and the evolution of self-contained disciplines began towards the end of the eighteenth century and into the next, by which time gentlemen of science and indeed fine artists were developing their own specializations from 'a chaotic world of knowledge'.[49] It was at this time that the concepts of 'amateur' and 'professional' too were changing; those who had previously and rigorously pursued scientific goals unremunerated were being supplanted by those in universities and elsewhere who followed scientific 'careers'.[50]

It has been noted that 'Science of the eighteenth century is a dialogue between individuals and societies, culture and nature.'[51] Indeed, such a dialogue is a major theme of the recent scholarly literature surveyed above. A similar dialogue is certainly true of Catesby's work in multiple ways. His achievements were both recognized and affirmed by the men of science connected to the Royal Society, and thus integrated into the political, social and cultural aspirations of the time. His development as a naturalist and artist throws light on the ways in which gentlemen amateurs learned their skills. His artistic borrowings illuminate the widespread practice of imitation and copying amongst artists at this period (Chapter 4). In these and other respects he was typical of his time. In other ways his independence from prevailing trends, and the originality of his eye and his artistic practices, set him apart from the

drier and more consistent representation of most other eighteenth-century natural history illustrators. It is these qualities that give his images their perennial appeal.

The present study is indebted to the work of Frick and Stearns, whose comprehensive assemblage of manuscript sources in *Mark Catesby: The Colonial Audubon* (1961) laid the foundations for all later work on Catesby.[52] The contextualizing of Catesby's work in Meyers and Pritchard, *Empire's Nature: Mark Catesby's New World Vision* (1998), has likewise been influential. The most recent anthology, *The Curious Mister Catesby*: *A 'Truly Ingenious' Naturalist Explores New Worlds* (2015) edited by Nelson and Elliott, grew out of papers presented by a broad group of scientists and historians at a conference to mark the 300th anniversary of Catesby's arrival in the New World, which took place in November 2012 in Richmond, Virginia, the Smithsonian Libraries and Archives, Washington, DC, and Charleston, South Carolina. Important new biographical information gathered by Nelson specifically for that book has been invaluable for this study.

The book is organized around the significant surviving repositories of material culture connected with Catesby's life and work. Following a survey of the fields of interest against which Catesby carried out his work (Chapter 1), Chapter 2 aims to show the ways in which aspects of his character may be understood through his life and work. Chapter 3 sets out the technical, artistic and other processes involved in the creation and publication of his books. Chapter 4 discusses the materials, techniques and sources for Catesby's art. Chapter 5 seeks to evaluate his horticultural achievement from the evidence of his gardening activities and plant introductions provided in his writings and herbarium specimens. The final chapter attempts to evaluate Catesby's contribution as a naturalist by drawing particularly on his letters, his surviving collections, and contemporary documentation of plant and animal specimens received by Sloane. Appendices include a 'Note on Catesby's Plant and Animal Specimens', a 'Note on Catesby's Paper' (with a section on watermarks contributed by Peter Bower), and transcriptions of all of the letters by Catesby that have been found. Subsections of the Bibliography are devoted to Catesby's published works and their derivatives (contributed by Roger Gaskell) and to the authorities Catesby cites in his *Natural History* (contributed by Leslie Overstreet). An illustrated catalogue raisonné of Catesby's drawings and his related natural history specimens, co-authored with Stephen Harris, is in progress.[53]

Note on citation of plant and animal names

In assigning plant and animal names to the specimens he collected, Catesby employed a combination of vernacular and Latin names in his book: English and Native American common names and, where none existed, names he coined himself; and, for scientific designations, descriptive Latin phrases (polynomials) provided by the botanist William Sherard, taken from the works of other natural history authors, and some again invented himself (see Chapter 6, pp. 212–13, and Bibliography: Catesby's authorities, pp. 332–4). Cumbersome Latin polynomials were eventually replaced when Linnaeus made consistent use of a binomial system.

The present book employs all these categories of names. Catesby's own names (either common or Latin) are used in the captions to his illustrations, and sometimes in the text. Familiar modern common names and current scientific names are used in the text, sometimes together with Catesby's names where the link between them is less obvious. In order to differentiate between names applied by Catesby and modern common and scientific names, Catesby's common names and Latin polynomials are quoted in inverted commas and in Roman, while modern common names are cited without inverted commas, and current scientific names (Latin binomials) are cited in the usual way in italics, using a capital letter for genus and lower case for species.

Gramen arundinaceum montanum, panicula longa angusta ... Syst. 113. ...

Gramen paniculatum, arundinaceum, panicula densa, spa-
- dicea Inst. r. h. 523. Vir. Ref. T. 76. et 99. Base.
 mont. prod. 58.

III. Gramen arundinaceum paniculâ mol-
li spadiceâ majus. C. B. Pin. 7. Theat. 95. ico. Prodr. Agrost. Helv. 21. Tab.
Gramen tomentosum, Lob. ico. et acerosum, Calamagrostis quorundam
Graminis loliacei 8. alia species. Thal. vulgo gramen plumosum Lob. ic.

Gramen plumosum Lobelii, spica candida et ... serici modo ...
lucente J. Bauh. Hist. Tom. II. L. 18. C. 115. p. 476. Chabr. 186. ic. ... arundinaceum acerosum et tomentosum ...
Gr. arundinaceum J. Schw. Cat. 95. Adv. Park. Alt. 462. in Tabula.
Arundo sylvatica latior panicula molli candida et serici
modo lucenti Hist. Oxon. p. 3. 218. ... Mon. n. 2. S. 8. Tab. 8. f.
2. serie 2. Cic. nov. bon.

‡ Gramen Dumetorum panicula acerosa semine papposo
R. Hist. ... 1. 2. 87. forte quod Rajus se vid. fecit in sepibus quibusdam
Agri Northamtoniensis et Essexiensis et Gr. 3. Syn. p. 406. Ed. Test.
Gr. plumosum Lob. quod vel si describit ex Lobelio, hujus loci est
Gr. tomentosum arundinaceum Ger. Em. 9. Cic. Lob.

Calamagrostis sive Gr. tomentosum Park. 1182. Cic. Lob.
et. Calamagrostis nostras Sylva St. Joannis Park. Th. 1180. descr. 1181.
propr. Park. Th. Lob. Johnson 42. Raj. Hist. II. 1282.
Calamagrostis nostras Lob. Adv. Park. Alt. 462. in Tab.
Gr. arundinaceum paniculatum, montanum, panicula spadiceo viridi
C. B. 8. semine papposo Scheuchz. Hist. Alp. 409. Meth. gram. 28. Base
calamagrostis val harundinaceum forte Babylonium Lob. Adv. 3.
 Scheuchz. Meth. gr. 2.

IV. Gramen arundinaceum panicula molli Camp. Elyss. t. 1. p. 61.
spadicea minus. C. B. Pin. 7. ... Theat. 95. mont. prod. 58.
Graminis loliacei octavi tertia species. Thal. 51.

Gr. paniculatum palustre, praealtum, axila, panicu-
- la arundinacea Pontad. Comp. Tat. Bot. 56.
an Gramen arundinaceum alterum C. Bauhini Lob. Adv. Park. Alt.
462? in Tabula. Scamptoni
Calamagrostis minor glumis rufis et viridibus Petiv. Conc. Gr. n. 69. Syn. Ed.
III. 401.

Gr. arundinaceum, montanum, panicula flavescenti

Catesby's World

A CULTURAL AND SCIENTIFIC CONTEXT

'the Scholar took his place near the Naturalist,
and the Mathematician near the Antiquarian or the Painter'[1]

Mark Catesby (1683–1749) was born in East Anglia in 'the thirty-fifth year of King Charles II',[2] and died in London in the reign of George II. Between these two monarchs, five others had reigned – James II, William III and Mary II, Anne, and George I. The England of Catesby's childhood had, after the Act of Union of 1707, become part of the United Kingdom of Great Britain, while on the Continent there had been almost continuous war between the Nine Years War (1688–97) and the War of Spanish Succession (1701–14). Further afield, the development of the American colonies was bringing about a huge expansion in trade, voyages of exploration and economic expectation.

Catesby lived and worked against this backdrop of political turmoil and change both at home and abroad. For him, however, the aims of science, not confined by national boundaries, took precedence over war and politics. His pioneering life and work were made possible by the expanding empire, and by the international scientific networks of which he was a part. The interconnectedness of activities and interests brought him into contact with many different groups of people and individuals from all walks of life.

He began his *Natural History of Carolina, Florida and the Bahama Islands* with a clear statement about his early vocation to study natural history: 'The early Inclination I had to search after Plants, and other productions in nature, being much suppressed by my residing too far from London, the centre of all Science, I was deprived of all opportunities and examples to excite me to a stronger

pursuit after those things to which I was naturally bent.' What led Catesby to state that London was 'the centre of all Science'? And in what sense was he 'deprived of all opportunities and examples' to pursue 'those things to which [he] was naturally bent'? The part of East Anglia in which he had spent his youth was the focus of an active network of learning, both scientific and antiquarian – or, in the term used at the time, curiosity.[3] His early life in Suffolk and Essex evidently provided him with a context and several important contacts which proved crucial in the formation and encouragement of his interests (fig. 11).

Regional natural history circles

At the centre of this East Anglian network was 'the father of natural history in Britain', John Ray (1627–1705), who had moved back to his Essex home at Black Notley in 1662 after giving up his fellowship and appointments at Trinity College, Cambridge.[4] Ray's seminal work on classification from direct observation of species according to similarities and differences provided a new taxonomic method for the next generation of natural philosophers, amongst them Isaac Newton and Hans Sloane. Ray was to keep up an active correspondence with Sloane until the end of his life, Sloane sending him copies of newly published books on natural philosophy from London. Ray's first book, *Catalogus plantarum circa Cantabrigiam nascentium* (Catalogue of the plants growing around Cambridge),[5] also began the trend for regional natural history studies (fig. 12).[6]

FIGURE 10

William Sherard, 'Pinax',
pre-1728. Detail of fig. 19.

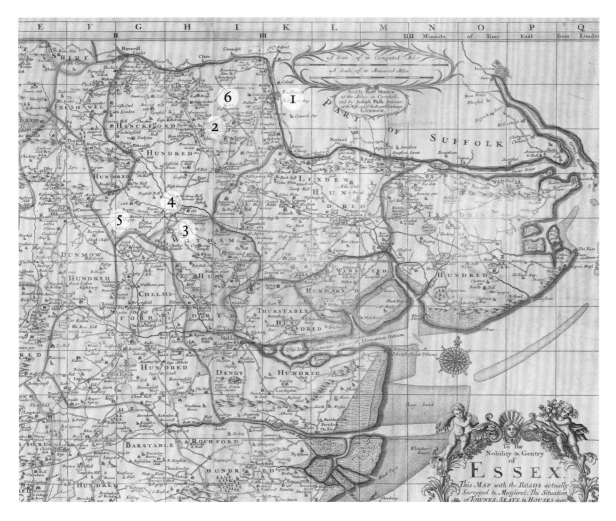

FIGURE II

Robert Morden and Joseph
Pask, *Map of Essex 'with the roads
accurately surveyed and measured'*,
marked with place names
connected with Catesby, *c*.1700,
detail. Hand-coloured engraving,
65.3 × 83.3 cm.

1: Sudbury
2: Castle Hedingham
3: Black Notley
4: Braintree
5: Felstead
6: Gestingthorpe

Cambridge University Library,
Maps.aa.17.G.7

Side by side with Ray's studies in natural history
went his interest in philology and other antiquar-
ian subjects. During his travels around England in
1662 with his former student Francis Willughby,
he recorded Roman and medieval remains, church
architecture, ancient monuments and epigraphy;
in 1691, he published his *Collection of English Words
not Generally Used*, a work which has been described
as 'the starting-point for the study of dialect and
folk-speech'.[7]

Three miles away from Ray in Braintree lived his
protégé and later executor, the apothecary and bot-
anist Samuel Dale (*c*.1659–1739). Like Ray's, Dale's
interests spanned both natural history and antiq-
uities. His two major works were a *materia medica*
(compendium of medical substances), the *Phar-
macologia* (1693), and *The History and Antiquities of
Harwich and Dovercourt in the County of Essex* (1730),
a book which combined both local history and natu-
ral history (fig. 13). In the diary of his journeys from

Braintree to Cambridge kept during 1722–38, Dale
describes collecting medicinal plants for his garden
and visiting cabinets of *materia medica*, alongside vis-
its to Roman forts and church monuments.[8]

A friend of Ray and Dale was Catesby's maternal
uncle, the antiquarian Nicholas Jekyll, who lived
nearby in Essex at Castle Hedingham. Jekyll had
inherited an important library of manuscripts from
his grandfather Thomas Jekyll, a friend of the great
seventeenth-century antiquary William Camden,
and items from the collection were loaned by Nich-
olas Jekyll to other antiquaries, including Ray.[9] Ray
consulted Jekyll specifically about local dialects, ac-
knowledging help from 'my ingenious friend Nich-
olas Jekyll' in his *Collection of English Words*. Another
antiquary who was part of the circle was William
Holman, who made much use of Jekyll's library for
his projected book on the 'history and antiquities of
Essex' (fig. 14). Jekyll urged Holman to add some-
thing on natural history to his book, suggesting that

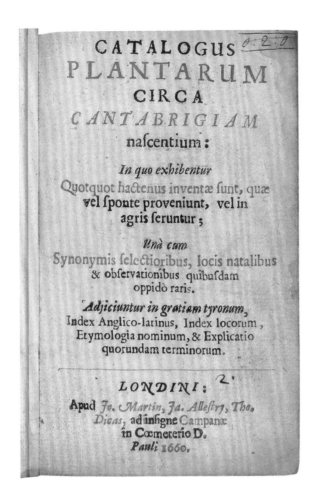

FIGURE 12

John Ray, title page, *Catalogus plantarum circa Cantabrigiam nascentium*, London, 1660. 14.3 × 8.7 cm.

Cambridge University Library, CCE.47.37

FIGURE 13

Samuel Dale, 'Bivalve fossils', *History and Antiquities of Harwich*, London, 1730, tab. XII. Engraved plate, 21.9 × 17.1 cm.

Cambridge University Library, Ll.14.30

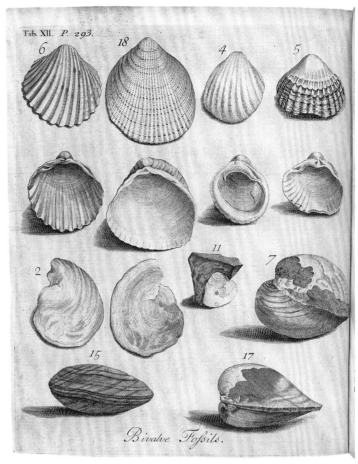

'Mr Dale would help with this,'[10] later noting that Dale in his *History of Harwich* had covered ornithology, fossils, botany, fish, etc., as well as history.[11]

Horticulture was a mutual interest for Dale and Jekyll. One of the preserved plants in Dale's herbarium is a specimen of everlasting pea, *Lathyrus latifolius*, which he collected from Jekyll's garden in 1711 (fig. 15).[12] Dale may have shared with Jekyll some of the seeds Catesby sent back from his first trip to the New World between 1712 and 1719; later Jekyll was to receive seeds from South Carolina directly from his nephew. Catesby's request that his uncle pass certain seeds, roots and berries on to William Sherard, as well as to Cromwell Mortimer, secretary of the Royal Society, indicates that Jekyll was also in contact with the scientific world in London.[13]

Other members of the East Anglian natural history circle with whom Catesby may have come in contact were two Nonconformist ministers, Mansell Courtman at Castle Hedingham and Samuel Petto at Sudbury. Courtman was a naturalist and collector with a particular interest in insects, provid-

FIGURE 14

Nicholas Salmon, manuscript title page, *The History and Antiquities of Essex, from the Collections of Thomas Jekyll of Bocking, Esq. ...*, London, 1740. 35.8 × 22.9 cm.

Cambridge University Library, 7460.a.1

ing specimens from his collection for Ray to describe in his *Historia insectorum* (history of insects) (1710).[14] He also shared with Ray and Jekyll an interest in English dialects, and along with Jekyll was cited by Ray in his *Collection of English Words*.[15] Samuel Petto (*c.*1624–1711) was a much respected pastor of the independent chapel in Friars Street, Sudbury.[16] His interest in natural science led him to contribute a paper to the Royal Society's *Philosophical Transactions* on a parhelion observed in Suffolk in August 1699.[17] Growing up within such a network, it is not surprising that Catesby – with his self-proclaimed interest in natural history from a young age – should have made use of it. In his youth he visited Ray frequently, and either through Ray or his uncle Nicholas Jekyll was adopted by Dale as a protégé and later became a dedicated plant collector for him.[18]

During the last part of his life Catesby became associated with another prominent regional network for the exchange of scientific and antiquarian information, which modelled itself consciously on the London learned societies of the Royal Society and Society of Antiquaries. In Lincolnshire in 1710 a group of gentlemen *virtuosi* had founded the Spalding Gentlemen's Society.[19] Originating in informal meetings at a local coffee house in Spalding, the group became organized more formally under a secretary, the antiquary and lawyer Maurice Johnson, in 1712.[20] Among its members were Johnson's friend William Stukeley, also an antiquary and a natural philosopher who lived nearby in Holbeach; Isaac Newton, who gave a substantial quantity of books in 1724; Hans Sloane and Alexander Pope. Catesby was to be elected an honorary member in 1743.[21] The society's main subjects of discussion were antiquarian and literary, but as with the Essex circle, its members were equally interested in natural history. In the minutes for a meeting on 28 January 1733, there is a record: 'That at the Royal Soc. 14 Inst. was read an Accurate description of the most uncommon Fowles & Plants in Carolina drawn, painted and described by Mark Catesby there.'[22] When Johnson reported on the society's activities to Cromwell Mortimer at the Royal Society in 1737, he listed its facilities, including 'an Airpump, Microscopes, Thermometre, Barometre, several large Portfolios with Prints and Drawings in them of various sorts; but above all, we have raised a publick lending library of above 1000 volumes kept clean and safe in presses'. Johnson, who was also a keen gardener,

further recorded that 'we open into a little garden of our own where our Servant (who is a curious Florist) produces most Flowers for their Sorts in Season.'[23]

The word 'curiosity', used frequently among such networks of learning, had a number of meanings, ranging through 'inclination to enquiry', 'accuracy', 'exactness', 'a nice experiment' and 'rarity'.[24] Applied both to works of art and to nature's workmanship, it has been defined as 'both a state and a way of seeing' and as 'the beginning of science'.[25] It also indicated the broad range of intellectual interest which only

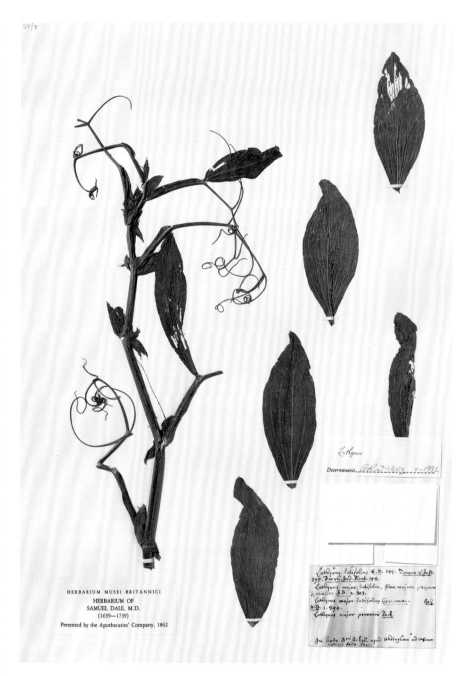

FIGURE 15

Everlasting pea, *Lathyrus latifolius*, from Nicholas Jekyll's garden. Plant specimen with Dale's label, 40.7 × 28.5 cm.

Natural History Museum, London, Department of Life Sciences, Algae, Fungi and Plants Division, Dale Herbarium, no. 57/9

in the nineteenth century would come to be used of someone labelled a 'polymath'. As we have seen, Catesby was to use the term to describe his own interest and 'passion' in the opening lines of his *Natural History*, where he wrote that 'my Curiosity was such, that ... I soon imbibed a passionate Desire of viewing as well the Animal as Vegetable productions in their native countries.' He also came to refer to his widening circle of contacts as 'my Curious Friends'.[26]

London, the 'Centre of all Science'

These regional manifestations of 'curiosity' or scientific enquiry and exploration into the natural world were demonstrative of a larger movement of intellectual ferment, at the centre of which was the Royal Society of London. Fundamental to this movement was the notion of a 'Republic [or 'Commonwealth'] of Letters' between 'curious friends' – a European and, at its fullest extent, worldwide sharing of information through the exchange of letters, reports, books, specimens and other material. Catesby's East Anglian contacts and education, while providing him with the initial impetus to pursue a life in natural history, at the same time whetted his appetite for the scientific activities centred in London around its prominent figures, collections and gardens, libraries, publishing houses, and societies and other meeting places for discussion and exchange of material.[27] On his return from Virginia in 1719, he made the most of his knowledge of New World natural history together with the fruits of his collecting and his artistic activities to integrate himself into the cultural life of the metropolis. In 1726, after returning from his second trip to the New World, Catesby was to make London his home for the rest of his life. It was thus against the background of the cultural and scientific life of London that Catesby's life's work was brought to completion.

During the second half of the seventeenth century, excitement about the natural world was one of the reactions to the religious and political turmoil that had erupted into the Civil War. The period was characterized by the immense scientific discoveries of Hooke, Boyle and Newton. In 1687, four years after Catesby's birth, Newton had published his *Philosophiae naturalis principia mathematica* (mathematical principles of natural philosophy); and in 1703, when Catesby was twenty, Newton was elected president of the Royal Society of London, founded in 1660 'for Improving Natural Knowledge'. Newton was to hold this position until his death in 1727. Under him, the Royal Society was to lead the intellectual quest for gaining knowledge based on empirical observation, experiment and verification rather than on classical authority.[28] This new method of an 'objective' observation of nature had been articulated by the philosopher John Locke, who in his *Essay Concerning Human Understanding* (1689) emphasized the importance of the use of the senses in acquiring knowledge.[29]

Science and religion were closely intertwined in the debates of the day. Whilst the study of the natural world was primarily a scientific pursuit, for most it was also part of the religious framework in which nature was understood as the manifestation of the works of God as the divine creator.[30] There was no conflict between science and religion. John Ray had articulated an important attitude through his belief that the study of nature revealed the wisdom of God and wonder of creation. In his *Catalogus plantarum Angliae* (catalogue of English plants), he wrote, 'I know of no occupation that is more worthy or more delightful ... than to contemplate the beauteous works of Nature.'[31] He articulated this fully in his *Wisdom of God manifested in the Works of the Creation* (1691), which has been described as a 'treatise upon the adaptation of form to function in nature'.[32] Ray's 'natural theology' was taken up by many of the natural philosophers of the following generation, including Newton, and it is evident in the work of Catesby and his fellow natural history authors.[33]

Plant collecting

Naming and classifying new species for the ever-growing catalogue of nature was one aspect of 'Improving Natural Knowledge'. The aim of achieving scientific comprehensiveness existed side by side with the urge to collect rare natural objects and identify commodities for potential mechanical and medicinal use.[34] To these various ends, members of the Royal Society and other wealthy individuals sponsored plant collectors and explorers to travel to America, Africa and the Near and Far East to collect new material which could then be added to the 'philosophical stock' or 'general banck' of experimental learning.[35] The material collected was incorporated into collectors' cabinets, used for medicine and for commercial gain from colonial enterprise.[36]

The Royal Society published detailed instructions about the phenomena travellers were encouraged to observe. Robert Boyle wrote a treatise entitled *General Heads for the Natural History of a Country, Great or Small; drawn out for the use of Travellers and Navigators*, in which information was to be sought under the headings of Mineral, Vegetable and Animal Kingdoms.[37] The apothecary James Petiver in his *Musei Petiveriani* (1695) directed collectors to follow Boyle's instructions.[38] The prose style in which the findings of collectors should be recorded was also specified, the Royal Society 'preferring the Language of Artizanz, Countrymen, and Merchants, before that of Wits, or Scholars'.[39] The aim was that observations recorded in collectors' accounts and journals, together with specimens, should provide scientists with a new corpus of objective data on which to build a scientific explanation of the physical universe. Some of this data was published in the Royal Society's *Philosophical Transactions*, and some in books written by the collectors themselves, as Catesby was to do.[40]

Outstanding among the plant collectors during this period was the clergyman John Banister (1654–1692).[41] Sponsored by the botanist Bishop Henry Compton to collect in Virginia, Banister, like Catesby after him, was to enjoy hospitality and patronage, as well as a well-stocked library, in the plantation home of the Byrd family of Westover, Virginia.[42] Banister's accidental death during a plant hunting expedition prevented him from carrying out his planned publication of a 'Natural History of Virginia'. Instead, his findings were incorporated by John Ray in the second volume of his *Historia plantarum* (London, 1704),[43] while other data the naturalist had assembled was published in the *Philosophical Transactions*.[44] Banister had recognized the need to illustrate natural history specimens as well as describe them in words, and had taught himself drawing for this reason (fig. 16); yet partly because of cost and partly potential inaccuracy, Ray did not include illustrations in his *Historia plantarum*.[45] In the words of one commentator, 'Banister's contribution far outshone those of the men sent after him: … and no one with his exceptional background, talent, and enthusiasm could be found to replace him until Mark Catesby more than a quarter of a century later recorded the natural history of Carolina and Florida.'[46]

John Lawson (1674–1711), another English explorer and collector in the New World, in his *New Voyage to Carolina* (1709), was to hail Banister as 'the greatest Virtuoso we ever had on this Continent'.[47] Lawson was sponsored by a group of the ruling landlords (the Lords Proprietor) to survey the natural resources of North Carolina; the 'Description and Natural History' and 'An Account of the Indians of North-Carolina' which he included in his book were to have been developed into a much fuller account of the natural history of North Carolina had he too not lost his life, in his case at the hands of the Tuscarora tribe in 1711.[48] Nevertheless, Lawson's book, described as 'one of the best travel accounts of the early eighteenth-century colonies', proved im-

FIGURE 16

John Banister, 'Plantae papescentes' (Appalachian blazing star, *Liatris squarrulosa*), 1690s. Pen and ink, 21 × 16.3 cm.

British Library, London, Sloane MS 4002.88

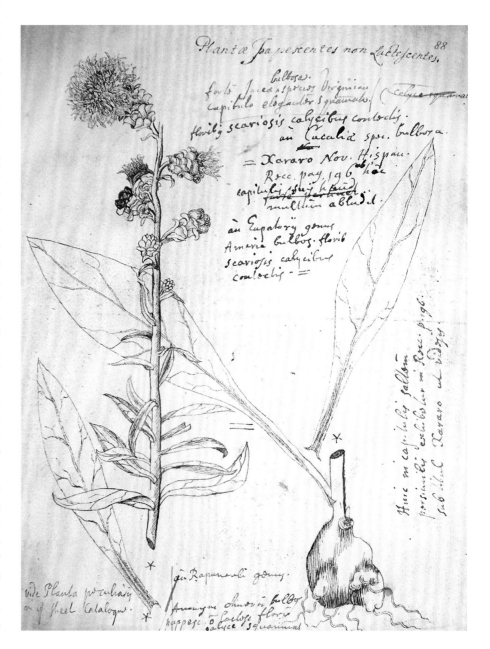

FIGURE 17

John Lawson, 'Dictionary' in 'An Account of the Indians of North-Carolina', *The History of Carolina*, London, 1718, pp. 226–7. 20.8 × 15.9 cm.

Cambridge University Library, Syn.5.71.14

mensely influential.[49] Written in a plain, direct style, including its vivid 'Journal' of the author's 'A thousand Miles Travel among the Indians, from South to North Carolina' and its 'Dictionary' of words and phrases from several different indigenous languages, the work was indispensable to many later travellers and collectors (fig. 17). It was to provide a seminal reference work for Catesby, who (specifically) noted his debt to Lawson's 'Account of the Indians': 'Mr. Lawson, in his account of Carolina, printed Anno 1714, has given a curious sketch of the natural dispositions, customs, &c. of these Savages. As I had the same opportunities of attesting that Author's account as he had in writing it, I shall take the liberty to select from him what is most material, which otherwise I could not have omitted from my own observation.'[50]

Academic botanists, herbaria and botanic gardens

Pre-eminent among the academic botanists attempting to catalogue the enormous number of new species arriving from foreign parts, and to incorporate them (with cumbersome Latin polynomials) into a taxonomy, was William Sherard (fig. 18), known as 'the Maecenas of botany' by his contemporaries.[51] After studying law at Oxford, Sherard made three grand tours on the Continent as a travelling companion and tutor, where he came into contact with two of the most distinguished Continental botanists – Joseph Pitton de Tournefort in Paris and Paul Hermann, professor of botany at Leiden. He also travelled and collected plants in Italy, and spent a fifteen-year period in Turkey as British Consul in Smyrna (Izmir), where he studied and collected the plants of Asia Minor.[52] At his death, he left funds for the founding of the first chair in botany at Oxford, named after him. His magnum opus – his so-called 'Pinax' – was an attempt to 'to publish an account of the world's plants' by updating the list of 6,000 plants included by the Swiss botanist Caspar Bauhin in his *Pinax theatri botanici* (catalogue of the theatre of plants) (Basel, 1623), with every known species discovered since then.[53] Left unfinished at his death, the ambitious project was taken over by Sherard's German protégé, Johann Jakob Dillenius, who likewise left it unfinished. The 'Pinax' survives as an unpublished manuscript in the Department

of Plant Sciences at Oxford, a resonant symbol of the belief that it was possible to make an exhaustive catalogue of the world's known plants (fig. 19).[54] It was Sherard who recognized Catesby's potential as a plant collector, and who, after seeing his collection of plant specimens and drawings made in Virginia, assembled a group of sponsors to send him to collect in South Carolina. Of the several plant collectors Sherard sponsored in the New World, Catesby was to be by far the most successful.[55]

Plants were sent from foreign parts in the form of the *hortus siccus* (literally, dried garden) of preserved, pressed specimens which could then be studied and compared with other specimens in collectors' herbaria. A labelled herbarium was the essential tool for serious eighteenth-century botanists, 'providing a link between a plant's identity and the evidence of its occurrence at a particular point in time and space'.[56] Live plants in barrels of soil and seeds were also sent by collectors, and these, once propagated, became part of the botanical garden or *hortus vivus* (living garden). Some of these gardens were kept by naturalists for the purpose of studying rare and exotic plants.[57] Others were more specifically for growing medicinal plants.

FIGURE 18

Unknown, *William Sherard*, pre-1728. Oil on canvas, 82.2 × 69 cm.

University of Oxford, Department of Plant Sciences

FIGURE 19

William Sherard, 'Pinax', pre-1728. 27.4 × 19.4 cm (leaf size).

Sherardian Library of Plant Taxonomy, University of Oxford, MS Sherard 46, fols 29v–30r. University of Oxford, Department of Plant Sciences

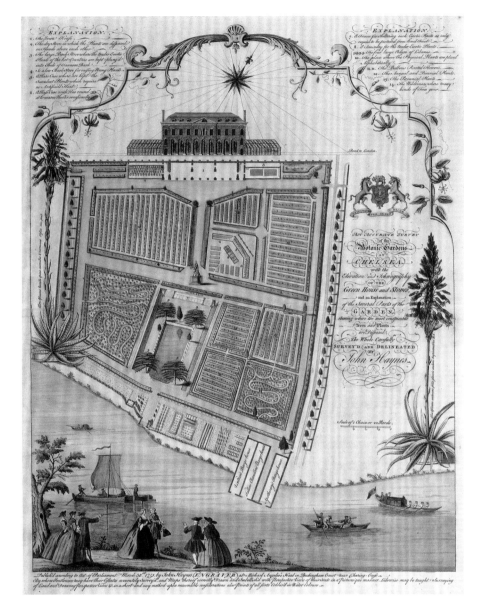

One of the most famous of these dedicated physic gardens was that of the Society of Apothecaries – the Chelsea Physic Garden – founded in 1673 for the purpose of training apprentice apothecaries to study the medicinal plants grown there; the plants or simples from the garden were then processed in the laboratories in the Apothecaries' Hall at Black-friars. From 1722 the Apothecaries were required to supply fifty herbarium specimens a year to the Royal Society, and during this period, under the direction of Philip Miller (1722–70), their garden became the most renowned physic garden in Britain and a 'pivot of horticultural debate and plant dissemination' (fig. 20).[58] Plants sent from all over the world, including by Catesby from North America, were grown in the

Chelsea garden (fig. 21), and in its turn, it exchanged seeds with other physic gardens such as the equally famous Hortus Botanicus at Leiden.

In 1728, under Philip Miller, a group of the most prominent nursery gardeners based in and around London joined together to form a Society of Gardeners; in 1730 they published the first volume of their *Catalogus plantarum*, or *A Catalogue of Trees, Shrubs, Plants, and Flowers both Exotic and Domestic which are propagated for Sale in the Gardens near London*. Their stated purpose was 'to promote the Introducing among us such foreign Trees, as may contribute either to Usefulness or Delight', with the aim also to bring order into plant nomenclature.[59]

Many private owners – both in and outside London – likewise had gardens of rare plants in which new discoveries and exotic plants were prized. One such garden owner was William Sherard's brother, James, also a botanist, and an apothecary who had made a fortune from his London practice.[60] His garden at Eltham, Kent, then a small village around nine miles outside London, included hothouses for exotics and became renowned as one of the finest in England for rare and valuable plants, containing 'many species new to science or little known and never before illustrated'.[61] Catesby knew James Sherard, sent him plants from South Carolina, and frequently asked to be remembered to him in his letters to William.[62] He may have got to know the Kent countryside on visits to the Eltham garden. He wrote of the landscape at the foothills of the Appalachian Mountains that it was 'a very pleasant Hilly country infinitely excelling the inhabited parts both for goodness of land and air resembling the best parts of Kent but in some places affording much larger prospects'.[63]

The contents of James Sherard's Eltham garden were commemorated in a large two-volume catalogue, *Hortus Elthamensis*, published in 1732, containing 324 illustrations of 417 plants, described, drawn and engraved by Dillenius.[64] Recording several plants grown from seeds which Catesby sent William Sherard from the Bahama Islands, the book was considered 'one of the most important pre-Linnaean works' (figs 22 and 23). It was to be cited frequently by Linnaeus in the *Species plantarum* (1753).[65]

The Duchess of Beaufort's garden at Badminton, Gloucestershire, was another private garden renowned for its rarities and exotics grown using newly developed hothouses (fig. 24).[66] The duchess, Mary Somerset, was a serious, self-trained botanist

FIGURE 21

Philip Miller, *Catalogus plantarum officinialium quae in horto botanico Chelseyano aluntur* (catalogue of pharmaceutical plants raised in the Chelsea Physic Garden), London, 1730. 19.7 × 12.6 cm.

Cambridge University Library, CCD.47.133

who assembled over a quarter of a century (until her death in 1714) an enormous geographical range of plants, both in her garden and in the twelve volumes of her herbarium. Live plants and dried specimens, which she identified from her extensive library of botanical works, came from as far afield as the West Indies, Africa, India, Sri Lanka, China and Japan.[67] The duchess employed William Sherard as a tutor to her grandson, no doubt so that she could benefit from his botanical expertise.[68] Like James Sherard, Mary Somerset had a visual record made of choice exotics in her garden – a sumptuous florilegium, painted on vellum by Everard Kick between 1703 and 1705 (fig. 25).[69] Kick was recommended to the duchess by her neighbour in Chelsea, Sir Hans Sloane, who had employed him to make drawings of plants for his two-volume *Voyage to the Islands Madera ... and Jamaica* (1707–25), as well as of zoological and other subjects for his natural history albums.

Sloane also sent the duchess seeds and specimens which she cultivated both at Badminton and in her London garden at Beaufort House, and she in turn shared seeds and botanical curiosities with Sloane (fig. 26).[70]

The Quaker merchant and botanist Peter Collinson (1694–1768) was responsible for introducing many new plants into cultivation in his gardens, which became celebrated for their American exotics (see fig. 80).[71] His first garden was at his house at Peckham, then a small hamlet south of London; from 1749, he spent two years transplanting his trees and shrubs into what was to become a more famous garden at Ridge House, Mill Hill, Middlesex, a property inherited from his father-in-law. Its contents were later to be catalogued in *Hortus Collinsonianus*, drawn up from unpublished lists Collinson had begun in 1722.[72] A nineteenth-century biographer was to write, 'Natural History in all its

FIGURE 25

Everard Kick, thorn apple, snowdrops and saxifrage, 1705. Watercolour and bodycolour over graphite on vellum, 58.4 × 42.5 cm.

Badminton House, Gloucestershire

parts, Planting, and Horticulture, were his delight. He cultivated the choicest exotics, and the rarest English plants. His garden contained, at one time, a more complete assortment of the Orchis genus, than, perhaps, had ever been seen in one collection before.'[73] Equally known as a promoter of botany and a friend of everyone in the horticultural world, Collinson himself was to record late in life: 'I often stand with wonder and amazement when I view the inconceivable variety of flowers, shrubs, and trees, now in our gardens and what there were forty years ago; in that time what quantities from all North America have annually been collected by my means of procuring.'[74] Collinson assisted also with publication of the works of others. When Catesby returned from the Bahamas in 1726, Collinson was to give him a substantial interest-free loan to enable him to proceed with plans for his book, a gesture that resulted in Catesby's gift to him of a copy of the *Natural History*.[75] Further, Collinson was responsible for encouraging a number of noble garden owners to subscribe to Catesby's book, including the dukes of Argyll, Bedford and Richmond, and his particular friend, Lord Petre.

Landscape and nursery gardens

The 8th Baron, Lord Petre, was at the forefront of the new taste in landscape gardening, to which Alexander Pope was a major influence, both in his poetry and prose and in the example of the garden he created with Charles Bridgeman at Twickenham. Pope's line 'First follow Nature and your Judgment frame' pointed the way to a more natural and 'painterly' style to replace the formal taste for geometrical and architectural framing of nature.[76] As part of the new school of gardening, 'Amphitheatres' of evergreens were created to balance 'wilderness' plantations and open parkland, and straight lines replaced by serpentine shapes and vistas on to rolling landscapes.[77] Petre was perhaps the most ambitious of the nobleman garden enthusiasts, and his garden at Thorndon Park in Essex became renowned for its rare trees and shrubs and stoves (heated greenhouses) for tropical plants (see fig. 193).[78]

FIGURE 26

'Black Bean' from Barbados given to Hans Sloane by the Duchess of Beaufort, c.1700. 3.9 × 3.9 × 0.8 cm.

Natural History Museum, London, Department of Life Sciences, Algae, Fungi and Plants Division, Sloane 'Vegetable Substances', no. 7004

North American shrubs and trees were supplied by the nursery trade and collectors such as Catesby. In addition, Collinson established a scheme whereby John Bartram, a Quaker farmer in Philadelphia, supplied seeds and seedlings at five guineas a box to wealthy English garden owners.[79] As Collinson observed, 'The present excellent Taste of the Nobility & Gentry to embellish their plantations with all the Variety of Trees, Shrubs & Flowers which are produced in our North American colonies has given great encouragement to the annual importation of Plants and Seeds which arrive here in the Spring months.'[80] Collinson recorded that Petre 'planted out forty thousand of all kinds of trees, to embellish the woods att the head of the park on each side of the avenue to the lodge, and round the esplanade ... His stoves exceed in dimensions all others in Europe.'[81] When Petre died of smallpox in 1742 aged 29, Collinson wrote to Linnaeus that his death was 'the greatest loss that botany or gardening ever felt in this island', adding that 'he spared no pains nor expence to procure seeds and plants from all parts of the world, and then was as ambitious to preserve them.' He further added that 'the collections of trees, shrubs, and evergreens, in his nurseries at his death ... amounted to 219,925, mostly exotic.'[82]

Charles Lennox, 2nd Duke of Richmond, was another noble garden owner whose estate at Goodwood, West Sussex, was renowned for its landscape planting. The architect Colen Campbell was to write of the 'Park, Gardens and Plantations which for the beautiful variety and extension of prospect, spacious lawns, sweetness of herbage, delicate venison, excellent fruit, thriving plantations, lofty and aweful trees, is inferior to none' (fig. 27).[83] Richmond also built a menagerie in his gardens that became renowned as a repository for exotic animals, many sent by other collectors.[84] Among several natural history artists who visited the duke's seat at Goodwood to draw the animals was Catesby's friend George Edwards, who wrote that 'though, of necessity, [the duke's] time was taken up by the important affairs of the public, yet his doors were always open to men of learning, science, and ingenuity.'[85] Among

these Edwards's portrait of the duke's tame 'Java Hare' (Brazilian agouti, *Dasyprocta leporina*) inspired a similar watercolour by Catesby which provided the model for a plate in the Appendix to his book. Recording that 'his Grace the Duke of Richmond ... was pleased to think it worth a place in this collection', the agouti was one of a number of anomalous additions Catesby made to the Appendix (see figs 168 and 169).[86] Richmond in his turn was to subscribe to three copies of Catesby's *Natural History*.

From the beginning of the eighteenth century commercial nursery gardens had begun to proliferate in answer to the demand from garden owners, although they could not supply exotic trees and plants on the scale required for plantations such as those of Petre and Richmond.[87] By the 1720s several nurseries, including those of Thomas Fairchild (and later his nephew Stephen Bacon) at Hoxton, Robert Furber at Kensington, and Christopher Gray at Fulham, were becoming well known,[88] and in the middle of the century Peter Collinson recorded:

> Mr Derby and Mr Fairchild had their gardens on each side the narrow alley [now Pitfield St in Shoreditch] leading to Mr George Whitmore's at the further end of Hoxton. As their gardens were small they were the only people for exotics, and had many stoves and green-houses for all sorts of aloes and succulent plants; with oranges and lemons and other rare plants. At the other end of the town were two famous

FIGURE 27

Thomas Bucknall, *A Plan of Goodwood Park and Warren*, 1732, detail. Pen and ink and watercolour, 155 × 109.3 cm.

West Sussex Record Office, GW E4992

FIGURE 28

Nehemiah Grew, title page,
*Catalogue & description of the
natural and artificial rarities
belonging to the Royal Society ...,*
London, 1681. 31.7 × 20 cm.

Royal Society of London

nurserymen, Furber and Gray, having large tracts of land in that way, and vast stocks; for the taste of gardening increased annually.[89]

Before he went to Virginia Catesby was introduced to Fairchild, very likely by Dale, who was a friend of the nurseryman. Some of the 'most specious [showy ornamental plants] ... in Tubs of Earth' he sent back from Virginia 'at the request of some curious friends' were destined for Fairchild.[90] On his return in 1719, and before his trip to South Carolina, Catesby was able to inspect the progress of some of these plants in Fairchild's garden. Later, when he returned from South Carolina, he established his own garden in Hoxton connected to that of Fairchild and then Bacon, subsequently moving to work closely with Gray in Fulham.[91]

Museum and other collections and the art scene

Collections of rare plants in gardens were complemented by collections of rarities of all sorts indoors. Many private individuals, as well as institutions, had cabinets of natural and artificial objects, assemblages that owed their origins to Renaissance Kunstkammern.[92] The Royal Society had a Repository from soon after its foundation, the contents of which were catalogued in Nehemiah Grew's *Catalogue & description of the natural and artificial rarities belonging to the Royal Society* (London, 1681) (fig. 28). The objects were listed according to type, beginning with 'Human Rarities' and ranging through other animals, plants, minerals and 'Artificial matters', and the text was illustrated with thirty-one plates of engravings made after the objects.[93] By the time of Catesby's membership, many of the objects were displayed in a room lined with cabinets, fitted with drawers below for small objects such as fossils and shells, and glazed above to display the larger items on shelves, including varnished 'animal parts' and mounted animal skeletons.[94] Members were allowed to borrow items, as, for example, in 1723 when 'Dr Sherard desired leave to borrow some of the Plants out of the Repository for 10 or 12 days which was granted.'[95] But the Repository suffered from the lack of a curator, and its contents fell into a state of disrepair. When Zacharias von Uffenbach saw it during his visit to London in 1710, he noted: 'Hardly a thing is to be recognised, so wretched do they all look.'[96] Minutes made by the Repository

committee show repeated attempts to clean, reorder, and display its contents properly, and by 1736 it had been brought to a 'Good State and Condition ... by the great care and Application of the Gentlemen of the Committee'.[97] During 1733, Catesby was one of those appointed to the Repository committee, taking his turn in the chair when required.[98] In May that year, the committee was invited to Hans Sloane's house 'in order to view the manner of the preserving and ranging the several sorts of Curiosities in his Collection, that they might then better judge what may be proper to be order'd in the Repository of the Royal Society'.[99]

Of the many private collections in London, that of Catesby's sponsor and subscriber Sir Hans Sloane (1660–1753) was by far the largest and most famous (fig. 29). A physician by training and profession,

Sloane had from his youth 'been very much pleas'd with the Study of Plants, and other Parts of Nature'.[100] Botany had formed a significant part of his education in this period when medicine and botany were closely allied, but for Sloane it remained a lifelong passion. The extensive collections of Caribbean plants and animals he made in 1687–8, during a fifteen-month stay in Jamaica as personal physician to its governor, the 2nd Duke of Albemarle, were published in his *Voyage to the Islands Madera ...*, frequently referred to as the *Natural History of Jamaica*. He continued to collect both naturalia and artificialia until the end of his long life (he died in 1753 aged 92); by 1729, his collections and library had spread to eleven large rooms of his town house in Bloomsbury Square, and in 1742, having outgrown that building, they were moved to his country mansion in Chelsea (fig. 30).[101] The collections were made available 'on proper Notice to admit the Curious to the sight of his Musaeum', where people came to visit and admire (amongst them Frederick, Prince of Wales, and George Frideric Handel).[102] By 1725, Sloane recorded that he had 136 'Books in Miniature or Colours, with fine Drawings of Plants, Insects, Birds, Fishes, Quadrupeds and all sorts of natural and artificial rarities'. These were arranged according to their subject matter. The artists, naturalists, collectors and others who met at Sloane's house formed a network through which scientific information, specimens, books, art and sources of artistic inspiration were exchanged.[103] Among the artists and illustrators who congregated there were Everard Kick, Michael

FIGURE 29

Stephen Slaughter, *Sir Hans Sloane*, 1736. Oil on canvas, 125.7 × 101 cm.

National Portrait Gallery, London, NPG569

FIGURE 30

John Barlow after Edward Ward, *North Front of the Manor House at Chelsea*, 1810. Engraving, 12 × 19 cm.

London Metropolitan Archive, record no. 23878

FIGURE 31

Allan Ramsay and studio, *Dr Richard Mead*, 1740. Oil on canvas, 126.4 × 101 cm.

National Portrait Gallery, London, NPG15

FIGURE 32

Unknown, *Interior of Dr Mead's Library*, 1828, in W. MacMichael, *The Gold-Headed Cane* (1828), ed. with notes by G. C. Peachey, London, 1923. Engraving, 5 × 7.5 cm.

Cambridge University Library, Keynes. Y.2.19

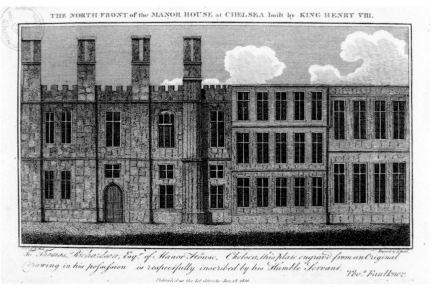

Vandergucht, John Savage, George Edwards, Georg Ehret, Eleazar Albin and, after his return from Carolina, Catesby. Edwards was perhaps the most prolific of the artists who contributed to Sloane's albums;[104] he records that Sloane encouraged him as an illustrator of natural history and made his collections available to him – an experience that must have been similar to Catesby's: 'your Generosity, in giving me all possible Encouragement in the Art of Designing after Nature ... to my great improvement in that Art ... [and] in giving me a full Liberty at all Times, for these many Years past, to consult and examine that inestimable Treasure of Nature and Arts, collected by the worthy Industry and Labour of a great Part of your Life'.[105] In due course, Catesby's book was to take its place in Sloane's library, which became as renowned as his collections.[106] When Pehr Kalm visited Sloane in 1748, he noted particularly that in one of the library rooms there 'were kept books which contained coloured drawings of different kinds of natural objects, such as the costly works of Mariana [Merian], Catesby, Sebe, Blackwell etc.'[107]

Amongst the collectors and patrons in Catesby's world, the physician Dr Richard Mead (1673–1754) was the figure who most clearly bridged the intersection between science and art (fig. 31). As one of the 'Men of Wealth' who 'lent a helping hand' to both artists and scientists, he was exceptional not only in his wealth but in his generosity in sharing it with others.[108] Thirteen years Sloane's junior, Mead was described as 'the most eminent Physician of his time'.[109] As Sloane had also been, Mead was appointed physician to members of the royal family; he attended Queen Anne on her deathbed, and became Physician in Ordinary to George II. He also published a number of medical treatises, including *A Mechanical Account of Poisons* (1702), a *Short Discourse concerning Pestilential Contagion and the Methods to be used to prevent it* (1720), and a *Discourse on the Scurvy* (1749).

In addition to his substantial collection of zoological specimens (to which Catesby contributed),[110] Mead assembled the finest art collection in London. This covered classical sculpture, ancient paintings, gems, coins, medals, Old Master and contemporary paintings, prints and drawings, and a library of around 10,000 books and rare manuscripts (fig. 32).[111] Housed in a specially built gallery in the garden of his house on Great Ormond Street, these collections were made available every morning to schol-

ars and artists. Here Mead gave 'free and constant access of men of different qualifications to his table, who were each employed the rest of the day at his peculiar work or study … the Scholar took his place near the Naturalist, and the Mathematician near the Antiquarian or the Painter. Every one found himself surrounded with objects capable of instructing him, or exciting his emulation.'[112] Mead patronised both English and foreign artists, including Godfrey Kneller, Alan Ramsay, Jonathan Richardson, Louis-François Roubiliac, William Hogarth, Jean-Antoine Watteau and Joseph Goupy, as well as Georg Ehret and the group of natural history illustrators already noted as being part of Sloane's 'academy'. Catesby, who in his *Natural History* recorded Mead's 'zealous patronage of arts and sciences', was one of those who benefited from his financial support and his friendship. When funding from his other supporters ceased on his return from Carolina, it was thanks to what was evidently a substantial sum from Mead that he was enabled to 'carry … the original design of [his *Natural History*] into execution'. Catesby's way of thanking his patron was to coin the name 'Meadia' and to apply it to *Dodecatheon pulchellum*, variously known as the North American cowslip, shooting star or pride-of-Ohio, which he included as the first plate of the Appendix to his book (fig. 33). Mead was also one of two doctors who attended Catesby at the end of his life.[113]

The Duke of Chandos headed the list of the noblemen who sponsored Catesby's visit to the South Carolina. Famous for his patronage of Handel and Pope, James Brydges's magnificent estate at Cannons, Middlesex, was renowned for its gardens laid out by James London, and its Palladian palace built under the successive direction of John Vanbrugh, William Talman, John James and James Gibbs. Daniel Defoe wrote that Cannons was 'so Beautiful in its situation, so Lofty, so Majestik … that a Pen can ill describe it, the Pencil not much better'.[114] In 1721 Brydges solicited Catesby's help as one of two gentlemen 'whose capacity and knowledge may be usefull' to go out to Africa on behalf of the Royal African Company 'to make such discoveries as they can of ye Products of those Parts of ye World'.[115] While it is not certain that Catesby met Chandos in person to discuss this project, it is possible that he may have journeyed out to Cannons, nine miles from the centre of London, to meet the duke (fig. 34). There he would have encountered the baroque splendours

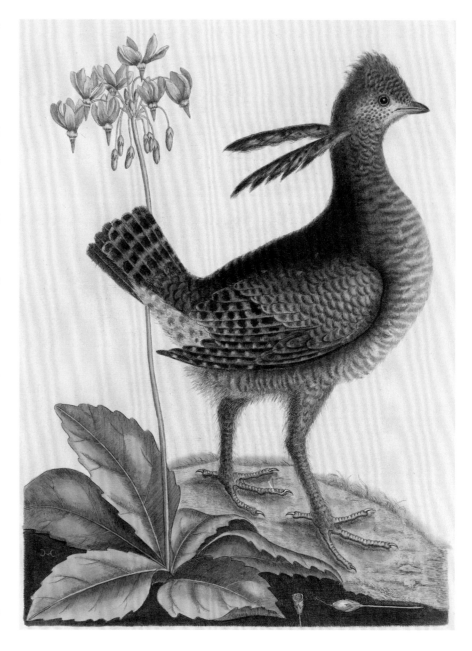

of the interiors of the palace with their sumptuous art collections, the pleasure gardens with their water features and gilded statues, as well as meeting a number of musicians, artists, writers and the gardener Thomas Knowlton, with whom he was to form a close friendship.[116]

One of the many artists employed by Chandos was the painter, professional copyist, etcher and fashionable drawing master Joseph Goupy (1689–1769).[117] Goupy, whose series of copies of Raphael's cartoons was bought by Chandos in 1719 (fig. 35),[118] was also to design stage sets for Handel; and after his appointment in 1727 as cabinet painter to Frederick, Prince

FIGURE 33

Mark Catesby, 'Meadia' (after Georg Ehret) and 'Urogallus minor', *Natural History*, 1747, Appendix, plate 1. Hand-coloured etching, 51 × 35 cm.

Royal Society of London

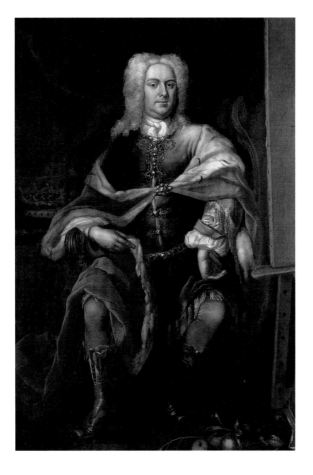

sors and subscribed to two copies of the *Natural History*.[120] However they first met, it was Goupy, acclaimed particularly for his etching skills, who was to give Catesby lessons in that medium.[121] The artist's studio, 'next door to the sign of the Tower' in New Bond Street, was a meeting place for art collectors, connoisseurs, and other painters and engravers of the day, including James Thornhill, Michael Dahl, Jonathan Richardson, George Vertue and Bernard Lens, who like Goupy had been members of Sir Godfrey Kneller's Great Queen Street academy of artists.[122] Catesby's visits to Goupy's studio were probably made during 1726–7, and he may have met some of these prominent figures in the art world (fig. 36).

A glimpse into the contemporary art collecting scene and taste for paintings is given by the illustrator and picture dealer Gerard Vandergucht (son of the well-known engraver Michael), who was employed by Hans Sloane to engrave many of the illustrations for his *Natural History of Jamaica*. Vandergucht worked for various London print sellers and booksellers, but later became a picture dealer and supplier of artists' materials, working from a shop in Lower Brook Street, London.[123] One of his many private clients was Richard Richardson, son of the phy-

of Wales, he became involved in making drawings for garden buildings and furniture for the prince's new gardens at Kew.[119] Catesby may have been introduced to Goupy through several of their shared patrons, including Chandos, Mead and Edward Harley, 2nd Earl of Oxford, another bibliophile, collector and patron of the arts, who was one of Catesby's spon-

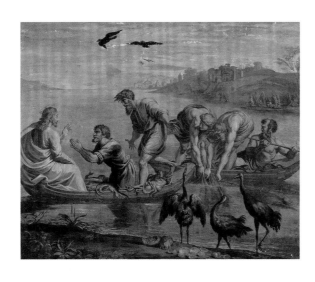

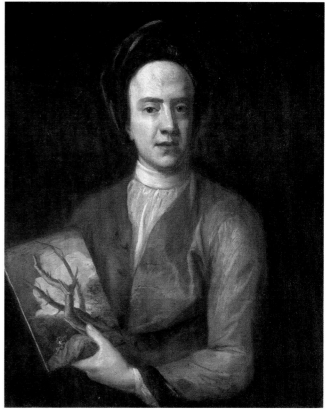

sician, botanist and owner of a well-known garden in Bierley, Yorkshire, Dr Richard Richardson.[124] In a letter to the junior Richardson in 1749 Vandergucht offered him two Old Master paintings: 'One of Paul Veronese … a Martyrdom of a Saint … which I think would make a good companion to your Peter Corton [Pietro Cortona], if the size is pretty near. The other is a *Landskip* by N. Poussin which … is, I believe, near the size of the sketch of the Bacchanal you had of me. The price of the Paul Veronese is twenty guineas; the Landskip eight guineas.'[125] It is interesting to note that the price of the Veronese painting ('two foot nine inches wide, and one foot nine inches high') was just slightly less than the cost of Catesby's two-volume book.[126] The senior Richardson subscribed to two copies of the *Natural History*.

Republic of Letters

Linking the regional learned circles with 'London, the centre of all science' was the dominant notion of the 'Republic of Letters'. Not just in Great Britain, but in the New World and as far afield as China, letters, together with parcels of seeds, growing plants, live and preserved animals and other items of curiosity, maintained this vast network of shared information. It was through this medium of exchange that national boundaries were crossed, and ideas, discoveries and natural history specimens were disseminated across the globe (fig. 37). The surviving groups of letters of this period indicate both how wide the circle of correspondents was and how great the variety of intersecting interests, from the natural to the created world and – what we would now differentiate as – science to art. The philosopher John Locke, in a letter to Sloane from Essex in which he thanked him for sending 'news from the commonwealth of letters into a place where I seldome meet with any thing beyond the observation of a scabby sheep or a lame horse', indicates how influential the notion was.[127]

It was predominantly through letter writing that Hans Sloane was to communicate with a worldwide network of scientists, naturalists, artists, antiquarians and others, including, on a more personal level, the families of his friends and patients. Not including his official correspondence in his capacity as secretary to the Royal Society between 1693 and 1713, his surviving private correspondence amounts to over thirty volumes containing approximately

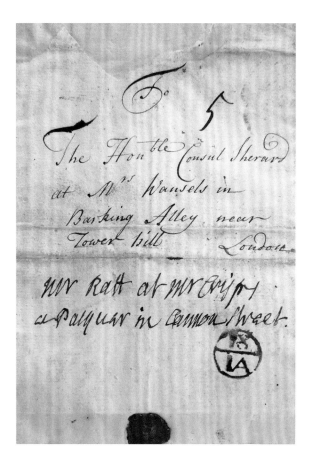

FIGURE 37

Mark Catesby, letter to William Sherard, 30 October 1724.

Royal Society of London, Sherard Letter Book, MS 253, no. 180

5,000 letters;[128] in the different fields of natural history alone these letters testify to his encyclopaedic interests. Amongst all his correspondents, his older contemporary John Ray was to provide a powerful formative influence on the development of Sloane's interests (see fig. 48).[129] Parallel to his letters, Sloane's manuscript catalogues of the natural history specimens he received from his global network of correspondents provide vivid demonstration of the wide-ranging interests they shared from animal and vegetable to mineral substances and manmade artefacts (fig. 38).[130]

Peter Collinson, a central figure and 'encourager' in the natural history circle, as we have seen, was another prominent member of the Republic of Letters (see fig. 80). An inveterate writer and recorder, he wrote hundreds of letters to people in every walk of life, from gardeners to peers of the realm, and to correspondents across Europe, Russia, North America and the West Indies.[131] His correspondence with the fellow Quaker plant collector John Bartram, over thirty-four years, 'forms one of the great records of enduring friendship and eighteenth-century natural science'.[132] Collinson's habit of annotating his books

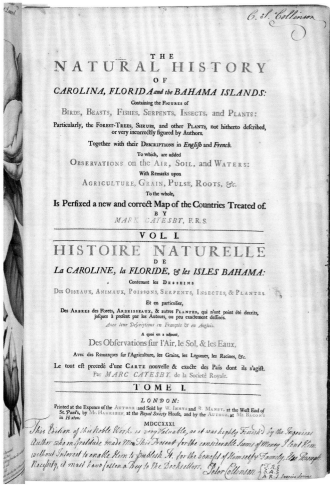

FIGURE 38

Hans Sloane, manuscript catalogue 'Fossils IV', 'Shells', fol. 37, with specimen 5459 sent by Catesby from the Bahama Islands, c.1726. 29.7 × 18 cm.

Natural History Museum, London, General Library

FIGURE 39

Mark Catesby, title page annotated by Peter Collinson, *The Natural History of Carolina, Florida and the Bahama Islands*, I, London, 1731. 51.8 × 35.6 cm.

Peter Collinson's copy of the *Natural History* previously at Knowsley Hall

meant that he also left valuable information in the form of memoranda and inscriptions. It is thanks to some of these, for example, in his copy of Catesby's *Natural History*, that we have several crucial pieces of evidence for Catesby's life (fig. 39).[133]

It was through correspondence that the apothecary and collector James Petiver built up his substantial collections.[134] John Ray wrote that he was 'a man of greater correspondence in Africa, India, & America then any one I know of besides'.[135] Writing to leading naturalists around the country and abroad, he enlisted help in gathering information and specimens from fellow apothecaries, customers at his shop 'at the sign of the White Cross', ships' surgeons, sea captains, merchants, plant collectors and missionaries, to whom he supplied printed instructions, including his 'Brief Directions for the easie making, and preserving collections of all natural curiosities'.[136] Equally prolific was Richard Richardson, whose correspondence with many of the most

significant naturalists of the day 'filled twelve volumes'.[137] Through his letters, as well as those of his friend, the gardener Thomas Knowlton, who corresponded with around forty garden owners, we have vivid details of the lives, interests and enthusiasms of Catesby's milieu.[138]

Not only were manuscript letters exchanged, but letters were printed in certain publications. The Royal Society's *Philosophical Transactions* published extracts from a wide variety of letters containing matters of both scientific and antiquarian interest.[139] For example, extracts from two of Thomas Knowlton's letters to Catesby were published there, one on the discovery of the Roman town of Delgovicia in Yorkshire, and the other 'An Account of two extraordinary Deers Horns, found under Ground in different Parts of Yorkshire'.[140] The botanist Richard Bradley in his *General Treatise of Husbandry and Gardening* (1724) wrote: 'The Gentlemen who have any Thing new and instructive to communicate, are

desired to send their Letters directed for me at Mr. Fowler's, Mathematical Instrument Maker, at the Globe in Swithin's Alley, near the Royal-Exchange, Cornhill; And any one who is desirous of my Advice may readily command it.'[141] Bradley printed one letter from Catesby to the nurseryman Thomas Fairchild.[142]

The same scholarly dialogue evidenced in the learned societies and the Republic of Letters flourished in other meeting places such as the London clubs, coffee houses and taverns. Often these were informal societies and groups of like-minded enthusiasts, some of which existed for only a few months. Members shared their discoveries and collections, carried out experiments, went on 'herborizing' trips, and sometimes took the results of their activities to the Royal Society.[143] The most well known of these clubs was that which met on Friday evenings at the Temple Coffee House, which from 1689 until *c.*1706 exchanged botanical information, specimens and communications from home and abroad; the group also went on botanizing expeditions.[144] Another 'Botanical Society' began in 1721 as weekly meetings in the Rainbow Coffee House, before it moved to a private house. At meetings, 'every member was obliged to exhibit a certain number of plants, to make observation upon their characters, and to set forth their various uses.'[145] The gardener Philip Miller and apothecary Isaac Rand were both members of this group. As we have seen, Miller was also instrumental in forming the Society of Gardeners, a group of prominent gardeners and nurserymen situated in and around London.[146] Every month they met at Newhall's Coffee House in Chelsea to examine and compare the flowers and fruits they had cultivated, recording and describing them in a register.[147] The Society of Apothecaries also carried out herborizing excursions. John Martyn was to write to the Scottish surgeon-apothecary Dr Patrick Blair on 20 August 1720: 'I herbarised with the apothecaries this month. We dined at the Green-Man, at Dulwich, and made a pretty good collection.'[148] The communications and collecting activities of these groups led Dr Blair to describe them as the 'Botanic Chorus' (fig. 40).[149]

As noted, the promotion of foreign enterprise with both commercial and colonial dimensions was an important element in the Royal Society's chartered purpose to 'Improve Natural Knowledge', much of it being conducted via the 'commonwealth

of letters'.[150] Soon after the foundation of the Royal Society, a Committee for Foreign Correspondence had been set up with two secretaries appointed to deal with correspondence with the Far East, the Levant, Muscovy and the Americas.[151] The energy and determination with which this quest was conducted prompted the Royal Society's biographer, Thomas Sprat, to write 'that in a short time, there will scarce a Ship come up the Thames, that does not make some return of Experiments, as well as of Merchandize'.[152] During the era of colonial expansion, the society was to sponsor, either wholly in part, more than forty scientific expeditions into different parts of the world.[153]

Several figures actively involved in colonial enterprise were among Catesby's patrons, including, as we have seen, the Duke of Chandos, a leading figure in the setting up of the Royal African Company.[154] He had hoped Catesby's services could be harnessed to the company in its prospecting for drugs, plants and spices. Sloane, with his first-hand experience from his visit to Jamaica, his positions as secretary and later president of the Royal Society, and his wide

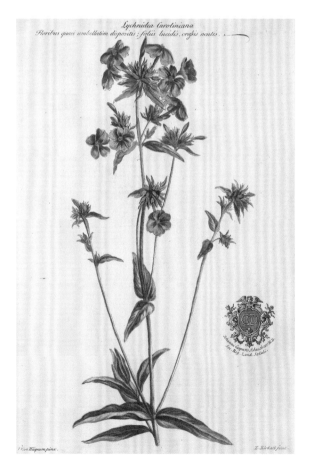

FIGURE 40

Elisha Kirkall after Jacobus van Huysum, 'Lychnidea Caroliniana', in John Martyn, *Historia plantarum rariorum*, London, 1728–37, plate 10. Etching and coloured mezzotint, 52.2 × 35.9 cm.

Cambridge University Library, MH. 7.19

social network, often received invitations to lend his patronage to colonial business ventures, although his main interest was in the contribution that exploration and commerce could make to science.

Francis Nicholson was actively engaged in promoting the natural productions of South Carolina, the colony of which he had been appointed governor. His reason for paying Catesby a £20 stipend to travel to South Carolina was primarily to further the investigation of its natural resources. The money Catesby received was specifically designated to be employed 'for the uses and purposes of Royal Society'.[155] Throughout his years spent as a naturalist and explorer in South Carolina and the Bahamas, Catesby was conscious of meeting his obligations to his patrons, while at the same resolved to keep his focus on his personal ambition to create the *Natural History*. These twin aims, couched under the concepts of 'benefit' and 'beauty', are articulated in his dedication to Queen Caroline of Volume I of his book, where he writes, 'I esteem it a singular Happiness … that I am the first that has had an Opportunity of presenting to a Queen of Great Britain a Sample of the hitherto unregarded, though beneficial and beautiful Productions of Your Majesty's Dominions.'[156] Colonial interest was a recurring theme in the written correspondence of individual members of the Royal Society, including, as we have seen, the letters of Peter Collinson and John Bartram. On his return from the New World, Catesby was to continue an active correspondence with his old, and some new, friends across the Atlantic, such as William Byrd, John Clayton, John Mitchell and John Bartram.[157]

The geographical span encompassed by the Republic of Letters, as well as the enormous range of subject matter, indicated the extent to which scientific and artistic circles overlapped in Catesby's time. As defined in Samuel Johnson's *Dictionary*, the word 'science' meant 'knowledge', 'any art or species of knowledge', or 'certainty grounded on demonstration', while 'art' was defined as 'a science', or 'the liberal arts', in addition to bearing a rather specific meaning of 'a trade'.[158] Thus, as we saw in Mead's house, men of 'different qualifications' worked alongside each other, and 'the Scholar took his place near the Naturalist, and the Mathematician near the Antiquarian or the Painter.'

While 'boundaries were fluid and interchange fruitful' in the definitions of art and science,[159] there was a far greater distinction between the status of those who were called 'amateurs' (literally 'lovers' of arts), who were not 'tradesmen' and did not work for money – thus mainly people of noble or gentlemen's class – and 'professionals' who were 'mere artificers', working with their hands.[160] For Catesby, as with other gentleman amateurs of his time, his acquisition of specialist knowledge as both a naturalist and an artist came, as has been indicated, through association with experts and other practitioners and through books. But in his case, the expertise for which he was recognized internationally both during and after his lifetime was gained not only through working 'with his mind' (as a natural philosopher and a creative artist), but through his mastery of practical skills such as collecting and preserving natural history specimens, and copper-plate etching. Unlike Sloane, for example, he did not have the money to employ others to do the mechanical work; rather, in his case there was a blurring of the distinction between the old understanding of amateur and professional and between artist and craftsman. And it was partly because of this that he was able to produce the unique work he did.

Carduelis

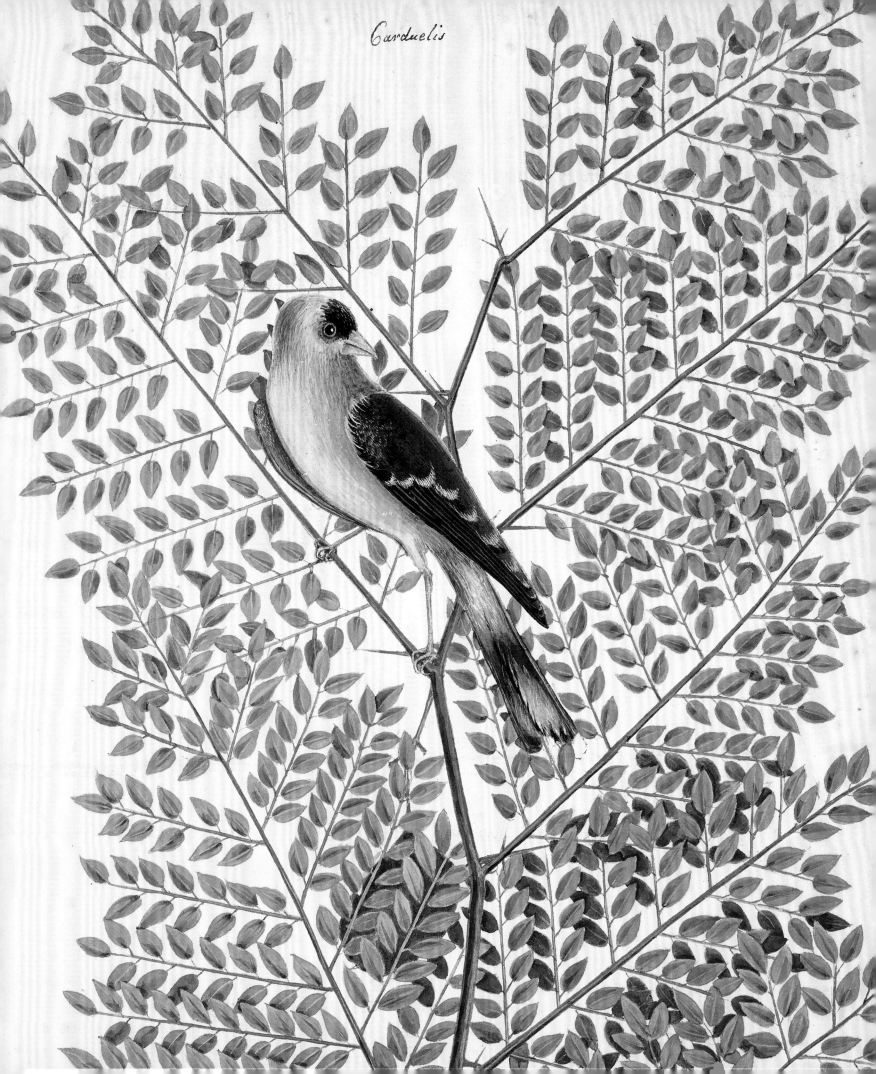

Catesby's Life and Character

'The strong inclination I had to these subjects, joined to the love of truth,
that were my constant attendants and influencers.'[1]

'The ingenious author Mr. Catesby, born of a Gentleman's family at Sudbury in Suffolk', was how Peter Collinson described Catesby sometime after death (fig. 43).[2] From a family of minor gentry, his father, John Catesby (c.1642–1703), 'of Sudbury, Suffolk, Gent[leman]', was a well-respected figure in the civic life of the Suffolk town.[3] Sudbury, located on the River Stour near the border with Essex, had become prosperous through its cloth-manufacturing industries in the late Middle Ages (fig. 45). Reflections of this wealth can still be seen in its churches and some of its seventeenth-century buildings such as the house in 5 Friars Street with its remarkable wall painting showing birds and other animals set against a landscape of meadows and a walled town (fig. 42).[4]

John Catesby, described as 'an eminent attorney in the borough', held the offices of town clerk and mayor on several occasions,[5] and he owned a substantial number of properties in Sudbury and Essex, as well as houses in London (fig. 44).[6] Catesby's mother, Elizabeth Jekyll, 'of Hedingham Castle, Essex',[7] came from a family of lawyers and antiquaries: her grandfather was the prominent antiquary Thomas Jekyll (1570–1652), a contemporary of the historian William Camden.[8] Thomas's significant collections of manuscript material relating to the history of East Anglia were inherited by Elizabeth's brother, Nicholas, who, as we have seen, was part of a notable scholarly circle in East Anglia.

Mark Catesby, the fifth son of John and Elizabeth, was one of several of their children to be baptized in St Nicholas Church, Castle Hedingham, six miles south of Sudbury.[9] His baptism is recorded in the parish register: 'Anno Dom 1683 the thirty-fifth year of King Charles the Second … Mark Catesby son of John Catesby gent and Elizabeth his wife Baptiz March 30th'. A suggestion of his subsequent renown appears in the fact that an inscription in paler ink was added sometime later with his date of birth, 'Natus March 24th 1682' (fig. 46).[10]

The Jekyll side of the family and the village of Castle Hedingham appear to have figured more prominently in Mark's childhood than the Catesbys of Sudbury.[11] Names of the Catesby family occur frequently in the registers of St Nicholas Church, and after John Catesby senior's death in 1703, Mark's uncle, Nicholas Jekyll, assumed the role of head of the family. Something of Jekyll's standing is revealed

FIGURE 41

Mark Catesby, 'The American Goldfinch' and 'Acacia', 1722–5. Detail of fig. 64.

FIGURE 42

English school, wall painting showing birds in a landscape with a town behind, 1650s, detail during conservation. Painting on plaster, approx. 220 × 250 cm (full painting).

5 Friars Street, Sudbury, Suffolk

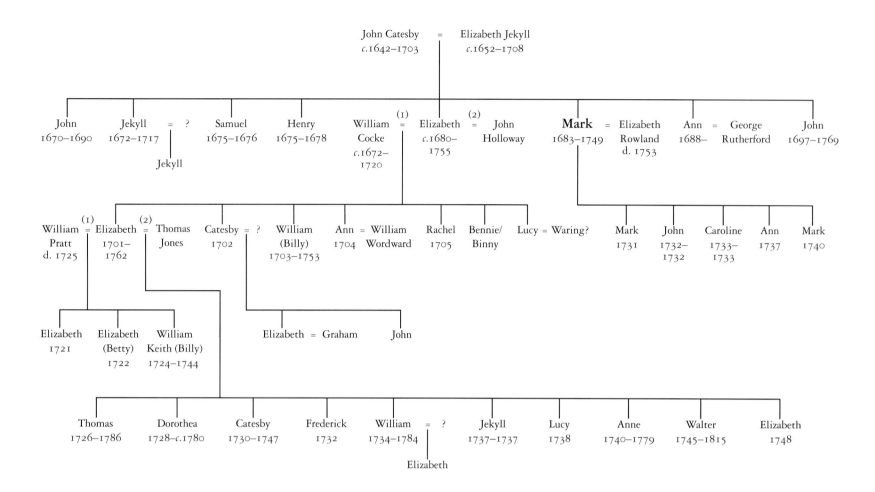

in a letter Sir Alexander Spotswood, Governor of Virginia, was to write to Henry Compton, Bishop of London, referring to Catesby as 'a Gentleman now in this Country, a nephew of Mr. Jekyll's of Castle [Hedingham]'.[12]

Catesby had a gentleman's education, probably at a good grammar school, where he gained a reading and writing knowledge of Latin and French, and an elegant prose style.[13] The most prominent grammar school in the region was Felsted School, Essex, which he may have attended, as did, it seems, his younger brother, John, who was later to share Mark's interest in natural history.[14] While the records are missing for the years that Mark would have been at the school, in December 1710 a boy named 'Catesbie' is recorded in form 6 of the 'Upper Master's end' of the school (the lowest class of the senior school), the class appropriate for the twelve-year-old John Catesby (fig. 47).[15] In the decade preceding Mark's school years, two other figures had been at Felsted who were later to play important parts in his life in Virginia: William Byrd II of West-

FIGURE 43

Catesby family tree

FIGURE 44

Surrender of Sudbury borough charter and petition for new charter, with common seal of the borough and signature of John Catesby as mayor of Sudbury, 9 October 1684, detail. Pen and ink and wax seal on vellum, 29.5 × 34.5 cm.

Suffolk Record Office, Bury St Edmunds, EE 501/1/10

over, Virginia, whose father sent him there to learn how to become an English gentleman, and William Cocke, who married Catesby's older sister Elizabeth, and became physician and advisor to Alexander Spotswood in 1710.[16]

Felsted had a tradition of educating both 'persons of quality' and 'gentlemen scholars' (sons of gentry from the region) as well as 'charity boys'. Founded in 1564 by Richard Riche, Lord Chancellor under Edward VI, its headmaster during the time that Byrd and Cocke were there was Christopher Glascock (headmaster 1650–90), who had a reputation as a philologist, and under whom the school became more distinguished with 'many fine gentlemen ... and so many excellent scholars sent thence to the University [of Cambridge]'.[17] Catesby, however, if he attended the school, would have entered under Glascock's successor, the Reverend Simon Lydiatt (1690–1712), described as 'an excellent scholar, an industrious man and a good teacher' who published an anthology of Latin and Greek epigrams in 1696.[18] In addition to Greek and Latin verse composition, still a staple exercise for boys in the upper school, and rhetoric learned from reading classical histories, pupils by this period would also have been taught some modern languages, as well perhaps as Hebrew, and mathematics, geometry and possibly natural philosophy.[19] Byrd, for instance, knew Hebrew, French and Italian, which he is likely to have learned at school, and he may have read or been introduced at Felsted to some of the books which he was later to own in his renowned library, such as Sir Thomas Elyot's *The Boke Named the Governour* and Richard Brathwait's *The English Gentleman* (1630).[20] In terms of breadth of education, 'It was expected that the well-educated were widely educated, with a competency in both the arts and sciences ... Rigid distinctions between disciplines were unheard of.'[21]

Unlike his two older brothers John and Jekyll, Mark did not attend either of the universities of Oxford or Cambridge, or one of the Inns of Court.[22] An independence of mind, combined with his stated 'passion' and 'inclination' for natural philosophy from a young age, may have led him to choose a more practical way of acquiring the skills he needed; instruction under prominent figures such as Ray, Dale and Courtman in the circle of natural philosophers near to home would have provided a more useful training than he could have gained in the universities. At this period, it was usual for gentlemen

amateurs to acquire their scientific education from each other, through the use of private libraries and collections, via active written correspondence and from attendance at learned meeting places, societies and clubs.[23] Catesby's friend Peter Collinson was an example of someone who learned the principles of botany from books, from correspondence with his learned friends, and from practical experience in his own garden.[24]

After his father's death in 1703, when Mark was twenty, his uncle showed an active, even paternal interest in his nephews' and nieces' lives. Mark wrote fairly frequently to Jekyll from America, sending family news from Williamsburg and accounts of his exploits in Virginia and South Carolina. Jekyll often shared the news with his friend and fellow antiquary William Holman, and it is from their correspondence that we have a few more personal details about Catesby.[25] The sporadic arrival of letters from America, however, sometimes caused Nicholas concern; in April 1723, for example, he was anxious for Mark's safety following the severe hurricane that hit Charleston. Dale reported to Sherard, 'His Uncle hath not had a Letter from him for some time, and is in pain least [*sic*] the great flood should have carried him away.'[26]

FIGURE 47

Old School Room, Felsted School, *c*.1900. Sepia photograph, 8.7 × 13.4 cm.

Felsted School Archives, Felsted, Essex

FIGURE 48

Thomas Hudson, *John Ray*, 1747.
Oil on canvas, 237 × 145 cm.

Trinity College, Cambridge,
Oils P.166

of contact in England (fig. 49). Catesby's 'apprenticeship' as a naturalist is likely to have been with Dale. Dale's collecting work for Ray, during which he travelled over much of East Anglia in search of plants, would have provided an ideal opportunity for Catesby to learn the skills of the collector. Dale's garden, too, where, as he stated, under Ray's guidance he raised many difficult species from seed, may have been where Catesby acquired his working knowledge of horticulture.[30] Dale exchanged plants with other garden owners, including Richard Walker of Trinity College, Cambridge, from whom he acquired tulips. In one of his diary entries Dale recorded, 'The morning before I left Cambridge I went into Dr Walker's garden who gave me 4 plants of the Aster Cheopodij folio etc. <u>Hort. Elthamen</u>. and a root of the Campanula Persicae folio flora albo duplici, both of which I planted in my garden, upon my return.'[31]

Catesby is likely to have had access to Ray's library, herbarium and other natural history collections when he visited him at Black Notley. At Ray's death in 1705, Dale, as Ray's executor, not only was responsible for cataloguing Ray's library for sale, but inherited 'all his collections of natural curiosities'.[32] As Dale's protégé, therefore, Catesby had

Towards the end of his life Catesby recounted to Pehr Kalm how from childhood he had visited the famous naturalist John Ray. Kalm reported that Catesby 'had been born in Essex about 6 English miles from Mr Ray's birthplace, where Ray had spent most of his time and died and was buried. When he was a small boy, Mr Catesby had often visited Ray.'[27] George Edwards later alluded to Catesby's friendship with Ray in a letter in which he recorded that Catesby 'Hapned to fall into acquaintance of the great naturalist Mr. Ray, who then lived in Essex not far from him. This acquaintance inspir'd Catesby with a genius for natural history' (fig. 48).[28] The 'acquaintance' could have been made either through his uncle or through Nicholas Jekyll's friend Dale.

Samuel Dale, Ray's disciple and collaborator, lived just above a mile away from Jekyll in Braintree. There, like other botanists, he had his own library and garden, and he and Jekyll shared books which, as we have seen, were in turn circulated amongst other members of their circle, including Holman.[29] Dale became a significant figure in Catesby's life, and during his time in Virginia was to be his main point

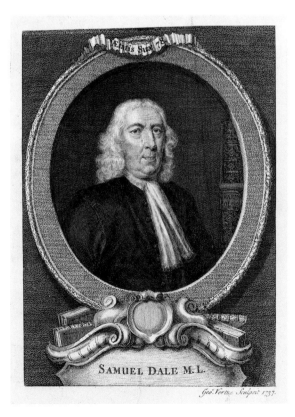

FIGURE 49

George Vertue, *Samuel Dale aged 78*, 1737. Engraved frontispiece to Samuel Dale, *The History and Antiquities of Harwich and Dovercourt in the County of Essex*, London, 1730.

Cambridge University Library, Ll.14.30

further opportunity to study the great naturalist's books and collections as well as access to Dale's own impressive library. Dale's letters to Sherard indicate his keen collecting of the major botanical books as they were published. On the death of his friend the apothecary James Petiver in 1718, Dale wrote to tell Sherard that he was making 'a Catalogue of such Botanick Books as I have already that so when Mr Petivers Books come to be sold, you will please to buy for me such as I have not, and especially Tabern[aemontan]us Icones which I hope you will permit me to have before any foreign commission'.[33] A year later he wrote: 'In yours of Oct last you told me that Mr Vaillants History of Plants about Paris & Mr Boarhaave's Catalogue with figures would be out by May which month being now near expired I am in hopes they are published which if they are I desire you will please to let me know at what shop I may buy 'em … As also when you expect the new edition of Rays Synopsis.'[34] Dale was also able to afford expensive books such as Merian's *Metamorphosis insectorum surinamensium* (1705), a work that was to provide an important model for Catesby's own work; in 1722 he recorded taking his copy to compare with one in the university library at Cambridge: 'In the afternoon I went with Mr Mason to the schools to see and compare my Merian of Insects with the folio copy in the Library.'[35] Dale bequeathed his botanical books and herbaria to the Chelsea Physic Garden, and at his death in 1739 they were housed in three large and three smaller oak cabinets which still survive in its library rooms.[36]

Catesby inherited a number of London properties on his father's death in 1703: 'All my Houses … in the parish of St Bridgett at St Brides London – and all my other Houses in London not before bequeathed'.[37] When the business of administering these properties necessitated visits to London, Catesby no doubt took the opportunity to make contact with the horticultural and natural history worlds of the metropolis. Importantly, at Hoxton he met Dale's friend Thomas Fairchild, who was amongst the unnamed recipients of Catesby's plant consignments from Virginia.[38] Catesby also visited some of the gardens and garden owners around London. On a label accompanying a specimen of 'sicamore' (identified as *Platanus occidentalis*) later sent to Dale from Virginia, he commented, 'This is called Sicamore here. I take it to [be] the Plattanus of the West, not uncommon amongst the gardiners abt London.'[39]

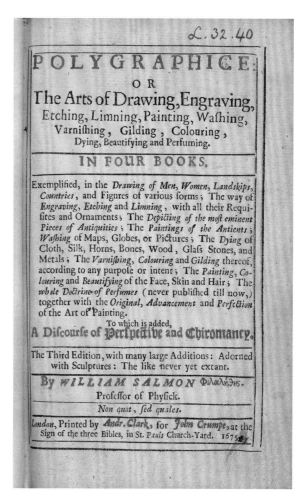

Catesby stated clearly, 'I was not bred a painter.' Just as he was self-trained as a naturalist, so he was as an artist. In the late seventeenth century only the upper classes employed drawing masters; however, tuition in drawing, music, dancing, fencing and other subjects extra to the usual grammar school education could sometimes be had from masters travelling to the provinces.[40] By 1734, Catesby's nephew Keith William Pratt was learning drawing at his school in Chelsea: 'As to his progress in Learning, I hope he'll be an honour to his Master, having greatly improved in French, Latin, Greek, Writing and Arithmetick; Musick, Drawing, Fencing, he hath learnt as far as was thought necessary for a Gentleman.'[41] Like other amateur artists, however, Catesby acquired drawing skills by copying illustrations in books, in addition to using the numerous manuals by authors such as William Salmon and Henry Peacham (fig. 50).[42] Such manuals were specifically designed to instruct the amateur artist, although the emphasis in the majority of these

of nature in a country but imperfectly explored and where her beauties were displayed in a more extended and magnificent scale, than the narrow bounds of this country exhibited'.[46] Two years after his mother's death in 1708,[47] Catesby, together with his surviving older brother Jekyll and younger sister Ann, sold some of the properties they had inherited from their father, signing an indenture on 25 October 1710 (fig. 51).[48] For Mark, this was the period at which he was planning his trip to America; that same year his sister Elizabeth's husband, William Cocke, whom she had married 'without her father's consent', emigrated to Williamsburg, Virginia, to take up a position as personal physician to Spotswood.[49] Elizabeth and two of their children delayed joining her husband until 1712.[50] Her need to be accompanied on the long voyage, and the opportunity of sharing the Cockes' family home in Williamsburg, may have provided the catalyst for Catesby's decision to go with her. As he was to record in the Preface to his *Natural History*, 'Virginia was the Place (I having Relations there) suited most with my Convenience to go.'[51] He and Elizabeth left England early in 1712 on board the *Harrison*, arriving in Virginia on 23 April. Their arrival was recorded by a note in William Byrd's diary that 'the fleet has come in … that had my goods, thank God,' and that 'Mrs Cocke also was come in the Harrison and two of her children.'[52]

William and Elizabeth Cocke's home was in the newly developed town of Williamsburg.[53] They and their family (they had had seven children by 1710) lived in moderately wealthy style, acquiring eight plots and a house in the capital.[54] One of these was very likely the plot later inherited by Catesby's niece Elizabeth, on the north-west edge of the town in an area beyond the college gardens and those of the Governor's Palace (fig. 52).[55] During William's absences to England, Mark would surely have played his role in family affairs, helping to manage the property and keep an overseeing eye on his sister's young family.[56] Nicholas Jekyll reported to William Holman on 20 September 1712: 'Last post my nephew wrote me a letter dated 1st August; they were all well' – despite his niece and two of the children having caught an infection he describes as 'the sneazering', which 'Dr Cocke in his Letter makes light of'.[57]

In the same letter Jekyll recorded: 'Part of his time [Mark] uses in making a large collection of plants &c. for Mr Dale, having the assistance of a Col. Bird,

FIGURE 51

Indenture signed between members of the Catesby family, 25 October 1710, detail. Pen and ink on vellum, 40 × 77.5 cm.

Suffolk Record Office, Bury St Edmunds, 1674/14

publications was on figure and landscape painting, and botanical illustration was rarely touched upon. Catesby may have taught himself further by copying engravings of the work of old masters.[43] Just as John Banister, in 1682, wrote to his London correspondents that he was teaching himself to draw in order to illustrate the plants he was collecting, so Catesby realized early on that illustrations were a necessary part of the naturalist's skills (see fig. 16).[44] While the earlier botanical books in Ray's and Dale's libraries would have been illustrated with woodcuts, from the mid-seventeenth century most of the botanical works produced on the Continent were illustrated with copper engravings. The style of Catesby's pen and ink of drawing, with its use of cross-hatching, was influenced by the illustrations in such books.[45]

Richard Pulteney, author of *Historical and Biographical Sketches of the Progress of Botany* (1790), wrote that Catesby's passion for natural history 'led him to cross the Atlantic, that he might read the volume

FIGURE 52

'Frenchman's Map' showing the town of Williamsburg, marked with Catesby–Cocke and Custis plots, 1781. Pen and black and red ink on paper, 40 × 63 cm (including mount).

1: Capitol Building
2: College Gardens
3: Governor's Garden
4: Palace Green
5: Market Square
6: Custis plot
7: Cocke–Catesby plot

Special Collections Research Center, William & Mary Libraries, MSS Acc. 2009

a vast rich man there.' Catesby himself was understated in his description of his collecting activities, later recording in the *Natural History* 'that in the seven years I resided in that country (I am ashamed to own it) I chiefly gratified my inclination in observing and admiring the various Productions of those Countries; only sending from thence some dried specimens and some of the most specious [that is, showy] of them in Tubs of Earth.'[58] But as we will see, he was to be extremely active in his collecting: in addition to the extensive collection he made of dried specimens and live plants 'in Tubs', he collected seeds from a considerable quantity of different plant species.[59]

Through his brother-in-law William Cocke, Catesby was introduced to Virginians 'of quality', including the owners of plantations on the James River. Chief amongst these was Cocke's old school-fellow, William Byrd II, also a member of the Council of Virginia – in Nicholas Jekyll's words 'a vast rich man' (fig. 53). Catesby was to spend extended periods of time at the Byrd family estate at Westover, several miles up the James River from Williamsburg.[60] Byrd, whose father had sent him to Felsted for his schooling, then trained in law at the Middle Temple, and through the influence of his father's friend Sir Richard Southwell in 1696 became a Fellow of the Royal Society.[61] Together with his interest in natural philosophy and a love of literary and intellectual life, he enjoyed fashionable society, numbering amongst his friends members of the English gentry and nobility; one of these was the young Lord Perceval (or Percival), whom he accompanied on his literary travels around England in 1701.[62] Catesby's arrival in Williamsburg would have been an import-

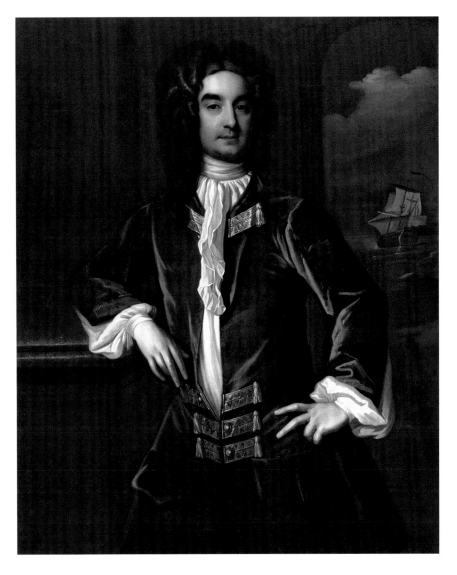

FIGURE 53

Hans Hysing, *William Byrd II*,
*c.*1724. Oil on canvas,
127 × 106.5 cm.

Virginia Museum of History and
Culture, Richmond, VA, 1973.6

period when Catesby was there, Byrd's house was an extensive wooden mansion (it was later to be built in stone), grandly furnished with English furniture and portraits (fig. 54). The library, renowned as the finest in Virginia, was eventually to house twenty-three walnut bookcases containing over 2,500 books. Byrd was constantly adding to the library, keeping up with contemporary literature as well as regularly reading Hebrew, Greek, Latin, and sometimes French, Italian and Dutch. Amongst several subjects which would have been of particular interest to Catesby were the section on natural history, which included many important seventeenth-century works left by John Banister, and the largest collection of gardening books in colonial America. Byrd's library also functioned as a gallery for his collection of portraits of family and friends,[65] and contained a collection of prints, a fine spinet and harpsichord, and his letters and manuscripts housed in a trunk.[66]

During Catesby's sometimes prolonged visits to Westover, he and Byrd spent time walking around the plantation and garden, looking at prints and books together in the library, and enjoying wine and conversation. While Byrd carried out the daily routine of managing his plantation and his servants, conducting his family affairs and undertaking public duties such as meetings at the Council in Williamsburg on which he sat with William Cocke, Catesby explored the fauna and flora of the plantation and swamp and spent time drawing and painting. It may have been watching Catesby's artistic activities that later inspired Byrd to take lessons with the drawing master Eleazar Albin in London between 1717 and 1719 (fig. 55).[67] Further details of Catesby's friendship with Byrd and of the lifestyle at Westover which he had described to his uncle are contained in a letter from Nicholas Jekyll to William Holman. Catesby had asked his uncle for information on the history of the Parkes of Gestingthorpe, into whose family Byrd had married through his wife, Lucy Parke,[68] and Jekyll was keen to send back any information Holman could 'get together':

ant event for Byrd: an English gentleman from the same part of East Anglia in which Byrd had spent his school years (and perhaps even an alumnus of Byrd's old school), and with connections to the natural philosophy circles which had formed around John Ray. Despite the very different temperaments of the two men – the extrovert and sociable Byrd and the private and reserved Catesby – they were to form a strong friendship based on their shared interests. While Catesby offered 'skil and curiosity' in horticulture, Byrd, in his turn, was the ideal person to provide Catesby with an introduction to the surrounding country and its natural resources, as well as assistance with his plant collecting.[63]

From Byrd's diaries we gain a vivid picture of the grand and cultured lifestyle that Catesby was to experience at Byrd's plantation home.[64] During the

> I would fain make some sort of Flourish if I could
> bring it in with truth, how they are related to this and
> that other Family for no other reason [than] it ... must
> infinitely please Collonell Bird's Lady who would fain
> know something of her Ancestors, and at [the] same
> time oblige him who is so much my nephew's friend
> and who it seems the very best bred of gentlemen there

and who does live and is served after the English way.
For tho many are served in plate and in great grandure
do live, yet at table are served with half naked Indians
&c but he with white Men, and in livery; also he has a
most noble Library, in a spatious room, divided into
Classes.[69]

After his first visit in April, Catesby stayed at West-
over for a longer period of three weeks during May
and June.[70] In the afternoon of 24 May, Byrd writes:
'[Dr Cocke's] daughter [Catesby's niece Elizabeth],
Mr Catesby and I went into the swamp to see the
nest of a humming bird and the Doctor followed
along. However, we found a nest with one young and
one egg in it. In the evening we took a walk about the
plantation and at night we drank a bottle.'[71] On 27
May, 'In the afternoon we went into the library to see
some prints. We spent the afternoon in conversation
and in the evening we took a walk [in the garden]
and ate some cherries. At night we had a syllabub
and drank a bottle and were merry.'[72] On 30 May, 'In
the evening Mr Catesby and I took a walk about the
plantation and did not return till dark. At night …
we talked til about 10 o'clock.' On 4 June, 'we had
11 people at dinner'; on 7 June, '[in] the evening …
Mr Catesby and I took a walk about the plantation
and I ventured to eat 6 cherries.' On 8 June, the two
friends went to church, heard a good sermon, and
'in the evening we took a walk about the plantation

To William Byrd of Westover in Virginia Esqr.
this Plate is humbly Dedicated by Eleazr. Albin

and ventured to eat more cherries.' On 9 June, they went to Williamsburg 'on board the Harrison where we drank some strong beer'[73] and the next day 'went to the capitol to Council' where 'at night the Doctor [William Cocke] was sworn in secretary'. On 12 June, 'we proceeded to Westover where we found all well thank God. We drank some syllabub and talked til 9 o'clock and then retired.' On 13 June, 'Mr Catesby and I took a walk about the plantation and I drank some warm milk at the cowpen.' On 14 June, 'The rain kept us till 10 o'clock and then we returned home and were so merry that Mr Catesby sang' – Byrd's comment suggesting this was unusual behaviour for the normally reserved Catesby.

Catesby made another extended visit to Westover in autumn that year. He arrived on 17 September, after dinner, bringing a letter from William Cocke; 'we gave him some victuals. Then we took a walk about the plantation. At night we drank some punch and were merry.' On 25 September, on a visit to Colonel Bassett's plantation on the Pamunkey River, 'Mr Catesby and I took a walk about the plantation and found it inclosed by marsh and therefore must be very unwholesome. Mr Catesby killed two snakes in the pasture.'[74] On 27 September, the day after both friends had been 'a little out of order', 'Mr Catesby went in the river with me and had a violent looseness which carried away his fever.'[75] And on 29 September, 'In the afternoon I put several things in order in the library and at night Mr Catesby came and told me he had seen a bear. I took Tom L-s-n [sic] and went with a gun and Mr Catesby shot him. It was only a cub and he sat on a tree to eat grapes. I was better with this diversion and we were merry in the evening.'[76]

By contrast with the intensive collecting programme of Catesby's later visit to South Carolina and the Bahamas, his stay in Virginia lacked the pressures of demanding patrons, and the years he spent there appeared to him with hindsight to be leisured. However, his comment that during the seven years he lived in Virginia he had 'chiefly gratified my inclination in observing and admiring the various Productions of those Countries' gives no hint of the active programme of exploration and collecting he undertook.[77] 'Observing' and 'admiring' denoted for Catesby not only energetic travelling and collecting, but preserving, packing and shipping specimens back to England, as well as recording his finds in written accounts and drawings.[78] He was equally active in developing his horticultural skills, experimenting with growing plants in his friends' gardens as well as his own.[79]

Exploring the Tidewater and river courses, he scoured the region for new plants and animals, using his knowledge of English fauna and flora to compare differences in species, and recording variations in soil, geology and the seasons (fig. 56). As Banister had found before him, Westover was a good starting point for penetrating into the Virginia wilderness.[80] In 1714 Catesby made a more extensive journey inland to the Appalachian Mountains to examine the source of the James River. His unnamed companion may have been William Byrd, who was later to describe the scenery and natural history in similar terms to Catesby.[81] During the journey they delighted in the beauties of the landscape, examined rock formations, found fossils, hunted bear and shot wild geese, which, being 'very fat by feeding on fresh water snails … were in great plenty'. Climbing to the top of a ridge of 'very lofty rocks … [we] could discern some of the nearer mountains and beheld most delightful prospects.' When they were about twelve miles from the mountains, they left the river, and 'arriving at the foot of the first steep hill we pursued a Bear, but he climbing the rocks with much more Agility than we, he took his leave. Proceeding further up, we found by many beaten tracts, and dung of bears, that the mountains were much frequented by them, for the sake of the chestnuts, with which at this time these mountains [abounded].'[82] Both Catesby and Byrd had an interest in geology, which led Catesby to observe near the head of one river a church built by a cave which had been formed by herds of cattle licking the nitrous salt in the soil; he commented that the church had 'attained the indecent Name of Licking-hole Church' (see fig. 56).[83]

In the same year Catesby made an expedition to the Caribbean islands, very probably inspired by the descriptions and illustrations of West Indian flora and fauna in Sloane's *Voyage to the Islands Madera … and Jamaica* (1707).[84] After the English had taken Jamaica from the Spanish in 1655, there was keen European interest in the potential drugs, dyes and foodstuffs to be discovered from the 'local inhabitants, either European, Indian or Black', as Sloane described them.[85] Sloane's *Natural History of Jamaica* was the authority to which Catesby referred most frequently in his own *Natural History*.[86] During this trip, made on board a ship carrying sheep to Ja-

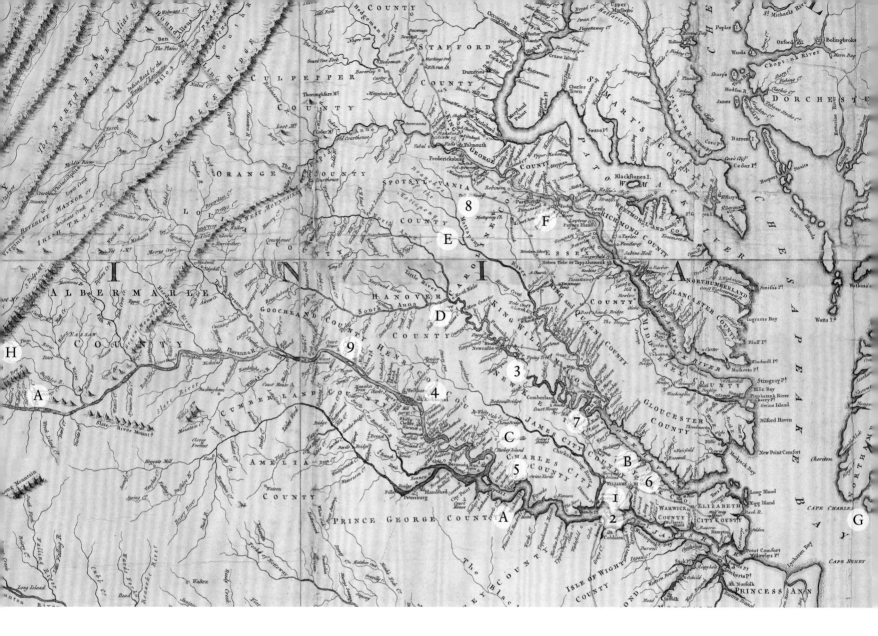

maica, Catesby also visited Hispaniola, Puerto Rico, Barbados and Bermuda (fig. 57). He watched birds, observed the variations between trees growing on the islands and mainland, and collected plants to send to Dale and other garden owners at home.

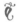

Catesby returned to England in the autumn of 1719, possibly in part to administer his property and finances following the death of his remaining older brother, Jekyll, in September 1717.[87] He arrived in East Anglia not only with a large consignment of plant specimens for Dale, but also with a collection of paintings of Virginian flora and fauna. The plant material Catesby had sent Dale during his stay had been a topic of discussion between Dale and his mentor William Sherard, and on Catesby's return,

Dale was quick to tell Sherard not only about the specimens Catesby had brought with him but also about his paintings. On 15 October, Dale wrote:

> Mr Catesby is come from Virginia, he hath brought me about 70 specimens of which about half are new, these I shall likewise send up in the box for your view … He intends again to return, and will take an opportunity to waite upon you with some paintings of Birds etc which he hath drawn. Its pitty some incouragement can't be found for him, he may be very usefull for the perfecting of Natural History.[88]

Two months later he wrote again to Sherard, saying: 'Mr Catesby came last week to visit me, to whom I gave your service. I know not when he intends for Virginia but designs for London shortly, when he will waite upon you. I am sure you will be pleased with the drawings of Birds and Plants he hath, and if

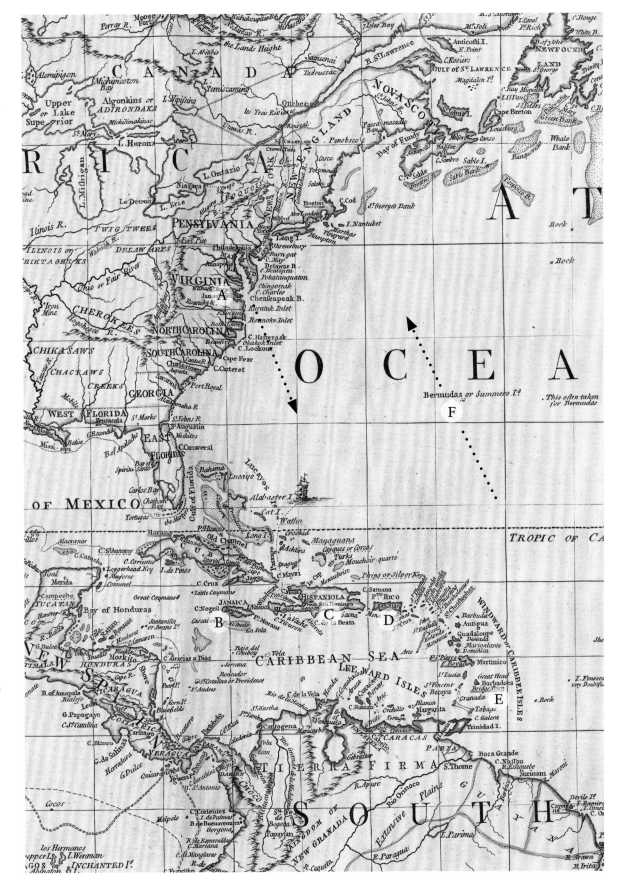

he had incouragement, might be very usefull in perfecting the Natural History of those parts.'[89]

After having spent so long abroad, Catesby would no doubt have had many affairs to attend to in Suffolk and Essex, not only in the wake of his brother Jekyll's death. Either for this or other reasons, it was not until five months later that he met Sherard in London. His delivery of a letter from Dale dated 11 May 1719, beginning 'Worthy Sir, The bearer hereof Mr Mark Catesby comes now to waite upon you,'[90] signals the beginning of Catesby's friendship with Sherard as well as a period during which Catesby's journeys between Essex and London allowed him to act as a conduit between the two botanists, sometimes carrying parcels of plant specimens and books as well as messages and letters.[91] Dale's anticipation

of Sherard's approval of Catesby's watercolours was well founded. Sherard was later to write to Richard Richardson, on the basis of Catesby's Virginian watercolours and plant collections, that Catesby was 'pretty well skill'd in Natural history [and] designs and paints in water colours to perfection'.[92] Among the watercolours Catesby showed Sherard may have been those featuring 'The Baltimore Bird' (*Icterus galbula*), 'The Red-Start' (*Setophaga ruticilla*) and 'The Soree' (*Porzana carolina*), bird species the artist notes specifically that he saw only in Virginia (fig. 58).[93] 'The Green Snake' (*Opheodrys vernalis*), which he showed entwined around the 'Cassena' or 'Yapon' (yaupon, *Ilex vomitaria*), must also have been painted in Virginia as the species is not found further south than the higher elevations of Virginia.[94]

FIGURE 58

Mark Catesby, 'The Soree', 1712–19. Watercolour with touches of bodycolour over graphite, inscribed in pen and ink, 26 × 37 cm.

Royal Library, Windsor, RCIN 925905b

Evidently Sherard was impressed enough by Catesby's abilities – both as an artist and a plant collector and naturalist – to take on the task of looking for sponsors to enable him to return to America. And from Catesby's comment in his Preface, it may have been Sherard who first encouraged the idea of creating his *Natural History*. Catesby wrote that Sherard 'favoured me with his Friendship on my return to England in 1719 … [and also] by his advice (tho' conscious of my own inability) I first resolved on this undertaking, so agreeable to my inclination'.[95] Another young naturalist to whom Sherard similarly offered encouragement was John Martyn, a promising botanist who was later to become professor of botany at Cambridge. Introduced by the Scots physician Dr Patrick Blair to Sherard in November 1719, Blair wrote that Martyn 'valued the opportunities of improvement which his new acquaintance might afford, and how kindly the juvenile inquirer was encouraged by that distinguished Botanist'.[96] It may well have been Sherard who introduced Catesby to Martyn at about this time; Catesby's professional exchange with Martyn was also to be influential in his formulation of ideas for the *Natural History*.[97]

During the two to three year period between his two North American trips,[98] Catesby was partly occupied with family affairs, now spread between Virginia and East Anglia, and he often met his niece Elizabeth's husband, William Pratt, in London.[99] At the same time he was pursuing his horticultural interests, and he spent time at the Hoxton and Chelsea gardens where exotic plants were being raised, including some from seeds he had sent from Virginia. At Fairchild's in Hoxton he admired a scarlet horse chestnut in flower in 1719, and he also took note of a 'Cassena or Yapon';[100] at the Chelsea Physic Garden he saw a black walnut tree and what he identified as a hickory nut.[101] He was likewise developing his artistic skills. No doubt he visited Sloane's renowned collections and studied his print collection and albums of natural history drawings; Sloane would have been especially interested in Catesby's watercolours and presumably hoped the artist might prove useful in making additions of New World species to his 'Miniatures' albums. In 1720 Catesby acquired a copy of *Aesop's Fables* illustrated with etchings made after drawings by the distinguished animal painter Francis Barlow.[102] As we will see, this book was to be an important influence on Catesby's own natural history illustrations (fig. 59).[103]

Although it seems that Catesby's original plan may have been to return to Virginia, Sherard and members of the Royal Society circle were keen for a naturalist to take on the unfinished work of John Lawson, who had planned to publish a comprehensive book on the natural history of Carolina following his unillustrated *New Voyage to Carolina* (1709). During September 1720, the possibility was being discussed of the artist Eleazar Albin going to Carolina and the Caribbean to paint insects – a plan, however, it seems Albin may have turned down.[104] Catesby's demonstration of his skills as both naturalist and artist appealed not only to the members of Sherard's scholarly circle but to collectors and noble garden owners, as well as to Francis Nicholson, newly appointed as Governor of South Carolina. On 20 October the Council Minutes for the Royal Society recorded that Nicholson had recommended Catesby as 'a very proper person to observe the Rarities of [South Carolina] for the uses and purposes of the Society … [and granted him] the Pension of Twenty Pounds per Annum during his Government there'.[105]

A delay of several months to the realization of the plan occurred, however, when one of Catesby's other sponsors, the Duke of Chandos, suggested that

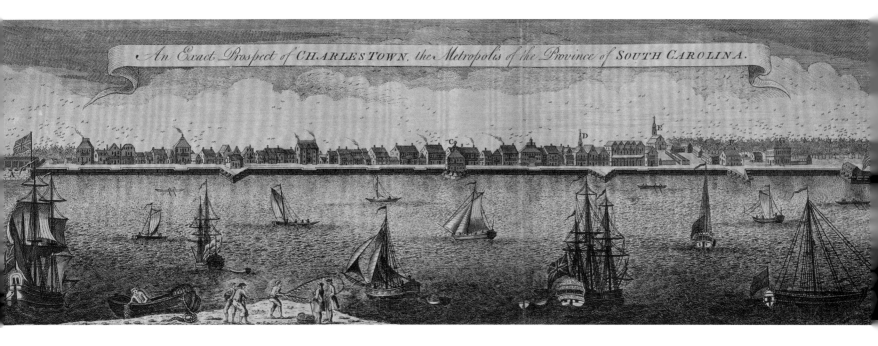

An Exact Prospect of CHARLESTOWN, the Metropolis of the Province of SOUTH CAROLINA.

Catesby's skills could be used instead in the service of the Royal African Company. In view of the duke's status and financial power, it would have been difficult for Catesby not to acquiesce with his desires; he was later to place Chandos at the top of the list in the Preface to his book of his twelve sponsors, arranged according to rank rather than size of subscription.[106] Sherard, however, expressed his disappointment in a letter to Richardson: '[Africa] is a sickly place and I could wish [Catesby] had held to his resolutions of going to Carolina, but I think he's now too far engaged with the Duke of Chandos to think of it.'[107] By December 1721, however, the original plan of sending Catesby to Carolina had been reinstated, and on 27 January 1722 Sherard reported to Richardson: 'Mr Catesby goes next week for Carolina. He has put off his going till the last ship. I have got sufficient subscriptions ... and I hope he'll make me suitable returns that I may furnish all my friends.'[108] Catesby's own statement of the purpose of the trip was articulated slightly differently in a letter he wrote from Charleston in 1723 to another of his patrons, Edward Harley, Earl of Oxford: 'It is impossible for me to send Botanical and other collections to every of my Subscribers, and to perform what I concieve [sic] I am principally sent here for [–] to discribe the Natural productions of the Country[.]'[109]

❧

After nearly three months at sea, Catesby arrived in Charleston on 3 May 1722 (fig. 60). A sense of his seriousness of purpose is given by his reference to the copy of Willughby and Ray's *Ornithology* he brought out from England, with which he identified a turnstone caught on board.[110] His seven-year stay in Virginia had provided him with excellent training for the period of exploration and collecting that was now to occupy him for the next four years.[111] Not only had it given him direct experience of working in the field, and knowledge of the equipment and type of assistance he would need, but also an authority that could only come from experience. Collecting, of

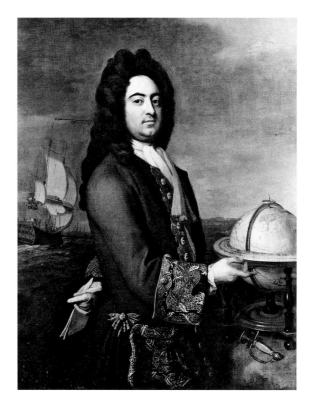

FIGURE 60

Bishop Roberts and William Henri Toms, *An Exact Prospect of Charlestown, the Metropolis of the Province of South Carolina*, 1739. Engraving, 50.8 × 171.4 cm.

Gibbes Museum of Art, Charleston, SC, accession no. 1940.014.0005 (Gibbes Museum purchase)

FIGURE 61

Michael Dahl, *Francis Nicholson*, pre-1728. Photograph of lost oil painting.

Maryland State Archives, Annapolis

FIGURE 62

Charles Mortier, *Carte particuliere de la Caroline*, marked with Catesby's journeys, 1696. Hand-coloured engraving, 47 × 58.5 cm.

Private collection, Charleston, SC

course, was his first remit, together with preserving and shipping his specimens back to his sponsors; but his parallel aim – and the one which was the more important to him personally – was to record the fruits of his explorations and collecting in text and images.

Just as in Virginia Catesby had used his family connections to help in his explorations of the country, so in Carolina he immediately made good use of his initial contact with the governor. In his first letter to Sherard he reported, 'The Governor recieved me with much kindness to which I am satisfyed your Letter contributed not a little' (fig. 61).[112] Through Francis Nicholson Catesby not only was to get a sense of the topography of the region and where to begin his

collecting, but also had introductions to plantation owners whose 'hospitality and kind entertainment … much contributed to facilitating the work I went about'.[113] The country seats of a number of these plantation owners were in the parish of Dorchester, at the head of the Ashley River, and nearby Goose Creek, a tributary of the Cooper River.

Between his arrival in Charleston in May 1722 and January 1725 when he left for the Bahama Islands, Catesby traversed many hundreds of miles, visiting the coastal areas of the Low Country or Tidewater, and following the Ashley, Cooper and Savannah rivers towards their sources in the foothills of the Appalachian Mountains. Evidence from some

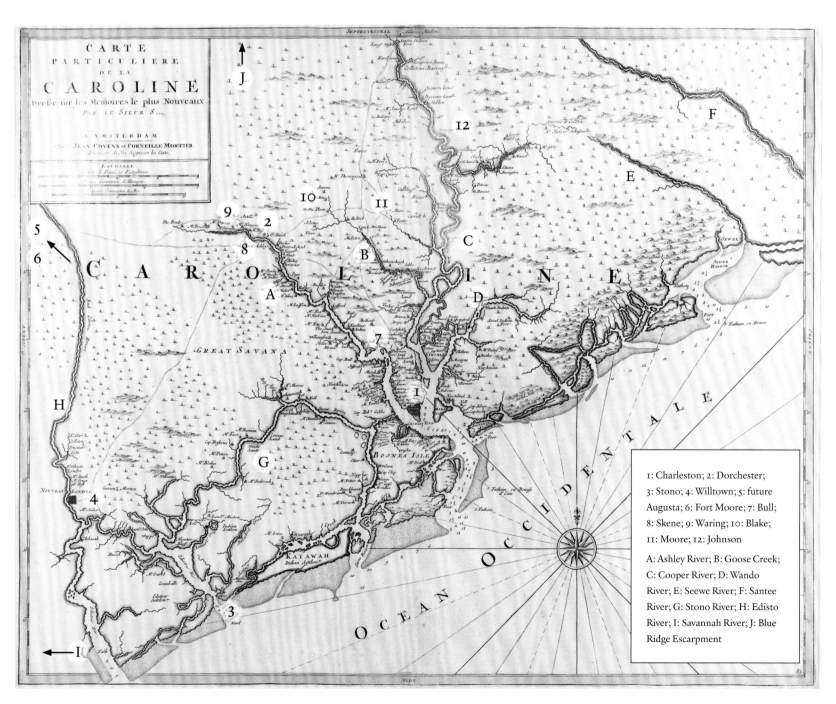

1: Charleston; 2: Dorchester; 3: Stono; 4: Willtown; 5: future Augusta; 6: Fort Moore; 7: Bull; 8: Skene; 9: Waring; 10: Blake; 11: Moore; 12: Johnson

A: Ashley River; B: Goose Creek; C: Cooper River; D: Wando River; E: Seewe River; F: Santee River; G: Stono River; H: Edisto River; I: Savannah River; J: Blue Ridge Escarpment

View in St James's Goose creek — Chas. Glover Esqr.

FIGURE 63

Thomas Coram, *View in St James's, Goose Creek*, 1792. Oil on paper, 13 × 23 cm.

Gibbes Museum of Art, Charleston, SC, accession no. 1990.005.0010 (Gibbes Museum purchase with funds provided by the Winnie Edwards Murray Fund)

of the plants he collected shows he penetrated the backcountry as far as the Southern Blue Ridge Escarpment (fig. 62).[114] In order to traverse this largely uninhabited country, Catesby would have followed Native American trails, on foot or on horseback; at other times he may have travelled by canoe or periagua.[115] A view by Thomas Coram painted in 1792 at Goose Creek gives an idea of the swampy terrain of this area (fig. 63).

Catesby repeated his visits to certain areas at different times of year in order to collect plants at successive stages of their flowering and fruiting.[116] The results of his collecting were sent to his sponsors and a few friends and family members in consignments every few months – at least 2,000 dried plant specimens, an unknown number of seeds and living plants, over 150 zoological specimens, as well as some ethnographic artefacts.[117] In parallel with his collecting activities, he made drawings and paintings of the fauna and flora, including around thirty duplicate watercolours for Hans Sloane.[118]

The house Catesby used as his base for collecting expeditions while in Charleston – which he described as 'the house I am at when in Town'[119] – was that of his friend, the Oxford-educated Thomas Cooper, a learned 'doctor of physick' and experimental natural philosopher. Cooper's extensive library of medical and other books would have been useful to Catesby.[120] His and Cooper's friendship included their shared interest in the medicinal properties of plants but more generally their hope to 'improve Natural Knowledge'.[121] Cooper's invitation to Catesby to join him as artist to 'deliniat[e] Birds and other Natural Productions' on a proposed expedition to Mexico was to come to nothing when their joint appeals to Mead, Sherard and Sloane for support were unanswered.[122] Although no records survive of the location of Cooper's house, Catesby writes of a south-facing room in which he dried, mounted and recorded his plant specimens in preparation for sending them to England, and presumably also preserved and packed his zoological specimens. It must have been here too that he wrote up his field notes, corresponded with his sponsors in England, and worked up his field sketches into watercolours. He also recorded what is likely to have been Cooper's garden, substantial enough for him to transplant trees to from the wild.[123] While in the city he frequently had to attend the Customs House to collect letters and cargoes arriving from England,

FIGURE 64

Mark Catesby, 'The American Goldfinch' and 'Acacia', 1722–5. Watercolour and bodycolour with gum, over pen and ink, 37.8 × 26.8 cm.

Royal Library, Windsor, RCIN 924857

FIGURE 65

Henrietta Drayton, *Ashley Hall*, c.1820. Watercolour over pencil, 20 × 32 cm.

South Caroliniana Library, University of South Carolina, Columbia, SC, accession no. 2090

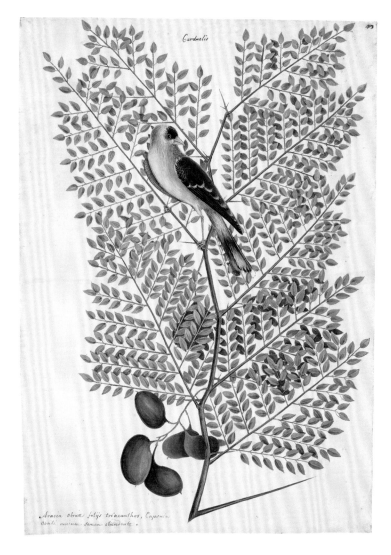

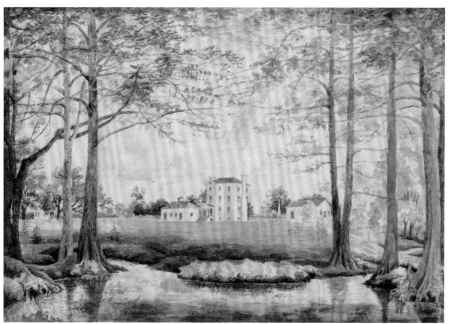

and importantly to cultivate ships' captains so as to ensure his own cargoes were looked after properly during the sea voyages home.[124] Another task was to search out local carpenters to make up boxes, barrels and other containers when supplies had not arrived from his sponsors in England.[125]

The plantation houses of the 'Gentlemen of the County', as Catesby described them,[126] situated mainly along the Ashley and Cooper rivers, were set in landscaped gardens in several-thousand-acre estates. Their mansions were typically built in brick, with many storeys and windows, projecting wooden 'piazzas' and porches, and numerous outhouses to accommodate the slaves on whose labour the successful establishment of cash crop plantations was reliant. Two of Catesby's hosts were previous governors: James Moore (who had preceded Francis Nicholson) owned a substantial house and gardens at Boochawee plantation in St James Goose Creek Parish, near Dorchester at the head of the Ashley River (see fig. 63),[127] and Robert Johnson, who was experimenting with growing crops including rice, cotton and silk at his plantation, Silk Hope, in St George's Parish on the Cooper River.[128] Johnson actively supported Catesby in his work, accompanying him on horseback during his collecting expeditions through the Low Country, and provided him with recipes for pickling sturgeon and making caviar which Catesby read to the Royal Society and published in his *Natural History*.[129]

Amongst the group of plantation owners near Dorchester at the upper reaches of the Ashley River was Thomas Waring, a member of the Royal Council who later became a commissioner to encourage silk manufacturing.[130] It was at Waring's seat, Pine Hill, that Catesby identified the only 'Water acacia' (water locust tree, *Gleditsia aquatica*) that he saw during his time in South Carolina (fig. 64);[131] he was later to record the find in the *Hortus Britanno-Americanus*.[132] While staying with another member of the Royal Council, William Bull, at Ashley Hall, one of the earliest plantations on the Ashley River, Catesby planted a 'stately, quarter-mile avenue of live oaks' for his host (fig. 65).[133] He also discovered the dahoon, *Ilex cassine*, 'a very uncommon plant in Carolina, I having never seen it but at Col. Bull's Plantation on Ashley River, where it grows in a bog'.[134]

One of the wealthiest men in the province was Colonel Joseph Blake, who at Newington plantation on the upper Ashley River built a fine brick mansion

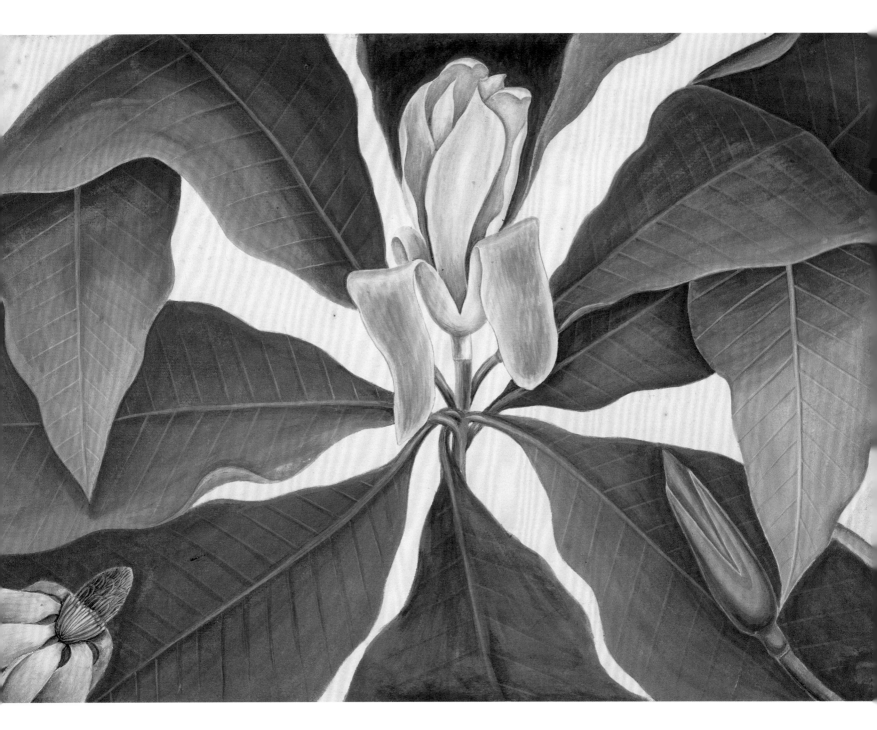

with elaborately laid-out gardens, ornamental waters, and an avenue with a double row of live oaks on each side.[135] While staying at Newington Catesby had a narrow escape. Soon after rising from his bed in a ground floor room one morning, while he was drinking tea with his host in a nearby room, the African slave who went in to make the bed discovered a rattlesnake, *Crotalus horridus*, 'vigorous and full of ire, biting at every thing that approached him' coiled between the sheets.[136] His anxious uncle Nicholas reported the 'unhappy experience' to William Holman: 'my Nephew Mark Catesby in South Carolina

lying in a Lower room at a Gentleman's house found a huge old Rattle snake which climbed out as big again as [one he had encountered] at Virginia [which had been] in bed all night long with him in between the sheets.'[137] We do not know whose house it was where Catesby recorded sitting out on a porch 'in a sultry evening, with some company … when one of us let fall, from a pipe of tobacco, some light burning ashes, which was immediately catched up and swallowed by a frog … This put us upon tempting him with a red-hot wood-coal, not less than the end of ones finger, which he also swallowed greedily.' He

FIGURE 66

Mark Catesby, 'The Umbrella Tree', 1722–5. Watercolour, 37.8 × 26.8 cm.

Royal Library, Windsor, RCIN 926041

concluded that the southern toad, *Anaxyrus terrestris*, mistook the glowing ember for a fire-fly, an insect he saw often on hot nights in Virginia and Carolina (see fig. 219).[138]

Of all Catesby's hosts it was Alexander Skene, 'one of the most considerable men in the Country and ... of the most generous and genteel Spirit', with whom Catesby spent most time, writing to Peter Collinson that he was 'very often at his house'.[139] Skene's 1,300-acre estate, New Skene plantation, was in the parish of St George at Dorchester, and it was Skene's and Catesby's shared interest in horticulture that led Catesby to spend much time there. He was later to remember a row of umbrella trees, *Magnolia tripetala*, that were growing 'in great plenty ... particularly in the path leading from Mr Skene's house to his Savanna' (fig. 66).[140] It was from 'Mr Skeyns' that he wrote to Collinson to suggest an exchange of plants between the two garden lovers.[141]

Many plantation owners also possessed elegant town houses with gardens. Catesby would have known William Bull's town house, built around 1720 at Lower Meeting Street, Charleston, which was similar in design and construction to his Ashley Hall, and like that residence luxuriously furnished (fig. 67).[142] No doubt some of the fine furniture Catesby recorded being made out of wood of native American trees adorned Bull's and other of his wealthy friends' houses; he notes seeing 'beautiful tables' made out of 'loblolly bay',[143] cabinets and tables made of black walnut, the colour of which 'approaches nearer to black than any other wood',[144] and tables and cabinets and 'other curious works in joinery' made of 'mancaneel', 'beautifully shaded with dark and lighter streaks'.[145]

Catesby's descriptions of living and working closely with Native Americans as he explored the uninhabited parts of the country were in stark contrast to these glimpses of the lifestyle of the wealthy plantation owners. He told Sherard that there were two main dangers of travelling in 'remote parts': one, 'the fear of being lost', and the other, 'meeting with unfriendly Indians'. The violent end that his predecessor John Lawson had met at the hands of the Tuscarora in 1711 made him well aware of the potential dangers posed by unfriendly tribes.[146] For Catesby, it was important to cultivate the indigenous peoples both for reasons of self-preservation and to act as his guides, as well as, importantly, for what he could learn from them of their use of plants and animals

for food, medicine, clothing, ceremonies and utensils.[147] While members of some tribes had acquired some English and a little education (Catesby recorded that 'Reading and writing is the highest erudition that I have known or heard any of them attain to'),[148] he himself learned the native names of plants and animals, and as Lawson had done before him, some basic vocabulary and phrases (see fig. 17).

He recorded that he had many opportunities of 'seeing and observing the various nations of Indians inhabiting the whole extent of North America', but aside from his anthropological interest, it is clear that he made close personal contact with members of several different tribes.[149] Despite the fact that the indigenous peoples were very 'reserv'd and averse to reveal their secret mysteries to Europeans',[150] he was evidently accepted into their society. Accompanying Native Americans on long marches – 'I have often travelled with them 15 and 20 miles a day for many days successively' – he hunted, cooked, ate, drank and slept cheek by jowl with them in their 'cabbins', observing, for instance, that 'their bodies emitting none of that rankness that is so remark-

FIGURE 67

William Bull House, 35 Lower Meeting Street, Charleston, built *c*.1720.

able in Negroes; and as in travelling I have been sometimes necessitated to sleep with them, I never perceived any ill smell ... though their cabbins are never paved nor swept, and kept with the utmost neglect and slovenliness.'[151] Stamina was required to keep up with them on their hunting expeditions, as they 'are indefatigable, and will travel further, and endure more fatigue than a European is capable of ... running and leaping ... with surpassing agility'. Taking part in hunting panthers, Catesby noted how 'if not killed outright [the panther] descending furiously from the tree ... attacks the first in his way, either man or dog, which seldom escape alive.'[152] He was game to try everything his guides ate, recording that he 'often partook of' the elaborate meals they

kets and clay pipes, these included an 'Indian apron' of mulberry bark cloth sent to Hans Sloane and a 'waistcoat' made of deerskin sent to his brother, a garment he described as part of 'their ordinary Winter dress', worn in the coldest weather with 'the Skins of Bears, Beavers, Rackoons, &c. besides warm and very pretty Garments made of Feathers'.[157]

He noted of their character that the Native Americans 'seem to be a very happy people' and are 'very peaceable [and] they never fight with one another except drunk. The women particularly are the patientist and most inoffensive creatures living: I never saw a scold amongst them, and to their children they are most kind and indulgent.'[158] But by contrast to their 'peaceable nature' with members of their own tribe

FIGURE 68

Native American basket of split cane, dyed with plant dyes, given by Colonel Francis Nicholson to Hans Sloane, 1720s.

British Museum, London, Department of Africa, Oceania and the Americas, id. 00419779001

prepared for their festivals,[153] including 'the hindpart of [alligator's] belly and tail ... The flesh is delicately white, but has so perfumed a taste and smell, that I could never relish it with pleasure.'[154] Amongst other culinary details, he noted that they used wood ashes instead of salt, except for the Chickasaw, who used 'very sharp salt in cristalline lumps, which they told me was made of a grass growing on rocks in fresh rivers'.[155]

He made careful observations of the indigenous techniques for making canoes and weaving baskets – one of 'their masterpieces in mechanicks ... made of cane in different forms and sizes, and beautifully dy'd black and red with various figures; many of them are so close wraught that they will hold water' (fig. 68).[156] On several occasions he bought Native American artefacts or perhaps exchanged them for European-made items. As well as Cherokee baskets

were the 'diabolical ceremonies' they used in torturing their enemies, 'whom they murder gradually with the most exquisite tortures they can invent'.[159]

Catesby had several first-hand experiences of 'the fear of meeting with unfriendly Indians'. One of these was during a buffalo hunting expedition (fig. 69)[160] 'with five of [the Chickasaw] Indians and three white men' around Fort Moore, when he recounted that their group, returning 'loaded with skins, and barbecued buffalo', narrowly missed a bloody confrontation with twenty of the warring tribe of Cherokees: 'Though the Cherikees were also our friends, we were not altogether unapprehensive of danger, so we separated from our Indian companions, they shortening their way by crossing swamps and rivers, while we with our horses were necessitated to go further about, with much difficulty, and a long march, for want of our Indian guides.'[161] But unlike other

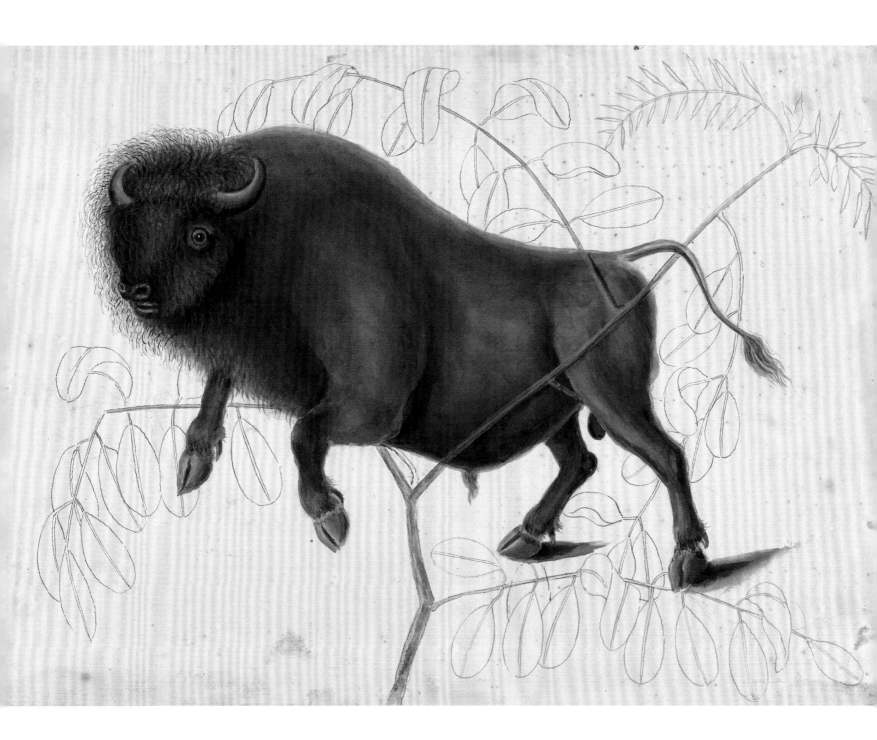

FIGURE 69

Mark Catesby after Kick, 'Bison
Americanus' and 'Pseudo
Acacia', 1722–5. Watercolour and
bodycolour, heightened with gum
over graphite; plant outlines in
brush and green watercolour over
graphite, 26.9 × 372 cm.

Royal Library, Windsor, RCIN
926092

contemporary accounts of the drama of survival in
the wilderness, Catesby played down the aspects of
hardship. The letters of the collector Thomas More,
also sponsored by William Sherard, who was collect-
ing in New England during the years that Catesby
was in South Carolina, are full of complaints of
physical fatigue and other obstacles;[162] and even the
indefatigable John Bartram collecting in Pennsyl-
vania was to speak more of difficulties and dangers
than Catesby did.[163] Catesby was both too deter-
mined and too curious to allow obstacles to get in
his way. He was, in fact, fearless in his urge to collect,

examine and sample the unknown, as demonstrated
by several incidents he recounted dryly. One was the
temporary blindness he experienced from the poi-
son of a 'mancaneel' tree in the Bahama Islands:

I was not sufficiently satisfied of [the virulent and
dangerous properties of these Trees], till, assisting
in the cutting down a Tree of this kind on Andros
Island, I paid for my incredulity: some of the milky
poisonous juice spurting in my eyes, I was two days
totally deprived of sight, and my eyes and face much
swelled, and I felt a violent pricking pain the first 24

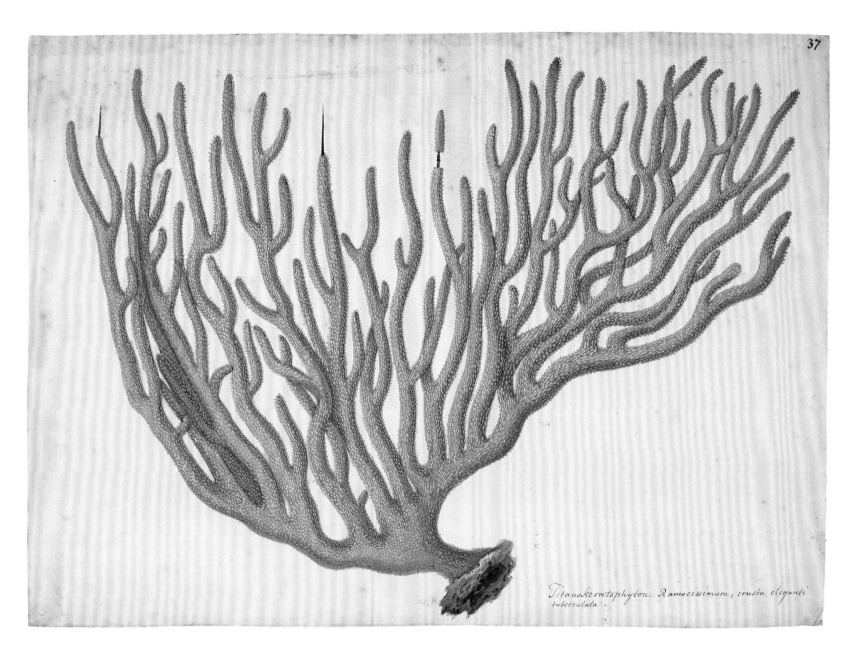

Titanokeratophyton Ramocissimum, crusta eleganti tuberculata.

hours (which from that time, abated gradually with the swelling, and went off without any application or remedy; none in that uninhabited island to be had).[164]

The last part of Catesby's sojourn in the New World was spent in the Bahamas. He arrived there in January 1725, returning finally to England probably in the spring of 1726. During this year, with his base in the governor's residence at Nassau in Providence Island,[165] as well as exploring the diverse botany, geology and other aspects of the natural history, he took particular pleasure in investigating the rich marine life of the different islands. His accounts include descriptions of catching and losing a devil

fish, boiling turtles,[166] and finding that he could observe the fishes, corals, shells and other 'submarine productions' at a great depth on account of the clear water: 'The water is so exceeding clear, that a depth of twenty fathom, the rocky bottom is plainly seen, and in calm weather I have distinctly and with much pleasure beheld variety of fish sporting amidst groves of corallines and numerous other sub-marine shrubs, growing from the rocky bottom, amongst infinite variety of beautiful shells, fungus, astroites, etc.' (figs 70 and 71). [167] His collecting activities on several of the islands continued unabated; in addition to the Bahamian plants and seeds sent back to Sherard, he collected a large number of sea urchins,

FIGURE 70

Mark Catesby, 'Titanokeratophyton Ramocissimum, crusta eleganti tuberculata', 1725–6. Watercolour and bodycolour over graphite, 12.9 × 27.2 cm.

Royal Library, Windsor, RCIN 925983

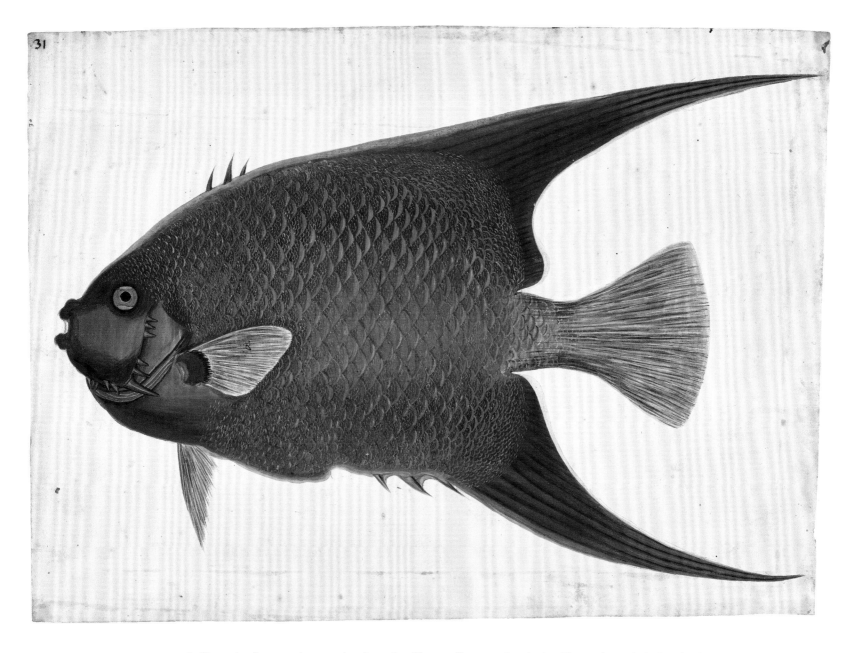

FIGURE 71

Mark Catesby, 'The Angel
Fish', 1725–6. Watercolour
and bodycolour and gold over
graphite; whitening out around
fins, 27.1 × 37.9 cm.

Royal Library, Windsor, RCIN
25976

shells and other marine productions for Sloane.[168]
Perhaps lack of funds necessitated him returning
to England sooner than he would have liked; but,
whatever the reason, he later recorded his regret at
not being able to spend longer in the Bahamas:

> Though the figures of the most remarkable trees,
> shrubs, &c. of the Bahama Islands are here exhibited,
> many things remain undescribed for want of a longer
> continuance there; particularly four kinds of palms,
> which, as it is a tribe of trees inferior to none, both as
> to their usefulness and majestic appearance, I regret
> my not being able to give their figures, or at least a
> more accurate description of them, especially of the

silver-leaf and hog-palms, of which, I think, no notice
has been taken.[169]

On his return to England in 1726, Catesby seems
straight away to have settled in London. With no
family ties remaining in East Anglia, he was free to
concentrate his energies single-mindedly on creat-
ing his *Natural History*.[170] As we have seen, for him,
London 'was the centre of all Science', at the heart of
which was the Royal Society with its library, collec-
tions and like-minded natural philosophers.[171] The
lively social world of theatre, music, masquerades

FIGURE 72

Richard van Bleeck, *Thomas Fairchild*, *c*.1723. Oil on canvas, 73.8 × 61.5 cm.

University of Oxford, Department of Plant Sciences

ten to his niece Elizabeth Jones;[175] and he was still there in 1731/2 when the title page for the first volume of the *Natural History* recorded that the book is 'Sold ... by the Author at Mr. Bacon's in Hoxton'.[176] However, from around the date of Stephen Bacon's death (*c*.1733), Catesby appears to have moved his horticultural activities to the nursery of his friend Christopher Gray in Fulham.[177] Gray's garden was situated 'between Parson's Green and Fulham ... on both sides of the King's road' – and it would seem that Catesby may have had land within Gray's nursery as part of an arrangement similar to that he had had with Fairchild and Bacon.[178]

From soon after his return to London the main focus of Catesby's professional life was his work on the *Natural History.* His later statement that 'the whole [book] was done within my house, and by my own hands' gives only a faint indication of what must have been a period of intense activity for him.[179] Finding that hoped-for support from his sponsors of having his watercolours engraved professionally was not forthcoming, he took on the task of etching his drawings himself, learning the skill with the help of lessons from leading London printmaker Joseph Goupy.[180] While there were financial advantages to his decision to publish the book by subscription, he was under constant pressure to bring out a part every few months in order to honour his guarantee to his subscribers.

On the completion of the first twenty plates that made up Part I of the *Natural History* in May 1729, Catesby had an audience with Queen Caroline.[181] At this he showed her some of his drawings, presented her with the first part, and sought permission to make her the dedicatee of the book (fig. 73).[182] As was usual court procedure, an announcement of the royal audience was printed in several newspapers: 'London. The last Week Mr. Catesby (introduced by the Right Honourable the Lord Cartaret) presented to her Majesty the first Volume of his Natural History of Florida, Carolina and the Bahama Islands; containing a great Variety of the Animal and Vegetable Productions of those Countries, which the Author hath been several Years collecting from the Life.'[183] Permission was granted, and Catesby wrote in his dedication 'To the Queen' in the customary rhetorical style:

Madam ... Your great Goodness in encouraging all Sorts of Learning, hath emboldened me to implore

and balls centred around the court, which features vividly in his friend William Byrd's diary accounts of London life, makes no appearance in Catesby's writings.[172] In fact, so elusive was he that at one stage members of his family did not know where he was living; in June 1728 George Rutherford, married to Catesby's younger sister Ann, wrote to his niece, Elizabeth Jones, who was staying in Chelsea during a visit to England, 'your Uncle Mr Mark Catesby is now in London, but I cant tell you where he lodges.'[173]

While there is no hard evidence, it would seem that thanks to an arrangement with his friend Thomas Fairchild (fig. 72), the Hoxton suburb of north London, characterized by its nursery gardens, became Catesby's home.[174] Perhaps in return for accommodation and a plot of land within the nursery, Catesby shared his knowledge and experience of rearing American plants with Fairchild, with what is likely to have been commercial gain to both. It was 'at Mr Fairchild's in Hoxton' that Catesby advertised the *Natural History* in his 'Proposals' of *c*.1728. After Fairchild's death in October 1729, Catesby continued living and working at Hoxton when the nursery business was taken over by Fairchild's nephew Stephen Bacon; in the second edition of the 'Proposals', printed probably in 1729, he changed his address to 'at Mr. Bacon's in Hoxton'. In March 1730 he gave Hoxton as his address on a letter writ-

FIGURE 73

Enoch Seeman, *Queen Caroline of Ansbach*, c.1730. Oil on canvas, 238.9 × 146.7 cm.

Royal Collection, RCIN 406182

it in May at their first reception. He is so backward to communicate what he knows at all times in conversation, and by letter so cautious of ostentation and boasting, that he runs into the contrary extream of too much reservation, even to a fault. I must not show his letters.[185]

Soon after his audience with the queen, Catesby paid his first visit to the Royal Society on 22 May 1729 when he presented the 'Proposals' and Part I of his book. Thereafter he attended a number of meetings as the guest of the secretary, Cromwell Mortimer, and other fellows Peter Collinson, John Martyn, Philip Miller and Johann Amman.[186] In 1730 Mortimer published his 'account' of the 'Proposals' and Part I;[187] and on completion of the first five parts making up Volume I of the book, proposed by his friends John Amman and John Martyn (fig. 74), Catesby was elected a fellow on 26 April 1733, being admitted a week later when he 'signed his obligations' (fig. 75).[188] After this he became a frequent vis-

Your Royal Protection and Favour to my slender Performance. I hope Your Majesty will not think a few Minutes disagreeably spent, in casting an Eye on these Leaves; which exhibit no contemptible Scene of the Glorious Works of the Creator, displayed in the New World; and hitherto lain concealed from the View of Your Majesty.[184]

But Nicholas Jekyll, anxious that his nephew be recognized for 'his time, travels, danger, assiduity and skill in finding out natural discoveries' and hoping too that he might be financially rewarded for his efforts, was frustrated by Catesby's modesty and reticence in his audience with Queen Caroline. On 9 October that year Jekyll wrote in some frustration in answer to Holman's enquiries:

You ask what my Nephew Mark got of the Queen. And I cannot tell what, as when he presented the Book … in May when he waited on her Majestie she gave him nothing, nor can I tell what any have done for him since … I know he might present at Kew Garden with

FIGURE 74

Catesby's nomination certificate for membership of the Royal Society, 1 February 1733. Pen and ink on paper.

Royal Society of London

itor to Crane Court, Fleet Street, where the society had its offices, library and Repository, and took an active part in events (fig. 76).[189] His practical, artistic and scholarly judgements were respected: he was appointed an official draughtsman, a member of the committee for overseeing the Repository, and was asked to review books, including, significantly, in 1735, Linnaeus's *Systema naturae*, a task, however, he did not accept.[190] At meetings of the society he read several of his own papers as well as papers submitted by others. He accompanied guests to meetings and proposed a number of his friends and associates for membership.[191]

In the summer of 1733, perhaps allowing himself a short break after completing the first volume of his *Natural History*, Catesby made a visit to Holland. Thomas Knowlton reported: 'Mr Catesby has published his fifth part with a preface & is gone over to Holande[. H]e wrot to me to Know if he could be of any sarvice to me there.'[192] It is likely that Catesby visited Leiden at the invitation of his friend Johan Gronovius, professor of botany there, and would surely have taken a copy of Volume I of his *Natural History* with him. As well as seeing Leiden's famous botanic garden, he would have had the chance to study the plant specimens and manuscripts Gronovius had received from John Clayton in Virginia which Gronovius was to publish in his *Flora Virginica* (*c*.1739–43).[193] Catesby's offer of 'service' to Knowlton would no doubt have been to bring books and plants back to him.[194]

Ten years later, in 1743, Catesby completed the tenth part – which ended the second volume – of the *Natural History*. Queen Caroline had died in 1737, but a new royal patron emerged in Princess Augusta, wife of Frederick, Prince of Wales, who shared the interests in gardening and exotic plants of her late mother-in-law (fig. 77).[195] We know nothing about Catesby's audience with Princess Augusta, which must have occurred sometime during the early or middle part of 1743. In his dedication to her he wrote: 'Such an instance of Goodness [as shown in Queen Caroline having 'condescended to over-look and approve my Drawings'] emboldened me to hope Your Royal Highness would vouchsafe the like Honour to this Second and Last Volume'.[196] Having obtained, as he put it, 'Pardon for [his] Presumption' in seeking her patronage, on 15 December that year he presented the dedication along with the tenth part of the book to the Royal Society together with the rest

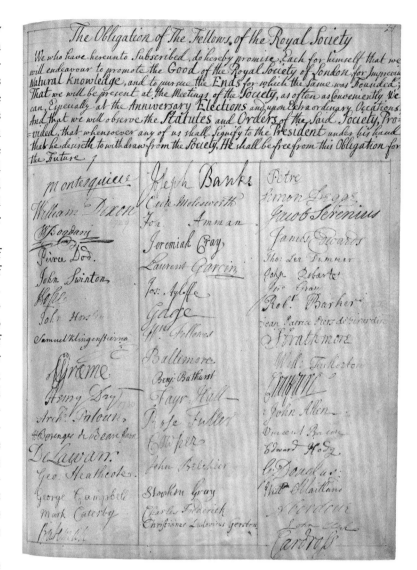

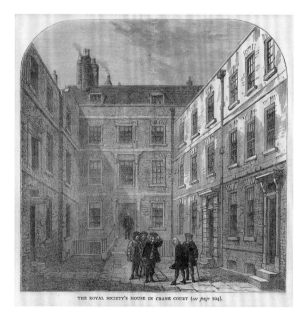

THE ROYAL SOCIETY'S HOUSE IN CRANE COURT (see page 104).

of the accompanying material – title page, index, Preface, map, Account and List of Encouragers.[197]

Soon after this on 29 December 1743, Catesby, together with George Edwards, was elected a member of the Spalding Gentlemen's Society (fig. 78).[198] His honorary status meant that he did not have to pay the annual fee, or 'present some valuable book to the Society' on his admission.[199] It seems that he never visited or even corresponded with the society, but his joining the ranks of the distinguished group of members was a mark of recognition of his contribution to the world of learning.

Catesby revealed nothing about his personal life in his writings. By 1730, however, he had met Mrs Elizabeth Rowland, probably a widow, who had her own daughter Elizabeth, and was to bear Catesby five children. For reasons unexplained, he did not marry her for another seventeen years. Their marriage is recorded on 8 October 1747, in St George's Chapel, Mayfair – described by a modern author as 'one of the famous churches where marriages were performed without license or publication of banns, and although they were considered clandestine, were nevertheless valid and binding'.[200] Before that, however, Mark and Elizabeth had their children, the first three of whom, Mark, John and Caroline died young.[201] Their last two, Ann, baptized on 27 December 1737, and a second son Mark on 6 July 1740 (implying the death of the older son Mark), survived into adulthood.[202] The first three children's births, and the deaths of John and Caroline, are recorded in the parish register of St Giles, Cripplegate, a mile and a half south of Hoxton, suggesting that Catesby and Elizabeth may have moved to that parish during the summer of 1730.[203]

Around eighteen months before the end of Catesby's life, Linnaeus's student Pehr Kalm recorded visiting him at his home. Kalm's journal entry for 23 May 1748 reads: 'The whole afternoon I spent with Mr Catesby, a man renowned for his splendid but expensive book on the *Natural History of Carolina* in America … [He] seemed to be a man of about fifty years old. He was a little near-sighted, and now spent his time reading and furthering his knowledge of natural history.'[204] In July the following year Catesby's friend Thomas Knowlton wrote to Richard Richardson:

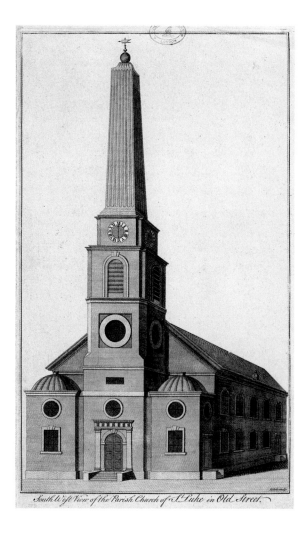

South West View of the Parish Church of S.^t Luke in Old Street.

FIGURE 79

Benjamin Cole, St Luke's, Old Street, London, *c*.1750. Engraving, 37 × 22 cm.

London Picture Archive, record no. 7678

When I was in London, I saw … Mssrs Catesby and Edwards, who has materials for a third volume of Birds, Flies, and Animals etc. but poor Mr Catesby's legs swell, and he looks badly. Drs Mead and Stack said there were little hopes of him long on this side of the grave. He spoke to me of his Appendix [to the *Natural History*], which he said you had not got; therefore desired me to speak to you about it.[205]

Five months later, in December 1749, while 'Crossing the way in holbore, [Catesby] fell and was taken up Senceless … He receiv'd in his fall a bruse in his head … He had his son with him, a Boy of 8 years old, who could give no satisfactory account. He was put in a Coach and carried home to his wife in that Condition.'[206] He died a few days later, just before Christmas, leaving 'a Wife, a Son and Daughter yong'; Edwards was amongst those who attended his funeral at St Luke's Church, Old Street (fig. 79).[207] His death was announced in the *Gentleman's*

Magazine and in other newspapers including the *Caledonian Mercury*, whose notice was printed a week later: 'On Saturday Morning died at his House behind St Luke's Church, aged seventy, the ingenious Mr. Mark Catesby, who was Author of a Work, entitled, *A Natural History of Carolina*.'[208]

It was Catesby's friend Peter Collinson, however, who left the fullest announcement of his death – one that was to become much quoted as a memorial or epitaph – published in the *Gentleman's Magazine* in January 1750:

On Saturday morning, the 23rd of December, died at his house behind St. Luke's Church, in Old Street, the truly honest, ingenious, and modest Mr. Mark Catesby, F.R.S., who, after travelling through many of the British Dominions on the Continent and in the Islands of America, in order to make himself acquainted with the customs and manners of the natives, and to collect observations on the animals and vegetables, which he there very exactly delineated and painted on the spot, with these materials returned to England, and compiled a most magnificent work, entitled, *A Natural History of Carolina*, with two hundred and thirty copper-plates,[209] which does great honour to him and to his native country, and perhaps is the most curious and elegant performance of the kind that has any where appeared in Europe; wherein, not only the rare beasts, birds, fishes, and plants were drawn, engraved, and exquisitely coloured after the life, from the original paintings by his own hands, but he has also added a map, and a general history of those countries. He lived to the age of seventy, well known to and much esteemed by the curious of this and other nations, and died much lamented by his friends; leaving behind him two children and a widow, who has a few copies of this noble work undisposed of. P. Collinson, F.R.S., F.S.A., A.R.S., Sueciae Socius.[210]

Catesby's will does not survive, but we know that he bequeathed his copy of Linnaeus's *Hortus Cliffortianus* (1737) to his friend Thomas Knowlton.[211] In Elizabeth Catesby's will made 4 January 1753, she left 'to my loving cousin, Jekyll Catesby, a second volume of Mr Catesby's Natural History, to make his set complete'[212] and 'all the rest, residue and remainder of my estate, whatever money, goods, plates, and all that I may be possessed of or entitled unto … to my two loving children, Mark Catesby and Ann Catesby, to be equally divided between them'.[213] Jekyll Catesby was appointed executor, and Peter Collinson was

one of the two witnesses. The 'rest, residue and re-mainder' of the estate amounted to little more than the contents of Catesby's studio, Edwards recording that 'His whole fortune[, his] household Stuff, Coppy of his histor[y], original drawings, and Copper plates[,] did not amount in the whole to 700£.'[214] While his twentieth-century biographers note that Catesby had 'impoverished himself through his devotion to natural history',[215] the value of his art materials was not inconsiderable.[216]

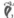

We have seen how closely Catesby's work and interests were woven into his life's story – themes that will be expanded in the chapters devoted to the different aspects of his work that follow. While much about Catesby the man is evident from the passion, dedication and achievement of his life's goals, further insights into his character emerge from his letters and from his friendships.

Disclaiming credit for his own achievements, he was to write alongside the last plate of his *Natural History*: 'I arrogate nothing to myself upon this performance, so much as the strong inclination I had to these kinds of subjects, joined to the love of truth, that were my constant attendants and influencers.'[217] Modesty was attributed to Catesby by his friends, as well as by his uncle, who commented that his nephew was 'by letter so cautious of ostentation and boasting, that he runs into the contrary extream of too much reservation, even to a fault'.[218] George Edwards wrote:

> He was in his behaver much of Gentleman and gained the respect of all his acquaintance[. H]e was to[o] Modest to rise in the world by Pushing his interest amongst the great, to many of whom he had Acces[. H]e was under the frowns of fortune yet through his Great prudence and oeconomy Steared his cours to the end without either runing in debt or being troublesom to his friends[. H]e dyed regretted by all who knew his merrits.[219]

The physician and botanist Richard Pulteney, known himself for his modesty,[220] was to write that Catesby 'lived in acquaintance and friendship with many of the most respectable members of [the Royal Society,] being greatly esteemed for his modesty, ingenuity, and upright behaviour'.[221] These qualities are echoed by Pehr Kalm, who recorded after his visit to Catesby's home in 1748: 'He was a very ordinary, gentle, kind and civilised man without any pretension.'[222]

The fact that no portrait of Catesby appears to have been made would seem to be another indication of his modesty.[223] A few details of his appearance and character are, however, provided in a written portrait by Emanuel Mendez da Costa, a friend who spent time with Catesby during the last two years of his life:

> Mr Mark Catesby, author of the excellent and celebrated work, 'The Natural History of Carolina', &c. died in December 1749. I compute he was about 70, tall, meagre, hard favoured, and sullen look, and was extremely grave or sedate, and of a silent disposition; but when he contracted a friendship he was communicative, and affable. He left a widow, a son and a daughter. He often told me he believed he was descended from the Catesby of Richard III.[224]

For someone who had had to depend on his own resources in North America during the significant periods devoted to collecting in the field, and then over the twenty years working as artist and author, it is not surprising to learn that he was 'of a silent disposition'. A comment made in 1736 in a letter by William Byrd, 'I wish you will be so kind as to call on my freind Mr Catsby [*sic*] now and then, to know if he have any letter or commands for me. He is such a philosopher, that he needs a monitor to put him in mind of his friends', corroborates the impression of a private man not naturally inclined to sociability.[225]

But Catesby also had a gift for friendship, regardless of status or wealth, something of which is indicated by the trust he clearly gained from the indigenous people he lived and worked with during his stay in South Carolina. Both Pulteney's comment that he 'lived in acquaintance and friendship with many of the most respectable members of [the Royal Society]', and the unusually wide social spectrum of Catesby's friends, ranging from professional gardeners to noblemen, are indicative. Amongst his closest friends, Thomas Fairchild, Peter Collinson and Thomas Knowlton, both generosity and a shared passion for botany and gardening were the common thread. It would seem that Catesby responded to significant kindness from Fairchild on his return from four years in the New World, when he was faced with a lack of obvious means of funding for what was to turn out to be an enormously

expensive project. Their close working arrangement, which enabled Catesby to live and work in London, was based on mutual respect for each other's professional expertise. While letters between Fairchild and Catesby are lacking, the fact that Fairchild in his will left 'one guinea for a ring to his friend and witness, Mark Catesby' indicates a close friendship.[226]

The extensive correspondence of Peter Collinson, by contrast, contains many demonstrations of the Quaker merchant's warm, generous and open personality, to which Catesby was drawn.[227] Among Catesby's surviving letters, it is Collinson who stands out as being the one friend (rather than sponsor) to whom Catesby wrote while he was in South Carolina,[228] and it was Collinson's 'substantial' interest-free loan which enabled him to proceed with the plans for his book.[229] Something of their easy friendship emerges from the fact that Catesby was often at Peckham, advising Collinson on his garden, sharing his delight or disappointment in horticultural successes and failures, and assiduously recording in watercolour his more spectacular and unusual plants.[230] Collinson's loyalty to Catesby – through promoting Catesby's work to Linnaeus, his 'epitaph' to his dead friend (see above), and his continued support of Catesby's widow[231] – indicates the extent of their friendship (fig. 80).

Catesby's friendship with Knowlton, which began while the gardener was working for James Sherard (from the end of 1720 to 1725), was likewise forged through a mutual devotion to 'beloved botaney'.[232] In Knowlton, Catesby encountered a love of gardening similar to his own, while Knowlton's skill in cultivating rare and exotic plants complemented Catesby's first-hand knowledge of North American species.[233] Unusually for a gardener, Knowlton had adequate means to form an impressive botanical library of his own, and he and Catesby exchanged books as well as plants and seeds. Knowlton both subscribed to Catesby's *Natural History* and actively promoted it amongst his circle of friends and patrons.[234] And, as we have seen, it was to Knowlton that Catesby left his copy of Linnaeus's *Hortus Cliffortianus*.

Amongst the twelve 'Notable Persons and Gentlemen' Catesby listed in the Preface to the *Natural History* as giving him 'assistance and encouragement', William Sherard was the one with whom he had the easiest relationship. Sherard's scholarly and single-minded approach to botany (Pulteney described him as living 'with the greatest privacy in

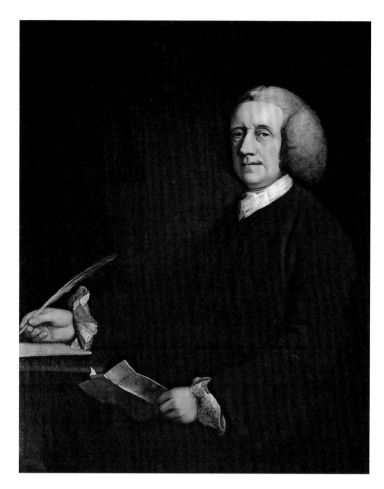

London, wholly immersed in the study of natural history'),[235] together with his outgoing and generous nature, allowed the two to have an open and fruitful working friendship, which was, however, cut short by Sherard's early death only two years after Catesby returned to London.[236]

In terms of Catesby's relationships with the aristocratic and other patrons higher up the social hierarchy, we glean little from his respectful tone. It says something of his character, however, that while maintaining the respect due from a social inferior, he stood his ground over Sloane's extra demands of making duplicate watercolours for both him and one of Catesby's aristocratic sponsors, Lord Perceval.[237] But with Richard Mead, a warmer relationship was forged based on the latter's generosity. A hint of Catesby's private loyalties emerges in his choice of Mead rather than Sloane as the recipient of a cargo of snakes in glass jars;[238] and he later made a public gesture in coining the botanical name 'Meadia' in honour of his patron. Mead, together with Thomas Stack, attended Catesby at the end of his life.[239]

FIGURE 80

Unknown, *Peter Collinson*, 1740s.
Oil on canvas, 102 × 76 cm.
Mill Hill School, London

With George Edwards, Catesby appears to have had both a close working relationship devoid of rivalry and a genuine friendship (fig. 81). Both engaged on writing and illustrating natural history publications, Catesby allowed Edwards to watch him at work and taught him the technique of etching.[240] Catesby trusted Edwards enough to loan him his drawings so that Edwards could colour his own copy of the *Natural History* as accurately as possible.[241] In his turn, Edwards allowed Catesby to copy for use in his book one of the drawings of animals Edwards had made for Sloane, and gave him another which formed the model for a plate in the *Natural History*.[242] Edwards was closely involved after Catesby's death in helping his widow with arranging and selling his working materials, and thereafter in the publication of a second edition of his book.[243] In terms of their friendship, Edwards, who described Catesby as 'my good friend',[244] attended his funeral, and later recorded a number of

biographical details in a letter written to the naturalist Thomas Pennant. There, as we have seen, he enumerated Catesby's qualities and 'merits'. By contrast, while it is clear that Catesby and Ehret also worked closely together, the personal side of their friendship remains obscure.[245]

A glimpse of Catesby's family loyalties and affection is shown in one of his letters to his niece Elizabeth Pratt. On 22 June 1722 he wrote from Charleston in reply to news from her that as 'no place abounds so much with my nearest and dearest Relations as Virginia so from no place is good news more acceptable,' signing it, 'Dear Niece, Yr most affectionate Unkle'.[246] We also learn in a letter from his uncle Nicholas Jekyll to William Holman in December 1722 that Catesby had attempted to make the sea journey from Charleston to Williamsburg to visit his family, but he had narrowly missed drowning: 'In the ocean the ship Founderd and sank and as many as could got into Boats, the rest (who were most) perished. In that deplorable condition [they were riven about] without all sustenance all helps and all hopes for severall days and nights: but when they little expected it God sent a ship which made to [rescue them] and took them in and they are at home.'[247] While Jekyll compared the near disaster to 'St Paul's escape from shipwreck at Malta', it is characteristic of Catesby that he made no reference to this incident elsewhere.

From these various glimpses of Catesby, we are given the picture of a private, reserved and unassuming man, affectionate to his family, loyal to his friends, and single-minded and dedicated to his life's work. Added to these impressions are what Catesby himself conveys in his writing, as much by his omissions as by his own comments and understatement. It is notable that he makes no mention of the personal, family vicissitudes that befell him. Just one glimpse of his acquaintance with death is revealed in his comment of how the colours of some species of fish 'deprived but a few minutes of their element, like beauty in a human countenance extinguished with life, visibly degenerate from a pleasing variety of the most glorious colours imaginable, to such as are extremely dull and sordid'.[248] The events in his private life and the effect they had on him remain buried beneath the external aspects of his working life, above all his tireless investigations of and passion for the natural world, shared with his readers through his monumental book.

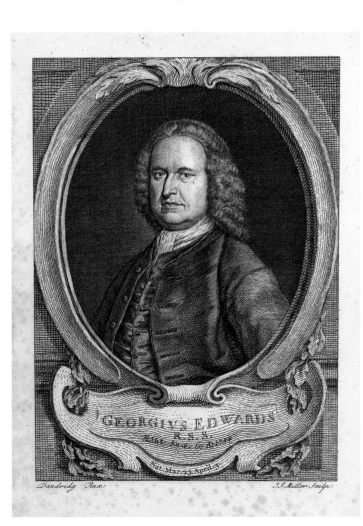

GEORGIVS EDWARDS
R.S.S.

Dandridg Pinx: J.S.Miller Sculp:

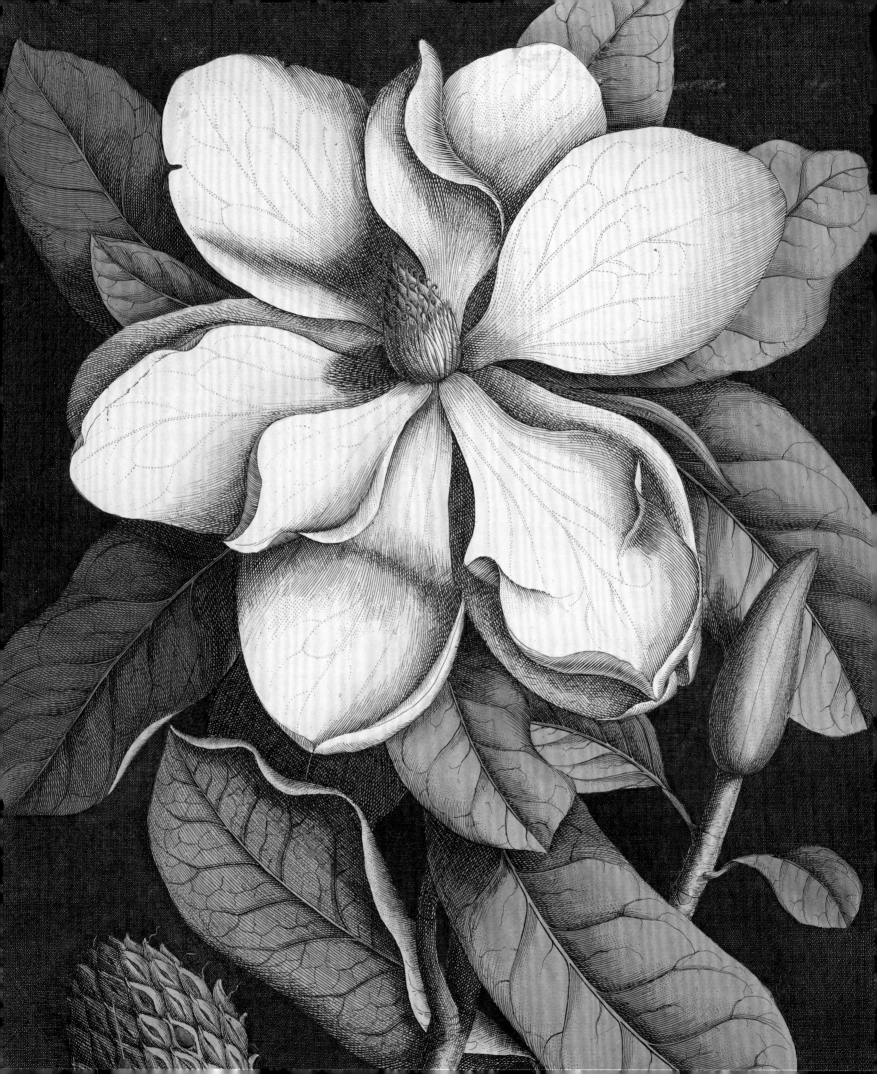

Catesby's Publications

'In [the Natural History*] he has with unbelievably lifelike colouring, presented the rarest trees, plants, animals, birds, fishes, snakes, frogs, lizards, and insects that occur in that place. It is difficult to believe that it is not the real thing that stands in its natural colour on the paper.'* [1]

This was how Linnaeus's pupil Pehr Kalm described the book that had occupied Catesby for the major part of his working life. Its total of 220 hand-coloured full-page plates, published in eleven parts, took Catesby just over twenty years to complete from his return from South Carolina and the Bahama Islands in 1726 to the publication of the Appendix in 1747.

For Catesby coloured images were of prime importance to the identification of plants and animals, as he was to state so clearly in the Preface to his book: 'The Illuminating of Natural History is so important to a perfect understanding of it, that I may aver a clearer Idea may be conceiv'd from the Figures of Animals and Plants in their proper colours, than from the most exact Description without them.' [2] He may have hoped, if not expected, that his sponsors would be as interested in helping to finance the end product of his collecting and his drawings as they had been in supporting him during the earlier stages of the project. The careful wording in his Preface about ceasing their support – despite their approval of his 'Labours' – so that he was not able to pay for his images to be engraved professionally suggests his disappointment:

> At my return from America, in the Year 1726, I had the Satisfaction of having my Labours approved of, and was honour'd with the Advice of several of the above-mentioned Gentlemen, most skill'd in the Learning of Nature, who were pleased to think them worth Publishing; but that the Expence of Graving would make it too burthensome an Undertaking, this

Opinion, from such good Judges, discouraged me from attempting it further: And I altered my Design of going to Paris or Amsterdam where I at first proposed to have them done. [3]

The best engravers of the time were indeed Dutch, Flemish and French, and Catesby was familiar with many of their illustrations in works on natural history. Some of them, including the Flemish Gerard Vandergucht, worked in London; Vandergucht had engraved the elegant plates of Sloane's *Voyage to the Islands Madera …*, which Catesby knew well (fig. 83). Vandergucht was also one of the engravers employed by the botanist Leonard Plukenet in several of his works, including *Amaltheum botanicum* (1705). Among French engravers were Jean-Louis Roullet, who made the plates for Charles Plumier's *Description des plantes de l'Amérique* (1693) after Plumier's own drawings, illustrations which were to have an influence on Catesby's own plates (see fig. 149), [4] and Claude Aubriet, who both drew and engraved the illustrations for Joseph Pitton de Tournefort's *Institutiones rei herbariae* (1700–3), another work consulted by Catesby. Maria Sibylla Merian's *Metamorphosis insectorum surinamensium* (1705), with its hand-coloured etchings by Pieter Sluyter, Josef Mulder and Daniel Stoopendal, and Johann Commelin's *Horti medici amstelodamensis* (1697–1701), with unsigned engravings 'done from the life' after drawings by Johan and Maria Moninckx, [5] were also well known to Catesby. [6]

Other authors of botanical books were to experience the costly production of images as a major obstacle to the completion of their work. The bot-

FIGURE 82

Georg Ehret, 'Magnolia altissima', *Natural History*, 1743, II, plate 61. Detail of fig. 98.

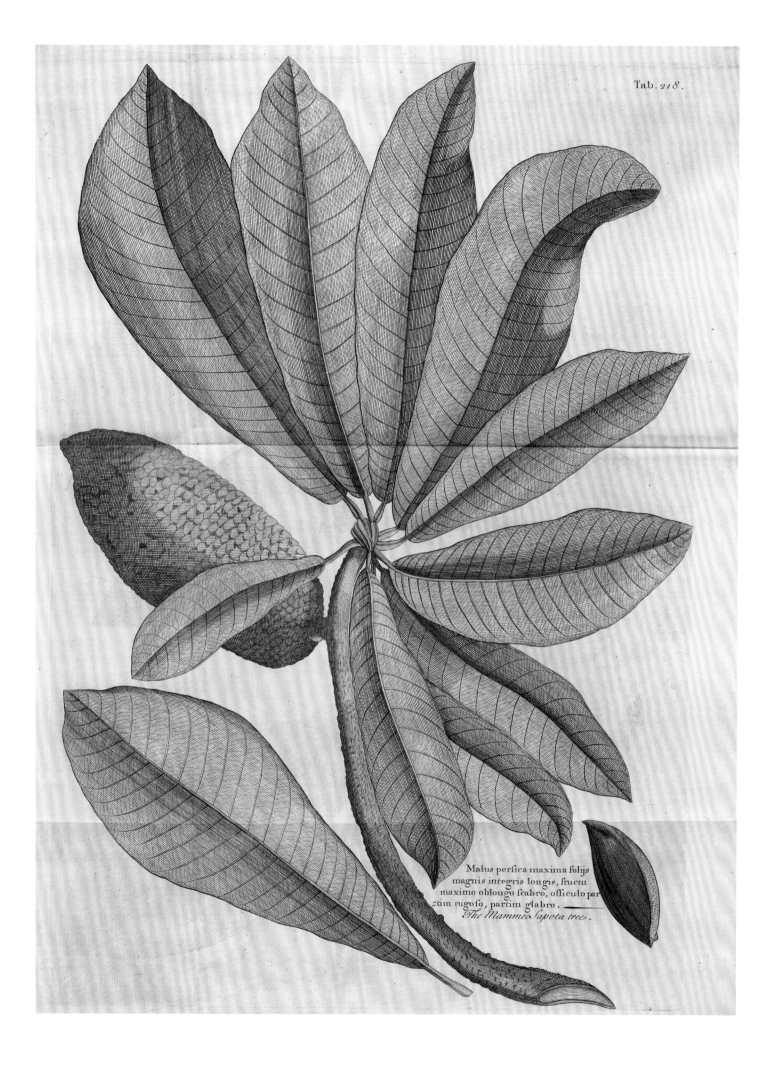

Tab. 218.

Malus persica maxima folijs
magnis integris longis, fructu
maximo oblongo scabro, osficulo par-
tim rugoso, partim glabro. ――――
The Mammee Sapota tree.

anist and apothecary John Martyn, for example, published five 'decades' of his large-format *Historia plantarum rariorum* (1728–37), with colour-printed mezzotint plates.[7] But lacking adequate support for such an expensive publication, he had to stop after five parts and fifty plates.[8] The Society of Gardeners' *Catalogus plantarum* (1730) ceased after the first of its five projected parts for the same reason.[9] Later Philip Miller took the decision for his *Gardeners Dictionary*, published in eight editions between 1731 and 1768, that the main objectives of the society – to standardize names and register plants that could be acclimatized – could be achieved without the expense of illustrations.[10] And in 1753 Linnaeus, while acknowledging the high quality of botanical works illustrated with copper plates – especially 'illuminated' or hand-coloured ones – was to lament their expense: 'in my opinion that costly invention of engraving Illustrations in copper and printing them is now ending in luxury [and] the ruin … of this noble science itself.' He added:

> One cannot deny that those costly figures, which the more Recent Authors have engraved on copper, are much better than those of the Early Botanists, because with copperplates more of the smallest parts can be rendered than with woodcuts, and more distinctly. Their use, however, has so increased the price of the books that not a few Sons of Botany who are reared in modest circumstances are compelled to do without such high-priced books.[11]

But Catesby was not a man to be deterred, and if Continental engravers could not be hired, his solution was to teach himself the methods for transferring drawn images to copper plates for printing. Thus, it was that 'At length by the kind advice and Instructions of that inimitable Painter Mr Joseph Goupy, I undertook, and was initiated in the way of, etching them myself.'[12] Catesby was not the only artist to etch his own plates. In etching, the artist draws with a needle on to the soot-blackened ground, a far easier technique for a competent draughtsman to learn than engraving, which involves using a burin or graver directly on the copper plate, and was not only a slower and more expensive process but one which required several years of training. Thus, for the engraved lettering and numbering of the plates, it is likely that Catesby sought the help of professional engravers. In order to aid the letter engraver, he etched identification labels lightly on to

his plates, without bothering to reverse them; these were then cleaned off after the plates were professionally lettered and before they were printed. One such temporary label, however, was omitted in the plate cleaning process: on Plate 9, Volume II, the word 'Snapper' can be seen back to front (fig. 84).[13]

Catesby's decision to etch may also have been influenced by an awareness of the advantages of retaining control over this stage of the process of reproducing his images.[14] A professional engraver, on the other hand, had to interpret the naturalist's drawing, and this could lead to errors without close supervision, as John Ray discovered:

> The Gravers we employed [for Ray and Willughby's *Ornithologia* of 1676] though they were very good Workmen, yet in many Sculps they have not satisfied me. For I being at a great distance from London, and all advices and directions necessarily passing by Letter, sometimes through haste mistook in my directions, sometimes through weariness and impatience of long Writing sent not so clear and full instructions as was requisite; and they as often neglected their instructions, or mistook my meaning. Notwithstanding the Figures, such as they are … they are the best and truest, that is, most like the live Birds, of any hitherto engraven in Brass.[15]

Despite its advantages, mastering the technical requirements of etching, with the trial and error that was part of the process, followed by the length of time needed to etch each of the 220 plates himself, added months and years to the timescale for Catesby to produce his book (figs 85 and 86).[16] A further consideration for him was the risk of handing his original watercolours over to another party:

> as my honour and credit were alone concerned, I was resolved not to hazard them by committing any part of the Work to another person: besides, should any of my original Paintings have been lost, they would have been irretrievable to me, without making another voyage to

America: since a perpetual inspection of them was so necessary towards the exhibition of truth and accuracy in my descriptions.[17]

On the completion of his work Catesby stated proudly: 'the whole [book] was done within my house and by my own hands.'[18] While this was true for the drawing and etching of his plates and the preparation of their accompanying texts, he would have had to have sought the help of professional tradespeople for several stages of the book: the engraved lettering and numbering of the copper plates, as noted, the setting and printing of the text, the printing of the plates on a rolling press (very probably at a different printing shop), and the gathering and sewing of the leaves.[19]

The 'Proposals'

Publishing the work by subscription was the solution Catesby adopted to meet the next stage of producing the book without backing from his sponsors. Al-

though subscription publication had been operating for several decades, the example of his friend John Martyn, who published his *Historia plantarum rariorum* by subscription, the first volume of which was printed in 1728, provided an obvious model.[20] Martyn had published a 'notice' on 10 November 1727 setting out the conditions on which he proposed to publish his book 'whose price of subscribing is one guinea to be paid down, and half a guinea at the delivery of each decad'.[21] As the first colour plate flower book to be issued in parts, this offered a further precedent for Catesby. His teacher Goupy, who offset his costs of production through selling his prints by subscription, provided a further precedent.[22] The authors of the Society of Gardeners' *Catalogus plantarum*, under their spokesman Philip Miller, stated clearly the advantages of publishing by subscription, although, in the event, as noted, the book did not proceed beyond Part 1: 'we thought it more advisable to publish it in several Parts, making each Part an entire Piece of itself … so that, if the Design met with Encouragement, we might have an Opportunity of

1728.[24] Entitled 'Proposals, for printing an essay towards a natural history of Florida, Carolina and the Bahama islands …', Catesby stated that he 'intended to publish every Four Months Twenty Plates, with their Descriptions, and printed on the same Paper as these Proposals' (fig. 87). In a letter to his friend John Bartram written twelve years later when he was working on the tenth part of his book, Catesby explained further his decision to bring out the book in parts: 'This laborious work has been some years in agitation; and as the whole, when finished, amounts to twenty guineas, a sum too great, probably, to dispose of many, I chose to publish it in parts: viz., twenty plates with their descriptions, at a time, at two guineas. By this easy method, I disposed of many more than I otherwise should.'[25]

Catesby's 'Proposals' was distributed via the bookseller William Innys, cited in the 'Proposals' itself as well as in some of the advertisements.[26] Peter Collinson, an enthusiastic promoter of Catesby's work, was also responsible for circulating some copies. In a letter of 6 August 1729 to a fellow Quaker, Thomas Story, Collinson wrote:

> By what thee hints of Lord Lonsdale[,] no doubt but he's Curious in the productions of nature, & having so good an opportunity of sending a Proposals of an Ingenious Friend of Mine, its very probably his Work may be acceptable to Him and thee[,] in wch the productions of North America are Curiously Exhibited to View[.] When I survey 'Em my soul is fild with adoration to our Great Creator for his Goodness[,] Mercy & Blessings to Mankind.[27]

Collinson had likewise helped to distribute John Martyn's 'Proposals', informing him, 'I have dispersed 4 of your proposalls – Two to Hambro – One into the West and the others in the North and two remain in my hands for Holland.'[28]

The fact that Catesby reprinted his 'Proposals' broadside three times – indicated by the change of name at the bottom from Thomas Fairchild to Stephen Bacon and other typographical variations – suggests that he needed to keep promoting his book.[29] One attraction to potential subscribers, however, was that unusually, as the 'Proposals' stated, he did not ask for payment from his subscribers until receipt of each part:[30] 'Encouragers of this Work are only desired to give their Names and Places of Abode to the Author and his Friends, or the Places here under-named: that no Money being desired to

adding more Plates to each Part … and if the Publick did not approve of our Undertaking, we might drop it without being too great Losers.'[23]

John Martyn's prospectus was among several that Catesby would have known when he produced his own broadside prospectus, probably first issued in

be paid 'till each Set is deliver'd; that so there be no Ground to suspect any Fraud, as happens too often in the common way of Subscription.' But choosing this payment method meant that Catesby had to find substantial funds before being able to advertise his book in order to guarantee that he could pay for the costs of the copper plates, supplies of paper and ink, and the fees of the typesetters, letter engravers and printers. Having stated that 'the Expence of Graving' would have been 'too burthensome an Undertaking', it is unlikely he would have had the necessary funds to bear such production costs either. Catesby's friend Peter Collinson not only helped with the distribution of copies, but provided a loan of 'considerable Sums of Money … lent … without Interest to enable [Catesby] to publish [the book]'.[31] The loan must have been made, or at least discussed, soon after Catesby's return from America.

In order to save expenditure on paper (which generally accounted for half the production costs for unillustrated books), it appears that Catesby ordered only as many copies of his book to be printed as he had subscribers for.[32] Examination of surviving copies by Leslie Overstreet has revealed the existence of several settings of the text of Parts 1–4. As more subscriptions came in, the texts for the early parts would have needed to be reset for printing while a longer print run was ordered for later parts.[33]

An estimate of the number of copies produced overall is provided by the 'List of Encouragers'.[34] The list included a total of 155 names, but with the extra copies purchased by five of the subscribers (Hans Sloane, for example, bought five copies), the total number of books accounted for is 166. In addition to this, ten of those listed were booksellers in London and Plymouth; on the basis that they may have ordered several copies each, an estimate of the total number of copies sold by around 1743, when the main body of the work was completed, is 180–200.[35] The book clearly continued to sell, for Catesby went on to produce an eleventh part, the Appendix, finally published in 1747. And according to the statement made by Peter Collinson after Catesby's death in 1749, his widow subsisted on the sales of further copies for two years.[36]

Arranging his materials

Over the two years after his return from America, during which he was learning to etch and preparing

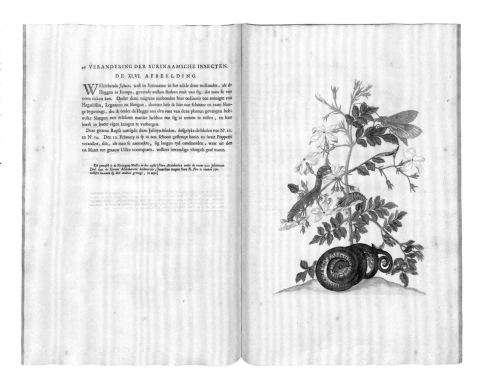

to advertise his book via the 'Proposals', Catesby was engaged in the elaborate process of working out the order, content and composition of his book. This involved reviewing his drawings, watercolours and written accounts to decide on the number of plates and an overall structure for the book, as well as designing the arrangement and combination of images for the individual plates.[37] His original plan for ten parts of twenty plates each was stated not only in the 'Proposals' but after completion of the tenth part, when he was to announce: 'The part now publish'd, of the *Natural History of Florida and Carolina*, concludes 200 Plates, which are all that were at first designed … of the Collection I brought from America.'[38]

Catesby may have been influenced in his decisions about the physical format of his book by Merian's *Metamorphosis insectorum surinamensium* (1705, 1719), the work which could be said to have initiated the spate of folio colour plate natural history books in the early eighteenth century. Merian's book provided a pattern for the pairing of plates with text so that each double-page opening showed a plate with a facing page of text (figs 88 and 89).

For the order of the birds, Catesby initially followed Ray's classification in his *Ornithology* (1678) – Ray himself having adopted the pattern of the sixteenth-century encyclopaedists such as Aldrovandi,

ANGUIS GRACILIS FUSCUS.

The Ribbon-Snake. | Serpent grefle & brun.

 HIS is a slender Snake, usually not much bigger than the Figure. The Upper Part of the Body dark brown, with three parallel white Lines, extending the whole Length of the Body; the Belly white. They are very nimble and inoffensive.

 E Serpent eft long & grefle, n'étant d'ordinaire pas plus grand que la figure; le deffus de fon corps eft d'un brun foncé, avec trois rayes blanches & parallèles, qui s'étendent tout du long du corps: Le ventre eft blanc. Ces Serpens font très agiles, & point dangereux.

Arbor baccifera, laurifolia, aromatica, fructu viridi calyculato racemofo.
Hift. Jam. Vol. II. p. 87. Cortex Winteranus. Offic:

WINTER'S BARK. | L'Ecorce du Capitaine *Winter*, ou la Canelle blanche.

THESE Trees grow usually about twenty Feet high, and eight or ten Inches in Thickness, in the thick Woods of most of the *Bahama Islands*; the Leaves are narrow at the Stalk, growing wider at their Ends, which are broad and rounding, having a middle Rib only; they are very smooth, and of a light shining Green: In *May* and *June*, the Flowers, which are pentapetalous, come forth in Clusters at the Ends of the Branches; they are red and very fragrant, and are succeeded by round Berries in Size of large Peas, green, and when ripe (which is in *February*) purple, containing three shining black Seeds, flat on one Side, otherwise not unlike in Shape to a Kidney Bean; these Seeds in the Berry, are invelop'd in a flimy Mucilage. The whole Plant is very Aromatick, the Bark particularly being more used in Distilling, and in greater Esteem in the more Northern Parts of the World than in *England*. This Bark is that which is commonly known at the Shops by the Name of *Winter's Bark*, tho' truly not the right, as Sir *Hans Sloane* has judiciously informed us.

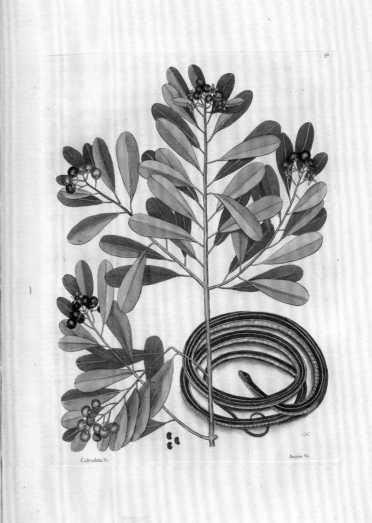

Belon and Gessner.[39] Beginning with the birds of prey, Catesby moved through the perching and song birds, followed by the waders, and ending with the water birds. After the first eight plates devoted solely to birds, however, he began to depict the birds in the context of plants and trees, some chosen as typical of their habitat or as providing their food. During this stage of arrangement, he also experimented with showing his subjects in varied, less conventional poses. Merian's book was the first to present animals in environmental contexts – in her case depicting insects with the plants on which they fed or with which they were otherwise associated. She and Catesby were the sole natural history illustrators of the period to adopt this practice, each having had the advantage of observing and sketching their subjects in the field.[40]

Catesby explicitly mentioned this aspect of his own illustrations when he noted in the Preface that 'where it could be admitted, I have adapted the Birds to those Plants on which they fed, or have any relation to.'[41] He also explained why he had illustrated more birds than other animals: 'There being a greater Variety of the feather'd Kind than of any other Animals (at least to be come at) and excelling in the Beauty of their Colours, besides having oftenest relation to

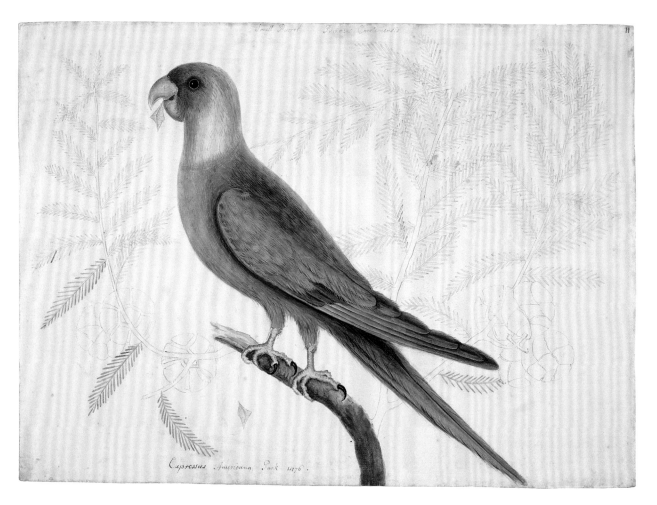

FIGURE 90

Mark Catesby, 'The Parrot of Carolina' and 'The Cypress of America', 1722–5. Watercolour and bodycolour over pen and brush and ink, 36.8 × 37.1 cm.

Royal Library, Windsor, RCIN 924824

FIGURE 91

Mark Catesby, 'The Parrot of Carolina' and 'The Cypress of America', *Natural History*, 1731, I, plate 11. Hand-coloured etching, 51 × 53 cm.

Royal Society of London

shown springing from a generic perch, the formula with which Catesby seems to have begun the composition; the bird has a seed ('kernal') of the cypress in its beak, having apparently just dropped another. In the etched plate the branches and fruits of the cypress are fully worked up and provide a dense foliage habitat for the bird. Of the hundred plates of birds in Volume I, seventy-four are combined with plants and two with corals.

Simultaneously with his work on the order and arrangement of the images, Catesby had to finalize the texts to accompany each plate. This must have meant consulting the notes he had made on the different species – recorded on the spot in his field notebooks and written up at greater length when he returned from his expeditions – and composing the texts in the format in which they were to appear on the pages facing the plates. The survival of two groups of his manuscripts for the Appendix shows how he corrected details of content and made improvements to his style and punctuation as a late stage of this process. The more complete set of these manuscripts is now housed in the library of the University of Virginia; consisting of sixteen sheets, stitched together as a pamphlet, it may represent Catesby's fair copy prepared for the typesetter.[44] A second group of manuscript texts survives in the Morgan Library and Museum, New York; these are loose sheets written out neatly and corrected by Catesby for several pages of the Appendix (fig. 92).[45] As with the fair copies at the University of Virginia, the elegant arrangement of the text on the page demonstrates how Catesby's sense of design extended to his written as well as his drawn work.

Hand colouring the prints and timing of Volume I

Catesby completed and issued the first twenty plates with accompanying texts of his book – Part I – in May 1729, presenting it, as we have seen, to Queen Caroline, and to the Royal Society at his first attendance there that month (fig. 93).[46] The following February the publication was advertised in the *London Evening Post*, with a further advertisement placed in the *Country Journal or the Craftsman* later in the month.[47] During the three-year period since his return from America he had been extraordinarily productive. He had needed to rethink his plan for engraving his drawings and had come to a financial arrangement with Collinson; he had mastered the technique of

the Plants on which they feed and frequent; I was induced cheifly [*sic*] (so far as I could) to compleat an Account of them.'[42] His drawing of the Carolina parakeet, *Conuropsis carolinensis*, shows how his image of the parrot perching on a generic branch evolved into the printed composition in which it was integrated with the bald cypress, *Taxodium distichum*, in whose 'lofty branches' Catesby observed those birds breeding and feeding: 'amongst which [they] delight to make their Nests, and in October (at which time the seed is ripe) to feed on their kernals' (figs 90 and 91).[43] In the drawing, two branches of the tree with its foliage and fruit, sketched in outline only, are

FIGURE 93

Dates of the presentation of the parts
of the *Natural History* to the Royal
Society, London.[1]

Part: contents	Date presented to the Royal Society	Cromwell Mortimer's 'Account' in *Philosophical Transactions*
Volume I		
Part 1: text & plates 1–20	22 May 1729	⟩
Part 2: text & plates 21–40	8 January 1730	⟩36, no. 415 (1730), pp. 425–34[2]
Part 3: text & plates 41–60	19 November 1730	⟩
Part 4: text & plates 61–80	4 November 1731	37, no. 420 (1731), pp. 174–8
Part 5: text & plates 81–100[3]	23 November 1732	37, no. 426 (1732), pp. 447–50
Volume II		
Part 6: text & plates 1–20	4 April 1734	38, no. 432 (1734), pp. 315–18
Part 7: text & plates 21–40	15 January 1736	39, no. 438 (1735), pp. 112–17
Part 8: text & plates 41–60	7 April 1737	39, no. 441 (1736), pp. 251–8
Part 9: text & plates 61–80	7 June 1739	40, no. 449 (1738), pp. 343–50
Part 10: text & plates 81–100	15 December 1743	44, no. 484 (1747), pp. 599–608[4]
An Account	not before 1741[5]	
Appendix		
Part 11: text and plates 1–20	2 July 1747	45, no. 486 (1748), pp. 157–73[6]

1 Based on Overstreet, L., 2015, 'The Publication of Mark Catesby's *The natural history of Carolina, Florida and the Bahama Islands*', in Nelson, E. C. & Elliott, D. J., eds, *The Curious Mister Catesby: A 'Truly Ingenious' Naturalist Explores New Worlds*, Athens, GA, & London, tab. 12-1, p. 158. Overstreet notes that the apparent contradiction between the dates of receipt in the Royal Society *Journal Books* and the date of the individual issue of the *Philosophical Transactions* 'may be accounted for by delays in the journal's publication schedule' (p. 368, n. 8). Here the year quoted is the year for which an issue was intended, not the actual year of publication.

2 Mortimer presented his review of the first three parts to the Royal Society on 17 December 1730.

3 The title page to Volume I dated 1731 and the dedication for that volume were probably issued with this part.

4 'Read Nov. 19. 1747'.

5 The title page to Volume II dated 1743, dedication for that volume, list of subscribers, Preface and indexes to the whole work were probably issued with this part. The 'Account' and map were also issued with, or around the same time as, Part 10; internal evidence indicates not before 1741.

6 'Read Feb. 18. 1747–8'.

In his 'Proposals' Catesby stated that each part of the book containing twenty plates would be 'printed on the same Paper as these Proposals. The Price of which will be One Guinea … some Copies will be printed on the finest Imperial Paper, and the Figures put in their Natural Colours from the Original Paintings, at the price of Two Guineas.' Thus, we learn that both coloured and uncoloured versions of the book were offered to subscribers, and that the coloured version was to be printed on 'finest' quality 'Imperial' sized paper (*c*.21 × 14 inches).[52] There are records of two smaller size copies: an uncoloured copy, whose sheets 'are in size about twelve by fifteen inches' (roughly equivalent to 'royal' size), which he sent to his niece in America;[53] and a coloured copy on 'smaller paper' which he sent to John Bartram.[54] While Catesby does not mention a size for the uncoloured copies in his 'Proposals', it has been suggested that they were further differentiated from the more expensive coloured copies by being royal size.[55] However, apart from these two smaller copies mentioned by him, all the extant copies of the book so far identified are imperial size, suggesting that there was only a demand among Catesby's subscribers for the larger coloured books, which would have constituted objects of 'ornament' for the grander libraries.[56] It perhaps also confirmed his belief that

etching through his lessons with Goupy; planned out the order and content of at least several parts of the book; worked out a timing and produced and issued the 'Proposals'; completed the etching of twenty large copper plates in this newly learned craft and had them lettered by a professional engraver; supervised the colouring of around sixty sets of the twenty plates;[48] found printers for the plates and text; prepared the text for printing; found a translator for the parallel text in French;[49] had an audience with Queen Caroline to solicit her agreement to act as the dedicatee of the first volume of the book; and received positive responses from a certain number of subscribers. It is also clear that Catesby was still seeking subscribers after Part 1 of the book had been printed and presented to the Royal Society.[50]

Catesby had chosen the printer Godfrey Smith senior of 'Prince's-street in Spittle-fields' to print the text of the *Natural History*. Smith's name is not given in the book – the title page lists only booksellers where it could be purchased – but the use of the same decorated initial 'L' and head-piece elements (fleurons) that are found in Dillenius's *Hortus Elthamensis* (1732) – where the name of 'G. Smith' appears in the colophon of the second volume – led to his identification by Leslie Overstreet (figs 94 and 95).[51] By that date Dillenius, a subscriber to the *Natural History*, would have received the first several parts from Catesby and may have been encouraged to use the same printer for his own book on the garden of James Sherard.

tula florida, singula in singulis ramis, quæ mox deciderint præter unum alterumve, quod in florem abierit Senecioni non absimilem.

P. 111. Corona Regalis ortum debet Horto Badmingtoniensi, ubi triginta retro annis e seminibus peregre acceptis prima glivit planta, & ab hac materna planta in Hortum Dirrhamensem, indeque in Elthamensem pervenit.

P. 142. Fabaginis Capensis frutescentis majoris fructu a minori specie plurimum differt ; eum vero nonnisi siccum observare licuit, membranaceum, quadripinnatum seu quatuor alis instructum, singula in singulis alarum cavitatibus femina fusca oblonga, modice compressa continentem, ea forma, qua num. 1. & 2. fructus & semen seorsum in Tabula adsculpta sunt.

P. 148. Fruticem Virginianum trifolium, Ulmi samaris *Banist.* in aliis postea Hortis flores tulisse observavi numerosos, in racemis, quam nobiscum, amplioribus dispositos, fructus etiam vidi foliaceos viridantes, magis, quam in figura nostra, laxos & sparsos.

P. 224. post lin. ult. Huc referenda & eadem videtur, Smilax (forte) lenis, folio anguloso hederaceo *Cat. Hist. Nat. Car. p.* 51. *T.* 51.

ERRATA.

Pag.	lin.	pro	lege	Pag.	lin.	pro	lege	Pag.	lin.	pro	lege
13.	11.	fronte,	fronti.	77.	40.	spici,	spicis.	297.	25.	quorum,	quarum.
—	—	Nalalhabathu,	Nalalbatha	91.	17.	Flore,	Floræ.	346.	15.	prædita,	præditi.
—	14.	Halicacab,	Halicacabo.	147.	24.	crassitie,	crassitiei.	—	ult.	sententias,	sententiis.
—	32.	depicta,	depictæ.	161.	33.	oliorum,	foliorum.	362.	ult.	excrescint,	excrescit.
15.	28.	videntur,	videmur.	189.	6.	compositis,	compositis.	373.	32.	pressa,	pressu.
17.	25.	Comemelino,	Commelino.	196.	37.	veluti,	velluti.	377.	27.	caudicantia,	candicantia.
23.	19.	duodecennalibus,	duodecennalibus.	210.	22.	ungules,	ungues.	381.	14.	Thesaurarii,	Thesaurario.
27.	5.	179,	1719.	235.	42.	succossa,	succosa.	384.	22.	cui,	cum.
64.	22.	rotunda,	rotundo.	268.	20.	maturescunt,	maturescunt.	390.	17.	amplicaulem,	amplexicaulem.
68.	1.	conjugati,	conjugatis.	—	33.	auranti.	aurantio.	423.	29.	Vitago,	Vitcago.

❋ ❋ ❋ ❋ ❋

LONDINI: Typis G. S M I T H, in vico vulgo dicto *Prince's-street, Spittle-fields.*

'the Illuminating of Natural History is so important to a perfect understanding of it' was shared by those of his circle.

But demand for coloured versions meant that a substantial increase of time and expense would be involved in colouring each set of twenty plates. There are a number of contemporary claims that Catesby coloured at least some of his prints himself, and it is probable that for special copies of his book he did so, such as those he presented to Queen Caroline;[57] the copy he gave Collinson – who recorded that 'this edition ... is very Valuable, as it was highly Finish'd by the Ingenious Author';[58] and the Royal Society, which had 'all the cuts carefully painted by himself in their natural colours'.[59] While there were professional colourists, it was also customary at this period either to use members of the family (often wives and daughters) to do the colouring, as Eleazar Albin did, or to employ women or children, who could therefore be paid very little.[60] Further, we have confirmation from Cromwell Mortimer, secretary of the Royal Society, that Catesby did employ one or more colourists who worked 'under his directions'. Mortimer recorded in an inscription on Catesby's manuscript text for the Appendix: 'Thus ends the most magnificent work I know of since the art of printing has been Discover'd; the Descriptions are all given in both English & French & the figures being drawn by the Ingenious author, after life, were afterwards etched by himself & all the illuminated setts were colour'd under his directions & all touch'd up & finisht by his own hand.'[61]

Supervising the colouring of the prints, as well as touching them up himself, was the way that Catesby ensured the colouring was as accurate as possible, an aspect that, as he noted, was 'so particularly essential'.[62] He was not the only natural history artist to think in this way; George Edwards was equally concerned about ensuring the accuracy of the colouring of his books: an inscription in his hand in the copy of his *Natural History of Uncommon Birds* presented by him to the University of Cambridge records that it was 'revised, retouched and made to compare with the Original Coloured drawings by Geo Edwards April AD. 1760' (fig. 96).[63]

Whoever Catesby's colourists were, they may have worked in his home, as he himself suggested in his statement that 'the whole [book] was done within my house.'[64] Just as he was loath to hand over his watercolours to engravers, so too he would not have

wanted to risk the damage done to his originals by unsupervised colourists.[65] It is likely, therefore, that in common with other artists, rather than allow his original watercolours to be handled, Catesby would have produced one or more master sets of coloured prints to act as pattern plates for the colourists to follow. Such a suggestion is reinforced by the fact that Catesby's original watercolours do not show signs of having been handled by colourists; there are no paint splashes, brush trials or signs of fingering such as one might expect if the sheets had been

FIGURE 96

George Edwards, *A Natural History of Uncommon Birds*, London, 1743–51, with autograph inscription on endpaper, 1760. 29.1 × 22.5 cm.

Cambridge University Library, Syn.4.74.4

PICA glandaria cærulea criftata.

Cyanurus cristatus.

The Blew Jay.

IS full as big, or bigger than a Starling : the Bill black ; above the Bafis of the upper Mandible are black Feathers, which run in a narrow ftripe crofs the Eyes, meeting a broad black ftripe, which encompaffes the Head and Throat : its Crown-feathers are long, which it erects at pleafure : the Back of a dusky purple : the interior vanes of the larger Quill-feathers black ; the exterior blew, with tranfverfe black lines crofs every feather, and their ends tipt with white : the Tail blew, mark'd with the like crofslines as on the Wings. They have the like jetting motion of our Jay ; their Cry is more tuneful.

The Hen is not fo bright in colour, except which there appears no difference.

Geai bleu.

CET Oifeau eft auffi gros & même plus qu'un Etourneau : il a le bec noir, & au deffus de la bafe de la mandibule fuperieure il y a des plumes noires, qui forment une petite raye au travers des yeux, laquelle fe joint à une plus grande qui environne la tête & le gofier. Les plumes de fa crête font longues, & il les dreffe quand-il veut : il a le dos d'un pourpre fombre ; les barbes interieures des grandes plumes de l'aile font noires ; les exterieures bleües, avec des rayes noires au travers de chaque plume dont le bout eft bordé de blanc. Sa queüe eft bleüe, & marquée des mêmes rayes que fes ailes. Ce Geai a le même air que les nôtres mais fon cri n'eft pas fi difagréable.

La femelle n'a pas les couleurs fi vives, mais d'ailleurs il n'y paroit aucune difference.

Smilax lævis Lauri folio baccis nigris.

The BAY-LEAVED SMILAX.

THIS Plant is ufually found in moift places : it fends forth from its root many green Stems, whofe Branches overfpread whatfoever ftands near it, to a very confiderable diftance ; and it frequently climes above fixteen foot in hight, growing fo very thick that in Summer it makes an impenetrable Shade, and in Winter a warm Shelter for Cattle. The Leaves are of the colour and confiftence of Laurel, but in fhape more like the Bay, without any vifible veins, the middle rib only excepted.

The Flowers are fmall and whitifh ; the Fruit grows in round Clufters, and is a black Berry, containing one fingle hard Seed, which is ripe in October, and is food for fome forts of Birds, particularly this Jay.

Smilax à feüille de Laurier.

ON trouve ordinairement cette Plante dans des endroits humides, elle pouffe de fa racine plufieurs tiges vertes, dont les branches couvrent tout ce qui eft autour d'elle à une diftance tres confiderable, & montent fouvent à plus de feize piés de haut & deviennent fi épaiffes, qu'en Eté elles forment une ombre impénétrable, & en hiver une retraite chaude pour le betail ; les feüilles de cette plante font de la même couleur & de la même confiftence que celles du laurier mâle, mais elles ont plus la figure de celles du laurier femelle, & n'ont aucune veine vifible, excepté celle du milieu.

Les fleurs font petites & blanchâtres. Le fruit vient en grapes rondes, & n'eft qu'une baye noire qui contient un feul grain de femence dûr, qui eft meur en October, & qui fert de nourriture à plufieurs fortes d'oifeaux, mais principalement au Geai bleü.

FIGURE 97

Mark Catesby, *Natural History*, 1731, I, p. 15, showing paint trials. 41.7 × 30.5 cm.

Smithsonian Libraries and Archives, Washington, DC, Scuncat, catalogue record no. 542459

97).[66] Despite the signs of heavy use, damage and staining, the high quality of the colouring could well indicate the hand of the artist himself: the handling of colours is subtle and it is notable that the pigment is applied thinly to allow the etched lines and contours to be clearly visible, with the colour of the paper left to create the highlights.

Significant variations in colouring are indeed evident from a study of different copies of the first edition of Catesby's book, indicating not only that several hands were responsible for different parts but that the same parts could be coloured at different times.[67] These variations include different interpretations both of markings and colours – some of which deviate in important ways from the descriptions of the marks and colours specified by Catesby in his text. For example, the colour of the leaves of *Magnolia grandiflora*, which Catesby writes 'are of a shining bright green, except their under sides, which are of a russet red colour', are in some versions of the print painted so that the upper side is shown as russet and the underside as green (figs 98 and 99). Catesby's painted bunting, *Passerina ciris*, with its 'back green, inclining to yellow', in some copies lacks the bright yellow back creating the spectacular rainbow effect of its plumage (figs 100 and 101). The mounds or hillocks on which Catesby shows several of his birds are also variously interpreted, sometimes in a painterly way with the use of different brown and green pigments to describe the contours, and at other times with an application of one pigment only (figs 102 and 103). A further difference of interpretation can be detected in the description of the white markings of birds and fishes: in some copies the paper is left unpainted while in others white bodycolour is applied (figs 104 and 105).

It is also clear not only that different colourists handled pigments in various ways (for example, some used pigments in transparent washes, while others applied them in more opaque form), but that different ranges of pigments were used by different colourists. Such variations can be seen most dramatically by comparing the red pigments used in the same parts of different copies: for example, a comparison of the flamingo plates in two particular copies (Volume I, Part 4, Plate 74) shows that one colourist used a crimson red (probably a lake) while the other used a bright orange red (probably vermilion) (figs 106 and 107). However, by the time of the next part of the same copies, a very bright intense red pig-

passed from one colourist to another and well handled. Amongst the surviving copies of the *Natural History*, however, one that may have served as such an exemplar for colourists is the variant copy in the Smithsonian which Catesby later sent to John Bartram. The copy is dirty, has many old tears and stains from unidentified spilled substances, and generally has been subject to much wear and tear. It also bears numerous pigment splashes, spills of powdered pigment, and colour trials with the brush, both on the edge of the plates and on the facing text pages (fig.

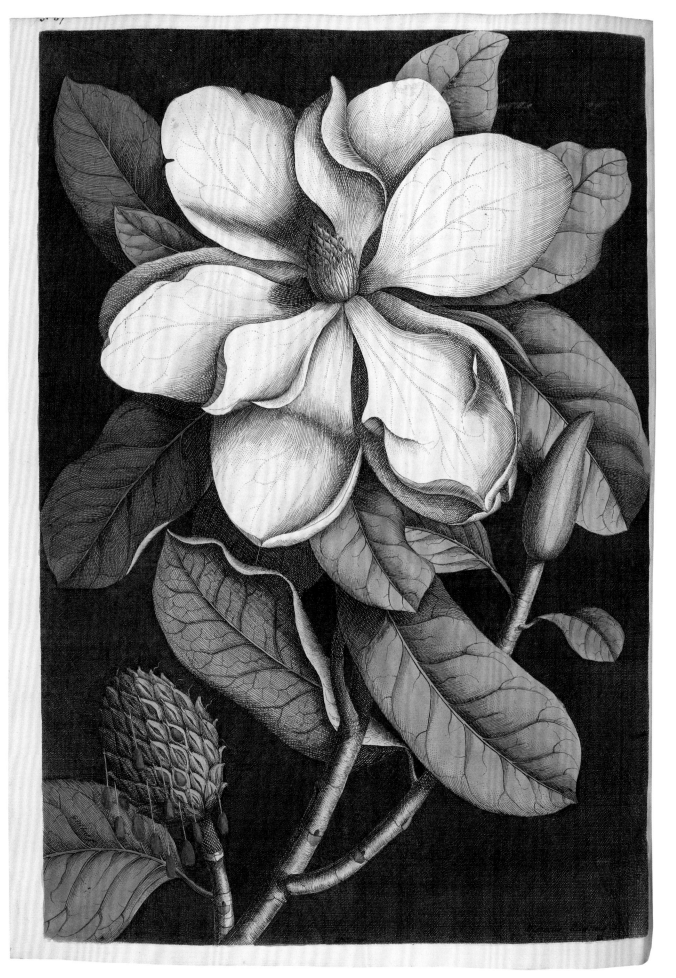

FIGURE 99

Georg Ehret, 'Magnolia altissima'
with incorrect colouring of leaf,
Natural History, 1743, II, plate 61.
Hand-coloured etching,
51 × 35 cm.

Trinity College, Cambridge,
Rothschild 572/II

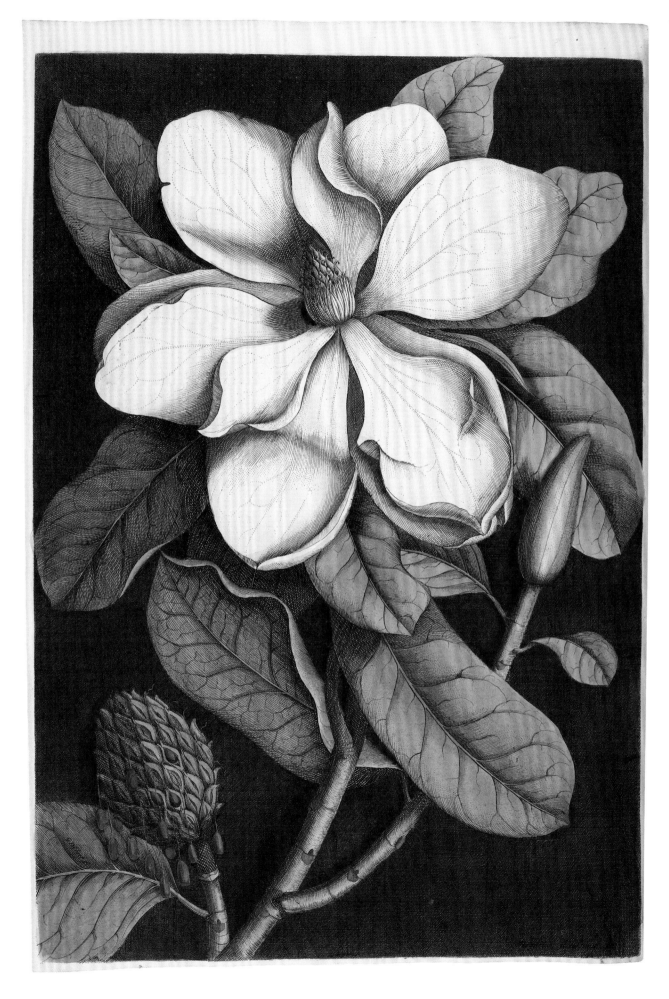

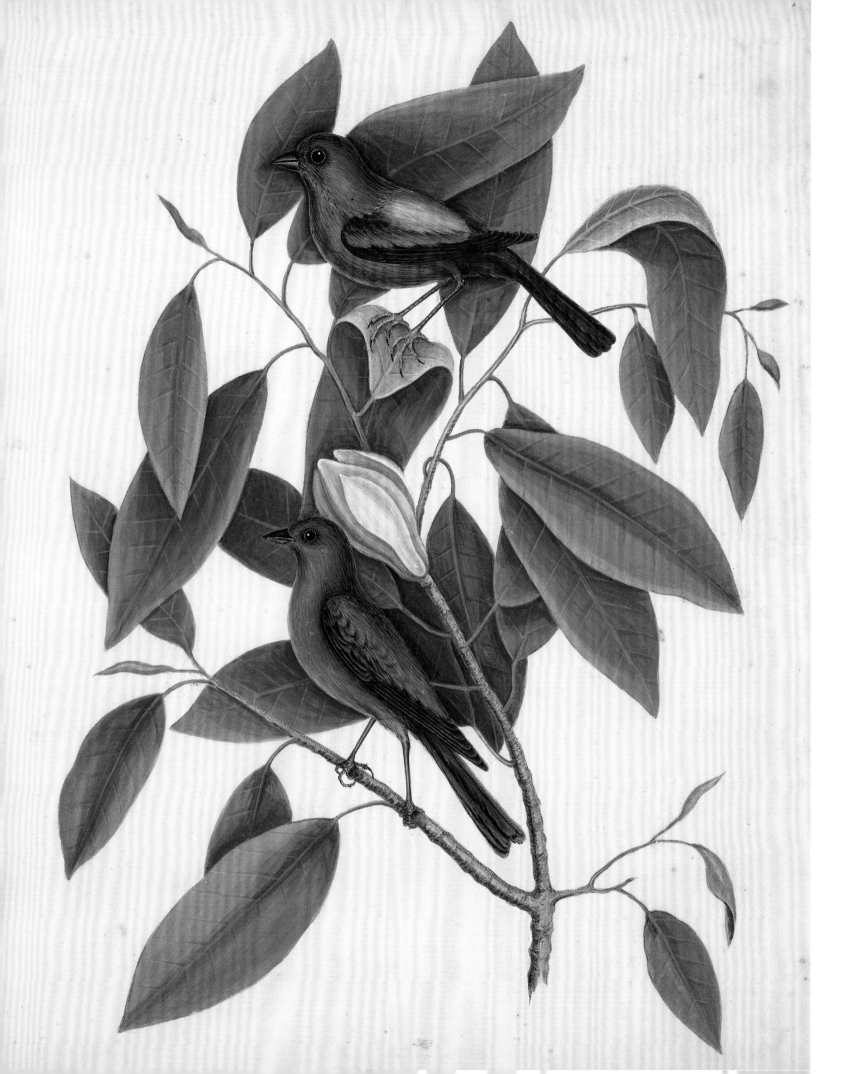

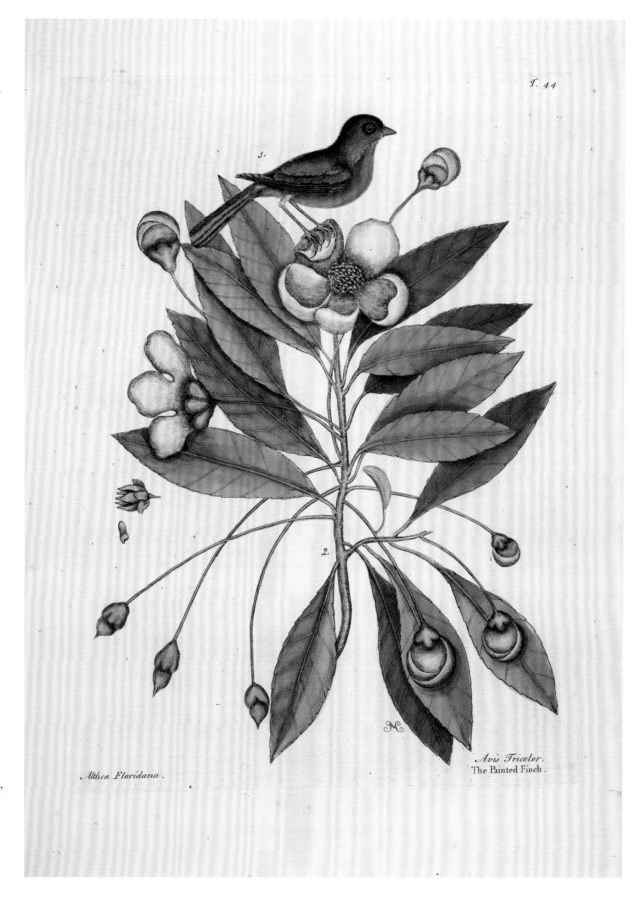

T. 44

Althæa Floridana.

Avis Tricolor.
The Painted Finch.

FIGURE 102

Mark Catesby, 'The Red-leg'd
Thrush' and 'The Gum-Elimy
Tree' with variant colouring of
hillock, *Natural History*, 1731, I,
plate 30. Hand-coloured etching,
35 × 51 cm.

Trinity College, Cambridge,
S.17.67

FIGURE 103

Mark Catesby, 'The Red-leg'd
Thrush' and 'The Gum-Elimy
Tree' with variant colouring of
hillock, *Natural History*, 1731, I,
plate 30. Hand-coloured etching,
35 × 51 cm.

Trinity College, Cambridge,
Rothschild 572/I

Mark Catesby, 'The Parrot Fish', without white bodycolour on teeth, *Natural History*, 1743, II, plate 29. Hand-coloured etching, 35 × 51 cm.

Trinity College, Cambridge, S.17.68

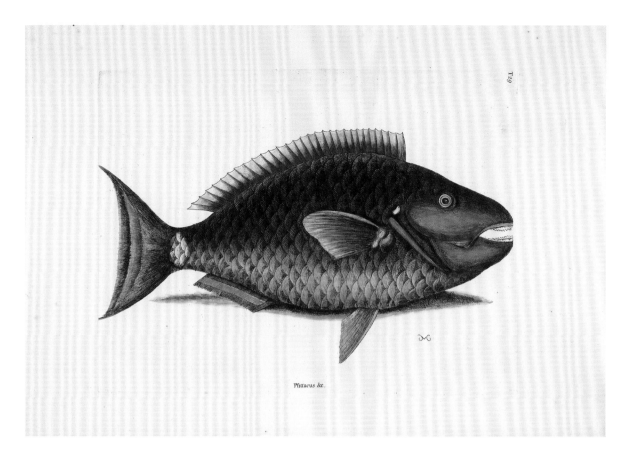

Mark Catesby, 'The Parrot Fish' with white bodycolour on teeth, *Natural History*, 1743, II, plate 29. Hand-coloured etching, 35 × 51 cm.

Trinity College, Cambridge, Rothschild 572/II

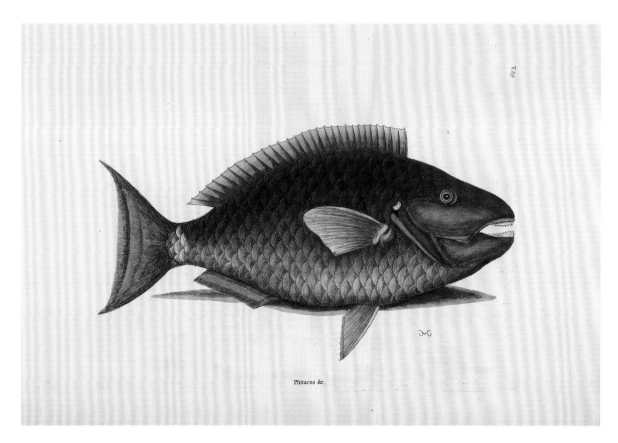

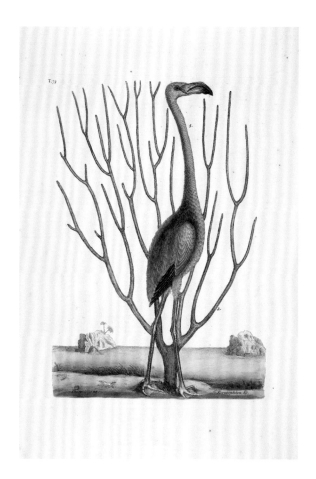

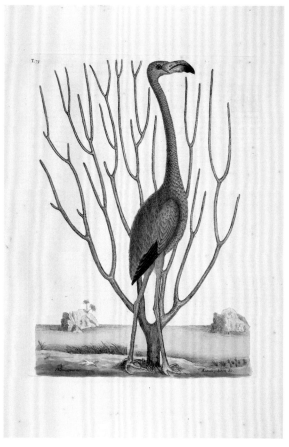

FIGURE 106

Mark Catesby, 'The Flamingo'
and 'Keratophyton Dichotomum
fuscum' with variant red pigment,
Natural History, 1731, I, plate 73.
Hand-coloured etching, 51 × 35 cm.

Trinity College, Cambridge,
S.17.67

FIGURE 107

Mark Catesby, 'The Flamingo'
and 'Keratophyton Dichotomum
fuscum' with variant red pigment,
Natural History, 1731, I, plate 73.
Hand-coloured etching, 51 × 35 cm.

Trinity College, Cambridge,
Rothschild 572/I

ment was used for the 'red curlew' (Volume I, Part 5,
Plate 84), implying either that a different colourist
was at work or that different pigments were in use a
year later (fig. 108).[68] The fact that different colour-
ists would appear to be at work in the same copies is
not surprising given the time span of the painting of
the parts: around four years for Volume I (Parts 1–5)
and ten years for Volume II (Parts 6–11).

Even by employing colourists, however, Catesby
found it hard to keep up with the demand, as he
noted in a letter to his niece Elizabeth Jones, writ-
ten from Hoxton on 1 March 1730: 'In the mea[n-
time] accept of my Nat History of your Country
w[hich] I shall continue to send as I publish them.
I send those uncoloured for two reasons, one is …
[line illegible] …, but indeed the principal reason
is I can at present but ill spare those painted[,] the
demand for them being quicker than I can supply.
This difficientsy shall be supplyed hereafter which
I hope you will excuse now[.]'[69] A few months later,
on 14 August 1730, we learn from a letter his uncle
Nicholas Jekyll wrote to William Holman that Part 3
was done, 'all but the colouring'.[70] From the fact that

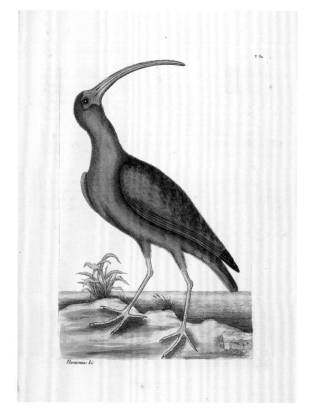

FIGURE 108

Mark Catesby, 'The Red Curlew',
with variant red pigment, *Natural
History*, 1731, I, plate 84. Hand-
coloured etching, 51 × 35 cm.

Trinity College, Cambridge,
S.17.67

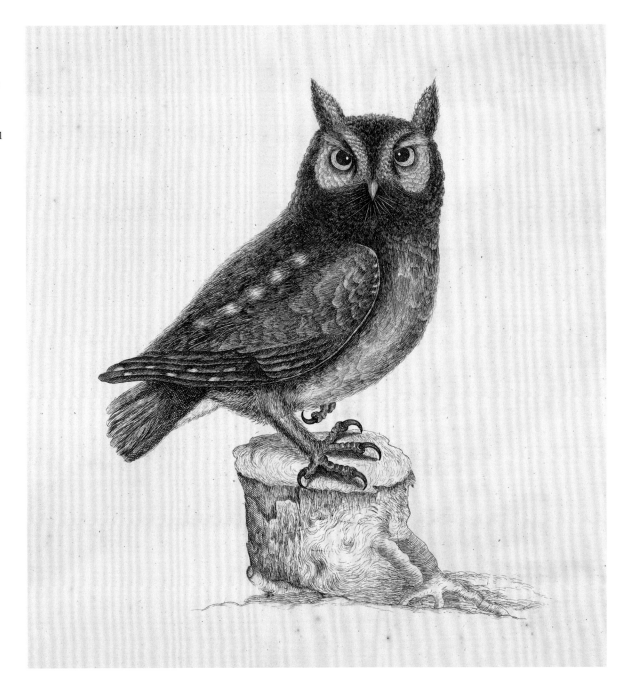

Part 3 was ready to be presented to the Royal Society on 19 November that year, it would seem that the colouring was done over a period of three months.

It has been suggested that as Catesby did not earn any income from the book until the first batch of copies of Part 1 had been distributed to subscribers after May 1729, he may have had to colour himself at least the copies with the first typesetting of Part 1. But as this would have amounted to around sixty impressions of twenty plates, he would have had to colour around 1,200 prints at the same time he

was working on the task of preparing the plates for Part 2.[71] The elaborate and time-consuming process involved in hand colouring would have made such a workload unfeasible. Moreover, the variations in handling, pigments and interpretation would in any case imply, as suggested above, that several hands were at work.

It should also be noted that Catesby continued to keep open the possibility of a demand for uncoloured copies (fig. 109). At the beginning of Part 10 where he began to incorporate images of lepidoptera into

the plates with plants, he wrote: 'In the following Plates are interspersed some remarkable Butterflies, whose colours are so various and intricately blended, that their figures and descriptions would give but a faint idea of their beauty, without being illuminated; which alone answers the purpose. But, as some copies may appear uncoloured, it will be necessary to supply that deficiency by words.'[72]

If Catesby had kept to his ambitious intention 'to publish every Four Months Twenty Plates, with their Descriptions',[73] he would have had to etch five plates per month and compose their accompanying texts, and once this material had been delivered to and collected from the letter engraver and printers, colour at least one set of the prints to serve as a pattern for the colourists. It is thus far from surprising that the process of completing each part took much longer than his original estimate (made, as is clear, before he knew that most, if not all, of his subscribers would sign up for coloured sets). Taking all aspects of his work into consideration, it is remarkable that Catesby made the progress he did through the five parts of his first volume. Part 2 of the book was presented to the Royal Society on 8 January 1730, seven and a half months after Part 1:[74] in it every plate combined a species of bird and plant. Part 3, also combining birds and plants in each plate, appeared ten months after this on 19 November 1730. Part 4 appeared after almost a further year on 4 November 1731; all but two birds (the herons) were combined with plants. And Part 5, the final part of Volume 1, was completed a year following this on 23 November 1732. Twelve of the waders, ducks and other water birds in this last part were shown without plants; two of them showed details of their bills actual size.

On the completion and issue of Part 5 in 1732, Catesby also sent his subscribers the preliminary material for Volume I: the title page (dated 1731), dedication and Preface.[75] This would normally have signalled that they could proceed to bind up the volume. However, Catesby also issued a printed 'Note' alerting subscribers that he intended to produce additional elements (fig. 110): 'There being a Frontice-Piece, Preface, and Maps of the Country's [*sic*], to be added at the conclusion of the Work. It is desired, not to bind up any of the Sets, 'till the whole are finished.'[76] Although no frontispiece seems ever to have been issued, a forty-four-page Account, a double-page map of south-eastern North America and the Caribbean region, a List of Encouragers,

along with a title page and index, were produced and sent to subscribers on the completion of Volume II in 1743 (fig. 111). As the final preliminary materials are usually found bound in Volume II, it would seem that the majority of subscribers ignored Catesby's advice about binding.[77]

Timing of Volume II

Catesby's progress with Volume II was slower. He took a year and a quarter to produce Part 6, which included thirty-three different species of fishes and one coral,[78] presenting it to the Royal Society on 4 April 1734. Part 7 took him another year and a half, and included eleven fishes, seven crustaceans (crabs), three reptiles (turtles), four corals[79] and six plants.[80] Part 8 appeared fifteen months later comprising nineteen reptiles[81] and twenty plants.[82] Part 9, completed two years after this, included six reptiles, four amphibians, eight mammals and twenty plants, starting with Ehret's spectacular plate of *Magnolia grandiflora* (see figs 98 and 99) and finishing with Catesby's plate of *Magnolia tripetala* (see fig. 66 for his preparatory drawing for this plate).[83] The arrangement with the magnolia plates at either end of the part seems, from a correction shown in the plate numbers, to have resulted from a late revision by Catesby made for aesthetic reasons. The original arrangement had begun with the two magnolia plates followed by six reptiles and four amphibians, and then eight mammals; this was changed by swapping the last mammal, the 'Pol-Cat' (eastern spotted skunk, *Spilogale putorius*) (see fig. 239) with the *Magnolia tripetala* plate which thus appeared as the last plate of the part (Plate 80).[84] Part 10, the final part of those originally planned, took another four-and-a-half years and contained twenty-six plants and twelve insects.[85] It is understandable that Catesby took longer to produce this part; with it he included the extra preliminaries that he had specified in his

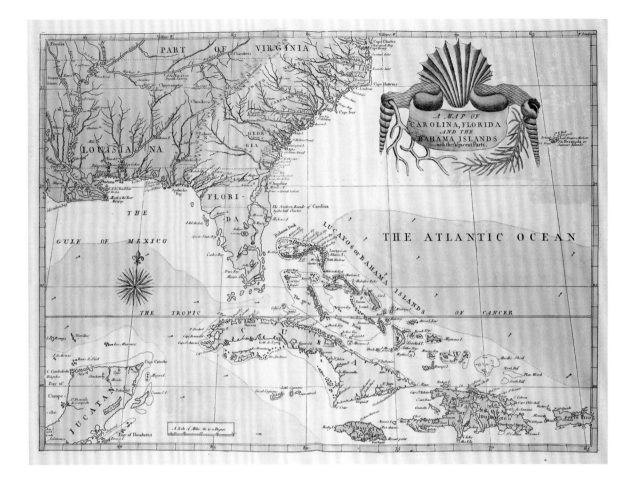

'Note' were intended for Volume I: the Account,
map and List of Encouragers, as well as the title page
and dedication leaf for Volume II, and a three-leaf
index to both volumes. The Account was composed
partly from his notes and journals written around
eighteen to twenty years previously.[86]

The Appendix

Catesby could have ended his book after Part 10, as
originally planned, but in an 'Advertisement' issued
with that part in 1743, he announced his intention to
publish an eleventh part of twenty plates and text, in
the form of an 'Appendix' to the book (fig. 112). This,
he wrote, would include both the drawings he had
left over from the earlier parts and some new ones
of plants and animals he had received from America:

> The Part now publish'd, of the *Natural History* of *Florida*
> and *Carolina*, concludes 200 Plates, which are all that
> were at first designed; but with what remains of the
> Collection I brought from *America*, and an Addition of

other non-descript Animals and Plants, received since from that Part of the World: I have now by me ample Materials for another Set of Twenty Plates, which if approv'd of, I design to add by Way of *Appendix*.[87]

Included in this group were also North American plants grown in English gardens and exotic animals (from other parts of the world) kept in captivity in the collections of his friends or sent as specimens from abroad (as in the case of the viperfish, *Chauliodus sloani*, sent by Catesby's brother from Gibraltar: see Chapter 6). It is notable that the original drawings for twelve of the images that make up the extra twenty plates are by other artists, with eight by Ehret, three by Aubriet and one by Edwards.[88]

Overall, the content of the Appendix illustrates the later stages of Catesby's career, demonstrating the links he had made with other artists during his years of working in London, as well as with the aristocratic owners of gardens and menageries, which provided new and 'curious' subject matter. Thus, while he was anxious to publish the remainder of the drawings of animals, insects and plants he had made in the New World, those images were now combined freely with the new material without demonstrating his earlier concern for ordering subject groups or conveying environmental connections. In fact, in only one plate of the Appendix did he make a connection between an animal and its habitat, showing the bison beneath a stem of the rose locust tree, *Robinia hispida*, with the comment, 'I never saw any of these trees but at one place near the Apalatchian mountains, where Buffelos had left their dung; and some of the trees had their branches pulled down, from which I conjecture they had been browsing on the leaves' (fig. 113).[89]

It took Catesby another four years to complete the Appendix, for which he had to compose a separate index, and during this time he made a number of changes to the table of contents that he had originally proposed in the 'Advertisement', omitting some subjects and including others.[90] Amongst those omitted were three 'Animals' – the 'Penguin', the 'Alka' and 'Anas: a beautiful duck from Newfoundland' – and three 'Vegetables' – the 'Flos passionis', 'Chrysanthemum' and 'Isora Altheae'. George Edwards described and illustrated several penguins in his *Natural History of Uncommon Birds*; his etching of the first of these, 'The Penguin', is dated 'August 22 1740', and was drawn from a 'Bird … lent me by Mr Peter Collinson', who 'could not tell me whence

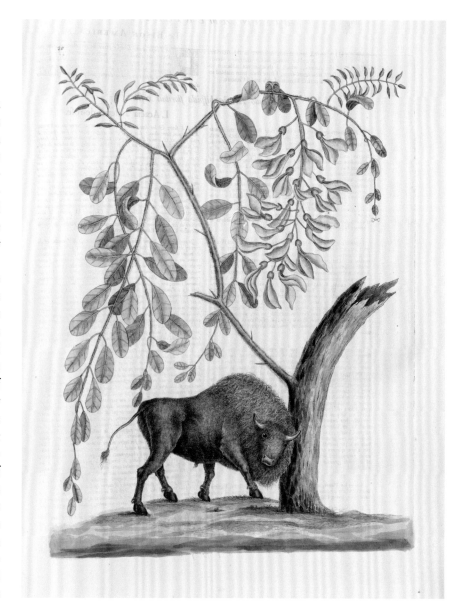

it came. I find them mention'd chiefly by Voyagers to the Straights of Magellan, and the Cape of Good Hope.'[91] Catesby is likely to have seen this specimen from Collinson's collection too, which may have been the one he originally intended to paint.

On the last page of the Appendix, Catesby included text in which he signed off from his work of eighteen years: 'I confess it is now time to conclude this extensive and laborious Work.'[92] Excusing himself to his subscribers for slowness (sixty-three of the named 'Encouragers' had died before seeing the completion of the book), he stated again the basis on which he had drawn and described the 'natural productions' of the New World:

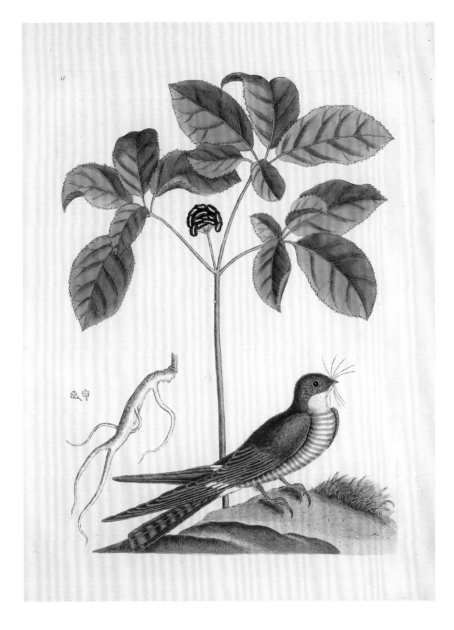

the materials … were collected from the living
subjects themselves, and in their native abodes; which
circumstances, though so very essential to a Natural
Historian, we know of no other History of Animals
in which they are sufficiently apparent; for the picture
of an Animal, taken from its stuffed skin or case,
can afford but a very imperfect idea of the creature,
compared with what is done from the life, not only as
regards their shape, spirit and gesture, but also their
beautiful colours … And as for Plants, it is easy to
conceive how imperfect the figures must be, which are
drawn from dried specimens, in comparison of those
taken from living Plants, as all those are which I have
exhibited.[93]

Later editions of the Natural History[94]

After Catesby's death, his friend George Edwards
played a significant part in the publication of two
later editions of the *Natural History*.[95] The title page of
the second edition of 1754, printed for the booksell-
ers 'Charles Marsh, in Round Court in the Strand,
Thomas Wilcox, over-against the New Church, in
the Strand, and Benjamin Stichall in Clare-Court',[96]
states that it was 'Revis'd by Mr. Edwards, of the
Royal College of Physicians'. The cost of the second
edition was 14 guineas, as opposed to 22 guineas for
the first edition. While the main text seems not to
have been changed in any way,[97] it would appear that
it was the plates that Edwards 'revised', including
correcting a number of details and removing extra-
neous etched details from the copper plates.[98] The
newly worded 'Proposals for re-publishing by sub-
scription a Natural History of Carolina, Florida and
the Bahama Islands', issued in 1753, while setting out
the 'conditions' on which the second edition was to
be published, notes: 'The Colouring of the Plates [is]
to be under the Inspection of Mr. Edwards of the
Royal College of Physicians,' a task that included
correcting a few instances in the first edition where
the colours did not conform to the text.[99] We know
that Edwards took a close interest in the colouring
of Catesby's plates from the fact that he borrowed
Catesby's original drawings in order to paint his
own copy of the *Natural History*.[100] Edwards's own
preference for brighter colours, visible in this copy
he painted himself, is reflected overall in the colour-
ing of the plates of the second edition where the pig-
ment tends to be applied more thickly, leaving the
etched lines less visible.

The third edition of 1771, printed for the book-
seller Benjamin White,[101] likewise described as 'Re-
vis'd by Mr. Edwards, of the Royal College of Phy-
sicians, London', is made up of completely reset
text with various numbering and other changes.[102]
The heightened, sometimes gaudy, colouring of this
edition often departs from the original colours, and
it seems unlikely that Edwards was responsible for
supervising colouring that differed so significantly
from the original images which he knew well (fig.
114). His particular involvement in this edition,
however, appears to have been the addition of 'a
Linnaean Index of the Animals and Plants'. Like
Catesby, Edwards had first met Linnaeus in London
in 1736 and continued to keep up an active corre-

spondence with him; providing the *Natural History* with a list of Linnaean names added significantly to the scientific usefulness of Catesby's book.[103] The fact that the third edition remained available for another forty-five years was 'impressive testimony of its enduring value'.[104]

The appeal of Catesby's *Natural History* to a wider international audience is demonstrated in the number of ways in which his images were repurposed during the second half of the eighteenth century. The German engraver Johann Michael Seligmann published a compilation of smaller-sized versions of plates from Volume I of Catesby's *Natural History* which he alternated with versions of plates from Edwards's *Natural History of Uncommon Birds* and *Gleanings of Natural History* in a seven-volume series, *Sammlung verschiedener ausländischer und seltener Vögel …* (Nuremberg, 1749–76); the plates were bound with facing texts in German. Many of Catesby's subjects, which are lettered prominently in German in Gothic script, are given decorative landscape vignettes in the style of Edwards, and in some cases the different elements of Catesby's compositions are rearranged in order to fit them on to the smaller format plates (fig. 115).[105] The colouring is generally of poor quality and sometimes deviates from the originals. Variations of these compilations were published in French under the title of *Receuil de divers oiseaux étrangers et peu communs …* (nine parts in eight volumes, Nuremburg, 1768–76), and Dutch, *Verzameling van uitlandsche en zeldzaame vogelen, benevens eenige vremde dieren en plangewassen …* (nine parts in five volumes, Amsterdam, 1772–81). A separate anthology of plates and texts derived from Volume II of the *Natural History* was published under the title *Piscium, serpentum, insectorum, aliorumque nonnullorum animalium …* (Nuremberg, 1750; reissued 1777); this contained engravings by Nikolaus Friedrich Eisenberger and Georg Lichtensteger, mainly stiffer and hand coloured more brightly than the versions by Seligmann. The fact that these various publications 'were issued and even reissued was a tribute to their author, even though neither he nor his family profited by them'.[106]

The afterlife of Catesby's images is further demonstrated by the publication in the *Gentleman's Magazine* of a series of small-size hand-coloured woodcuts and etchings after Catesby's plates, printed together with short excerpts from their texts.[107] There the *Natural History* is described as 'a work which exceeds

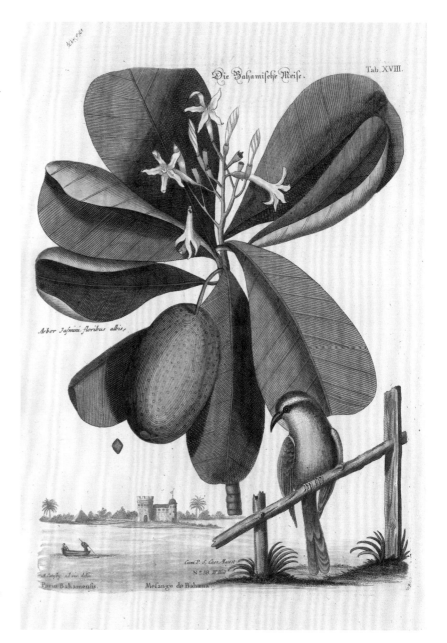

all others of the same kind for its beauty, accuracy and splendour'.[108] Fifteen of Catesby's images were published in the magazine over five years from 1751 to 1755, helping to disseminate his work to a readership far outside that of his own books (fig. 116).[109]

Later publications

During the last years of his life Catesby produced two further illustrated works: a single-sheet 'Catalogue of American Trees and Shrubs' (published *c*.1742) and the *Hortus Britanno-Americanus …* (published posthumously in 1763, with its later issue, the

FIGURE 115

Johann Michael Seligmann after Mark Catesby and George Edwards, 'Die Bahamisense Merise', *Sammlung verschiedener auslandischer und seltener Vögel …*, 1749–76, tab. XVIII. Hand-coloured engraving, 42 × 24 cm.

Cambridge University Library, S395.bb.74.1

FIGURE 116

J. Cave after Mark Catesby,
'Cuculus: Or Cuckow of Carolina;
from Mr Catesby's Nat. Hist',
Gentleman's Magazine, 22, 1752,
tab. 9. Hand-coloured engraving,
12.9 × 20.8 cm.

Cambridge University Library,
R904.20

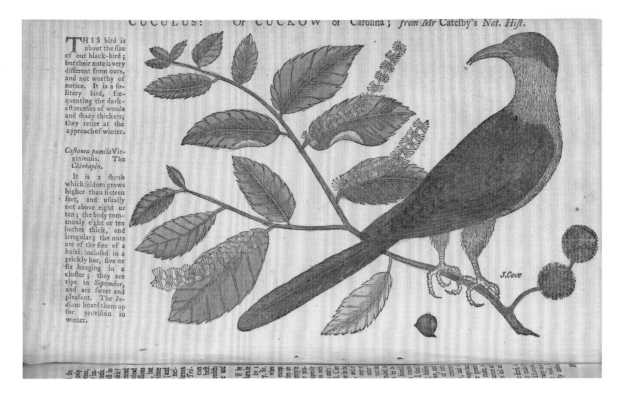

Hortus Europae-Americanus…, published in 1767). These two publications are often overlooked, partly because they were overshadowed by Catesby's main life's work, and partly because of their rarity in terms of the copies that survive. Both publications are important, however, not only for their artistic merit but for demonstrating Catesby's increasing focus on horticultural matters towards the end of his life.

Catesby's broadside entitled 'A Catalogue of American Trees and Shrubs …' was published by the nurseryman Christopher Gray. Although undated, it would seem from various pieces of internal evidence to have been issued around 1742 (see below). It consists of a central image of the bull bay (*Magnolia grandiflora*) etched by Catesby, whose monogram appears at the base of the stem; the 'Catalogue' of plants, listed alphabetically under their Latin names with English names given beneath each entry, is arranged in columns to either side and below the image (fig. 117). Just as in the *Natural History*, the text of the 'Catalogue' (other than the plant names) is given in French as well as English.

Catesby's illustration was adapted from a composite engraving by Ehret made from at least two watercolour studies of the single magnolia flower and its bud, which Ehret had watched develop on a tree in Sir Charles Wager's garden in the spring

of 1737 (fig. 118);[110] he had written to his patron Dr Christoph Trew that he 'drew every part of it in order to produce a perfect botanical study'.[111] Catesby's image of the flower is reversed from that in Ehret's engraving, and the damaged tepal in Ehret's realistic portrait of the flower is shown 'repaired' in Catesby's etching (where it appears in a '4 o'clock' position). The not entirely successful 'repaired' tepal suggests that Catesby himself invented this element of the composition;[112] he also added to the composition an image of the cone or fruiting head with hanging seeds, an element which Ehret had already used (though with slight variations) in his plate entitled 'Magnolia altissima' made for the *Natural History* (see figs 98 and 99). The somewhat stiff appearance of the fruiting head again suggests Catesby's rather than Ehret's authorship; Ehret's version in his composite engraving is very different in both form and style, not least in that he shows some of the follicles opening outwards to discharge the seeds.[113]

Catesby's broadside is unusual in that the text, rather than being printed separately as letterpress, is engraved on the same copper plate as the image. As with the engraved lettering of the plates in the *Natural History*, it is likely that a professional letter engraver would have been employed to carry out this skilled task.[114]

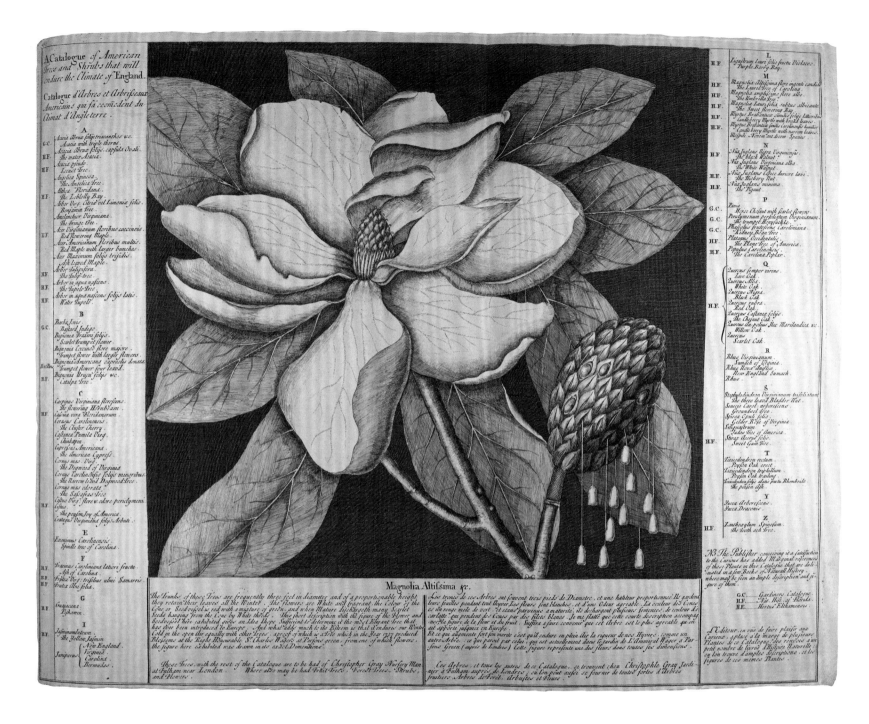

FIGURE 117

Mark Catesby, 'A Catalogue of American Trees and Shrubs that will endure the Climate of England', c.1742, published by Christopher Gray, Fulham, mounted into Catesby's *Natural History*, II. Etching, 38.7 × 50.2 cm.

Oak Spring Garden Foundation, Upperville, VA

Various dates have been proposed for the issue of the 'Catalogue'.[115] Although a date of 1737 has been suggested,[116] there are two citations in it which point to a later date. The first of these gives Catesby's *Natural History* as the authority for *Magnolia grandiflora*, which was only published (as Plate 61 of Part 9) in June 1739. The second gives Catesby's book as the authority for *Robinia hispida*, which was the very last plate to be published in the *Natural History* in July 1747 (see fig. 113) and would therefore suggest that the 'Catalogue' post-dated the issue of the Appendix. But what seems undoubtedly to be a reference to the 'Catalogue' was made in a letter five years earlier by Dr Christoph Trew, dated 17 October 1742, in which he wrote of 'a catalogue of all the American trees and shrubs that completely accommodate themselves to the English climate and are found in London on the property of Christopher Gray, a gardener in Fulham not far from London'; a list of exactly the same plants as those listed in the 'Catalogue' is included in this letter.[117] A further mention of a catalogue which is likely to have been Catesby's is in the letter Catesby sent Linnaeus on 26 March 1745, in which he wrote, 'And whatever other American Plants in

FIGURE 118

Georg Ehret, 'Magnolia altissima', 1737. Hand-coloured engraving, 50 × 30 cm. Mounted into Collinson's copy of the *Natural History*, previously at Knowsley Hall, Volume I, opposite the title page.

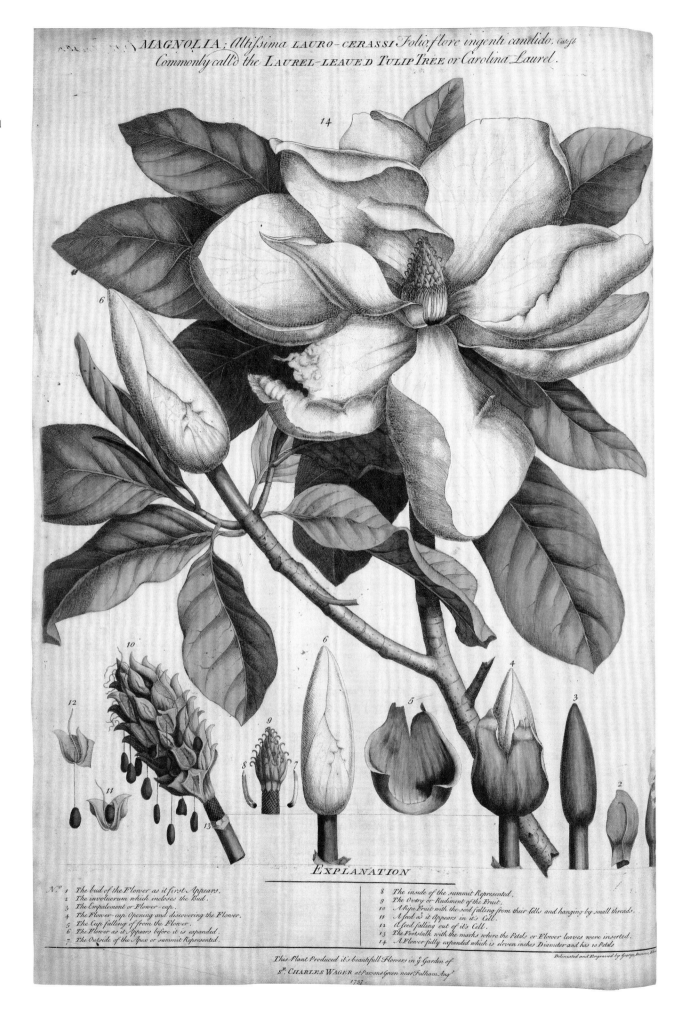

MAGNOLIA: *Altissima* LAURO-CERASSI *Folio, flore ingenti candido.* Cat. fl.
Commonly call'd the LAUREL-LEAUED TULIP TREE or Carolina Laurel.

EXPLANATION

Nᵒ 1 The bud of the Flower as it first Appears.
2 The involucrum which incloses the Bud.
3 The Empalement or Flower-cup.
4 The Flower-cup Opening and discovering the Flower.
5 The Cup falling of from the Flower.
6 The Flower as it Appears before it is expanded.
7 The Outside of the Apex or summit Represented.

8 The inside of the summit Represented.
9 The Ovary or Rudiment of the Fruit.
10 A Ripe Fruit with the seed falling from their Cells and hanging by small threads.
11 A seed as it Appears in it's Cell.
12 A seed falling out of it's Cell.
13 The Footstalk with the marks where the Petals or Flower leaves were inserted.
14 A Flower fully expanded which is eleven inches Diameter and has 10 Petals

This Plant Produced it's beautifull Flowers in ye Garden of
Sᵗ. CHARLES WAGER at Parsons Green near Fulham Aug.
1737

Delineated and Engraved by George Dionisius Ehret

this inclosed catalogue will be acceptable, you may freely command any that I am possessed of' (see fig. 250).[118] The evidence would thus seem to point towards Catesby's catalogue being published in around 1742 (before 17 October, the date of Trew's letter). This would mean that at least one of the references in the 'Catalogue' to a plate in the *Natural History* was made several years in advance of its publication and that Catesby had evidently already decided what he was going to publish in the book.

The collaboration between Catesby and Gray in the production of this catalogue would have served a double purpose of advertising the plants for sale in Gray's nursery and promoting Catesby's *Natural History*. A note at the end states: 'The Publisher conceiving it a satisfaction to the Curious has added Marginal references of those Plants in this Catalogue that are delineated in a few Books of Naturall History, where may be seen an ample description and figure of them.' Of the seventy-two catalogue entries, thirty-five are cross-referenced to Catesby's *Natural History*.[119] While prospective buyers of plants were directed to Catesby's book, Gray could also have hoped that they would be tempted to purchase specimens of these shrubs and trees by seeing Catesby's spectacular full-page colour illustrations of them.

The idea of a horticultural manual, the *Hortus Britanno-Americanus: or, A curious collection of trees and shrubs, the produce of the British colonies of North America; adapted to the soil and climate of England ...* (1763), may have arisen through Catesby's work with Gray on the 'Catalogue'.[120] Indeed, Catesby's manual may also represent the continued collaboration between the two men, not least in providing further advertisement for Gray's Fulham nursery, which is mentioned prominently in the Preface:

> Few people have opportunities of procuring these things from America; wherefore, lest I should seem to treat of what cannot be got at all, or with very great difficulty, it seems proper to mention, that Mr. Gray at Fulham has for many years made it his business to raise and cultivate the plants of America (from whence he has annually fresh supplies) in order to furnish the curious with what they want; and that through his industry and skill a greater variety of American forest-trees and shrubs may be seen in his gardens, than in any other place in England.[121]

Gray's nursery is also cited in a number of places in the text where the equivalent texts in the *Natural History* mentioned Fairchild and later Bacon's Hoxton nursery.[122] Fairchild had died in 1729, and Bacon was dead by May 1733.[123] In general, references to other specific gardens mentioned in the *Natural History* have been removed (including reference to Catesby's own garden), although several mentions of Peter Collinson's have either remained or been added. Collinson continued to be active in his gardens at Peckham and later Mill Hill until his death in 1767 (see Chapter 5).

Catesby appears to have worked on the *Hortus* during the last two years of his life.[124] There is one internal date that indicates he was working on it during this period: in the entry for 'The Catalpa-tree', *Catalpa bignonioides*, he notes that the tree 'did in August 1748 produce, at Mr Gray's, such numbers of blossoms, that the leaves were almost hid thereby'.[125] Further dating evidence is contained in several references in the book to plants he had published in the Appendix to the *Natural History* in July 1747.[126]

Catesby described the *Hortus* as a 'small tract [which] is designed intirely for use', explaining further:

> I have endeavoured to contrive it in the most intelligible and compendious manner I was able, both in regard to the style and also the figures of the plants here exhibited; judging it unnecessary to fill several pages with repeated directions for the management of every plant, when a few lines may suffice for the greater part of them ... As to the figures of the plants with all their parts, as leaves, flowers, fruit, &c. though they are comprised in little room, they are nevertheless represented in their natural size, which necessarily gives a more perfect idea than if they had been contracted to a smaller scale.[127]

The short title of the work – *Hortus Britanno-Americanus* (the British-American garden) – echoes the titles of a number of other books published in the later seventeenth and early eighteenth centuries, most notably in Catesby's circle the *Hortus Elthamensis* (1732) of the plants growing in James Sherard's garden at Eltham in Kent, and *Hortus Cliffortianus* (1737) of George Clifford's garden in Hartekamp in the Netherlands, both of which refer to the particular gardens of their respective owners (fig. 119). In Catesby's title the concept of 'garden' is extended beyond the plots of land relating to individual owners to embrace both Britain and her North American

HORTUS BRITANNO-AMERICANUS:

OR, A

Curious Collection of TREES and SHRUBS,

The Produce of the BRITISH Colonies in NORTH AMERICA;

ADAPTED TO

The SOIL and CLIMATE of ENGLAND.

WITH

OBSERVATIONS on their CONSTITUTION, GROWTH, and CULTURE:

AND

DIRECTIONS how they are to be collected, packed up, and secured during their Passage.

Embellished with Copper Plates neatly engraved.

By MARK CATESBY, F.R.S.

LONDON:

Printed by W. RICHARDSON and S. CLARK,
For JOHN RYALL, at Hogarth's Head, in Fleet-Street. M DCC LXIII.

from the equivalent plates in the *Natural History*, in most cases showing the plants 'in their natural size', with their salient parts 'condensed' from the earlier compositions to illustrate their fruit, flower, seed and leaves 'comprised in little room'.[132] So, for example, seed pods, berries, cones or blossoms of a plant are taken from their natural position in the original illustration and placed in their original size alongside or overlapping the leaves and stems of the plant (fig. 120).

Four totally new images were added to the *Hortus*; two of these are of plants not included in the *Natural History*: no. 34, 'Jove's Beard', *Sempervivum tectorum*, and no. 84, 'The Palmeto-tree of Carolina', *Sabal palmetto* (fig. 121). The third, no. 18 of 'The White Walnut-tree', *Juglans cinerea*, is briefly described but not illustrated in the *Natural History*.[133] The fourth, no. 4, is a newly etched small-scale image of 'The Umbrella Tree', *Magnolia tripetala*, which Catesby explained 'there was a necessity of reducing ... to this small scale' because 'the circle of leaves at its full growth [measures] nine feet' (see fig. 215, no. 4).[134] In addition, seventeen new plants not included in the *Natural History* are described, but not illustrated.[135]

There are various puzzling features about the *Hortus*. One of these is that the numbering of the plates has been done carelessly in the wrong orientation, which has led to several whole plates being shown upside down (because the binders followed the incorrect orientation of the numbers)[136] or on their side;[137] in Plate 21, for example, the shadow cast by the pignut appears nonsensically to be floating above it (see fig. 120). There is an explanation given for the absence of illustrations for the seventeen new plants: 'the remaining [seventeen] are described, but not graved, which is thought altogether unnecessary, because their description alone gives a clear idea of them without any other assistance; which is not the case of those that are figured.' This explanation, however, is not entirely convincing as in some instances a plant title is given with no description,[138] and in other instances illustrations *had* been provided (and therefore by implication thought necessary) in the *Natural History*.[139]

There is too a mystery about why the book was not published until fourteen years after Catesby's death. This time lapse has suggested to some commentators that the text was not in fact written by Catesby, but adapted from the relevant sections in the *Natural History* by someone else, such as its publisher John

FIGURE 119

Mark Catesby, title page,
Hortus Britanno-Americanus, 1763.
38 × 30 cm.

Natural History Museum,
London, Botany Library, Special
Collections

colonies, conjuring up the idea of plants shared between the two geographical regions.[128]

The 'small tract', a slim quarto volume, consists of a two-and-a-half-page Preface, a list of contents, and a catalogue of eighty-five plants (identified by Latin polynomials with English names for most of them);[129] then follow sixteen hand-coloured etched plates, measuring 10¼ × 10¼ inches (26 × 26 cm).[130] All but two of these square plates are divided into quarters to show four separate images of plants (making a total of fifty-eight plant illustrations).[131] The images in the plates are re-etched details taken

Ryall.[140] A number of statements in the text, however, can only have been written by Catesby, such as the comment that 'I never saw these trees growing but near the little town of Dorchester on the Ashley river' added to the description of 'The Purple-berried bay'.[141] And in the entry for 'The Dahoon Holly', having noted in the *Natural History* that 'it grows particularly at Colonel Bull's plantation on Ashley river', Catesby added an extra detail in the *Hortus*: 'in a bog much frequented by alligators'.[142] To the description of the habitat of *Magnolia tripetala*, he observed: 'in Carolina they are in greater plenty [than Virginia], particularly in the path leading from Mr Skene's house to his Savanna' (see fig. 66);[143] and in the text accompanying 'The Cedar of North America' he added more first-hand comments:

> in America I have frequently gathered specimens from a grove of these trees, and even from a single tree, that have agreed with all the different characters by which they have been distinguished in England. I was told by a person of probity and curiosity, that he carried some berries of the Bermudas cedar from thence, and raised trees from them in Carolina, where the trees became more like in appearance to the Carolina cedar trees than to those of Bermudas; therefore it is not to be wondered at that such-like changes appear in England, where the soil and climate differ vastly from those parts of America where cedars grow.[144]

The etchings have been criticized as being of poor quality.[145] But despite the careless numbering, the successful way in which the images have been adapted from the original compositions in the *Natural History* to fit into the compact square format of the plates of the *Hortus*, the artistic decisions involved in creating these new designs, and the style of cross-hatching all indicate Catesby's hand, even if the quality of the etching is not always as fine as in his earlier work.[146] Fourteen of the plates bear his monogram; although these were added rather randomly to the plates and without Catesby's usual flair for incorporating them into the overall composition (see Chapter 4), the fact that four of the monograms are correctly orientated with respect to the images, but as bound (following the incorrect orientation of the engraved numbers as described above) appear upside down or on their sides, indicates that they are likely to have been done by Catesby himself.[147]

A possible explanation for these puzzling features could be the fact that Catesby was engaged on the text and plates at a late stage in his life, during the period when his health was failing – a plausible reason both for the less fine quality of the etchings and the incompleteness of the work at his death. Whilst the task of adapting and condensing the compositions from his original plates may have been straightforward, inventing totally new designs for a significant number of plates would have been time-consuming and exacting work. Thus, only four out of the new plants were illustrated, leaving the editor the task of having to compose the unsatisfactory paragraph of explanation about the missing illustrations in order to complete the work. Likewise, the wrong orienta-

FIGURE 120

Mark Catesby, 'The Black Walnut-tree', 'The White Walnut-tree', 'The Hiccory-tree' and 'The Pig-nut', and 'The Chinkapin', *Hortus Britanno-Americanus*, 1763, plates 17–18, 20–21, 22. Hand-coloured etching, 26 × 26 cm.

Natural History Museum, London, Botany Library, Special Collections

tion of the plate numbering could also be explained by it being done after Catesby's death and therefore unsupervised by him.

The additional text Catesby wrote for the *Hortus* consisted mainly of his 'observations on [the] constitution, growth, and culture [of the trees and shrubs of America]' as well as his '[directions] how they are to be collected, packed up, and secured, so as to preserve them in good condition during their passage; which are matters of the utmost consequence, though less known even than their culture'.[148]

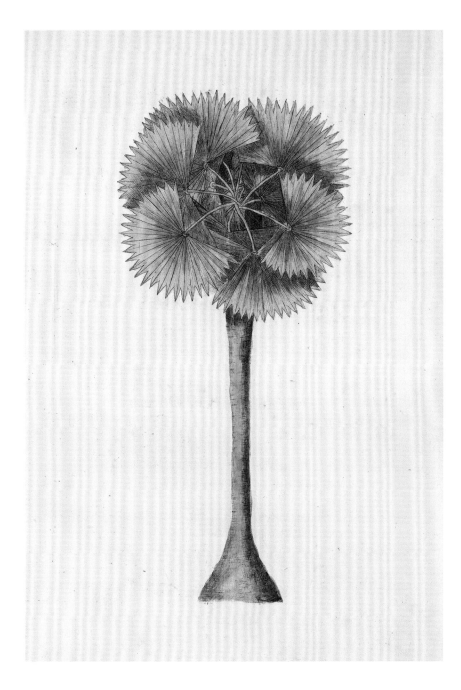

Catesby began the *Hortus* with four magnolias, moving on to nine species of oaks; following that he proceeded through forty-five individual species of trees and shrubs, taken out of order from those included in the *Natural History*. From numbers 59–85, there are only two illustrations;[149] seventeen of these plants are new to the *Hortus*, and seven of the new plants consist of names only with little or no description. Of the seventeen new plants added to the *Hortus*, most have either very cursory or no descriptions. Of the four that have longer texts, 'the Palmeto-tree of Carolina' (no. 84) is one of those for which a new illustration is provided, Catesby having previously noted in the Account that he would have wished to include it the book (fig. I2I): 'many things remain undescrib'd for want of a longer continuance [in the Bahama Islands]; particularly four kinds of palms; which, as it is a tribe of trees inferior to none, both as to their usefulness and majestic appearance, I regret not being able to give their figures, or at least a more accurate description of them.'[150] It is tempting to suggest that the majority of the new plants with little text and no illustrations may have been plants in Gray's nursery, possibly added later by him to those which Catesby had described and illustrated, and to propose that Gray might have been involved in seeing the book through the press.[151]

The mysterious history of the book ends with a reissue in 1767. This was brought out under the more geographically inclusive title of *Hortus Europae-Americanus: or, A collection of 85 trees and shrubs, the produce of North America; adapted to the climates and soils of Great-Britain, Ireland, and most parts of Europe* ...: a reflection of the growing audience in the expanding gardening world in which Catesby had played such an active part.[152]

One unillustrated paper that Catesby read to the Royal Society, and which was published in the *Philosophical Transactions*, should also be mentioned in this section.[153] On 5 March 1747 he presented to the society his paper on bird migration containing 'some thoughts concerning the places to which, those birds, usually called birds of passage, retreat unto, when they take their leave of us: and the manner in which they convey themselves to those places'.[154] The paper was published in 1747 in the *Philosophical Transactions* as 'Of Birds of Passage',[155] and gained further circulation through the *Gentleman's Magazine* where a shorter version was published in October the following year.[156]

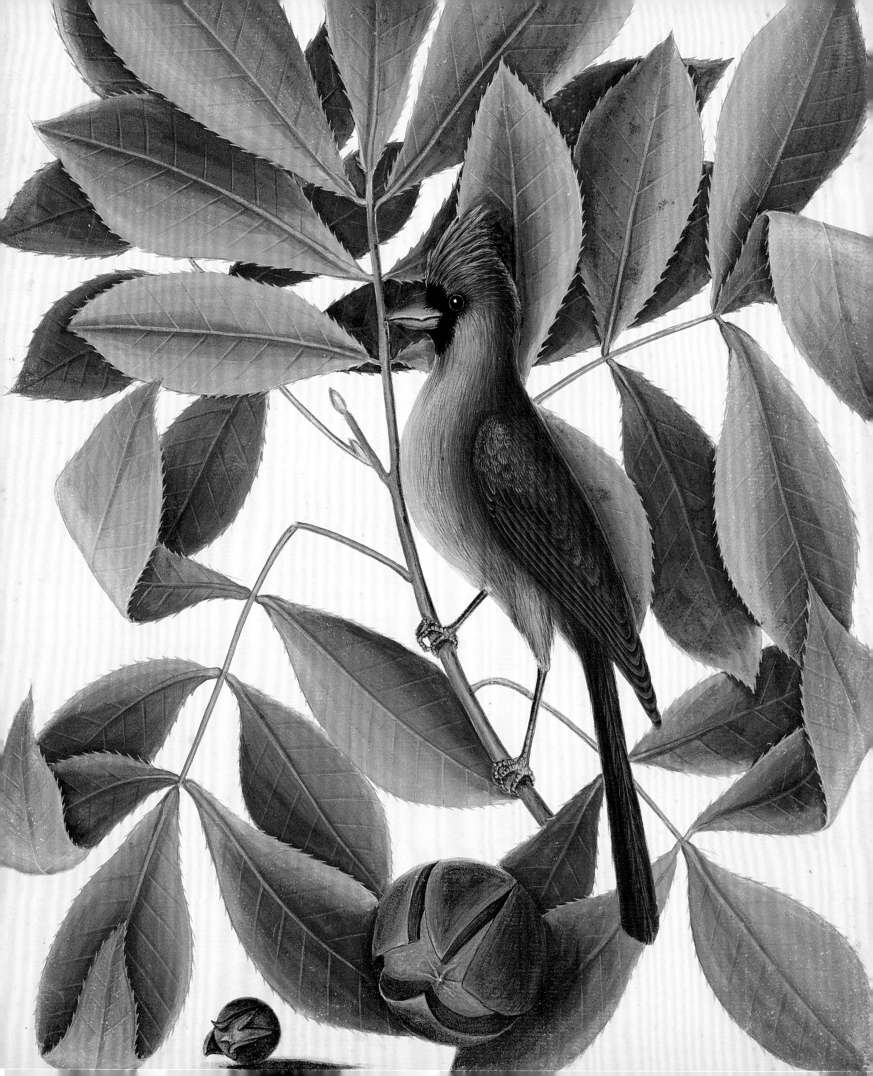

Catesby as Artist

'As I was not bred a Painter I hope some faults in Perspective,
and other niceties, may be more readily excused.'[1]

Catesby's statement about his artistic abilities in the Preface to the *Natural History* provides us with the important information that he had no professional training as an artist. And yet, the ways in which he educated himself in the skills he needed, added to his decision to etch his own plates, gave him exceptional control over the images he published in his book. So successful was he that George Edwards was to follow his example and, unlike most other contemporary illustrators of natural history, was to etch his own watercolours for the plates of his acclaimed books.[2] Nonetheless, Catesby's prime impulse to create images of the natural world arose from his being first and foremost a naturalist rather than an artist. His art was, as he stated, designed to 'serve the Purpose of Natural History'.[3]

Artistic training

From the early seventeenth century, learning how to 'limn' – to paint in watercolour and bodycolour, usually on a small scale – had been one of the accomplishments of the gentleman amateur.[4] By the eighteenth century the use of the word limning had expanded to mean 'to draw; to paint any thing', and the word 'paint' was used alongside 'limn' and 'illuminate' to denote the technique of painting in watercolour and bodycolour.[5] Catesby recorded that for 'the illumination of figures' of plants and animals he had tried to use colours 'most resembling Nature'. In his view, 'The Illuminating of Natural History' was 'essential to the perfect understanding of it'.[6]

Drawing had entered the curriculum as a taught discipline in grammar schools by the late seven-teenth century, although we do not know if Catesby learned it when he was at school in the 1690s.[7] The techniques of both drawing and limning could also be learned from the increasing number of manuals being produced for amateurs. William Sanderson's *Graphice, the use of the Pen and Pensil, or the most Excellent Art of Painting* (1658) was one of the earliest manuals on the pictorial arts to be published in English (fig. 123). The second part of the work, entitled 'The Use of the Pensil in the most Excellent Art of Limning, in Water-Colours', drew heavily from the treatises of Nicholas Hilliard ('The Art of Limning', *c.*1600) and Edward Norgate ('Miniatura', 1627), whose work had not been published but had circulated in manuscript form. Other popular manuals included Henry Peacham's *The Compleat Gentleman* (1661),[8] which incorporated his earlier treatise on the *Art of Drawing with a Pen, and Limning in Water Colours* (1606),[9] and *Polygraphice: Or the arts of drawing, engraving, etching, limning, painting, washing, varnishing, gilding, colouring, dying, beautifying and perfuming ...* (1685) of William Salmon, whose text was mainly taken from other authors (see fig. 50). William Byrd had a copy of Salmon's book, described as 'one of the most influential art manuals [available] in America', which Catesby could have consulted in the library at Westover.[10] Another popular manual was Richard Blome's *The Gentlemans Recreation* (1686), which, in its detailed section on 'Drawing and Painting' with lists of colours, 'how to grind, wash, mix and temper them, how to lay them on, what brushes and other equipment to use', included specific instructions for 'Drawing Beasts, Birds and Flowers'.[11] In addition to such manuals on materials and tech-

FIGURE 122

Mark Catesby, 'The red Bird', 'The Hiccory Tree' and 'The Pignut', 1722–5. Detail of fig. 146.

GRAPHICE.

The use of the Pen and Pensil.

OR,

THE MOST EXCELLENT ART

OF

PAINTING:

In Two PARTS.

By WILLIAM SANDERSON, Esq;

LONDON,

Printed for *Robert Crofts*, at the signe of the *Crown* in *Chancery-Lane*, under *Serjeant's Inne*. 1658.

FIGURE 123

William Sanderson, *Graphice, the use of the Pen and Pensil, or the most Excellent Art of Painting*, London, 1658. 26.6 × 17.4 cm.

Cambridge University Library, SSS. 41.15

niques, there were collections of prints for amateur artists to copy, such as *A Booke of Beasts, Birds, Flowers, Fruits, Flies and Wormes ...* (1658), published by Thomas Johnson, and other versions of Crispijn van de Passe's *Hortus floridus ...* (1614).[12]

Catesby is reticent about the way in which he developed his skills in draughtsmanship. However, it is clear that copying the works of other artists formed a crucial part of his training. In his youth he is likely to have had access to illustrated works on natural history in the collections of the naturalists John Ray and Samuel Dale, and later in the libraries of William Byrd in Virginia, Thomas Cooper in Charleston, and Hans Sloane and the Royal Society in London. Catesby's acquisition in 1720 of a 1703 edition of Francis Barlow's *Aesop's Fables* was a clear indication of his turning to book illustrations for models for his own images (see fig. 59). Barlow, the first English professional trained etcher, was also one of the foremost illustrators of animals of the period, and his prints were part of the standard

repertoire of animal images for amateur artists to copy. In his *New and Englarged Catalogue ... of Elegant Drawing Books*, the print seller Carington Bowles listed 'Barlow's Birds and Beasts' under two different sections in '67 excellent and useful prints, being a collection of the chief works of that eminent master; and engraved by himself, Hollar, Place, &c. all drawn from the life showing in their natural and peculiar attitudes, a vast variety of birds, fowls, and beasts, folio'.[13] As we will see, Catesby's close study of Barlow's *Aesop's Fables*, a book with which he may have been familiar from much earlier in his life, was to influence his own art in several ways.[14]

Practising penmanship was another way that gentlemen artists and *virtuosi* trained themselves in fluency of the pen; exercises in calligraphy and flourishes, which translated easily into a fluent and confident style in pen drawing, were available in a number of manuals. Catesby's elegant hand – which can be seen in his letters, his envelopes with flourished capitals, the inscriptions on his drawings, as well as his etched monograms – demonstrates his interest in penmanship.[15] A number of manuals designed for the use of professional clerks as well as amateurs, of both sexes, were available; Catesby may, for example, have been familiar with Richard Daniel and Edward Cocker's *Daniel's Copy-Book, or A Compendium of the Usuall Hands of England, Netherlands, France, Spain and Italie ... With sundry Figures of Men, Beasts, and Birds, done Alavolee, Written and Invented by Richard Daniel Gent. and Engraven by Edward Cocker Philomath* (1664).[16] The flourished capital letters seen in Catesby's letters addressed to Sherard, Sloane and Dillenius, for example, show similarities to some of those in Daniel and Cocker. Alphabets demonstrated in George Bickham's *Penmanship made easy, or the Young Clerk's Assistant* (1733) suggest that Catesby may have adopted the 'Italian' or 'Round' hand, or contrived a mixture of the two (figs 124 and 125).[17]

In another comment about his art Catesby wrote, 'I humbly conceive that Plants, and other things done in a Flat, tho' exact manner, may serve the Purpose of Natural History, better in some Measure, than in a more bold and Painter like Way.'[18] In addition to his usual modesty, there is perhaps a certain defensiveness in justifying the benefits of depicting 'Plants, and other things' in a 'Flat, tho' exact manner'; he was fully aware of the increasing number of natural history books being produced in London, illustrated with high-quality plates by professional

FIGURE 124

Richard Daniel and Edward Cocker, *A Compendium of the Usuall Hands of England, Netherlands, France, Spain and Italie ... Written and Invented by Richard Daniel Gent. and Engraven by Edward Cocker Philomath*, London, 1664, p. 21. Engraving, 23 × 34.7 cm.

Cambridge University Library, Lib.2.66.1

FIGURE 125

Mark Catesby, letter to Johann Jacob Dillenius (detail), postmarked 3 February, 1736. Pen and ink, 28.9 × 23.6 cm.

Oxford, Department of Plant Sciences, MS Sherard 202, fol. 117

Continental artists. John Martyn's *Historia plantarum rariorum* (1728–37) and the Society of Gardeners' *Catalogus plantarum* (1730), for example, were both illustrated in coloured mezzotint by the Dutch painter Jacob van Huysum, younger brother of the well-known Dutch flower painter Jan. Continental flower books were also circulating in England and setting a high standard for British botanical artists. Notable among these were the French court artist Nicolas Robert's *Recueil des plantes gravées par ordre du Roi Louis XIV* (Paris, 1701), engraved by the artist, and Maria Sibylla Merian's *Metamorphosis insectorum surinamensium* (Amsterdam, 1705), containing hand-coloured etchings after her life-size watercolours by several professional Dutch engravers.[19]

It is possible that Catesby had access to painted as well as engraved natural history illustrations early in his life. A volume of meticulous small-scale watercolours of birds, fishes and other animals by Johann Jacob Walther (1604–1676/7) – 'drawn with great curiosity and exactness by an excellent hand' and purchased in Strasbourg from a fisherman, Leonard Baldner, by Ray and Willughby – provided models for images in their *Ornithology* (1678) and *De historia piscium* (1686), both these works being completed and published by John Ray after Willughby's death in 1672.[20] The volume of watercolours was inherited by Willughby's daughter Cassandra, who married the Earl of Carnarvon, later the Duke of Chandos, in 1713. As Chandos and Catesby were in contact over the latter's possible involvement with the Royal African Company during the period Catesby was visiting London (1719–21), it is conceivable that he had access to these drawings;[21] if so, he would have seen examples of rendering bird plumage and reptile and fish scales minutely in watercolour and bodycolour (fig. 126). During this same period Catesby had the opportunity to meet Sloane and visit his renowned collection with its 'Books of Miniature or Colours, with fine Drawings of Plants, Insects, Birds, Fishes, Quadrupeds, and all sorts of natural and artificial Curiosities', including two volumes of prized vellums by Nicolas Robert, as well as a spectacular series of watercolours of plants and insects by Merian.[22]

Working methods and techniques

Over three hundred of Catesby's drawings and watercolours have survived, the majority made in preparation for his *Natural History* (see forthcoming

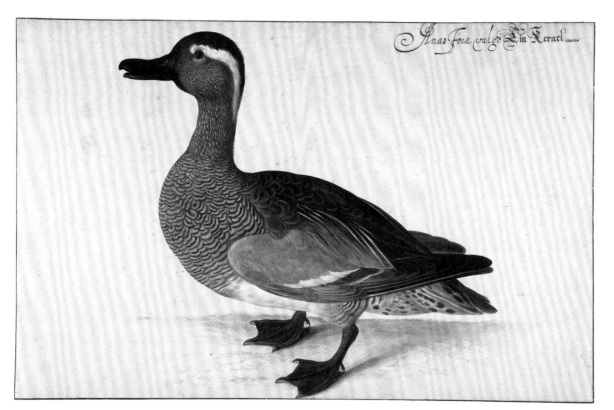

FIGURE 126

Johann Jacob Walther, 'Anas
Fera vulgo Ein Kernel', c.1660.
Watercolour and bodycolour
heightened with gum,
25.6 × 40.4 cm.

(Drawing reproduced in lieu
of image from Willoughby
volume, which was inaccessible
during 2020.) The Metropolitan
Museum of Art, NY, Elisha
Whittelsey Collection, 2006.495

Catalogue). He left only a few comments about his working methods; other than these, we must glean information from the drawings themselves. Importantly, however, he did specifically state that he drew and painted in the field, recording in his Preface: 'I employed an Indian to carry my Box, in which, besides Paper and materials for Painting, I put dry'd Specimens of Plants, Seeds, &c. as I gather'd them.' The fundamental difficulty of drawing and painting in outdoor conditions was managed partly thanks to his Native American companions, whose 'First Care was to erect a bark hut, at the approach of rain to keep me and my Cargo from wet'.[23]

Catesby made a distinction between his field sketches and worked up drawings when he commented on his image of the American bison, *Bison bison*, that the animal was 'already described in the Account of Beasts, p. 27, but having then by me only a sketch of the Animal, which I thought not sufficient to make a true figure from, I have since been enabled to exhibit a perfect likeness of this awful creature'.[24] The discovery of a number of sketches on the versos of the sheets bearing watercolours, which had been pasted down in the three-volume copy of the *Natural History* at Windsor, allows us to see at least part of Catesby's process of working from sketches to fin-

ished compositions.[25] While the majority of these preliminary sketches are in pen and ink, a few have small details in colour suggesting that this was the type of painting Catesby did in the field (fig. 127).[26] Recording details in colour on the spot allowed him to work up the full coloured image or 'figure' later when he returned from field trips to his various residences, where he had supplies of paper, pigments and other painting materials as well as the facility to work indoors.[27] In a letter to Sherard sent 'from Mr Skeins Jan. 4th 1722/3', he wrote of 'being from Town where my papers are'.[28] On occasion, whether because he did not have his paints with him or for other practical reasons, he used written colour notations, such as in his sketches for 'Arum maximum Egyptiacum' (arrowleaf elephant's ear, *Xanthia sagittifolium*) annotated 'green' and 'yellow' (fig. 128), and the tulip tree, *Liriodendron tulipfera*, marked 'yellow green', 'deep green', 'green' and 'umber'.[29] It is possible that Catesby devised some sort of colour chart for use in the field as an aid to recording colours accurately. The survival of an elaborate guide to paint colour compiled in Delft in 1692 by A. Brogert, entitled *Traité des couleurs servant a la peinture à l'eau*, suggests that such guides were in use by artists at this period.[30]

FIGURE 127

Mark Catesby, 'Terebinthus
major' (*Bursera simaruba*),
1722–5. Pen and ink over graphite
with parts in watercolour and
bodycolour, 27 × 37.5 cm.

Royal Library, Windsor, RCIN
925923 verso

FIGURE 128

Mark Catesby, 'Arum maximum
Egyptiacum' (*Xanthosoma
sagittifolium*), 1722–5. Pen and
ink with colour annotations,
26.5 × 37.5 cm.

Royal Library, Windsor, RCIN
926000 verso

Some of the drawings found on the versos of the sheets fall into the category of compositional sketches rather than field drawings. Usually drawn in outline only, in pen and ink or occasionally graphite, they reveal the way in which Catesby established the overall composition or arrangement on the page of his subjects. These outlines were either traced or copied for use in the final composition.[31]

Catesby's fluency in the use of the pen made it the natural drawing medium for his preliminary sketches, the majority of which were made in pen and ink. However, most show traces of graphite under-

drawing, indicating that this is how he made his first design or 'draught', signs of which may sometimes have been rubbed out. Such a method was described in Sanderson's manual where charcoal was advised as the best medium 'to touch over your draught lightly at the first', with 'Black-lead pencils to go over your Draught more exactly the second time', using 'a Feather of a ducks wing … [to] wipe out at pleasure what you desire to alter in your Draught'. Finally, the artist was advised to use 'Pens made of a Ravens quill, to finish your design; which will strike a more neat stroke than the common quill: but you must

be very exact here, for there is no altering what you do with the pen'.[32] Different birds' quills were used for different-sized pens as well as for the handles of brushes (called 'pencils' at that period), graded from swans' quills to larks in size.[33] Graphite was also the medium that Catesby used for transferring his images from one sheet to another. The verso of one of his watercolours of the purple pitcherplant, *Sarracenia purpurea*, for example, shows that the outline of the main trumpet-shaped leaf has been traced through in graphite from the recto (fig. 129); this outline was then, it seems, transferred to his second composition showing the pitcherplant with the southern leopard frog, *Lithobates sphenocephalus* (see figs 155 and 156).[34]

Catesby's emphasis on the importance of painting specimens fresh rather than from preserved or dead models reinforces his claim that some painting was done in the field: 'In designing the Plants, I always did them while fresh and just gathered; and the Animals, particularly the Birds, I painted while alive (except a very few) and gave them their Gestures peculiar to every kind of Birds. Fish, which do not retain their colours when out of their Element, I painted at different times, having a succession of them procur'd while the former lost their colours.'[35] Reptiles and amphibians, however, were more easily caught and could be kept alive in boxes or cages at home as 'they will live many months without sustenance; so that I had no difficulty in painting them while living.'[36]

In addition to noting that living organisms change colour when they are 'out of their element' or dead, Catesby observed that the changing seasons generate an infinite spectrum of colour within plants, particularly in respect to the green in leaves:

> give me leave to observe there is no Degree of Green, but what some Plants are possess'd of at different Times of the Year, and the same Plant changes its Colour gradually with it's Age, for in the Spring the Woods and all Plants in General are more Yellow and bright; and as the Summer advances, the Greens grow deeper, and the nearer their Fall are yet of a more dark and dirty Colour. What I infer from this is, that by comparing a Painting with a living Plant, the difference of Colour, if any, may proceed from the above-mention'd Cause.[37]

As a naturalist, Catesby was concerned to capture the colours he observed in nature as accurately as

possible in his paintings. His painter's eye for the range, tones and nuances of colour can be seen equally in the vocabulary he uses in his accompanying texts. He describes the colour red, for example, variously as 'bright scarlet', 'crimson', 'deep red', 'claret', 'muddy red', 'dirty red', 'blood-red', 'dusky red', 'cloudy red', 'russet red', 'reddish brown or fulvous colour', 'brick red', 'reddish umber' or 'the colour and consistence of red sealing wax'. As a careful practitioner he aimed to ensure that his colours would last (for example, that the pigments should not fade, discolour or flake). He wrote: 'Of the Paints, particularly the Greens, used in illumination of the figures, I had principally a regard to those most resembling Nature, that were durable and would retain their lustre, rejecting others very specious and shining, but of an unnatural and fading quality.'[38] His use of the word 'lustre' implies an interest in the light-reflecting qualities of colours, and ways of illustrating, for example, the fact that many plant leaves have a shiny and a matt side. The science of colour was a subject about which he was aware through the work of the Royal Society. Its researches into colour from its earliest days had included studies of dyes and artists' pigments as part of efforts to compile a 'history of trades';[39] Robert

Boyle in his *Experiments and Considerations touching Colours* (1664), for example, discussed experiments with making colours from flowers and berries. In 1667, the botanical artist Alexander Marshal (*c*.1620–1682), who had a reputation for making his own colours out of organic pigments, had been approached by Thomas Povey, secretary of the society, for advice on different techniques of painting and colour making; Marshal, however, was reluctant to release such 'pretty secrets'.[40] Richard Waller, a fellow of the society, like Marshal a talented gentleman amateur artist, had attempted to standardize colours with his 'Table of Colours' presented to the society in 1686 as a more accurate basis for describing the natural world.[41]

By Catesby's time pigments were available ready ground and could be bought from many print shops as well as directly from artists' colour-men, as advertised in *The Art of Painting in Miniature* (1729). There the author, after listing the colours to be used by watercolourists, states, 'All the colours above-specified, with every implement and Utensil, necessary in the Practice of Painting in Miniature, are prepared and sold at most Print-Shops in London and Westminster' (fig. 130).[42] George Bickham, a colour-man, print colourer and print seller, advertised in 1747, 'The very best Transparent Water Colours in Phials: Likewise the best mix'd Gum Water to mix in Shells for colouring Prints'.[43] Nonetheless, during this period artists continued experimenting with colours and making their own pigments. A collection of notes entitled 'Divers Receipts in Painting' with in-

formation on preparing colours, as well as on various artists' and craftsmen's techniques, was assembled by the apothecary and collector James Petiver in 1712; amongst this are recipes and instructions from Albin and Edwards, as well as a 'Mr Harrison's Receipt for Pinck'.[44] At the end of his *Natural History of Uncommon Birds*, George Edwards published some advice for amateur artists entitled 'A Brief and General Idea of Drawing, and Painting in Water-Colours: intended for the Amusement of the Curious, rather than for the Instruction of Artists', which included 'a few Hints on the Preparing of Colours'. Amongst these he published one of his own 'discoveries': 'a Secret relating to purifying Indigo'.[45]

Catesby too is likely to have made at least some of his own colours, as indicated by his attempts to match pigments with the colours he observed in living plants. His description of collecting cochineal beetles from the Opuntia cactus (prickly pear, Cactaceae) strongly suggests he was doing so in order to dry them to make the red pigment carmine.[46] The pigment was very expensive to buy as large numbers of insects had to be collected in order to make a small amount of colour.[47] An unpublished watercolour of the cactus which he did not include in the *Natural History* is inscribed, 'Opuntia or India Fig on which the Cochineal is found' (fig. 131).[48] Catesby's friend

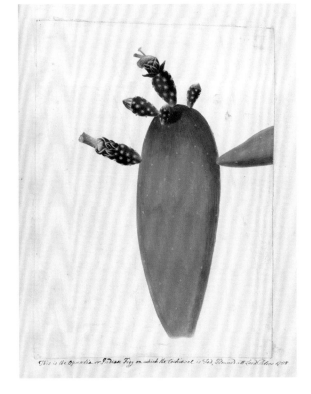

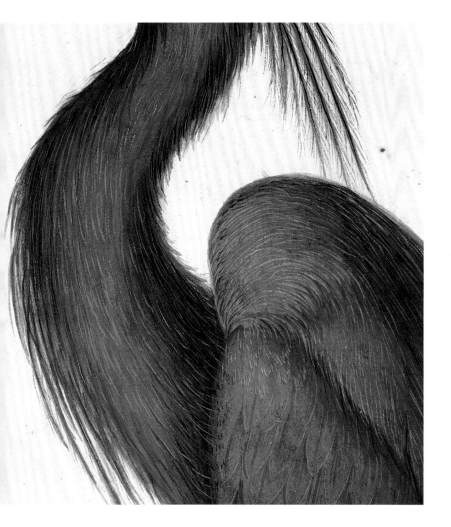

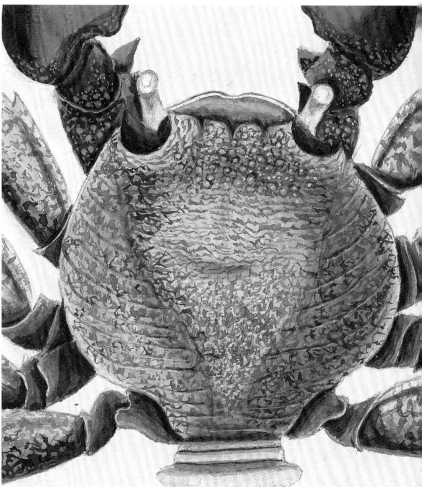

John Bartram appears to refer to Catesby's own colours in a letter of 1742. So that he could send Catesby some of his own drawings of animals, he asked, 'I should be much obliged to thee if thee would be so kind to send me a little of your best Colors.'[49]

Catesby's statement that he 'had principally a regard to those [paints] … that were durable and would retain their lustre, rejecting others very specious and shining, but of an unnatural and fading quality' further suggests that he had experimented with different sorts of pigments.[50] An examination under UV light and high magnification of some of Catesby's watercolours showed that he used both copper-based and organic green pigments, applying them sometimes separately to different areas of the same watercolour, and sometimes mixed together.[51] Catesby's care in choosing his pigments, as well as his preparation of them, is borne out by his surviving watercolours, which have retained the intensity and brightness of their colours.[52]

As noted, he could have learned how to 'lay on his colours' both from manuals and from studying other artists' work.[53] Edwards, in his instructions for amateurs, described the process for limning or 'Painting in Water-Colours' by which, after laying in the ground, the artist would work from dark to light: 'When you have laid your Ground, the usual Way is, to shadow first with the same Colours you have laid in, only with less White in them, till you come to your deepest Shadows, wherein is no White at all … When the dark shadows are finished, you may begin to heighten the Lights, by adding White to the Colours with which you laid in the different Parts of your Picture.'[54]

Catesby employed the same basic process with some particular characteristics of his own. After 'draughting' the design in graphite, he reinforced the composition mostly, as noted, in pen and ink, although sometimes in brush and pigment (see fig. 90).[55] In the usual way, he then laid in the underlying

FIGURE 132

Mark Catesby, 'The blew Heron' (*Egretta caerulea*), detail of plumage, 1722–5. Watercolour and bodycolour over graphite, 27.1 × 37.9 cm.

Royal Library, Windsor, RCIN 925911

FIGURE 133

Mark Catesby, 'Red motled Rock Crab' (*Grapsus grapsus*), detail of markings of shell, 1725–6. Watercolour and bodycolour over pen and ink and graphite, 37.2 × 26.9 cm.

Royal Library, Windsor, RCIN 925982

tone in a single colour, after which additional layers either of the same or different pigments were added for the local colour and modelling. The next stage involved fine brushwork to describe details such as bird plumage and the patterns and texture of crustacea (figs 132 and 133). Highlights were added last in white – either as thin washes or as an opaque mixture – and gum arabic was used to add further depth to certain shadows and very often to the eyes of animals. Catesby also employed a number of more experimental techniques to obtain the effects he wanted, sometimes overlaying colours when dry, at other times applying them wet on wet, mixing them with different quantities of white, and applying white as a thin wash over the top of the pigment. He used a particular technique of applying a thin colour wash over a thick application of lead white especially to enhance the eyes of animals and other features (fig. 134).[56]

The very fine detail Catesby added to his watercolours was done by forming the hair of the brush into a fine point, as in the advice about brushes (or 'pencils') given in Sanderson:

> Furnish your self with Pencils of all sorts; which how to chuse do thus, take a pencil and put the hairy end between your lips, wetting it a little by drawing it through your lips, being moist, two or three times; as small as a hair, which if it do, it is good; but if it is spread, or any extravagant hairs stick out of the sides, they are naught; you may try them by wetting in your mouth, and attempt to draw a line on the back of your hand.[57]

Catesby's choice of paper was also important in enabling him to achieve the effects he desired. Edwards advised that 'Paper proper for Drawing … ought to be neither over nor under-gummed [sized]' and 'be of an even clear Grain and Surface' for 'An under-gummed Paper hath a contrary Inconveniency, for the Colours are apt to run through it, and spread beyond your Design on the Out-Line.'[58] A study of

Catesby's papers has shown that he used the same fine quality Continental paper for both drawing and printing his plates.[59] The smooth, well-sized paper needed to have a finish without too much absorption to take the watercolour pigments and ink without risk of them running.

Drawing from nature

In the text accompanying the final plate of the Appendix, Catesby reiterated his belief in the importance of drawing from nature rather than from preserved specimens, which 'can afford but a very imperfect idea of [animals], compared with what is done from the life, not only as to what regards their shape, spirit, and gesture, but also their beautiful colours'.[60] While, as we will see, there were to be numerous examples of Catesby turning to other illustrations for images of animals in particular, the fundamental inspiration for his work came directly from his own observations of the natural world. But 'done from the life' or drawing *ad vivum* referred to a complex multilayered process in which depicting a subject as fully and authoritatively as possible involved many different visual strategies.[61] The result was usually a synthetic image created from observation of many different exemplars rather than a portrait of an individual specimen. As Florike Egmond has shown, a number of commonly used visual strategies in the depiction of the natural world can be traced back to the early fifteenth century or earlier.[62] Egmond uses modern photographic terms to describe some of these strategies; for example, in order to show the different stages of a plant's growth – from bud to flower to fruit and seed – an artificial 'time lapse' process was often used; to illustrate the actual size of an animal or plant detail (such as a bird's head or beak or a plant seed), a 'zoomed-in' image might be included actual size alongside the full image in reduced scale. A commonly used format was *pars pro toto* where a branch of a tree or shrub with representative leaves (and perhaps flowers and fruit) stands in for the whole.

Catesby was well versed in this long tradition, as his drawings reveal. A wide variety of visual strategies can be seen in his drawings of plants. Images in which buds, flowers and fruit are shown as they could not have been seen in nature are created (see, for example, figs 204, 209, 210 and 220). Alongside his arrangement of the flowering stem of the 'Broad-leav'd Guaiacum (boxwood, *Jacaranda caerulea*), he adds an inset image of a stem bearing life-size fruits, together with a fruit shown in section (fig. 135).[63] Most of Catesby's depictions of shrubs and trees are made using the *pars pro toto* format; while in the majority of cases a truncated branch or stem is placed on the page devoid of context, occasionally it is depicted as if growing from the soil; for example, a single stem of *Robinia hispida* is attached to a section of trunk shown growing out of the ground (see fig. 113).[64] While an analysis of reproductive parts was not yet part of the requirement of botanical illustration during the pre-Linnaean years in which Catesby was working, his later plant images begin to reveal an increased concern with such details. The plates of both the mahogany (*Swietenia mahagoni*) and balsam (*Clusia rosea*) trees in Part 10 of his book introduce numbered keys to details of flowers, fruit at different stages of ripening, and seeds (see fig. 210).

Catesby's practices as a collector and naturalist also play a part in his 'designing … Plants'. While recording that the shape, pattern of growth, colour and texture of plants needed to be done when they were 'fresh and just gather'd', the layout and design of many of Catesby's plant drawings owe a debt to the techniques of preserving plant specimens for herbaria.[65] It is not accidental that Catesby used paper of the same sheet size and quality for both drawing and mounting plant specimens;[66] the way in which he pressed and arranged the actual plant specimen could be translated easily into the composition of the illustrated plant (fig. 136). Thus, the manual techniques of fitting truncated and flattened specimens on to the herbarium sheet become tropes of many of the drawn and etched images: features such as 'broken' and bent stems and folded over leaves can be seen, for example, in his images of the mockernut hickory tree, *Carya tomentosa* (see fig. 146); sheep laurel, *Kalmia angustifolia* (see fig. 173); and red maple, *Acer rubrum* (see fig. 204). Catesby's eye for bold and elegant arrangements is seen equally on his herbarium and drawing sheets.

The close connection between Catesby's drawings and specimens as sources of information is conveyed dramatically in a pen and ink drawing of a waterlily flower (American lotus, *Nelumbo luteo*), alongside an actual specimen of its leaf which he sent to William Sherard (fig. 137). Unable to preserve the fleshy water-lily flower, he drew it instead, informing Sherard on the accompanying label, 'The flower

FIGURE 135

Mark Catesby, 'The Bahama Finch' and 'The Broad-leav'd Guaiacum', 1722–5. Watercolour and bodycolour over pen and ink, 37.5 × 27 cm.

Royal Library, Windsor, RCIN 924856

42

Fringilla Bahamiensis.

*Arbor Guajaci latiore folio Bignonia flore,
cærulea, fructu duro in duas partes diviliente seminibus
alatis imbricatim positis*

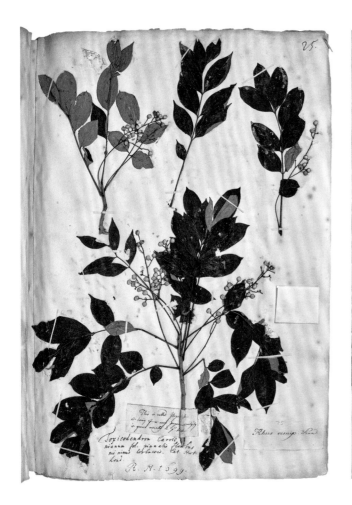

FIGURE 136

Mark Catesby, poison sumac (*Toxicodendron vernix*), 1722–5. Plant specimen with Catesby's label 'Poyson Ash', 54 × 38 cm.

Natural History Museum, London, Department of Life Sciences, Algae, Fungi and Plants Division, Sloane HS 212, fol. 25

FIGURE 137

Leaf of American lotus, *Lotus nelumbo*, collected 1722. Plant specimen with labels by Sherard (top right) and Dillenius (lower left), 36.7 × 24 cm.

Oxford University Herbaria, Sher-1090-10

I could not preserve so have sent this scetch' (fig. 139).[67] Similarly, on a herbarium sheet sent to Sloane with the pressed specimen of black tupelo he added a pen and ink sketch of a fruiting stalk, a feature which was lacking from the specimen itself (fig. 138 and see fig. 212, no. 27). In both cases the drawn and actual specimens serve equally as vehicles of botanical information.

Capturing the 'shape, spirit and gesture' of animals in the wild was, of course, more challenging than 'designing the Plants … while fresh and just gather'd'. Catesby adopted several methods to indicate the size of larger animals, including the 'zoomed-in' technique of depicting actual-size details of the head or other parts, either on their own (see fig. 236) or combined with an overall view of the creature (fig. 140). Elsewhere he used inventive strategies such as suggesting the height of the flamingo, *Phoenicopterus ruber*, by placing it in front of what appears to be a tree, but is in fact a specimen of coral, *Plexaurella dichotoma* (fig. 141),[68] or the life-size head and front section of the great hogfish,

FIGURE 138

Mark Catesby, black tupelo, *Nyssa sylvatica*, 1722–5. Plant specimen with detail of fruit added in pen and ink, 54 × 38 cm (mount size).

Natural History Museum, London, Department of Life Sciences, Algae, Fungi and Plants Division, Sloane HS 212, fol. 77

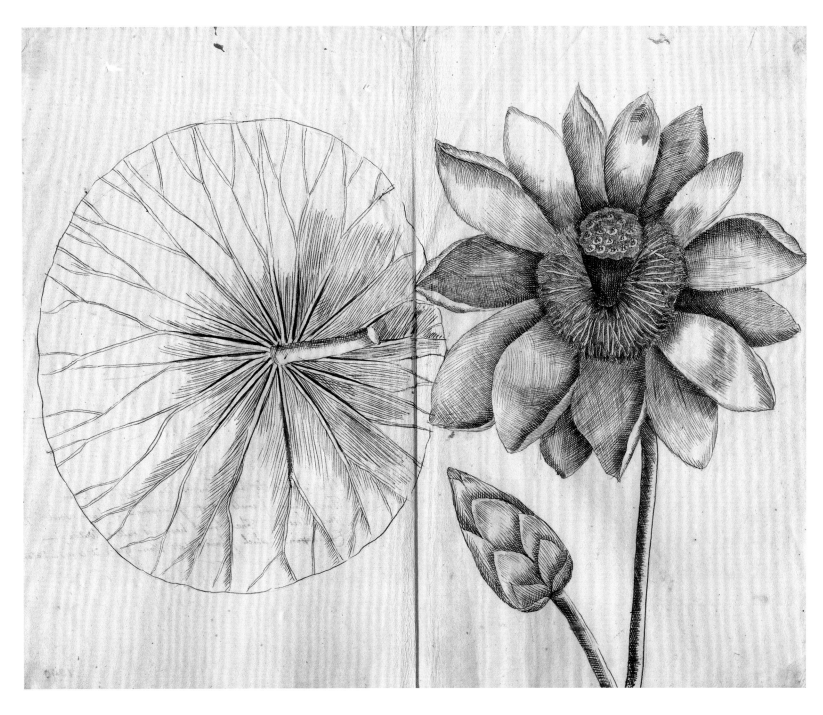

FIGURE 139

Mark Catesby, 'Egyptian
Bean' (American lotus, *Lotus
nelumbo*), 1722–5. Pen and ink,
31.4 × 38.3 cm.

Oxford University Herbaria,
Sher-1090-10

Lachnolaimus maximus, which could not be contained on the page (see fig. 143).[69] He succeeded in conveying the 'gesture' of many animals – their essence or individuality, or what is known as the 'jizz' of birds – in the varying ways he illustrated form, motion and personality: the 'jetting motion' of a screeching blue jay (*Cyanocitta cristata*) (fig. 142); the twisting of snakes mirrored by the shapes of roots or tubers, as in 'The little brown Bead snake', *Storeria dekayi*, and coral bean, *Corallodendron humile* (NH, II, 49); frogs poised to leap and in the act of leaping (see fig. 221); and squirrels and a chipmunk with their front paws 'greedily' clasping nuts and fruit (see fig. 161).[70] In his depiction of animals shown 'in context' in their natural habitats, Catesby departed dramatically from the tradition of illustrating natural history subjects isolated on the page.[71] In so doing he conveyed not only their 'spirit and gesture' but importantly how they were part of the larger natural world.[72]

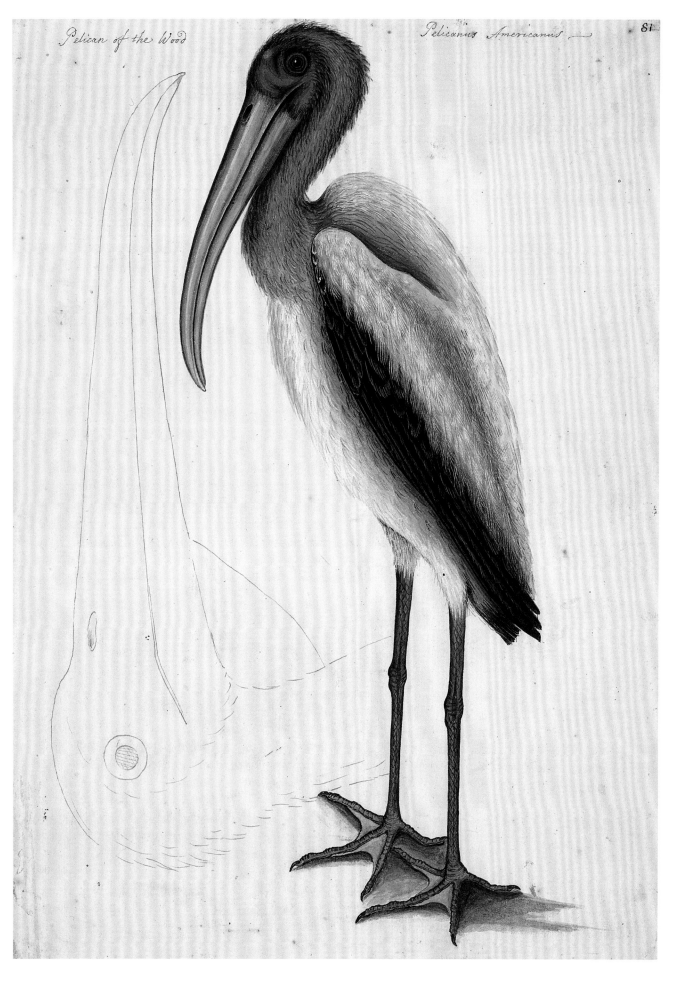

Pelican of the Wood

Pelicanus Americanus

81

FIGURE 140

Mark Catesby, 'The Wood Pelican'
with detail of head life-size,
1722–5. Watercolour and
bodycolour over pen and ink,
detail of head in pen and ink,
37.5 × 27 cm.

Royal Library, Windsor, RCIN
925915

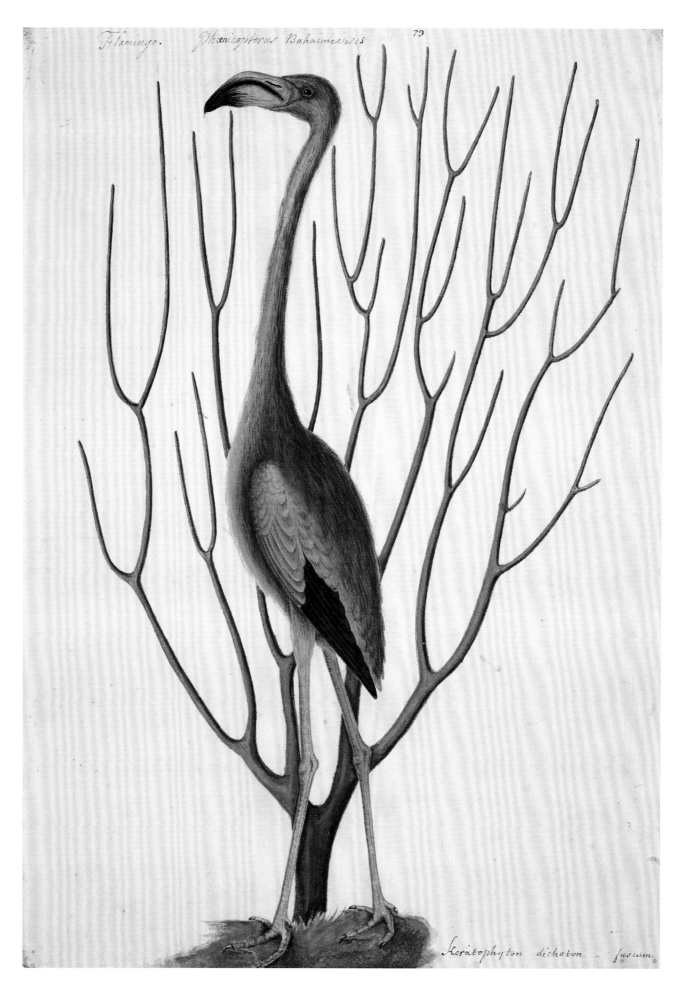

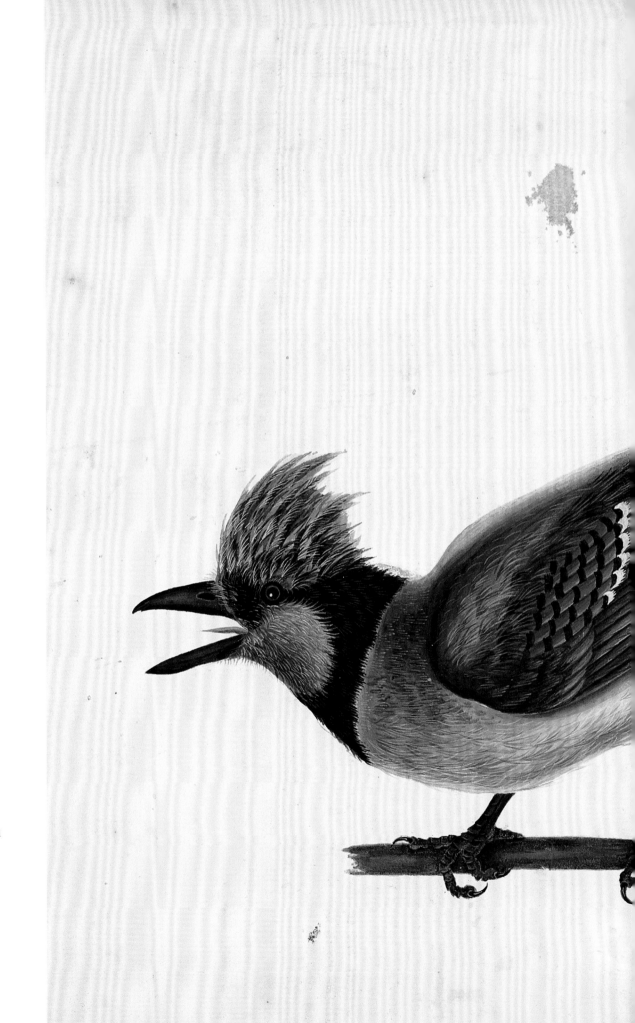

FIGURE 142

Mark Catesby, 'The Blew Jay' and
'The Bay-leaved Smilax', 1722–5.
Watercolour and bodycolour
heightened with gum, over pen
and ink, 27.4 × 36.8 cm.

Royal Library, Windsor, RCIN
924828

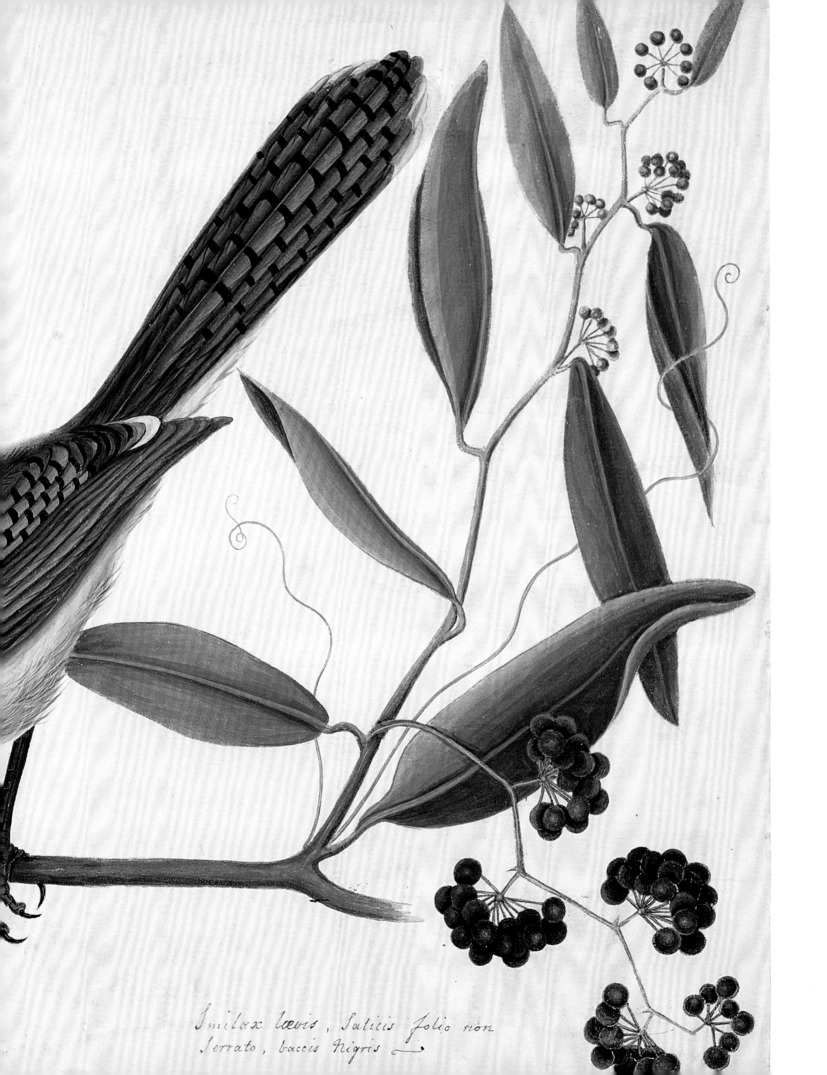

Smilax lævis, Salicis folio non serrato, baccis Nigris

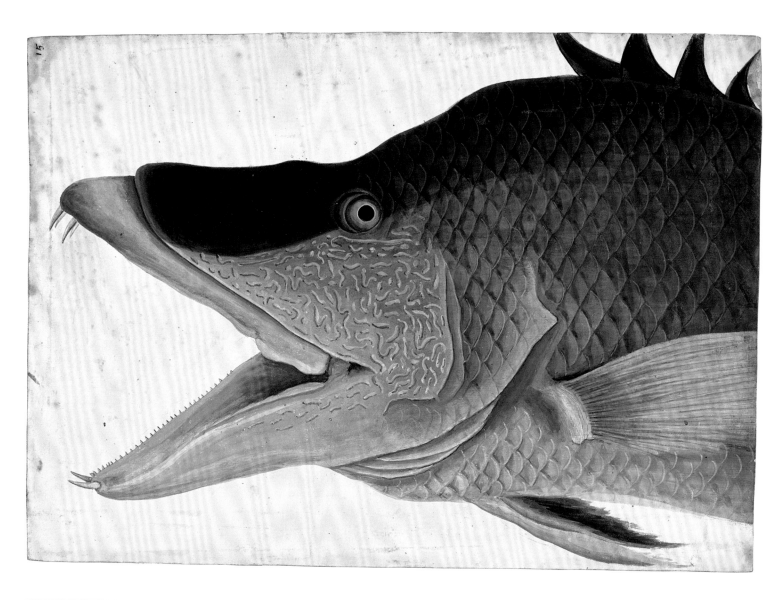

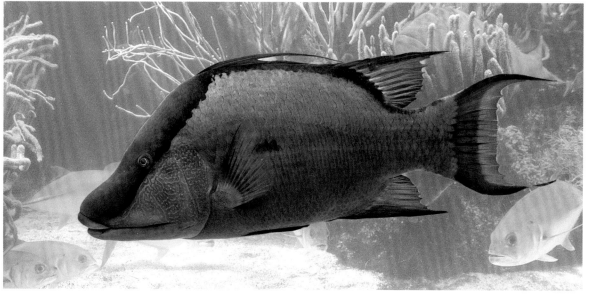

FIGURE 143

Mark Catesby, 'The Great Hog-Fish', 1725–6. Watercolour and bodycolour over graphite, 27 × 38 cm.

Royal Library, Windsor, RCIN 925959

FIGURE 144

Hogfish, *Lachnolaimus maximus*.

Courtesy of Brian Gratwicke

We have seen how Catesby was captivated by the 'most glorious colours imaginable' in nature, and how at the same time he strove to be accurate to the hues he observed, rather than enhancing them by use of 'specious' or 'unnatural' colours. Of all the groups of animals he saw, he chose to 'compleat an account of birds' because they 'excel in the Beauty of their Colours'.[73] When he went to the Bahama Islands he discovered that the colours of fishes were equally spectacular, and noted, 'I was surprised to find how lavishly nature had adorned them with Marks and Colours most admirable.'[74] But these colours were as fugitive as they were beautiful, and he needed to go to great lengths to reproduce them accurately, painting them 'at different times, having

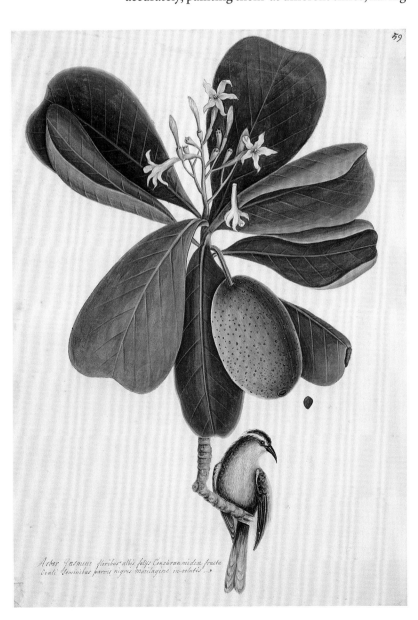

a succession of them procur'd while the former lost their colours', for 'of all others, the inhabitants of the waters are subject to the greatest and most sudden changes, and the most brilliant fade the soonest.'[75] Notwithstanding, he succeeded mainly in rising to these challenges, as a comparison of his image of the giant hogfish with an actual specimen indicates (figs 143 and 144).[76]

Another aspect of Catesby's delight in the colours of the natural world was his perception of the ways in which colours of animals and plants reflected each other. Often in his watercolours, and the prints he made after them, he juxtaposed different elements whose colours he observed to mirror each other. Sometimes a tiny feature is emphasized to show such matching colours, as for instance in the placing of the cedar waxwing, *Bombycilla cedrorum*, with its distinctive 'eight small red patches at the extremities of eight of the smaller wing-feathers, of the colours and consistence of red sealing wax' on a stem of Carolina allspice, *Calycanthus floridus*, with its flowers made up of 'copper-colour'd petals'.[77] He noticed that the Baltimore oriole, *Icterus galbula*, with its underparts of 'a bright colour, between red and yellow', bred 'usually on the Poplar or Tulip-tree' (tulip tree, *Liriodendron tulipifera*), the lower part of whose flowers were 'shaded with red and a little yellow intermixed'.[78] Moreover, Catesby observed the ways in which not only in colour but in form fauna and flora could reflect or juxtapose each other, and the swelling shape of the breast of the Baltimore oriole is also mirrored in the convex lower sections of the petals of the tulip tree flower. Again, in the watercolour of the Bahama bananaquit, *Coereba flaveola bahamensis*, the bird's curved yellow breast reflects the 'oval form … shaded with green, red and yellow' of the seven year apple, *Casasia clusiifolia* (fig.145).[79] Sometimes a play on shared shapes helps further to convey the 'spirit and gesture' of animals, as in the northern cardinal where the sharp angles of the raised crest and angular bill are emphasized by the serrated sharp pointed leaves of the mockernut hickory tree and the triangular shaped segments of the outer shell of its nut (fig. 146).

Artistic influences

But inspiration from nature went hand in hand with inspiration from art, and an examination of Catesby's drawings and prints reveals a whole vari-

Nux Juglans Virginiana alba minor, fructu Nucis Moschata simili, cortice glabro, summo fastigio veluti in
aculeum producto. Pluk: Alma 264

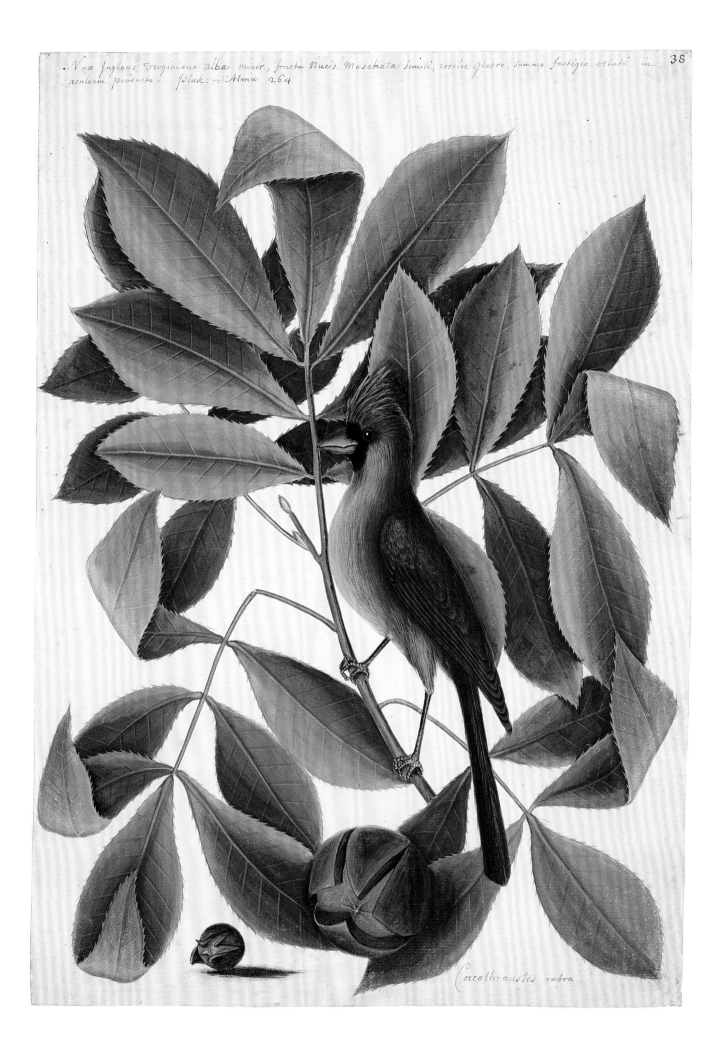

Coccothraustes rubra

ety of ways in which he was influenced by the work of other artists, ranging from subtle, possibly unconscious echoes to exact copying or even tracing. Sloane's collection offered an extraordinarily rich source of natural history imagery. Both the printed books and compilations of prints in his library and the unrivalled collection of drawings he was forming in his 'Books of Miniature or Colours' provided Catesby with direct access to some of the most highly prized groups of natural history drawings by earlier Continental artists as well as by contemporary artists working directly for Sloane. Here Catesby was able to study images by others of the fauna and flora he had seen and drawn himself in the wild, as well as some plants and animals he had not seen. These images, many also drawn from life, were to provide him with alternative sources for authoritative representations.[80] At the same time, working in Sloane's collections gave him the opportunity to meet other artists engaged in describing the natural world and to compare and exchange material and different artistic approaches and techniques.

The works of Maria Sibylla Merian provided an important reference for Catesby. Sloane owned not only a printed copy of the *Metamorphosis insectorum surinamensium* (1705) but, as noted, two albums of Merian's original watercolours – one with a full set of the Surinam compositions together with thirty-one variants for the Surinam volume, and the other containing 160 watercolours of varying format from all periods of her career.[81] As one of the earliest illustrated works devoted exclusively to the natural history of any part of the New World, Merian's work provided a model for Catesby.[82] It was not just as an artist, however, but as a field naturalist and explorer that Merian's example influenced him. She had spent two years with her daughter in the rain forests of Surinam between 1699 and 1701, collecting, studying and painting the life cycles of tropical moths and butterflies. Vital to her work had been the observation of fauna and flora in its native environment, and her resulting images emanated from her direct observation and detailed studies made from the life. In her illustrations she pioneered the concept of portraying insects and their host plants together, often as part of a dramatic narrative in which one form of animal life is predating another.[83]

In what has been described as his 'break with the past',[84] Catesby showed many of his birds in combinations with the plants with which they were asso-

ciated: 'where it could be admitted, I have adapted the Birds to those Plants on which they fed, or have any relation to.'[85] Merian's bold compositions on folio-size pages, sometimes with plant leaves not contained by the edges of the sheet, are echoed in a number of Catesby's arrangements. His striking image showing a five-lined skink, *Plestiodon fasciatus*, sitting on the cut open fruit of the pond-apple, *Annona glabra*, recalls Merian's prickly custard apple, with a moth larva similarly positioned on a cross-section of the fruit (figs 147 and 148). Several of his etchings of plants with large moths or butterflies occupying corners of the pages echo similar compositions among Merian's Surinam plates where a moth is positioned at the diagonal opposite of the page to the fruit.[86] Like Merian too, Catesby illustrates predation in the natural world. The first plate of his book depicts a dramatic scene being enacted between a bald eagle, *Haliaeetus leucocephalus*, about to catch the prey dropped by an osprey, *Pandion haliaetus*, hovering above;[87] and a number of his other compositions show birds or animals poised to catch prey or reaching for fruit (see fig. 167).[88]

Merian was herself influenced by, and apparently set out to emulate, the work of the French naturalist artist Charles Plumier (1646–1704), who had described, drawn and etched hundreds of new plants found during his travels in America and the West Indies, in his *Description des plantes de l'Amérique* (1693) and his *Traité de fougères* (1705). For Catesby too, Plumier's plates were among the first images of American flora that he encountered, and he seems, either consciously or not, to have absorbed elements of Plumier's style into his own.[89] There is a striking originality to Plumier's life-size images of leaves, stems and other parts of exotic New World plants.[90] As he was often not able to fit a plant on to a page, they are shown either in part only or with sections superimposed on other parts, some simply in outline. Memorable images of Catesby's, such as his skunk cabbage, *Symplocarpus foetidus*, illustrating the large, veined, centrally placed life-size leaf of the plant, superimposed with examples of its 'succulent, monopetalous, hollow flowers' at different stages of their development, echo plates in Plumier's *Description* (figs 149 and 150).[91] Similar echoes can be found in Catesby's northern needleleaf, *Tillandsia balbisiana*, with its elegant tapering leaves rising tall from its tuberous root and hanging down to fill the page, and Plumier's 'Lingua Cervina longissimus' (genus

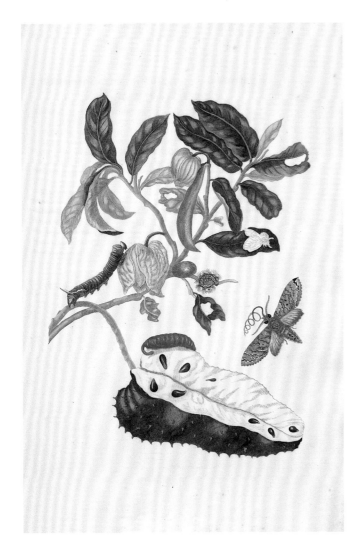

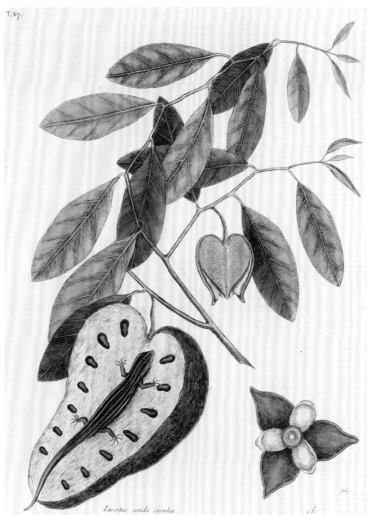

Lacertus cauda cærulea.

Danaea), which likewise seems only just to be contained within the page.[92]

More direct influence from illustrations of the New World can be seen in Catesby's reuse of watercolours by John White, the official artist during Raleigh's expeditions to Virginia in the 1580s. White's images were the first that most Europeans had seen of the fauna, flora and indigenous peoples of the New World, and they were to have an enormous impact.[93] Hans Sloane's collections contained both a volume of early seventeenth-century copies of these watercolours which he purchased, as well as copies of some of the originals which he commissioned for his own albums.[94] Catesby knew both the seventeenth-century 'White' volume, to which he made reference as 'M.S. Dni. Gualteri Raleigh penes D. Hans Sloane' (the manuscript of Sir Walter Raleigh in the collection of Sir Hans Sloane),[95] as well as the

eighteenth-century versions of some of the subjects, and he himself made copies of some of the latter versions.[96] In all but one case, the 'White' images Catesby adopted were integrated with his own plant studies when he came to arrange the material for his etched compositions.[97] In his preparatory drawings we see the process by which he arrived at these final compositions, with the plant outlines sometimes being added to the drawing of the animal.[98] Some of these plants were those on which he observed the animals feeding, such as the pond-apple for the guana ('This is an eatable fruit, very sweet, but somewhat insipid; yet it is the food of Guana's and many other wild creatures') and the blackwood *Picrodendron baccatum*, for the purple land crab, *Gecarcinus ruricola* ('Of these Fruit amongst many others these Crabs feed').[99] In the final arrangement of the checkered puffer, *Sphoeroides testudineus*, however, Catesby

FIGURE 147

Maria Sibylla Merian, prickly custard apple, flannel moth and hawk moth, *Metamorphosis insectorum surinamensium*, Amsterdam, 1719, plate 14. Hand-coloured etching, 53.5 × 36.4 cm.

Artis Library, University of Amsterdam, call no. AB legkast 19.01

FIGURE 148

Mark Catesby, 'The Blue-Tail Lizard' and 'Anona fructu viridi laevi', *Natural History*, 1743, II, plate 67. Hand-coloured etching, 51 × 35 cm.

Royal Society of London

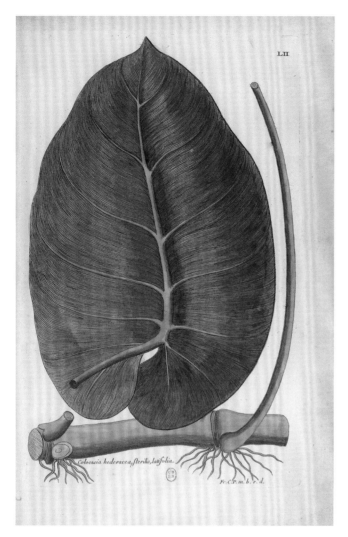

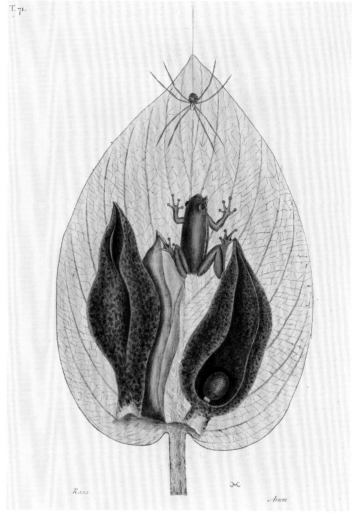

FIGURE 149

Charles Plumier, 'Colocasia
hederacea, sterilis, latifolia',
Description des plantes de l'Amérique,
Paris, 1693, plate LII. Hand-
coloured engraving, 38 × 23.5 cm.

Bibliothèque Nationale, Paris,
shelfmark, Reserve JD-16
(A)-Pet Fol

FIGURE 150

Mark Catesby, 'The Green Tree
Frog' and 'The Scunk Weed',
Natural History, 1743, II, plate 71.
Hand-coloured etching,
51 × 35 cm.

Royal Society of London

created an elegant but somewhat surreal image of
the fish apparently swimming in between two inter-
twined terrestrial plants (bastard torch, *Nectandra
coriacea*, and red milk-pea, *Galactia rudolphioides*), the
incongruity adding a mysterious aura to the odd-
shaped creature which it seems he never saw himself
(figs 151–3).[100] In his drawing of the fish, as in the
other 'White' copies, Catesby replicated the delicacy
of White's thinly applied watercolour washes, using
the white of the paper to convey the modelling and
highlights.[101]

The images of plants and animals made from the
life by Nicolas Robert in the garden and menagerie
of Louis XIII's brother, Gaston d'Orleans, at Blois
were among the treasures of Sloane's collection
of natural history drawings.[102] Robert, who later
became *peintre ordinaire de Sa Majesté* [Louis XIV]
pour la miniature, and chief illustrator of the newly

founded Academie Royale des Sciences, has been
described as 'the most accomplished botanical illus-
trator in Europe in the seventeenth century'.[103] For
Catesby, as for other artists who consulted Sloane's
collections, Robert's highly finished and meticulous
coloured drawings on vellum provided an unrivalled
source of images of exotic plants, birds, mammals,
insects, shells and other natural objects.[104] In 1686
when John Evelyn saw the collection of Robert's
vélins in William Courten's possession, he recorded
that it was 'such a collection as I have never seen in
all my travels abroad, either of private gentlemen
or princes. It consisted of miniatures, drawings,
shells, insects … all being very perfect and rare of
their kind, especially his books of birds, fish, flow-
ers, and shells, drawn and miniatur'd to the life.'[105]
Catesby studied Robert's 'miniatures' not only for
subject matter but for composition and technique,

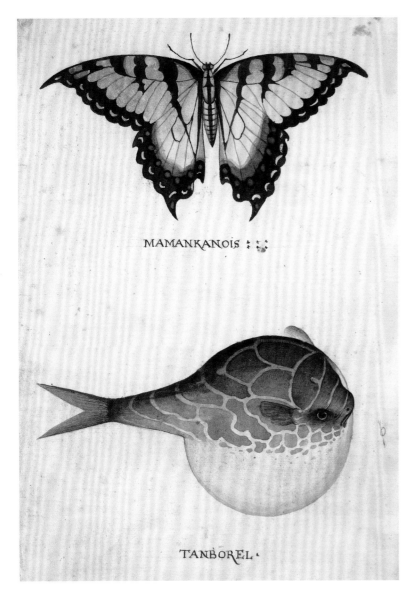

MAMANKANOIS

TANBOREL.

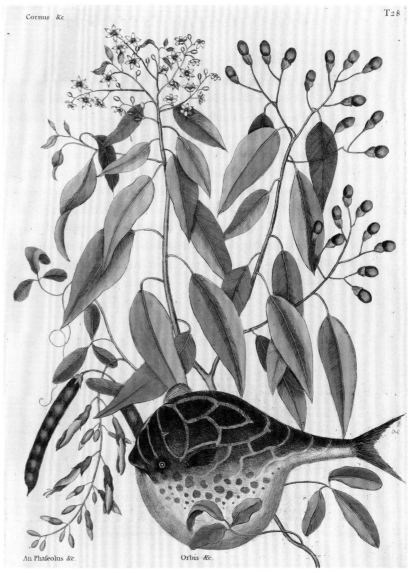

An Phaſeolus &c.

Orbis &c.

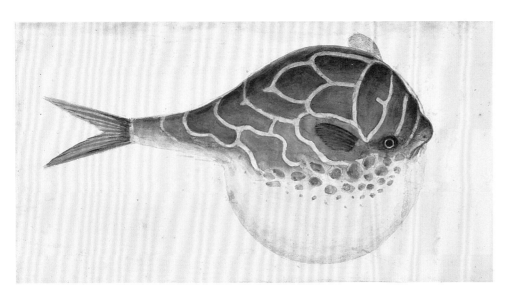

FIGURE 151

After John White, 'Tanborel',
and 'Mamankanois', 1580s.
Watercolour and bodycolour over
pen and ink and black lead,
38.9 × 24.7 cm.

British Museum, London,
Department of Prints and
Drawings, Sloane 5270.14

FIGURE 152

Mark Catesby, 'The Globe Fish',
'Cornus' and 'Phaseolus minor',
Natural History, 1743, II, plate 28.
Hand-coloured etching, 51 × 35 cm.

Royal Society of London

FIGURE 153

Mark Catesby, 'Globefish',
late 1720s. Watercolour and
bodycolour, 13 × 26.8 cm.

Royal Library, Windsor, RCIN
925973

FIGURE 154

Nicolas Robert, purple and yellow pitcherplants, with moth and butterfly, 1680. Watercolour and bodycolour on vellum, 38.1 × 24.8 cm.

British Museum, London, Department of Prints and Drawings, 5277.9

FIGURE 155

Mark Catesby, 'Sarracena, foliis brevioribus' and 'Sarracena, foliis longioribus', before 1739. Watercolour and bodycolour heightened with gum, over outlines in brush and watercolour and graphite, and ruled lines in graphite, 36.3 × 27.3 cm.

Royal Library, Windsor, RCIN 926022

and in two instances he may have traced Robert's images. He was fascinated by the exotic shapes of the different species of insect-eating *Sarracenia* he encountered in South Carolina and was inspired by the composition Robert had made from two of the species (fig. 154). Catesby experimented with two different combinations of leaves, flowers and fruits, basing the first closely on Robert's design with the stems placed in a striking diagonal pattern on the page (fig. 155), then adapting this in his second version to create a more upright design using his own drawings of the flowers shown at a later stage of their opening.[106] In his second composition he substituted an image of the southern leopard frog, *Lithobates sphenocephalus*, copied from his sample

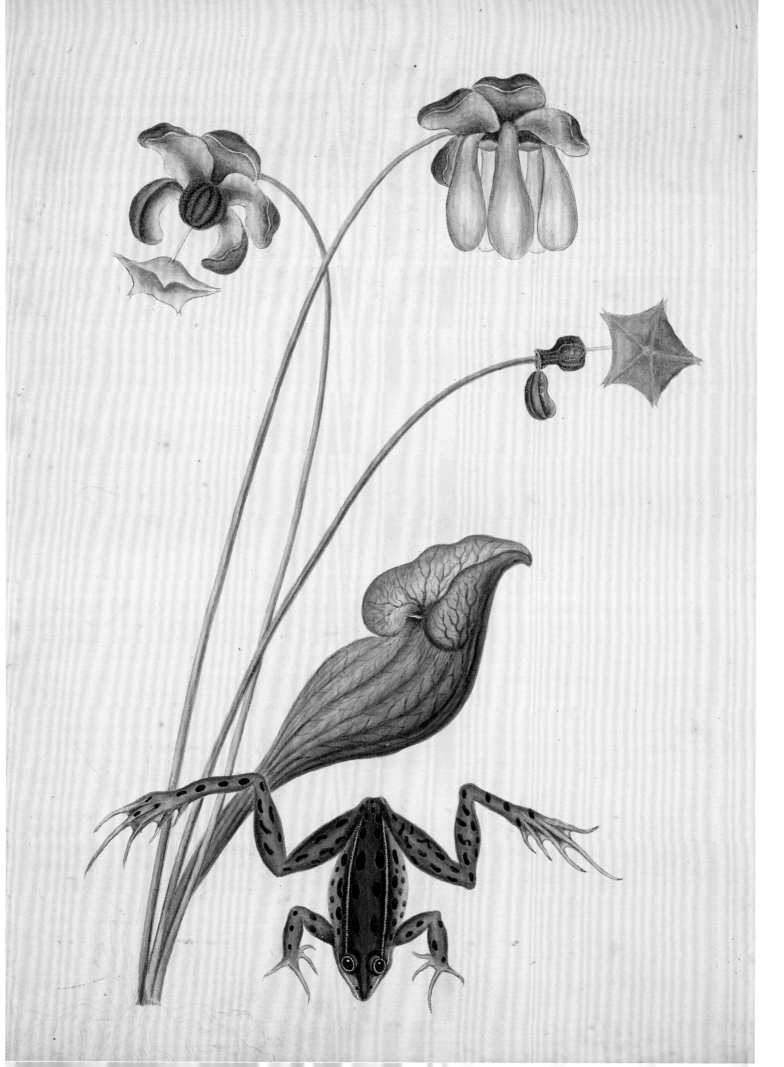

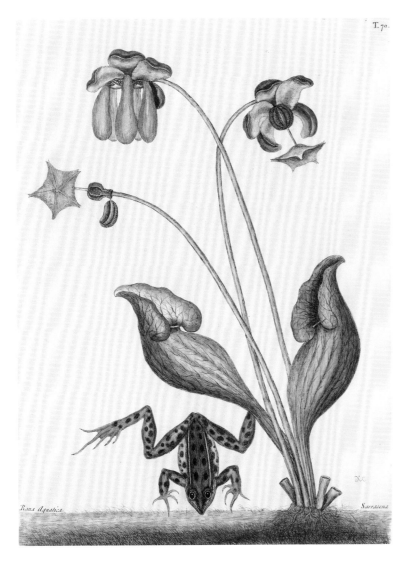
T. 70.

Rana Aquatica. Sarracena.

FIGURE 156

Mark Catesby, 'Sarracena, foliis
brevioribus' and 'The Water Frog',
before 1739. Watercolour and
bodycolour over graphite,
37.6 × 26.4 cm.

Royal Library, Windsor, RCIN
926021

FIGURE 157

Mark Catesby, 'The Water Frog'
and 'Sarracena, foliis brevioribus',
Natural History, 1743, II, plate 70.
Hand-coloured etching, 51 × 35 cm.

Royal Society of London

ever, he adapted his model to make a more 'scientific' illustration by adding several anatomical details – a separate detail of the rattle, a cross-section of it, a scale and a fang – as well as extra sections of the rattle at the end of the tail. While the separate section of the rattle was taken from a plate in Nehemiah Grew's catalogue of the Royal Society's Repository, the other details may have been made from his original observation (see fig. 225).[110]

The most brilliant of the official French court painters after Robert was Claude Aubriet (1665–1742).[111] Amongst the corpus of Catesby's preparatory drawings and watercolours for the *Natural History* at Windsor is a set of four of Aubriet's spectacular *vélins* of exotic plants: Spanish jasmine, *Plumeria rubra*; cacao, *Theobroma cacao*; Mexican vanilla, *Vanilla mexicana*; and cashew, *Annacardium occidentale*.[112] It is not known how Catesby acquired these, but it is possible they came via Sherard, to whom they may have been given by Aubriet in exchange for plants Sherard sent him.[113] None of these was native to North America or the West Indies, and they may have been painted from South American specimens collected by Charles Plumier and raised in the Jardins des Plantes.[114] Aubriet had a good understanding of plant structure, having worked with some of the great botanists of the time, including Tournefort, Vaillant and de Jussieu.[115] His plants are more stylized than Robert's, and were characterized by a use of opaque colour (rather than building up form through layers of watercolour), by hard almost metallic outlines, a heightened use of light and shade (especially noticeable in the treatment of the leaves), and a characteristic way of showing cut-off stems and fruits in cross-section (as, for example, in the cacao tree).[116] Catesby made a close study of Aubriet's technique; a copy by him of Aubriet's *Plumeria rubra* shows that he experimented with working in the same way on vellum. Painting on vellum demanded a particular expertise, and from this unfinished attempt it would seem that he abandoned the experiment (figs 158 and 159). He used these four *vélins* as models for four of his plates; however, unlike his use of drawings by Robert, he adapted Aubriet's drawings only minimally, choosing to reproduce them as plant studies in their own right.[117]

By contrast, two studies of a southern flying squirrel, *Glaucomys volans*, by Everard Kick (1639–after 1705), which Catesby may have acquired from Sloane, were worked into composite designs with

sheet of studies of three different species of frogs, for the butterflies Robert had added for decorative effect to his sheet in the customary tradition of florilegia (fig. 156). In so doing, he underlined a specific connection between the frog and *Sarracenia*, having observed that 'the hollow of these leaves … always retain some water; and seem to serve as an asylum or secure retreat for numerous insects, from Frogs and other animals, which feed on them.'[107] In the final etched plate created from these two studies, Catesby altered the composition still further to include a second leaf to balance the composition (fig. 157).[108]

Despite the fact that Catesby saw, and must have had the opportunity to draw, many rattlesnakes during his years in America, he chose to copy Robert's elegant image showing a rattlesnake curled up, with its head and its rattle raised prominently.[109] How-

plant studies.[118] Kick, together with Edwards, had
been a major contributor to Sloane's album 'Draw-
ings of Quadrupeds', which contained drawings
made from animals shown at Bartholomew's Fair
and other public venues. The two uncoloured draw-
ings executed in plumbago (graphite) depict a squir-
rel in 'flying' posture and crouching with a fruit in
its paws. Catesby reproduces the original drawings
faithfully but incorporates them into plant stud-
ies of his own. While the horizontal posture of the
flying squirrel is emphasized dramatically by plac-
ing the image of the animal at right angles to the
upright stem of the wild pine, *Catopsis berteroniana*,
the crouching animal is shown as if it had leapt into
the persimmon tree, *Diospyros virginiana*, to steal a
fruit which it holds in its mouth and paws (figs 160
and 161).[119] In each case Catesby retained the mon-
ochrome character of the drawings by tinting the
etchings very lightly in two tones of a brownish-grey
wash, also fitting his description of the 'light mouse
dun colour' of the animal.[120]

Catesby's interest in depicting birds and animals
in lifelike poses led him to study the illustrations of
Francis Barlow. Barlow had made his well-observed

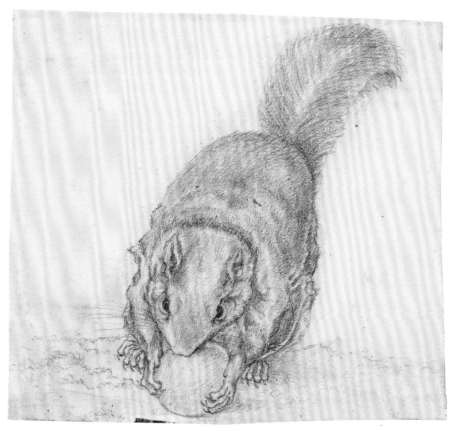

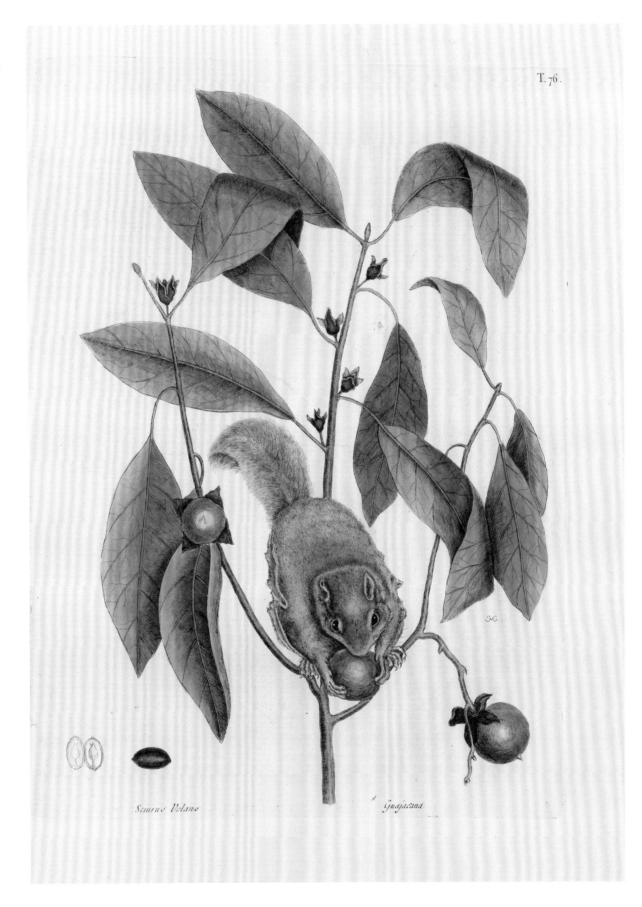

Sciurus Volans　　　　*Guajacana*

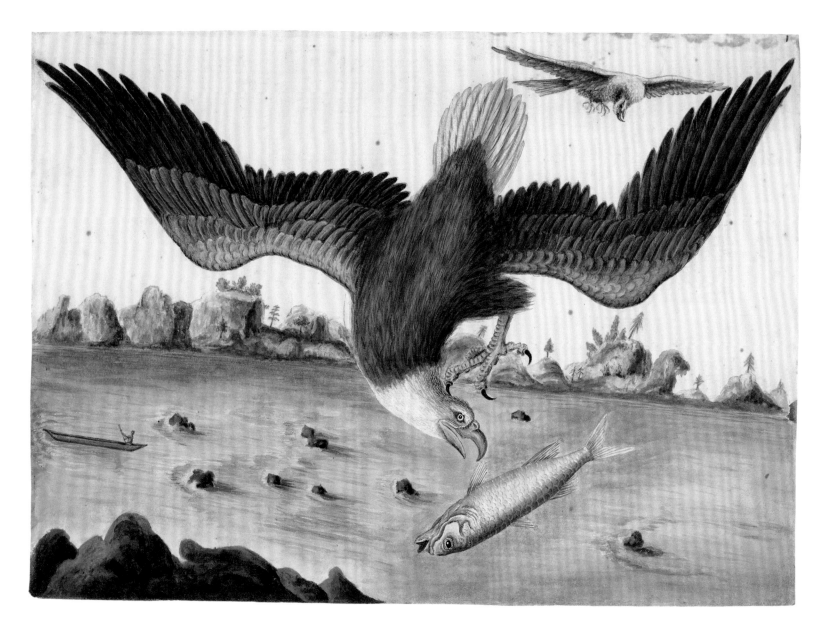

and anatomically correct drawings of animals mainly from the life; his illustrations contrasted dramatically with the stiff bird portraits of most illustrators of the seventeenth century where birds were shown in static profile on stumps, perches or mounds. In Barlow's plates for his edition of *Aesop's Fables* the subjects, depicted in lively, naturalistic poses (the 'natural and peculiar attitudes' described by Bowles), were combined with views of the English countryside and country pursuits.

Catesby had begun the *Natural History* with an apology for 'some faults in Perspective, and other niceties', and he turned to Barlow in particular for help with showing birds in foreshortened and twisted positions. Both the angled, swooping pose of the bald eagle diving to catch a fish dropped by the osprey and the severely foreshortened view of the osprey hovering above it in the first illustration of his book were adopted from Barlow's illustrations: the eagle from the diving hawk in the fable of 'The Doves and the Hawk', and the osprey from the hovering kite in the fable of 'The Kite, Frog, and Mouse' (figs 162–4).[121] The unusual pose of Catesby's red-winged blackbird, *Agelaius phoeniceus*, seen from above with its head to one side, was likewise adapted from the pose of Barlow's hawk; in this pose Catesby was also able to show the bird's red wing patches to best advantage.[122] The 'encounter' between the brown viper, *Heterodon platirhinos*, and the bull or cow, *Bos taurus*, the head of which appears as a sketch on the edge of

FIGURE 162

Mark Catesby, 'The Bald eagle' and 'The Fishing Hawk', 1726–9. Watercolour and bodycolour heightened with gum, over graphite, 27.1 × 37.5 cm.

Royal Library, Windsor, RCIN 924814

one of Catesby's drawings, recalls the meetings be-
tween animals in many of the fables, while the head
of the bull or cow itself is reminiscent of domestic
cattle in several of the *Aesop's* plates (figs 165 and
166).[123] The sketch represents an informal moment
in Catesby's practising his draughtsmanship where
he reveals both his close study of Barlow's illustra-
tions and trialling of compositional ideas. In his final
composition (*NH*, II, 45), however, he combined the
snake with his image of the arrowleaf elephant's ear
(see fig. 128) to illustrate the confusion of plant and
animal life he had witnessed after a flood (fig. 167):

> The Subject of this Plate is as it appeared to me at
> a great Innundation, where by the Violence of the
> Current, Fish, Reptiles, with other Animals and
> Insects, were dislodged from their Holes, &c. floating
> upon Heaps of Vegetable Refuse, where the voracious
> and larger Serpents were continually preying upon
> the smaller, as well those of their own Kind, as others,
> which in that Confusion were more easily surprized.[124]

There were two contemporary artists with whom
Catesby worked closely in different ways. George
Edwards was employed by Hans Sloane to draw an-
imals for his natural history albums from the 1720s
for many years, and drawings by him appear more
frequently in those albums than any other artist's
work.[125] Catesby met Edwards often during his visits
to Sloane's collection and, as we have seen, the two
artists became friends and had a close working rela-
tionship.[126] Edwards was influenced by the older art-

ist in a number of ways as he assembled drawings for
his *Natural History of Uncommon Birds*, the first vol-
ume of which was published in 1743 just as Catesby
was completing the tenth and penultimate part of
his book. Edwards followed Catesby's example in
etching his plates himself, and, as noted, it was from
Catesby that he took lessons. He may also have real-
ized the importance of supervising the hand colour-
ing of his prints from Catesby (see Chapter 3). On
his part, Catesby had the opportunity to examine a
number of Edwards's drawings in Sloane's albums
of exotic live animals made in aristocratic and other

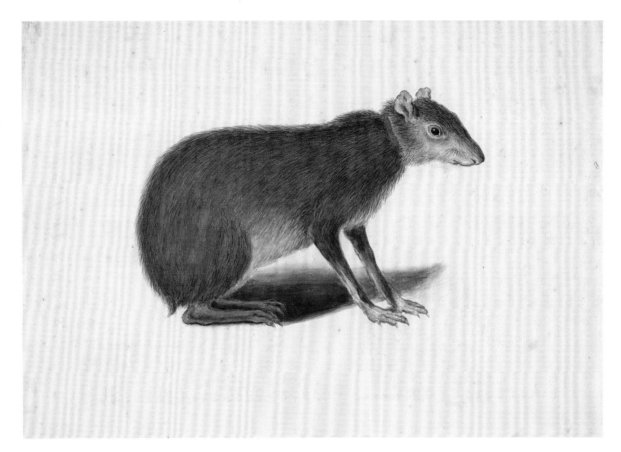

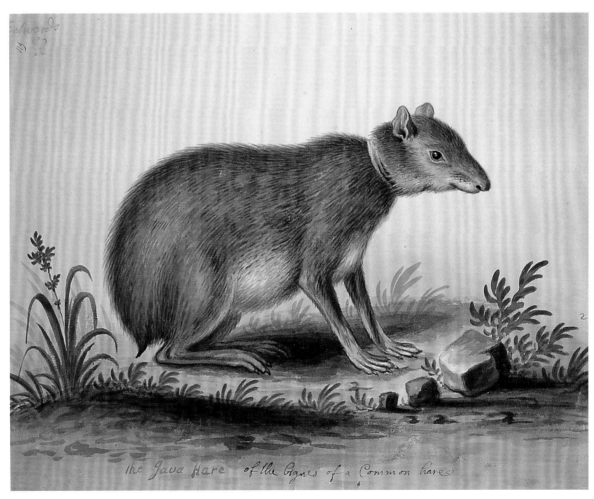

menageries and collections. One of these appears to have provided the model for an additional image to his Appendix: the 'Java Hare' (Brazilian agouti, *Dasyprocta leporina*) (figs 168 and 169).[127] In this copy Catesby demonstrated again his ability to imitate another artist's style, employing the looser watercolour technique that was characteristic of Edwards's style in his natural history illustrations. A further example of the interrelationship of the two artists' work can be seen in the way Catesby combined Edwards's drawing of a smooth-billed ani, *Crotophaga ani*, with his own of a pink lady's slipper, *Cypripedium acaule*, in Plate 3 of his Appendix.[128]

Of all the artistic influences on Catesby, that of the German artist Georg Dionysius Ehret (1708–70) was possibly the most significant, both on the content of the *Natural History* as well as on the development of Catesby's own style. Ehret had arrived in London in 1735 from Nuremberg, where he worked for a year before going to Holland early in 1736, where he met Linnaeus. There he was employed by George Clifford, director of the East India Company, to make drawings for the *Hortus Cliffortianus* on which Linnaeus was working, and he made the illustrations for Linnaeus's 'Tabella' demonstrating the reproductive parts of plants.[129] In 1736 Ehret returned to London where he settled. His horticultural training and first-hand experience of plants, combined with his extraordinary talents as an illustrator and intuitive sense of design, led him to become much sought after by aristocratic patrons.[130] Catesby is likely to have met him when he first arrived in London in 1735 via their shared connections with Hans Sloane, Richard Mead, Philip Miller and Peter Collinson. Ehret was drawing plants in Collinson's garden by about April 1735, and Collinson may have been responsible for introducing the two artists.[131] However, there is no documentation concerning their association other than what we can glean from a group of drawings and prints that indicate they were working closely together during a period of around ten to twelve years.[132] Throughout his life, Ehret was to supplement his income by selling single drawings of rare plants, either on paper or vellum, to naturalists and garden owners.[133] It is doubtful, however, that Catesby would have been in a position to buy these finished works of art in the way that Ehret's patrons were doing; rather it would seem that his acquisition of drawings from Ehret, all but one of which he himself etched as plates for the *Natural History*, was part

of a working relationship between artists – possibly partly as pupil and teacher – rather than a commercial one between patron and artist.[134]

This collaboration may have begun in 1737, when in August Ehret visited Sir Charles Wager, to whom he had been recommended by Collinson, to paint the one bloom of *Magnolia grandiflora* on a tree in his garden in Parson's Green.[135] The results of Ehret's work included not only a folio-sized, coloured engraving, lettered, 'This Plant Produced its beautifull Flowers in ye Garden of Sr Charles Wager at Parsons Green near Fulham. Augt 1737',[136] but another folio-sized etching in which the two-day-old flower and bud on a stem, together with an image of the fruiting head, are shown against a black background. This variant of the composition was published as Plate 61 in Part 9 of Catesby's book, issued in June 1739 (see figs 98 and 99). However, the fruiting head which appears in the lower left corner of Ehret's plate bears the hallmarks of Catesby's style, suggesting that Catesby contributed this particular element to Ehret's composition. Ehret's use of a black background to set off the white petals of the magnificent life-size magnolia flower adds further to the dramatic impact of the composition.[137] Inspired by Ehret's print, Catesby adopted a black background for his own plate of *Magnolia tripetala*, which in its original position would have followed Ehret's *Magnolia grandiflora* as Plate 62.[138] However, he appears to have decided that the juxtaposition of Ehret's spectacular plate and his own did not show his to advantage, as in a last-minute alteration he swapped his illustration of the skunk with his magnolia plate, placing the latter instead as the last print of the part.[139]

In Part 10 of the book, issued three-and-a-half years later in December 1743, Ehret and Catesby collaborated on two plates, Ehret providing a spectacular watercolour of the pawpaw, *Asimina triloba*, which Catesby adapted slightly and etched as Plate 85,[140] while Catesby's drawing of the sea-grape, *Coccoloba uvifera*, was adapted by Ehret and etched as Plate 96 (figs 170 and 171).[141] Catesby's preparatory watercolour for the plant with its four large leaves superimposed on each other was one of the flattest of his compositions; did he specifically choose this drawing in order that Ehret might 'improve' it with his superior etching skills, or did Ehret suggest taking on this somewhat unsuccessful composition as a challenge? However it came about, the end result

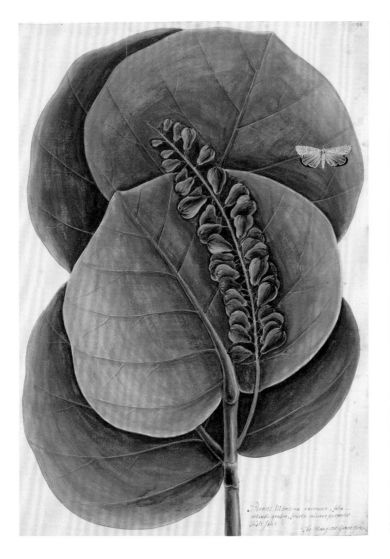

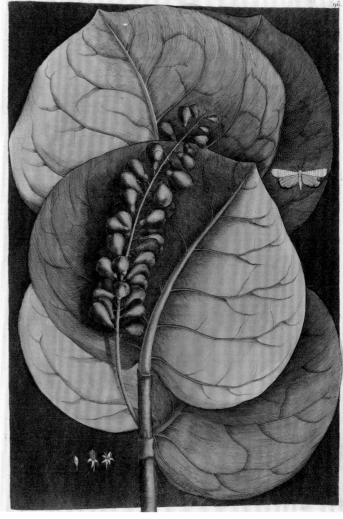

FIGURE 170

Mark Catesby, 'The Mangrove Grape Tree' and 'Phalaena Carolinia, minor', 1722–5. Watercolour and bodycolour over graphite, 37.8 × 26.4 cm.

Royal Library, Windsor, RCIN 926059

FIGURE 171

Georg Ehret after Mark Catesby, 'The Mangrove Grape Tree' and 'Phalaena Carolinia, minor', *Natural History*, 1743, II, plate 96. Hand-coloured etching, 51 × 35 cm.

Royal Society of London

was a rounder, more three-dimensional image in the etching than the watercolour, where again he enhanced it by setting it off against a black background.

Catesby's drawing for another plate in Part 10, the mountain laurel, *Kalmia latifolia*, was made from a stem of the plant which had flowered in England for the first time in Collinson's garden in 1740, and the following year in his own garden.[142] He and Ehret each drew a stem of the plant from very nearly the same angle, with Catesby tracing the central group of flowers and leaves from Ehret's composition.[143] Catesby's drawing, which he chose to publish rather than Ehret's, shows that he was learning from the professional artist how to convey three-dimensional forms in a more rounded way (see fig. 211). This may have been one of several occasions when Catesby and Ehret drew the same plant. Collinson stated that Ehret's drawing of the American ginseng, *Panax*

cinquefolius, was by Catesby: 'I also raised [the ginseng plant] from seed in my garden, perhaps the first place it made its appearance in Europe, and from whence Mr Catesby drew the plant that is published in his Nat. Hist.; it is a pretty humble plant, nothing striking in its figure, except when in seed, with its head of red berries.'[144] This could, of course, have been a slip of memory on Collinson's part, although it is possible that Catesby also drew the plant but chose to publish Ehret's illustration (see fig. 114).

The closeness of the two artists' collaboration is further displayed in a composition combining images of the great laurel, *Rhododendron maximum*, and sheep laurel, *Kalmia angustifolia*.[145] Catesby drew an upright stem of the sheep laurel, the plant having 'produced its blossoms at Peckham [in Collinson's garden], in September, 1743' (fig. 172), while Ehret produced his watercolour of the great laurel from a

dried specimen and a description of its colours sent to Catesby by Bartram (fig. 173). Catesby's decision to combine the images of each species in a single composition involved him in adapting his original drawing in order to fit the image into a corner of the sheet already almost filled by Ehret's watercolour; his ingenious solution to depict the stem bent over in the manner of a herbarium specimen shows again how closely entwined in his works were the skills of a naturalist and artist. In artistic terms, the closeness of Catesby's to Ehret's style in his two watercolours of the sheep laurel, including the fine handling of the veined leaves and white highlights to convey the modelling of the plant stalk, is further demonstration of Ehret's influence on his botanical art.[146]

Only one of the ten watercolours by Ehret which Catesby etched and included in the Appendix to the *Natural History* is signed. Ehret painted a flowering branch of the silky camellia (or 'Steuartia' as he called it) in Catesby's garden from the plant sent to Catesby from Virginia by John Clayton, which 'three months after its arrival … blossomed in my garden at Fulham, in May, 1742' (see fig. 196). Inscribed prominently 'G. D. Ehret pinxit Aug. 1743', it may originally have been a study that Ehret had intended to sell.[147] In the etching based on Ehret's composition, Catesby added his own images of the ruby-crown kinglet and the black and yellow mud-dauber, replacing Ehret's signature with his own monogram.[148] As with all the other drawings by Ehret which provided models for plates in the *Natural History*, Catesby either added his own images of birds, insects or plant studies to the etched compositions or adapted Ehret's composition in other ways.[149]

Catesby's watercolours of *Kalmia latifolia* and *Kalmia angustifolia* demonstrate clearly the way in which his botanical drawing changed as a result of Ehret's influence. Notwithstanding his statement that 'things done in a Flat, tho' exact manner, may serve the Purpose of Natural History, better in some Measure, than in a more bold and Painter like Way', his drawings demonstrate that he deliberately emulated Ehret's more rounded, three-dimensional approach to depicting plants, using devices such as the line of light falling on a stem, or leaves folded over to show the light reflected on their surfaces. Following Ehret, also, Catesby showed an increasing concern to depict botanical details – seeds, individual flower heads or buds, bulbs and roots – in a more scientific way. These are shown occasionally as 'still-life' ele-

ments with shadows, and sometimes more analytically with parts in cross-section or details numbered with a key.[150] And in his etching, Catesby adopted Ehret's use of a black background for his prints of *Magnolia tripetala* (*NH*, II, 80) and the lower left corner of the *Primula meadia* (see fig. 33).

Etching

Once he had decided to etch his drawings himself, Catesby may have consulted works such as Abraham Bosse, *Traicté des manieres de graver en taille douce sur l'airin …* (1645) and William Faithorne's *Art of Graveing and Etching* (1662), from which he could have

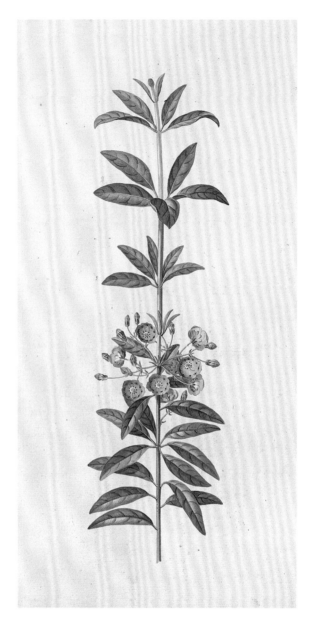

FIGURE 172

Mark Catesby, 'Chamaedaphne semper virens foliis oblongis angustis', 1743. Watercolour and bodycolour over graphite, 38 × 28.6 cm.

The Morgan Library & Museum, New York, 1961.6:4

FIGURE 173

Georg Ehret and Mark Catesby, 'Chamaerhododendros lauri-folio semper virens' and 'Chamaedaphne semper virens foliis oblongis angustis', 1743. Watercolour and bodycolour over graphite, heightened with gum, 37.5 × 27 cm.

Royal Library, Windsor, RCIN 926086

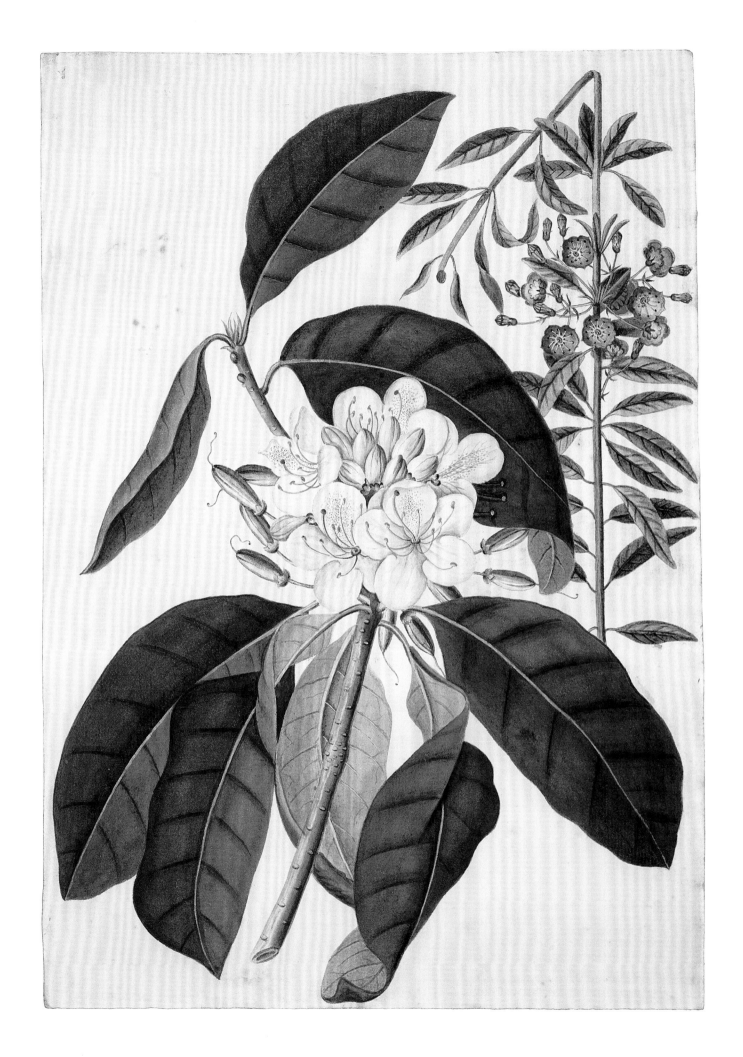

learned about the processes and tools involved in etching (fig. 174). There were evident advantages of etching over other printmaking media for an amateur to learn and employ as the method of translating drawings: the first, most obviously, is that the etching process is most akin to that of drawing.[151] Second was what William Gilpin identified in his *Essay on Prints* as the 'freedom' of etching: in his 'Observations on the different kinds of Prints', he distinguished the characteristics of three print techniques – engravings, etchings and mezzotints: 'the characteristic of the first is *strength*, of the second *freedom*, and of the third *softness*.'[152] While engraving with the burin required a high degree of training and skill, the freedom of drawing with the etching needle suited Catesby's calligraphic style well.

Significantly, however, he chose to have lessons with the foremost etcher of the day, Joseph Goupy, recording that it was under his 'kind advice and Instructions' that he 'undertook, and was initiated in the way of, etching [my prints] myself'.[153] Although Goupy was esteemed for his skills as an illustrator, he is not otherwise known to have been involved in natural history or scientific illustration.[154] In the opinion of William Gilpin, Goupy's etching skills lay in landscape, with 'a richness in his execution and spirit in his trees', and he considered he had a 'skilfull freedom by which his copies preserve the spirit of the original'.[155] In his own etching technique, Catesby tells us that, having mastered the skills he needed from Goupy, he developed his own etching style for his subjects, stating that he had 'not done [them] in a Graver-like manner, choosing rather to omit [the engraver's] method of cross-Hatching, and to follow the humour of the Feathers, which is more laborious, and I hope has proved more to the purpose'.[156] His study of the etchings in Francis Barlow's *Aesop's Fables* may also have influenced his use of a more draughtsman-like technique. In Barlow, too, Catesby had the example of how to convey the texture of birds' plumage and markings with greater naturalism (see, for example, fig. 109).[157]

Creating final compositions

If the particular medium of etching served Catesby well in helping him to translate his drawings into printed form, the fact of his having to be his own printmaker helped in other ways too.[158] Not needing to be servile to the original allowed him to cre-

FIGURE 174

William Faithorne, 'How to choose your needles wherewith to make your tools to etch with', *The Art of Graveing and Etching*, London, 1662, plate 3. Engraving, 10.4 × 6.4 cm.

Cambridge University Library, 6000.d.71

ate livelier prints than might have been the case if he had delegated this stage of the process.[159] There is a spontaneity and variety in his etchings in which he often balances areas of dense description with simple outline: in the great crested fly-catcher, *Myiarchus crinitus*, and bristly greenbrier, *Smilax tamnoides*, for example, the flat patterns and outlines of the plant leaves contrast with the soft texture of the bird's plumage and crest (fig. 175). The liveliness of Catesby's etchings is apparent when compared, for example, with the etched illustrations done for Eleazar Albin, whose drawings were reproduced by professional printmakers (fig. 176).[160] By contrast, George Edwards retained a certain naturalness in his etched plates. He records that like Catesby:

> I was discouraged, upon first thinking of this Work, at the great Expence of graving, printing, and other things, which I knew would be a certain Cost attended with a very uncertain Profit, till my good Friend Mr Catesby put me on etching my Plates myself, as he had

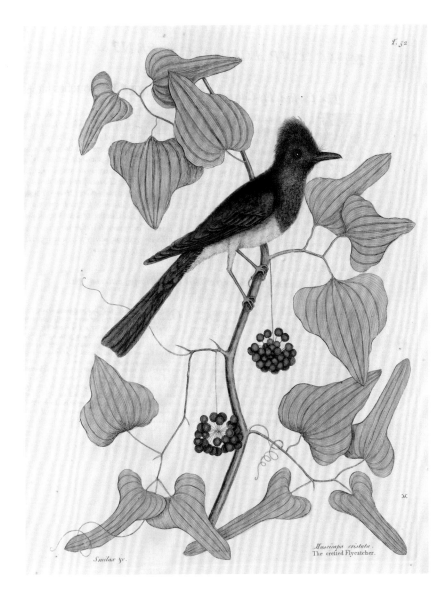

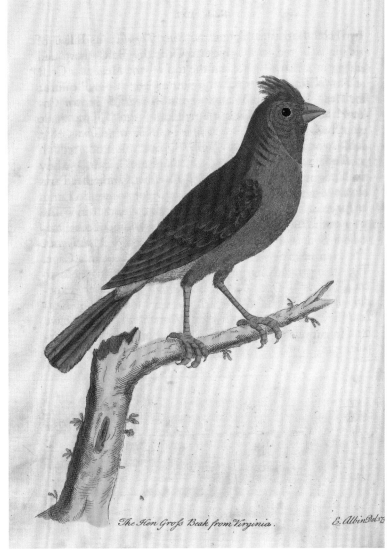

done in his Works; and not only so, but invited me to
see him work at Etching, and gave me all the necessary
Hints and Instructions to proceed, which Favour I
think myself obliged publickly to acknowledge.[161]

Most importantly, it was by retaining control over
the etching of his images that Catesby was able to
interpret and adapt his drawings freely, combining
and reassembling images in the process.[162] Edwards
also comments on the advantage of adapting his
drawings as he needed during the etching process:

> by doing them myself, I have retained in the Prints
> some Perfections, which would have been wanting,
> had I given my original Draughts to Ingravers to copy
> … I have been particularly careful in the extreme Parts
> of the Figures, to compare and adjust the Draughts

on the Copper with the original Drawings from which
they are taken, and many of the Plates were directly
worked from Nature itself, which is an Advantage that
few Works of this Kind have had.[163]

The extent to which Catesby reordered and arranged
his drawings – combining plants and animals that
had been drawn on separate sheets, such as speci-
men pages of crustacea (see fig. 240), amphibia and
reptiles (see fig. 235) or insects (see fig. 227); cutting
out and collaging elements on to other pages (see
fig. 170); and reducing or rearranging the layout of
his original compositions – demonstrates that for
Catesby the creative process continued until a late
stage of producing his illustrations.[164] Further, even
during the final stages of composing his etchings,

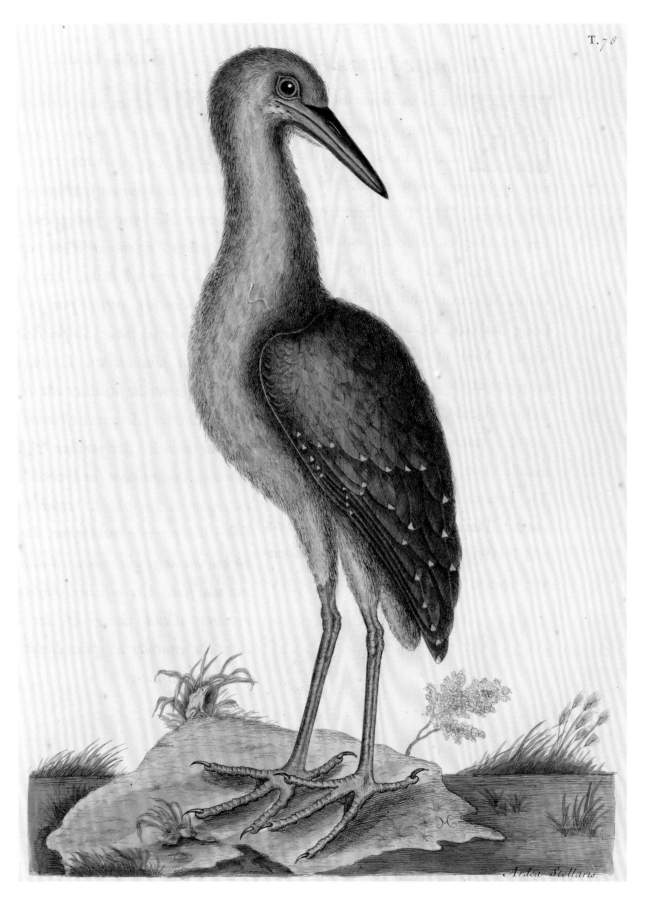

T. 78

Ardea Stellaris

FIGURE 177

Mark Catesby, 'The brown Bittern', detail, *Natural History*, 1731, I, plate 78. Hand-coloured etching, 51 × 35 cm.

Royal Society of London

An ACCOUNT of RELATION de la

C A R O L I N A, *C A R O L I N E,*
AND THE ET DES
B A H A M A Iſlands. Iſles de *B A H A M A.*

he incorporated elements from other printed illus-
trations. We have already seen that he used Barlow's
illustrations to *Aesop's Fables* for models of naturalis-
tic poses of birds and other animals. When it came
to etching his designs, he borrowed from the *Aesop's*
plates again, taking numerous details from the fore-
grounds of Barlow's scenes and incorporating them
into his own plates. The miniature toad in the cor-
ner of Barlow's plate for 'The Oxe and Toad' (see fig.
165), for example, is found sitting among reeds in
the background of Catesby's plate of the American

bittern, *Botaurus lentiginosus* (fig. 177).[165] The late ad-
dition of such details indicates both the keenness of
Catesby's eye as well as the delight he took in these
naturalistic details and their potential to enrich his
own compositions.

When it came to composing the trophy head-
piece for the 'Account of Carolina and the Bahama
Islands', usually bound in Volume II of the *Natural
History*, Catesby turned to De Bry's engravings after
John White's drawings in Harriot's description of
Virginia (1590).[166] From these he incorporated sev-
eral details of Native American artefacts – weapons,
tools and items of apparel – which he worked into his
design (fig. 178). The chieftain's head surmounting
the scrolling cartouche was borrowed from De Bry's
plate showing 'A Weroan or great Lorde of Virginia',
who wears, as the accompanying text states, 'the
hair on their heads long and bound up at the ends
in a knot under the ears' (fig. 179). The motif of the
shell spoon added beneath the head, used again as
the handle of one of the weapons in the arrangement
of objects below, is taken from De Bry's 'Their sit-
ting at Meat' (pl. XVI), where it is one of the cooking
utensils shown on the mat in the foreground.[167] Also
included in Catesby's trophy are a bow, an arrow, a

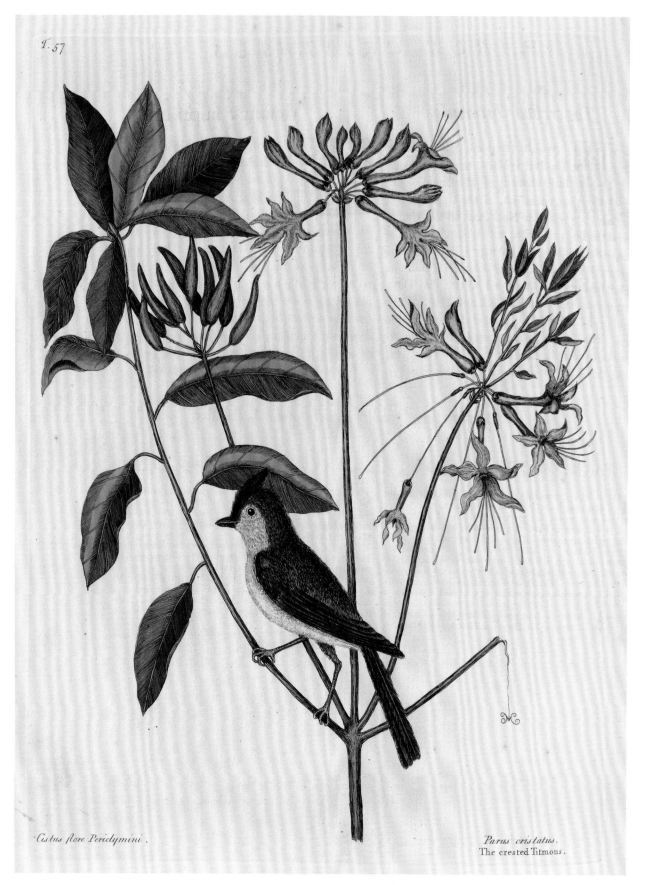

T. 57

Cistus flore Periclymini.

Parus cristatus.
The crested Titmous.

FIGURE 180

Mark Catesby, 'The crested
Titmouse', 'The Upright
Honysuckle' and 'The little yellow
Star-Flower', *Natural History*,
1731, I, plate 57. Hand-coloured
etching, 51 × 35 cm.

Royal Society of London

spear, a quiver of arrows, 'a chain of pearls or beads of copper', and an animal tail, part of the costume of the chieftain.[168] The images of the axe, paddle and pipe do not appear amongst the de Bry engravings; it is possible that Catesby drew them from memory, although he may of course have copied them from another source. As demonstrated elsewhere in his borrowings, Catesby's imaginative reuse of these elements represents a balance between his concern for documentary accuracy and his eye for poetic invention.

Although Catesby never signed his drawings, from the first plate of Part 2 of his book he began adding to his prints a monogram made from the intertwined initials 'MC'. This monogram does not appear on the prints consistently but is added in different places and ways, sometimes so that it forms an organic part of the design. It hangs, for example, on a thread like a spider from a broken-off stem of the upright honeysuckle (fig. 180), becomes a flourish on the torn-off stem of red flowering maple and the prey of the margate fish.[169] The elegant and decorative qualities of the monogram reflect Catesby's early training in calligraphy; at the same time there is an understatement in his way of signing his art that contrasts with the more clearly stated authorship of works by his contemporaries Ehret, Edwards and Albin.

While it is well known that the practice of 'borrowing' among artists was widespread at this period, it is noticeable that nowhere in his book does Catesby name the artists whose work he assimilated into his own compositions.[170] Many of his borrowings were made either from unpublished drawings (such as White's, Kick's, Ehret's and Edwards's) or were of select details from printed works (such as those by De Bry and Barlow). During the period of his working on the last five parts of his book, the Engravers' Copyright Act, passed in 1735 to protect engravers of original designs, was in force.[171] While the Act was made in respect of engravings rather than drawings or paintings, it is interesting to note that in the case of the three living artists whose work Catesby published as his own (Ehret, Aubriet and Edwards), he made changes to their designs when he etched them – a process which perhaps allowed him to feel he could sign the finished works with his own monogram.[172]

Catesby's imagery, illustrative methods and techniques demonstrate the ways in which he experimented freely with artistic conventions, both consciously and unconsciously, in a constant urge to explore and invent. As has been noted, his compositions range through a whole gamut of approaches and styles from scientific and analytic, naturalistic and iconic to decoratively charming and whimsical.[173] He also used wit and metaphor: his illustrations deliberately played on associations, comparisons and juxtapositions. Evidently, he did not intend the viewer to take literally his images of the flamingo standing in front of a disproportionate piece of underwater coral, or the checkered puffer swimming through terrestrial plants; there the coral and plants were added to emphasize particular qualities of those animals. But unlike the professional drawing master Eleazar Albin, who stated clearly that his art led him to nature, Catesby came to natural history illustration as a naturalist rather than an artist.[174] It was his first-hand experience of nature in the wild combined with his close observational practices that allowed him to illustrate the underlying connections between the plant and animal worlds. While he experimented creatively and inventively with artistic conventions, he remained faithful to his aim to illustrate nature, truthfully and accurately, or as he put it at the end of his book, to 'the strong inclination I had to these kind of subjects, joined to the love of truth, that were my constant attendants and influencers'.[175]

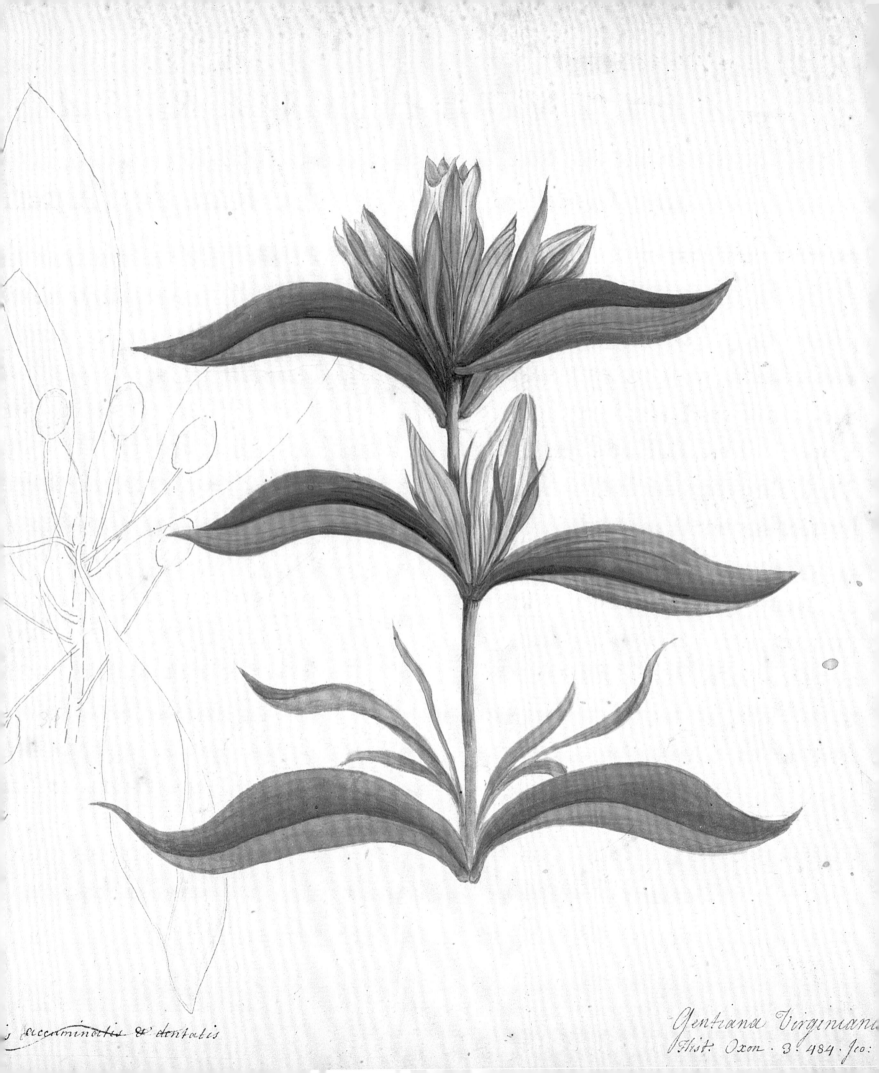

i accuminatis & dentatis

Gentiana Virginiana
Hist. Oxon. 3. 484. fco:

Catesby as Horticulturist

'The infinity of new Trees, Shrubs, &c. now of late introduced
by him into the gardens from North America,
fill me with the greatest wonder and astonishment imaginable.'

So Catesby's friend the gardener Thomas Knowlton wrote in 1749 to the botanist Richard Richardson in praise of Catesby's plant introductions to English gardens.[1] It was just five months before Catesby died. The Appendix to the *Natural History* had been completed two years before, and he was working on the *Hortus Britanno-Americanus*, his horticultural manual which was not to be published until fourteen years after his death. The process of the identification, introduction and cultivation of ornamental trees and shrubs from America, in which Catesby was so instrumental, was to have a transformative effect on the appearance of English gardens. At the same time, the iconic images he created of the flora and fauna of the New World – 'the horrid Graces of the Wilderness itself' – provide lasting symbols of this movement towards an appreciation of nature for its own sake.[2]

During the first half of the eighteenth century the formal garden in England was gradually giving way to the 'natural' or 'landscape' garden, identified primarily by the planting of newly imported trees and shrubs.[3] One of the pioneers of this change was Stephen Switzer, who in his *Ichnographia rustica* (1718) wrote of opening the garden up 'to the unbounded felicities of distant prospect, and the expansive volumes of nature itself'.[4] In part this movement resulted from a reaction against the formality of French and Dutch garden designs, and in part the influence of the Royal Society's empirical study of nature and the cataloguing of new species being brought back from abroad. Added to this was the literary influence of authors such as the 3rd Earl of

Shaftesbury, Joseph Addison and Alexander Pope. Shaftesbury, famously, was to write:

> I shall no longer resist the Passion growing in me for Things of a natural kind: where neither Art nor the Conceit or Caprice of Man has spoil'd their genuine Order, by breaking in upon that primitive State. Even the rude Rocks, the mossy Caverns, the irregular unwrought Grotto's, and broken Falls of Waters, with all the horrid Graces of the Wilderness itself, as representing Nature more, will be the more engaging, and appear with a Magnificence beyond the formal Mockery of Princely Gardens.[5]

In the Preface to the Society of Gardeners' *Catalogus plantarum* (1730), Philip Miller identified two different groups of people who were instrumental in bringing about the new changes in gardening: 'Procurers of Plants' and 'Encouragers of Gardening'.[6] Catesby, whose trip to Carolina was financed by his sponsors specifically in order to collect plants, undoubtedly belonged to the first group; the sponsors themselves were part of the group called variously 'Encouragers of Gardening' or 'Patriots of Horticulture'.[7]

Thomas Knowlton's comment quoted above praises Catesby's specifically horticultural skills and legacy. Aspects of Catesby's horticultural achievements, especially his contribution of plant introductions to the development of eighteenth-century landscaping with its 'theatrical' shrubberies, have been the subject of wide-ranging studies by Mark Laird.[8] The focus of the present chapter – based on information found in Catesby's plant labels, his

FIGURE 181

Mark Catesby, 'Gentiana Virginiana' (*Gentiana catesbaei*), 1722–5. Detail of fig. 200.

herbarium specimens, his letters and the text of his *Natural History* – is to explore his horticultural contribution in three main ways: his own gardening activities in America and England, the horticultural content of his publications with their contemporary influence, and his plant introductions.[9]

Catesby's gardening activities

Catesby was more than a 'Procurer of Plants' for his sponsors with their botanical gardens and collections.[10] It is clear that his skills extended to gardening itself, both during the periods of his life spent in Virginia and South Carolina, and later when he lived in London. Furthermore, his horticultural activities were carried out not just in his own gardens but in those of his friends.

From the references in his letters, plant labels and the *Natural History*, we know that Catesby already had considerable expertise in gardening when he first went to the New World. While there is no hard evidence, it is likely that he learned about the cultivation of plants in Samuel Dale's garden in Braintree, while his uncle Jekyll's garden at Castle Hedingham may also have provided some practical experience. More significantly, it would seem that Catesby gained specific knowledge of American exotics from Thomas Fairchild at his nursery in Hoxton prior to leaving for Virginia.[11] As Fairchild would have had a strong interest in receiving seeds and 'specious [plants] in tubs of earth'[12] directly from Catesby while he was in Virginia, he would surely have imparted advice about pruning, cultivation, and when and how to collect and transport specimens. As we have seen, Catesby also knew the Chelsea Physic Garden and its gardener Philip Miller, and was familiar with gardens in and 'about London'.[13]

It was fortunate for Catesby that when he first visited America in 1712 he was based in Williamsburg, the home of his sister and brother-in-law. A strong botanical connection had existed between Virginia's capital and England since the late seventeenth century, when John Evelyn and Henry Compton had exchanged plants with William Byrd I and other founders of William & Mary College who wished to promote scientific knowledge of native plants.[14] Thanks to the town planning and horticultural interests of governors Francis Nicholson and Alexander Spotswood, the town already had the beginnings of a gardening tradition. When Catesby arrived, Spotswood, who had succeeded Nicholson in 1710, was in the throes of designing a garden for the newly built Governor's Palace (fig. 182).[15]

As few skilled gardeners were available, there was a receptive audience for Catesby's horticultural knowledge amongst not only the culturally aspiring inhabitants of the young capital, but also the owners of plantation gardens mostly situated along the James and York rivers. But propagating native flora for use in gardens, as well as discovering what English plants could thrive in the Virginian climate, involved Catesby in a process of experimentation for which a garden of his own was necessary.[16] His references to 'my garden' in Virginia were in all probability to a plot situated within the grounds of his brother-in-law William Cocke's home in Williamsburg (see fig. 52). It was here that he experimented with transplanting species from the wild and attempting to cultivate them himself.

The lush indigenous flora that Catesby found in Virginia had been described enticingly by Robert Beverley in his promotional book, *The History and Present State of Virginia* (1705): 'Of spontaneous Flowers they have an unknown Variety … Almost

FIGURE 182

Attributed to William Byrd II, John Carwitham and Eleazar Albin, untitled illustration of Williamsburg buildings, showing the Governor's Palace and garden, Williamsburg, 1740s, detail of upper section. Engraving, modern impression from original copper plate, 25.5 × 34.5 cm.

Colonial Williamsburg Foundation, 1938-196, gift of the Bodleian Library

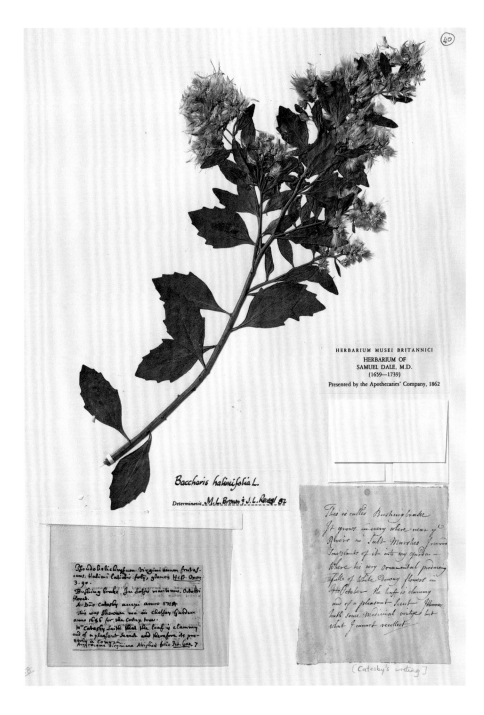

near the Rivers in Salt Marshes[.] I removed some plants of it into my garden where tis very ornamental producing [*word missing*] full of white downy flowers' (fig. 183).[18] Delighted by discovering a beautiful rose-coloured variant of white dogwood in the wild, *Cornus florida* f. *rubra*, which had blown down and its branches taken root,[19] he transplanted some cuttings from 'from the Mother Tree into Mr Jones Garden'.[20] Surely his own garden, as well as that of his niece Elizabeth Jones, would also have benefited from this rare find. Later in the *Natural History* he recorded the dogwood tree 'with the white Flower Mr. Fairchild has in his garden'. In his original watercolour he painted a stem of the tree bearing only white flowers, but in the hand colouring of the etching made from that image he showed the stem bearing both pink and white flowers (figs 184–6).[21] He observed that the tree was of ornamental value not just for its blossoms but for its berries, which were left by the birds: 'As the flowers are a great ornament to the Woods in summer, so are the berries in Winter, they remaining full on the trees usually till the approach of spring; and being very bitter are little coveted by Birds, except in time of Dearth.'[22]

Among plants Catesby attempted to raise from seed was the bay tree, *Persea borbonia*, which he found growing on Smith's Island at Cape Charles: 'I gathered some of the berries the latter end of Aprill last and sowed them the beginning of May and they came up in abt 6 weeks. I am told they grow plentyfully in James town Island 6 miles from us.'[23] He was less successful with the berries of the American hornbeam, *Carpinus caroliniana*, which 'never came up'.[24] Perhaps he also planted the 'sorrel tree', *Oxydendrum arboreum*, 'a very pretty plant' which he was later to tell Collinson he found growing 'between Williamsburgh & York'.[25]

Not surprisingly, observing birds went hand in hand with horticultural activities for Catesby. In a charming anecdote, he described watching in his garden a single 'Fieldfare of Carolina', *Turdus migratorius* (American robin), feeding off the berries of the evergreen Mediterranean buckthorn, *Rhamnus alaternus*: 'Having some trees of *Alaternus* full of Berries (which were the first that had been introduced in Virginia) a single Feildfare seemed so delighted with the Berries, that he tarried all the Summer feeding on them.'[26]

Outside Williamsburg, the most important plantation garden with which Catesby was associated

all the Year round, the Levels and Vales are beautified with Flowers of one Kind or other, which make their Woods as fragrant as a Garden.'[17] Throughout Catesby's descriptions of his gardening activities, observations on the ornamental qualities of this 'spontaneous' (indigenous) flora go hand in hand with practical horticultural information. For example, when he sent Dale a specimen of sea myrtle, *Baccharis halimifolia*, in 1714, he noted on the label, 'This is called Bushing brake. It grows every where

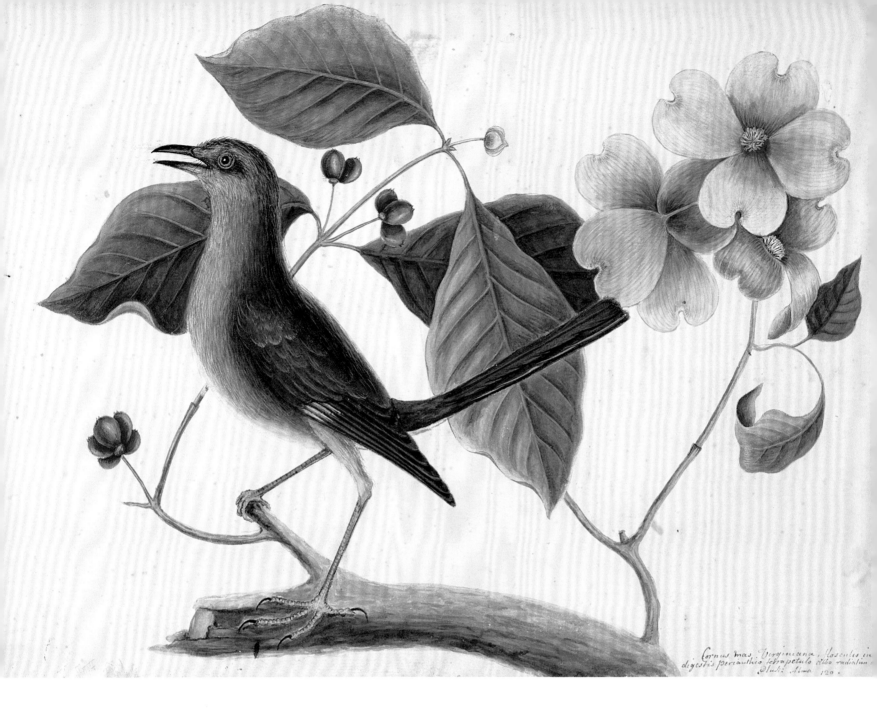

Cornus mas, Virginiana, flosculis in
digestis perianthio tetrapetalo albo radiatim
Pluk: Alma 120.

was that of William Byrd at Westover, whose diary entry for June 1712 records that 'Mr Catesby directed how I should mend my garden and put it into better fashion than it is at present.'[27] As we have seen, Byrd's father, William Byrd I, had also been a keen gardener and plant collector, and had laid out the grounds of Westover, the family home on the James River. There he had planted both exotic native and English plants sent by his botanist friends in England, including Jacob Bobart, second keeper of Oxford's Physic Garden, Hans Sloane and Leonard Plukenet. For two years, too, he had had the services of John Banister, who gardened at Westover between 1690 and his death in 1692. A plan of Westover made in 1701 shows a landscape laid out with avenues radiating from the house, a large area of swamps and marshes extending along the meandering river, and what appear to have been the principal pleasure gardens facing the river front (figs 187 and 188).[28]

Robert Beverley left a vivid vignette of ruby-throated hummingbirds, *Archilochus colubris*, feeding in the flower garden at Westover during the elder Byrd's time:

you can't walk by a Bed of Flowers, but besides the entertainment of their Beauty, your Eyes will be saluted with the charming colours of the Humming Bird, which revels among the Flowers, and licks off the

FIGURE 184

Mark Catesby, 'The Mock-Bird' and 'The Dogwood Tree', 1712–19. Watercolour and bodycolour over graphite, 27 × 38 cm.

Royal Library, Windsor, RCIN 924840

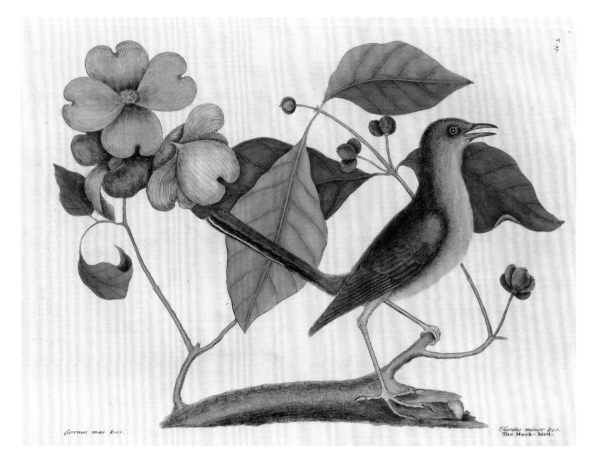

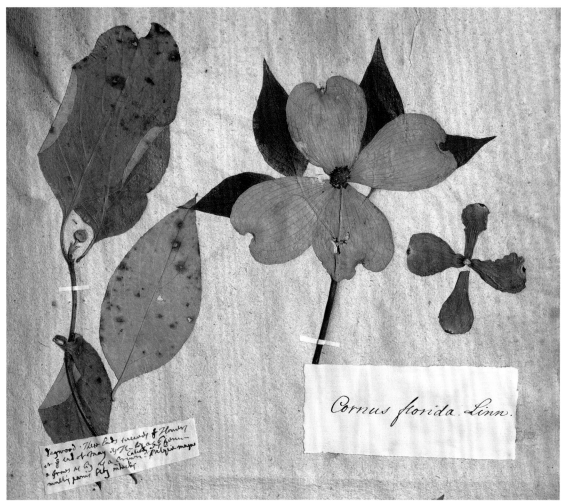

Dew and Honey from their tender Leaves, on which it only feeds. It's size is not half so large as an English Wren, and its colour is a glorious shining mixture of Scarlet, Green, and Gold. Colonel Byrd, in his Garden, which is the finest in that Country, has a Summer-House set round with the Indian Honey-Suckle, which all the Summer is continually full of sweet Flowers, in which these Birds delight exceedingly. Upon these Flowers, I have seen ten or a dozen of these Beautiful Creatures together, which sported about me so familiarly, that with their little Wings they often fann'd my Face.[29]

Catesby also described the bird's spectacular appearance; he may well have painted his watercolour of the hummingbird feeding on the trumpet creeper, *Campsis radicans*, in the gardens at Westover (fig. 189):

The Upper-part of the Body and Head of a shining Green; the whole Throat adorned with Feathers placed like the Scales of Fish, of a crimson metallic Resplendency; the Belly dusky white; the Wings of

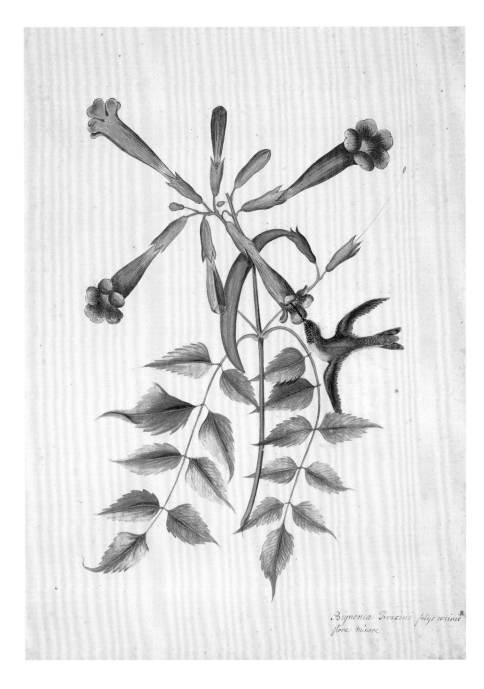

Bignonia Fraxini folijs coccinei flore minore

FIGURE 189

Mark Catesby, 'The Hummingbird' and 'The Trumpet Flower', 1712–19. Watercolour and bodycolour over graphite with whitening out, 37 × 26.5 cm.

Royal Library, Windsor, RCIN 925900

a singular Shape, not unlike the Blade of a Turkish Cymiter; the Tail Copper-Colour, except the uppermost Feather, which is green. The legs are very short and black. It receives its Food from Flowers, after the Manner of Bees; its Tongue being a Tube, thro' which it sucks the Honey from 'em. It so poises it self by the quick hovering of its Wings, that it seems without Motion in the Air. They rove from Flower to Flower, on which they wholly subsist.[30]

For the younger Byrd, who had cultivated his taste for gardens, plants and landscapes during his long periods of living in England, Catesby's horticultural skills and knowledge of English plants must have been invaluable.[31] Byrd was particularly fond of his orchards, and Catesby may well have advised him on better cultivation methods learned from Fairchild.[32] He was to comment in the *Natural History* about how well English fruit trees produced in America as compared to England, but was disparaging about the lack of proper cultivation. Peach trees grew in abundance and 'bear from the stone in three years; and I have known them do it in two. Were they managed with the like art that they are in England, it would much improve them; but they only bury the stone in earth, and leave the rest to Nature'; fig trees 'bear plentifully; but they are of a small kind, which may be attributed to their want of skilful management'; 'Plumbs and Cherries … and other cultivated fruits' from Europe 'have hitherto proved indifferent' 'in the management of which little else but Nature is consulted'.[33] Amongst the many fruits Byrd grew were peaches, figs, apples, pears, plums and cherries, as well as strawberries.[34] He also grew pomegranates successfully; Catesby reported that despite their being tender, requiring a 'salt-water situation' like oranges and lemons, 'I remember to have seen them in great perfection in the gardens of the Hon. William Byrd, Esq., in the freshes of James river in Virginia.'[35] It was during a visit to Westover in 1714 that Catesby found the yellow passion flower, *Passiflora lutea*, growing 'out of a pomegranate hedge in Coll. Birds garden'; he sent a pressed specimen of it to Samuel Dale (fig. 190).[36]

Byrd also owned one of the earliest greenhouses in the colonies.[37] Here he raised oranges, as Collinson was to record in a letter to Bartram, very likely from information given him by Catesby: 'I am told Colonel Byrd has the best garden in Virginia, and a pretty greenhouse, well furnished with orange trees.'[38] John Bartram's comment on Byrd's greenhouse suggests that after Catesby's departure Byrd lacked anyone with Catesby's level of horticultural skill: 'Col Byrd is very prodigal in Gates roads walks hedges & seeders trimed finely & a little green house with 2 or 3 [orange] trees with the fruit on but I saw very few that had a good notion of either good husbandry or house wifery.'[39] It may have been Byrd's garden to which Catesby referred when he noted of the 'Snake-Root' (Virginia snakeroot, *Aristolochia serpentaria*): 'By planting them in a Garden, they increased so in two years time, that one's hand could

not grasp the stalks of one Plant' (fig. 191).[40] Byrd, like many of his time, was interested in snakeroot because of its potential use as a cure for rattlesnake bites; the discussion of this was one of the topics in his letter which Catesby read to the Royal Society in 1738.[41] Byrd was also interested in cultivating vines with a view to producing wine; this again was a topic of mutual interest to him and Catesby, and also one that was aired in Bartram's letter to the Royal Society.[42] Catesby recorded:

> Grapes are not only spontaneous in Carolina, but all the northern Parts of America, from the latitude of 25 to 45, the Woods are so abundantly replenished with them, that in some Places for many Miles together they cover the Ground … From which indications one would conclude, that these Countries were as much adapted for the culture of the Vine, as Spain or Italy, which lie in the same Latitude. Yet by the Efforts that have been hitherto made in Virginia and Carolina, it is apparent, that they are not blest with that Clemency of Climate, or Aptitude for making Wine, as the parallel Parts of Europe, where the Seasons are more equal, and the Spring not subject, as in Carolina, to the Vicissitudes of Weather … which by turns both checks and agitates the rising Sap, by which the tender Shoots are often cut off.[43]

Byrd frequently mentioned pruning his vines, and his vineyards attracted a bear cub on to his land in September 1712 which Catesby shot 'as he sat on a tree to eat grapes'.[44]

Byrd's brother-in-law, John Custis, was another keen gardener with whom Catesby had dealings.[45] Catesby was first introduced to Custis, 'a Lover of Rarities', by Byrd at Westover, and together with Byrd was a frequent visitor to Custis's plantations at Queen's Creek, Arlington, about a mile north of Williamsburg on the Eastern Shore.[46] After his wife's death in 1715, Custis bought a house in Williamsburg with four acres of adjoining land on which he created a 'handsome' and well-stocked garden (see fig. 52).[47] With Catesby's help, Custis transplanted native varieties from his own plantations and elsewhere, and it was Custis's garden to which Catesby transplanted some of the pink dogwood saplings he discovered in the wild, later telling Collinson that he had 'brought and planted the ['Curious peach colour'd dogwood'] in [Custis's] garden'.[48] Encouraged by Catesby, Custis also ordered trees, shrubs and seeds from his English friends. In 1717 he wrote to

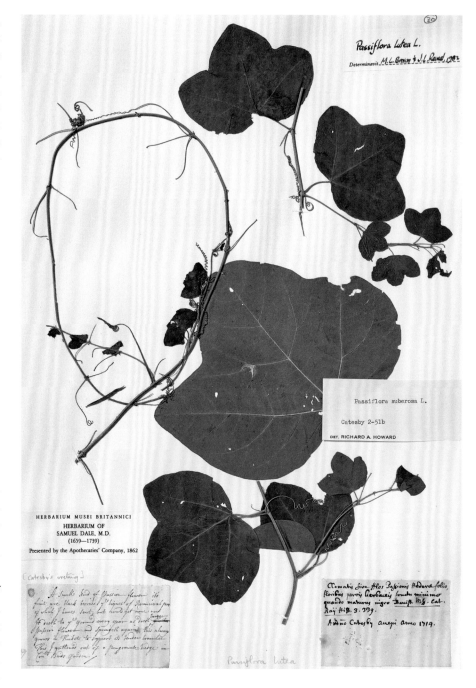

his agent in London, 'I have lately got into the vein of gardening and have made a handsome garden to my house; and desire you will lay out £5 for me in handsome striped hollys and yew trees, but most hollys … choose them with handsome body and not too big.'[49] Custis had a taste for the formal style of clipped evergreens in his garden; he was to write to Collinson that he was 'a great admirer of all the tribe of striped, gilded and variegated plants, and especially trees. I am told those things are out of fashion

FIGURE 190

Yellow passion flower, *Passiflora lutea*. Plant specimen with Catesby's and Dale's labels, 40.7 × 28.5 cm.

Natural History Museum, London, Department of Life Sciences, Algae, Fungi and Plants Division, Dale Herbarium, no. 30

FIGURE 191

Mark Catesby, 'The Snake-Root
of Virginia' and 'The Fieldfare of
Carolina', 1712–19. Watercolour
and bodycolour over graphite,
27 × 37.5 cm.

Royal Library, Windsor, RCIN
924842

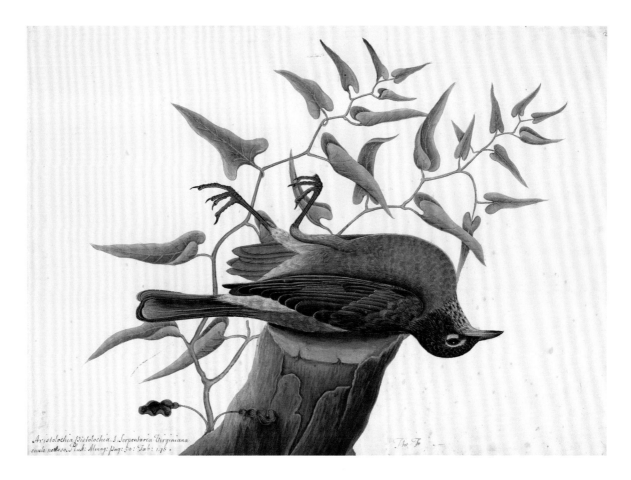

but I do not mind that I allways make my fancy my fashion.'[50] And in another letter to him he wrote, 'you are pleased to compliment me concerning my garden which I assure you in no way deserves it; my greens are come to perfection, which is the chief fruit of my assiduous endeavours.'[51]

On his arrival in South Carolina, Catesby was delighted to find that the country was 'inferior to none in fertility' and 'possessed not only with all the Animals and Vegetables of Virginia, but abounding with even a greater Variety'.[52] During his three to four year stay, he managed to keep up his horticultural activities despite spending the major part of his time collecting in the field. It seems that he had a garden which he tended in Charleston, probably that belonging to his friend the physician Thomas Cooper. There he amazed the local community and his friends with a show of spring bulbs sent by Sherard; despite the fact that the first crop of anemones and ranunculus Sherard sent were killed off by frost, the second 'were the wonder of Town and Country and indeed the finest and greatest variety of the Rununculas I ever saw'.[53] In August 1724 he reported that he had

planted the seeds of colocynth, *Citrullus colocynthis*, with success, although he could not discover how to preserve the fruits: 'I put into ground some seeds of Coloquintida which ripen early here and have made a great increase but how to cure them we are at a loss.'[54] The seeds of this desert plant may have been collected by Sherard in Turkey, and Catesby's (and perhaps Dr Cooper's) interest in preserving the fruit may have been connected to its medicinal properties.

During his explorations of the surrounding country, Catesby was constantly on the lookout for native plants that might be cultivated in both American and English gardens. In 1722 he sent Sherard the seed of a 'kind of perriwinkle' which 'grows in moyst places and trailes on the ground ... [and] would make a fine Edging for Beds'; and he noted of the 'purple seed [which] seems to belong to the sage kind but is more woody' which he sent in the same cargo that it is 'a very ornamental plant'.[55] But he was disappointed to find that there was surprisingly little local enthusiasm for gardening considering the richness of the indigenous flora.[56] In the same way Lawson had discovered a few years earlier in North Carolina that:

The Flower-garden in Carolina is as yet arriv'd but to a very poor and jejune Perfection. We have only two sorts of Roses; the Clove-July Flowers [carnations, *Dianthus*], Violets, Princes Feather [*Amaranthus hypochondriacus*] and Tres Colores [probably *Lantana camara*]. There has been nothing more cultivated in the Flower-Garden which, at present, occurs to my Memory; but as for the wild spontaneous Flowers of this Country, Nature has been ... liberal.[57]

However, when Catesby found the elegant *Catalpa bignonioides* growing in the wild and introduced it into gardens, he managed to rouse interest amongst garden owners. The dramatic appearance of the tree with its spectacular large leaves and long hanging pods, and its 'spreading bunches of white flowers', 'induced [them] to propagate it' (fig. 192):

> [it] was unknown to the inhabited parts of Carolina, till I brought the Seeds from the remoter parts of the Country. And tho' the Inhabitants are little curious in Gardining, yet the uncommon Beauty of the Tree has induc'd them to propagate it; and 'tis become an Ornament to many of their Gardens, and probably will be the same to ours in England, it being as hardy as most of our American Plants; many of them now at Mr. Bacon's at Hoxton, having stood out several Winters without any Protection except the first Year.[58]

With his eye for ornamental trees for gardens, Catesby recognized the potential of the 'American Ceder' (*Juniperus*), of which he was later to tell Dillenius he transplanted 'many hundreds' from woods both in Virginia and Carolina to the gardens of his friends: 'I am as I was always of [the] opinion that the American Ceders as they are vulgarly called are not Specifically different. In Virginia & Carolina my transplanting many hundreds of them from the woods into gardens gave me an oppertunity of observing them critically, and I am satisfied that their Juniper or Cypress like leaves is caused meerly from the difference of soil & climate.'[59]

A notable exception to the indifference of most inhabitants to horticultural matters was Catesby's friend Alexander Skene, a member of the colony's Council, with whom, as we have seen, Catesby often stayed on his plantation near Dorchester on the Ashley River. Skene was unusual for his interest not just in the potential of plants as commodities but in their ornamental qualities. In a letter to Collinson Catesby described Skene as 'one of

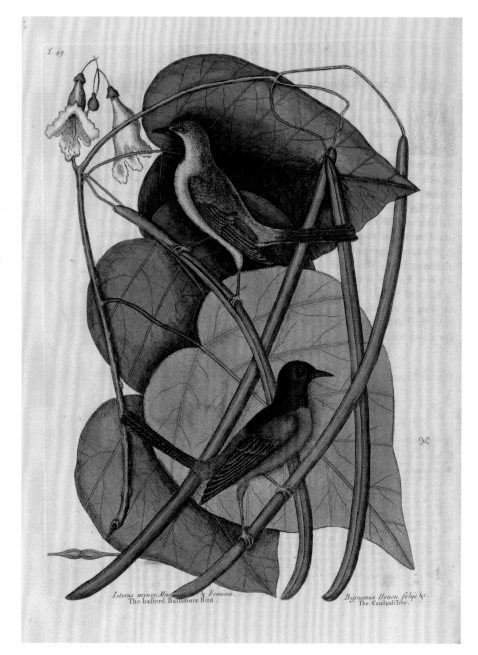

the most considerable men in the Country and ... of the most generous and genteel Spirit in it[,] but what most I concieve [*sic*] adds not a little to his commendation especially with us Bretheren of the Spade [is] that his genius leads him not only to the improvement of usefull but ornamental plants.'[60] Skene was clearly a like-minded spirit when it came to horticultural matters and was keen to send Catesby's friend Collinson American plants in exchange for 'the commonest things your garden affords'. On his list of desiderata were: 'Lillys all the kinds ... especially the different kinds of Red Lilly & red Mar-

FIGURE 192

Mark Catesby, 'The Catalpa Tree' and 'The Bastard Baltimore Bird', *Natural History*, 1731, I, plate 49. Hand-coloured etching, 51 × 35 cm.

Royal Society of London

tagons[.] Daffs all kind[,] Narcissus[,] White Hyacinss[,] Snowdrops[,] all kinds of Bulbs … Plants in Tubs [including] Any flowering shrub especially Syringa[,] the early and late Honeysuckel[,] Jessamy white[,] Lylech [lilac,] Guelderland rose[,] Pistatia Nut. No kind of Kitchen Garden Seed but what will be acceptable especially large winsor Beans.'[61]

Skene was, of course, interested in 'usefull' as well as ornamental plants and experimented with producing oil from the flowers of *Jasminum officinale*, a plant that Catesby noted was 'much esteem'd in the Eastern parts of the World for its medicinal and culinary uses'. He was later to tell John Bartram:

> At my going to Carolina I procured from Smyrna a Turkish Town in Asia, some seeds of Jesamum[,] a plant … I distributed … to many not doubting but my intention of introducing so usefull and beneficial a thing wo[u]ld succeed. But so little inclination have they to any thing out of the common rode that except my friend Mr Skene none of them I gave it to gave themselves any trouble about it. Yet some of these very negligent persons with all others that eat of Mr Skene[']s Oyl commended it and desired to know where to buy some of the same.[62]

During his stay in the West Indies Catesby singled out one other person for his unusual interest in horticultural matters, William Spatches.[63] In his description of the logwood, *Haematoxylum campechianum*, Catesby recorded:

> In the year 1725, I saw three of these Trees in the Island of Providence, which were raised from seeds brought from the Bay of Honduras, by Mr. Spatches, a Person of more than common Curiosity. He told me they were of three Years Growth from the Seeds; they were then about fourteen Feet high; their truncs strait, and about seven or eight Inches thick: their Heads branching regularly, and being in full Blossom, made a beautiful Appearance.[64]

With his usual concern for encouraging local interest in the useful properties of plants and a keen eye for their best conditions of growth, he continued:

> I could wish that the Inhabitants of our Southern Plantations could be induced to propagate it, as well for their own Advantage, as that we may be supplied by them, when wholly deprived of getting it from the Spaniards, as we have hitherto done, either by Force or Stealth.

If upon a Rock, these Trees will in four Years bear Seeds, and grow to the Thickness of eight Inches; a much quicker Progress may be expected when planted in a deep moist Soil, which Jamaica and many other of our Islands abound in.

After his return to London in 1726, Catesby's involvement in the practical aspects of horticulture continued unabated, despite the onerous schedule involved in the production of his book. The movement away from the rigid geometrical layout of garden design to 'more extended Rural Designs of Gardens, which approach the nearest to Nature' was gathering pace.[65] Catesby, by this time recognized as an authority on North American flora, advised his friends and patrons in horticultural matters, as well as cultivating plants himself. The chief arboriculturists among the wealthy landowners were Lord Petre, of Thorndon Park, Essex, and the 2nd Duke of Richmond of Goodwood, Sussex (who wrote of himself that 'no man living loves propagation … more than I do'),[66] both of whom were planting huge numbers of 'Americans': pines, cedars, cypresses, tulip trees and thujas (fig. 193).[67] One of Catesby's sponsors, the Earl of Oxford, at Wimpole Hall, Cambridgeshire, was another keen planter of trees; in 1724 Catesby sent him tubs of 'ornamental' shrubs and trees from South Carolina, and seeds, nuts, 'Seed-vessels' and cones of black walnut, hickory, pine, cypress and other trees.[68]

From 1726 to around 1733 while he lived in Hoxton, Catesby had his own plot of land within Fairchild's – and later Bacon's – nursery garden where he cultivated American plants. He recorded in the Preface to the *Natural History*: 'I have likewise taken notice of those Plants that will bear our English Climate, which I have experienced from what I have growing at Mr. Bacon's, Successor of the late Mr Fairchild at Hoxton.'[69] The Hoxton suburb of London was home to several nursery gardeners, so he would have been in the midst of a community of like-minded horticulturists (fig. 194).[70] From around the date of Stephen Bacon's death (*c.*1733), Catesby continued his horticultural activities in Fulham; his garden was connected with the nursery of his friend Christopher Gray.[71] In 1748 Pehr Kalm described Fulham parish as a London outskirt full of gardens 'lying … two English miles from Chelsea, and four miles to the south-west of London. All round … the country consists wholly of gardens and market-gar-

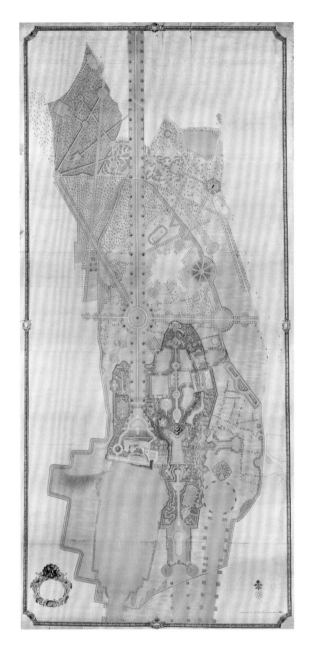

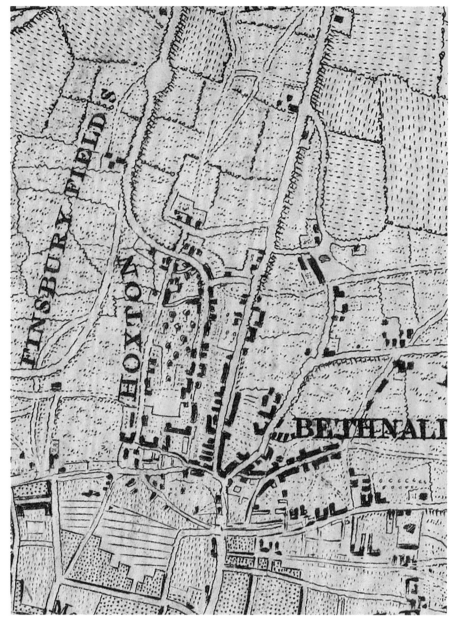

dens, giving it the appearance of nothing less than a pleasance' (fig. 195).[72]

Catesby raised plants which he had brought back from America, as well as experimenting with rearing the new species that were being sent over by his contacts: John Custis, John Clayton and John Mitchell in Virginia, and John Bartram in Pennsylvania. Through trial and error, he discovered what soil conditions were most successful for what plants, as he wrote to Bartram:

> I say that plants which in America grow in moist land, are generally killed when planted in such like [soil]

here. It is by experience found that a dry warm Soyl is most agreeable to American plants even Aquaticks. This I concieve [is] not from our too great cold in Winter more than with yours but from a difficiency of heat in our Summers, wherefore [a?] situation by being warmer may compensate for that difference in heat in a wet Situation.[73]

By contrast with the planters of South Carolina, there was an atmosphere of horticultural excitement amongst English garden owners over the arrival of new and exotic species from abroad. When gardeners such as Catesby succeeded in coaxing a

plant to bloom, the event was cause for general cel-
ebration and admiration. Amongst the successes in
Catesby's garden was the mountain laurel, of which
'some bunches of blossoms were produced in July
1740, and in 1741, in my Garden at Fulham'; it was
a stem of this that both he and Ehret painted.[74] He
concluded that its success was due to the fact that
the plants had been sent from Pennsylvania, whose
climate was not dissimilar to that of England.[75] Two
years later, he had another triumph, this time with
the 'Steuartia' (silky camellia, *Stewartia malacoden-
dron*): 'For this elegant Plant I am obliged to my
good friend Mr Clayton, who sent it to me from Vir-
ginia, and three months after its arrival it blossomed
in my garden at Fulham, in May, 1742.'[76] The follow-
ing year Catesby again invited Ehret to come and
paint it, Ehret producing the elegant signed water-
colour (fig. 196) which Catesby then etched for the
Natural History, adding his own images of the golden
crowned kinglet and black and yellow mud dauber
to his print.[77] The next year Ehret came again, this
time to paint the witch hazel, *Hamamelis virginiana*

(fig. 197), which arrived 'in a case of earth' from John
Clayton at Christmas, in full bloom after its three-
month journey from Virginia – a sight that must
have caused amazement and delight.[78]

Typical of horticultural experiments, however,
a successful outcome could never be guaranteed.
One elusive shrub was the great laurel, *Rhododendron
maximum*, of which Catesby recorded that 'though
they have been planted some years, they make but
slow progress in their growth, and seem to be one of
those American Plants that do not affect our soil and
climate.'[79] This was the plant that Ehret had had to
paint from a dried specimen sent by John Bartram.[80]
A related species was nearly as difficult: it 'is appar-
ently a cousin German to the Chamerhod: and can
no [more] than that be prevailed on to grow with us.
Yet after many years I have one plant that has pro-
duced some tufts of its beautiful [blossoms?] these
two years past, and yet the plant diminishes yearly.'[81]
Catesby was more optimistic, however, about his
attempts to grow the sweet bay, *Magnolia virginiana*:
'Mr Bartram of Pensylvania has discovered many of

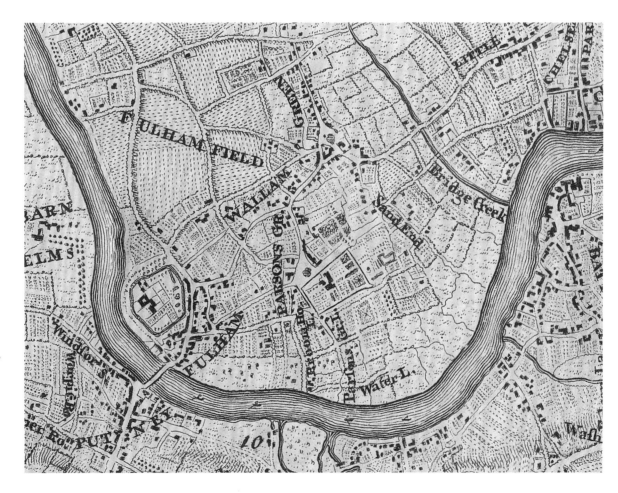

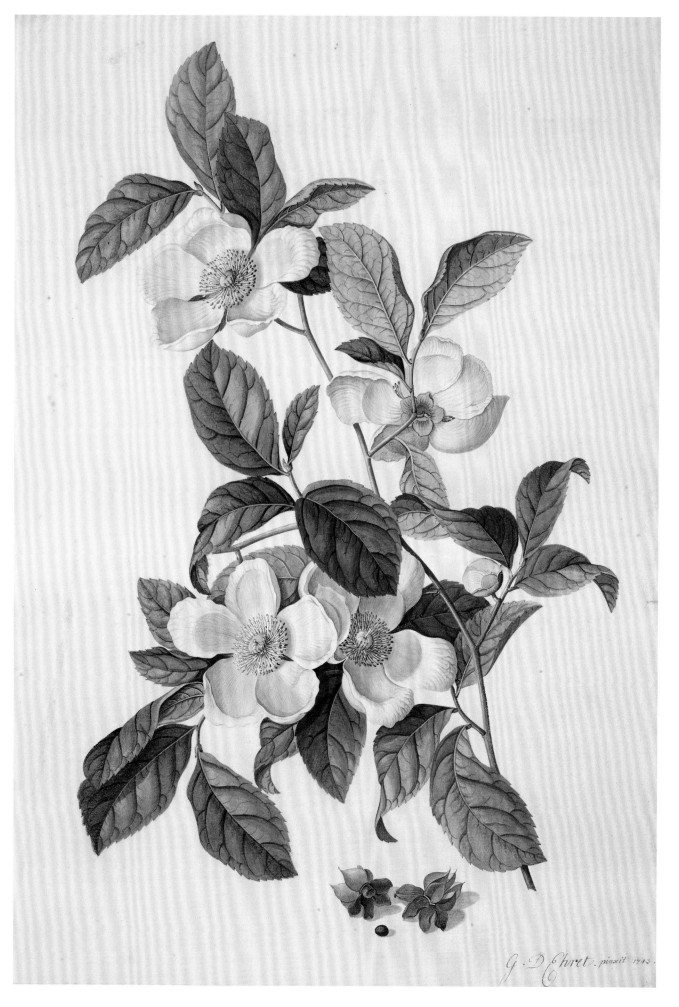

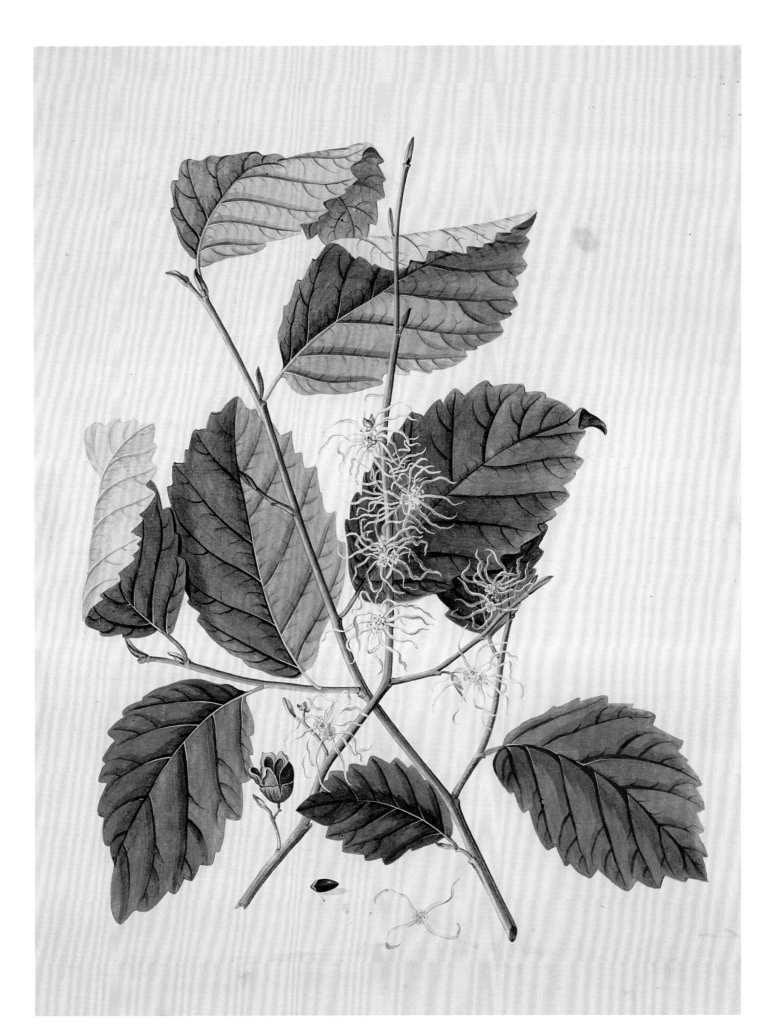

FIGURE 198

Mark Catesby, 'The Upright
Honysuckle', 'The Yellow
Jessamine', 'Hamamelis' and
'Frutex corni foliis conjugatis',
Hortus Britanno-Americanus,
London, 1763, plates 55–8. Hand-
coloured etching, 26 × 26 cm.

Natural History Museum,
London, Botany Library, Special
Collections

FIGURE 199

Elisha Kirkall after Jacobus van
Huysum, 'Aster Virginianus', in
John Martyn, *Historia plantarum
rariorum*, London, 1728–37, facing
p. 19. Etching and coloured
mezzotint, 52.2 × 35.9 cm.

Cambridge University Library,
MH.7.19

them in that province, from the seeds of which I am
in hopes of raising some'.[82]

Judging by his frequent mentions of plants grow-
ing in the nurseries of his friends Fairchild and
Bacon, and then of Christopher Gray, Catesby's
horticultural experience was put to good use by each
of them, while he no doubt gained from their know-
ledge and skills; in fact, the distinction between
what was growing in his own garden and in theirs
may have been blurred. By January 1730, Catesby
noted that 'most' of the eight species of oak he had
described in the *Natural History* 'are growing at Mr
Fairchild's'.[83] The sweet bay was flourishing at Hox-
ton 'where it has for some years past produced its
fragrant Blossoms, requiring no protection from the
Cold of our severest Winters'.[84] Thomas Knowlton
recorded that in 1729, when Fairchild died, Catesby
gave Bacon 'a few sorts of trees' from his own gar-
den, perhaps by way of encouragement to carry on
his uncle's business.[85] After Bacon took over the
Hoxton nursery, he managed to raise plants of the
'Yellow jessamine', *Gelsemium sempervirens*, 'where
by their thriving state, they seem to like our soil and
climate';[86] further success was had with the sassa-

fras, *Sassafras albidum*, several specimens of which
flowered at Hoxton 'where they have withstood the
cold of several winters'.[87] The 'Upright Honysuckle'
(mountain azalea, *Rhododendron canescens*), the 'red
flowering maple' (Carolina red maple, *Acer rubrum*
var. *trilobum*) and the sweet pepper bush (*Clethra al-
nifolia*) also flourished at Hoxton (fig. 198).[88] In 1724
the botanist Richard Bradley published monthly
letters from Fairchild listing the 'curious flowers'
growing in his garden, among which were signifi-
cant numbers of plants from Virginia and Carolina
likely to have been from Catesby. One that flowered
in October was 'Mr. Catesby's new Virginian Star-
wort' (large flowered aster, *Symphyotrichum grandif-
lorum*, formerly *Aster grandiflorus*), which continued
flowering in November and December.[89] Four years
later John Martyn was to write in his *History of Rare
Plants* that the '[starwort] was brought from Virginia
by Mr. Catesby and given to Mr. Fairchild, who has
since communicated it to other curious Persons. It
is hardy enough to stand in open Borders. But if the
Autumn proves bad, the Flowers are not so fair; nor
do they continue so long as those which are shel-
ter'd. It Flowers from the beginning of October to

FIGURE 200

Mark Catesby, 'Gentiana Virginiana' (*Gentiana catesbaei*) and sketch for *Nyssa sylvatica*, 1722–5. Watercolour, bodycolour and pen and ink, 16.5 × 20.5 cm.

Royal Library, Windsor RCIN 25905a

December; but has not yet ripen'd it's Seeds in our Climate' (fig. 199).[90]

Gray's garden, which became renowned for the success of its North American shrubs helped by the publication of his and Catesby's 'Catalogue' (see Chapter 3), showed off the smooth sumac, *Rhus glabrum*, in its 'full lustre' – Catesby noting that 'A warm summer is requisite to perfect the colour in our climate' (see fig. 230)[91] – and the mountain azalea, *Rhododendron canescens*.[92] Flowers grown there included the Indian pink, which was 'in blossom, the First of August, 1738, in the Garden of Mr. Christ. Gray at Fulham, and endures the Winter without any Protection' (see fig. 5),[93] and Elliott's gentian, *Gentiana catesbaei*, a species in which Catesby was later to be commemorated by Thomas Walter (fig. 200).[94] In a notice concerning Gray's nursery published in

1783, both Catesby and his friend Collinson were mentioned specifically: 'The large trees, among which are many rare oaks, were brought out of the first great nursery of North American trees in England in Fulham, belonging to … Gray, an eminent gardener; and the first who, being assisted by Peter Collinson, Mark Catesby, and other curious collectors, supplied England with the vegetable treasures of America.'[95]

The most notable of the private gardens with which Catesby was involved was Peter Collinson's at Peckham.[96] The two plant enthusiasts were kindred spirits, and they shared their delight in the profusion of North American exotics that Collinson grew – not only those raised from the seeds Catesby had sent and brought back from Carolina and the West Indies, but those which started to arrive after

1733 shipped in regular consignments by Bartram from Philadelphia.[97] For thirty years (1722–52), Collinson kept a private record of the plants he raised, and such was the 'high celebrity' of his gardens that he was urged by Linnaeus to publish his catalogue. In his response, however, Collinson wrote, 'You must remember I am a Merchant, a man of great business, with many affairs in my head and on my hands.'[98] Although there are no details of the design of Collinson's garden, a vignette of its overall appearance is provided in Pehr Kalm's diary entry of 10 June 1748: 'We went out to Peckham, a pretty town which lies 3 English miles from London in Surrey, where Mr Peter Collinson has a beautiful little garden, full of all sorts of the rarest plants, mostly West Indian, which are able to tolerate the English climate and stay out the entire winter.'[99] He adds that it was a 'neat and small garden', despite the number of trees and plants it contained, and that instead of placing boards around the edges of flower beds, Collinson used horseshoes which were 'all of the same height and stood tightly beside each other'. Catesby mentions that among the 'choicest exotics' planted in pots were three lilies: the 'elegant and stately Martagon [*Lilium superbum*] … [which] flowered in Perfection',[100] the 'Lilium Angustifolium', *Lilium philadelphicum*, which 'blossomed in Mr. Peter Collinson's garden at Peckham, Anno 1743', and the 'Lilium sive Martagon Canadense', *Lilium canadense*, which 'flower'd several years in Mr Collinson's garden' (fig. 201).[101] There were two rare species of orchid, the pink lady's slipper, *Cypripedium acaule*, and the greater yellow lady's slipper, *Cypripedium pubescens*, which 'were introduced to the garden of Mr. Peter Collinson … where they flowered in perfection' (fig. 202).[102] When the pride-of-Ohio bloomed in 1744 from seeds that Bartram gathered 'from beyond the Apalatchian mountains', Catesby deemed it appropriate to honour his patron Richard Mead by coining the name 'Meadia', *Primula meadia*, 'in gratitude for his … generous assistance towards carrying the original design of [his *Natural History*] into execution'.[103]

Collinson's garden was a meeting place for the natural history circle to which he and Catesby belonged. Many came to admire the rarities, but it was Catesby and Ehret who were summoned by Collinson when the blooms were at their best to make permanent records of them in watercolour. While Ehret painted *Primula meadia* (see fig. 33) and *Lil-*

ium canadense, Catesby painted the curious-looking skunk cabbage, *Symplocarpus foetidus*, annotating the plate made from his painting that it 'displayed itself in this Manner' in 1736 (see fig. 150).[104] It seems that both artists made watercolours of the American ginseng, *Panax quinquefolius*, which Collinson proudly recorded he had raised 'from seed in my garden, perhaps the first place it made its appearance in Europe', despite the fact that it was a 'pretty humble plant, nothing striking in its figure, except when in seed, with its head of red berries' (fig. 203).[105]

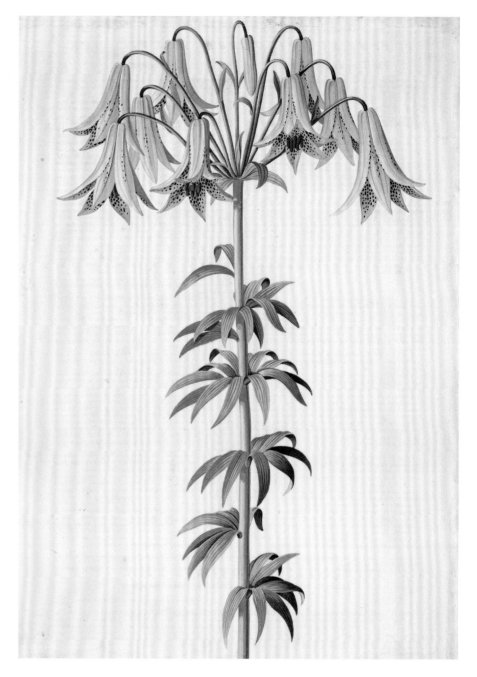

FIGURE 201

Georg Ehret, 'Lilium sive Martagon Canadense', 1743. Watercolour and bodycolour over graphite, heightened with gum, 40.3 × 30.1 cm.

Royal Library, Windsor, RCIN 926079

as well as their passion for gardens brought them together. Wager's garden was at his home known as Hollybush, a Queen Anne brick house at the south-east corner of Parson's Green.[109] He was an avid collector of exotics, many of which he acquired on his own travels or from other naval officers.[110] Collinson recorded that Wager brought plants of the toadflax, *Linaria tristis*, and the shrubby germander, *Teucrium latifolium*, from Gibraltar, and that he had the Florida swamp lily, *Crinum americanum*, 'from Guinea, and from his plant came all now in the gardens and stoves'.[111] While Wager was abroad, Collinson raised exotic plants in the heated greenhouses at Hollybush, an arrangement that must have been of mutual benefit to each of them.[112] Wager very likely became a subscriber to Catesby's *Natural History* through Collinson, and it was Wager's garden that both Catesby and Ehret visited regularly in August 1737 to inspect *Magnolia grandiflora*, 'one of which Blossoms expanded, measured eleven Inches over'.[113] As we have seen, Ehret made daily visits to record each stage of its flowering, and the same flower was also to provide the model for Catesby's etching used as the centrepiece for his 'Catalogue'.[114] Other spectacular trees in Wager's garden were the tulip tree, *Liriodendron tulipifera*, given to him by Collinson,[115] and the Carolina red maple, *Acer rubrum*, which Catesby had admired 'adorning the Woods earlier than any other Forest-Trees in Carolina' and found 'to endure our English climate as well as they do their native one' (fig. 204).[116] The tree was sometimes known at the time as 'Sir Charles Wager's Maple'.[117]

Many of the seeds and plants which Catesby collected in South Carolina and the Bahama Islands were destined for propagation in the garden at Eltham, Kent, belonging to William Sherard's brother, James.[118] The Sherard brothers together created a garden which became noted as amongst the finest in England. Occupying a two-acre site, it was 'a showcase of horticultural expertise' where plants were grown specifically for study.[119] In April 1724 Sherard reported to Richard Richardson that he was 'going to Eltham, to see what product there is of our Carolina Seeds; when I was there last, a good number were up; and the weather having been since very seasonable, I hope to see them past their Seed-leaves.'[120] Dillenius's *Hortus Elthamensis* (1732) contains several references to Catesby supplying seeds, including the Indian mallow, *Abutilon*, and

Amongst the flowering shrubs were mountain laurel, *Kalmia latifolia*, and sheep laurel, *Kalmia angustifolia*; like Catesby, however, Collinson had difficulty in raising *Rhododendron maximum*.[106] We also know that there were some impressive 'large Evergreens', forty of which Collinson was to transplant 'without injury' to his new garden at Mill Hill in 1749.[107]

The garden of Collinson's 'intimate friend, Sir Charles Wager, First Lord of the Admiralty' was another that Catesby knew well.[108] No doubt Collinson's and Wager's shared Quaker background

FIGURE 203

Mark Catesby and Georg Ehret,
'The Whip-poor-Will' and
'The Ginseng or Ninsin of the
Chinese', 1744. Watercolour
and bodycolour over graphite,
heightened with gum,
37.4 × 26.7 cm.

Royal Library, Windsor, RCIN
926085

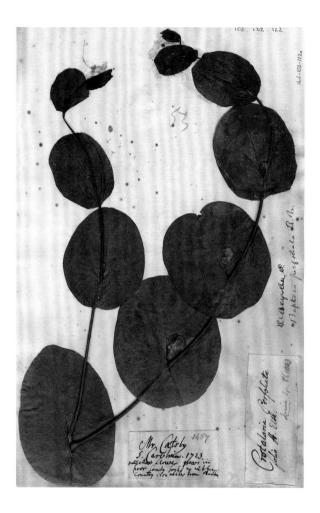

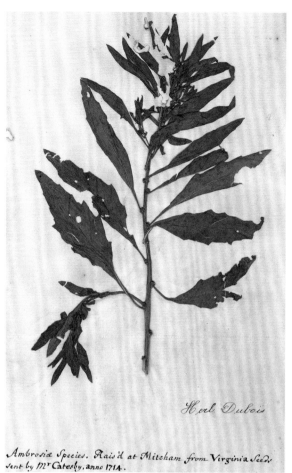

FIGURE 205

Catbells, *Baptisia perfoliata*, grown at Eltham from seed sent by Catesby, 1723. Plant specimen with labels by Johann Dillenius, 35.5 × 23.5 cm.

Oxford University Herbaria, Hort-102-122a

FIGURE 206

'Ambrosiae species' (probably a member of the family Amaranthaceae) raised at Mitcham garden owned by Charles Du Bois from seed sent by Catesby from Virginia in 1714. Plant specimen with Du Bois's label, 37.5 × 25.5 cm.

Oxford University Herbaria, DB-08568 (00087426R)

rattlepod, *Crotalaria*,[121] while many more references to Catesby supplying plants for the garden can be found on Dillenius's labels to preserved plants in his herbaria (fig. 205).[122]

The garden of Catesby's sponsor Charles du Bois at Mitcham, Surrey, was another that benefited from seeds sent by Catesby. Du Bois (1656–1740), a fellow of the Royal Society and treasurer of the East India Company, created a herbarium of around 13,000 sheets contained in seventy-four volumes.[123] A preserved specimen, probably a member of the family Amaranthaceae, is annotated 'Ambrosiae Species. Rais'd at Mitcham from Virginia Seeds sent by Mr Catesby, anno 1714' (fig. 206). It is not known that Catesby was in contact with du Bois before he left for Virginia in 1714, but it is possible that Dale shared some of the seeds Catesby sent him from Virginia with du Bois.[124] Catesby found du Bois a difficult sponsor; he wrote to Sherard, 'The discontent of Mr Du-Bois and the trouble he gives my Friends in receiving his Subscription is such that I had rather

be without it[;] I doubt not but I have suffered by his Complaints.'[125]

One of the gardeners employed by James Sherard at Eltham was Catesby's friend Thomas Knowlton, who, after going on to work for the Duke of Chandos at Cannons, was employed for many years by Richard Boyle, the Earl of Burlington, at Londesborough, Yorkshire.[126] Through Knowlton Catesby was able to follow the progress of plants he had helped to introduce to gardens further afield from London. It was in the garden of another of his subscribers, a wealthy plant lover, the 'curious Baronet, Sir John Colliton, of Exmouth in Devonshire', that *Magnolia grandiflora* first flowered in England.[127] Sir John Colleton (1669–1754), son of one of the Lords Proprietors of Carolina, likewise managed to grow the 'Acacia with rose-coloured flowers [*Robinia hispida*], a rare tree … procured … from his plantation at Carolina, [which] flourishes annually in his gardens at Exmouth in Devonshire'.[128] Whitton Park, Middlesex, the seat of another nobleman and subscriber, Lord Islay, was

FIGURE 207

William Wollett, *A View of the House and part of the Garden of His Grace the Duke of Argyl at Whitton*, 1757. Hand-coloured etching, 37.3 × 53.8 cm.

Orleans House Gallery, Twickenham

FIGURE 208

Dyrham Park with Orangery, built by William Talman in 1701, adjoining the East Front. Photograph.

National Trust Images, acc. no. 221267

known for its 'Evergreens and American Plants'.[129] Referred to by Horace Walpole as a 'tree-monger', Islay planted a 'kind of natural wood' in around 40 or 50 acres of land at Whitton Park. Famous for its magnificent cedars, there was 'a fine collection of exotics; amongst which ... the coffee tree, palm tree, torch thistle, and many others equally valuable for their scarcity and beauty' as well as evergreen oaks and a cork tree.[130] Catesby mentioned Islay for his successful cultivation of the 'Anona' (pawpaw), which 'produces its blossoms annually in the gardens of his Grace the Duke of Argyll' (fig. 207).[131]

One of Knowlton's friends was another talented gardener, John Powers, employed by the landowner and garden enthusiast William Blathwayt of Dyrham Park in Gloucestershire.[132] When Catesby returned from the Bahamas in 1726, he brought back seeds of the lily thorn, *Catesbaea spinosa*, which he distributed to many of his horticulturally minded friends, 'but none were so successful in raising it as Mr. Powers, a skilful and curious Gardiner, at Mr. Blathwait's of Derham, near Bath, who raised a Plant which produced many fair and ample Blossoms; some Specimens of which he sent to my friend Mr. Peter Collinson, in the Year 1734.'[133] Collinson, in his turn, recorded that 'Mr. John Powers, gardner to — Blaithwaite, Esq., at Derham, near Marshfield, Gloucestershire, raised several of the Catesbaea's from seed I sent him. He acquaints me that, in August, 1733, a plant of the lily thorn was two feet and a half high, and had sixty flowers on, in full beauty, at one time; at that time three trees in flower; will not thrive but in a stove.'[134] In addition to greenhouses, William Blathwayt senior had built an orangery in 1701, one of the few garden buildings of this period to survive (fig. 208).[135]

The horticultural content of Catesby's two books demonstrates a progression from his hopes of raising North American flowering shrubs and trees in England voiced in the *Natural History* to the results of his first-hand experience of cultivating them as recorded at the end of his life in the *Hortus Britanno-Americanus*. The subtitle of the *Natural History*, which states that the book contains 'the figures of birds, beasts, fishes, serpents, insects, and plants: particularly the forest-trees, shrubs, and other plants, not hitherto described', suggested the slant which was to be developed in the *Hortus*, whose full title spells out the more specific focus on horticultural matters: *A curious collection of trees and shrubs, the produce of the British Colonies in North America; adapted to the soil and climate of England, with observations on their constitution, growth and culture; and directions how they are to be collected, packed up, and secured during their passage.*

By the late 1740s when Catesby was writing the *Hortus Britannno-Americanus*, he had had twenty years of experience cultivating North American species in England, both in his own garden and in those of his friends and associates. He was thus able to write in the Preface to this book:

> By a long acquaintance with the trees and shrubs of America, and a constant attention since for several years to their cultivation here, I have been enabled to make such observations on their constitution, growth and culture, as may render the management of them easy to those who shall be desirous to inrich their country, and give pleasure to themselves, by planting and increasing these beautiful exotics.[136]

It is difficult for the modern reader to appreciate the sheer novelty and glamour of the flowering and fruiting plants which Catesby's illustrations in the *Natural History* presented to his readers. Philip Miller, for example, was to note about the flowers of the Bahamian cat's claw, *Pithecellobium × bahamense*, whose seeds Catesby gave him in 1726, that they 'have not yet appeared in England, but from a painting done from the plant in the country, they seem to be very beautiful' (fig. 209).[137] Catesby displayed each plant specimen 'here for the first time exhibited in the true proportion, and many colours' to its best advantage, like a modern plant catalogue, and many were enhanced further by the addition of a bird, other animal or insect.[138] The nineteenth-century English botanist

John Claudius Loudon observed: 'The appearance of such figures for the first time in England must have greatly contributed to induce the wealthy to procure the introduction of the trees they represented in this country.'[139] Catesby's subscriber John, 2nd Duke of Montagu, was one such wealthy owner of several gardens whose horticultural interests are reflected by the presence in his library not just of the *Natural History* and *Hortus Britanno-Americanus*, but a copy of Catesby and Gray's 'Catalogue' pasted into the back of the *Natural History*.[140] It was no doubt some of the 'Americans' described in the 'Catalogue' that Gray supplied to Montagu for his garden at Ditton Park, Berkshire. Montagu employed three gardeners in addition to Philip Miller as a consultant at Ditton, which was the main venue for his exotic plants, and which included a coffee tree, pineapples, Turk's head cacti and an 'India plant' raised in a hothouse.[141] Lord Burlington subscribed to three copies of the *Natural History*, suggesting he is likely to have included 'Americans' in the serpentine woodland walks he designed with William Kent at Chiswick House.[142]

In a letter requesting plants from John Bartram written in around 1742, Catesby specified that his particular interest was in the ornamental qualities of shrubs and trees: 'When I tell you they are plants of ornament I most desire, I must leave it to you what to send next tho' a few plants of Sassafras and Laurel will be acceptable[,] as coming from a Colder Country than Carolina I hope they will agree better with our Climate.'[143] Many of Catesby's comments on plants, as well as his images of them, indicate the sheer pleasure he took in the ornamental qualities of the exotic flora of the New World. Alongside botanical terms he frequently used adjectives such as 'elegant', 'stately', 'beautiful', 'glittering' and 'pretty' to describe the colours, shapes and manner of growth of different plants. Of the Bahamian cat's claw (which he called 'Acacia foliis'), Catesby wrote: 'The pods grow three together, in a wreathed or spiral manner, which nature seems to have designed for displaying its beauties for advantage; for had the pods been strait, as those of French beans, these glittering seeds would have been much obscured'.[144] He noted of *Robinia hispida* that 'what with the bright verdure of the leaves, and the beauty of its flowers, few trees make a more elegant appearance' (see fig. 113).[145] His delight in *Magnolia grandiflora* is expressed in almost poetic language: 'This stately tree perfumes the woods, and displays its beauties, from

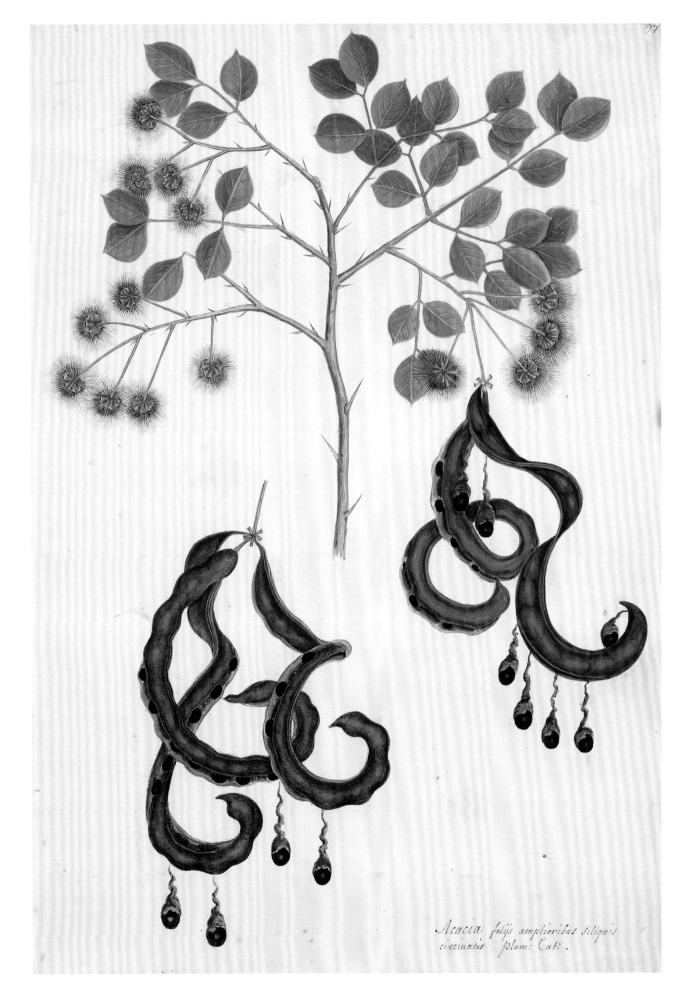

FIGURE 209

Mark Catesby, 'Acacia foliis amploribus, siliquis cincinnatis', 1722–5. Watercolour and bodycolour over brush underdrawing, heightened with gum, 37.2 × 27 cm.

Royal Library, Windsor, RCIN 926060

Acacia folijs amplioribus siliquis cincinatis Plum: Cat:.

May till November, producing first its fragrant and ample blossoms, succeeded by its glittering fruit. It retains the leaves all the year; which being of two colours, have a pretty effect, when waved by the wind, displaying first one side, and then the other.'[146]

Both pattern and structure were aspects of the plant world that fascinated Catesby. He noted of the 'Balsam-Tree', *Clusia rosea*: 'The whole plant is exceeding beautiful; and particularly the Structure of the Fruit, in all it's Parts, is a most exquisite Piece of natural Mechanism,' a comment that is reflected in the flat, almost abstract arrangement of the parts of the plant in his illustration (fig. 210).[147] A specimen of the fruit he collected survives in the 'Vegetable Substances' collection of Hans Sloane.[148] But in terms of both beauty and structure, the shrub which for Catesby took precedence over all the others was the 'Chamaedaphne foliis Tini' (mountain laurel, *Kalmia latifolia*): 'As all plants have their peculiar Beauties, 'tis difficult to assign to any one an Elegance excelling all others; yet, considering the curious Structure of the Flower, and beautiful Appearance of this whole Plant, I know of no Shrub that has a better Claim to it' (fig. 211).[149]

In common with the prevailing interests of the time, Catesby was concerned to discover the useful and potentially commercial properties of North American plants, their value as sources of food and their medicinal properties. While he learned of these characteristics from Native Americans and colonists, his intrepid curiosity led him to investigate edible, drinkable and other properties through first-hand experience. He noted that the fruit of the American persimmon, *Diospyros virginiana*, which 'will hang after the Leaves are dropped till December; ... having then lost much of its watry Parts, is shrivelled, candied, and very luscious, resembling in Taste and Consistence, Raisins of the Sun';[150] and of the black cherry, *Prunus serotina*, 'the fruit of some of these trees is sweet and pleasant; others are bitter. They are esteemed for making the best Cherry Brandy of any other'. The roots of the bristly greenbrier, *Smilax tamnoides*, were made into a 'Diet-Drink' by the 'Inhabitants of Carolina', who attribute 'great virtues to it in cleansing the blood, etc. They likewise in the Spring boil the tender shoots and eat them prepared like Asparagus' (see fig. 175).[151] 'The Bark [of the cascarilla, *Croton eluteria*] being burnt, yields a fine Perfume; infused in either Wine or Water, gives a fine aromatic Bitter.'[152]

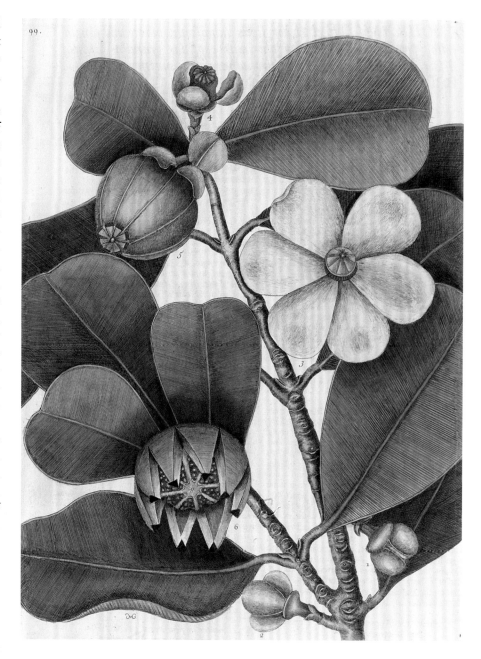

Amongst medicinal properties, the root of the may apple, *Podophyllum peltatum*, was 'said to be an excellent emetic, and is used as such in Carolina';[153] and 'A decoction of [Indian pink] is good against worms.'[154] The yaupon, *Ilex vomitoria*, whose leaves were 'parched in a porrage-pot over a low fire', 'they say restores lost appetite, strengthens the stomach, [and gives] agility and courage in war';[155] and the bodywood, *Bourreria baccata*, has similar virtues for the inhabitants of the Bahama Islands, where they 'make much use [of it], attributing to it great virtues; as strengthening the stomach, restoring lost appe-

FIGURE 210

Mark Catesby, 'The Balsam-Tree', *Natural History*, 1743, II, plate 99. Hand-coloured etching, 51 × 35 cm.

Royal Society of London

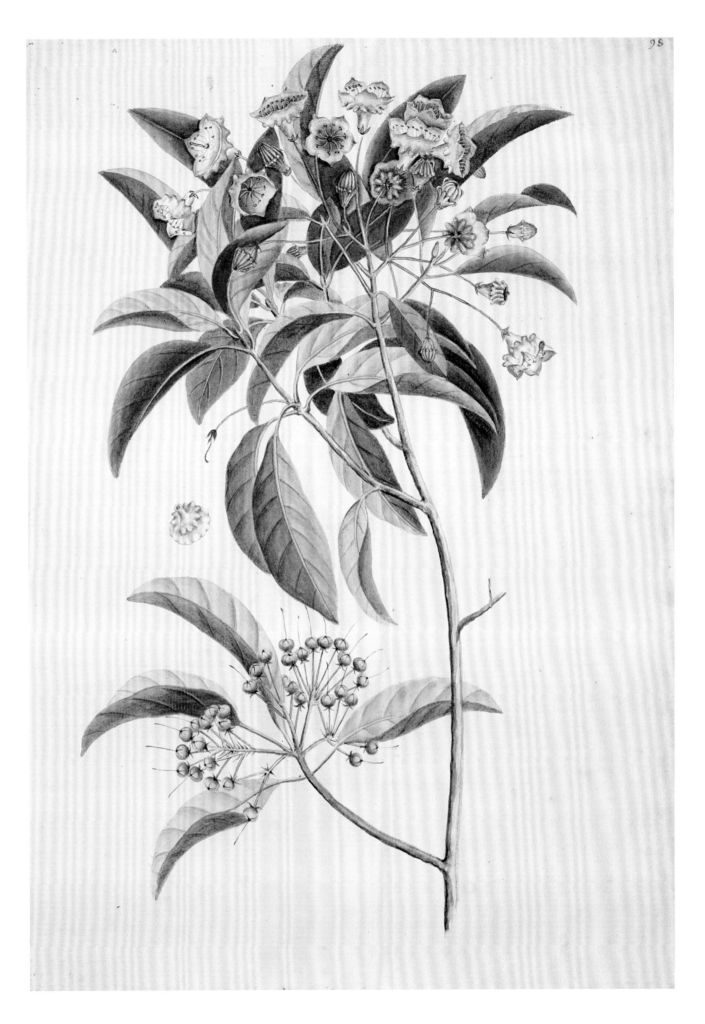

FIGURE 211

Mark Catesby, 'Chamaedaphne foliis Tini', 1722–5. Watercolour and bodycolour, heightened with gum over outlines in brush and watercolour and graphite, 37.5 × 26.8 cm.

Royal Library, Windsor, RCIN 96061

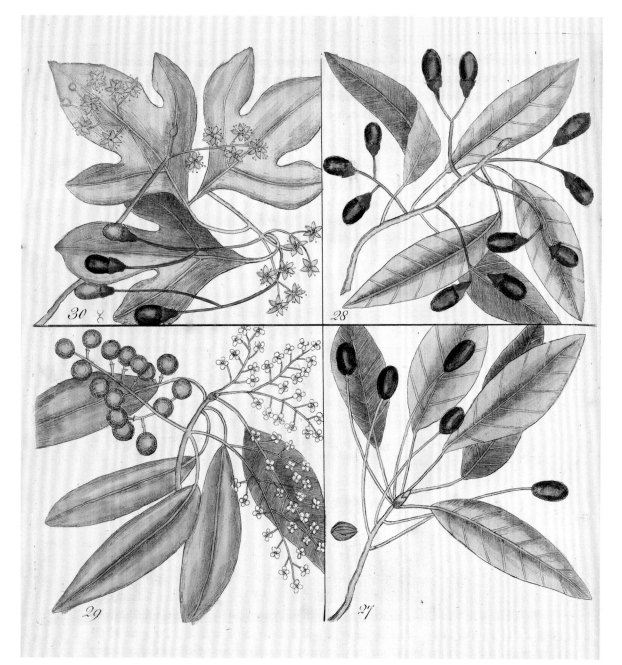

FIGURE 212

Mark Catesby, 'The Tupelo-tree',
'The Red Bay', 'The Purple-
berried Bay' and 'The Sassafras
Tree', *Hortus Britanno-Americanus*,
London, 1763, plates 27–30.
Hand-coloured etching,
26 × 26 cm.

Natural History Museum,
London, Botany Library,
Special Collections

tite, and other like virtues, as the Cassena is said to have on the continent'.[156]

Catesby frequently mentioned the quality of wood for building and joinery and other household uses: the wood of the 'Tupelo-tree' (black tupelo, *Nyssa sylvatica*) was 'curled and very tough, very proper for naves of cart-wheels and other country uses';[157] that of the 'Red Bay' (swamp redbay, *Persea palustris*) was 'fine grained, of excellent use for cabinets. I have seen some of the best of this wood selected, that has resembled watered satin; and has exceeded in beauty any other kind of wood I ever saw' (fig. 212: nos 27 and 28);[158] while the bark of the sweet gum, *Liquidambar styraciflua*, was both 'very fit for curious works in joinery … and also of singular use [to the Native Americans] for covering their houses',[159] and that of the sweet bay, *Magnolia virginiana*, which 'has a fine grain, very tough, and of an orange colour', 'is used by the Indians for making bowls'.[160]

Catesby's approach to horticulture was primarily practical and scientific. The parts of his forty-four-page essay, the Account, devoted to horticultural

matters included careful observations on the differences of climate and soil of the areas he explored.[161] He noted that the climate in North America was characterized overall by greater extremes in summer and winter than that of England, which meant that some plants susceptible to very hard frosts could not survive the winters there. There were particular areas, however, such as that near the sea where the moderating influence of the water on the climate meant that plants could grow while they could not inland; amongst these were oranges, pomegranates and figs, which flourished by the coast.[162] He made several comments about the potential of some areas for cultivation, such as the marshlands of Carolina, which were then not used other than for grazing land.[163] He identified the most fertile land at the sources of the rivers: 'the Richest Soil in the Country lies on Banks of those larger Rivers, that have their Sources in the Mountains from when in a Series of Time has been accumulated by Inundations such a Depth of prolifick matter, that the vast Burden of mighty Trees it bears, and all other Productions, demonstrates it to be the deepest and most fertile of any in the Country,' although there was, however, the danger of repeated 'inundations' in these areas.[164] We have already seen that the cultivation of grapes, with their potential for the production of wine, was a subject in which Catesby, Byrd and a number of their associates in the Royal Society were interested.

Alongside this scientific approach to horticultural matters, however, passages in the *Natural History* indicate Catesby's response to the aesthetic qualities of the unspoiled nature he encountered in the New World. His descriptions of the picturesque features of the landscape, such as hills, valleys, prospects and cascades of water, echo those in the writings of Shaftesbury and other promoters of the landscape garden. In his exploration of the lower ridges of the Appalachian Mountains, Catesby noted: 'Land rising imperceptibly ... forming gradual Hills, which also increase in Height, exhibiting extensive and most delightful Prospects';[165] rocks from which 'gush out plentiful streams of limpid water, refreshing the lower grounds, [which in] many places are received into spacious basons, formed naturally by the rocks'.[166] Elsewhere, he saw 'vallies ... replenished with Brooks and Rivulets of clear water ... where [herds of buffalos] solacing in these limpid streams enjoy a cool and secret retreat';[167] while the swamps of the lowland areas were 'filled with a profusion

of flagrant [*sic*] and beautiful Plants, [which] give a most pleasing entertainment to the Senses'.[168] He concluded overall that while the uninhabited parts of the country 'abound ... with blessings, conducing much more to health and pleasure ... these delightful countries are as yet left unpeopled, and possessed by wolves, bears, panthers, and other beasts.'[169]

Catesby's plant introductions

Although Catesby played an important role in the discovery, introduction and naturalization of a large number of North American plants and trees to England, unlike others he did not 'assume to himself the honour of the first discovery' of plants (as he noted disparagingly of the 'vain pretences' of John Mitchell).[170] His modesty has meant that his name is less associated with North American plant introductions than it might have been. The matter of whom to credit for the introduction of which species is also complicated by the existence of conflicting information by different authors, as well as by the fact that some plants flourished while others failed.[171] Thus, it is not possible to provide a definitive list of Catesby's introductions.[172]

As we have seen, Catesby was honoured for one of his introductions through having the genus named after him: the lily thorn (*Catesbaea spinosa*), found by him in the Bahama Islands (see fig. 220). He wrote: 'Near the Town of Nassau, in Providence, one of the Bahama Islands, I saw two of these Trees growing, which were all I ever saw.' He observed that its fruit 'was of an oval form, and of the size of a pullet's egg ... [it] has an agreeable tartness and good flavour, and seems as if it was capable of being improved by cultivation, but is little known.'[173] It was the 'small triangular seeds' of this fruit that Catesby distributed to many of his gardening friends on his return to England, including Knowlton and Collinson, who shared them with Powers. It was perhaps in the heated orangery at Dyrham Park that Powers had his success with *Catesbaea spinosa*. Unfortunately, in the severe winter of 1739 all the European specimens perished, although in 1760 Philip Miller managed to obtain new seeds for raising plants which he passed to Holland.[174]

When Catesby introduced *Catalpa bignonioides*, which he found in the 'remoter Parts' of South Carolina, to 'the inhabited Parts' where ''tis become an Ornament to many of their Gardens', he hoped it

would 'be the same to ours in England, it being as hardy as most of our American Plants'.[175] He sent fruits and dried specimens of it from Carolina to Sherard, Sloane and Dale, as well as bringing back seeds or possibly living plants when he returned to England (fig. 213).[176] Philip Miller recorded in 1733 that the tree was 'brought from the Bahama Islands by Mr. Catesby a few Years since', and William Aiton mentioned the 'Bignonia catalpa; introduced about 1726 by Mr. Mark Catesby'.[177] Miller further observed: 'It hath not, as yet, produc'd any Flowers in England, but is very hardy, and grows to be a handsome upright Tree.'[178] Some years later in 1745 it was amongst the 'Case of American Plants in Earth' Catesby had sent from London by his friend Dr Isaac Lawson to Linnaeus;[179] and by the time of his writing the *Hortus Britanno-Americanus*, Catesby was able to state categorically that 'it is since become naturalised in England; and did in August 1748 produce, at Mr Gray's, such numbers of blossoms, that the leaves were almost hid thereby.'[180] The subsequent success of the tree was recorded by Miller, who in 1752 could write, 'Now it is propagated pretty commonly in the Nurseries near London, and sold as a flowering Tree to adorn Pleasure-Gardens,'[181] and by 1768, 'It is now very plenty in the English gardens, especially near London, where there are some of them near twenty feet hight, with large stems, and have the appearance of trees.'[182]

Catesby was one of the earliest European naturalists to become acquainted with *Kalmia latifolia*, a shrub he described under the name of 'Chamaedaphne foliis Tini floribus bullatis umbellatis', which he found growing in Virginia and Carolina. Examples, however, were 'not common, but are found only in particular places. They grow on rocks, hanging over Rivulets, and running streams, and on the Sides of barren Hills, in a Soil the most steril and least productive I ever saw.'[183] He sent seeds and dried specimens of it to Sherard and Sloane, although surprisingly he seems not to have painted it while he was in America. Recording his repeated unsuccessful attempts at propagating it from seeds and live plants on his return to England ('After several unsuccessful Attempts to propagate it from Seeds, I procured Plants of it at several Times from America, but with little better Success, for they gradually diminished, and produced no Blossoms'), Catesby noted that Collinson was 'excited by a View of its dried Specimens, and Description of it'

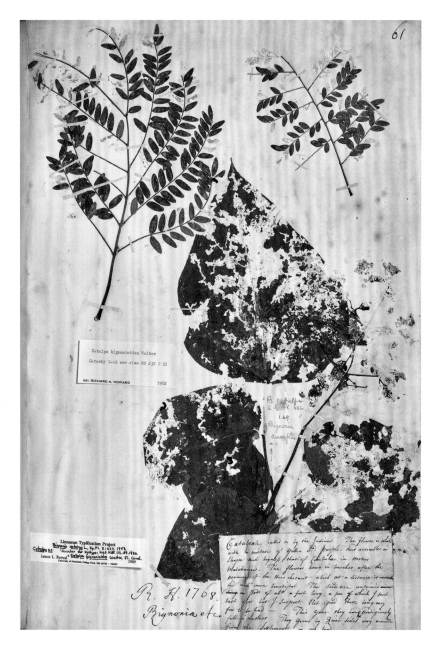

– presumably the descriptions Catesby had made in America, and perhaps the specimens he had sent either Sloane or Sherard – and as a result he 'procured some Plants of it from Pensilvania, which Climate being nearer to that of England, than from whence mine came, some Bunches of Blossoms were produced in July 1740, and in 1741, in my Garden at Fulham' (see fig. 211).[184]

Nevertheless, neither Catesby nor Collinson was given the credit for introducing the plant.[185] Instead, it was named after the Finnish botanist and pupil of Linnaeus, Pehr Kalm, who during his botanizing expedition to North America in 1748 described the ev-

FIGURE 213

Catalpa, *Catalpa bignonioides*, 1722–5. Plant specimen with Catesby's label, 54 × 38 cm.

Natural History Museum, London, Department of Life Sciences, Algae, Fungi and Plants Division, Sloane HS 212, fol. 61

ergreen shrub to Linnaeus. He wrote: 'their beauty rivals that of most of the known trees in nature; the flowers are innumerable, and sit in great bunches … Their shape is singular, for they resemble the crater of the ancients.'[186] Kalm went on to report: 'Dr Linnaeus, conformable to the peculiar friendship and goodness which he has always honoured me with, has been pleased to call this tree … *Kalmia latifolia.*'

It was Catesby, as discussed above, who was responsible for discovering the rose-coloured flowering dogwood, *Cornus florida* f. *rubra*, and who planted it both in his niece Elizabeth Jones's garden and in John Custis's in Williamsburg (see figs 184–6).[187] He sent berries of the white flowering tree several times to Samuel Dale ('The Dogwood Berries are oval and red of which I have sent often from Virginia to Mr Dale'),[188] and presumably to Fairchild too, who is credited as its first cultivator in England.[189] Later he was to send it to Sherard and Collinson from Carolina.[190] However, attempts to get the shrub to flower in England failed until Collinson recorded it as blooming in May 1761 in the garden of his friend Mr Sharp, of South Lodge, who invited him to dinner specifically to see it in flower. Collinson found it just as described and illustrated by Catesby: 'The calyx of the flowers is as large as figured by Catesby, and (what is remarkable) this is the only tree that bears these flowers amongst many hundreds that I have seen. It began to bear them in 1759.'[191]

Another shrub which Catesby introduced from the wild to gardens in South Carolina was the Carolina allspice, *Calycanthus floridus*, which he found 'in the remote and hilly Parts of Carolina but nowhere amongst the Inhabitants'; thirty years later it was growing commonly in Charleston gardens.[192] Catesby described the flowers of the shrub as 'resembl[ing], in form, those of the Star-Anemony, composed of many stiff copper-colour'd petals, enclosing a tuft of short yellow Stamina. The flowers are succeeded by a roundish fruit, flat at top. The bark is very aromatic, and as odiferous as cinnamon' (see figs 198: no. 58 and 233). Aiton recorded it as being 'Introduced 1726, by Mr Mark Catesby', suggesting that Catesby brought seeds back with him.[193]

Closer to habitation, Catesby found the American beautyberry, *Callicarpa americana*, growing in the woods near Charleston.[194] He painted its 'Clusters of very small red Flowers' and eye-catching 'Berries which succeed the Flowers [growing] in Clusters' (fig. 214) and sent seeds back to Phillip Miller. How-

ever, the shrub turned out to be one of the more difficult to naturalize, as Miller recorded:

> The seeds of this plant were sent me by Mr. Catesby, from Carolina, in 1724; and many of the plants were then raised in several curious gardens in England; most if not all of them were then raised in the open air, where they flourished very well for some years, but these were not succeeded by fruit; and in the severe frost in 1740, they were most of them destroyed … so that until the Doctor sent a fresh supply of seeds in 1744, there were scarce any of the plants living in the English gardens; but since then there has been quantities of the seeds brought to England.[195]

Catesby's name was connected with the introduction of several species of magnolia. In 1724, when Sherard wrote to ask him, 'How many Tulipfera's have you?' (fig. 215), Catesby had replied with a list and description of the three species.[196] One of these was the 'Laurel-Tree of Carolina', *Magnolia grandiflora*, of which he sent seeds to Sherard. In his second letter to Sherard written in June 1722, he described the species growing 'generally near Rivers and Bays to ye bigness of a large and tall Tree', noting: 'Its leaves very large and thick of a Shining Green the backside being of a reddish or fulvous colour which lessens much the beauty of the tree by giving it a rusty hew[.] Its flowers are very sweet and perfumes the Air[.] It is called here both laurel and Tulip Tree.'[197] He also noted elsewhere that 'their native place is Florida and South-Carolina; to the north of which I have never seen any nor heard that they grow.'[198] Catesby was closely associated with the tree during its earliest decades as a garden plant in Britain, recording its first appearance in Sir John Colleton's garden in Devon, and then in Sir Charles Wager's in Parson's Green. As discussed above, Wager's tree provided the model for the images made by Ehret which Catesby reproduced in both of his books, as well as in his 'Catalogue' (see figs 117 and 118).[199] Ten years after Catesby's death, Collinson noted that *Magnolia grandiflora* was flourishing in the Duke of Richmond's garden at Goodwood: '25 of these magnolias in his Grace the Duke of Richmond's Gardens at Goodwood / the Two largest about 20 foot high where they flower annually / and the Center Tree 17 inches in girth and the other 14 Inches ½ / 3 or 4 inches from the ground. / Octor: 2: 1759. Peter Collinson F.R.S.'[200]

Catesby recorded in the *Natural History* that the umbrella magnolia, *Magnolia tripetala*, was rare in

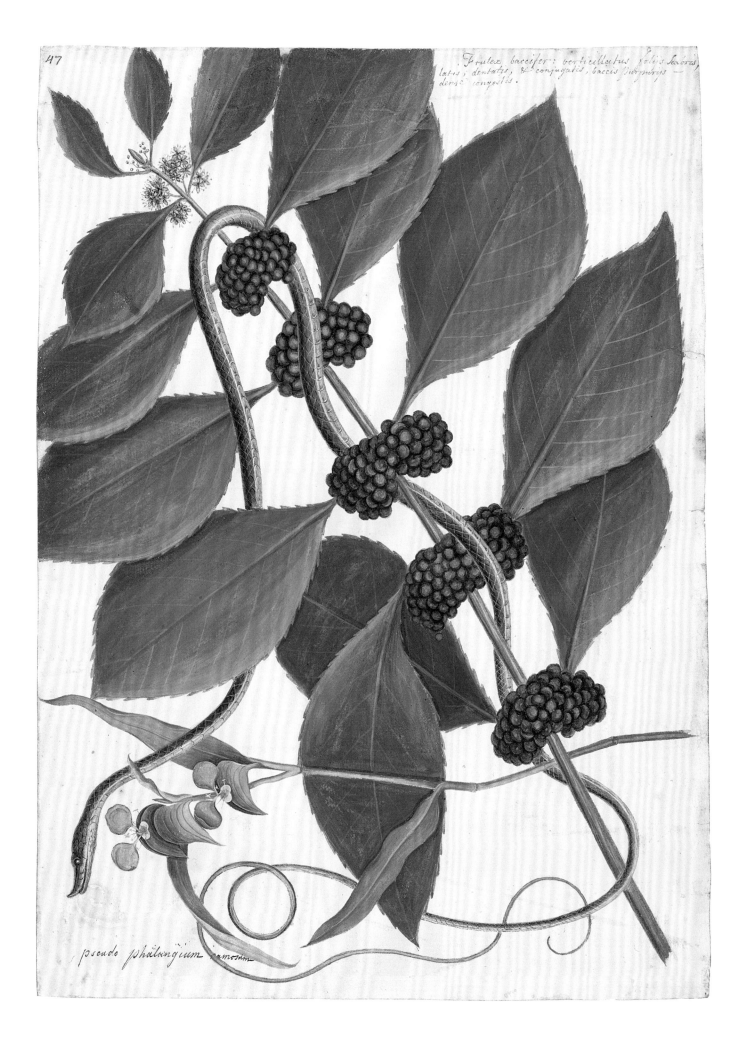

Frutex baccifer: verticillatus foliis scabris latis, dentatis, & conjugatis, baccis fimbriis — densè congestis.

pseudo phalangium ramosum

FIGURE 214

Mark Catesby, The blueish green Snake', 'Frutex baccifer, verticillatus' and 'Pseudo Phalangium', 1722–5. Watercolour and bodycolour over pen and ink and graphite, 37.5 × 27.5 cm.

Royal Library, Windsor, RCIN 925994

FIGURE 215

Mark Catesby, 'The Magnolia of Pennsylvania', 'The sweet flowering or rose Bay' and 'The Umbrella Tree', *Hortus Britanno-Americanus*, London, 1763, plates 2–4. Hand-coloured etching, 26 × 26 cm.

Natural History Museum, London, Botany Library, Special Collections

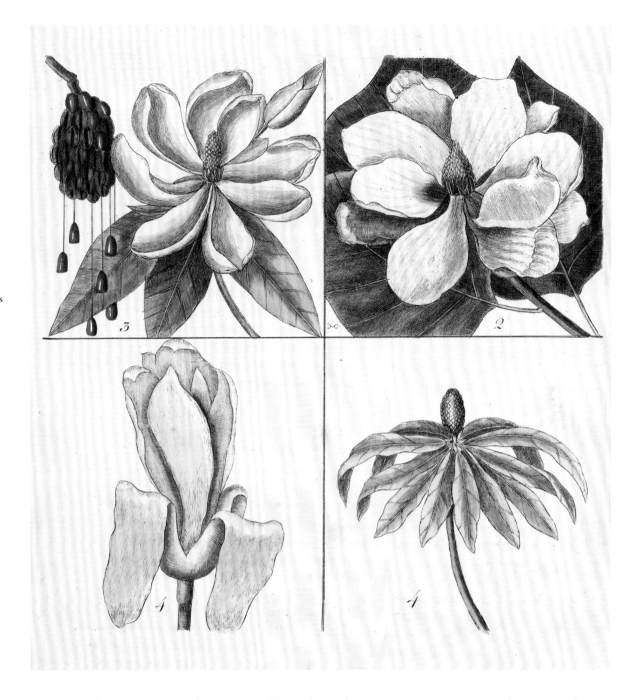

Virginia: 'I have never seen above two or three of these Trees, which grow at one place,' adding later in the *Hortus* that 'York River seems to be their most northern boundary in which they are known to grow.'[201] However, 'in Carolina they are more frequent, and grow in rich land', where, as we have seen, he found them on Alexander Skene's plantation.[202] He sent cones and seeds to Sherard together with those of *Magnolia grandiflora*.[203]

Magnolia virginiana, or sweet bay, had originally been introduced to Bishop Compton's garden by John Banister in 1688.[204] Catesby sent seeds of it several times to Sherard in 1723 and 1724,[205] although they seemed not to flourish as he later recorded that new specimens were being sent from Virginia by John Clayton: 'Specimens of this tree were first sent me in the year 1736 by my worthy friend John Clayton, Esq., of Virginia, and from the only tree known in that country. Since which, Mr. Bartram of Pensylvania has discovered many of them in that Province, from the Seeds of which I am in hopes of raising some.'[206] Later still he was

able to note in the *Hortus* that 'from the vigorous appearance of two or three very young plants now growing at Fulham, and which I believe are the only ones growing in England, there is good reason to hope this majestic tree may easily be naturalised to our northern parts.'[207]

When it came to useful rather than ornamental trees, Catesby noted 'the excellency of [the] wood' of mahogany, *Swietenia mahagoni*, 'for all domestick uses' and that it 'is now sufficiently known in England: and at the Bahama Islands, and other countries, where it grows naturally [and] it is in no less esteem for ship-building, having properties for that use excelling oak, and all other wood, viz. durableness, resisting gunshots, and burying the shot without splintering'.[208] He was amazed that the tree could become so vast growing out of rocks:

> No one would imagine, that Trees of this Magnitude should grow on solid Rocks, and that these Rocks should afford sufficient Nutriment to raise and increase the Trunks of them to the Thickness of four Feet or more in Diameter; but so it is, and the Manner of their Rise and Progress I have observed as follows: The Seeds being winged, are dispersed on the Surface of the Ground, some falling into the Chinks of the Rocks, and strike Root … and swell to such a Size and Strength, that at length the Rock breaks, and is forced to admit of the Roots deeper Penetration; and with this little Nutriment the Tree increases to a stupendious Size in a few years, it being a quick Grower.[209]

After 1721 the trade in wood from the West Indies increased dramatically with the lifting of duties from timber imported into Britain from British possessions in the Americas.[210] On Catesby's return from the Bahamas in 1726, he gave Thomas Knowlton seeds of the mahogany, hoping that it might be possible to naturalize the tree in England (fig. 216). Knowlton's grandson, also Thomas, recorded in a manuscript which was given to William Aiton that it was introduced 'before 1734, by Mark Catesby'.[211] Catesby pointed out:

> The Mahogony is a remarkable instance of how greatly beneficial some of the American trees may prove; and likewise to shew, that length of time and proper opportunities are requisite to discover their nature and uses; for this tree could not possibly have escaped observation of the first Europeans that settled in Jamaica; and yet the excellence of its wood was not

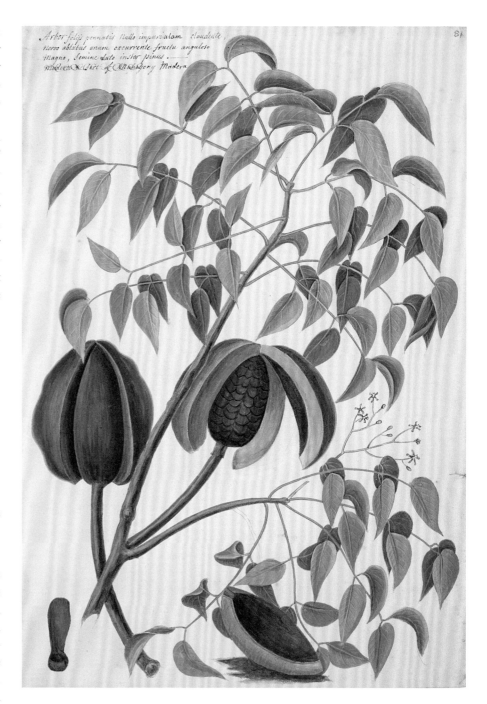

taken notice of till at least an hundred and fifty years afterwards.[212]

It was in the publications of Catesby's friends John Martyn and Philip Miller that the propagation in English gardens of some of the seeds and plants sent by Catesby from America was first recorded. In his *Historia plantarum rariorum*, Martyn included 'Aster Virginianus', already recorded as 'Mr Catesby's blue starwort' in Fairchild's monthly lists (see fig. 199),

in addition to seven plants which Catesby sent to the Chelsea Physic Garden from Carolina and the Bahama Islands.[213] One of these, the 'Brunella Caroliniana' (selfheal, *Prunella vulgaris*), Martyn recorded 'was raised in the Physick Garden at Chelsea, in the Year 1725, from Seeds sent over by Mr. Catesby[;] it has since been communicated to several other Gardens. It may be sown in the open Ground, without any care. It resists the Winters very well: and may also be propagated by parting the roots.'[214]

Two years after Martyn's publication, in the Society of Gardeners' *Catalogus plantarum* (1730), Miller recorded that a number of other North American shrubs and trees sent or brought over by Catesby had been propagated successfully by the leading nursery gardeners and were now available for purchase. One of these was the catalpa; this had recently been described and illustrated (as Plate 49) by Catesby in Part 3 of his *Natural History*, to which Miller was able to refer the reader for more information (see fig. 192): '[The catalpa] hath been lately brought from America by Mr. Catesby, and is at present very little known in England. It is hardy, and quick of Growth, but hath not yet produc'd any Flowers with us: For a farther Description, we shall refer the Reader to Mr. Catesby's *Natural History of Carolina*, which he is about publishing.'[215]

Catesby's introductions of North American plants occurred at the beginning of the early eighteenth-century revolution in horticulture, when the 'extended rural designs' described by Miller were superseding the earlier taste for artificiality and formality in gardens.[216] Vital to the success of Catesby's horticultural activities was his first-hand experience of observing plants growing in the wild, together with the collecting and transporting techniques he developed over the years as a field collector in North America and the West Indies.[217] However, the quantities of seeds and plants which he sent back and brought home with him constituted only one stage of a long and complicated process of naturalization. His part in this process, involving repeated attempts at introduction and experimentation, is therefore often obscured.

Importantly, however, Catesby's legacy as an introducer of North American plants is dependent not just on the plant specimens he brought or had sent over and helped to raise, but on the illustrations made for the *Natural History*, later adapted for the *Hortus Britanno-Americanus*. These images inspired garden owners with their first view of the beauty of many exotic New World species and spurred them on to attempt to cultivate them.[218]

An assessment of Catesby's contribution as a horticulturist, therefore, is inseparably linked to his work as a naturalist and as an artist. As a naturalist and collector, one of his aims was to identify plants in the wild that had hitherto been unremarked and to introduce them to gardens in America and England. To do this successfully involved a scientific interest in botany and significant horticultural skill. As an artist, his detailed observation of plant life, together with his eye for form, variety and colour, allowed him to create permanent records from the ephemeral subjects of the gardens and landscapes he helped to transform.

Sir London 26 March 1745

Printed in Linn. Corresp.
v. 2. 440.

On board the assurance Capt. Fisher ———
is a Case of American plants in Earth, They a
a present to you from my good friend Dr Lawson.
I knowing this his intention by his consulting me to kno
what plants I thought would be acceptable, I selected the
as being hardy and Naturallised to our Climate & consequently
somewhat better adapted to endure your colder Air, yet I wis
they do not require as much protection from the severity of you
Winters, as plants from between the Tropicks do with us ——
possibly you have already some of them, yet if but a few of
them be acceptable I shall be much pleased, And whatev
other American plants in this inclosed Catalogue will be
acceptable, you may freely command any that I am
possessed of — In regard of that Esteem your merit clain

I am Sir

Your most Obedient
Humble Servant
M. Catesby

N1 This case of plants were
intended to be sent last May
and they were sent to the ship
with the consent of the Skipper
yet they were refused to be taken
on board

Cypressus Americanus
Linden. Arbor Tulipifera
Cornus Americ:
Populus Nigra Carol:
Bignon. Periclymenum
Purple. Barba jovis Arborescens
Phaseoloides
Arbor Virg: Citriæ folio
Even. Euonimus Americ:
Aster Americ: frutescens

Lychnidea flore purpureo
Stirax Aceris folio
Bignonia — Catalpa
Angelica Spinosa
Pseudo Acacia
Anopodophyllon Canadense
Phaseoloides frutescens
Rubus Americanus

CHAPTER 6

Catesby as Naturalist

'[Here] is a large feild for someone for natural inquirys, and tis much to be lamented
that we have not some people of skil and curiosity amongst us.
I know of no body here capable of makeing very great discoverys.'[1]

William Byrd wrote these words to Sir Hans Sloane six years before Catesby arrived in Virginia in 1712. During the seven years Catesby spent exploring the natural history of Virginia and the West Indies, he was to prove himself to be exactly the naturalist Byrd had hoped for. Throughout this first period in the New World, Catesby was honing his skills as a collector in the 'feild … for natural inquirys' and, in so doing, laying down the foundations for his subsequent collecting trip in South Carolina and the Bahama Islands. As Stephen Harris notes of Catesby's botanical work, 'scientific plant collection – getting a plant from the field to the herbarium, where it may be studied in detail – is a complex process. The skill and decisions made by a collector in the field determine a specimen's scientific value.'[2] Catesby's botanical and zoological knowledge, keen observation, systematic collecting programme and methods for preserving and transporting material, together with the interpretation of his findings, were models of their kind, and all contributed to the esteem in which he came to be held by the academic naturalists and collectors in England. This chapter explores each of these aspects of his work.

Catesby's achievements, however, were more far reaching than as collector 'of skil' for the curious. He lived at a period when the world of science was on the cusp of change, when systems of classification and nomenclature were being revolutionized, and when scientific knowledge was to begin the process of evolution into a scholarly discipline and the natural philosopher to morph into a professional scientist.[3]

While Catesby was working on the first volume of his *Natural History* Linnaeus brought out the first edition of his seminal publication, the *Systema naturae* (1735). Such was the respect in which Catesby was held by the Royal Society that in December of that same year he was asked to review Linnaeus's publication, a copy of which had been sent to him by Johan Gronovius.[4] During the decade following Catesby's death, it was the expanded edition of Linnaeus's *Systema naturae* (tenth edition, 1758), together with the first edition of his *Species plantarum* (1753), that subsequently became the starting point for modern botanical and zoological nomenclature. Linnaeus's revolutionary ways of cataloguing and naming animals and plants, however, came just too late for Catesby, whose work had been carried out for the *virtuosi* or gentlemen amateurs of the Royal Society.[5] Nonetheless, as his twentieth-century biographers noted, it was 'on the foundations laid by Catesby [that] the great systematists of an age of systems built their grand taxonomic structures'.[6] Although Catesby did not live to see the fruits of these developments, he played a significant part in helping to bring them about.

Linnaeus's extensive use of Catesby's *Natural History* in both his *Species plantarum* and *Systema naturae* means Catesby's book retains significance in botanical and zoological nomenclature.[7] Of the 187 plants illustrated by Catesby in the 220 plates of his book, 131 were to be cited by Linnaeus and given new binomial names, and about forty of them were to serve as type specimens: the individual chosen by a taxonomist – based either on a physical specimen or on

FIGURE 217

Mark Catesby's letter to Carl Linnaeus, 26 March 1745. Detail of fig. 250.

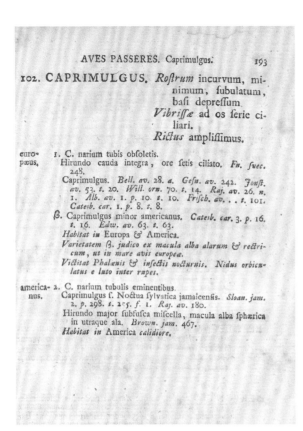

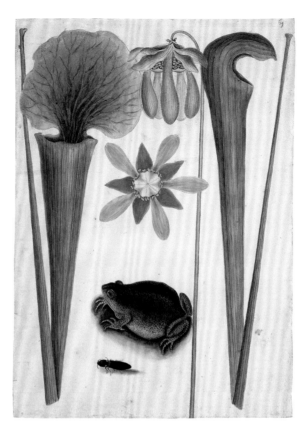

FIGURE 218

Carl Linnaeus, entry for 'Caprimulgus' citing Catesby's plate and text (at *Natural History*, Appendix, 16), *Systema naturae*, Stockholm, 1758, I, p. 193. 20.5 × 12.5 cm (leaf size).

Cambridge University Library, S382.d.75.1

FIGURE 219

Mark Catesby, 'The Land Frog', 'Sarracena, foliis longioribus' (yellow or Catesby's pitcherplant, previously *Sarracenia × catesbaei*); right hand leaf now recognised as hooded pitcherplant, *Sarracenia minor*, 1722–5. Watercolour and bodycolour heightened with gum, over graphite, 37.5 × 36.5 cm.

Royal Library, Windsor, RCIN 26020

an image of one – to serve as a reference point for a new scientific name.[8] Of the 257 zoological subjects described and illustrated by Catesby, 139 were to be cited by Linnaeus (the majority of these were birds and fishes, but they also included amphibians, reptiles, and insects and other invertebrates) (fig. 218).[9] But even before this, Linnaeus had cited Catesby's newly published plates in his *Hortus Cliffortianus* (1737), the sumptuous illustrated catalogue of the plants growing in the Anglo-Dutch banker George Clifford's garden in the Netherlands, which in some ways was a forerunner to the *Species plantarum*.[10] Catesby was also to be commemorated in the generic *Catesbaea* (Rubiaceae) and in a number of plant species names (fig. 219).[11] He included his image of the lily thorn, *Catesbaea spinosa* (Rubiaceae), with a characteristically modest postscript as the last plate of the *Natural History* (fig. 220).[12] Catesby's recognition in animal species names included his iconic American bullfrog (*Lithobates catesbeianus*) (fig. 221) and five of his snakes.[13] Later in the eighteenth century the naturalist Johann Reinhold Forster, who sailed with James Cook on his second voyage, was to use Catesby's *Natural History* as one of the sources for his *Catalogue of the Animals of North America* (1771).

This was the first book on North American fauna to incorporate Linnaean binomial nomenclature, and Catesby was cited particularly for his birds, fishes, amphibians and reptiles.[14] Subsequent eighteenth- and nineteenth-century botanical and zoological publications also cited Catesby, and his comments and illustrations continue to be cited in scientific literature to the present day.[15]

Collecting in the field

The plates and descriptions of the *Natural History* upon which Linnaeus built were the culmination of Catesby's collecting activities in the New World. What enabled him to produce them were his years of careful observation and the development of systematic collecting strategies in the field. Such expertise was a fundamental aspect of his work as a naturalist. In addition to his organizational skills and efficient collecting methods, and his knowledge of botanical collections and literature, however, he also had the character and stamina to cope with the physically challenging and dangerous activity of collecting flora and fauna in the wild.[16] The botanist and Linnaean scholar William T. Stearn noted: 'Botanical explo-

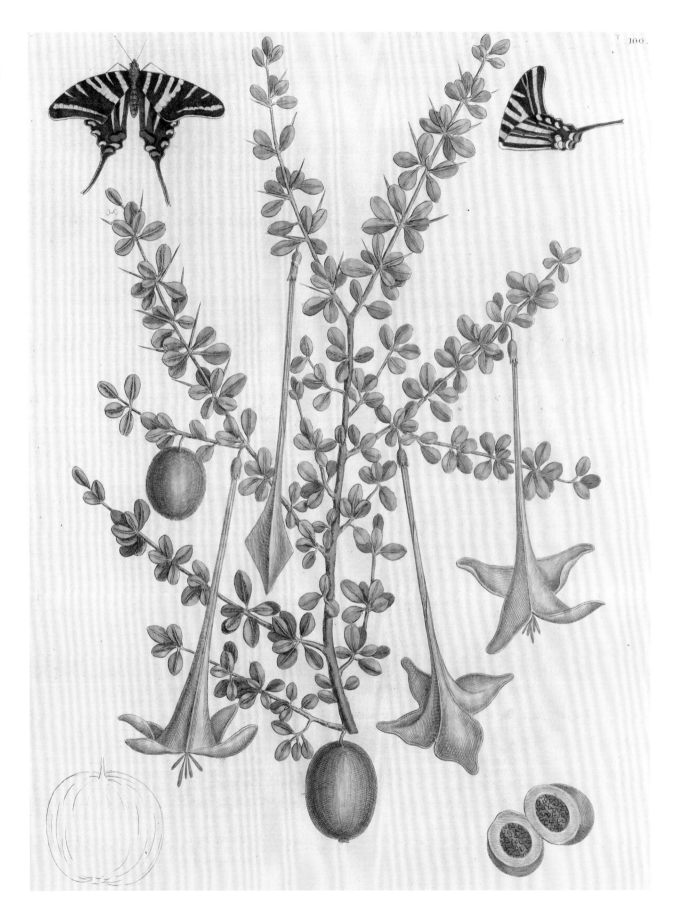

Mark Catesby, 'Frutex Spinosus Buxi foliis' (*Catesbaea spinosa*) and 'Papilio caudatus Carolinianus', *Natural History*, 1743, II, plate 100. Hand-coloured etching, 51 × 35 cm.

Royal Society of London

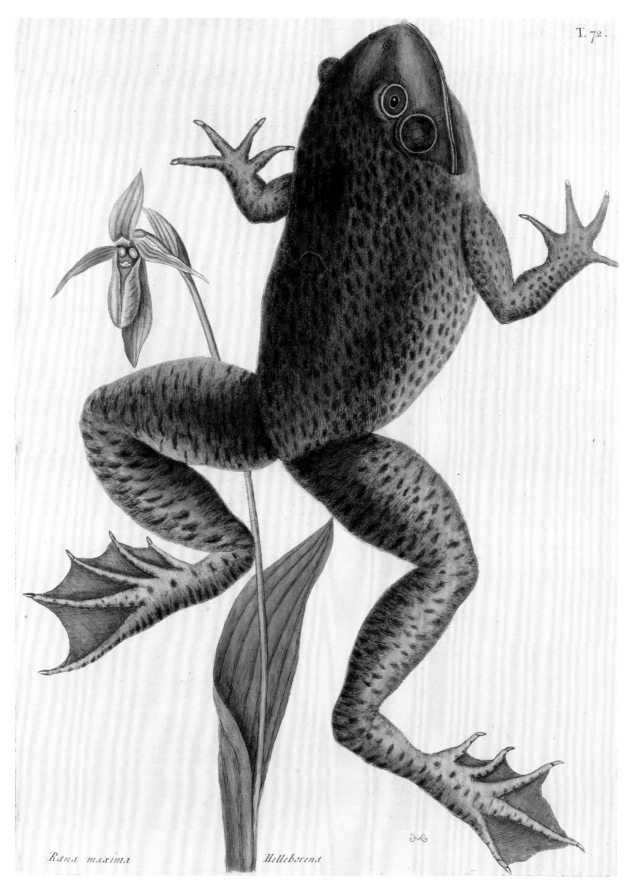

T. 72.

Rana maxima Helleborena

FIGURE 221

Mark Catesby, 'The Bull Frog'
(*Lithobates catesbeianus*) and
'The Lady's Slipper of
Pensilvania', *Natural History*,
1743, II, plate 72. Hand-coloured
etching, 51 × 35 cm.

Royal Society of London

ration calls for more than botanical knowledge. It calls for curiosity, zest, mental tenacity and a capacity to endure drudgery, hard work, discomfort and privation.'[17] Catesby possessed such qualities. Often travelling long distances with Native Americans and other local inhabitants, avoiding the dangers of wild animals and warring tribes, sleeping rough in extreme weather, and living off the products of hunting and fishing, he typically made light of the discomfort of working in the field. By contrast, the letters of the Welsh naturalist Thomas More, sponsored by Sherard to collect in New England, are dominated by complaints of 'drudgery, hard work [and discomfort]'.[18] Above all, Catesby displayed the single-minded focus and dedication of the born naturalist – summed up simply by him as his 'passion … for Plants and other productions of nature'.[19]

There is no doubt that Catesby would have set off for his role as collector fully prepared with a knowledge of the travel literature available and of the work accomplished by his predecessors. Robert Boyle's *General Heads for Natural History, proposed for Travellers and Navigators* (1692), and broadsheets by John Woodward (1696) and James Petiver (undated), were amongst the texts for natural history collectors. They directed what equipment the collector should take, not only for collecting but for preparing the items for preservation and packing for transportation back to England. Woodward's 'Directions for the Collecting, Preserving and Sending over Natural things from foreign countries' covered minerals and fossils, plants, fungi, animals and ethnographic objects under fifteen headings.[20] Petiver's 'Brief Directions for the easie making, and preserving collections of all natural curiosities' concentrated most fully on his main interests: plants and insects.[21]

Catesby also had the examples of his predecessors John Banister and John Lawson. Initially sponsored as a collector by Bishop Compton and later encouraged by William Byrd I, Banister had spent over ten years in Virginia up until his death in 1692, collecting plants and describing the botany of the colony.[22] His dedication to botany, together with his talent and passion, provided Catesby with an example of a colonial field naturalist who explored, collected, taught himself to draw specimens, compiled catalogues and accounts, and planned an illustrated 'natural history of Virginia'. Catesby may have considered that he was following on from where Banister left off.[23] Certainly, having the active encouragement

of William Byrd II, access to Banister's books in Byrd's library at Westover, and introductions to Virginians with shared interests all contributed to the ideal environment for Catesby to pursue his collecting and exploring activities. Between 1700 and 1706 Hans Sloane and James Petiver had enlisted a group of local individuals in South Carolina to collect natural history specimens for them.[24] Petiver sent out brown paper and other collecting materials, and in return large consignments of plant specimens, marine molluscs and insects were sent to him, as well as fossils collected on the banks of the Ashley River. Some of this material was published in 'An Account of Animals and Shells sent from Carolina to Mr. James Petiver, FRS' in *Philosphical Transactions*, with which Catesby would have been familiar.[25] It was also during this period that John Lawson made his journey by canoe from Charleston to North Carolina, where he settled and became surveyor general. As we have seen, his *New Voyage to Carolina* (1709), with its reissue, *The History of Carolina* (1714, 1718), was an important influence on Catesby, with its list of over 300 species of plants and around 150 animals.[26]

'Occular testimony'

Catesby built on the work of his predecessors in the field with his own observational skills. John Woodward had urged collectors: 'For the time of making Observations none can ever be amiss, nor indeed hardly any place wherein some Natural Thing or other does not present it self worthy of Remark.'[27] This emphasis on the empirical method promoted by the Royal Society – the importance of direct observation and analysis, or what Catesby himself described as 'occular testimony' – was clearly congenial to him.[28] Throughout the *Natural History* and elsewhere in Catesby's surviving writings, his keen observational practices are in evidence. Already during the first stage of his explorations in Virginia and the West Indies, he demonstrated both a naturalist's eye and an adventurous spirit. In 1714, while in the Bermudas, he climbed the high rocks surrounding the islands in order to shoot breeding white-tailed tropicbirds, *Phaethon lepturus*, 'but those clifts being inaccessible, prevented my seeing their nests and eggs'.[29] Ocular testimony involved him in the 'most patient Observation' of animal behaviour,[30] watching the interaction of species with their environment, recording variations within the same species, carrying out

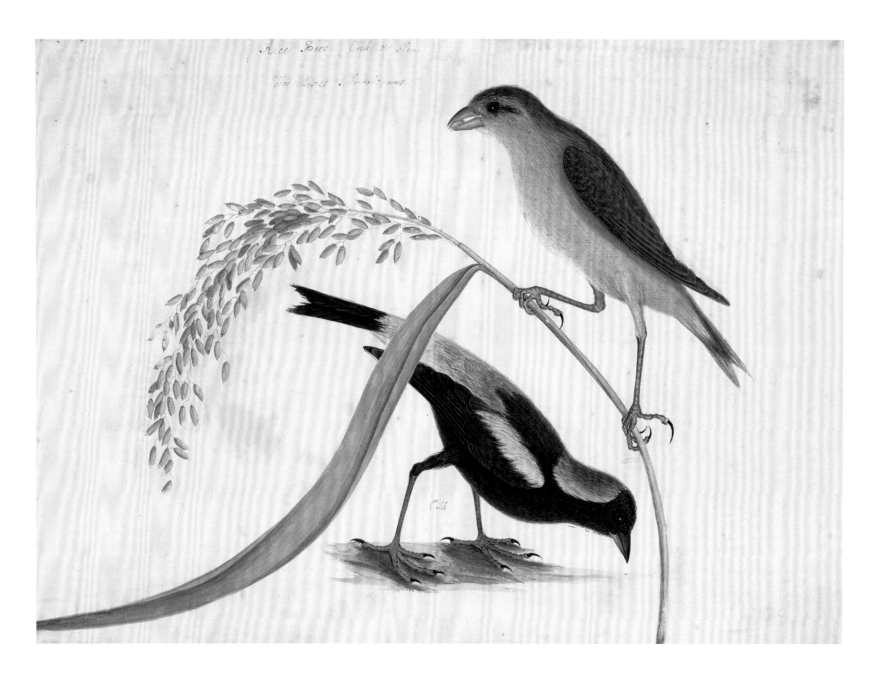

anatomical dissection, inspecting organisms under a microscope, and developing theories based on his observations. Amongst the last was his theory on the migration of birds prompted by hearing flocks of bobolinks, *Dolichonyx oryzivorus*, flying overhead on three consecutive nights as he lay on a sloop in a bay at Andros Island in September 1725 (fig. 222).[31]

Catesby's lively descriptions reveal a spontaneous delight and absorption in the animal world. He commented with pleasure and precision on the beauty, variety, movement and sometimes astonishing features of animal behaviour. After long hours of concentrated watching of the spider-hunting and

nest-building activities of the blue mud wasp, *Chalybion californicum*, he wrote:

> It is to be observed, that the Wasp cripples its Spiders, with an intent not only to disable them from crawling away while she is accumulating a sufficient store of them, but also that they continue alive to serve the nympha with a supply of fresh food, till it enters into its change; in order for which it spins itself a silken case, in which it lies in its chrysilis state all the Winter, and in the spring gnaws its way through the clay-structure and takes its flight. They are silent, but in the very action of plaistering and forming their fabricks,

FIGURE 222

Mark Catesby, 'The Rice-Bird' and rice (*Oryza sativa*), 1725–6. Watercolour and bodycolour heightened with gum, over pen and ink and graphite, 26.8 × 37.3 cm.

Royal Library, Windsor, RCIN 924827

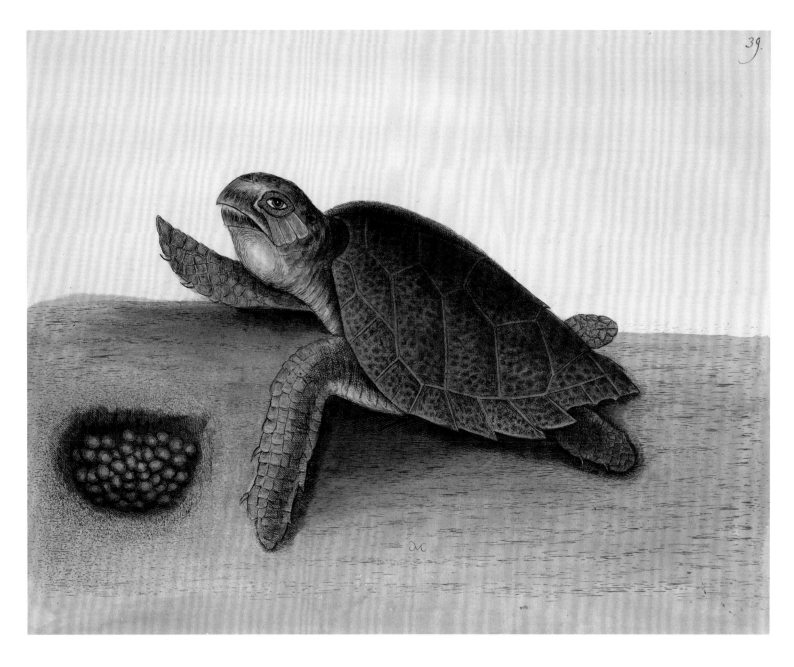

FIGURE 223

Mark Catesby, 'The Hawks-bill Turtle', *Natural History*, 1743, II, plate 39. Hand-coloured etching, 51 × 35 cm.

Royal Society of London

which, so soon as they set about they strike up their odd musical notes, and with surprising dexterity and odd gesticulations cheerfully perform the business they are about, and then cease singing, till they return with a fresh mouthful of moist clay, repeating their labour in this manner till the whole is finished.[32]

In the Bahamas he was diverted by the annual breeding migration of purple land crabs, *Gecarcinus ruricola*, during which they 'descend the Hills in vast Numbers to lay their Eggs near the Sea, whatever they meet with in their Passage they go over, never going aside let Houses, Churches or what will stand

in their Way: They have been known to enter in at a Window, and on a Bed, where People who never before had seen any, were not a little surprised.'[33] He observed that although most species of marine turtle were usually 'timerous and make little Resistance when taken, in time of Coition all the kinds are very furious and regardless of Danger.' An example was the male green sea turtle, *Chelonia mydas*, which

> Copulates by the help of two Horns or Claws under his fore-Fins, by which he holds and clings to the fleshy Part of the Neck of the Female: They usually continue in Copulation above 14 Days ... They never go on

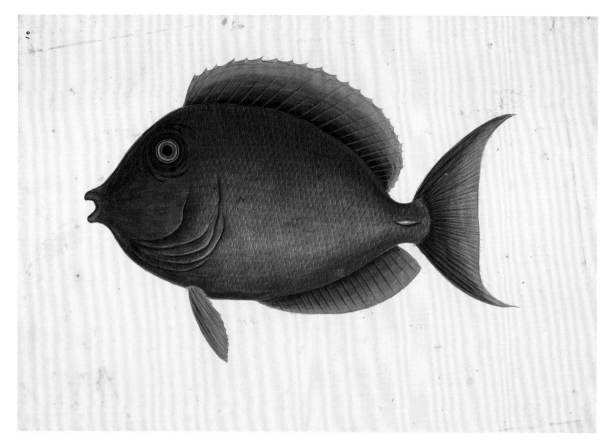

FIGURE 224

Mark Catesby, 'The Tang', 1725–6. Watercolour and bodycolour over pen and ink and graphite, 27 × 37.5 cm.

Royal Library, Windsor, RCIN 925951

Shoar but to lay their Eggs, which is in April; they then crawl up from the Sea above the flowing of high Water, and dig a Hole above two Feet deep in the Sand, into which they drop in one Night above an hundred Eggs, at which Time they are so intent on Natures Work that they regard none that approach them, but will drop their Eggs into a Hat if held under them.[34]

Just such a nest appears in the image of the hawksbill turtle, *Eretmochelys imbricata* (fig. 223). Catesby recorded dramatic accounts of predation among marine animals, noting that such 'accidents I have often been diverted with in the shallow seas of the Bahama Islands; where the water is so exceeding clear, that the smallest shell may be distinctly seen at several fathom dept, when the water is smooth'. Among these was the 'swift Swimming and very voracious [barracuda, *Sphyraena barracuda*]' 'some of the largest size [of which] have frequently attacked and devoured men, as they were washing in the Sea'.[35] On one occasion, he watched fascinated a barracuda 'pursue and bite off a third Part of [the tang, *Acanthurus coeruleus*] behind; which when he had swallowed he deliberately bit off half the remain-

ing Part, and devoured the whole Fish at the third mouth-full' (fig. 224).[36]

Observing raccoons catch oysters and crabs by the sea, he was intrigued by the way that, when they thrust their paws into oysters to 'disable them', 'they are often catch'd by the sudden closing of it, and held so fast (the Oyster being immoveably fixed to a Rock of others) that when the Tide comes in they are drowned.'[37] And on one occasion he relished witnessing the moment when a 'water viper', *Agkistrodon piscivorus*, met its match in a catfish, *Ameiurus catus*: 'One of these ['water vipers'] I surprized swimming a Shore with a large Cat-Fish … [which had] two sharp bones, on each Side of its Gills, which were so fixed in the Jaws of the Snake, that he could not disengage himself with all his Twists and Distortions, and in that Condition being in Danger of drowning, was necessitated to swim a-shore, where the Murderer was slain.'[38]

Catesby clearly considered examining the contents of animals' stomachs and other anatomical details a necessary part of his observations as a naturalist (fig. 225).[39] Dissecting a dead raccoon, perhaps one of those he had watched drown by fishing for

oysters, he found that 'Through their Penis runs a bone in form of an S.' Querying the reasoning behind alligators' swallowing stones to aid their digestion, he noted that 'in the greater Number of many I have opened, nothing has appeared but chumps of Light-wood and Pieces of Pine-Tree Coal, some of which weighed eight Pounds, and were reduced and wore so smooth from their first angular roughness, that they seemed to have remained in them many Months.'[40] 'In the maw [of the oystercatcher] was found nothing but indigested Oysters,'[41] while the stomach of the 'goat-sucker' 'was filled up with half-digested Beetles, and other insects; and amongst the remains there seemed to be the feet of the Grillotalpa, but so much consumed that I could not be certain.'[42]

Pondering the resemblance between the white ibis, *Eudocimus albus*, and its juvenile (which he misidentified as another species he named the 'brown curlew'), he suspected 'they differed only in sex, but by opening them, I found testicles in both the kinds.'[43] Attempting to discover males amongst the 'infinite swarms' of bobolinks that arrived in September, 'by opening some scores prepared for the spit, I found them to be all Females.' However, when he repeated the experiment in spring he found that 'both sexes were plainly distinguishable.'[44] His image of the bird is the only one in which he intentionally depicted both male and female of the species.[45]

Spending so much time in the wild observing plant and animal life, Catesby could not but be

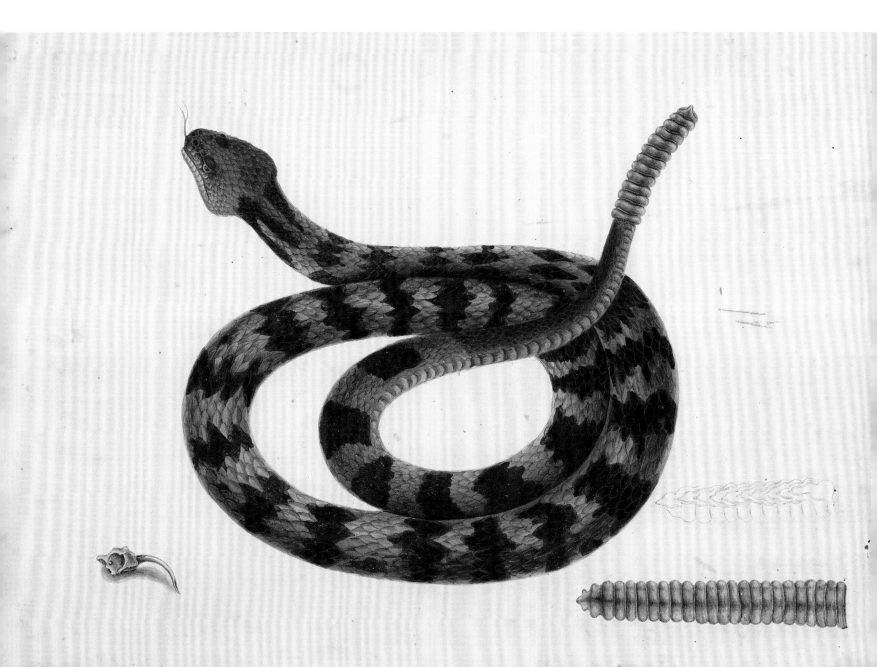

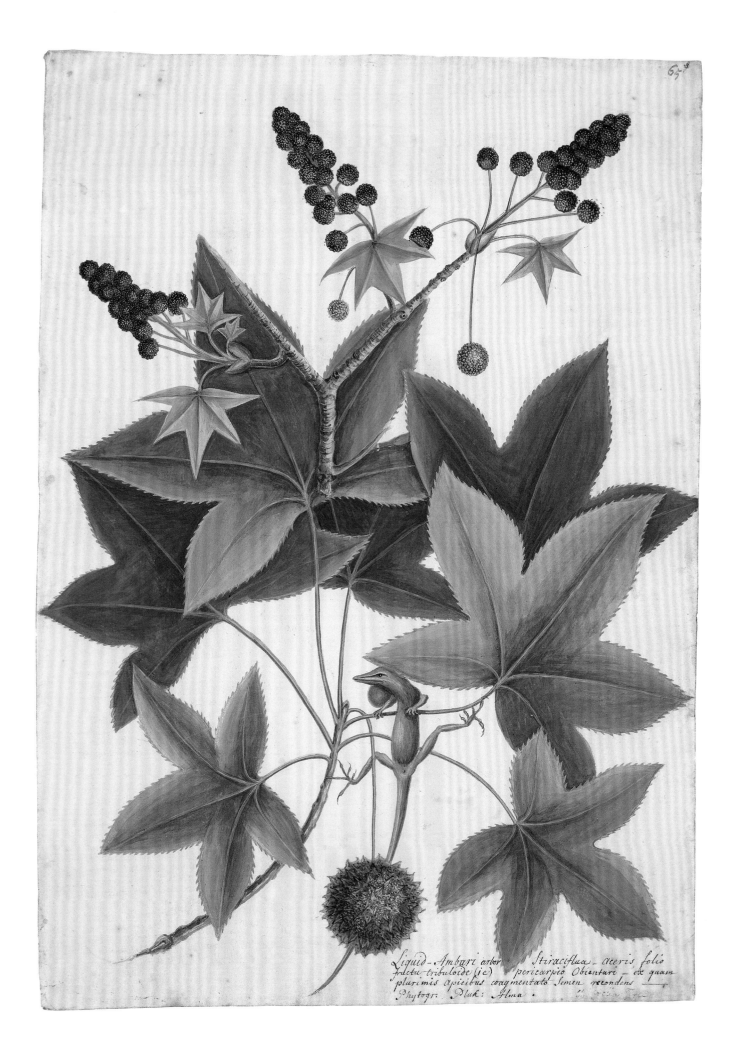

Liquid-Ambari arbor Stiraciflua aceris folio
fructu tribuloide (ic) pericarpio Orientari ex quam
plurimis apicibus coagmentato Semen recondens
Phytogr. Pluk: Alma.

aware, often in wonderment, at the 'great Design' by which flora and fauna were adapted to each other. Such adaptation did not simply include the relationship of animals 'to the Plants which they feed on and frequent';[46] he was equally struck by how different aspects of the natural world reflected each other visually in shape, colour and form, connections he described not only in his images, as we have seen, but in his written observations. He noted how camouflage for defence and/or predation was one reason for such visual similarities. In the case of the alligator:

Nature seems in some measure to have recompensed their Want of Agility, by giving them a Power of deceiving and catching their Prey, by a Sagacity peculiar to them, as well as by the outer Form and Colour of their Body, which on land resembles an old dirty Log or Tree, and in the Water frequently lies floating on the Surface, and has the like Appearance; by which and his silent Artifice, Fish, Fowl, Turtle, and all other Animals are deceived, suddenly catch'd, and devoured.[47]

He watched the ways in which the 'Green Lizard of Carolina' (green anole, *Anolis caroliniensis*) 'change their colour, in some measure, like the Camelion; for in a hot day, their colour has been a bright green; the next day, changing cold, the same Lizard appeared brown' (fig. 226).[48] With the 'Green-Lizard of Jamaica' (Graham's anole, *Anolis grahami*) he observed the process now known as aposematism, in which a colour change can act as a warning signal to predators: 'When they are approach'd to, they by filling their Throat with Wind, swell it into a globular Form, and a scarlet Colour, which when contracted the red disappears, and returns to the Colour of the rest of the Body. This swelling Action seems to proceed from menacing, or deterring one from coming near him, tho' they are inoffensive.'[49] And in the land hermit crab, *Coenobita clypeatus*, he admired another sort of adaptation where 'Nature has directed it for the Security of that tender Part to get into and inhabit the empty Shell of a Fish that best fits its Size and Shape: When the Crab grows too big for the Shell to contain, it leaves that and seeks another more commodious, so continues changing his Habitation as he increases in largeness' (see fig. 241).[50]

During Catesby's earlier stay in the New World when he visited several islands in the West Indies, he made notes on how the same species of cedar tree, *Juniperus* sp., manifested variations according to its island or mainland habitat as well as between individual islands.[51] Many years later he reported his findings in a letter to Dillenius:

Nor could I when in Bermudas distinguish any material difference between the Ceders of that Island and those on the Continent except that their Leaves are generally thicker and more succulent. I find in some written observations I made when there that their stems grow to a greater heigh[t] without leaves, their heads not so spreading and being generally taller & handsomer trees than those of the Continent[,] all which difference may proceed from a very different soil which is throughout the Island a white Chalky Rock. Another remark of them made was this, that this Island being placed as it were between the Torrid & Temperate Zone has not the scorching heats of the one nor the ridged cold of those Countries … many of which altered so much from those I had lately seen in Jamaica & Hispaniola that it was some time before I could determine them to be the same kind.[52]

Such observations led him to theorize about the effect of climate on growth patterns. For instance, the 'Plat Palmetto' (palmetto palm, *Pseudophoenix sargenti*), a tree 'whose leaves were formerly made into hats, bonnets, &c. and … the berries [into] buttons', showed growth variations he concluded were caused by climate differences: 'In the year 1714, I observed all these Islands [the Bermudas] abounding with infinite numbers.' Consulting the local inhabitants, he learned that, 'with their nicest observations, they could not perceive them to grow an inch in height, nor even to make the least progress in fifty years.' However, he later noted that trees of the same species in South Carolina were growing to their 'usual stature, which is about 40 foot high', and concluded that the 'smallness of the Northern ones, is occasioned by their growing out of their proper climate.'[53] He made similar observations of the pawpaw noting: 'The fruite here tho eaten is not very delicious but in the West Indies its' a very delicate fruite if it be the same which its' said it is[,] showing what alteration that Clymate makes in the fruit.'[54] In this instance, however, he was misled, as the papaya of the West Indies, *Carica papaya*, is a different plant.

As these comments demonstrate, Catesby made his observations of the natural world on the basis of examining, where possible, multiple examples of plant and animal species. When it came to animals, he recorded characteristics such as size, weight,

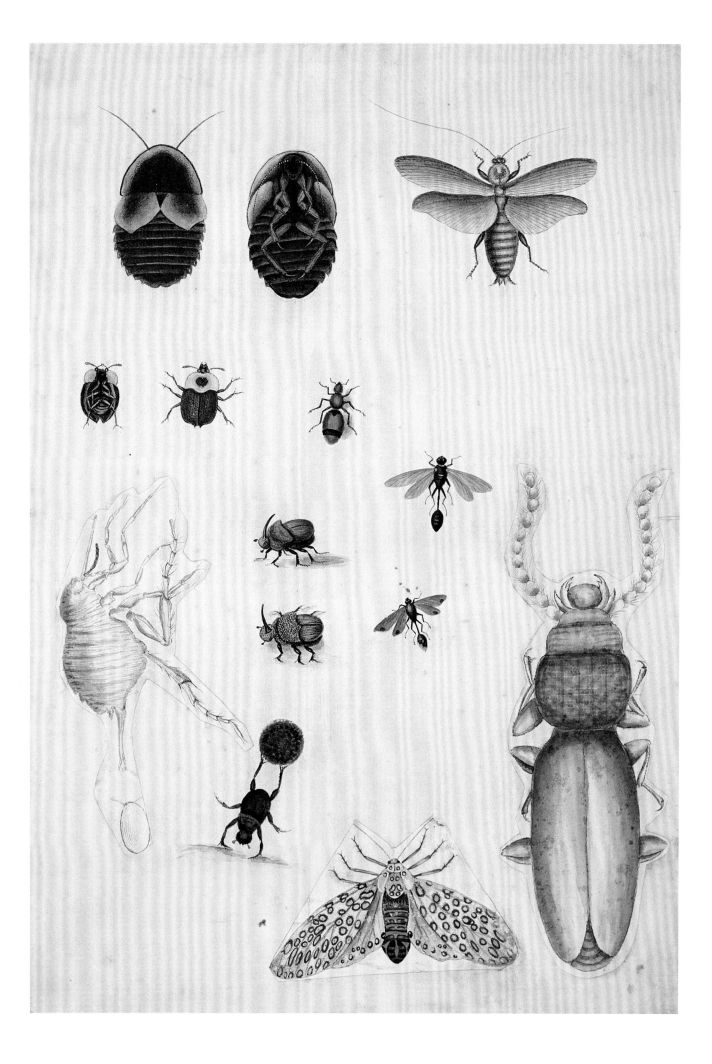

colour, gender, diet, flight, calls and anatomical findings on the basis of repeated examples rather than from a random sample. Equally rigorously, he tested information imparted by the local inhabitants both against his own findings and against the published material available to him. Thus, he wrote, 'It is commonly reported that these Turkeys weigh sixty Pounds a piece, but of many hundred that I handled, I observed very few to exceed the Weight of thirty Pounds.'[55] In his discussion of hummingbirds, he commented: 'Hernandes bespeaks the Credit of [i.e. misleads] his Readers: 'tis no idle Tale, when he affirms the Manner of their lying torpid, or sleeping, all Winter; in Hispaniola, and many Places between the Tropicks. I have seen these Birds all the Year round there being a perpetual Succession of Flowers for them to subsist on.'[56]

Microscopical examination of the natural world had been an integral part of scientific research in the Royal Society since its foundation when Robert Hooke was appointed as curator of experiments.[57] For as keen an observer as Catesby, examining objects under a lens to discover details not visible with the naked eye had great appeal, and later in his life he became a friend of fellow member of the Royal Society, Henry Baker, who wrote that 'by the help of Glasses … [we can] admire the minutiae of nature.'[58] While he was in the Bahamas, Catesby had use of what appears to be one of the earliest recorded mentions of a microscope in the American colonies.[59]

In 1725, during the course of his stay with the governor, George Phenney, Catesby recorded examining under a microscope the parasites that Phenney was extracting from his feet. With this microscope he produced magnified images and accounts of the parasitic chigoe flea of the tropics, *Tunga penetrans*, and a beetle (possibly belonging to the family Carabidae) discovered by Phenney 'as he was searching of his feet for Chegoes'. Catesby drew both in monochrome, as they would have appeared magnified, noting of the beetle: 'The natural size of this Insect was that of the spot over its head; but magnified, it appeared of the size and form here exhibited' (fig. 227).[60] Of the flea he wrote:

> This Insect, in its natural size, is not above a fourth part so big as the common Flea, but magnified by a microscope it appeared of the size of the figure here represented … It had six jointed legs, and something resembling a tail, under which is represented one of its eggs, the size of which is so small that it can hardly be discerned by the naked eye; but magnified by a glass, appeared as here represented.

These are the only images Catesby appears to have made under magnification. He might have had the use in the field of a portable microscope such as one Baker described and illustrated as the 'Mr Wilson's Single Pocket-Microscope', a single screw barrel into which different strength lenses could be fitted (fig. 228).[61] However, apart from the occasion with Governor Phenney, it may not have been until Catesby returned to London that he began to use a microscope regularly, as it is only from the 1740s that he mentioned using one.[62] In his written description of the 'The Porcupine of North America' included in the *Natural History*, he noted that 'the Point of every Quill is very sharp and jagged, with very small Prickles, nor discernible but by a Microscope.'[63] George Edwards, who included 'The Porcupine from Hudson's Bay' in his *Natural History of Uncommon Birds*, illustrated 'the Point of a Quill magnified', which suggests that perhaps he and Catesby might have studied porcupine quills under a microscope together (fig. 229).[64] Catesby also used a microscope to inspect the fruit of *Rhus glabrum* growing in Christopher Gray's nursery, noting: 'The berries that compose the panicles are yellow, thick set with numerous filaments, or small threads of a purple or scarlet-colour, best discerned by a Microscope, which, receiving a reflexion from the yellow,

Pl. I.

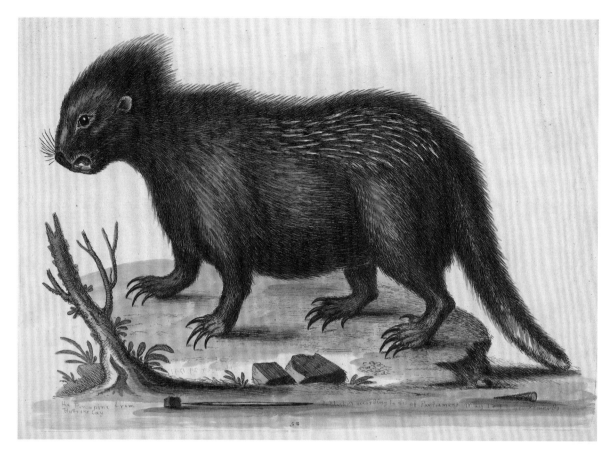

FIGURE 229

George Edwards, 'The Porcupine
from Hudson's Bay' with 'a Quill
of its natural Shape and Size, and
the point of a Quill magnified',
*A Natural History of Uncommon
Birds*, London, 1743–51, I, plate
52. Hand-coloured etching,
22.5 × 29.1 cm.

Cambridge University Library,
Syn.4.74.4

causes the scarlet colour, which nothing can excel,
more especially when the sun shines upon it.'[65] A
study of the shrub made by his friend Ehret was used
by Catesby as the model for a plate in the Appendix
to the *Natural History* (fig. 230).[66]

Collecting in the field: flora

Botany was the primary area in which Catesby was
involved as a collector while he was in North Amer-
ica and the Caribbean. Not only were plants the
'natural productions' most eagerly sought after by
his patrons for their multiple uses – in medicine,
scientific botany, horticulture and agriculture – but
Catesby's personal interest in horticulture led him
to concentrate on the plant world.[67] Thus, while he
observed, collected and drew other areas of the nat-
ural world, plants occupied the greatest part of his
collecting energies, and were also to provide the
unifying thread of his *Natural History*. The survival of
hundreds of his herbarium specimens, together with
some of their labels, in addition to his letters from
Carolina to Sherard and Sloane and several other

patrons, provide valuable information about the
methods Catesby developed for plant collecting.[68]

On arrival in South Carolina, knowing that his
patrons were keen for new and unknown plants,
Catesby made a deliberate decision to collect in
areas that had not already been explored by natu-
ralists. Writing to Sherard a few days after arriving
in Charleston he reported, 'I am told up the rivers
there are abundance of fossils and petrifactions and
that those parts have not been searched for plants
which gives me hopes in some measure of effecting
what you perticularly desire.'[69] And he informed him
of his programme, 'never to be twice at one place in
the same season for if in the Spring I am in the low
Country[s, in the Summer] I am at the head [of the]
Rivers [and] the next Summer in the low Countrys
so alternately that in 2 years [I collect in /g]et the
two different parts of the Country.'[70]

By June, six months later, he had travelled '40
miles up the Country' where he had gathered the
majority of the contents of two books of plants he
was about to send; 'And in a few days am going a
greater distance another way' (see fig. 62).[71] The dis-

FIGURE 230

Georg Ehret, 'Rhus glabrum',
early 1740s. Watercolour and
bodycolour heightened with gum,
over graphite, 39.2 × 30 cm.

Royal Library, Windsor, RCIN
926071

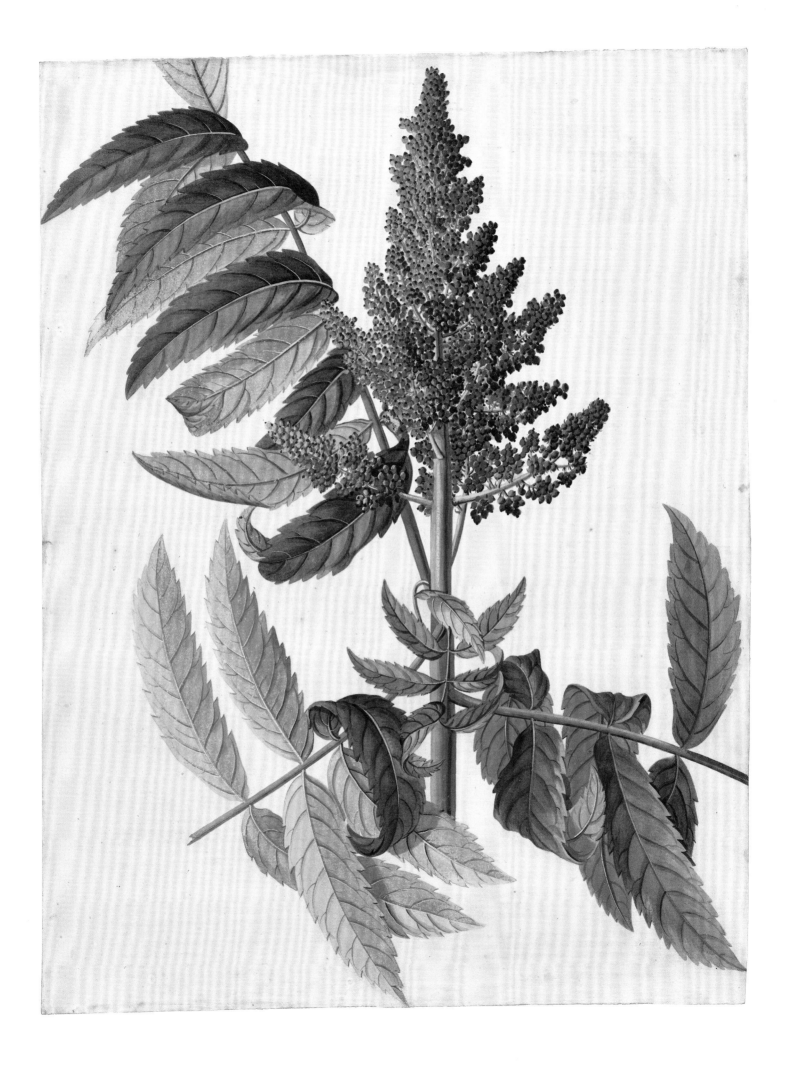

tances involved meant that sometimes he could not collect the flower or seed of a plant at the appropriate time: 'tho' many plants are common in all parts of the Country, others are only in particular places so that if I collect the plant in flower tis' ten to one I have an opertunity of collecting seed unless I goe 100 miles or more for it[.]'[72] In the low country, however, the flat terrain and easy access meant he was able to collect more frequently, and in August 1724 he was able to tell Sherard: 'In the Settlements I have gone through all months.'[73]

Catesby followed the advice of Woodward and Petiver to collect duplicates and triplicates of each specimen where possible, not least as he had many sponsors and friends to satisfy. He told Sherard that 'out of the last sent I reserved some which I now send so that those with the triplicates I presume may be spared, not that I know who they will be acceptable to except Mr Dale, for I have sent two Books to S[i]r Hans, so pleas to doe with them what you think fitt.'[74] As well as distributing the material among Catesby's sponsors, Sherard gave some specimens to other botanical friends. Writing to Richard Richardson on 22 October 1722, he informed him, 'I had a letter this week from Mr. Catesby, at Carolina, who sent me two quires of dry'd plants, forty of which were new: by the last ships, which may arrive before Christmas, he promises me a much larger collection, with seeds and fruits, which you may depend on.'[75]

While Catesby also sent separate consignments directly to particular sponsors and friends, he tried to keep by him for reference purposes a sample of everything he collected, even though sometimes, as he told Sherard, he was not able to collect enough material to do this.[76] After his first expedition '40 miles up the Country' made in June 1722, he pointed out to Sherard: 'The more specimens I collect of one plant the more time it takes and consequently prevents my collecting so many kinds as otherwise I should especially when I am several Hundred miles off it will increase their Bulk.'[77] The pressure from his sponsors clearly continued, for by 1724 Catesby was obliged to write to Sherard, 'I hope it cant be expected I should send Collections to every of my Subscribers which is impracticable for me to doe.'[78]

Travelling on foot, horseback and by water long distances while carrying his cargo of plants, collecting and painting equipment, provisions, a gun and a change of clothes was exhausting and almost impos-

sible on his own.[79] And indeed after the first summer of collecting, he fell ill in September with a 'swelling in the cheek', brought on by 'over heating my self', and told Sherard in December that he needed help: 'I can plainly perceive that I cant make a general collection without help[,] for in the summer the heats are so excessive[, even] … tho the time for seed and roots is more temperate Yet they [occur] in such different parts of the Country and at such distances one from the other that the fatigue is too great and by which I got my late illness.'[80] Shortly after this he asked Sherard for money to buy an African slave to assist him, informing Sherard: 'The making large Collections of seed &c is so fatigueing that I cannot effect with[out] help for which the next Negro Ship that arrives here I designe to buy a Negro Boy which I cannot be without.'[81] After several repeated requests, by the following spring Catesby had gone ahead and bought the slave for £20.[82] It is likely that Catesby took the unnamed boy on the next long trip made in March 1723 to Fort Moore, the frontier garrison on the Savannah River 140 miles up the country. But there are no further references to this African slave. Catesby was also quick to enlist friends and others to help as opportunities arose. Amongst one such collaborator was the previous governor, Robert Johnson, who accompanied him on local collecting expeditions made on horseback.[83] On other occasions Catesby mentioned being in the company of several people during his expeditions, when his loads could have been lightened, and during the three months he was confined indoors 'in great misery having my fface twice cut and laid open with lents and injections every day', he sent people out to collect plants on his behalf.[84] Further, when he heard that others were making journeys, he asked them to collect material on his behalf, although delegating the collecting process was not always successful.[85]

Importantly, Catesby actively sought the assistance of Native Americans, as Banister in Virginia and Lawson in Carolina had done before him. Their practical help as guides and luggage bearers, and their knowledge of the terrain and of potential danger from other tribes, wild animals and poisonous plants, were crucial (see Chapter 2). One had the task of carrying Catesby's collecting equipment, a box capacious enough to contain not only his plant specimens, but his painting and collecting materials, including large amounts of paper, and 'pasteboards' to keep the paper and its contents flat.[86] In

JAMES PETIVER

his BOOK,

For a *Collection* of whatever *Trees, Shrubs, Herbs, Graſſes, Ruſhes, Ferns, Moſſes, Sea,* or *River-Weeds,* &c. you ſhall find.

Directions for the gathering of Plants.

1. OBſerve to gather that part of each Plant which hath either *Flower, Seed,* or *Fruit* on it, but if none, gather it as it is, and if the *Leaves* which grow near the *Root* of the *Plant,* differ in Shape from thoſe which grow at the top, (which frequently happens in Herbs) be pleaſed to add two or three of thoſe lower Leaves to compleat the *Specimen.* And of each *Tree, Shrub, Herb,* &c. be pleaſed to Collect 3 or 4 *Samples.*

2. On whatever *Tree, Shrub, Herb, &c.* you find any *ripe Seed,* or *dry Fruit,* as *Nuts, Podds, Heads,* &c. Beſides the Specimen gather ſome of the *Seed* or *Fruit* apart, with two or three of its *Leaves* (and *Flowers* if it have any) putting them into a piece of waſte Paper, marking it with the ſame Mark or Number you do the Specimen. The like to be obſerved if you find any peculiarity in the *Wood, Bark, Root, Gum, Rozin,* &c. of any *Tree* or *Herb.*

3. Wherever you go *aſhoar,* or into the *Fields* or *Woods,* carry with you the *Collecting-Book* (to gather the *Samples* or *Specimens* in, which you muſt ſhift into this Book the ſame Day, or within two or three at fartheſt after you have gathered them) alſo a *Knife, Pen and Ink,* or *Pencil,* three or four Sheets of waſte Paper (with ſome *Thread*) to wrap the *Fruit* or *Seed* in.

4. Entitle each *Collection* according to the *Place* and *Time* you gather them in, *viz.* Theſe Plants were gathered at the day of *Anno* Dom.

5. If to any *Plant* you can learn its *Name, Vertue,* or *Uſe,* it will very much add to the Illuſtration of it,
And to the Satisfaction of
Your moſt Obliged Friend and Servant,
James Petiver.

Books bound in past board which I have not yet recd. The past board covers are of great use.'[88] He several times requested renewed supplies of pasteboard from Sherard, together with paper and other items including boxes. Petiver also specified the need to take 'a Knife, Pen and Ink, or Pencil, three or four Sheets of waste Paper (with some Thread) to wrap the Fruit or Seed in'.[89] Catesby must also have carried what Petiver described as a 'pencil booke' in which to record his field notes, information which he later transcribed into a more substantial written record or 'observatory booke'.[90] It was this information which provided the text for his plant labels, the accounts sent to his sponsors, and in due course the text for his book.[91]

Soon after arrival at Charleston Catesby asked Sherard to clarify the type of information that his sponsors required, and whether it was only new or unusual plant species that he needed to collect: 'I desire to know whether you require to know the soyl every plant and tree grows [in] or at least those that are doubtfull or whether I should or in what manner discribe any except those that are remarkable, odd, or uncommon plants[.]'[92] As well as making decisions about what, where and when to collect, and what information to record about habitat, Catesby was aware of the need to choose specimens with reproductive parts that would allow identification. His surviving specimens show that he was mainly successful in this.[93]

Labelling specimens was an equally essential part of the plant collector's work, as a specimen was of little value without a label providing a context.[94] Catesby was careful to label his specimens; although many of his labels have been lost during later rearrangements, over a hundred in his hand survive with their related plants in the Sloane, Dale, Petiver, Sherard and Du Bois herbaria.[95] Varying in length between those simply giving the plant name and those with much longer descriptions, information on the labels might describe the appearance of the plant, comment on its similarity to another plant, its habitat, on rare occasions the precise location it was gathered, its season of flowering or fruiting, its scent, and its medicinal or other virtues and practical uses. So, while for a specimen of *Quercus marilandica* Catesby simply recorded 'Black Oak' (fig. 232), for the bald cypress, *Taxodium distichum,* he noted the size, girth and overall appearance, its habitat and precise location, the fact that (unusually for

his 'Directions for the Gathering of Plants', Petiver had instructed: 'Wherever you go ashoar, or into the Fields or Woods, carry with you the Collecting-Book (to gather the Samples or Specimens in, which you must shift into this Book the same Day, or within two or three at farthest after you have gathered them)' (fig. 231). Catesby's letters to Sherard indicate his using such a 'collecting' or 'botanical book' in the field – a book made up of quires of paper tied or stitched within boards.[87] In April 1724 he wrote: 'you say you will in next Ship [send] 2 paper

a conifer) it dropped its leaves in winter, and its use in building:

> The Virginia Cypress. Exceeding ye popler in bigness and the largest and tallest tree in Virginia[.] they grow in large and deep swamps allwayes in or near water and on sand banks in ye midle of James river[.] the root and some part of the tree alwaise under water. It grows very erect and of a vast bigness as ye pine till att ye top is its fine flourishing head[.] the leaves drop in Winter. The wood is of singular use for shingles for covering Houses[.] some of them are 30 foot in Circumference.[96]

On one occasion he added a sketch of an unripe fruit to the label of the Carolina allspice, *Calycanthus floridus* (fig. 233);[97] and another time he used a leaf instead of paper on which to draw the way that from 'large armes [of the pawpaw] proceeds smaller branches sett with such like circles of leaves which I [have] given a Scetch of on the back of the single leaf'.[98]

In addition to recording factual information, the label texts provide some of the most direct expressions of Catesby's pleasure in the beauty, novelty and variety of trees and plants seen in their native environment. He extolled the sweet gum, *Liquidambur styraiflua*, for its beautiful and aromatic scented leaves and the quality of its wood, as well as for its remarkable production of gum:

> Sweet Gum Tree. This is a large Timber Tree with beautifull and aromatick leaves but most remarkable for its sweet Gum – of which I have sent. The Wood of great use both for Carpenters and Joyners, some of it being very beautyfull. They never produce gum but where they have been wounded and I have often cut an old Tree (which produces the most) and have not got halfe a spoonful from the time of cutting which I did in the spring to winter[.] When it first issues from the tree its' liquid but of the sun and air it candies it.[99]

When he came across the catalpa 'very remote from the Settlements', his eye was caught by the beautiful appearance of the tree at a distance (see fig. 192):

> Catalpah called so by the Indians. The flower is white with a mixture of yellow and purple and resembles in shape and bigness that of the Cumbulu in Hortus Malabaricus. The flowers hang in bunches after the manner of the hors chestnut which at a distance it resembles tho' much more beautiful. The seeds are contained in pods of abt a foot long[,] a few of which

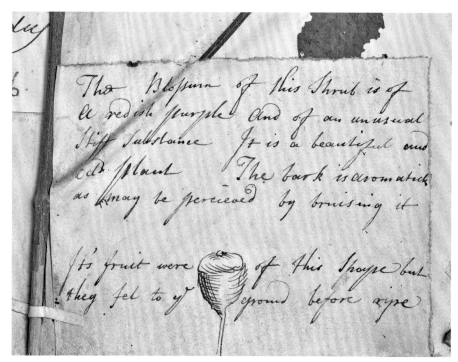

FIGURE 232

Blackjack oak, *Quercus marilandica*, detail, collected by Catesby, 1722–5. Plant specimen with Catesby's label, 54 × 38 cm.

Natural History Museum, London, Department of Life Sciences, Algae, Fungi and Plants Division, HS 232, fol. 93

FIGURE 233

Carolina allspice, *Calycanthus floridus*, detail, collected by Catesby, 1722–5. Plant specimen with Catesby's label and sketch in pen and ink, 54 × 38 cm.

Natural History Museum, London, Department of Life Sciences, Algae, Fungi and Plants Division, HS 212, fol. 16

I sent last year but I suspect not good. This year they hang prodigiously full in clusters. They grow by the sides of Rivers very remote from the Settlements in rich land.[100]

When Catesby returned from his collecting expeditions, he was faced with the exacting process of separating out the plant specimens, arranging and drying them. Petiver had instructed plant collectors that, having placed plants in botanical books as they gathered them, they 'must now and then shift these into fresh Books, to prevent either rotting themselves or Paper'.[101] Catesby, however, discovered that the humid conditions in South Carolina required putting them between new sheets of paper every day for two weeks, and checking them regularly: 'Its hardly credible the long time plants take in cureing in this moyst Country[.] I have frequently had them moldy and spoild by omitting shifting the next day after gathering one with another[;] less than a fortnight does not cure them and for the first week they require shifting every day[.]'[102] As he also discovered

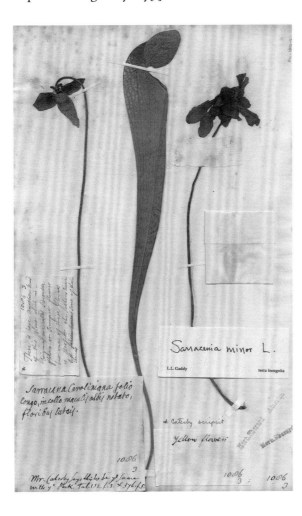

FIGURE 234

Sarracenia minor leaf and flower (right) and *S. flava* flower (left), collected by Catesby, 1722–5. Plant specimens with Catesby's and Sherard's labels, 36.2 × 22.9 cm.

Oxford University Herbaria, Sher-1086.3

and reported to Sherard, some plants were particularly prone to mould:

In looking over the Books I now send I find 5 or 6 plants mouldy, tho' they were perfectly well cured and well dryed, when put up and are kept in a dry, upper, South Room. In turning over those for Sr Hans I find the same plants mouldy and only those, so that I find some plants tho' not succulent are perticularly subject to it. The weather is indeed and has for some time been, extream Moist Cloudy and Sultry[.][103]

Likewise, he found that he needed to check his specimens to remove any insects before drying them properly. The trumpet shaped leaves (or 'pitchers') of *Sarracenia* in which insects were trapped needed particular treatment: 'At the bottom of its hollow leaves are always lodged Catterpillars[,] worms[,] bugs or other insects which is the cause I have cut them open to prevent rotting ye paper.'[104] But while with careful preparation he succeeded in preserving the 'pitchers', 'the leaves [petals] are of so little substance that they shrivele up and are not to be dryed' (fig. 234). On another occasion acorns started to germinate while they were laid out to dry in his room: 'The live Oke Acorns to my surprise sprout as they lye spread in my Chamber which makes me suspect their good success by the way[.]'[105]

Once the specimens were dry Catesby arranged them on good quality paper, heavy enough to support them,[106] attaching them with neat, finely cut paper straps pasted over the lower part of the stalks and across other parts to keep them from moving. His paper labels were either pasted in a similar way over the lower stem of a specimen (see fig. 233) or attached to a stalk with two slits in them.[107] The sheets were then put between pasteboard covers and transported loose-leaf or stitched roughly together.

Sherard, having gained experience of plant collecting while he was in Turkey and on the European Continent, advised Catesby to adopt a numbering system in order to keep track of his specimens;[108] Catesby followed the advice, although he explained why sometimes he had to give the plant a name instead of a number:

I have in the main followed your directions to number the plants and keep one of the same number by me[.] It sometimes happen[s] that I have but one of a kind which I am forced to send without a number not having another to keep by me[.] I chuse to name others

instead of numbering them having sometimes so few that I cant spare a specimen to keep by me and by the same name I shall easily know them again.[109]

Although the numbers Catesby gave the specimens have not survived, many of the plants in his watercolours bear a small number written in graphite usually at the base or to the side of a plant stem (see fig. 226).[110] This may have been Catesby's own cross-reference between his drawings and his numbered specimens, a method which allowed him to inscribe the Latin names on to the drawings once he had received this information from Sherard. The majority of his drawings are inscribed in pen and ink in his neat calligraphic hand, mainly along the top or bottom edge of the sheet (see figs 222 and 226); these inscriptions appear again in the titles given to the species in the *Natural History*.

At the same time as compiling preserved collections, Catesby was making living collections in the form of seeds, roots and growing plants sent in barrels or casks of soil. As we have seen, he was interested in cultivating North American flora in English gardens. Several of his sponsors shared this interest in addition to their desire to add to their collections of dried plants. Seeds, roots and living plants were in great demand by several of his friends, including Thomas Fairchild for his nursery garden at Hoxton, Collinson for his garden at Peckham, William Sherard for his brother James's garden at Eltham, and Philip Miller for the Chelsea Physic Garden (Chapter 5).

Collecting in the field: fauna, fossils and ethnographic objects

While Catesby's sponsors were primarily interested in the flora of the New World, several were hoping for rare and unusual animals to display in their collections.[111] A portion of Catesby's energies went into collecting fauna, presenting him with distinct problems of observation, collection and preservation. He explained in his Preface his reasons for concentrating on birds: they were among the easiest to catch; they were more numerous than other animals; and many would provide spectacular additions to English collections as 'they excel in the Beauty of their Colours'. Moreover, as a careful observer, it was impossible for Catesby not to be struck by the close connections between birds and 'the Plants

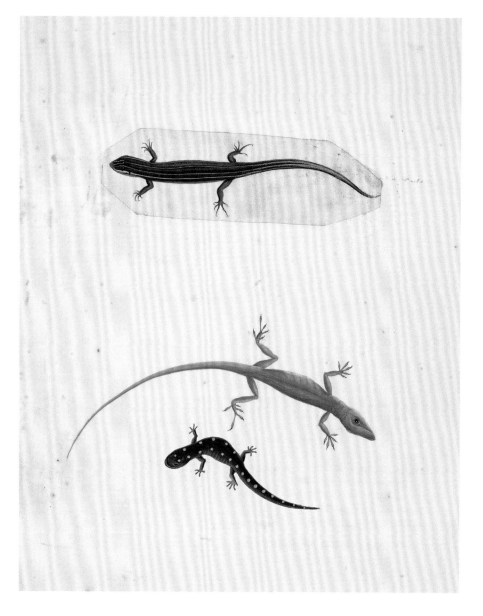

which they feed on and frequent'. His later decision to begin his book with images of birds rather than plants further underlines the prominence he gave them as a collector.[112] As for other categories of fauna, reptiles and amphibians were relatively easy to catch, examine and draw at close quarters (fig. 235).[113] Indeed among snakes, Catesby believed that 'very few … have escaped me', a claim he tested by showing his drawings to the local inhabitants: 'upon shewing my Designs of them to several of the most intelligent Persons, many of them confessed that they had not seen them all, and none of them pretended to have seen any other kinds.'[114] His drawings of snakes show the remnants of his numbering sys-

FIGURE 235

Mark Catesby, 'The Green Lizard of Jamaica', 'The Blue-Tail Lizard' and 'The Spotted Eft', 1722–5. Watercolour and bodycolour over graphite, with collage, 37.5 × 26.5 cm.

Royal Library, Windsor, RCIN 926018

ILLUMINATING NATURAL HISTORY

FIGURE 236

Mark Catesby, 'The Great Booby' and 'An Thymelaea foliis obtusis', 1722–5. Watercolour and bodycolour over graphite, pen and ink, 26.5 × 37.5 cm.

Royal Library, Windsor, RCIN 925921

tem, the numbers in this group being added in pen and ink.[115]

Having studied the first volume of Sloane's *Natural History of Jamaica* and aware that the coral reefs of the Bahama Islands there would provide greater access to fishes and 'Shells, Corallines, Frutices Marini, Sponges, Astroites, &c.', Catesby left those categories mainly until his visit. Mammals and insects were two groups in which he made very specific decisions in his collecting programme:[116] 'wild beasts' were of course the most difficult to catch, but as he considered that 'there are not many species different from those in the Old World,' he decided he could be economical about which he described.[117] It is interesting to note, however, that of the ten plates illustrating mammals, Catesby based nine on other artists' illustrations; only one, showing the Bahamian hutia, *Geocapromys ingrahami*, appears to have been an image original to Catesby.[118] In the case of insects, however, of which 'these Countries abound in numerous kinds', Catesby was honest about the fact that he simply did not have the time to make a comprehensive collection or 'delineate a great number of them'.[119]

Sloane was the principal patron to whom Catesby sent animal specimens; these were recorded by Sloane, along with the thousands of other specimens he received from around the world, in his series of manuscript catalogues compiled between

the mid-1680s and the late 1740s (see fig. 38).[120] However, unlike the preserved plants Catesby sent, only a handful of zoological specimens have survived, and the labels he wrote to accompany them have likewise disappeared.[121] The information we have about Catesby's collecting of animals is therefore more limited than what survives for the plants and, apart from comments made in the *Natural History*, is confined to a few letters and to the entries in Sloane's manuscript catalogues. Of the six recorded cargoes Catesby sent Sloane from South Carolina, three contained animals.[122] Among the fifteen different birds itemized in these cargoes were the eight different species of woodpecker he had identified.[123] The other birds were notable for being amongst the most colourful: the 'Red Bird' (northern cardinal, *Cardinalis cardinalis*), the 'blew bird of the Coccothraustes kind' (Eastern bluebird, *Sialia sialis*), the 'Tricolor' (painted bunting, *Passerina ciris*), the 'red Winged Black-Bird' (red-winged blackbird, *Agelaius phoeniceus*), 'the Bird with a yellow Spot on its' Crown … called here King Bird' (Eastern kingbird, *Tyrannus tyrannus*), the 'Blew Bird' (blue jay, *Cyanocitta cristata*), and a 'To-Whee ye black back bird with red on ye brest' (Eastern towhee, *Pipilo erythrophthalmus*).[124] At times Catesby managed only to preserve the heads of birds, especially in the case of larger species: among the bird heads he sent Sloane were those of an 'Oyster catcher' (American oystercatcher, *Haematopus palliatus*), a 'round crested Mergus' (hooded merganser, *Lophodytes cucullatus*), a whooping crane (*Grus americana*) and a 'great booby' (northern gannet, *Morus bassanus*) (fig. 236).[125] But he needed Sloane to specify whether he wanted less spectacular birds too: 'I am at a loss to know for want of hearing from you whether all kinds of Birds thus preserved will be acceptable to you or whether those only that are remarkable for colour or shape.'[126]

Although Catesby's surviving letters to Sloane mention stuffed specimens or skins of fifteen different bird species, the total Catesby sent him was significantly higher, with around forty specimens recorded in Sloane's catalogues, most of which were sent from Carolina.[127] Three bird species – the ivory-billed woodpecker, Carolina parakeet and passenger pigeon – which Catesby collected, illustrated and wrote about, became extinct in the early twentieth century, and his descriptions of the killing of the birds by the local populations, either for their beauty or for their destructive habits, now have an ominous

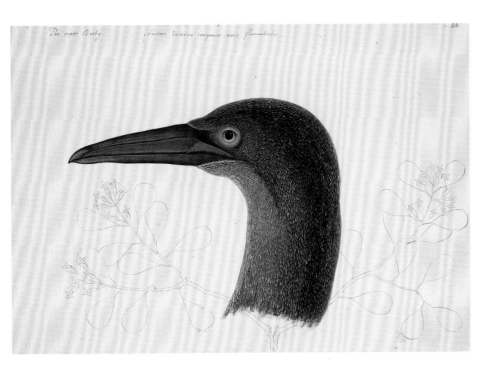

The river Booby Anseri bassano congener avis Plumipedibus 86

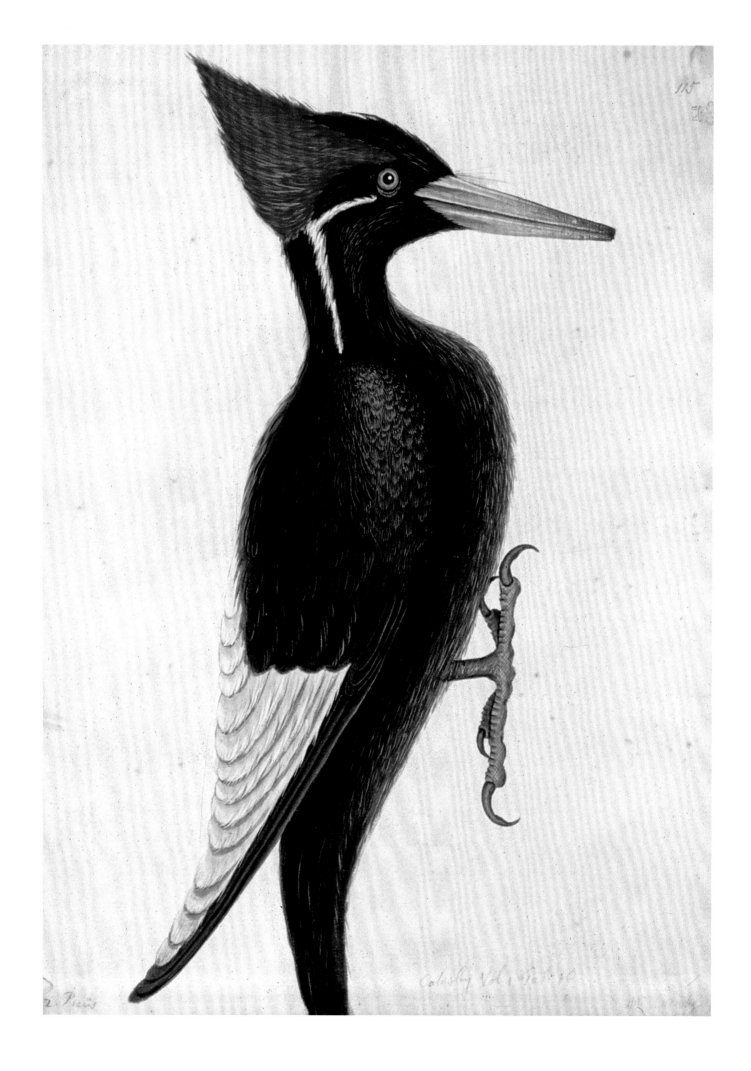

FIGURE 237

Mark Catesby, 'The largest white-bill Wood-pecker', duplicate drawing made for Hans Sloane, 1722–5 or 1726–9. Watercolour and bodycolour heightened with gum, over graphite, 37 × 27.2 cm.

British Library, London, Sloane Add MS 5263 f.115

ring.[128] It was the spectacular bill of the ivory-billed woodpecker, *Campephilus principalis*, that caused it to be overhunted by Native American tribes, although the species must equally have been sought after by European collectors (fig. 237). Catesby records that the bird was 'much valued by the Canada Indians, who make Coronets of 'em for their Princes and great Warriors, by fixing them round a Wreath, with their points outward. The Northern Indians, having none of these Birds in their cold country, purchase them of the Southern People at the price of two, and sometimes three Buck-skins a Bill.'[129] Carolina parakeets, *Conuropsis carolinensis*, were considered pests because of their 'numerous flights' which caused destruction of orchards in autumn; at the same time they were in demand for the rainbow colours of their plumage (see fig. 90).[130] And the damage wreaked by the passenger pigeons, *Ectopistes migratorius*, which 'come in Winter to Virginia and Carolina, from the North, [in] incredible Numbers', caused 'the People of New-York and Philadelphia [to] shoot many of them as they fly, from their Balconies and Tops of Houses; and in New-England there are such Num-

bers, that with long Poles they knock them down from their Roosts in the Night in great numbers' (fig. 238).[131]

Catesby's consignments to Sloane mention only two preserved mammals: 'The large Skin is that of a black Fox. They are very rare and are caught only in the mountains.'[132] 'The Small Skin is that of a Polcat [eastern spotted skunk, *Spilogale putorius*], they all vary in their marks two being never seen alike[,] some almost all white, others mostly Black with but little white which seems a Sport of Nature peculiar to this little Beast, at least I know of no other Wild Beast but what are all of ye same colour' (fig. 239).[133] He included some insects in his first consignment, while noting that 'I have more Insects than what I now send but they are lodged at distant places and I have not now an opertunity to send them.'[134] The 'distant places' were presumably the plantation houses of his friends where he stored some of his collections until he could either bring them back himself or arrange for others to do so.[135]

Catesby identified 'twelve different kinds' of snakes but could not send them until Sloane had sent

FIGURE 238

Mark Catesby, 'The Pigeon of Passage' and 'The Red Oak', 1722–5. Watercolour and bodycolour heightened with gum, over graphite, 26.9 × 36.3 cm.

Royal Library, Windsor, RCIN 924836

FOLLOWING SPREAD

FIGURE 239

Mark Catesby after Everard Kick, 'The Pol-Cat', 1726–39. Watercolour and bodycolour heightened with gum, over graphite, 26.8 × 38 cm.

Royal Library, Windsor, RCIN 926013

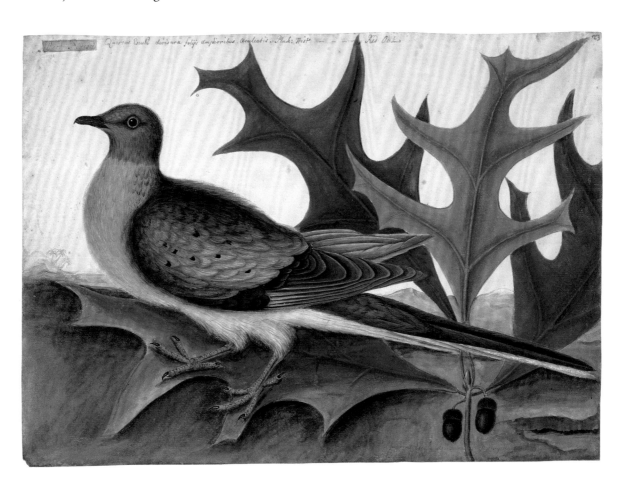

him supplies of 'Wide Mouthed Bottles to put them in, [as] I find Rum will not preserve large ones[.] If your important affairs will let you think out Sr I desire you please to order me a Case of large Bottles for Reptiles with a few proper Boxes for Birds and Insects.'[136] In a later letter he repeated his need for glass containers: 'I shall Sr send you a Collection of Reptiles so soon as I can procure glasses to put them in[.]'[137] Sloane was not, however, an assiduous correspondent; when a supply of jars eventually arrived, Catesby had to explain that the collecting season was almost over: 'I shall according to your order make a Collection of Snakes &c but the Season is so far spent before I received the Bottles to put them in that I fear I shall make but a small progress this summer, especially in the larger snakes, for which I have not had before now the bottles large enough to put them in.'[138]

It is interesting that there appears to be no mention of snakes from Catesby in Sloane's catalogue.[139] Did his collection ever arrive? And other than a piece of a tortoise shell, there are no mentions of other reptiles or amphibians.[140] In January the following year, however, Catesby sent several snakes in a large jar of spirits to Richard Mead, explaining to Sherard why he had not sent any in that consignment to Sloane: 'I have sent Dr Mead a large Bottle of Snakes p[er] Capt Levingston. Sr Hans I have sent none to[;] I could not possibly procure for both[.]'[141]

In Catesby's last letter to Sloane written shortly before he left for the Bahamas at the end of 1725, he specifically spoke of his hopes of finding 'a great variety of Shells and Animals' in those islands. He had already told him that there were not many to be found in Carolina; those he sent in his first consignment of animals had included 'two kinds of fresh water Mussels and two land Shels wrapped in another pap[er]', which he noted 'are all of the land kind I have yet seen'. In a later consignment, 'an entire collection' of shells were all 'I could ever discover or learn these Coasts afford'.[142] But, as he predicted, most of the 'Shells, Corallines, Frutices Marini etc' were to be found in the Bahamas, a fact he later confirmed in the *Natural History* where he stated: 'These [shells, etc.] I imparted to my curious Friends, particularly to that great Naturalist and Promoter of Science, Sir Hans Sloane, Bart.'[143] It is clear that here Catesby was extremely industrious in his collecting: a total of around eighty-six specimens of shells,

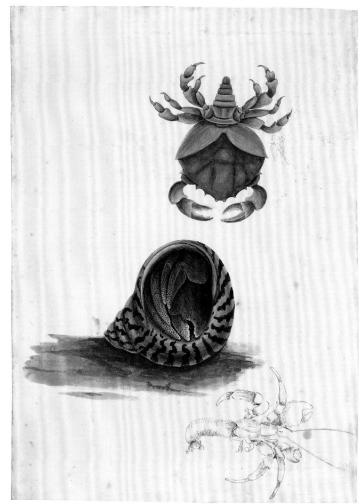

corals, crustaceans, starfishes and sea urchins from Catesby are listed in Sloane's catalogues, the majority of which give Bahama as the provenance (fig. 240).[144] Eight of the shells that he sent Sloane have survived, all but one of which, *Busycotypus canaliculatus*, are Bahamian.[145] One of these, the West Indian topsnail, *Cittarium pica*, was illustrated as the shell inhabited by the hermit crab, *Coenobita clypeatus* (figs 241 and 242). Numerous specimens of marine algae which Catesby also collected in the Bahamas can be seen among the mounted herbarium specimens sent to Sloane (fig. 243).[146]

Probably because of the lack of glass jars, Sloane appears to have received only a few fishes from Catesby. Among these were the head of the three-to-four-foot-long 'Great Hog-Fish', *Lachnolaimus maximus*, which Catesby illustrated in the *Natural History*, whose 'tail … being cut off before I had it, I cannot say of what Form it was', together with 'a pair

of large Fins of [the] same' (see fig. 143);[147] 'a small orbis' (checkered puffer, *Sphoeroides testudineus*);[148] 'the ovarium of a ray ... from Carolina' ('mermaid's purse' or ray egg case, Chondrichthyes);[149] and 'a young Shark stuff'd'.[150]

Catesby's methods for preparing 'stuffed' or 'skinned' animals required time, care, and trial and error, and like his methods for plant preservation, they were honed through experience.[151] A description of the technique he developed for preserving bird and presumably other animal specimens survives in the account he gave Linnaeus's student Pehr Kalm when Kalm visited him in London in 1748:

> Mr. Catesby described the method which he had used on his travels to prepare and preserve birds and fishes, which he intended to keep for his natural history collection. When he had captured a bird, he carefully cleaned out its inside, then sprinkled snuff all over it and put it into an oven which had the same heat as when bread is taken out of it. For if it is too hot, all the fat in the bird is melted. When the specimen had remained for a little while in the oven it was taken out to cool, then returned to the oven and the process continued until it was completely dried. The lesson is that the bird must not be dried too quickly, for too much heat not only causes the fat to run out but also spoils the plumage. Afterwards, if they have to be transported, they are put into casks or similar containers, and snuff is sprinkled over them to keep moths and such like away from them. Fishes are best preserved *in spiritu vini*.[152]

The success of preserving fishes in glass jars of spirits depended partly on the alcohol used and partly on well-fitting lids.[153] One rare surviving example contains a specimen of a viperfish, *Chauliodus sloani*, not collected by Catesby in South Carolina or the Bahamas but sent to him after his return from the New World by his brother John in Gibraltar.[154] John Catesby had joined the army in 1726 and in 1730 was sent with his regiment to Gibraltar;[155] no doubt encouraged by Mark, who was keen to learn about the natural history of the Iberian peninsula, he was an active collector and sent significant numbers of specimens either to his brother or directly to Sloane.[156] Mark used the viperfish that he subsequently gave to Sloane as the model for his drawing of 'The Viper-mouth' included in the Appendix to the *Natural History* (figs 244 and 245).[157] He made a duplicate drawing of the fish for Sloane.[158] He noted:

FIGURE 244

Viperfish, *Chauliodus sloani*, 1743–7. Fish specimen in spirits in eighteenth-century glass jar, 32.7 × 7 cm (jar).

Natural History Museum, London, Department of Life Sciences, Fishes, Amphibians and Reptiles Division, BN(NH) 1978.9.11.1

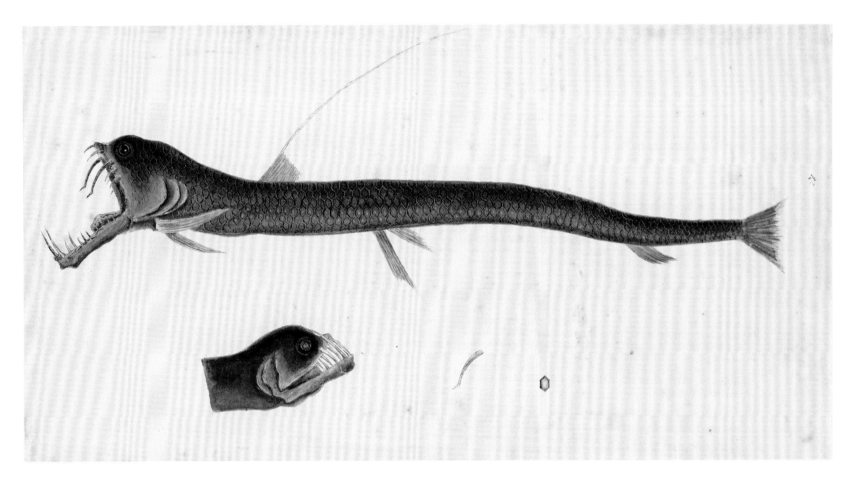

FIGURE 245

Mark Catesby, 'The Viper-
mouth', 1743–7. Watercolour and
bodycolour over graphite,
17.6 × 33.9 cm.

Royal Library, Windsor, RCIN
926089

It is without scales. In the state it was sent to me, it was of a brown colour, resembling that of the common Viper; but when just taken out of the Water, they are, as I am told, of a green colour, but marked all over with small hexangular divisions. This odd Fish was sent me from Gibraltar, in the Harbour of which place it was taken; and is now preserved in the celebrated Repository of Sir Hans Sloane.[159]

Along with his contemporaries and associates who were members of the Royal Society, Catesby was curious about the origin of fossils, not least because of the large number he came across in both Virginia and South Carolina. He recorded: 'All Parts of Virginia … abound in Fossil Shells of various Kinds, which in Stratums lie imbedded a great Depth in the Earth, in the Banks of Rivers and other Places, among which are frequently found the Vertibras and other Bones of Sea Animals.' While recognizing their organic origin, he subscribed to the contemporary diluvian belief that fossils were connected to the biblical Flood, noting: 'There is no Part of the Globe where the Signs of a Deluge more evidently appears

than in many Parts of the Northern Continent of America.'[160] Of the several specimens of fossil fish he gave to Sloane, one has survived, recorded by Sloane as 'The vertebre of a shark found enclosed in a stone in Carolina, given by Coll. Johnson to Mr. Catesby from whom I had it' (fig. 246).[161]

As indicated in Woodward's 'Directions', part of the natural history collector's remit was to observe and collect manmade artefacts of native peoples. Woodward specified that the collector should 'send over some of the Idols of the East or West Indians … as also of their Pictures: their Writing, whether upon Paper, or the Leaves or Bark of Trees … their Dome-stick Utensils: their Habits, or the things they wear, Skins of Beasts, Feather-dresses, Rings, Beads, &c. their Medicines: their Poysons: their Musical Instruments: their Weapons, Bows, Arrows, Darts, especially those that are headed or pointed with Flints, Bones, or Shells'.[162] We have seen that Catesby admired the fine workmanship of Cherokee woven cane baskets.[163] Of the several items of North American manufacture which he records sending over, at least one went to Sloane, who was forming an

impressive collection of ethnographic objects.[164] In November 1724, Catesby sent a consignment of natural history specimens to him with a note: 'Please Sr to let my Brother have the Indian Apron at the bottom of the Box except it will be acceptable to your Self[.]'[165] It is perhaps no surprise to find Sloane did indeed keep the apron, which is recorded (using the wording on the label Catesby sent with it) in his catalogue of 'Miscellanies' as an 'Indian Apron made of the Bark of Wild Mulberry. This kind of cloath with a kind of Basket they make with Split cane are the only Mechanick Arts worth noticing.'[166] Another object was a deerskin waistcoat, which this time, sent via Sherard, perhaps did reach his brother: 'With yours [the consignment of plants] comes a Box with 2 Books of plants for Sr Hans Sloan. I beg waistcoat may be given to my Brother Catesby[.]'[167] The garment would seem to have been one which Catesby described as part of the Native Americans' 'ordinary Winter dress … a loose open waistcoat without sleeves, which is usually made of a Deerskin, wearing the hairy side inwards or outwards in proportion to the cold or warmth of the season'.[168] Catesby's interest in their 'manufactures' is further shown in the trophy headpiece to the Account with its arrangement of ancient and ethnographic weapons and utensils (see fig. 178), including a Creek or Cherokee calumet pipe.[169]

Identification and nomenclature

The identification and naming of the flora and fauna he collected presented the field naturalist with an important but distinct and difficult set of demands. Academic botanists and zoologists in Europe, receiving specimens, expected to play the major part in this, but what pointers should and did the naturalist in the field provide? Catesby attempted as far as he could to name the specimens of plants and animals he collected while he was in America, applying descriptive Latin phrases: the polynomials used by naturalists before Linnaeus was to make consistent use of a binomial system. As with other explorers of the New World, Catesby's first point of reference was his knowledge of known species of the Old World and the use of works of authors who had treated these.[170] Unlike earlier generations of natural historians, however, he cited ancient or Renaissance authors relatively infrequently, most of them being little concerned with New World species.[171] Among

the works he consulted most often were John Ray's and Francis Willughby's *Ornithology* (1678), a copy of which he took with him to South Carolina; he also used the same authors' publication on fishes, their *De historia piscium* (1686). The works of other contemporaries who had studied the natural history of the New World included Leonard Plukenet, Joseph Pitton de Tournefort, Charles Plumier and Caspar Commelin for botany, and Hans Sloane's *Natural History of Jamaica*, covering both fauna and flora, which he referred to extensively.[172] As noted, he also knew the work of his predecessors John Banister and John Lawson.[173] Other authors and works, including Mattioli, Clusius and the *Hortus Malabaricus* cited in his letters and sometimes on his plant labels, suggest that while he was in America Catesby had the opportunity to consult reference books in the libraries of his colonial friends.[174]

When it came to assigning names to previously unnamed plants and animals, Catesby sought out the indigenous and English names in popular usage by consulting Native Americans and colonists. Others he coined, often basing them on resemblances to Old World species. He stated: 'As to the Plants, I have given them the English and Indian names they are known by in these Countries: and for the Latin names I was beholden to the … learned and accurate Botanist, Dr Sherard.'[175] From this we learn that for scientific nomenclature of plants, Catesby turned to William Sherard.[176] For Sherard, of course, the most important part of Catesby's work in the New World was the identification and collection of potentially new botanical species for incorporation into his

'Pinax' – his ambitious project of updating Caspar Bauhin's *Pinax* (1623) with all subsequent synonymy and discoveries (see Chapter 1). In response to Catesby's shipments of plants, Sherard communicated names and authorities back to Catesby.[177] Thus, for example, in their exchange over the much-debated plant St Andrew's Cross, *Hypericum hypericoides*, Catesby told Sherard that he was sending him 'a more satisfactory acc[oun]t of the plant St Andrews Cross which is the same you suppose in Mr Ray'.[178] After Catesby's return to London in 1726, he and Sherard continued to work together over the next two years until Sherard's death in 1728. After this it seems that Sherard's protégé Dillenius supplied a few names 'of the shorter kind', although, as a convert to Linnaeus's binomial system, Dillenius was anxious to inform Linnaeus that he had taken no part in Catesby's polynomials: 'In your last letter you advert to Catesby's names, as if I were particularly conversant with, or had perhaps communicated them to that author. I assure you he is indebted to me for but few, and those of the shorter kind. I had no hand in his long descriptive names.'[179] Other than the published literature, there was, however, no equivalent of Sherard for fauna, and Catesby appears to have invented many of the long Latin polynomials for birds and other animals himself.[180]

Shipment of specimens

The development of appropriate preservation techniques for his specimens, both preserved and live, presented the naturalist with specific technical challenges. Securing the safe transport of these back to London presented a wholly additional set. The process entailed trial and error as well as considerable luck. By the time he was collecting in Carolina, Catesby had had the experience of several years of sending natural history objects back to England from Virginia, and he was thus able to advise Fairchild on how best to transport plants the other way across the Atlantic. Indeed, the botanist Richard Bradley cited Catesby as the best authority for 'the carriage of plants by sea', publishing in his *Husbandry* the letter Catesby sent Fairchild.[181] Catesby described his method of using gourds as containers in a letter to Sherard:

> To send seed and roots as they ought to preserve
> them from rotting[,] those that are dry should be put

by themselves and the moist distinct in small gourds with sand. Putting them in papers only[,] especially the berries and ... seed[,] rots the paper and mixes the different kinds so that it hazards rotting some that had they been in a gourd would have been preserved and mixing the different kinds that without difficulty they cant be separated[.] I have found from my sending seeds from Virginia the necessity of having many of these small gourds of several sizes which this year I could not procure but I have laid out for some against the next[.][182]

Sometimes he also put seeds in packets of paper inside a gourd in order to keep different species separate: 'In the same gourd [as seed from the Erect Bay] in a paper are a few seed of what I think is a kind of Astralagus[,] the pods are in another small Gourd[.]'[183] The pods, cones, nuts, berries and seeds he sent to Sloane were incorporated into Sloane's 'Vegetable Substances' collection, the individual specimens of which were housed in sealed boxes with glass lids and bases so the specimens could be viewed from above and below (see fig. 26).[184] The boxes bear Sloane's catalogue numbers which relate to the entries in his 'Vegetable Substances' catalogue, where the descriptions clearly reflect the wording of the labels Catesby sent with the specimens.[185]

Catesby's reference to 'tubs' in his letter was to barrels or casks rather than our modern-day plant tubs, which would have left the sapling trees too exposed to sea water and poor handling.[186] An image of such barrels being used to transport tobacco can be seen in the cartouche in a 1755 *Map of Virginia* (fig. 247). The barrels were also large enough containers to take quite a number of young trees and plants in soil: in 1723 one cask sent to Sherard contained three specimens of the 'Erect Bay', three of 'Jessamy', two of the 'Pellitory Tree', one of 'Sassafras', two of a 'Purple Flowr Shrub' and one of 'The Root'.[187] Boxes designed with partitions were used to send items such as shells, jars and ethnographic objects as well as seed pods and roots so they could be kept separate. Catesby, for instance, mentioned that in one box there were 'seed vessels in the large partition with long stalks'.[188] The books of herbarium specimens were also included in these boxes. Catesby often inserted his letters for distribution into the books to keep them dry.[189] Moss, in which Dillenius had a special interest, was at least on one

FIGURE 247

Joshua Fry and Peter Jefferson, *A Map of the Most Inhabited Part of Virginia*, 1751, detail of cartouche showing shipment of tobacco in barrels. Engraving, 78.1 × 127.1 cm.

Cambridge University Library, Atlas.0.77.3

occasion used to pad out a box where it was put 'next the Cover'.[190] Catesby found that local carpenters were very expensive and he requested that boxes should be sent from England: 'Makannicks here are intolerably imposing and dear in their work[;] as an instance of it the Box the seed is in cost 20d, that is 4d sterling besides being obliged to them for working at any rate[.]'[191]

He had discovered (as he mentioned in his letter to Fairchild) that the most successful month to send plants by ship was October or during the winter months when live plants would be less likely to dry out and could be planted on arrival in spring.[192] His letters contain references to cultivating ships' captains so that they would take care of his cargoes, 'for it's no small favour from a master to secure a single box or parcel, and much more distinct parcels and Boxes'.[193] But when he was away on collecting expeditions he was not able to do this: 'My much absence from Charles Town prevents my acquaintance with Masters of Ships is requisite which often puts me in

some difficulty how to send by one who I can rely on that what I send may be put in a dry place, and they are many of them surly fellows that they are not to be prevailed on.'[194]

One way to curry favour was to give captains and ships' masters presents: 'I thought there could be not a more effectual way to induce Capt Clark to take care of what I send than to procure for him a Tub likewise for his Master Crawley from whome I expect a Subscription.'[195] Although ships' captains may have been won round, however, there were the usual dangers at sea to contend with. In his very first letter to Sherard, Catesby reported 'the Scandalous Acc[oun]t' of the *Grayhound* man-of-war 'being surprised and taken by 18 Spaniards who … had been trading with them[,] the Capt with eight Men being killed[,] the Lieutenant wounded and forced overboard but alive' and the Spaniards carrying off the treasure. Catesby's cargoes were on at least one occasion subject to pirate raids, with his collection of plants made in the spring of 1723 being 'much

FIGURE 248

Nicholas Pocock, *The Blandford Frigate*, c.1760. Pen and ink and wash, 42.5 × 55.4 cm.

Bristol Museum and Art Gallery, object id. M670

deminished and injured by pirats'.[196] The consignment of animal and plant specimens with a box containing the head of the northern gannet, sent to Sloane in August 1724 on board the *Blandford* man-of-war, replaced a previous collection of 'what were distroyed by the pyrats' (fig. 248).[197] In view of these dangers, Catesby was careful to keep tallies of what he had sent in each consignment, as is witnessed in his letters to Sherard and Sloane.[198] Catesby's friend William Byrd likewise experienced the difficulties of transportation by sea. In 1740 he wrote to John Handbury, his agent in England, about receiving his goods in 'a tattered condition':

> your convict ship arrived safe with the goods if one may call that safe where every thing is damagd and broke to pieces. I never saw anything so demolist as every parcel that belong'd to me was which partly owing to the careless way of packing, and partly to your masters tumbling them ashoar at Hampton, and tossing them into a warehouse, and they were rolled to the waterside

again, and put abord another ship, which call'd there by chance, or else we might have been several months without them.[199]

Scientific activities in London

Testimony to the quality of Catesby's scientific work was immediately apparent in his reception on his return to London, 'the centre of all Science', in 1726. In addition to the esteem in which he was held by his sponsors for the collections he had made for them,[200] he was now regarded as the foremost authority on North American flora and fauna (especially ornithology) by 'the most respectable members of [the Royal Society]'.[201] While needing to find funds and subscribers for his planned book, and beginning the challenging task of writing up and creating the plates from the material he had collected, drawn and observed first-hand in the field, he increasingly took an active part in the life of the Royal Society.[202] By

the time the 'Proposals' and twenty plates making up Part I of his book were completed in 1729, he was attending meetings as a guest of fellows, and four years later, on completion of Volume I of the book, he was himself elected fellow on 26 April 1733.[203]

Even before his election Catesby's skills as an artist were in demand. In November 1732, on the basis of the illustrations in the first four parts of the *Natural History* already presented to the Royal Society,[204] he was appointed one of its scientific draughtsmen when the Council 'Resolved that Mr Catesby be employed … to draw cuts for the *Register Book*', being paid according to 'such rates as on examination should appear reasonable'.[205] Clearly, Catesby's images were judged to accord with the scientific ideals of the society in their depiction of objects which allowed members to distinguish, identify, name, catalogue and add to the 'philosophical stock'. Over the following seventeen months, Catesby was evidently engaged in making drawings for the society, and on 30 April 1734 Mortimer showed the Council 'Draughts of Plants and Animals made by Mr Catesby, to be inserted with the copies of the Papers they related to in the Register Books'.[206] The financial arrangement agreed was that Catesby should be absolved his annual membership subscription of 52 shillings, paid quarterly, in return for supplying the required drawings.[207]

Once a fellow of the Royal Society, Catesby took an increasing part in its business. A few months after his election, no doubt recognized for his technical skill in preserving and displaying natural history specimens, Catesby was appointed a member of the committee for overseeing its museum, the Repository. The committee was charged with 'reviewing the manner of the preserving and ranging the several sorts of Curiosities in the museum', and Catesby is recorded as attending during September and October 1733, sometimes taking his turn in the chair.[208] In May 1734 he presented the museum with an item from his own collection: the skin of a skunk given to him by Native American traders in South Carolina.[209]

His first-hand knowledge and observations of North American natural history were shared through the various papers he delivered at Council meetings. The longest of these, read over two sessions and deemed an 'entertaining' and 'curious Communication', was an account of 'The Aborigines [Native Americans] of America', 'compiled partly from his own Observations, concerning [their] State

and Conditions in America, his conjectures about their Origination; his description of their Manners, Customs, Habits, Diet, Arts, ways of Life, Habitation, Manufactures &c.';[210] others were on the subject of 'the manner of making Pitch and Tar in Carolina',[211] and 'an account of the method used in Carolina for the striking of Sturgeon according to the practice of the Indians'.[212] But the most notable for its originality was his paper on bird migration presented on 5 March 1747, containing 'some thoughts concerning the places to which, those birds, usually called birds of passage, retreat unto, when they take their leave of us: and the manner in which they convey themselves to those places' (fig. 249).[213] In this account, developed from his observations of swallows and other birds of 'the swallow tribe' in America, as well as of flocks of bobolinks flying overhead during September in the Bahama Islands, Catesby put forward a rational theory of migration in rejection of the commonly held belief that such groups of birds hibernated in mud or in caves or hollows of trees. In his conclusions he has been considered by ornithologists to be 'years ahead of his time'.[214] He also helped to disseminate foreign scientific publications, amongst these reading papers sent by several friends: Johann Amman from St Petersburg, 'wherein he mentions many particulars relating to the natural History of Animals in those parts';[215] Thomas Knowlton on a 'description of two extraordinary pairs of Deers Horns that were found under ground in different parts of Yorkshire';[216] and William Byrd covering various topics, including ginseng, rattlesnakes and snakeroot cures.[217]

Catesby was asked to review several foreign scientific publications. His report on one, a substantial six-volume work on insects by the French scientist de Réaumur, *Memoires pour server a l'histoire des insectes* (Paris, 1734), is particularly interesting for the light it throws on Catesby's own working methods and practices. His detailed 'Account', based on a reading of the French original of Réaumur's work, was a careful digestion of its contents composed in four long parts, and contains his comments on the scientific method, quality and exactness of Réaumur's work.[218] He highlighted particularly the fact that Réaumur's work was based on empirical observation rather than second-hand sources:

the Book has less of compilation or things taken upon trust than most others that I know of the same bulk,

Some remarks on American Birds.

The Birds of America generally excel those of Europe in the beauty of their plumage but are much inferior to them in mellodious notes, for except the Mockbird, I know of none that merrits the name of a Song Bird, unless the red Bird known in England by the name of the Virginian Nightingale may be allowed it: This difficiency I have Observed to be still greater in Birds of the torrid parts of the World, whose chattering Odd cries are little entertaining, this is evidenc'd in a Small tract printed in the year 1667. giving an account of Surinam, then possessed by the English, which says that the Birds there, for beauty claime a priority from most in the World, But making no other harmony but in horror, one howling, another Screiching a third as it were groning, and lamenting, all agreing in their ill concerted voices

In America are very few Europian land Birds, but of the Water kinds there are many if not most of those found in Europe, Besides the great variety of Species pecculiar to those parts of the World.

Admitting the World to have been universally replenished with all animals from Noas Ark after the general deluge and that those Europian Birds which are in America found their way thither at first from the Old World, the cause of disparity in number of the land, and Water kinds, will evidently appear by considering their different Structure, and manner of feeding which enables the Water fowl to perform a long voyage, with more facility, than those of the land: The Europian Waterfowl (tho they travel Southerly in Winter for food) are most of them Natives of very northern parts of the World where they return to and make their Principal abroad, this their Scituation probably may have facilitated their passage

by

it being almost throughout either an accurate recital of the author's own Experiments or a verification of those made by Natural Historians of the best Note before him, or *in fine* has judicious consequences drawn from these Experiments and Observations … Such is the method this curious Author has followed throughout his whole Book in relating all the Circumstances however minute, which he could collect from most patient Observation if they seem'd to have a tendency to the illustration of his subject.[219]

FIGURE 249

Mark Catesby, 'Some Remarks on American Birds', 5 March 1747. Autograph manuscript.

Royal Society of London, Letters and Papers, no. 49, p. 1

Réaumur's book, illustrated with high quality engravings with details done under high magnification, demonstrated his belief in the importance of images.[220] His comment, 'Les Desseins dissent bien plus vite ce qu'ils ont a dire', echoes Catesby's own that 'I may aver a clearer Idea may be conceiv'd from the Figures of Animals and Plants in their proper colours, than from the most exact Description without them: wherefore I have been less prolix in the Description.'[221] Catesby's summary of Réaumur's opinions of the work of other natural history authors on insects may perhaps indicate something of his own opinions of these authors: 'Writers on Insects, he says, are but few and gives his opinion in the chief of them. Ray's descriptions, though good, generally tire people to read many at a time. Madam Merian's figures are fine, but want descriptions. Albin's book seems calculated only for the eye. Goedart was a better Painter than Observer: and yet his Treatise is one of the best on this subject, especially the Latin edition by Lister.'[222]

Catesby was also asked to review a Latin monograph on mosquitoes by a German scientist, Johann Matthäus Barth (1691–1757), entitled *De culice dissertatio* (1737).[223] Like Réaumur's lengthy book, this short account is illustrated (in two plates only) with anatomical views of the male and female insect seen under the microscope.[224]

But by far the most significant of the books on which Catesby's opinion was sought was the first edition of Linnaeus's *Systema naturae* (1735), which, in December 1735, the Royal Society 'referr'd to Mr. Catesby to give an account'.[225] Catesby, however, declined to review the work, which was subsequently referred to his friend, the physician Thomas Stack, who wrote an account of it two and a half years later.[226] Catesby was already engaged in 1735 both in writing his lengthy accounts of Réaumur's *Insectes* for the society[227] and in preparing Part 7 of his *Natural History*, but his reason for declining the task may have been more complicated than simply lack of time. He was over halfway through compiling his own book; what classificatory system he had followed was based on John Ray, and to have embraced Linnaeus's revolutionary system at this point in his work would surely have made it impossible for him to complete the remainder already mapped out.[228]

While Catesby's reaction to Linnaeus's system of botanical and zoological classification and nomenclature is not recorded, the reserved or even negative

response of several of his contemporaries is. In 1736 Linnaeus paid a month-long visit to England, with letters of introduction from Gronovius to the leading men of botany, including Hans Sloane, Philip Miller, Johann Dillenius, John Martyn, Peter Collinson and Catesby. The twenty-nine-year-old Linnaeus's arrogance towards these respected botanical 'elders', most of whom had spent their lifetimes working within different systems, made things difficult initially. Sloane, whom Linnaeus (keen to inspect his legendary museum) visited first, was by then 76; he had spent decades painstakingly arranging his thousands of natural and artificial objects according to type, and it is easy to imagine that Linnaeus's revolutionary ideas for cataloguing the natural world might not have been welcome.[229] Although Linnaeus, according to Richard Pulteney, 'beheld with astonishment the collections of Sloane, and, with rapture, the *Herbaria* of Petiver, Plukenet, Budelle [the botanist Adam Buddle, 1662–1715], and of many others there reposited, whose names were familiar to him',[230] including no doubt the North American and Caribbean plant specimens collected by Catesby, he did not cite them in his *Species plantarum* of 1753.[231] In the case of both Sloane and Catesby, it was the published plates of their respective natural history books that Linnaeus was later to use extensively for his classifications rather than their herbarium specimens.[232]

Recording that 'the main object of my journey' was to visit the Chelsea Physic Garden in order to procure interesting plants for his patron George Clifford's garden, Linnaeus did not at first endear himself to Philip Miller by telling him not to 'use such names [polynomials]; we have shorter and surer ones.'[233] After a brief stand-off, the two subsequently became friends, and by the eighth (and final) edition of his popular *Gardeners' Dictionary* (1767) Miller had adopted fully Linnaeus's binomial nomenclature.[234] When Linnaeus visited Oxford, Dillenius, by then Sherardian professor of botany, like Miller did not take kindly to him at their first meeting, commenting to James Sherard, who happened to be with him: 'This is the man who has thrown all botany into confusion.'[235] But Dillenius was quickly persuaded by Linnaeus's system. While we have no certain evidence that Dillenius showed him William Sherard's herbarium, Pulteney did record that 'at Oxford [Linnaeus] inspected, with no less satisfaction [than Sloane's herbarium], the *Pinax* of Sherard, which he had eagerly wished to see pub-

lished, and of which Dillenius had completed about a fourth part.'[236] Meanwhile, Collinson, receiving Linnaeus in typically gracious fashion and taking pride in showing him his small garden at Peckham, offered to help make his *Systema naturae* more widely known.[237] However, he wrote to John Bartram that Linnaeus's book was 'a curious performance for a young man, but his coining of a new set of names for plants tends but to embarrass and perplex the study of botany … Very few like it.'[238]

Despite the fact that Linnaeus met Catesby during his visit to London, no details of their encounter are recorded.[239] What does appear, however, is that for some reason, either then or subsequently, Linnaeus took against Catesby; a year after his visit to

FIGURE 250

Mark Catesby's letter to Carl Linnaeus, 26 March 1745. Autograph letter, 19.5 × 31 cm. Linnean Society of London, L0612

London, Dillenius was prompted to write to Linnaeus, 'Catesby is an honest, ingenuous man, who ought not to be suspected of error or fraud, as you seem inclined to do.'[240] Collinson acted as loyal intermediary between Catesby and Linnaeus, reporting on the progress of Catesby's book, and arranging for parts of it to be sent to Linnaeus.[241] One of two known letters that Catesby wrote in 1745 to Linnaeus in Uppsala accompanied a consignment of plants which Catesby noted he had 'selected … as being hardy and naturallised to our Climate & consequently somwhat better adapted to endure your colder Air'.[242] The plants included 'Cornus Americ:' (*Cornus florida*), 'The Catalpa Tree' (*Catalpa bignonioides*) and 'Pseudo Acacia' (*Robinia hispida*) (fig. 250). Clearly continuing to be respected as an authority on North American species, Catesby also took the opportunity to send Linnaeus a copy of his 'Catalogue of American Trees and Shrubs', adding that if any plant included in it might 'be acceptable, you may freely command any that I am possessed of '.[243]

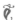

The year 1736 when Catesby and Linnaeus met might be considered a significant moment in the history of early modern science, representing the ending, in Catesby's work, of the old systems of taxonomy, or the pre-Linnaean age, and the beginning in Linnaeus's of the modern nomenclatural system still in use today. In the decades following the publication of the first part of Catesby's *Natural History*, Linnaeus was to revolutionize the naturalist's profession, and in the process, along with others including William Sherard, Catesby's pioneering contribution in multiple ways was occluded. Nevertheless, despite never publicly voicing respect for Catesby's work, Linnaeus paid it the highest compliment by using it extensively in his own publications.[244] The quantity of Catesby's illustrations and descriptions of North American flora and fauna on which Linnaeus based his binomials itself gives some measure of the en-

during nomenclatural importance of Catesby's botanical and zoological work.

At the same time, Catesby himself had played a significant part at an early stage of the long process towards the professionalization of the scientist and the evolution of scientific knowledge into scholarly disciplines.[245] His high standards as a practitioner in the overlapping areas of collecting, illustrating, writing, publishing and horticulture demonstrated that 'Catesby was not an amateur as most of his friends were, but a man for whom science had become a vocation.'[246] Assuring Sherard of his 'collecting plants and seeds which all give place to when opertunity offers',[247] Catesby applied himself to his work in the spirit of a professional rather than a dilettante. The rigorous methods and application he demonstrated both to collecting and to ensuring his collections reached his sponsors resulted in an enormous quantity of plants being added to English herbarium collections.[248] The quality of this surviving material is revealed in the fact that these specimens are still of value to present-day botanists in their interpretation of the Linnaean species of North America. Not only the collections and the visual and written records Catesby made, but his pioneering publication of much of this material, and the exchange he subsequently stimulated with naturalists at home and abroad, were to play a significant part in the scientific revolution under way in Europe. The many strands of his life's work, culminating in his *Natural History of Carolina, Florida and the Bahama Islands*, formed – as his biographers were to state over two centuries later – 'a fitting monument to Catesby's pertinacity, imagination, artistry and scientific accomplishments'.[249] Catesby's own assessment of the artistic and scientific accomplishment represented by the *Natural History* was a characteristically modest one:

> however accurately human art may be exercised in the representation of Animals [and Plants], it falls far … short of that inimitable perfection so visible in Nature itself.[250]

Blodgettia confervoides Harv.

B. S. 31.

Halotea flabellata.

B. S. 12.

Gymnosorus variegatus ?

B. S.

Avainvillea
Mazei m. f. Bon.
Dictyosphaeria fav

B. H. S. 4.

laria crenulata Lam.

Caulerpa paspaloides
var. phloeides J. Ag.

Caulerpa paspaloides (Bory) Grev.

M. a Weber van B.
in Ann. Jard. B
XV. 1898 p. 35

B. H. S. 16.

Laurencia sp.

Caulerpa
plumari

Note on Catesby's Plant and Animal Specimens

An idea of the extent of Catesby's collections of plant and animal specimens can be gleaned through his letters and their accompanying lists, the text of his *Natural History*, Sloane's manuscript catalogues, and in what survives of the specimens themselves now found in the Natural History Museum, London, the Department of Plant Sciences, Oxford, and a few other locations. From these sources the number of preserved, dried plant specimens Catesby sent or brought back from his travels is estimated at around 2,000 in addition to an unknown number of seeds and living plants,[1] and between 150 and 200 zoological specimens. While very few of the zoological specimens have survived, large numbers of the preserved plant specimens are extant.[2]

Surviving plant specimens

Natural History Museum, London: total *c.*914 specimens[3]

Sloane Herbarium: HS 212 & HS 232: 235 folios (*c.*584 specimens). 41 specimens bear Catesby's autograph labels

Dale Herbarium: 98 folios extracted from Dale's general herbarium; 51 specimens bear Catesby's autograph labels

Petiver Herbarium: HS 159 & HS 162 (specimens given to Petiver by Dale): 17 folios

Sloane Vegetable Substances: 215 boxes.[4] (Sloane 'Vegetable Substances'; MacGregor, 1994, nos 7–9)[5]

Oxford, Department of Plant Sciences: total *c.*912+ specimens[6]

Sherard Herbarium: 419+ (348 localized to Virginia, Carolina, South Carolina and Bahama Island of Providence; 71 unlocalized); 28 bear Catesby's autograph labels[7]

Du Bois Herbarium: 459 (localized to Virginia, Carolina or South Carolina)[8]

Dillenius Herbarium: 34[9]

London, Linnean Society: total *c.*3–7 specimens

LINN 80.55, *Panicum* sp., labelled, 'Ex Carolina Ad quod genus Plantarum hoc refert'[10]

Cambridge, University Herbarium, Department of Plant Sciences: total 1 specimen

John Martyn Herbarium: 1, mallow, Malvaceae (CGE 08762), labelled in Martyn's hand, 'Sent by Mr Catesby from the Isle of Providence. JM.'

Edinburgh Botanic Garden: total 6 specimens

Du Bois specimens: 6 (localized to Virginia, Carolina or South Carolina)[11]

Total surviving plant specimens: *c.*1,840[12]

FIGURE 251

Marine algae and seaweeds, 1725–6. Specimens collected and mounted by Catesby. Detail of fig. 243.

Surviving animal and fossil specimens

Natural History Museum, London

Fishes (1): viperfish, *Chauliodus sloani*, Sloane 'Fossils V', no. 1142 (drawn: RCIN 926089 & BL, Sloane Add MS 5267.67; etched: *NH*, Appendix, 19); see fig. 244

Shells (8): listed in Sloane 'Fossils II', no. 748: *Natica canrena*; no. 1182: West Indian topsnail, *Cittarium pica* (drawn: RCIN 925978; etched: *NH*, II, 33); no. 1443: *Astraea imbricata*; no. 1443: *Astraea longispina*; no. 1482: *Fasciolaria tulipa*; no. 1487: *Cymatium pileare*; no. 1894: *Busycon canaliculata*; no. 2815: *Murex pomum*;[13] see fig. 242

Fossils (1): listed in Sloane 'Fossils V', no. 1142: Jurassic shark vertebra, possibly *Carcharhinidae*, from phosphate beds, South Carolina (specimen NHMUK PV P 73130);[14] see fig. 246

Total surviving animal specimens: 10

Animal, fossil and mineral specimens listed in Sloane's manuscript catalogues[15]

'Birds': 40 birds (Sloane 'Fossils V'; MacGregor, 1994, no. 25)

'Quadrupeds': 2 mammals, 1 reptile (Sloane 'Fossils V'; MacGregor, 1994, no. 25)

'Fishes': 7 fishes, 1 fossil shark vertebra [see no. 1142 above] (Sloane 'Fossils V'; MacGregor, 1994, no. 25)

'Corals': 17 corals and octocorals (Sloane 'Fossils I'; MacGregor, 1994, no. 21)

'Echini': 7 sea urchins (Sloane 'Fossils I'; MacGregor, 1994, no. 21)

'Echini Marini': *c.*15 sea urchins (Sloane treatise entitled 'Echini Marini'; MacGregor, 1994, no. 27)

'Crustacea': 3 crabs (Sloane 'Fossils I'; MacGregor, 1994, no. 21)

'Stelle marine': 3 starfishes (Sloane 'Fossils I'; MacGregor, 1994, no. 21)

'Shells': 51 or more shells (Sloane 'Fossils II, III, IV'; MacGregor, 1994, nos 22–4)

'Insects': 8 insects[16] (Sloane 'Insects'; MacGregor, 1994, nos 13–14)

'Pretious Stones' and 'Metals': none found[17] (Sloane 'Minerals I–IIIB'; MacGregor, 1994, nos 15–18)

Total specimens: *c.*155

Ethnographic artefacts

Catesby records sending three items of native American manufacture:[18]

'Indian Apron made of the Bark of Wild Mulberry' (Sloane 'Miscellanies', no. 1203)[19]

Cherokee woven cane baskets (Sloane 'Miscellanies', no. 1218)

Native American deerskin waistcoat (letter 14 to William Sherard, 13 November 1723; *NH*, Account, p. viii)

1 James Petiver records that Dale received seeds of 101 species sent by Catesby from Virginia (BL, Sloane MS 3339.73v–75r; cited by Jarvis, C. E., 2019, '"The most common grass, rush, moss, ferns, thistles, thorns or vilest weeds you can find": James Petiver's Plants', *Notes & Records*, online article, 27 November, https://doi.org/10.1098/rsnr.2019.0012.

2 When estimating the total number of specimens collected by Catesby several factors must be considered, including what was lost in transit, the subsequent decay of specimens, and later reorganization and labelling of material (see note 7 below).

3 Dandy, J. E., 1958, *The Sloane Herbarium: An Annotated List of the Horti Sicci composing It ...*, London.

4 This total includes specimens Catesby collected himself in South Carolina and the Bahamas, as well as those sent to him by John Clayton from North America and by his brother John from Gibraltar (Pickering, V., 2017, 'Putting Nature in a Box: Hans Sloane's Vegetable Substances Collection', PhD thesis, Queen Mary College, University of London).

5 Sloane's manuscript catalogues, now mostly housed in the General Library of the NHM, are listed in MacGregor, A., 1994, 'Sir Hans Sloane's Catalogues', in MacGregor, A., ed., *Sir Hans Sloane: Collector, Scientist, Antiquary ...*, London, pp. 291–4.

6 Clokie, H. N., 1964, *An Account of the Herbaria of the Department of Botany in the University of Oxford*, Oxford; Harris, S. A., 2015a, 'The Plant Collections of Mark Catesby in Oxford', in Nelson, E. C. & Elliott, D. J., eds, *The Curious Mister Catesby: A 'Truly Ingenious' Naturalist Explores New Worlds*, Athens, GA, & London, pp. 173–88; Harris, S. A., 'The Collections of Mark Catesby in Oxford', online database, https://herbaria.plants.ox.ac.uk/bol/catesby; Stephen Harris, pers. comm.

7 An additional 196 specimens, bearing the locations Virginia, Carolina, South Carolina or Providence, may have been collected by Catesby. However, other collectors were operating in some of these areas and are known to have contributed to Sherard's herbarium: Stephen Harris pers. comm. See also Clokie, H. N., 1964, pp. 77–9.

8 An additional 18 specimens, bearing the locations Carolina or South Carolina, may have been collected by Catesby: Stephen Harris, pers. comm.

9 Some of these specimens are of plants cultivated from seeds collected by Catesby and grown in the James Sherard's garden at Eltham, Kent (Harris, S. A., 2015a, p. 186).

10 Savage, S., 1945, *A Catalogue of the Linnaean Herbarium*, London, p. 13. Jarvis notes: 'A few of Catesby's specimens are to be found in LINN,' but only makes mention of the specimen of *Panicum* sp. (Jarvis, C. E., 2007, *Order Out of Chaos: Linnaean Plants Names and their Types*, London, p. 198).

11 These specimens, duplicates from the Du Bois Herbarium, were apparently sent to Edinburgh in the 1880s after Isaac Bayley Balfour, seventh Sherardian Professor of Botany in Oxford, ordered the herbarium to be unbound and rearranged (Druce, G. C., 1928, 'British Plants contained in the Du Bois Herbarium in Oxford', *Botanical Exchange Club Report 1727*, pp. 463–93). The specimens are:

?*Platanthera* sp. (Orchidaceae). 'Sent from South Carolina by Mr Mark Catesby'.

Kalmia latifolia L. (Ericaceae). 'Sent from South Carolina, anno 1724 by Mr Mark Catesby'.

Sabatia angularis (L.) Pursh (Gentianaceae). 'Sent from South Carolina by Mr Mark Catesby, anno 1724'.

Pediomelum canescens (Michx.) Rydberg (Fabaceae). 'Sent from South Carolina by Mr Mark Catesby, anno 1723'.

Rhynchospora colorata (L.) H. Pfeiffer (Cyperaceae). 'Sent from South Carolina by Mr Mark Catesby, anno 1724'.

Polygala ramosa Elliott (Polygalaceae). 'Sent from South Carolina by Mr Mark Catesby, anno 1724'.

12 This total is likely to have been substantially higher, see notes 2 and 7 above.

13 Wilkins, G. L., 1953, *A Catalogue and Historical Account of Sloane's Shell Collection*, London, p. 37. For Sloane no. 1182, see Bauer, A., 2015, 'Catesby's Animals (other than Birds) in *The Natural History of Carolina, Florida and the Bahama Islands*', in Nelson, E. C. & Elliott, D. J., eds, *The Curious Mister Catesby: A 'Truly Ingenious' Naturalist Explores New Worlds*, Athens, GA, & London, pp. 231–50, fig. 17-11.

14 Sendino, C., 2016, 'The Hans Sloane Fossil Collection at the Natural History Museum, London', *Deposits Magazine*, no. 47, pp. 13–17 [p. 16].

15 See MacGregor, A., 1994, pp. 291–4.

16 These figures are tentative as this catalogue was only partially checked before lockdown owing to the Coronavirus pandemic in March 2020.

17 As note 16.

18 See Chapter 2, p. 56 and Chapter 6, pp. 211–12.

19 This catalogue is housed in the BM, Department of Africa, Oceania and the Americas.

Note on Catesby's Paper and Dating of Drawings

With contribution on watermarks by Peter Bower

As a naturalist, artist and author/publisher, Catesby used paper for four specific purposes: mounting his herbarium specimens, painting his watercolours, printing the plates and text leaves of his *Natural History*, and writing his manuscripts and letters. An examination of representative samples of Catesby's papers used for each of these purposes has shown a remarkable homogeneity of paper manufacture and quality.[1] The fact that Catesby used the same paper not only for drawing and for mounting his plant specimens, but also for both the plates and text of his book was unusual;[2] it suggests that he was responsible for purchasing large quantities of the same paper stock rather than, for instance, leaving it to the printer to supply his own.

Although by the end of the eighteenth century certain English mills were producing some of the best paper in Europe, in Catesby's period the best quality 'white paper' was made in the Netherlands and France, with lesser quality 'brown paper' being manufactured in England.[3] While, in common with other naturalists, Catesby would have used brown or other coarse paper for collecting, drying and wrapping his plants, he used white paper for the final stage of mounting the pressed specimens.[4] Both white and brown paper types were available from stationers' shops in London as well as pasteboard, which Catesby found 'of great use' for pressing and packing specimens.[5] We know from his letters that he took supplies of paper with him to America; on several occasions he had to ask William Sherard for new supplies, and in one letter tells him: 'I want Paper and have desired my Brother to send some.'[6] He received

a 'Box of Paper' from Sherard on 14 February 1724, and on another occasion there is mention of Sherard sending '2 paper Books bound in past board'.[7]

White paper was available in different grades, often described as 'super-fine', 'fine' and 'coarse' (or 'retree') depending on the quality of linen and other fibres used to make it.[8] In Catesby's day there were two main types of white paper – writing and printing paper; while they were made on the same moulds, the weight and finish of the sheet varied according to the degree of beating the fibre and the degree of gelatine sizing. Writing paper, which was also used for drawing and for prints which were to be hand-coloured, needed to have a finish without too much absorption to take water-based ink and watercolour pigments without risk of them running: that is, it needed to be smooth and hard-sized.[9] Catesby specified his use of 'finest Imperial' paper for the coloured copies of his *Natural History*; he appears to differentiate this from the paper to be used for the uncoloured copies, which he noted were to be printed on 'the same Paper as these Proposals'.[10] As the watermarks are the same in both the coloured and the uncoloured copies (and the copies of the Proposals identified) (see fig. A14 below), any difference of quality would appear to have been in terms of finish and weight rather than in production by different manufacturers. A significant difference in weight can be discerned between the paper used for mounting herbarium specimens (heaviest) and that used for letter writing (lightest).

The watermarks of Catesby's papers indicate that he used paper from the prominent Dutch and

French, and occasionally Italian, paper mills. The list below identifies the different watermarks and countermarks, while the table (fig. A14) shows their distribution in the different groups of Catesby's papers.

Watermarks, countermarks and paper sizes

English watermarking practice in Catesby's time was for laid papers to centre the watermark (Fleur-de-lis, Maid of Holland, Posthorn, Royal Arms, etc.) in one half of the sheet with a countermark (generally the maker's name, with or without a date) centred in the other half of the sheet. Figure A1 indicates the positions of the marks in a full sheet of laid paper. When folded once (to make a folio) each page would carry the watermark or the countermark. If folded twice (to make a quarto) then each page would carry half of either the watermark or the countermark. The less commonly found corner mark appears in the corner of the sheet. Paper is made in batches, so while the papers used by Catesby may have been made on the same moulds, variations between batches would have occurred, resulting from different blends of rags, the degree of beating the fibre to pulp, and varying drying times causing different amounts of shrinkage within the sheet. These factors would have led to a subtle but rich variation between the different batches.

In the descriptions below, the different watermarks and countermarks have been listed in a running sequence under 'types'.[11] Unless both watermark and countermark can be seen in the same sheet, it is not possible to say which countermark

goes with which watermark; where matches have been seen they are indicated in the table (fig. A14).

TYPE A: *FLEUR-DE-LIS*
on an ornamented shield, with or without various pendant marks such as 4, 4WR and LVG

The pendant mark 4WR (fig. A2) was originally the mark of the sixteenth-century Strasbourg printer Wendelin Richel, in operation between 1535 and 1555, who had paper made for him by several different papermakers, but because of the quality he demanded in his paper, the mark was appropriated by papermakers all over Western Europe.

The pendant LVG letters below the watermark are the initials of the Dutch papermaker Lubertus van Gerrevinck, who worked the Phoenix mill at Egmond aan den Hoef, near Alkemaar, Holland. He and his brother Joachim bought the mill in 1691. His name and initials continued to be used by his sons, Abraham and Isaac van Gerrevinck, through-

out the first half of the eighteenth century. The van Gerrevinck family had a Europe-wide reputation as fine papermakers, and Lubertus's initials and sometimes his name were appropriated by several English papermakers in their watermarks as signs of quality.

Paper bearing this watermark and related countermarks was used by Catesby for mounting his specimens, for his watercolours, and for printing the plates and texts of his book.

TYPE B: *PRO PATRIA*

Originally Dutch, the *Pro Patria* watermark (fig. A3) depicts the Maid of Holland in a palisaded garden, accompanied by the Lion of the Seven Provinces, holding a sabre and seven arrows, symbolizing the Seven Provinces. The Maid is holding a lance surmounted by a cap of liberty. The mark was later used by many English paper mills for writing papers. Without the countermark it is almost impossible to identify who made the paper.

This watermark occurs in Catesby's writing papers.

TYPE C: *ARMS OF THE CITY OF LONDON*
plain

During Catesby's lifetime papers with this watermark (fig. A4) would have been made for Dutch merchants by mills in the Angoumois in France worked by Claude de George and Henri Durand. One main source was the Moulin de Verger at Puymoyen, south of Angoulême, which made paper for the Dutch factor Abram Janssen. Papers from this source were sold in London by Abram's brother Theodore, who set up business near St Paul's as a stationer. The mark is commonly found in English writing papers, including Catesby's.

TYPE D: *ARMS OF THE CITY OF LONDON*
ornamented

The ornamented version of the Arms of London watermark (fig. A5) is found with a DP countermark from Dierck Pieterzon de Jong, who worked Der Visser (The Fisher) mill at Zaandijk in north Holland between 1694 and 1722.

This watermark occurs in Catesby's writing papers.

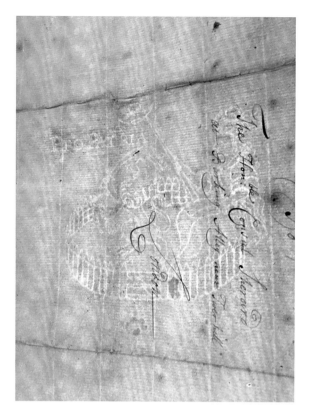

The bunch of grapes (fig. A7) indicates a traditional French sheet size, 'Raisin' or its variants, 'Petit Raisin' and 'Grand Raisin'. The partial set of initials found in the countermark identified in Catesby's papers possibly belong to Pierre Sallée, who worked a mill near Angoulême in the first half of the eighteenth century.

This watermark is found in Catesby's writing papers.

TYPE G: HONIG

Countermark (fig. A8) made by Cornelis and Jan Honig, who operated Der Vergulde Bijenkorf (The Gilded Beehive) mill at Zaandijk in north Holland. The partnership was formed in 1712.

Found in Catesby's drawing and printing papers.

TYPE H: IHS/I VILLEDARY

Several generations of papermakers, all called Jean Villedary, operated the Vraichamp, Beauvais and La Couronne mills in the Angoumois, France, from

FIGURE A5

Type D (Arms of the City of London, ornamented), letter 30, 26 November 1724.

Royal Society of London, MS 253, no. 181

TYPE E: *POSTHORN*

on a shield, with or without pendant marks such as 4WR or maker's initials

The Posthorn mark (fig. A6) indicates the sheet size, 'Post' or 'Large Post', and is found in writing papers. The paper probably came from Holland.

This watermark is found in Catesby's writing papers.

FIGURE A6

Type E (Posthorn on shield with/ without initials), letter 18, 16 January 1724.

Royal Society of London, MS 253, no. 174

FIGURE A7

Type F (Grapes), letter 7, 5 January 1723.

Natural History Museum, London, Department of Life Sciences, Botany Autograph Collection

1668 to 1758 (fig. A9). Although the Villedary family had worked the mills from 1668, the use of the full name rather than the IV initials appears to date from the 1690s. Most of the paper produced by the Villedary family was made for Dutch factors such as Abram Janssen, Francois van Tongeren, Pierre van Tongeren and Gilis van Hoven. During the 1690s Abram Janssen's brother Theodore moved to London, setting up as a paper merchant, and papers made by Villedary began to be used in England.

During the various European wars in the mid-eighteenth century, part of their operation was moved to Hattem in Guelderland, Holland, in order to safeguard their extensive export business, allowing the Villedary to continue trading with England. Many Villedary sheets bear the initials LVG of the celebrated Lubertus van Gerrevinck. The Villedary continued to operate the Hattem mill until 1812.

Found in Catesby's drawing and printing papers.

TYPE I: IV

The most common countermark found in use in papers used in England during the eighteenth century is IV (fig. A10). These are the initials of Jean Villedary, but there is little evidence that any of the Villedary used this countermark themselves. Both Dutch and English makers used it as a countermark.

Found in Catesby's drawing and printing papers.

TYPE J: CROWN/GR
with or without circle, laurel leaves, etc.

This was one of the most common countermarks during the eighteenth century (fig. A11). The GR countermark was originally Dutch, being the Latin initials for Gulielmus Rex, William, Prince of Orange. The mark was then copied by English makers, who used it to stand for George Rex. It is next to impossible to identify who actually made these papers.

Found in Catesby's writing papers.

TYPE K: DR

Probably Denis Rousell, who worked one of the paper mills around Mortain in Normandy during the first half of the eighteenth century (fig. A12). Mills from this area had been supplying paper to England since the sixteenth century.

Found in Catesby's writing papers.

Type J (Crown/GR with circle & laurel leaves), letter 44, 26 March 1745.

Linnean Society of London

Type K (DR), letter 17, 16 January 1724.

Royal Society of London, MS 253, no. 173

Type L (G or C MT), trial proof etching for *Natural History*, 1731, I, plate 29.

Morgan Library & Museum, New York, 1961.6:8

TYPE L: G OR C MT MONOGRAM

This corner mark is typical of those seen in papers made in the mills around Genoa (fig. A13). Unfortunately, the records of who was making what around Genoa are very incomplete and it is difficult to place them with any certainty.

Found occasionally in Catesby's drawing and writing papers.

WATERMARKS AND PAPER SIZES

The most common sizes of paper in use in Catesby's time were imperial (approx. 30 × 22 in.), royal (approx. 18 × 14 in.), post (19½ × 15¼ in.) and foolscap (17 × 13½ in.).[12] The sizes are nominal because of variations between mills and batches as noted above. In some instances, details of the design of the mark differ according to the paper size; this is true, for example, of the ornamentation of the crown in the *Fleur-de-lis* mark. In other instances, as for example with the *Post* and *Raisin* watermarks, the paper size is indicated by the watermark.

Dating Catesby's drawings

Catesby's watercolours were made during three main periods of his life: in Virginia (1712–19), South Carolina and the Bahama Islands (1722–6) and London (1726–47). Catesby did not date his drawings, and as the watermark evidence indicates that he was using very similar paper stocks throughout the years he was working, his paper use does not allow us to identify a chronology for his drawings.

Internal evidence, however, provides some markers. At the end of the *Natural History* he wrote: 'should any of my original Paintings have been lost, they would have been irretrievable to me, without making another Voyage to America.'[13] Other comments in his letters about individual drawings, as well as the statements he made in his book about painting in the field and from fresh specimens, corroborate the evidence that the larger part of his watercolours was made while he was abroad.[14] Within this group, certain drawings that could only have been made in Virginia can be dated to that seven-year period (1712–19), and those he made of plants and animals during his stay in the Bahama Islands can be dated between late 1725 and 1726, while the rest can loosely be dated between 1722 and 1725.[15]

Another group of drawings can be dated to after Catesby's return from America. Most of these drawings served as models for plates in the Appendix to the *Natural History* and were made from plants newly arrived and growing in Catesby's and other people's gardens, and from illustrations copied from Sloane's albums and actual objects in his museum. In addition, during this period Catesby acquired a number of drawings from other artists, two of which are signed and dated, by Edwards and Ehret respectively, 1743.[16]

1 Papers examined: Bodleian Library: 'Proposals'; BL: George III's first edition copy of *NH* and letters; CPG: uncoloured first edition copy of the *NH* & 'Proposals'; LS: 1 letter, first edition copy of *NH*; NHM: Sloane Herbarium, HS 212 (86 folios) and 232 (120 folios) and 1 letter; MLM: 6 drawings, 1 print, 11 manuscript folios; RL: Catesby's watercolours and original mount sheets (263 drawings; *c*.220 mount sheets); RS: Catesby's letters to Sherard (*c*.30 letters); SIL: 2 copies first edition of the *NH* & 'Proposals'.

2 Paper used for printing plates is 'Almost always of a different kind and quality from that used for letterpress [and] … is often a distinct source of evidence for dates of printing and publication' (Bridson, G. D. R., 1976, 'The Treatment of Plates in Bibliographical Description', *Journal of the Society for the Bibliography of Natural History*, 7, pp. 469–88 [p. 475]; and Gaskell, R., 2004, 'Printing House and Engraving Shop: A Mysterious Collaboration', *Book Collector*, 53, pp. 225–6).

3 Coarse quality paper included blue as well as brown and 'drab' – the colours ranging from buff and grey to olive-green according to the colour and cleanliness of the linen (flax) or cotton rags used to make the paper. For an account of English manufactured paper during this period, see Krill, J., 2001, *English Artists' Paper: Renaissance to Regency*, 2nd edn, New Castle, DE, pp. 47–67.

4 Such paper is recommended for natural history collectors by Petiver in his 'Directions' (see fig. 231); see Jarvis, C. E., 2018, '"Take with you a small Spudd or Trowell": James Petiver's Directions for Collecting Natural Curiosities', in MacGregor, A., ed., *Naturalists in the Field: Collecting, Recording and Preserving the Natural World from the Fifteenth to the Twenty-First Century*, Leiden & Boston, pp. 212–39 [p. 217]. The paper Catesby used for wrapping seeds and shells, as described in his letters to Sherard (see letters 5, 10, 25), is also likely to have been of the coarser type. While none of Catesby's brown paper has survived, an example can be seen in the mounting sheets used by Petiver: see fig. 186.

5 For Catesby's use of pasteboard, see Chapter 6, p. 201, and letters 2, 14 and 22.

6 Letters 14, 22, 25.

7 Letter 22; a request for paper is made twice in this letter, with Catesby commenting that the pasteboard was useful as well.

8 Krill, J., 2001, p. 50.

9 Printing ink was oil based and printing paper therefore could be soft (i.e. less well) sized.

10 'It is intended to publish every Four Months Twenty Plates … printed on the same Paper as these Proposals … For the Satisfaction of the Curious, some Copies will be printed on the finest Imperial Paper and the Figures put in their Natural Colours from the Original Paintings' ('Proposals'). For paper sizes, including 'Imperial', see p. 229 and Chapter 3, p. 79.

11 Several of the watermarks found in Catesby's papers are also found in the James Leman album of watercolour designs for silks (1706–16), now in the V&A; they are described and illustrated by Bower, P., 2018, 'The Papers used for Watercolour Designs for Silks by James Leman (1688–1745) in the Collections of the Victoria & Albert Museum', *The Quarterly*, 108, October, pp. 1–20.

12 The best reference for the complex matter of paper sizes is Labarre, E. J., 1952, *Dictionary and Encyclopaedia of Paper and Papermaking*, Amsterdam, pp. 246–72. Sizes are given here in inches because those are the measurements the mould was made in.

13 *NH*, Appendix, p. 20.

14 See Chapter 4, pp. 108, 121.

15 Dates derived from these periods are assigned to the drawings in the Figure Captions and the forthcoming Catalogue.

16 See forthcoming Catalogue. Among these later watercolours are *Primula meadia* (RCIN 926065) painted by Ehret, 1744; *Hamamelis virginiana* (RCIN 926066) painted by Ehret, December 1743; *Crotophaga ani* (RCIN 926068) by Edwards, dated 1743; *Megarhyssa atrata* (RCIN 926069) sent by Bartram to Collinson, 1740s and painted by Catesby; *Pancratium maratimum* (RCIN 926070) by Catesby, 1743; *Rhus glabra* (RCIN 926071) grown in Gray's garden and painted by Ehret, 1740s; *Lilium philadelphicum* (RCIN 926074) grown in Collinson's garden and painted by Ehret, 1740s; *Lilium canadense* (RCIN 926079) by Ehret, 1740s; *Stewartia malacodendron* (RCIN 926082) signed and dated by Ehret, 1743; *Magnolia virginiana* (RCIN 926084) by Ehret, *c*.1736; *Chordeiles minor* (RCIN 926085) from specimen sent by Clayton, 1740s, and painted by Catesby; *Panax quinquefolius* (RCIN 926085) by Ehret, 1746; *Kalmia angustifolia* by Catesby and *Rhododendron maximum* (RCIN 926086) by Ehret, *c*.1743; *Dasprocta leporina* (RCIN 926087) by Catesby after Edwards's drawing made in Duke of Richmond's collection, 1740s; *Acanthodoras cataphractus* (RCIN 926088) from Sloane's museum, by Catesby, 1740s; *Chauliodus sloani* (RCIN 926089) sent from Gibraltar, painted by Catesby, 1740s; *Bison bison* (RCIN 926090) by Catesby from watercolour in Sloane's albums, 1740s.

Watermark/ Countermark	Papermaker/ Country	Source in Catesby's Papers	Collection	Date of Paper Usage
Watermark				
Type A (fig. A2) Fleur-de-lis on a crowned shield with 3 variant pendants: '4' '4WR' '4LVG'	The 3 variants come from different mills in Holland. Despite the LVG pendant, it is unlikely that any come from Lubertus van Gerrevinck's mill.	Herbarium mount sheets (HS 212, 232) Drawings Appendix MS (MLM, MA 6038) *NH*, George III's unique 3-volume copy, drawing mount sheets, and text folios (made up of 1st & 2nd edns) *NH*, George III's copy (pts 1–10) (BL, 44.k. 7–8) *NH*, Bartram copy (pts 1–4) *NH*, Cromwell Mortimer copy *NH*, Royal Society copy *NH*, Linnean Society copy *NH*, uncoloured copy, possibly Samuel Dale's (pts 1–6) 'Proposals'	NHM RL MLM RL BL SIL SIL RS LS CPG SIL, CPG	1722–6 1712–47 *c.*1746 1729–54 1729–43 1729–31 1729–47 1729–47 1729–47 1729–37 1728–9
Type B (fig. A3) *Pro Patria*	Holland or England	Catesby's letters to Sherard	RS	1722–5
Type C (fig. A4) Arms of City of London: plain	Probably from the Angoumois, in France, imported via Holland	Catesby's letters to Sherard	RS	1723
Type D (fig. A5) Arms of City of London: ornamented	Probably from Holland	Catesby's letters to Sherard	RS	1723
Type E (fig. A6) Posthorn on shield w/without initials	Probably from Holland	Catesby's letters to Sherard	RS	1722–5
Type F (fig. A7) Grapes	France	Catesby's letters to Sherard Catesby's letter to Collinson (letter 7)	RS NHM	1722–5 1723
Countermark				
Type G (fig. A8) Honig (found with water-mark type A)	Holland	Drawings *NH*, several copies	RL RL, BL, SIL, RS, LS	1712–47 1729–47
Type H (fig. A9) IHS Villedary (found with watermark type A)	France	Drawings in RL Drawing in MLM (1961.6:5) *NH*, several copies	RL MLM RL, SIL, LS	1712–47 1712–47 1729–47

Type I (fig. A10) IV (found with watermark types A and C)	Holland or England	Herbarium mount sheets (HS 212, 232) Drawings *NH*, several copies 'Proposals'	NHM RL RL, BL, SIL, RS, LS Bodleian	1722–5 1712–47 1729–47 1728–9
Type J (fig. A11) Crown/GR with circle & laurel leaves	Dutch or English	Catesby's letter to Sherard (letter 4) Catesby's letter to Linnaeus (letter 44)	RS LS	1722 1745
Type K (fig. A12) DR	France	Catesby's letter to Sherard (letter 17)	RS	1724
Corner mark				
Type L (fig. A13) G or C MT monogram	Genoa, Italy	Drawing (RCIN 924854) Proof print in MLM (1961.6:8)	RL MLM	1722–5 Possibly 1760s

Catesby's Letters

Catesby's letters constitute a primary source of information about his life and work, together with his drawings and herbarium specimens. They reveal first-hand details of his travelling, collecting, observations of the natural world, friends and family, and his enjoyment, frustrations, and hopes for his life's work. The letters range from hasty notes to longer narrative accounts, whilst some are simply lists or announcements of material being sent. These documents are artefacts in themselves: they bear the physical evidence of the precariousness of their three-month sea journeys across the Atlantic, being handled in customs houses, pubs and coffee houses, and their eventual receipt by their intended addressees. As paper was expensive, letters were written on sides of a single folded leaf of paper (cut as needed from a larger sheet), which was then addressed on a blank side, folded and sealed. Sometimes recipients reused letters for their own needs to record lists and other memoranda. In this way the narratives of the physical artefacts themselves complement their rich documentary content.

By far the largest number of Catesby's letters to have survived are those he sent to William Sherard from South Carolina. These are housed in the Sherard Letter Book (RS, MS 253). A much smaller number sent to Hans Sloane, together with two to Edward Harley, Earl of Oxford, are in the BL. One letter to Collinson survives (NHM), two to Dillenius (OUH), and one to Linnaeus (LS).[1] A letter to Fairchild is known only from a published version.[2] Several letters to John Bartram and to Catesby's niece Elizabeth are in America (Library of Congress,

Washington, DC, and Historical Society of Pennsylvania, Philadelphia).

While a number of the letters have been wholly or partially published in the past, all have been re-transcribed here except in three cases where the original letters could not be located (letters 37, 40 and 41); some are published for the first time. Catesby's spelling has been retained, but modern punctuation and missing words are added between square brackets for ease of comprehension. His deletions are indicated by a line through the word. Some lines of text in Catesby's letters to Sherard have been obscured by opaque tape applied in a conservation exercise carried out in the 1960s; the obscured parts are signalled in italics within square brackets. The transcription of each letter is followed by a textual note giving the document's provenance and detailing the salient features of the material text. Biographical and contextual information has been footnoted, together with references to relevant illustrations and passages within the book. The formal calendrical change from the Julian 'Old Style' year (ending 24 March) to the Gregorian 'New Style' year (beginning 1 January) was made in England in 1752, later than in parts of Europe, and as a result it was common to double date during this period as Catesby does. The letters are captioned and cited in this book in NS.

1 A second letter to Linnaeus is now missing (Uppsala University Library, letter L5288).

2 Bradley, R., 1724, *A General Treatise of Husbandry and Gardening*, 3 vols, London.

The letters are published here in chronological order.

Letter no.	Letter date	Recipient
1	5 May 1722	William Sherard
2	20 June 1722	William Sherard
3	22 June 1722	Elizabeth Pratt
4	9 December 1722	William Sherard
5	10 December 1722	William Sherard
6	4 January 1723	William Sherard
7	5 January 1723	Peter Collinson
8	7 February 1723	William Sherard
9	19 March 1723	William Sherard
10	10 May 1723	Hans Sloane
11	10 May 1723	William Sherard
12	16 May 1723	William Sherard
13	26 June 1723	William Sherard
14	13 November 1723	William Sherard
15	15 November 1723	Hans Sloane
16	Undated (1723?)	Thomas Fairchild
17	16 January 1724 (i)	William Sherard
18	16 January 1724 (ii)	William Sherard
19	17 January 1724	William Sherard
20	12 March 1724	Hans Sloane
21	6 April 1724	William Sherard
22	Undated (probably 1724)	William Sherard
23	15 August 1724	Hans Sloane
24	16 August 1724	William Sherard
25	20 August 1724	Edward Harley
26	30 October 1724 (i)	William Sherard
27	30 October 1724 (ii)	William Sherard
28	15 November 1724	Edward Harley
29	24 November 1724	William Sherard
30	26 November 1724	William Sherard
31	27 November 1724	Hans Sloane
32	27 November 1724	William Sherard
33	5 January 1725	Hans Sloane
34	10 January 1725 (i)	William Sherard
35	10 January 1725 (ii)	William Sherard
36	1 March 1730	Elizabeth Jones
37	30 December 1731	Elizabeth Jones
38	Postmarked 3 February 1736	Johann Jakob Dillenius
39	10 December 1737	Johann Jakob Dillenius
40	20 May 1740	John Bartram
41	25 February 1741	John Bartram
42	Undated (probably 1742)	John Bartram
43	Undated (April 1744)	John Bartram
44	26 March 1745	Carl Linnaeus
45	15 April 1746	John Bartram
46	17 November 1748	John Bartram

Selected letters to or referencing Catesby

47	7 February 1724	William Sherard to Hans Sloane
48	12 June 1728	George Rutherford to Elizabeth Jones
49	undated (c.1741)	John Bartram to Catesby

1 William Sherard, London, 5 May 1722[1]

Charles Town May 5th 1722

Honrd Sr

As you commanded me I take ye first opertunity of letting you know of my arrival here 3d May which day fortnight before we were in Soundings, and within a few leagues of our port, but a violent and contrary wind set us back into the Current of the Mexican Gulf, otherwise we have had a Short and easy voyage[.][2] The Governor recieved me with much kindness to which I am satisfyed your Letter contributed not a little.[3] In Lat 25 and 300 leaugues from land (the Canary Iles being ye nearest ~~land~~) we had an Owl and other Birds hovering about our Ship[;] how an Owl that are so incapable of long flights that they are wont to be brought [*4 words illeg. under repair*] down by Boys on Shore should hold it so long on the wing is to me surprizing[.][4] On the Coasts of America we had several other Birds came on Board us which gave me an opertunity of discribing some of them as well as some fish.

Amongst the Birds the Turn stone or Sea plover of Mr Willoughby was one which by comparing with his discription of it agrees exactly.[5] I had not the same opertunity at Sea of ~~seeing~~ meeting any plants except the Gulf weed with which the ~~Sea at~~ Ocean at places was covered. One of our passengers who had been often in the Gulf told me he never saw the Gulf weed[6] there not any where south of the Bahamas where he says he has seen it grow – amongst the Rocks under water.

We spoke with the Grayhound Man of War on this Coast from whome we had the Scandalous Acct of that Ship being surprised and taken by 18 Spaniards who for several days had been trading with them[,] the Capt with eight Men being killed[,] the Lieutenant wounded ~~but~~ and forced overboard but alive.[7] The Man of War haveing a Sloop[8] which they sent to trade on the Coast ~~to trade~~ and that appearing, the Spaniards thought fit to quit the Ship and retire in their Boat but carried off all the treasure being assisted by one of ye Man of War's Men ~~in the Ac~~ much diminished by ~~tion~~ who being the principal instrument in the treacherous Action went of[f] with the Spaniards. I am told up the rivers there are abundance of fossils[9] and petrifations and that those parts have not been searched for plants which gives me hopes ~~(if God gives me health)~~ in some measure

of effecting what you perticularly desire which shall always be the utmost endeavours of

Sr
Yr most obliged and faithfull Servt
M Catesby

I hope Sr you'll excuse Blots but the Ship being now under Sail prevents my transcribing it
Be pleased My Humble Service to Mr Sherard Dr Delinius and all Friends[10]

For / The Honble Consul Sherard to be / left at the Coffee Shop in Barking / Alley near Tower Hill / London

1 RS, Sherard Letter Book, MS 253, no. 163, 1 leaf (22 × 31.4 cm), folded; letter on sides 1–2, address on side 4 with stain from red sealing wax. Inscribed on side 4 in pen and ink in unknown hand, 'May 1722'; in Sherard's hand in pen/ink and in graphite, lists of plants.

2 The letter records Catesby's arrival in Charleston after three months at sea (Chapter 2, pp. 50–51).

3 Colonel Francis Nicholson was the first governor to be appointed by the Crown in 1721 following the end of proprietary government. He had a personal interest in science and education and paid Catesby a £20 annual stipend to collect in the colony (Fraser, W. J., Jr, 1989, *Charleston! Charleston! The History of a Southern City*, Columbia, SC, p. 38; and see Chapter 1, p. 33, Chapter 2, pp. 49–50).

4 The owl was probably of the family Strigidae (Krech, S., III, 2018, 'Catesby's Birds', in MacGregor, A., ed., *Naturalists in the Field: Collecting, Recording and Preserving the Natural World from the Fifteenth to the Twenty-First Century*, Leiden & Boston, pp. 279–331 [p. 286]).

5 Ruddy turnstone, *Arenaria interpres*, drawn and etched by Catesby: RCIN 925907 (*NH*, I, 72). Catesby was able to identify it from his copy of John Ray's *Ornithology*, London, 1678, p. 26, which he had on board and which was his principal ornithological authority.

6 Gulf weed was very likely the brown algal genus *Sargassum*.

7 A man of war was a British Navy warship or frigate propelled by sails as opposed to a galley propelled by oars. The name of the ship that Catesby travelled on is not recorded, but at least nine ships and their masters are recorded in his letters. Relations between English and Spanish colonists continued to be strained following Queen Anne's War in the American colonies (1702–13) and the Yamassee War (1715–16) when Native American nations joined forces with the Spanish and massacred several hundred South Carolina colonists (see also letter 41).

8 A sloop was a sailboat with a single mast.

9 For one of the fossils that Catesby collected in South Carolina, see fig. 246.

10 Catesby refers to William Sherard's brother, James Sherard (1666–1738), for whose garden at Eltham, Kent, he sent seeds for cultivating. The German botanist Johann Jakob Dillenius (1684–1747) described and illustrated the plants grown at Eltham in his *Hortus Elthamensis*, 1732. See Chs 1, p. 19; 5, pp. 165-8; fig. 205.

2 *William Sherard, London, 20 June 1722*[1]

Charles City[2] – June 20 – 1722

Honrd Sr,

I wrote to you 2 days after my arrival which was the 5th of May[.] I thought of ~~deffer~~ deferring sending these 2 books of plants til I made a larger Collection but I concluded you'd approve of my sending the first opertunity what I had got.[3] I am but now returned from 40 miles up the Country with the greater part of these plants and in a few days am going a greater distance another way.[4] The more specimens I collect of one plant the more time it takes and consequently prevents my collecting so many kinds as otherwise I should especially when I am several Hundred miles off it will increase their Bulk. I desire to know whether Sr Hans and Mr Dubois expects distinct collections or whether what I send them shall be mixed with your which will take up less time and enable me to send the greater variety[.][5] If you doe not impart any of these to Sr Hans and he knows I have sent I fear he will resent it[.] I leave it Sr to your discretion what to doe[.] The next I send which wont be till ye summer is past I hope to give a general satisfaction to which I shall add seeds[.] I hope in my next to send you the Trees, with specimens of all the kinds of snake roots some of which are not known in Virginia.[6] I desire to know whether you require to know the soyl every plant and tree grows [in] or at least those that are doubtfull or whether I should or in what manner discribe any except those that are ~~odd an~~ remarkable, odd, or uncommon plants[.] The same 2 sorts of Trumpet or Sidesaddle flowers are here as in Virginia – I have had ye opertunity of sending but one kind[.][7] One of the flowers you will find to have more leaves than the rest and is perfect[,] the ~~other flowers~~ rest are imperfect ['whan' *erased*] wanting those thin leaves which fall away in a day or 2 at most and the flower remains without them in the Shape you see for several Months. At the bottom of its hollow leaves are always lodged Catterpillars[,] worms[,] bugs or other insects which is the cause I have cut them open to prevent rotting ye paper.

From a specimen of a laurel flower I saw of yours from this place I concluded it to be the Umbrella but was mistaken for this Laurel is what is not in Virginia[.] It grows here generally near Rivers and Bays to ye bigness of a large and tall Tree[.] Their bodys ~~gener~~ often 2 foot Diameter[,] its flower very large [*letters erased*] composed of very thick and white leaves much like the Umbrella flower[,] Its leaves very large and thick of a Shining Green the backside being of a reddish ~~of a~~ [*illeg. word crossed out*] ~~colour~~ or fulvus colour which lessens much the beauty of the tree by giving it a rusty hew[.] Its flowers are very sweet and perfumes the Air[.] It is called here both laurel and Tulip Tree[.] This, & the small Laurel of Virginia, which here is called more properly Bay, and the Umbrella are of the same Tribe producing Cones & Seed alike tho the circular form of the Umbrella leaves I mean their being placed in such form makes that, at a greater distance from the other 2. Here are 3 kinds of Bays one of them the Virginia laurel, the other [*illeg. word crossed out*] grows in Virginia ~~bay~~ and resembles much our English Bay both in flower and Berrys but is both of a fainter Scent, and colour, being not of so deep a green. The third Bay is not found in Virginia[.] It grows here to a good height with a straight Body[,] its top naturally of a regular piramidal form[.] I have seen some sawn into boards that[8] have ~~16~~ been 18 inches broad – excellent for Tables and fine Work. This has likewise a fine white flower Sweet Scented but is tenacious of it not defusing its odors like the Great Laurel or first mentioned Bay.[9] ~~It is but now on the blow or I had sent some specimens of it.~~ It was forgot to put up past-board which [is] of great use.[10]

If Sr you can spare a few common Roots such as Lillys (except the White Lilly)[,] Martagons[,] Daffodils or any bulbose root I shall be glad of them to gratify some gentlemen at whose houses I frequent for many of them are desirous of such [~~their~~] improvements and here is very little either for use or ordnance tho' the Country is productive of every thing.[11] A Sloop is expected here in August from Suranam with Coffe Trees.[12] But as the winter's Cold some years kill Orange Trees here so I fear it will the Coffee[.] The Bahama Isles must be the place for them.

The Moss next the Cover is I think what you desired of Mr Dale of some[.][13] It grows on all Trees but most on ye pine, it hangs in such quantity on the Boughs every where that it darkens ye Woods and I doubt not but contributes much to the bad air by obstructing it[.][14] It is of great use to Cattle in winter[;] they eat it greedily and its said to be good ffodder[.]

A root of Jappan Lilly will be acceptable[.] Here are 4 or 5 different kinds of Lillys including the Attamasco[;][15] one I have seen white many on a stalk set like ye Jappan Lilly all which I hope to send Mr Sherard to whome and Dr Delinius I beg my humble service may be accepted from

Sr
Yr most humble Servt
M Catesby

To / The Honble Dr Sherard / At Mrs Wansels / in Barking / Alley near Tower Hill / London

1 RS, Sherard Letter Book, MS 253, no. 164, 1 leaf (30.5 × 38.5 cm), folded; letter on sides 1–2, address on side 4, with remains of wax seal. Inscribed on side 4 in Sherard's hand, 'Answ. Feb. 22. 1723/3 p. Capt. Smiter/ R[eceived] Oct. 5. 1722'; at right angles, annotations with names of plants, etc. Watermark type C (fig. A4); countermark type J (fig. A11).

2 ['City' written over 'Town'] In left-hand margin Catesby wrote: 'This Town within this few days is made a City with a Mayor &c.,' recording Governor Francis Nicholson's act, 'For the Better Government of Charles Town', passed by the Assembly in June 1722. This changed the name of the town to Charles City and Port to be governed by a mayor, six aldermen and twelve councilmen who would govern for life and elect their successors. Objections by many Carolinians that the act would create 'the completest Oligarchy … ever' led to the Crown disallowing it, and local government was not established in Charles Town until after the American Revolution (Fraser, W. J., Jr, 1989, pp. 38–9).

3 This was the first of approximately twenty consignments of plants recorded in Catesby's letters to Sherard.

4 He was probably following the course of the Ashley, Savannah or Cooper river, possibly as far as the seat of one of the plantation owners; 'another way' perhaps indicated his following one of the other rivers (see fig. 62).

5 Sir Hans Sloane (1650–1753), was one of Catesby's principal and most demanding sponsors; Catesby was to find Charles Du Bois (1658–1740), treasurer of the East India Company, a difficult sponsor in other ways (letter 35).

6 ['Virginia' written over 'England'.] Species of snakeroot, including *Aristolochia serpentaria*, were sought after as potential antidotes to snake bite.

7 Catesby collected specimens of three species of *Sarracenia* (pitcherplants): *S. flava*, *S. purpurea* and *S. minor* and painted all three (see figs 155, 156, 157, 219 and 234).

8 ['that' is written over 'have'; another 'have' then follows.]

9 The different species of magnolia described here are umbrella-tree, *Magnolia tripetala*; bull bay, *Magnolia grandiflora*; sweet-bay, *Magnolia virginiana*; they are discussed further at letter 22.

10 Pasteboard, commonly used in bookbinding, was stiff board formed from layers of paper or pulp pasted together. Catesby inserted his mounted plant specimens between sheets of pasteboard to keep them flat and dry (see Chapter 6, p. 201).

11 Catesby refers to the plantation owners to whom he was offering horticultural advice.

12 Coffee, brought by the Dutch, as well as cocoa, tobacco, sugar and indigo, were grown in Dutch Guiana (Suriname) in the first half of the eighteenth century.

13 Catesby had presumably sent this plant to his friend, the apothecary and botanist, Samuel Dale (*c*.1659–1730). Dale, from whom Catesby is likely to have learned his plant-collecting and horticultural skills, was the main recipient of the plants Catesby sent from Virginia (see Chapters 2 and 5).

14 Spanish moss, *Tillandsia usneoides*.

15 Atamasco lily, *Zephyranthes atamasca*, painted by Catesby: RCIN 926081 (*NH*, Appendix, 12).

3 Elizabeth Pratt, York River, Gloucester County, Virginia, 22 June 1722[1]

Charles City June 22 – 1722

Dear Niece[2]

The Bearer Capt Daniel brought me the latest acct of your welfare for as no place abounds so much with my nearest and dearest Relations as Virginia so from no place is good news more acceptable[.] I came from London the beginning of Feb: last and left all well in Essex and Suff[olk] as I did Mr Pratt who I often saw in London.[3] I wish I could send you tho it was only a specimen of what this Country produces other than what Virginia does[,] but Rice[,] Pitch and Tarr being the productions of both places makes it impracticable[.] I believe in my Sisters Lr I have mentioned Pine Apples but this man has been

here a fortnight longer than he intended so that they are past sending[.]

My hearty service to Mr Pratt, and if I could in any thing here be serviceable to him it would be with the no small satisfaction of ~~Dear~~

Yr most affectionate
Unkle and Humble Servt
M Catesby

Dear Niece
My kind love attends
Nephew Catesby[,] Niece
Rachael with the Rest.[4]

For Mrs Pratt/ York River/Virginia.

1 Library of Congress, Jones Family Papers, 1649–1896, MS 2810, fol. 149r-v, 1 leaf, folded; address on side 2, wax seal. In another (possibly the recipient's) hand, 'Mark Catesby, 1722/ Catesby'.

2 Catesby's sister Elizabeth and her husband William Cocke, had seven children. Their daughter Elizabeth, the addressee of this letter, was the child to whom Catesby was closest. It appears that she shared his natural history interests: not only did they exchange natural history specimens but Catesby later sent her parts of his *Natural History* (letters 36 and 37). Elizabeth married William Pratt by whom she had two children who survived infancy; on his death in 1725 she married Thomas Jones, by whom she had ten children (fig. 43). Also see letter 48.

3 Members of the Catesby and Jekyll families lived in Castle Hedingham, Essex, and Sudbury, Suffolk (Chapters 1–2 and letter 48). Thomas Pratt appears to have had business in London; Elizabeth and Thomas's son, Keith William Pratt, was to go to school in London (Chapter 2, p. 40).

4 Catesby and Rachael/Rachel Cocke were two of Elizabeth's siblings.

4 *William Sherard, London, 9 December 1722*[1]

Charles City December 9th 1722

Honrd Sr
I have desired Mr Hammerton (who has promised me take care of and convey to you 3 Books of dryed plants and a Box of roots and seed) to send this off post [haste] for fear he should neglect the delivery of it. Under the lid of the Box is a letter wrot[e] in hast[e] giving an account of what is sent.[2]

Had I gourds or convenient things to have put them up separate I would have done it, tho' I am in hopes by the method I have taken they will not rot.[3] The misfortune of my being ill is the reason I have been so deficient in the collection of seed, &c.

About the middle of September here fell the greatest floud attended with a Hurricane that has been known since the Country was setled[.] Great numbers of Cattle, Horses, Hogs and some people were drouned[.] The Deer were found frequently lodged on high trees, the wind was so violent that it tore up by the roots great numbers of Trees, and disrobed most others of their leaves[,] Cones and Seed, so that [even] had I been well, the Collection would have fallen much short of other years[,] perticularly it dispersed all the Laurels[,] Umbrella and many other things I sent out for but none to be found[.][4] The great quantity of wet with the warm weather that has ever since been has caused a spring in the midle of winter for imediately after the rain the apple Trees Blossom'd ~~and are~~ succeded by apples now hanging on the Trees almost ripe[.] And It is now so warm that I am in only my Shirt and the Frogs are in full Tune[.] Yet tis' expected we shall have some extream hard weather[.] This time twelve months it froze in ye house[.]

This place is within a trifle as dear as the West Indies[;] few European good[s] are sold for less than 300 p[er] Cent and oftner for 400 or 500[.] Besides rum punch and Madera Wine which are the principal liquors drank [*sic*] here we have beer from Philadelphia tolerable good; But Beer from London I have not known cheaper than 10d p[er] Bottle which is equivalent to 2d sterling.[5] Fish is in great plenty and cheap.

~~I hope it not expected~~ I hope It is not expected that what I send should be to every one separately – but in the manner I have now sent for indeed tis' almost impracticable without half my time lost besides the difficulty of having them put in a dry place for it's no small favour from a master to secure a single box or parcel, and much more many distinct parcels and Boxes. To send seed and roots as they ought to preserve them from rotting[,] those that are dry should be put by themselves and the moist distinct in small gourds ~~which this year I could not procure~~ with sand. Putting them in papers only especially the berries and mo[ist?] ... [*obscured in gutter*] seed rots the paper and mixes the different kinds so that it hazards rotting some that had they been

in a gourd would have been preserved and mixing the different kinds that without difficulty they cant be separated[.][*words obscured in gutter*] I have found from my sending seeds from Virginia the necessity of having many of these small gourds of several sizes which this year I could not procure but I have laid out for some against the next[.][*obscured in gutter*] Makannicks here are intolerably imposing and dear in their work[;] as an instance of it the Box the seed is in cost 20d that is 4d sterling besides being obliged to them for working at any rate[.]

I both began and ended the year to disadvantage the first in arriving late and missing many things that appeared early in the Spring[,] and in the fall my illness obstructed and tho this year I am much short of what I intend next yet I can plainly percieve that I cant make a general collection without help[,] for in Summer the heats are so excessive in [= and] tho the time for seed and roots is more temperate Yet they [occur] in such different parts of the Country and at such distances one from the other that the fatigue is too great and by which I got my late illness by over heating my self. So that I have resolved to buy a Negro Boy which will cost about 20li sterling[.][6] Wherefore Sr because of the uncertainty of my B[r]other[']s being in Town and presuming you will have an opertunity of having 20li of mine in your Hands I beg you will please to let me know if I may draw upon you for the above summ which will be a kindness to

Sr
Your most Obliged and Obedient Servant
M. Catesby

A packet of Lrs [letters] I have put into the Midle Book of Plants which be pleased Sr to send to Mr Collinson[7] who will give them to some Hedingham Man[8] at the Spread Eagle or Cross Keys in Grace Church Street[.] Pray my Humble Service to Mr Sherard & all Friends.

For / The Honble Consul Shepard at / Mrs Wansels in Barking / Alley near Tower Hill / London

1 RS, Sherard Letter Book, MS 253, no. 165, 1 leaf (30.5 × 39 cm), folded; letter on sides 1–2, address on side 4 and traces of seal. Inscribed on side 4 in unknown hands, 'Feb. 1723' and 'Rec. Feb. 9. 172/3.'; in Sherard's hand, 'Answ. Fy. 22 – per C[ap]t. Smiter'. Watermark type C (fig. A4); countermark type J (fig. A11).

2 Catesby sometimes sent lists of the contents of his cargoes as inserts in his letters, and sometimes separately in the boxes with the specimens, as here.

3 Catesby found that hollowed out sealed gourds provided useful containers for the shipping of seeds which could be kept dry and separate from other plant specimens (see, for example, letters 5 and 35).

4 This was one of two violent hurricanes Catesby experienced during his stay in South Carolina (see letter 24).

5 Colonial currency used a different unit value for £ s d from British sterling currency.

6 The abbreviation for pound (£) was 'li', also used for weight.

7 Catesby's friend, cloth merchant and keen botanist Peter Collinson (1694–1768), had his business in Gracechurch Street in the City of London. His garden at Peckham became well known for exotic plants (see Chapter 5).

8 The letters were presumably destined for Catesby's uncle, Nicholas Jekyll, at Castle Hedingham, Essex, perhaps for him to distribute to other family members in Suffolk.

5 *William Sherard, London, 10 December 1722*[1]

Charles City December 10 – 1722

Sr

I wrote to you 5th of May the day after my arrivall as I did the 20th of June following with seed,[2] plants[,] all which I hope you have recieved. I have not had the good fortune to have one from you, hearing of your journey to France &c I conceive that the reason[.] I likewise wrote to Mr Dubois when I wrote last to you but hear nothing from him.[3] Abt the middle of September [*illeg. word crossed out*] before I had compleated collecting plants I was siezed with a Swelling in my Cheek which impostumated and ~~was~~ was cut[,] and by the ignorance as I suspect of the Surgeon I have been confined within doors these 3 months in great misery having my fface twice cut and laid open with lents and injections every day.[4] I had not troubled [you] with this unpleasant subject but to shew the reason that I have not nor could I possibly doe what was expected in Collecting seeds roots &c and in dryed plants I lost at least a month[.] I hope next summer if God [*illeg. word crossed out*] gives me life and hea[l]th to retrive this lost time. Amongst the plants you'l find a good variety of grasses I think ~~not~~ not many less than 30 different kinds of mosses[,]

I have discovered more kinds since these were put up[.] The reason that I have named some and disc[r]-ibed the[i]r colour is that they are so much altered since they were dried that I suspected you would be at some loss especially as to their colour which quite alters in some. I am but just able to ride out and have made a shift to collect these few seeds I have sent but hope by another Ship to make an addition of Acorns and Cones for all other things are gone[.]

I have deferred writing to you that I might give you an acct of the seed and roots I now send and my being out on that design has so contracted my time which will that I shall now only give you the follow-ing account of the seed I now send what I send.

The Bulb'd Roots is a white Na[r]cissus that grows here in any soyl and increases prodigiously in gar-dens a very beautifull flower[.]

In the large partition I have put these [*illeg. word crossed out*] Narcissus[.]

They may easily be distinguished from one an-other and separated tho' could I have procured Gourds I would have put them distinct[.] The Acorns are all of of the Water Oake specimens⁵ of which I have sent with small leaves roundish at the end. The Bay seed Berries is of that Kind that resemble the common English[.] The Dogwood Berries are oval and red of which I have sent often from Virginia to Mr Dale[.]⁶ The small Gourd No. 1 contains white seed of a water shrub, I never saw leaves or flowers[.]

[*list to right of previous paragraph*]
Hors[e] Chestnuts
(Acorns
(Bay
(Seed vessels of the Erect Bay
(Dogwood Berries

The other small seed are what came out of the seed vessels in the large partition with long stalks[.] To distinguish it from the other kind I call it the Erect Bay⁷ from its remarkable strait growing[.] I don't know a more stately and beautifull tree tho neither leaf nor flower has any scent. In the same gourd in a paper are a few seed of what I think is a kind of As-tragalus[,] the pods ['are' *erased*] are amongst the pa-pers of seed in another small Gourd[.] It has scarlet flowers[,] is a plant of great ornament[,] the root is like that of Briony[.]

In the Gourd No. 2 The largest red seed is a kind of perriwinkle[, it] grows in moyst places and trailes

on the ground, seems as it would make a fine Edging for Beds[.]

The other purple seed⁸ seems to belong to the sage kind but is more woody[,] a very ornamental plant.

In the Gourd No. 3 are 3 pods of the Astragalus with Pine Kernels and small Shrub Haw[.]

The larg[e] Haws are a pleasant Eating fruit and some of them as large as small Crabs.⁹ These are scat-tered in both partitions[.] Phillirea Seed or rather [*illeg. word deleted*] Alarternus different from what we have in England having the edges of the leaf smooth and not jagged[.]¹⁰ Amongst Gulph weed in one of the Book of Plants is a kind of ffungus tho' more like a Bulbed flower[,] its of perfect fungus consistence and springs up and decays like it[,] the whole is of a pale flesh colour[.] Its better disc[r]ibed by one I have drawn[.]¹¹

The small round Cones are what is Spruce pine[.]

The few large Seed in a Gourd is I think the White Pine but the next I send I[']le be more perticular which I hope will be this winter[.]

The Boat is going off so I beg you will excuse Hasty foul writing for the reason aforesaid[.]

I have no more service than to subscribe myself

Sr
your most Faithfull Humble servant
M Catesby

To / The Honble Consul Sherard / At Mrs Wansels in / Barking Alley / near Tower Hill / London

1 RS, Sherard Letter Book, MS 253, no. 166, 1 leaf (30.5 × 37.8 cm), folded; letter on sides 1, 2, addressed on side 4 and inscribed in Sherard's hand, under repair, 'Answ. Feb. 22. 1722/3 / Per Capt. Smiter'; in another hand, 'Near Tower Hill'.

2 ['seed' written over 'dryed'.]

3 The lack of response from his sponsors not infrequently hampered Catesby's work.

4 Catesby's cheek infection may have been caused by a gum or tooth abscess, which in an era before antibiotics would have been difficult to treat.

5 Water oak, *Quercus nigra*.

6 Eastern flowering dogwood, *Cornus florida*. For a specimen of the leaf and flower sent to Dale from Virginia, see fig. 186.

7 'Erect Bay', possibly another name for the umbrella magnolia, *Magnolia tripetala* (see letter 22).

8 The 'perriwinkle' may have been partridgeberry, *Mitchella repens*, as illustrated by Catesby in *NH*, I, 20, and the 'purple seed', American beautyberry, *Callicarpa americana*, illustrated ibid., II, 47.

9 'Crabs' refers to crab apples.

10 *Phillyrea* and *Alaternus* were evergreen shrubs, *Alaternus* probably a species of buckthorn.

11 A reference to his drawing of black adder tongue fungus, *Geoglossum glabrum*, RCIN 924850 (*NH*, I, 36).

6 *William Sherard, London, 4 January 1723*[1]

from Mr Skeins Jan. 4th 1722/3[2]

Honrd Sr

I being from Town where my papers are I cannot recollect the day but it was last month I sent 3 Books full of dryed plants with a Box of Seeds Roots &c all I could possibly get because of my illness with [which] I have mentioned in my last to you before mentioned[.] I intrusted them with Mr Hammerton on board Capt Lester who promised me to deliver them safe to you. About the middle of last month was the first of my being able to goe out and what few things I now send are all I could get it being so late in the year[,] they were with ten times the difficulty got than had I been able to collect them 2 months agoe[.] I have not had the good fortune yet to hear from you or any of my Friends except Mr Collinson. Some gentlemen here are at a loss to know how in Turky they draw oyl from the Jessamum[.] I intreat you'l pleas to send what you know concerning it.[3]

The seed[,] Nuts &c are as follows[4]

[*list to right*]
~~Black Walnut~~
Hickery
Pignut
Live Oke
Chestnut
Willow
Water Okes
with 2 or 3
 other sorts
mixt
Dogwood
Cassena

Haws
Tuberose
~~Rice, straw[?] Bulb~~
Olive leaved Bay

These Nuts and Acorns haveing as I imagine been sent from America not only by me but others and perhaps discribed by Dr Plucknet so that I concieve they are not unknown to you which makes me in a doubt whether it signifies ~~any thing~~ to say any thing about them but as possibly they all may not be known to you so will say as follows[4]

The Black Walnut here grows neither in so great plenty nor with so fine a grain as in Virginia[.] I have seen a Tree of it in Chelsey Garden[5] and I think of the Hickory Nut[.] The Pignut much resembles The Hickory but the leaves are less[,] they all three grow in the Highest land and often to a large size especially the black walnut. Hickory here as in Virginia is esteemed the best fire wood[.] Live Oke grows in greatest plenty near the Salts.

Chestnut Oke from the leaf resembling that of a Chestnut is usually the largest of the Okes and grows in high rich land. Willow Oke the leafe resembles that of Willow but not quite so long[,] they never grow but in moyst places as ~~does~~ the Water Oke grows in such like places and generally together. The Willow Oke grow to be very large but the Water Oke never so, but small[.] The Timber in both resembles and are equally bad from the great quantity of the Willow and Water Oke acorns lying under the Trees after Christmas when all others are gone[.] I imagine they are in no request with the Hogs ['which' *erased*][.] The rest are unavoidably mixt[,] I suppose they are White Black and red Okes.[6]

Cassena or Yapon I think not the same that I have seen at Fairchilds[.][7] No berry bearing Tree excels it in beauty[,] every berry looking like so many transparent Cornelians[.]

I have at several times sent from Virginia Dogwood berries but I don't remember to have heard of any trees raised from them or any others in England. In March and Aprile they are full of white Blossoms and may as properly be called the Emony Tree as the popler is called a Tulip Tree[,] it resembling a single Emony as nearly as the other does a tulip[.] They are a small regular Tree[,] the wood white and almost as hard as box and of as fine a grain[.] The few haws sent I gathered in a wet swamp from a small single bush the stem not bigger than a Rice Straw[.]

The Olive leaved Bay I have but a few days since discovered[.] I have named it so from its' leaves somwhat resembling those of the Olive tho' bigger, in December it hung full of Berries perfectly round and of a deep purple almost black colour[.] From between the leaves which grow opposite are small joynted foot stalks on which the berries are fixed usually 3 or 4 on a cluster[.] All that I have hitherto seen grow on the Banks of a fresh River[.][8]

Tuberoses grow and increase here so prodigiously that a single root in 19 months time will increase so as to fill a peck and blows from May til December[.] I have sent some to fill the Box if they will be acceptable I can send enough their fibers were shot which I fear will obstruct their blowing[.] The next Cargo I send will be pieces of Wood or a Box of plants or both together as I have convenience[,] in the mean time I am

Sr
Your most obedient Servt
M Catesby

In my last I beg'd the favour (which I now repeat) that you would be pleased to pay a 20li Bill for I concieve you have so much in yr hands[.] The making large Collections of seed &c is so fatigueing that I cannot effect with[out] help for which reason the next Negro Ship that arrives here I designe to buy a Negro Boy which I cannot be without.[9]

To / The Hon:ble Consul Sherard / at Mrs Wansels in / Barking Alley / near Tower Hill / London

1 RS, Sherard Letter Book, no. 168, 1 leaf (30.5 × 38.6 cm), folded; letter on sides 1–3, address on side 4. Annotated in Sherard's hand, 'Answ. May 8. 1723'.

2 Catesby was staying with his friend Alexander Skene on his 1,300-acre estate, New Skene plantation, in the parish of St George at Dorchester. Skene's and Catesby's shared interest in horticulture led Catesby to spend much time there (Chapter 2, pp. 55; and 5, pp. 156–7).

3 Skene was experimenting with producing oil from the flowers of *Jasminum officinale*, a plant that Catesby noted was 'much esteem'd in the Eastern parts of the World for its medicinal and culinary uses' (Chapter 5, p. 156; letter 43).

4 Catesby refers to Leonard Plukenet (1642–1706), Royal Professor of Botany and gardener to Queen Mary, whose *Phytographia* (1691–2) and other works he consulted (Bibliography, p. 333).

5 A reference to the Chelsea Physic Garden.

6 Catesby describes and illustrates nine species of oak in *NH*, I, 16–23.

7 The nursery garden of Thomas Fairchild (*c*.1667–1729) at Hoxton specialised in American exotics. Catesby was to live at Hoxton and work closely with Fairchild on his return to London in 1726. The 'Cassena or Yapon', yaupon, *Ilex vomitoria*, is often mentioned in Catesby's letters. Its uses as a diet drink by Native Americans, as well as his own use of it as tea drunk with milk and sugar, are described in a letter to Jacob Dillenius (letter 39). He illustrates it at RCIN 926007 (*NH*, II, 57).

8 American devilwood, *Cartrema americanus*, illustrated at *NH*, I, 16.

9 Charleston was one of the major markets for enslaved people being traded from West Africa to South Carolina at this period (Chapter 6, p. 198, n. 82).

7 *Peter Collinson, London, 5 January 1723*[1]

Mr Skeyns Jan: 5th 1722/3

Sr
Being from my papers I can't tel the day but about the middle of last month I sent what seed &c I was able to collect by reason of my illness which I have before mentioned in a Letter to you by the aforesaid Cargoe directed to the Consul[.][2] I repeat my thanks to you for your kind thoughts of me. By yon silence of Dr Lloyd[3] I conclude nothing is to be done there[.] I have made all the efforts I could possibly to collect these few Seeds and Acorns for the time was so far spent before I was able to goe out that it was with difficulty we got these it being Mid: december[.] They are as follows, distinguished by the Notched Tallys

[*list to right*]
Black walnut
Hickory Nut
Pignut
Live
Chesnut
Willow
Water Okes
with 2 or 3
other sorts
mixt
Dogwood
Cassena
Haws
Bay a new kind
Tuberose

The Nuts grow to be large Forrest Trees[.] The live Oke you have seen at Fairchilds[.]⁴ The Chesnut and Willow resembles the leaves of what they are named from[.] The Dogwood is a small but very beautifull flowering Tree[.] The Olive leaved Bay is what I have discover'd but 3 days since[.] Not haveing seen the[m] Blow I can only say it's a very beautifull evergreen[.] This makes the fifth [*erased word*] of the Bay kind none of which have been yet known in England.

The gentleman you'l recieve a letter from is one of the Most considerable men in the Country and I may add of the most generous and genteel Spirit in it[,] but what [*erased word*] most I concieve adds not a little to his commendation especially ~~especially~~ with us Bretheren of the Spade that his Genius leads him not only to the improvement of usefull but ornamental ~~things~~ plants which will induce him to be more intent in sending what from hence will be most acceptable to you, You sending in return the commonest things your Garden affords which generally will be more acceptable than the choisest things you have[;]he has had roots sent by Dr Udale but wants many more[.]⁵ I do not propose by this to cease sending and corrispo[n]ding with [*word erased – 'which'?*] you but when Mr Skeyn and I send together the Cargoes will be alike And when I send from another place you shall recieve from me an Acct of what I send to the Consul if any thing be in it that is not in Mr Skeyns which I shall always direct for I am very often at his house[.] I[f] you think fit of this Corrispondance I desire you will write to Mr Skeyn[,] if you will exchange plants out of your Garden sent in Tubs for plants from hence let him know it[.] I['}le give a Catalogue of what is most desired as follows[,] [*word erased*] except white Lillys all the kinds will be acceptable especially the different kinds of

No kind of Kitchen Garden Seed but what will be acceptable especially large winsor Beans[.] Tuberoses increase here so prodigiously [*word erased*] that one root or cluster will fill Half a Bushel.⁶ The few I send are only to fill up[.] I desire that my Northern Knigh[t] (for I can't think of his name)⁷ may partake of these[.] I earnestly intreat you will burn or concell this Letter and the purport of it for reasons you easily concieve[;] to be more plain I would have none know but this is a Corispondant of your own seeking[.]⁸ I shall always send you or direct to be sent you the greater quantity ~~of~~ confiding that you will let ~~send~~ friend Fairchild or some one or 2 who I shall desire partake of the [*over erased word*] Cargo which will be as Big as what I send to ye Consul which is designed for many and when ever I send them I shall acquaint you with it that if there [is/may be: *word under seal*] any thing you have not you may partake of it, for all parts of the Country affords not the same and possibly I may have an opertunity of sending from one part of ye Country what another affords not[.] I have tired you so will conclude

Kind Sr
Your Most Assured Friend
and Humble Servt
Catesby

For Mr Collison

Seed of	Plants in Tubs	Red Lilly & red
Primrose	Any flowering Shrub	Martagons
Polianthus	especially Syringa	Daffs all kind
Violet	the early and	Narcissus
Lavender	late Huneysuckel	White Hyacinss
Laurustina	especially Laurustina	Snowdrops
Yew	Hollys	all kinds of
	Yew	Bulbs will
	Jessamy white	be acceptable
	Lylech	
	Guelderland rose	
	Pistatia Nut	

1 NHM, Department of Life Sciences, Botany Autograph Collection, 1 leaf (22.5 × 34 cm), folded, with enclosure (letter 7a); letter on 3 sides, addressee's name on side 4.

2 This is the only one of Catesby's letters to Collinson which survives, although it is clear he wrote at least one other. Unlike his other sponsors, Collinson was an assiduous correspondent.

3 Dr Lloyd may have been another sponsor whom Collinson was attempting to attract for Catesby. Collinson was later to be active in looking for subscribers for Catesby's book (Chapter 1, p. 23, Chapter 3, p. 73).

4 Clearly Collinson also patronised Thomas Fairchild's nursery at Hoxton, no doubt acquiring American exotics for his garden at Peckham.

5 The reference is probably to the cleric botanist, Dr Robert Uvedale (1642–1722), who had a large garden at Enfield well known for its exotic plants; his herbarium was later acquired by Hans Sloane.

6 Tuberose, *Polianthes tuberosa*, the sweet-smelling ornamental plant originally native to Mexico.

7 Possibly Lord Islay (1682–1761), 3rd Duke of Argyll, a Scottish nobleman who was to subscribe to Catesby's *Natural History* (see p. 294, n. 34). Islay is mentioned in letter 30.

8 Collinson was a friend rather than paid up sponsor of Catesby's. He was later to give Catesby an interest-free loan to enable him to finish his book, as recorded in the copy of the *Natural History* Catesby gave him (KH).

7a Enclosure in letter 7 to Collinson

The largest Gourd contains
the olive leaved Bay which are blackish
Berries
Dogwood Berries
Willow Oke Acorns
Chesnut Oke Acorns which
are the largest
9 Black Walnuts
Some Hickory nuts which are ye
biggest and some [*illeg. as torn*] / sort of Pignuts
The smaller Gourd contains
Live Oke Acorns
Cassena small Berries
Pignuts ~~and Hic~~
The rest of the Box is filled up
with Tuberose roots Hickory Nuts
Pignuts and Mixt Acorns

8 *William Sherard, London, 7 February 1723*[1]

Charles City Feb 7 1722/3

I hope Sr you have recieved by Mr Baldwin the Box of Seeds &c and letters dat 5 Jan. I have severall months expected to hear from you but am not yet so happy[.][2] I thought there could not be a more effectual way to[3] induce Capt Clark to take care of what I send ~~than~~ than to procure for him a Tub likewise for his Master Crawley from whome I expect a Subscription.[4] The Tub I have ordered for you contains as follows

The Erect Bay as that of which I have before mentioned and sent seed
The Jessamy is very Fragrant and produces in March and later end of Feb: large yellow flowers
The Pellitory or Tooth ache Tree is that with Prickles[5]

The purple flowering shrub with purple Berries also called here Bermudas Currance with severall stif woody stems rising from the root.

[*list to right of previous parargraph*]
plants
(Erect Bay – 3
(Jessamy – 3
(Pellitory Tree –2
(Sassafras – 1
(Purple Flowr Shrub – 2
(The Root – 1

The root so called by way Eminence by a famous Negro Dr who I have been credibly informed have done great ~~great~~ good with the juice of the root boyled or infusion[.] It is the smallest of the plants in the Tub with small plants stalks and has now longish green leaves[.][6] It is an excellent stomacick and highly cryed up for other its virtues[.] If these plants come safe I beg you'l please to let Mr Du Bois partake where you have duplicates[.][7]

I am Sr your most
faithfull humble Servt
M Catesby

To/The Hon. Consul Sherard/ at Barking Alley
Near/ Tower Hill/ London

1 RS, Sherard Letter Book, no. 167, 1 leaf (19 × 30.5 cm), folded; letter on sides 1–2, address on side 4 with postmark. Annotated in Sherard's hand, 'April 18 1723'; in two other hands, 'Catesby' and 'Febr. 1722/Catesby'.

2 Catesby continued to lament the lack of a response from Sherard.

3 ['to' written over 'for'.]

4 Catesby's reference to a 'subscription' here is presumably to another sponsor for his collecting trip.

5 The 'Pellitory or Tooth ache Tree' was Hercules' club, *Xanthoxylum clava-herculis*, which Catesby drew and etched as RCIN 924839a (*NH*, I, 26).

6 The identity of the root is uncertain.

7 Catesby hoped that Sherard would be responsible for distributing plants to other sponsors; he had earlier written to Sherard that sending individual cargoes to individual sponsors would be time consuming and detract from his collecting progress (letter 2).

9 *William Sherard, London, 19 March 1723*[1]

Carolina 80 miles from Charles City
March 19 – 1723

Sr

In case My Brother (to whome I have wrote) is not in Town I have taken the liberty repeated before of drawing the 20li Bill on you payable to Mr Wallace on order.[2] I am now on my journey to Fort Moor a frontier garrison 140 miles up the Country and at my return designe to write more at large and send by our Governor (who is returning home) what plants &c I have collected this year tho I can't help saying my not recieving one Letter from you in answer to so many you have recd from me is not makes me very uneasy[.][3] Not but that the discouragement shall obstruct the performance of my Duty so far as I am able[.][4] I beg Sr you'l comply with the above and excuse this trouble from Sr

Yr most faithfull
Humble Servt
M Catesby

To / The Honble Consul Sherard / at Mrs Wansel's in Barking Alley / near Tower Hill / London

1 RS, Sherard letter book, no. 169, 1 leaf (22.3 × 34.5 cm), folded; written on side 1, address on side 2, postmark, patched hole indicates position of cut-out seal. Annotated in another hand, 'March 1723'.

2 This was Catesby's younger brother John (1697–1769); his two older brothers had died by this date (fig. 43).

3 Fort Moore was a garrison town on the Savannah River, opposite the town of Augusta. It was a major Native American trading centre in South Carolina for deerskins and animal hides. Catesby used it as a base for several collecting expeditions (see letter 11 and Chapter 2, pp. 52, 56; fig. 62). It would appear that he sent a consignment of plants and other specimens back to England under the care of General Nicholson.

4 Sherard's first reply to Catesby was written on 2 February 1723; it was acknowledged by Catesby in letter 11.

10 *Hans Sloane, London, 10 May 1723*[1]

Charles City May 10th 1723

Honrd Sr

This Box contains so indifferent a Collection that I am in a doubt whether to send it or not[.] The Shels are all what the Coast affords or at least what I could find in several miles walking on the Shore. I hope before I return to send you a greater variety from the Bahama's if health permits. I would have gone with Mr Rogers in November last had not a long fit of illness prevented me, which has indeed influenced my not sending you a better collection.[2]

Amongst the Shells there are in a paper two kinds of fresh water Mussels and two land Shels wrapped in another pap[er] which are all of the land kind I have yet seen. The few seed are all I could find yet ripe except 4 kinds which are of last years production gathered abt Christmas[;] in the next Cargoe Ile send specimens of their leaves[.] I intreat Sr you'l please to let Consul Sherard partake of these seed. I have more Insects than what I now send but they are lodged at distant places and I have not now an opertunity to send them.[3]

1[.] The largest of the Birds seems to be of the Cuckow kind[,] it retires from this Country in the Winter[.] 2[.] The Virginia Nightingale is sufficiently known[.] 3[.] Other kind of red Bird are is here only in Summer[.] 4[.] The Blew Bird is the only one of the kind I ever saw and seems to be of the Coccothraustes kind[,] the third I believe that is yet known[.] 5[.] The Smallest Bird I call a Tricolor ti'l you will please to give it a more proper name[,] they breed here but retire south in Winter. Its' Noat is not extraordinary[.] 6[.] The red Winged Black-Bird is both gregarious and graniverous asociating with 3 other kinds of that family in prodigious flocks and doe much mischief to rice and other grain. 7[.] The Bird with a red head is a Wood Pecker[,] the 6th of it's kind here. 8[.] The Bird with a yellow Spot on its' Crown is called here King Bird not improperly whether on account of it's Golden Crown or from it's tyrannizing quality for it persues and put to the rout all Birds from the biggest to the least[.][4]

Here are twelve different kinds of Snakes that I have seen[.] I am in Great Want of Wide Mouthed Bottles to put them in, I find Rum will not preserve large ones[.] If your important affairs will let you think out Sr I desire you please to order me a Case of large Bottles for Reptiles with a few proper Boxes

for ['for' repeated] Birds and Insects and to Honour me with what perticular commands you have for me[.]

I am with the Greatest Respect
Yr Honrs
Most oblidged Humble Servt
Mark Catesby

To / The Honble Sr Hans Sloan / at his House in Soho / London

1 BL, Sloane MS 4046, fols 352–3, 1 leaf, folded; letter on side 3 and along edge of side 2, address on side 1, with wax seal (2 lions passant).

2 Woodes Rogers, sea captain and privateer, was the first royal governor of the Bahama Islands. He was succeeded by Governor George Phenney who was Catesby's host during his stay in the Bahamas between 1725 and 1726 (Chapter 2, p. 58).

3 This is the only mention in his letters of Catesby collecting insects. For images of some of those he collected, see fig. 227.

4 Catesby's cargo includes eight different species of birds; it is clear from the list that Sloane was most interested in colourful birds. Catesby made a number of duplicate drawings of these for Sloane's albums (Chapter 2, p. 52; fig. 237). The birds listed here include: (3) 'red Bird' (northern cardinal, *Cardinalis cardinalis*); (4) 'Blew Bird of the Coccothraustes kind' (Eastern bluebird, *Sialia sialis*); (5) 'Tricolor' (painted bunting, *Passerina ciris*); (6) 'red Winged Black-Bird' (red-winged blackbird, *Agelaius phoeniceus*); (8) 'the bird with a yellow Spot on its' Crown … called here King Bird' (Eastern kingbird, *Tyrannus tyrannus*).

11 *William Sherard, London, 10 May 1723*[1]

Charles City May 10th 1723

After long expectation I had the pleasure of yours p[er] Capt Smiter dat 2nd Feb: last. Since the 3 Letters and things you own the reciept of I sent p[er] Capt Clark in ye Crawley a Box of Plants in a Tub 8th Feb: and on Jan: 5th p[er] Capt Quick a Box of Acorns and Seed all which I hope you have er'e now recd.

In ye beginning of Aprile I was at Savanna Garrison about 150 miles almost west of Charles City and 300 from the mouth of the Savanna river on which it stands. The Inhabited part of the Country is a sink in comparison of it. It is one of the sweetest Countrys I ever saw[.] The Banks of the river perticularly where

the fort stands is 200 foot perpendicular in most places from whence are seen large prospects over the tops of the trees on the other side of the river which is generally low but prodigious rich land[.] Most part of the Country hereabts is composed of moderate hills and vallys like the best parts of Kent[,] aboundance of little Rivulets fall into the great one and form delicious places for habitations[.] I am so enamoured with the place that I can't forbear tireing you with a tedious relation of what I saw.

I have sent you Sr what plants I have hitherto collected and I promise my selfe several of them new especially those from the Savanna River tho' my short stay of 5 days would not permit me to make any great progress[.] There are two obstructions in travelling in these remote parts[,] one is the fear of being lost[,] the other is meeting with Indians as five of us hapned to doe as we were out a Buffello hunting tho' they hapned to be those we were at peace with[,] they were about 60[.]2

I designe to goe again in July being induced chiefly to collect the seed of many things.

I have in the main followed your directions to number the plants and keep one of the same number by me[.] It somtimes happen that I have but one of a kind which I am forced to send without a number not having another to keep by me[.] I chuse to name others instead of numbring them having sometimes so few that I cant spare a specimen to keep by me and by the same name I shall easily know them again.3

I recd a Lr from Sr Geo: Markham concerning ['concerning' *repeated*] one of the Snakeroots called St Andrews Cross[,] as soon as I can Ile' send him root and branch with what I know of it[.]4 I find my friend Conll Bird rodomontade tale [tell] of it[.]5 We have none of the Sugar Cane here[,] as you suppose our winters are now and then too severe[.] If not too late I shall be glad if you'l please to spare me a Cone or 2 of the Ceder of Libanus[.] As you have ordered I have sent Sr Hans seperately as likewise a few dryed Birds and what Shells these Shores afford which are but indifferent[.]6 I have put in Sr Hans's Box a few seed[,] all that are yet ripe[,] there is amonst them 4 kinds of Smilax if I miscall them not[,] the seed of them were gathered in Winter of last years growth[.] I have desired him that you may partake of all[.] Mr Garden gives his humble service[.] He is going to sea in our Man of War for 2 or 3 months for his hea[l]th being much troubled with ringworms.7 I hope my Brother has paid you the 20li you were

so kind to disburse for me which was an additional favour to[8] ––

Sr
Yr Most Obedient Servt
M Catesby

Pray Sr my Humble Service to Mr Sherard[.] I have desir'd my Brother to send me a pound [of] his best Bark powder'd.[9] Likewise to Dr Delineus and Mrs Wansel[.][10]

[*illeg. words crossed out*] Youl please to let Mr Rand or Mr Dale have where you have duplicates and somtimes triplicates[.][11] They must have patience[.] I hope to satisfy all of degrees[.] Its hardly credible the long time plants take in cureing in this moyst Country[.] I have frequently had them moldy and spoild by omitting shifting the next day after gathering one with another[;] less than a fortnight does not cure them and for the first week they require shifting every day[.][12]

To / The Hon.ble Consul / Sherard at Mrs Wansels / in Barking Alley / Near Tower Street / London

1 RS, Sherard Letter Book, no. 171, 1 leaf (32.5 × 40.9 cm), folded; written on sides 1 and 2, annotated on side 2 by Sherard, 'Dr Dill.', address on side 4.

2 Catesby gives a longer account of this incident in *NH*, Account, pp. xiii–xiv (see Chapter 2, p. 56). He refers further to his contact with the 'Cherikees' (the Eastern Band of Cherokee) in letters 15, 18 and 20; see also Chapter 2, p. 56.

3 For his practice of numbering plant specimens, see Chapter 6, p. 201.

4 Sir George Markham (1666–1736), 3rd Baronet of Sedgebrooke, Lincolnshire, was a politician, Fellow of the Royal Society, and one of Catesby's sponsors. Like others in the natural history circle, Markham was interested in snakeroot as a potential cure for snakebite; St Andrew's Cross, *Hypericum hypericoides*, was one of several species Catesby collected (see also letters 2 and 17).

5 Catesby stayed with William Byrd on his estate at Westover outside Williamsburg during his trip to Virginia (1712–19) and remained in correspondence with him after his return to London (Chapter 2). Catesby clearly felt Byrd 'inflated' accounts of the power of snakeroot to cure snakebite.

6 Letter 10 lists the contents of this consignment to Sloane.

7 This was the Revd Alexander Garden (*c*.1685–1756), a Scottish Episcopalian who had been educated at the University of Aberdeen and was rector of Barking Church, near the Tower of London, close to Sherard's lodgings in Barking Alley (see note 10 below). Garden was appointed the Bishop of London's commissary to South Carolina, and became rector of St Philip's Church, Charleston, in 1720 (Amentrout, D. S., 'Garden, Alexander', *South Carolina Enclycopedia*, http://www.scencyclopdedia.org/sce/entries/garden-alexander-2/, accessed 26 June 2020). He was a vigorous supporter of the Church and education, and a friend of Francis Nicholson (Fraser, W. J., Jr, 1989, p. 39). He should not to be confused with the Scottish physician and naturalist Alexander Garden (1730–1791), who knew Catesby's work and was later to collect in South Carolina for Linnaeus.

8 A reference to the £20 Catesby borrowed to buy an African slave (see letter 4).

9 Powdered Peruvian bark, *Cinchona officinalis*, which contains quinine, was used as a remedy for malaria.

10 Sherard never married; when he was not with his brother James at Eltham, he lodged at a good address in London 'at Mrs Wansel's, Barking Alley, near Tower Hill'. It was common for middle-class landladies to take in middle- or even upper-class tenants as lodgers who could therefore benefit from their domestic services (without implying any other relationship). The lodgings must have been spacious, as not only did Dillenius live there too for a period, but Sherard was able to house his substantial collection of antiquities and herbaria in these chambers (Margaret Riley, pers. comm., and Riley, M., 2011, '"Procurers of plants and encouragers of gardening": William and James Sherard, and Charles du Bois, Case Studies in Late 17th- and Early 18th-Century Botanical and Horticultural Patronage', DPhil thesis, University of Buckingham, pp. 238–46).

11 The botanist and apothecary Isaac Rand (1674–1763) was Praefectus (director) of the Chelsea Physic Garden; Catesby sent him several consignments of plants together with Sherard's (see letters 14, 15).

12 For the exacting process involved in preserving plants, see Chapter 6, p. 201.

12 *William Sherard, London, 16 May 1723*[1]

Charles City May 16 – 1723

Sr
I think it necessary to let you know by a line that I have sent you a parcel of Plants p[er] Capt: Robinson for fear of delay[.][2]

I am Sr
Your most Humble
Servt
M Catesby

To / The Honble Consul / Sherard att – / Mrs Wansels in / Barking Alley near / Tower Hill / London

1 RS, Sherard Letter Book, no. 172, 1 leaf (19.5 × 31 cm), folded; letter on side 1, address on side 2. Inscribed on side 2 in Sherard's hand, 'p[e]r Ship Dolphin', in another hand, 'May 1723'. Watermark type C (fig. A4).

2 This is an instance of Catesby sending a letter separate to a consignment, wisely as it turned out, as Captain Robinson's ship was attacked by pirates and the cargo of specimens partially destroyed (letter 13).

13 *William Sherard, London, 26 June 1723*[1]

June 26 – 1723[2]

PS[3]

Sr

I dread the mischief the Pirates have done to the things I sent[.][4] I have not the opertunity of seing and putting them up in the best manner again tho Capt Robinson has promised if they are wet to dry and put them up as well as he can[.] I have had so much luck to preserve this and most of my Letters but Capt Robison's acct of the plants is so imperfect that I am wholly ignorant of the damage[.] I intreat youl please ~~to~~ if my Brother is not in Town to give your self [the] trouble of letting him know of this pacquet and he will order on[e of our: *hole in sheet*] Country men to call for it[.][5] Our Governor is going home [*hole in sheet: missing word ending in* 'me'] if I return from a remote part of the Country where I am [presently?: *hole in sheet*] you may exp[ect] another Cargo[.]

I am Sr
Yr most Humble
Servt
M Catesby

PS

I hope Sr you will excuse (considering I am pent for time) this Blotted account and my not transcribing the Letter which I am forced to send as the Pirats left it[.] Capt Hicks is not arrived which causes a suspicion that the Pirats have taken him.[6] These

come p[er] Capt Roe who came in here from an attempt to recover plate from a Spanish Wreck off the Bahamas but has failed[.][7]

For The Honble Consul Sherard / at Mrs Wansels in Barking Alley / near Tower Hill / London

1 RS, Sherard Letter Book, no. 185 (bound out of order at the end of the sequence of Catesby's letters to Sherard), 1 leaf (35.5 × 42 cm), folded; written on side 1, address on side 4. Inscribed on side 4 in another hand, 'Jun. 1723'. Portion of letter torn away on fold, with some words missing.

2 Unusually no place is given.

3 This is the only instance of Catesby adding 'PS' to the head of the letter to signal a postscript at end of letter.

4 Catesby's cargo for Sloane was also on the Dolphin and was likewise damaged by the attack (see letter 15).

5 Catesby had sent a packet of letters to his relatives in Suffolk and Essex together with his consignment to Sherard.

6 Pirates were a major hazard at this period, many operating out of the West Indies. Daniel Defoe's *History of the Robberies and Murders of the most notorious Pyrates* (London, 1724), written under the pseudonym of Captain Charles Johnson, describes 'their first Rise and Settlement in the Island of Providence, in 1717, to the present Year 1724'.

7 A Spanish fleet attempting to invade Charleston was wrecked in a storm off Providence Island in 1720 (Fraser, W. J., Jr, 1989, p. 38); Captain Roe may have been hoping to recover treasure from this.

14 *William Sherard, London, 13 November 1723*[1]

Charles Town Nov: 13 1723

Honrd Sr

I being in a remote part of the Country Your Lrs p[er] Capt Clark of 19th Ap: and 8th May came not to my hands til 6 weeks after his arrival which was about mid September[.] Of the 2 Boxes of plants Capt Clark brought that which I designed for you had a Sassafrass Tree or 2 which I thought would be more acceptable than that you recieved which had more kinds but of all which Fairchild have viz: Arbor Judæ, Styrax, Cassena and Prick[l]y Ash.[2] I suppose ere this You would have recieved my Spring Collection p[er] Capt Robinson after having been I fear much deminished and injured by pirats[.] I would

have rectified if as he had he ['promised'? *word covered by repair*] would bring them on shore. I doubt not but he has told you all[.] I shall be glad to hear of their being better than I expect[.] Sr Hans Sloans I expect suffered. My Letter to him I had again and was forced to seal it up ~~again~~ trod on and dirty as it was[,] not having time to transcribe it.

At the same time I sent Sr Hanse a small Collection of Shells and dryed Birds &c which if he has recd in tolerable condition I hope he will cease complaining but I fear they have suffered if not all lost[.][3] What I send now both seeds and plants were most or a great part of them collected in the Months of July and August 200 miles from this place toward the Head of Savanno River[.] Of the plants there are of most of them Triplicates and some 4 Specimens of a kind so I must beg you'l please to impart of them to Mr Dale and Mr Dubois. The Gourd Marked with a X is for you[,] the smallest for Mr Collinson and the other for Mr Rand[.] The Bay seed in the small gourd is all I have sent with what is loos in ye Box[.] Please to let Mr Collinson and Mr Fairchild have some[.] Please to let Mr Fairchild have one of ye Syringa pods and Mr Collinson two[.] The reason I am necessatated to trouble you thus is that I dare not for fear of rotting put ye Berrys in the gourd and could not get the ~~lo~~ pods in being too Long. Mr Collinson has procured several subscriptions which oblidges me to send him a greater quantity than otherwise there would be occasion for[.][4]

Halfe a dozen Martagons if you please to Mr Collinson[.] There are loose in ye Box Roots of a very beautifull kind of Satyrion but I fear the[y] won't ~~bear~~ bare being out of the Ground so long.

Next Aprile Ile send you some seed of the Serpentaria[.] It was too late when I recieved your Letter concerning it[.][5]

The Acorns[,] Seed and Cones of fforrest trees are very few accasioned I believe by a late and uncommon Frost succeeding a forward warm Spring[.] I never yet have had ye favour of a Letter from Mr Dubois tho at parting He gave me Hopes of somwhat concer[n]ing Pitch, Tar &c. which you must Remember …[6]

I have recd the past board you sent but not the paper mentioned in your first dat 22 of Feb: last[,] nor the Boxes[.] In answer to some part of your first Letter as follow[:]

You desire some more of the Horschesnut and say it is new to you[.] Its' growing at fairchilds where I have seen it 4 or 5 years since with its' scarlet flowers[.] I have now sent some mixt with the rest with white flowers which I never before saw. I never heard the Sugar has been here the winters are too cold[,] Ginger I believe will doe with some trouble[,] Indigo has been made in great quantities but the increas is so much greater in the West Indies that here its' left off.[7] I doe not forget the 2 kinds of Reeds you desire growing on the sea side as soon as I have an opertunity[.]

The Buds that are in the Box of Seeds are of Popler of which amongst the specimens is a leaf[;] it grows no where in the Settlements nor doe I remember to have seen it in Virginia[.] Therefore [I] conclude it not to be the same Mr Bannister gives an account of which I think is inserted in the Transactions of the R. Society.[8] The leaf nor Bark has any smell nor does any gum issue from it's wounded parts. Yet the Buds only that contain the succeeding flowers contain this odoriferous Balsam[.] Nor doe these buds proceed from the Boosom of each leaf but grow separate and are large and not small as he says[.] I hope in the Spring to give an acct. of its flowers and seed for the seed are ripe beginning of Ap:[.] These Buds by that time you'l recieve them will have been gathered abt 4 months yet will I believe retain so much of its Balsam as to smell[;] whether somwhat valuable could not be made of this.[9]

Here are some years great quantities of Walnuts Pignuts and Hickory Nuts[;] whether it would be worth any ones while who understood it to extract oyl from them it being to be done I concieve with much greater ease here where the nuts are in such plenty than in France where there can't be neare the quantity[.] Here might likewise be drawn great quantities of oyl of Bay from a Tree not much different from ours in Europe[.]

Your not mentioning Mr Parker in neither of your last Lrs I suspect he refuses to subscribe[.]

I believe the small round podded Accacia is new. I don't remember it desc[r]ibed by Dr Plucknet or any one[,] it is very uncommon here[,] it usually grow by Rivers sides and generally in shallow water[.][10] It's leaves are so like those of the large podded Locust that the difference is hardly disernable[.] I have gathered some Specimens but fear they'l hardly be dry enough to send now[.]

I can't recollect that I have escaped sending the Specimens of one Forrest Tree except the Spanish Oke which I must now defer til next year.[11]

You may Sr expect before sowing time a Box or 2 or what I can get of Fforest Cones and Seeds but they most of them [keep/decay? *this line in gutter obcured by opaque tape*] kind in the Country not a Tree could I find that had any of this year's growth[.] I hope to succeed better with the pines[.] I have wrote to Mr Rand to inform him of his Gourd.[12] ~~I must intreat you please to convey to Sr Hans his Lr who I suppose you seldom fail of seeing at ye meeting of ye Society~~ I fear I have tired you so will conclude

Sr
Your most faithful
Humble Servt
M Catesby

PS With yours comes a Box with 2 Books of Plants for Sr Hans Sloan. I beg wastcoat may be given to my Brother Catesby[.][13] I hope Sr you'l excuse my Blots and other mistakes having little time

To / The Honble Consul Sherard / at Barking Alley near / Tower Hill / London

1 RS, Sherard Letter Book, no. 170, 1 leaf (32.4 × 41.5 cm), folded; letter on sides 1, 3, with the last lines at right angles on side 2, address on side 4. Inscribed in Sherard's hand, 'paper & boxes/glasses Nov. 1723'.

2 This is further indication of Catesby's familiarity with the plants raised in Fairchild's Hoxton garden.

3 Sloane's 'complaining' indicates something of the difficulty Catesby experienced in satisfying him.

4 Another reference to Collinson's looking for further sponsors for Catesby's collecting (see letter 7).

5 Probably a reference to Virginia snakeroot, *Aristolochia serpentaria* (see letter 2).

6 Lower edge of sheet with remainder of sentence cut off.

7 Sherard, like others in his circle, was interested in plants as potentially profitable commodities, as well as ornamental and other plants new to him.

8 Catesby refers to the Revd John Banister, who collected in Virginia before his death in a plant-collecting accident in 1692. Several of Banister's papers were published in the *Philosophical Transactions of the Royal Society*, with which Catesby was familiar (see Chapter 1, p. 31).

9 Probably 'The Balsam Tree' (pitch apple, *Clusea rosea*) which Catesby drew (RCIN 926063) and published as *NH*, II, 99 (fig. 212).

10 For Leonard Plukenet, see letter 6, n. 3.

11 The Spanish or southern red oak, *Quercus falcata*, was not mentioned in the list of oaks Catesby sent earlier (letter 2).

12 See letters 11 and 15 for other consignments sent to Isaac Rand.

13 Catesby collected several ethnographic objects, including this garment which may have been what he described as part of Native Americans' 'ordinary Winter dress … a loose open waistcoat without Sleeves, which is usually made of a Deer-skin' (see Chapters 2, p. 56; 6, p. 212).

15 *Hans Sloane, London, 15 November 1723*[1]

Charles Town Nov: 15 1723

Sr
I hope you have recieved the remains of a Cargo of Plants, Birds, Shells &c which unfortunately fel into the hands of Pirats. I shall be glad to hear the danger less than I expect. The Master Capt Robinson came in after being taken to refit but the time he tarryed was so short that it prevented his bringing them on Shore as he promised[,] otherwise I could have put them again in some order[.][2]

I now send you Sr what Plants I collected 300 miles from the mouth of Savanno River[,] a very pleasant Hilly country infinitely excelling the inhabited parts both for goodness of land and air resembling the best parts of Kent but in some places affording much larger prospects and generally rich land as ye world afford[.][3] The greatest part of what I now send were collected in July and August in this Country and considering the difference between it and the inhabited parts I hope the Specimens will prove as different and New to you.

Next Summer if God permits I design to visit the Cherikees a Numerous Nation of Indians inhabiting part of the Apalathean Mountains about 400 miles from hence[.][4] I have sent Mr Rand a large Collection of Seeds most of them collected from the same place[.][5]

Depriving you no longer of your more important minutes I conclude Sr

Yr most faithful Humble Servt
M Catesby

1 BL, Sloane MS 4047, fol. 90, 1 leaf (21 × 16.4 cm); written on side 1, side 2 blank with no address.

2 This cargo for Sloane was on the same ship as a cargo for Sherard that was attacked by pirates (letter 14).

3 Catesby sent a fuller more effusive description of the landscape of this place to Sherard in his letter of 10 May (letter 11).

4 Catesby mentions this trip to the Appalachians again to Sloane in letter 20, and to Sherard in letter 18. He seems not to have made the planned expedition, however, as there is no further mention of it in his letters.

5 This indicates that he had sent Isaac Rand a separate consignment (see letters 11 and 14).

16 *Thomas Fairchild, Hoxton, date unknown but before 1724*[1]

To Mr Fairchild

Sir

I desire when you send Plants by Shipping to remote Parts, to send them in Tubs, and not in Baskets; for Baskets contribute much to the Miscarriage. Winter is the best Time; October if it could be, and to put the Tubs in the Ballast, which keeps them moist and moderately warm. So managed, I have had best success with Plants from England; for on the Quarter-Deck they are often wetted with Salt Water, and require the greatest Tendance from bad Weather, and even with the greatest Care they miscarry, as they did with me. It is so hot in the Hold in Summer, that they spend their Sap at once, and dye, so that is not a Time to send any Thing.[2]

Mark Catesby

1 Letter known only from partial publication in Bradley, R., 1724, III, pt 2, pp. 57–8.

2 Fairchild submitted Catesby's instructions for transporting plants by ship for publication in Richard Bradley's *General Treatise of Husbandry and Gardening* (1724); Bradley invited 'Gentlemen who have any Thing new and instructive to communicate … to send their Letters directed for me at Mr. Fowler's, Mathematical Instrument Maker, at the Globe in Swithin's Alley, near the Royal-Exchange, Cornhill' (III, pt 2, pp. 75–6). This is the only (partial) letter from Catesby to Fairchild known; plants in Fairchild's nursery garden at Hoxton are, however, mentioned several times in Catesby's letters to Sherard.

17 *William Sherard, London, 16 January 1724 (i)*[1]

Charles Town Jan: 16 – 1723/4

Sr

I have had the honour of Yrs dat. 20 Dec: 1722 but deferred answering it til' I could send the seed or get a more satisfactory acct of the plant – St Andrews Cross which is the same you suppose in Mr Ray.[2]

The Woods in Virginia are full of it tho' not common here. I remember to have heard Mr Bird commend it, but amongst the Indians, Virginians and Carolineans who trade with them it is not in ye greatest esteam[,] yet somtimes used with success as I have been told. That which is in most repute among the Indians is a plant not unlike plantain but with a Tuberus root[,] a specimen or 2 of which I have sent Dr Sherard with several specimens of St Andrews Cross with its flower[,] root and seed vessel of which I have desired him to impart to you.[3]

Where a vein or Artery is pricked by the bite of a Rattle Snake no antidote will avail any thing, but Death certainly and suddainly ensues sometimes in 2 or 3 minutes which I have more than once seen.[4]

I wish Sr I knew what would be ~~serviceable~~ acceptable to you or that you will please lay your Commands on me in any thing I am capable of serving you in which is not only my inclination but Duty of

Sr
Yr most oblidged
Humble Servt

I being at a great distance from where the St Andrews Cross grows at the time of ye ripe seed is the reason I have sent no more of it. I suspect that which hangs to the plant is ~~is~~ not ~~mature~~ ripe. It grows in this Country only Towards the mountains [*rest of sentence cut off*]

1 RS, Sherard Letter Book, no. 173, 1 leaf (24.6 × 22.3 cm), lower edge with signature trimmed off; letter on side 1, side 2 blank.

2 The reference is to John Ray's *Historia plantarum* (London, 1686–1704); it would appear that Sherard had cited Ray in his letter to Catesby.

3 Catesby refers to James Sherard here, to whom it appears he sent separate consignments of plants.

4 Catesby indicates his scepticism about plant cures for rattlesnake poison based on his experience of seeing people die within minutes of being bitten; earlier he reported on his friend William Byrd's 'rodomontade' tales of plant cure (letter 11).

18 *William Sherard, London, 16 January 1724 (ii)*[1]

Charles Town Jan: 16 1723/4

Honrd Sr

I hope er'e this you have recieved p[er] Capt Clark my last Cargo of plants &c seeds &c, and that you will find the greater part of them new. Many of the seeds are from plants I could not send specimens of, I not being ~~I not being~~ where they grow at the time of blowing. I thankfully recieved your Box of Roots & seeds all in good order except the Emonies & Ranunculus's which I scspcct wcrc not pcrfcctly dry when put up, tho' I think some of all the seed [will? *– illegible on edge of sheet*] come up. I repent of my having spake of and given you expectation of ~~of~~ Bulbs perticularly of one very remarkable for its' Beauty[;] I have gone in search and have done what possibly I could to procure it but have as yet been unsuccesfull. In less than 20 years they were seen within the Inhabitants but have since that time dis~~s~~appeared supposed to be by Cattle or Hogs that roots ym up. Here is another kind of Lilly which ~~has a~~ tho the flower is large its bulb is very small and grow always in very wet places[;] I have transplanted them in Gardens but never would flower. Except the well known Martagon and those before mentioned here are no bulbs worth sending for their Beauty only, tho' that is not the reason I have omitted it for indeed I have been always absent from where they grow at the proper time of taking them out of the ground[.]

Coll Johnson who if you see him (as he promised me he would) will inform you how we were both disappointed in getting pine apples, acorns and other Forrest seed for in riding many miles here was not a pine Tree of any kind that hath fruit on it except one Tree which I caused to be cut down but the seed was abortive and not worth sending[.][2] There was the like scarceaty of Acorns except which and the Pines and Fir there is ~~nothing~~ no seed or[3] plant that I have omitted sending that has either come within my view or intelligence only those whose seed was not mature or plant not in flower when opertunity

offerd to gather them for tho' many plants are common ~~at~~ in all parts of the Country, others are only in particular places so that if I collect the plant in flower tis' ten to one I have an opertunity of collecting seed unless I goe 100 miles or more for it[.] And to collect every thing is impossible but with many years application. My method is never to be twice at ~~the same~~ one place in the same season for if in the Spring I am in the low Country[s, in the Summer] I am at the head [of the] Rivers [and] the next Summer in the low Countrys so alternately that in 2 years [I collect in /g]et the two different parts of the Country.[4] Next Summer I hope to goe further west and visit the Cherikees a Nation of Indians very numerous inhabiting ~~the~~ that part of the Apalithian Mountains parellel to this place [*under repair*].[5]

I remember Sr you told me you did not desire any Shells to be sent but ~~what~~ what was the product of the land and fresh water Rivers[.] I have not yet been able to discover above 3 different kinds from the Rivers and as many inhabiting the Land. Those of the mussle shape are of the rivers and those of the snail kind of the land. I have by me several pieces of wood cut but am in a doubt as whether you want to see the grain of the wood as in your direction you say with the Bark on, many Trees [*start of* 'have' *erased*] are almost all [*illeg. word under brown tape*] ti'l they are of a large bigness which then require very large pieces to have both heart and Bark.[6]

The next Summer as I have said I designe to spend in the Mountains and in such places where I have not yet been[.] And if my Subscriptions are thought fitt to be continued another year and that you approve of it I propose to goe to the Bahama Ilands[.][7] I have nothing more to add than that my Service may be made acceptable to Mr Sherard and ~~and~~ Friends ~~perticularly to~~ from

Sr
Your
Most faithfull Humble Servt
M Catesby

Ile be pleased Sr when you see my Brother or any opertunity offers to let him know of the Box directed for him.

I fear I have tired your already yet Ile venter to relate (in as short a manner as I can) an odd accident that hapned about the beginning of last February[.] I being at the house of Coll Blake [*beginning of name*

under brown tape] a Negro woman making my Bed a few minutes after I was out of it cryed out a Rattle Snake[.] We being drinking Tea in ye other room which was a ground flore, and being surprised with ye performance of the wenches bawling, went to see the cause, and found that the wench had laid a Rattle Snake actually between the sheets in ye very place I lay, vigorus and full of ire biting at [*whole word torn off*] every thing that approach't him. Probably It crept in for warmth in the night, but how long I had the company of [this] charming bedfellow I am not able to say.[8]

To / The Hon:ble Consul Sherard / in Barking Alley near / Tower Hill / London

1 RS, Sherard Letter Book, no. 174, 1 leaf (36 × 44 cm), folded; address on side 4. Inscribed by Sherard, 'Jan. 1724'. Watermark type E (fig. A6); countermark type K (fig. A12).

2 Robert Johnson, who preceded Francis Nicholson as Governor of South Carolina, and was like him interested in promoting profitable natural commodities, actively supported Catesby in his work, accompanying him on several collecting expeditions (see Chapter 2, p. 53).

3 ['or' written over 'that', erased.]

4 Catesby's systematic method was in marked contrast to other collectors who gathered opportunistically (see Chapter 6, pp. 196–8).

5 See letter 15, n. 4.

6 Sherard, in common with other collectors of the period, had a collection of wood samples, used partly for the academic purpose of describing the characters of different species, but also as part of the widespread interest in identifying profitable plant commodities. There was a further medicinal interest in the search for substitutes for expensive bark, such as lignum vitae and Jesuit's bark, then being shipped from the tropics (see Catesby's request for powdered bark, letter 11).

7 This is the first mention Catesby makes in his letters of a trip to the Bahama Islands.

8 Catesby was staying with Colonel Joseph Blake, one of the wealthiest men in the province, who owned a fine brick mansion with elaborately laid-out gardens on his Newington plantation on the upper Ashley River. This account of the incident with the rattlesnake is corroborated by a similar one in the *NH*, II, p. 41 as well as in a letter Catesby sent to his uncle Nicholas Jekyll (Chapter 2, p. 54).

19 *William Sherard, London, 17 January 1724*[1]

Charles Town Jan. 17 1723/4

Sr
This gives you notice of a Box of Seeds &c under ye care of Mr Rothmaller in Capt Rider[.][2] They are mostly Duplicates of what I sent last p[er] Capt Clark which I hope you have long age [ago] recd. The Yellow Branch on the Top of the Box is ye product of the Sea, the other grows on Sand Banks near the sea[.] I send the greater quantity of the Sweet flow-ring Acacia because ti's a Tree not only of a fragrant Scent but very Ornamental and of great use[,] of quick growth and easily raised as ['at' *erased*] several large Trees at Hedingham will make appear[.][3] I have now no more to add but enjoyment of Yr Health is ye sincere wish of

Sr
Yr most Dutifull Servt
M Catesby

1 RS, Sherard Letter Book, no. 175, 1 leaf (21.2 × 15.7 cm), folded; letter on side 1, side 2 lacking address. Annotated with a list of plants in Sherard's hand in graphite, and inscribed in another hand in pen and ink, 'Jan. 1723'. Watermark type B (fig. A3).

2 Mr Rothmaller may have been a passenger to whose care Catesby charged this consignment.

3 This 'Acacia' was the thorny honey locust, *Gleditsia triacanthos*; a specimen in Sherard's herbarium (Sher-2274) sent from Carolina has a label in Sherard's hand 'Acacia Honey tree'. The plant is mentioned again in Catesby's letter to Jacob Dillenius (letter 38). Catesby's reference here to 'several large Trees at Hedingham' is likely to be to his uncle Nicholas Jekyll's garden at Castle Hedingham.

20 *Hans Sloane, London, 12 March 1724*[1]

Charles Town March 12 – 1723/4

Honble Sr
I hope you have ere this recieved p[er] Cap.t Rowe (who sailed from hence the 10 of May last) a Box of dryed Birds, Shels, and insects. Since which I have done my selfe the honour of writing per Capt Clark in ye Crawley Nov: 14 last with 2 Books of dryed plants. Concluding you have recd those by Capt

Rowe I doe not repeat sending any of ye same again. With one I sent before I now send 7 kinds of wood peckers which is all the kinds except one I have discovered in this Country[.]

The Shells I now send are an entire collection of what I could ever discover or learn these Coasts afford. And of the land and fresh water Shels I sent p[er] Capt Rowe are likewise all I have seen[.]

I am at a loss to know for want of hearing from you whether all kinds of Birds thus preserved will be acceptable to you or whether those only that are remarkable ~~only~~ for colour or shape. However the Icons of all I hope to produce which will make no small addition to ye history of Birds[.][2]

I shall Sr send you a Collection of Reptiles so soon as I can procure glasses to put them in[.][3]

The names of ye Birds are
Six kinds of Woodpeckers[4]
Jay[5]
Blew Bird[6]
Lark[7]
Red winged Starling Acolchichi of Willughby's
 Appendix[8]
To-Whee ye black back bird with red on ye brest[9]
Head of an Oyster catcher[10]
Head of ye round crested Mergus[11]

I am now Setting out for the Cherikees a Nation of Indians 300 miles from this place & who have lately declared War with another Nation which diverts them from injuring us and gives me an opertunity of going with more safety.[12] What perticular commands you'l please to send me – shall be faithfully observed to ye best of my capacity ~~by Sr~~ by

Sr
Yr most Obedient Humble Servt
M Catesby

1 BL, Sloane MS 4047, fol. 147, 1 leaf (34 × 22.6 cm), folded; written on side 1, side 2 blank. Watermark, type E (fig. A6).

2 In addition to the images ('icons') of birds Catesby made for his book, he made a number of 'duplicate' drawings for Sloane (see Chapter 2, p. 52, and fig. 237).

3 Catesby's reference to 'glasses' is to glass jars or bottles in which birds, snakes and other animals were preserved in alcohol (see Chapter 6, p. 211, fig. 244). He requested glass jars several times from Sloane, whose slowness in sending them meant he could not send the specimens required.

4 Six tally marks appear after the word 'woodpeckers', perhaps added by Sloane on receipt of the consignment. The eight species Catesby included amongst the woodpeckers were: ivory-billed, *Campephilus principalis*; pileated, *Drocopus pileatus*; hairy, *Leuconotopicus villosus*; red-headed, *Melanerpes erythrocephalus*; red-bellied, *Melanerpes carolinus*; downy, *Dryobates pubescens*; northern flicker, *Colaptes auratus* (Catesby's 'gold-winged woodpecker'); and yellow-bellied sapsucker, *Sphyrapicus varius* (his 'yellow-belly'd woodpecker'). While the last two species are currently differentiated from other woodpeckers by their respective names 'flicker' and 'sapsucker', they are in fact members of the woodpecker Family (Picidae), the genetics of which is more unsettled than other bird Families (I thank Shepard Krech III for this information). See Chapter 6, pp. 203 and fig. 237.

5 Bluejay, *Cyanocitta cristata*.

6 Eastern bluebird, *Sialia sialis*.

7 Horned lark, *Eremophila alpestris*.

8 Red-winged blackbird, *Agelaius phoeniceus*.

9 Eastern towhee, *Pipilo erythrophthalmus*.

10 American oyster catcher, *Haematopus palliatus*.

11 Hooded merganser, *Lophodytes cucullatus*.

12 The comment highlights what Catesby had described to Sherard as one of the 'two obstructions in travelling in these remote parts[,] one is the fear of being lost[,] the other is meeting with Indians' (letter 11). For this planned expedition to the Eastern Band of Cherokee, see letter 15, n. 4.

21 *Willliam Sherard, London, 6 April 1724*[1]

Charles Town Aprile 6 1724

Honrd Sr
I was sensably troubled with your last Lr to me of complaints[.] It was ~~dated~~ without any date. My uneasiness is somwhat mittigated when I reflect that by this time, and by what I shall now say [~~only~~ *under tape*] I may be credited your resentment is abated. I shall not ~~indicate~~/vindicate my remissness in writing or any thing else I am knowingly tardy of [*another word under tape*][.] But I protest before God I never can be more industrious in collecting whatever I could possibly meet with either those few days I was at Savanno Garrison or since.[2]

The Spring in that Country in March (the later end of which time I was there) is very near as backward as in England and somtimes set backwarder by a hard frost which has again hapned in ye Set-

tlements this [*space*]³ of March having killed all the fruit in blossum, deprived the Oranges Trees of all their leaves and blossoms[,] even Okes, and other Trees and plants that sprung are blasted[.] Therefore plants except gathered imperfect and without flower at that? time are not in such quantities and especially seeds which I protest I could not find there above 2 or 3 ~~seeds~~ [of] every kind ripe with diligent search. I own there is nothing I have been so remiss in sending as a large quantity of the cones of pines[,] fir and acorns[.] It may seem as an excuse to say that the floods or late frosts have impeded it but the falsity of such a pretence would be very foolish when ['when' *repeated*] you may so easily be informed perticularly by Conll Johnson who assisted me in getting many and perticularly endeavoured to get the cones of pines and acorns.

I never have been able to discover (tho' with no small enquiry and search) more kinds than the fresh water and land Shells I sent 16 Jan: last which as I remember are ~~six of~~ 3 of a kind.

You say Sr several of my Subscribers complain which surprises me[.] I could not learn by enquiry and asking those I saw that Collections would be acceptable to any but Sr Hans, Your Self, and Mr Dubois. I wish I could know what was required and by whome[.] I hope it cant be expected I should send Collections to every of my Subscribers which is impracticable for me to doe.

However Il'e doe to ye best of my abilities nor can I say or doe more[.] I should have thought aboundance of my time lost if at my return to England I could have shown no more than the collections I send[,] not that any thing obstructed my collecting plants and seeds which all give place to when opertunity offers.⁴

In your Lr of the 22nd Febr: 1722/3 you say you will in next ship [send] 2 paper Books bound in past board which I have not yet recd. The past board covers are of great use. I want paper and have desired my Brother to send me some.⁵ The parcel of seed now sent is what I collected for thee at Savanno River in October last but Negroes [?] used to bring [?] me time enough to send to … [*last line obscured by tape*].

[*List on right-hand side and at right angles to rest of text*]

	(Live Oke	–	1	Notched
	(White with a fine grain	–	2	
	(Chesnut	–	3	
Okes	(Smamp [swamp] red	–	4	
	(Black	–	5	
	(Highland red	–	6	
	(Willow	–	7	
	(Water	–	8	
	Fir	–	9	
	Richland Pine	–	10	
	Swamp Pine	–	11	
	Ceder	–	12	
	Dogwood	–	13	
	Arbor Judæ	–	14	
	Sassafras	–	15	
	highland Tupelo	–	16	
	Water Tupelo	–	17	
	Maple	–	18	
	Erect Bay	–	19	
	Popler or Tulip Tree	–	20	
	(Red Bay	–	1	
	(Sweet Gum Styrax aceris fol	–	2	
	(~~Chinkapin~~ – –		3	
long Notches	(Sweet flowring Bay	–	3	
	(Chinkapin	–	4	
	(Hickory	–	5	
	(Wild Cherry	–	6	
	(Holly	–	7	
	(Myrtle	–	8⁶	
	(Red Bay without Bark			

I got this wood at a Gentleman's who is the most observing and knowing in this kind of any [man] ~~men~~ in ye Country[,] he makes 10 kinds adding to these, Cours grained White Oke & highland Willow leaved black Oke[,] these last I could not find[.]⁷ These are the same kinds yt are in Virginia tho' ye names of some differ as they often doe here, they not being called every where in this Country by ye same names. I cannot ~~hardly~~⁸ allow there's above 8 or 9 at most distinct kinds and yet some people multiply them to half as many more; which proceeds only from difference of soyl or other natural accidents for I have often observed Okes ~~as well as~~ to partake of the likeness of 2 kinds that it was difficult to distinguish them[,] their leaves and bark being half one and half ye other.

Another cause I concieve makes mistakes in distinguishing them is that most people here have no

regard to ye leaf but to the Bark and Grain of ye wood only especially the latter which oft differs according to ye nature of ye soyl they grow in respect to dry and wet[.][9]

Here are 4 kinds of pine besides the Fir which is called here Spruce pine. The Pitch pine and ye Swamp I shall send ye first opertunity[.] These are multiplyed by some to 6 or 8, only from a little alteration of the bigness or grain according to ye place of growing … [*next 2 lines illeg. under tape in gutter*] could not be marked with greater ease for as soon as cut off [??rol] on every one to prevent mistakes[.] The best wood is what is here called the red Bay[,] some specimens of which I have sent[;] it very nearly resembles our common Bay in England bearing the same Berries[,] the leaf larger and longer and not altogether so fragrant[.] They grow no where large but near the Sea and generally on small Ilands some of them to ye bigness of 3 foot in diameter[.][10]

I beg you'l pleas Sr to remind my Brother if you see him to send the paper and shall be glad of the 2 p.[aper] books coverd with past board[.]

Amongst the B [*erased word*] flower roots you were so kind to send Me most of the Emonies and Ranunculus were planted in Charles Town at a Dr of Phisick's house at whose house I am at when in Town[.] A The great frost in the middle of March cut of[f] all the Ranunculus & Emonies yet a second crop arose tho' imperfect were the wonder of Town and Country and indeed the finest and greatest variety of the Ranunculus I ever saw[,] 10 kinds of the Ranunkulus appeared and doubtless many more there were sent if the frost had not spoyled them[.] What with the frost and ye succeeding hot sun they are reduced to a few but the Emonies hold it[.][11]

I am
Sr
as before Yr most oblidged humble
Servt
M Catesby

[*first words illeg. under tape at top of side 4 of letter*] notches refers/refer? to ye Names[.] There are 2 without notches[,] one is red Bay without Bark which is the [*illeg. under tape*] same sort of wood as that which is marked with a long notch [*illeg. under tape*] and the bark on. The other tree is from the upper part of the [common? *illeg. under tape*] centre of the Tupelo Tree that [is] notched being taken from near ye root to

shew ye difference in hardness[.][12] There are remaining about [*another word under tape?*] 12 sorts which I have not had an opertunity of getting[.] There are besides several shrubs yt never arrived to ye bigness of my wrist which you'l please to let me know whether to send or not[.]

With ye seed now sent is the seed of Sena which grows in this Country[,] by comparing it with ye discription a [figure? *illeg. under tape on rt hand edge of paper*] in Matthiolus it seems to be ye true Alexandrean Sena[,] it has ye same effect with that it was introduced [here? *illeg.*] it not being a native, it flourishishe here wel[l].[13] I need not mention what I sent by Capt Clark 13th Nov: last hearing by Capt Smiter he was entered ye River before he came left ye douns[.][14] Since which I have wrot to you by Mr Rotherwell 16 January last[.]

Mr Garden is tolerably well and gives his humble service. We are in no expectation with of parting with our Governor this Summer[.][15] Aboundance of people has this Winter been carried off by ye plurisey pestilence[.][16] I shall not fail (God spare my life) of sending ye laurel seed with ye Umbrella and Snakeroot[.] I did not forget them but was distant from where they grew at the time of seeding and relyed on more than one that dissappointed me in not procuring them.

I am Sr
Your most ffaithfull Servt
M Catesby

1 RS, Sherard Letter Book, no. 176, 1 leaf (35.7 × 44.6 cm), folded; letter sequence follows sides 1, 3, 2, 4. Side 4 inscribed in Sherard's hand, 'Answ. Oct. 15. 1724'.

2 By this date Catesby had sent fourteen letters and eleven or twelve consignments to Sherard, and had reason to be 'sensably troubled' at what seems to have been a complaint of his supposed inactivity by his sponsors, none of whom (apart from Sloane) had any experience of the difficulties of collecting in the field.

3 The space left by Catesby indicating he intended to go back and fill in the exact date.

4 A reference to his intention to produce his illustrated *Natural History*, a project which had been encouraged (or even suggested) by Sherard himself (see Chapter 2, p. 49).

5 This is an indication that Catesby depended on paper supplies sent from England (see Appendix 2). He is clearly in need of supplies as he reminds Sherard of his request for paper and pastebooks later in this letter.

6 [3–8 all renumbered over 4–9.]

7 Catesby refers to his friend Alexander Skene (see letter 6).

8 [Catesby wrote 'I can hardly allow' before crossing out 'hardly' and squeezing in 'not' attached to 'can'. He also inserted 'at most' making his statement more emphatic.]

9 This is an indication of Catesby's close observations of species differences, and the way in which environmental factors could produce variations between them (see Chapter 6, p. 193).

10 Swamp redbay, *Persea palustris*, drawn at RCIN 925898 (*NH*, I, 63).

11 Dr Thomas Cooper's house in Charleston was Catesby's base during his time in South Carolina, and Catesby planted many of the bulbs he requested from Sherard in Cooper's garden (see Chapters 2 and 5).

12 Probably black tupelo, *Nyssa sylvatica*, drawn by Catesby at RCIN 924855 (*NH*, I, 41).

13 Alexandrian senna, *Senna alexandrina*, a native of upper Eygpt, was used then as now as a laxative. Catesby's authority was Pietro Andrea Mattioli's *materia medica*, his *Commentarii*, 1554 (see Bibliography, p. 333).

14 By the 'douns' Catesby refers to the Downs, the sheltered anchorage off the east Kent coast, between Deal and the Goodwin Sands. Ships waited there for a suitably easterly wind to take them into the Thames or English Channel.

15 Francis Nicholson remained as Governor of South Carolina until 1725 when he was succeeded by Arthur Middleton.

16 There was an epidemic of quinsy (a form of acute tonsillitis) in Charleston in 1724 (Waring, J. I., 1964, *A History of Medicine in South Carolina, 1670–1825*, Columbia, SC, 'A List of Epidemics in South Carolina', for 1724 – 'Quinzey', Appendix, pp. 371–2).

22 *William Sherard, London, undated*[1]

In your last Letter is ye following quere[2]

How many Tulipifera's have you

There are 3 whose seed and seed vessels are alike differing only in bigness

1st The Laurel is a tall and large Tree[,] some of them 3 foot Through[.] It's blossom is white as large as the crown of a mans hat[,] the Cone when ripe is of a pale red discharging from the many little cavities red seeds which fall not to the ground imediately but hang by small white threds about 2 inches long. This stately Tree is alway green[.][3]

2d – The Smaller Laurel or Bay ~~This~~ is usually a Shrub Tree tho' I have seen them as big as my body[.] The flower is white and very fragrant[.] The seed vessel differs from the Laurel in nothing but it's being much less[.] The flower likewise resembles ye Laurel but is not above the 10th part so big, in mild winters this tree retains it's leaves but a sharp frost cause them to drop[.][4]

3d Umbrella ~~both~~ in flower and seed vessel very much resembles the laurel[.] The tree is rather a Shrub 12 and 16 foot high[,] not often so big as a mans leg. The leaves are usually 2 foot long growing 8 or 10 together in a circular form, from the midle of which grows a very large white flower like that of the laurel succeeded by a single cone like that of ye Laurel retayning it's red seed in ye same manner[.] It is bare ~~of leaves~~ of leaves in Winter.[5]

1 RS, Sherard Letter Book, no. 177, 1 leaf; side 1 written on by Catesby, side 2 used by Sherard to make a list of plants (these appear to be plants he wanted from Mexico; each item is crossed through).

2 The leaf appears to have been an enclosure in a letter, probably accompanying letter 21 or 23. It lacks an addressee and signature, date and place, and is set out as a series of answers to Sherard's question about how many species of magnolia Catesby had identified ('How many Tulipifera's have you[?]'). There was a certain amount of confusion surrounding the different species, partly because of the use of several names for each. Catesby identifies three here; after his return to England he was to describe and illustrate a fourth, 'The Magnolia of Pennsylvania', the cucumber tree, *Magnolia acuminata*, which he published in the appendix to his book (*NH*, Appendix, 15), and also discussed in letter 43. He published all four species in *HBA*.

3 'The Laurel', southern magnolia or bull bay, *Magnolia grandiflora*. In letter 2 Catesby notes that it was also called 'Tulip Tree' or 'Great Laurel'; in *HBA* he describes it as 'The Laurel-tree of Carolina' (p. 1).

4 'The Smaller Laurel or Bay', sweetbay magnolia, *Magnolia virginiana*. Described in *HBA* as 'The sweet flowering or rose Bay' (p. 3).

5 'Umbrella', umbrella magnolia, *Magnolia tripetala*. Catesby described this as growing 'to a good height with a straight Body' (letter 2); it may have been what he elsewhere referred to as the 'Erect Bay' (see letter 5). Described in *HBA* as 'The Umbrella-tree' (p. 4).

Charles Town Augt – 15th – 1724

Honourable Sr

I recieved Yrs of the 17th Aprile last. I shall according to your order make a Collection of Snakes &c but the Season is so far spent before I recieved the Bottles to put them in that I fear I shall make but a small progress this summer, especially in larger snakes, for which I have not had before now the bottles large enough to put them in.[2]

I send now the first half of the Summers collection which I hope will afford you many new plants for many of them are ye same of those distroyed by the Pyrates. The Bird's head in the Box has a Body as big as a goose and web footed, I call it the fisher from it's preying on fish, which it does after the manner of the Kingsfisher [sic] precipitating it self from on high into the water with great violence and there remaining about a Minute. They are never seen but at Sea Bays and the mouths of large Rivers.[3] The large Skin is that of a black Fox. They are very rare and are caught only in the mountains.

The Small Skin is that of a Polcat, they all vary in their marks two being never seen alike[,] some almost all white, others mostly Black with but little white which seems a sport of Nature peculiar to this little Beast, at least I know of no Wild Beast but what are all of ye same colour[.][4] I hope ere now Sr you have a Box of Shells and dryed Birds by Capt Robinson with a Lr of the 12 March last[.]

My sending Collections of Plants and especially Drawings to every of my Subscribers is what I did not think would be expected from me[.] My design was Sr (til you'l pleas to give me your advice) to keep my Drawing intire that I may get them graved, in order to give a genll History of the Birds and other Animals, which to distribute seperately would wholly ffrustrate that designe, and be of little value to those who would have so small fragments of the whole. Besides as I must be obliged to draw Duplicates of whatever I send, that time will be lost which otherwise I might proceed in the designe and consequently be so much short in proportion to what is sent. I beg Sr if you (as I flatter my self you will) think this reasonable that you will pleas to satisfy Ld Persival, who no doubt but will be influenced by what you say[.][5]

That I might not be thought remiss and to give all content I can to my Subscribers I designe to tarry here another year. Unless the following designe has

requires my being at home sooner which Sr I beg leave to communicate to you, which is this. Here is a gentleman who practices Phisick[,] his name is Couper and is of Wadham Colledge in Oxford and tho' he has extraordinary business in his profession and by far the best of Any Body in this Country, He designes to leave it through a desire of seeing the remote parts of this Continent in order to improve natural knowledge, and as his genius bends most to the Mathematicks, he proposes to communicate to the R: Society what observations he makes in Astronomy. And Perticularly in his way of Practice.

The principal obstruction in such an undertaking, I concieve is the unsafe travelling amongst so treacherous and jealous people as the Spaniards. It's concieved a pasport or Lr of Protection might be procured from Old Spain to facilitate the designe, with more safety, which if it could, would be a sufficient ob[l]igation to gratify the learned in such observations as should be required of him. And as he is so kind to tel me my Company is one principal inducement to his undertaking it[,] so I could with no less satisfaction embrace such a designe with a moderate encouragement, if it could be accomplished witho[u]t the danger of being imprisoned[,] and as deliniating Birds and other Natural Productions ~~of~~ would be no small embellishment to such an undertaking. If from London I could not I would if possible procure from Paris or Amsterdam a painter to goe with me with me which probably in a very few years would produce No Mean Collection of Unknown Productions[.][6]

I cant Sr without to[o] much confidance and regret request the favour of your advice in this affair when I have already transgressed so long on your important hours[,] so I conclude

Sr
Your Most Dutifull Humble Servt
M Catesby

To / The Hon:ble Sr Hanse Sloane / Bar.t at his house in Soho / London

2 Catesby repeats his need for glass jars or bottles (see letter 20).

3 The bird was a juvenile northern gannet, *Morus bassanus*, which Catesby named 'The Great Booby'. He had probably found this specimen dead or wounded on a river shore in Georgia, recording that he had 'several times found [these birds] disabled, and sometimes dead', surmising that they had met 'with Sharks, and other large voracious Fishes, that maim and sometimes devour them'. No doubt this was the reason he only sent Sloane the head, which he also drew at RCIN 925921, and published as *NH*, 1, 86 (see McBurney H., 2019, 'Mark Catesby's Plate "The Great Booby"', in Droth, M., Flis, N. and Hatt, M., eds, *Britain in the World: Treasures from the Yale Center for British Art*, New Haven & London, pp. 40–43).

4 The black fox was probably a melanistic fox, *Vulpes vulpes*, which is mostly black and was in high demand for its pelt; the 'Polcat' was an eastern spotted skunk, *Spilogale putorius*, a specimen of which Catesby also presented to the Royal Society's Repository (Chapter 6, p. 216).

5 Catesby tries to excuse himself from making duplicate drawings for Sloane and another of his sponsors, Lord Perceval (1683–1748), 1st Earl of Egmont. For the duplicates, or versions, of the drawings he executed for Sloane, possibly some of them after his return to England, see fig. 237 and forthcoming Catalogue.

6 'Couper' is Dr Thomas Cooper, in whose house Catesby lodged in Charleston. Neither Sloane nor Sherard responded to Catesby's request for support for the project to travel in Mexico as artist companion to Cooper (see Chapter 2, p. 52). Lacking such support, the last part of Catesby's sojourn was spent in the Bahama Islands.

24 *William Sherard, London, 16 August 1724*[1]

Charles Town Augt 16 – 1724

Honrd Sr

I have recieved yrs of the 14th Feb: last with the Box of Paper[.] In this Collection I now send I hope you'l find many new kinds they being many of them of what were distroyed by the pyrats[.]

In the Settlements I have gone through all months so I fear the latter part of this Summers collection will not afford many kind[s]. I could with much more ease have remained in the Settlements and not taken the pains I have done in collecting in remote parts, but I am certain the collections would not have contained near so many new plants. Having now collected in most parts of the Country, the number of new plants must consequently decrease. However I shall continue to collect every thing I meet with, not only new but of those I have alread[y] sent[.]

I hope Sr you have recieved the Specimens of wood[2] with a Bag of berry's of an ever green Tree which I sent as soon as I recieved. I am determined with my selfe tho' at my own expence to continue here another year or at the Bahama Ilands but your sentiments concerning it shall be my guide which I beg you'l please to favour me with when you write next.

What Query's your Letter contain[s] are answered in the paper that contains the seeds and plants perticularly those pieces sent in the Book, 5 of which remain unanswered they not being yet in Blossom. In your Letter is this (the ash sent in seed is very perticular but I saw no specimen of it) I suppose you mean it's blossoms which I have not seen.

The berry's of the Angelica Spinosa will not be rype til October.[3] I have not seen any more of the Fern kind than what were in the first parcel of plants I sent.

Here is none of the Virginia Firr that produce the small Cone.

I wish I knew what plants are living of those I sent in Tubs[,] it would prevent my sending the same again and make room for others not yet sent[.]

I was necessated to leave the town in Aprile otherwise I must have been idle at ye productive time and an opertunity not offering then I was obligded to leave it to be sent by the next ship which was the [*blank*].[4] The Berries are what I spoke for and were sent me from Savanno Town and sent the first opertunity after I recieved them[.] My Letter of advise was neglected to be sent with them so at my return I sent another by the next ship [.] Not yt any thing but the Berries could take harm[.]

On ye 14 of the month we had the last of a hurry can which drove some Sloops, Boats and Canoes ashore[,] uncovered some houses but did no material damage.[5] This gust was attend[ed] with ['with' *repeated*] a prodigious quantity of Rain so that at Santee[,] a very large River to ye north[,] the Inhabitants lost all their corn by ye flood[.][6]

I cant forbear Sr communicating to you an affair which I hope will not appear to you so unreasonable or unpracticable but that I may hope for your advice and assistance in it. It is this. Here is a gentleman with whome I have contracted a ffriendship, who has a strong inclination to see the remoter parts of this Continent perticularly Mexico in order to improve Natural Knowledge. It may be requisite to let you know his name is Couper, his practice is Phisick, ~~he~~ and is from Wadham Colledge in Oxford. He is the only one so qualified in this Country, and has all

the considerable business in it. The least I can add is that he is beloved and esteemed by all who can give a judgment of probity and engenuity. As his Natural Genius bends to the Mathematticks he proposes to communicate to the Royal Society, what Observations he makes in Astronomy and perticularly in his way of practice &c[.] The principal Obstruction in such an undertaking I concieve is the unsafe travelling amongst so treacherous and jealous a people as the Spaniards are. But it's concieved a passport or Lr of protection might be procured from Old Spain, to facilitate the designe with safety which if it could, would be a sufficient Obligation on him to gratify the learned in such Observations as should be required of him. And as he is so kind to tel me my Company is one principal inducement to ye undertaking so I could with no less satisfaction embrace such a designe if it can be accomplished. [*illeg. sentence crossed out*] I refer you Sr to a Lr Mr Couper has wrote more at large to Dr Mead concerning this affair.[7] I am not so bent on this affair but that I know the necessaty of my first going to England, were it only to give a further account of my labours here; But in ye mean time I intreat you'l pleas to send me your sentiments concerning it.

In looking over the Books I ~~now~~ now send I find 5 or 6 plants mouldy, tho' they were perfectly cured and well dryed, when put up and are kept in a dry, upper, South Room. In turning over those for Sr Hans I find the same plants mouldy and only those, so that I find some plants tho' not succulent are perticularly subject to it. The weather is indeed, and has for some time been, extream Moist Cloudy and Sultry[.]

I put into ground some seeds of Coloquintida which ripen early here and have made a great increas but how to cure them we are at a loss.[8] Whether or not it would be worth while to export ym to England? I remember in my first collection to have sent specimens of a large red flowring Convol: It has a large parsnep root and is not annual. It seems to agree with discription of the Scammony but how to reduce the juice of it to the consistance of that in ye shops, none knows here[.]

Whether Opium might not be made here if we had ye true Poppy from Turky and knew their method of making it? Whether Rhubarb if it could be procured would agree with this Clymate? Or Wormseed? Here's a gentleman intent on ye procuring and propagating things of this kind, and has desired me to get him what information concerning them I am

able which I fear I am too unreasonable to request of you havin[g] already given you too much trouble[.][9] I procured laurel Berries after I had seal'd up the Gourd which is the reason I did not put them into. The loose Cones in the Box are those of the Umbrella[,] the small are the Sweet flowring Bay. The Laurel Cones are somwhat larger and not altogether so long as the Umbrella otherwise very like them. I dare not put any of the Cones in[,] they being very Moyst and in a rotting condition, and would have hazarded the rest[.]

I beg you'l pleas to give my Service to Dr Delineus & Mrs Wansel and accept

the same from
Sr
Yr Faithful humble Servt
M Catesby

To / The Honble Consul Sherard / at Barking Alley near / Tower Hill / London

1 RS, Sherard Letter Book, no. 178, 1 leaf, folded; beginning on side 3, continuing at right angles on sides 2 and 1, address on side 4. Inscribed on side 4 in Sherard's hand, 'Answ. Jan. 27. 1724/5', and in another hand, 'Aug. 1724'.

2 For Sherard's collection of wood, see letter 18. [A large gap follows the word 'wood' suggesting an insertion to be made.]

3 The plant was devil's walking stick, *Aralia spinosa*, characterized by its sharp spiny stems.

4 [A gap left for the name of the ship, not filled in.]

5 This is the second hurricane Catesby experienced while he was in South Carolina, although less violent than that of September 1722 when animals were left 'lodged on high trees' (letter 4).

6 The Santee River, 143 miles long, is the second largest river on the eastern coast of America.

7 Dr Richard Mead (1673–1751), physician and art collector, was one of Catesby's sponsors who later gave him a substantial sum which enabled him to 'carry … the original design of [the *Natural History*] into execution' (see Chapter 1, p. 28).

8 Coloquintada, *Citrullus colocynthis*.

9 This would seem to be another reference to Alexander Skene, who was interested in promoting profitable agricultural commodities. [The next part, written in different ink in a larger hand, was clearly added at a later date.]

25 *Edward Harley, 2nd Earl of Oxford, Wimpole Hall, Cambridgeshire, 20 August 1724*[1]

Charles Town Carolina

My Ld
Considering the Obligations I have to your Lordsp it was a great uneasiness to me to hear of your Lordsps displeasure, and even now am so unhappy not to know what your Ldship requires of me[.][2]

Not many months after my arrival here I wrote to Mr Morley requesting him to let me know what would be acceptable to your Ldship, and since that repeated it again. The real reason I did not write to your Ldship proceeded not from Neglect, but out of defferance to your Ldship's high station, thinking a Letter to Mr Morley (if he thought fit to communicate to your Lordship) would acquit me with more decentcy.[3]

I have sent to Dr Sherard a Collection of half this summers production of the ornamental part of which I have desired him to send for your Lordsps Garden. I have put up some plants in Tubs of Earth which I designe to ['to' *repeated*] send the first opertunity. What else will be acceptable I am ignorant of til' I have the honour of knowing your Lordships pleasure[.] It is impossible for me to send Botanical and other collections to every of my Subscribers, and to perform what I concieve I am principally sent here for to discribe the Natural productions of the Country[.] Not but I am obliged both in Duty and inclination to comply to ye best of my power with what ever commands your Lordship lays on me for which reason, and that I would be less omissive in giving general content[,] I design (if God permits) to continue here another year at my own expence[.]

I am
Yr Lordships most Humble and Dutyfull Servt
M. Catesby

1 BL, Add MS 70374, fol. 48, 1 leaf (23 × 18.5 cm), folded; written on side 1. Watermark type E (fig. A6). Although the letter is undated, its date is given by Catesby in his next letter to Harley (letter 28).

2 Edward Harley was one of Catesby's sponsors. Catesby's apologetic and deferential letter was presumably occasioned by a complaint Harley made to Sherard. Despite Catesby not receiving a reply to this (or, as he mentioned, either of his earlier two letters), he nevertheless sent a consignment of ornamental plants for Lord Harley's gardens at Wimpole (letter 28).

3 Mr Morley appears to have been Lord Harley's gardener.

26 *William Sherard, London, 30 October 1724 (i)*[1]

Charles Town Oct 30th 1724

Honrd Sr
My last was by Capt Martin who sailed from hence 20 Augt 1724 in the Blandford – Man of War with 4 Books of Dryed Plants, and a Gourd of Seed ['of Seed' *repeated*] all collected in the upper parts of the Country[.] These now sent are collected in the Settlements and are the productions of Augt, Sept, and October. And having before sent the Collections of those Months, I fear these will produce but few new kinds and if I tarry here another year unless I goe a great distance from the Settlements at least 300 Miles South I shall be able to collect very few new.[2]

Out of the last sent I reserved some which I now send so that those with the triplicates I presume may be spared, not that I know who they will be acceptable to except Mr Dale, for I have sent 2 Books to Sr Hans, so pleas to doe with them what you think fitt. Of the 5 specimens sent for seed I have sent 2 of them[,] another is not yet ripe and remaining 2 are I suspect gathered at too great a distance.

What seeds I now send are as follows[.] Two Gourds full in a Popler or Tulip Tree Box filled up with live Oke Acorns and the Cones of Cypress and a few hors Chestnuts ~~Seed~~[.][3] I have reserved as many more of the Cypress Cones to send with the next Cargo which will consist chiefly of Pine and Firr Cones and what Acorns I can possibly get which this year (and which often happens) are very scarce. I shall also send some Berries which are not yet ~~ripe~~ dry. The live Oke Acorns to my surprise sprout as they lye spread in my Chamber which makes me suspect their good success by the way[.] These are all I could procure but hope to get a few more to send with the next, as also if possible some or all the other kinds or at least a Specimen of them with their Cups as you require[.] I send the Black Walnuts in a seperate Box for tho' the[y] have lain spread in a dry Chamber a fortnight and are seeminly dry yet when put in a Box I find the[y] give which would endanger what ever were put to them so I send them seperate.[4]

I want to know whether any more Tubs of Plants will be acceptable and what are alive of those already sent that I may if required send others. I concieve it may not be amiss to wash of[f] the musilage [mucilage] from the Laurel and Umbrel[la] Seeds for the notion is here that they will not grow unless eat and voided by fowls[.]

I hope I may in no long time expect your answer to what I sent p[er] Capt M[artin] – 20 Augt last that I may have your Sentiments concerning my continuing here another year and especially what I wrote concerning the Mexican Expedition concerning which Dr Couper wrote to Dr Mead 2 months before.

My much absence from Charles Town prevents my acquaintance with Masters of Ships [els] is requisite which often puts me in some difficulty how to send by one who I can rely on that what I send may be put in a dry place, and they are many of them surly ffellows that they are not to be prevailed on.[5]

Last September towards the end of it hapned a severe ffrost[.] Its now the 26 of October and we have had but one small frost, which hapned 14 days past[.] Tho' the frost was hardly desernable yet it put a stop to the ripening some taller Rice[,] except one shower the weather has been has been for these 7 weeks perfectly serene and as hot as tis usually with us in May and so continues. The Leaves Trees seem not inclined to drop their leaves and yet the ffields (I mean the grass) looks every where Russet and winter like and in many places plants are blossoming which I hope will afford me a few more specimen[.]

Tho' those Trees which drop their leaves are not quite destitute of them til the middle of Nov: yet after the first floud which is usually in the beginning of Sep: the Earth turns russet and no more of it's verdure to be seen ti'l the spring[.]

I beg Sr you will pleas to tender my due respects to all my Friends and believe me

Sr
Yr Faithful Humble Servt
M. Catesby

To / The Honble Consul Sherard

1 RS, Sherard Letter Book, no. 179, 1 leaf, folded; written on side 1, address on side 2. Inscribed by Sherard, 'Answer'd Jan. 27. 1724/5' and in another hand, 'Oct. 1724'. Remains of wax seal lower edge.

2 Perhaps another reference to the long trip Catesby mentioned earlier (letters 15, 18 and 20).

3 'Popler or Tulip tree' refers to the tulip poplar or tulip tree, *Liriodendron tulipfera*, which Catesby illustrated at *NH*, I, 49 (RCIN 925880).

4 He is repeatedly concerned about the adequate preservation of his specimens.

5 Catesby describes the need to persuade ships' masters to take proper care of his cargoes, another practical aspect of the work involved in shipping them.

27 William Sherard, London, 30 October 1724 (ii)[1]

Charles Town October 30 – 1724

Sr

This is to acquaint you of a Box of Seed &c in the Alexander[,] Capt King Master

The Plants and other things Il'e send the first opertunity with Notice

Please Sr to let my Brother have the Indian Apron at the bottom of the Box except it will be acceptable to your Self[.][2]

Pray if it can be ~~conciel~~ concele your recieving any from Sr Hans for I can't possibly send his by this Ship[.]

I am Sr
Yr most Humble Servt
M Catesby

To / The Honble Consul Shepard/ at Mrs Wansels in / Barking Alley near / Tower Hill London

1 RS, Sherard Letter Book, no. 180, 1 leaf, folded; written on side 1, addressed on side 2, wax seal.

2 Catesby sent another 'Indian Apron made of the Bark of Wild Mulberry' to Sloane (letters 31 and 33); these articles of Native American clothing were among several pieces of ethnographia Catesby collected (letters 14 and 31; pp. 56 and 212).

28 Edward Harley, 2nd Earl of Oxford, 15 November 1724[1]

Charles Town Nov: 15 1724

Sr

On the 20th of August last I did my Self the honour to ['to' *repeated*] write to your Lordsp to know what would be acceptable &c but not having recieved any of your Lordships commands since I came here I venter to send what I gues will be most acceptable vizt: The Seed and Cones of Ornamental plants.

The reason I now presume to write to your Lordsp: is I think the direction will be a cause of a more certain reception, the retarding of which may be detrimental to what is sent, which is contained in a Box, sent by Capt Easton in the Neptune – in the Box is a Gourd filled with seeds[,] the Box being filled up with the larger Nuts, and Seed-vessels, as Black Walnuts, Hickory Nuts, Pine Cones, Cypress, &c[.][2]

I humbly beg your Lordsps: pardon for this trouble

I am Yr Lordsps: most Dutiful
Humble Servt
Mark Catesby

1 BL, Add MS 70374, fol. 49, 1 leaf, folded; written on side 1, side 2 blank.

2 Catesby's consignment consists principally of ornamental trees for the Wimpole estate.

29 *William Sherard, London, 24 November 1724*[1]

November 24th 1724

Sr
On board The Cape Coast Capt – Traviso[2] Master are 2 Boxes one of them with ~~Gourds of Seed~~ Dryed Plants[,] the other full of Black Walnuts. in a few days I shall send the rest[.]

I am Sr
Yr most Humble
Servt Mark Catesby

For / the Honble Consul Sherard / at Barking Alley near / Tower Hill, London

1 RS, Sherard Letter Book, no. 181, 1 leaf (19.2 × 15.1 cm), folded; written on side 1, address on side 2. Inscribed in another hand, 'Nov. 1724.', a patch where seal was removed. Watermark type D (fig. A5).

2 Catesby left a dash before 'Traviso' for the captain's first name. The letter appears to have been written in a hurry, perhaps to catch the ship before it sailed.

30 *William Sherard, London, 26 November 1724*[1]

November 26 – 1724

Honrd Sr
I sent you last month p[er] Capt King [*4 dashes*] Box of Seed with a Lr of advice. The 25 of Nov: after I sent p[er] Capt [*space*] in the Cape Coast a Box of dryed plants and a Box of Black Walnuts.[2] These now sent contain duplicates of what I sent by Capt King with some never before sent. I never endeavoured at any thing more than to send a good quantity of Acorns, and Pine Apples.[3] But the same cause that prevented last did this year. The first year I came there was plenty but ilness then prevented me. I could not so much as get a few of the different kinds of oak ['s' *erased*] acorns for specimens as you required, there being as great a dearth of them as of Pine cones occasioned (as it often happens perticularly last year) by a forward Spring and a very late and Severe Frost, that spoiled this Years Crop of Oranges and other things that were put out[.] The Pine Apples are of what is called Swamp Pine[,] the only kind that produced Cones this year. The Hiccory Nuts are gathered from two Trees[,] they being of the same kind[,] only differing in bigness. I shall be glad to know what are living of those Plants I have sent in Tubs That I may make room for others by not sending the same again. As Shrubs and Trees are generally of more value than hearby [hereby] Plants, it will I concieve be requisite to know which of those I sent are not raised from seed that I may send the Plants. Dogwood a fine plant I don't remember to have heard it has been raised, nor Sassafras which I have not been able to procure for the Birds are so gredy of the berries that they seldom permit them to ripen.[4]

One Dr Sinclair is come here with a patent as he says for propogating Cuchinele[,] Nutmegs[,] Cloves[,] Pepper[,] Rhubarb[,] Opium[,] with inumerable other Drugs and Spices[.][5] Tis certain he has encouragement from some as Ld Iley, and as he says Mr Walpole and other great men[.] You will gues at the Man by the undertaking, yet as to Cuchinele he must know somwhat concerning it having been at Mexico and at places where it is produced[.] How such an Emperick and so ignorant a person can impose on such Men is unaccountable to me.[6]

Our Governor has leave to goe home but I believe he will not til the Spring; He urges me to goe with him in order to [*verb missing – perhaps* 'settle'] that affair I have twice wrote to you concerning, which I

impatiently expect an answer of, which shall determine me in whatever you shall pleas to advise.[7] In my last Sr I desired you would give me what account you could of making Opium, of Rhubarb, Scammony, Coloquintida[,] worm seed or any thing you [*word erased – perhaps beginning of* 'esteem'] think this Clymate proper for.

I am Sr your faithful
Humble Servt
M Catesby

To / The Honble Consul Sherard

1 RS, Sherard Letter Book, no. 182, 1 leaf, folded; written on sides 1 and 2, addressed on side 4. Annotated by Sherard, 'Rd March 12. 1724/5'.

2 Catesby left a series of four long dashes for the ship's name, and a space for the captain's name.

3 He is referring to pine cones rather than pineapples.

4 Catesby is understandably interested to know which of the seeds and living plants that he has sent have been raised successfully.

5 The list of potentially profitable drugs and spices includes cochineal, a scale insect, *Dactylopius coccus*, used to make the dye known as carmine. Catesby describes collecting cochineal, possibly to make the pigment himself (see Chapter 4 and fig. 131).

6 The references are to Lord Islay (see letter 7), and Sir Robert Walpole (1676–1745), 1st Earl of Orford, whose seat was Houghton Hall in Norfolk. Catesby is scathing of the idea that 'such great men' might be taken in by 'one Dr Sinclair', whose knowledge of local plants he clearly does not rate highly.

7 A reference to the proposed Mexico expedition with Dr Cooper which evidently had Francis Nicholson's encouragement.

31 Hans Sloane, London, 27 November 1724[1]

Charles Town Nov: - 27 - 1724

Honourable Sr
I hope ere' this You have recieved from the Blandford Man of War (who sailed from hence in August last) a Box of Plants and other things with a Lr of Advise.

I now send p[er] Capt Easton in ye Neptune a Box of Dryed Plants with an Indian Apron made of the Bark of Wild Mulberry[,] this kind of Cloath with a kind of Basket they make with Split cane is[2] the only Mecanick Arts worth Notice.

These Basket[s] with a kind of Tobacco pipe they make with marble Ile send the first opertunity.[3]

The Plants now sent were the productions of the last half Summer in the Settlements, having before sent You collections of the same Months I fear these will afford but few that are New to You.[4]

I am Sr
Yr most Dutyfull Humble
Servt
M Catesby

Moho tree
Corritoo – instead of Soap
Coffee
Cocoa – tree.
Nut – tree.
Calabass – five or six sorts.
Lime – tree.
Gun stock tree
Black – bark
Balsom. Mountain & Sea-side.
Barberrys.
Dibble wood.
Thorn – black & white
Guava – a Bastard Guava – a berry.
Mammée)
Pond) Apple
Custard)
Prickle)
Sower – sop.
Jack in a box.
Anchovy – a black never to be got out.
Choaky pear.
Snake – wood.
Plum – tree.
Bough – berrys.
Crab wood.
Indian Coney wood.
Soldier wood.
Tumerick [? *lower edge of sheet with word torn*] green & yellow.
All-Spice: black & red
Winter's Bark
Mastic: yellow & black
Timber:)
Broad-wood) sweetwood
Barbadocs)

Braziletto a red dye
good for ye french disease
Sappadilla
Service – berry) both dyes – ye
Forrest wood) tanners use ye bark

Monserrat.

Elder
Black nut, a rank poison.
Fiddle wood – black & red.
Hasle. tree.
Mammée Support.
Alligator pear.

Guana – wood.
Narrow leav'd, or black sweet wood.

Yellow Saunders. Ye Saw-dust will blister.

Knotted Knave.
Dog-wood. – skin of ye root poisons fish
Lignum Vitae.
Red-wood.
Mutton & porridge. – Leaves pouder'd
 good in ye flux

Indian Notter.

Locust. Bark good for ye flux.
Burr – wood. Small & great.
Gum-Elemi.
Trumpet – tree.
Box wood. small & great.
Mountain Cabbage.
Cassia.

Lignum Lignorum.
Rose wood, or Candle wood.
Pudding – Wood.
Chink – wood.
Garlick – wood.
Kite – wood.
Turpentine
Fish-root – tree – ye bark powder'd
 will both purge and vomit

Sugar Apple.
Mountain cherry – fruit
 good for ye flux
Yellow prickle wood &
 white.
Fig trees. Small & great.
Spanish Oak.
Birch wood.
Bird lime tree.

Pidgeon wood. black &
 white.
Bitter wood. ye very smoke
 will bitter ye meat.

Loblolly – black & white.
Silk cotton tree.
Bark log trees.
Mun-jack – white & red.
Coco-nut tree.
Palmeto royal. long & round
 leav'd.
Five finger.
Cock – wood.
Glass – berry.
Physick nut.
Chuckle Stone – tree.
Bay tree.
Sea side grape.
Chiego grape.
Tamarind.
Man-grove.

To / The Honble Sr Hans Sloan / At his house near
Soho / London

1 BL, Sloane MS 4047, fols 290–91, 1 leaf, folded; written on
side 1, list on sides 2 and 3, address on side 4, with postmark.

2 ['is' written over 'are'.]

3 Catesby sent another 'Indian Apron' to Sherard (letter 27).
What is likely to have been the same type of Native American
basket made of split cane and decorated with patterns coloured
with plant dyes was also given to Sloane by Francis Nicholson
(fig. 68).

4 The contents of this consignment appear mainly to be of
plants used as *materia medica*; there are also several useful for
their natural dyes. Among the medicinal plants are those used
as cures for 'french disease' (syphilis) and the 'flux' (dysentery),

a disease which commonly broke out on sea voyages. Also
included are powdered barks and roots used for bleeding and
vomiting, common treatments in eighteenth-century medicine
(for *materia medica* and Sloane's interests in medicinal plants, see
Chapter 1, pp. 15, 19; Chapter 5, p. 172).

32 *William Sherard, London, 27 November 1724*[1]

Charles Town Nov: 27th – 1724

Sr
This is to let you know of [a] Box of Seeds &c a Box
of Pine Apples & Hickory Nuts – on Board Capt
Easton – in the Neptune[.][2] I have likewise sent Ld
Oxford a Box of Seeds and Sr Hans Sloan one of
Dryed Plants[.] Also a Box of Seeds to Mr Walpole at
the Governors' request[.]

I am Sr
Yr most obedient Servt
M Catesby

I sent a fortnigh[t] since p[er] Capt Trevesey in the
Cape Coast two Boxes one of Dryed plants the
other of Black Walnuts – wth Lr of advise And by
Capt King in the Alexander[3]

To / The Honble Consul Sherard / in Barking Ally
near / Tower Hill / London

1 RS, Sherard Letter Book, no. 183, 1 leaf, folded; written on
side 1, address on side 2. Inscription in Sherard's hand, 'Answ[d]'
[*date torn off top of sheet*], and postmark.

2 Following the Earl of Oxford's complaint to Sherard
(letters 25 and 28), Catesby no doubt felt he should inform
Sherard of the consignment he had sent Lord Oxford. Colonel
Nicholson was presumably trying to curry favour with Robert
Walpole.

3 The ship's name 'Alexander' was written in later.

33 *Hans Sloane, London, 5 January 1725*[1]

Carolina Jan 5th 1724/5

Honble Sr

By Capt Martin in the Blandford Man of War who saild' from hence 20 August last I sent you a Box of dryed Plants. Nov: 27th p[er] Capt Easton in the Neptune I sent another Box with dryed Plants[,] an Indian Apron made of Bark &c with Letters of Advise.[2]

I am Sr preparing to goe to the Bahama Ilands to make a further progress in what I am about. This will add another year to my continuance in America. And tho' I doe not expect a continuance of my full subscriptions[,] yet I hope partly by your interest and continuance of your Favours, I may expect the greater part of it.[3]

This will Sr protract my proposed Mexico expedition, which I some time since wrote to you concerning, for your adv[i]se and approbation[.] I promise my self great variety of Shells and ['and' *repeated*] Animals not to be found here.[4]

Whatever commands Sr You'l pleas to Honour me with, please to direct to Carolina and I shall have them conveyed to me[.] Our Governor (from whome I have recieved all imaginable kindness[)] is returning home in about 6 weeks. I have now nothing more to add than that I am

Sr with the greatest respect
Your most faithful Humble Servt M Catesby

To / The Honble Sr Hans Sloan / Bart / London

1 BL, Sloane MS 4047, fols 307–8, 1 leaf, folded; written on side 1, sides 2 and 3 blank, address with remains of wax seal on side 4.

2 See letters 23 and 31.

3 There is no record of whether Sloane or any of Catesby's other sponsors financed this last part of his trip spent in the Bahama Islands.

4 Catesby collected a large number of shells and other 'marine productions' for Sloane during his stay in the Bahama Islands, as can be seen from Sloane's listing of them in his manuscript catalogues (see Chapter 6 and Appendix 1).

34 *William Sherard, London, 10 January 1725 (i)*[1]

Charles Town – Jan 10 1724/5

Sr

With some things sent my Unkle are the Sena Seed you desired with ~~one 3~~ 2 or 3 more which I have desired him to send you[.] Mr Collinson has likewise a Letter for you[.][2] I would have sent them together but they were put up at Different times[.]

I am going to the Bahama's but having wrote at large in the above sd [signed] Letter to which I refer you I conclude

Sr
Your most obedient Servt
M Catesby

I have sent Dr Mead a large Bottle of Snakes p[er] Capt Levingston. Sr Hans I have sent none to[;] I could not possibly procure for both[.]

I have wrote to Sr Hans to let him know of my going. I intreat you'l pleas when you see him to give it him[.][3]

To / The Hon:ble Consul Sherard at/ Mrs Wansels in Barking Alley / near Tower Hill / London

1 RS, Sherard Letter Book, no. 183a, 1 leaf, folded; written on side 1, addressed on side 4. Inscribed in Sherard's hand, 'Answ. 29. July 1725'.

2 It is clear from this comment that Catesby used both his uncle and Peter Collinson as separate conduits for botanical material and letters destined for Sherard.

3 Sloane and Mead were the two of Catesby's sponsors most interested in receiving collections of snakes. In his letter to Sloane of 10 May 1723 (letter 10), Catesby noted that he had identified twelve species of snakes; however, he was hampered in sending specimens by Sloane's slowness in answering his request for glass jars. Several jars of snakes are listed under 'Animals preserved in spirits' in the sale of Mead's collection following his death in 1755 (see Chapter 6, n. 141).

Carolina Jan 10 – 1724/5

Sr

I have recieved all your Letters perticularly the last I recieved was dated 15 October ~~172~~ last per Capt Maffant & came to hand 28 Nov:. I am concerned to hear on the arrival of Capt Maffant that he could give No Account of the arrival of Capt Martin in the Blandford Man of War who sailed from hence Augt. 20 And by whome I sent a Box with 4 Books of Plants and to Sr Hans, with a Tub of plants to Ld Oxford. October following I sent a Box of Seed by Capt King in the Alexander[.] November 24 per Capt Trevesey in the Cape-coast I sent 2 Boxes one with plants the other with Seed & Nuts. Nov 27: p[er] Capt Easton I sent two Boxes one with Seed in Gourd, the other with Pine Cones[,] Nuts, Acorns, &c., with a Box of Seed for Ld Oxford and another of plants to Sr Hans with Lrs of advise to all[.] In a parcel to my Unkle I have sent you all the Sena Seed I could procure and some Seed of a Wild Marjoram not before sent and of Rattle Snake Root all which I recieved from a remote part of the Country[.] The Rattle Snake Seed is I think what I have before sent. At my Unkles request for Mr Mortimer I have sent Ceder Berries, which the beginning of this month I by accident found on an old Tree, except which amongst many Thousands I could not see one that had any.[2] I have desired my Unkle to send you some if desired tho' I fear they will be too late to sow this spring.

I am Sr preparing for the Bahama Ilands which will add another year to my continuance in America[.] I doe not propose to my self a continuance of my full subscription[.] But I hope & Trust by a continuance of your interest & kindness that I may expect enough to defray my expences[.] Tho' I have such an inclination to prosicute what I am about, that were going to my disinterest I should with reluctancy be prevented[.] If I am favour'd with your further Commands, please to direct as formerly and I shall have them sent me.[3] The discontent of Mr Du-Bois and the trouble he gives my Friends in recieving his Subscription is such that I had rather be without it[;] I doubt not but I have suffered by his Complaints.[4]

The Mexico expedition seems protracted for some time[.] I hope in answer to mine of the 20 August I shall recieve your opinion concerning it[.] Our Governor from whome I recieve all imaginable kindness is returning here in about a Month or 6 Weeks.

I beg Sr you'l please to make my Humble Service acceptable to Mr Sherard[,] Dr Delineus, Mrs Wansel and believe me

Sr
Your faithful humble Servt
M Catesby

1 RS, Sherard Letter Book, no. 184, 1 leaf, folded; written on sides 1 and 2, accompanying list on separate leaf (35a).

2 This is a reference to Cromwell Mortimer (1693–1752), secretary to the Royal Society, with whom Nicholas Jekyll was friendly.

3 Catesby repeats the hope voiced in his letter to Sloane (letter 33) for support for his collecting in the Bahama Islands.

4 Catesby clearly found the lack of direct communication from Du Bois and his complaints sent via Sherard to be trying. Du Bois did, however, receive a large quantity of specimens from Catesby (see Appendix 1).

35a List on separate smaller sheet bound together with letter 35[1]

Gourd with the
Tally No 1

Contains
Olive leave Bay round black Berries
Cassena
Live Oke which are the small
Acorns

The large [st] Acorns are Chesnut Acorns
with a few others mixt

The rest are pignuts

The Gourd N.2 contains
Willow Oke
Dogwood Berries
Hickory Nuts
Pig Nuts

in the smallest Gourd
are a kind [of] Haw

The rest of the Box is filled with Turberoses [,] Hickory nuts, Pignuts and 2 or 3 sorts of Mixt Acorns

1 RS, Sherard Letter Book, bound with no. 184, 1 leaf; written on side 1, blank on side 2.

36 Elizabeth Jones, Hanover County, Virginia,
1 March 1730[1]

Hoxton 1st March 1729/30

Dear Niece

I had the pleasure of Yours of July last tho' not before 5 months after Packs arrival[.] I confess I have been shamefully dilatory but as Your Mother who I have served no better will forgive me I confide in You for the same favour[.] I am much obliged to Mr Jones for his kind intentions of sending me some things but you have omitted sending me an account of what kinds of ffruite will be acceptable which I expect ['from'? *word torn off*] the season, which is Autumn Next [.][2] in the mea[ntime – *torn off*] accept of my Nat History of Your Country w[hich – cut away] I shall continue to send as I publish them. I send those uncoloured for two reasons, one is [*last word of line cut; following line barely legible as paper worn through along the horizontal fold*] p[…] g […] which […] painted […] is hid,[3] but indeed the principal reason is I can at present but ill spare those painted[,] the demand for them being quicker than I can supply – this difficientsy shall be supplyed hereafter which I hope you will excuse now[.][4]

Cones, Acorns & Seeds of all kinds will be acceptable especially a large quantity of Popler and Cypress Seeds with some white Walnuts.

I am Dear Niece Mr Jones's
& Your Most Affectionate Humble
Servt
M Catesby

1 Library of Congress, Jones Family Papers, 1649–1896, MS 2810, fol. 401r, 1 leaf, folded; written on side 1.

2 Elizabeth and her uncle continue to exchange natural history specimens (see letter 3). The uncoloured copy of the *Natural History* he sends her has not been identified (Chapter 3, p. 79).

3 The first reason appears to relate to the etchings being clearer when not 'hid' by the colouring.

4 Catesby's comment is important for the information it provides about the labour-intensive process of hand-colouring the plates of his book (Chapter 3, pp. 80–90).

37 Elizabeth Jones, Hanover County, Virginia,
30 December 1731[1]

December 30 1731[2]

Dear Niece,
My Sister gives me the pleasure of informing me of your welfare and increase of Family, on which I heartily congratulate Mr. Jones and you, for I assure you no tidings can be more gratefull to me than that of your prosperity.[3]

I have sent you a continuation of my Nt. Hit. Vizt the second, third, and fourth parts of which are all I have yet published.[4] In the Proposals at the beginning of the first part you may see in what manner I publish them.[5]

I am,
Dear Niece,
Mr Jones' and your Most affectionate
Humble serv.t
M Catesby

I am much desirous of a ground squirrel if it lies in your way conveniently to send me one.[6]

To Mrs. Jones

1 Library of Congress, Jones Family Papers, 1649–1896, MS 2810, fol. 446 (whereabouts unknown: removed from file in 1980 and not replaced).

2 This missing letter is published in Jones, L. H., 1891, *Captain Roger Jones of London and Virginia*, New York, pp. 218–19.

3 It would appear that Catesby's sister Elizabeth had informed her brother of the birth of her grandson Catesby Jones, Elizabeth and Thomas Jones's third child (of ten children), born in Hanover County, 6 March 1730 (see fig. 43).

4 Catesby had sent his niece Part 1 of his book in March 1730 (see letter 36).

5 For his 'Proposals for Printing an Essay towards a Natural History', see Chapter 3.

6 Catesby seems not to have had the opportunity to paint the 'ground squirrel' (Eastern chipmunk, *Tamias striatus*) while he was in America. The illustration he later included in Part 9 of his book, published in 1739 (RCIN 926032, *NH*, II, 75), was based on studies of the animal in Hans Sloane's collection by Everard Kick and an unidentified seventeenth-century artist, suggesting that his niece did not manage to send him a specimen.

Sr

I am as I was always of opinion that the American Ceders as they are vulgarly called are not Specifically different. In Virginia & Carolina my transplanting many hundreds of them from the woods into gardens gave me an oppertunity of observing them critically, and I am satisfied that their Juniper or Cypress like leaves is caused meerly from the difference of soil & climate, and as Mr Collinson agrees with me, that the leaves of these trees grow more compact and like those of Cypress in New England & ye Northern parts, and more open and divided in Carolina & to the South, and no wonder if seeds brought from another world should produce even a greater variation since they differ so much not only on the same continent but in the same Field, and often on the same Tree is to be seen all the differencies (except that of colour) which hath been observed.[2] A large tree have seldom any or b[ut] very few Juniper leaves, and those only on the undermost branches but small trees of 4 or 6 feet high are often wholly cloathed with Juniper leaves, tho' most commonly the upper part of the tree with Cypress leaved [*sic*] which [*illegible word erased*] allways appear of a much darker green than those with Juniper leaves[,] appearing so as I conceive from a deception of the Opticks by the different structure of the leaves. These Trees in woods generally run up with small stems 30 feet high thinly set with branches of ~~Cyp~~ Juniper leaves up to the top or head of ye tree which is Cypress. Those Trees which grow in more open places and are frequently preserved for a shade for Cattle grow generally not so high but to a much larger size spreading much and tepering to the top piramidally & cloathed entirely with Cypress leaves except a few of the undermost branches which are Juniper. As to the extream parts of the Cypress sort having their twigs round & some 4 square is a variety to be found in most large trees. The White Ceder except in ye difference of the wood seem to differ nothing from the others nor could I when in Bermudas distinguish any material difference between the Ceders of that Island and those on the Continent except that their Leaves are generally thicker and more succulent. I find in some written observations I made when there that their stems grow to a greater heigh[t] without leaves, their heads not so spreading and being generally taller & handsomer trees than those on the Continent[,] all which difference ~~may~~ may proceed from a very different soil which is throughout the Island a white chalky Rock.[3] Another remark of them made was this, that this Island being placed [*illegible word erased*] as it were between the Torrid & Temperate Zone has not the scorching heats of the one nor the ridged cold ~~of the oth~~ of those Countries which are parellel to it in latitude and consequently productive of plants of both clymates many of which I observed here which before I never saw north of the Tropick particularly the Manghala & others, many of which altered so much from those I had lately seen in Jamaica & Hispaniola that it was some time before I could determine them to be the same kind.[4]

I infer from this that many plants of the same species growing ~~in~~ at great distances in different Climes & Soil ~~spurt~~ spourt into various little differencies tho' much too small to deem them a different kind: In this I am confirmed having often observed it in a great many plants in which I could find instancies. The dwarfe Oak tis' true produces acorns when not above 2 feet high therefore may well deceive the curious enquirer who may imigine them by the general course of Nature in other trees ~~to have at one certain size~~ to retain that usual height in ~~in~~ bearing acorns, but in reality it is only the extream poverty of the soil where these dwarfe trees grow that causes their humility for near them where the land is better are the same kind of Oaks of 20 feet in height[,] they grow only in wet places[,] some of the leaves not unlike Willow Oak but retain not alwaies the same form, often [spo]urting into forks & blunt angles shaped like my Water Oak T[upel]o which I beleive it to be[,] the hogs rejecting the Acorns of them and are gredy of all other kinds[.] Several of the Oaks of America retain so little of a certain form in their leaves which run into such various shapes that it is difficult ['difficult' *repeated*] to distinguish them, and I have frequently gathered 6 or 8 leaves from one tree which no one could imagine but to be produced from so many several Trees. The Prickly Pear of Virginia is an Opuntium on which feed a small kind of cutchenel[.][5] The Honey tree of Virginia is the small leaved Acacia with a large pod figured in the Gardeners Catalogue[,] I think ye last plate in [the] book.[6]

I fear Dr I have been too tedious and yet had I been less it might not so well have satisfied your inquisative demands[.] I have published a 7th. part of my Work which Ile' send by the first oppertunity[,]

you shall inform me of it[.] If in any thing I can be servitable here command

Dr Sr
Your most humble Servt
M Catesby

To / Dr Dillenius / in Hollywell / Oxford

1 OUH, Department of Plant Sciences, MS Sherard 202, fols 117–18, no date, but before 3 February 1736, leaf 1 (28.9 × 23.6 cm) written on side 1 (with section written at right angles); leaf 2 (16 × 20.5 cm) written on sides 1 and 2; address on leaf 1, side 2, with remains of wax seal and postmarked 3 February. Annotated in Dillenius's hand, 'Answ. 11 Febr. 1736', 'Mr. Catesby, Cedars & Okes'.

2 Catesby's detailed observations about the way the same species of cedar tree, *Juniperus* sp., showed variations according to its habitat are in response to 'inquisitive demands' by Dillenius. The comments are evidence of Catesby's keen observational practices as a naturalist (see Chapter 6, pp. 187–96).

3 It is clear that Catesby was describing features of the trees he had recorded in his 'written observations' when he visited Bermuda in 1714.

4 The comment indicates that Catesby visited Bermuda after his trip to the West Indies in 1714 (see Chapter 2, pp. 45–6; fig. 57).

5 The cochineal insect (see Chapter 4, p. 109).

6 Catesby refers to the Society of Gardeners' *Catalogus plantarum* (1730) where the last plate in the book (21) is *Gleditsia triacanthos*, described as 'Acacia Americana Abruae foliis triacanthos. Sive as axillas foliorum spina triplici donata. Three Thorn'd Acacia or Locust Tree'. The plant is mentioned also in Catesby's letter to Sherard, letter 19.

39 Johann Jakob Dillenius, Oxford, 10 December 1737[1]

Dec: 10 – 1737

Sr

I have the pleasure of yours of the 5th. Inst. & I think you may conclude that its' the Cassena which Muntingius describes, It agreing with that much more than with the Cassioberry bush, or any other plant I know, besides the vomiting quality: the Indians are so far from rejecting the first infusion that (as I have said) they make a strong decoction of it, drinking and disgorging it with ease, I mean that they repeat it often & it works them much without straining or un-

easiness, but on the contrary, they say it is with pleasure, tho' it is not their constant drink.[2] The English inhabitants of the sea-coasts by living amongst the Indians, learn'd it of them, but they drink it by way of refreshment &c. & not as a vomit except when their Stomacks are foul, or they are otherwise out of order. The leaves which are never used without being parched are also drunk in the manner of Tea by some people amongst whome I have an hundred times made an agreable breakfast of it but with milk and sugar; so used it is very pleasant & never provokes to vomit, whether it was from the opinion of was possessed of, of its' virtues, but I thought while I drank it I had more spirits & was better in health than ordinary. I brought a large quantity of it over prepared, & I remember to have produced some of it at the Consul's. I cannot recollect whether I sent specimens of the Cassena, but I remember plenty of a kind of Alaternus, with a broader & thinner leaf than the Cassena[,] the stalks smaller & more pliant, of a brown or greenish brown colour; the stalks of the Cassena are remarkably light coloured[,] their leaves stiff as those of Holly, the Cassena is not near so bitter as the Cassioberrybush. Fairchild had a small plant of it[.] But I don't know that it is anywhere now in England – I will endeavour to get over some seeds and plants of it. I have recieved your parcel of Mr Nourse & will send it to Dr Gronovius in a few days, in a box with other things in a Box[.] I shall the first oppertunity send you 20 kinds of seeds, a part of the whole number I lately recieved from Mr Clayton & named by him.[3] I shall also trouble you with halfe a dozen of my plates coloured, to deposit as you think fit, as you were so kind to give me leave.

I wish you would let me know which are the plates of the last part, which I damaged in bringing to you, for I cannot be easy without changing them, knowing they cannot be bound without a blemish[.][4]

Please my Humble Service to Dr. Shaw & Dr. – Librarian & believe me

Dr Sr
Yr obliged Humble
Servt M Catesby

1 OUH, Department of Plant Sciences, MS Sherard 202, fol. 116, 1 leaf (20.5 × 16 cm); written on sides 1 and 2.

2 Catesby's authority is the Dutch botanist Abraham Munting (1626–1683), who published his *Naauwkeurige*

beschryving der aardgewassen (curious description of plants) in Leiden in 1696. Dillenius had asked Catesby for information about the plant used by Native Americans as a diet-drink, or vomit. Catesby identifies it as the 'Cassena' or yaupon, *Ilex vomitoria*, which he drank as tea while in America (he had sent an account of it in his letter to Sherard, 4 January 1723, letter 6).

3 Catesby was a friend of the Dutch naturalist Johan Fredrich Gronovius (1686–1762), professor of botany at Leiden (see pp. 62 and 183), with whom he exchanged books and specimens. John Clayton (1694/5–1773), a Virginian plant collector and naturalist, was another friend with whom he shared specimens and manuscripts.

4 Dillenius was one of a number of friends to whom Catesby gave plates or parts of his *Natural History*.

40 *John Bartram, Philadelphia, 20 May 1740*[1]

London, May 20, 1740

Mr Bartram:
Your kind remembrance of me, in the three plants you sent me with those of Mr. Collinson, encourages me to give you further trouble, though not without an intention of retaliation.[2]

As I have the pleasure of reading your letters, I see your time is well employed; therefore, in what I propose, I shall be cautious of desiring anything that may much obstruct your other affairs. But as you send yearly to our good friend Mr. P. Collinson, the same conveyance may supply me; which I shall confine to as narrow a compass as may be, for I find my taste is agreeable with yours, which is, that I regard most, those plants that are specious in their appearance, or use in physic, or otherwise. The return that I propose to make you, is my book; but it will be first necessary to give you some account of it. The whole book, when finished, will be in two folio volumes, each volume consisting of an hundred plates of Animals and Vegetables.[3]

This laborious work has been some years in agitation; and as the whole, when finished, amounts to twenty guineas, a sum too great, probably, to dispose of many, I chose to publish it in parts: viz., twenty plates with their descriptions, at a time, at two guineas. By this easy method, I disposed of many more than I otherwise should. Though I shall set a due value on your labours, the whole book would be too considerable to send you at once; therefore I propose to send you, annually, a Part for what you send me.

I having already told you what plants I most affect, shall, in the general leave it to you what plants to send me, though the specimens you send Mr. Collinson will somewhat direct me.

My method has been to set down a greater number of things than I could expect to be complied with, to be sent at one time; because, as all things are not at all times to be had, others may offer. Thus far, is a duplicate of my first letter to you.

1 Historical Society of Pennsylvania, Philadelphia, Bartram Family Papers; the original not located in 2014; Darlington, W., 1967, *Memorials of John Bartram and Humphrey Marshall*, New York & London, pp. 319–20 (the ending of Catesby's letter is not transcribed by Darlington).

2 Catesby was introduced to John Bartram (1699–1777), Quaker farmer in Philadelphia and self-taught naturalist, by Peter Collinson in the late 1730s. Catesby never met Bartram, but they became friends and corresponded and exchanged botanical and other material until the end of Catesby's life. This is one of six surviving letters from Catesby to Bartram (see also letters 41–3 and 45–6); one letter from Bartram to Catesby, undated but acknowledging Catesby's to him of 29 November (no year given but possibly 1741?), regrets that they had not known each other ten years earlier (letter 49).

3 Catesby proposed an arrangement with Bartram whereby he sent Bartram a part of his *Natural History* annually in return for plants from Philadelphia. For Bartram's copy of Catesby's book, see Chapter 3, pp. 79, 81; fig. 97.

41 *John Bartram, Philadelphia, 25 February 1741*[1]

25 February 1741

Mr. Bartram:
I have received from you a box of plants, containing a tree of the Sugar Birch, with others I could not tell, because I have no letter, or account of them. I conclude you had not received my letter, at your sending away the box of plants, otherwise I might have expected the favour of an answer.

The plants seem to be in good condition, and I heartily thank you for them; and in return, desire you'll accept the first part of my book; and for fear of Spanish depredations, I send, as above, a duplicate of my first letter.[2]

[*omissions by Darlington of parts of Catesby's original letter*]

In the box you sent, I find there are two plants of Chamaerhododendron, which seem not to agree with our climate; therefore, please to send no more, till better encouragement.

Your beautiful Rock Cistus, which for many year I have received from Carolina, but could never make it blossom, last July we were favoured with a sight of its elegant flowers; the first, I dare say, that ever flowered in Europe. It was from a plant you sent Mr. Collinson; the climate from which it came being nearer ours, than from whence those came that I was unsuccessful in. This plant is set again to blossom, though it increases not at all.[3]

Wishing you all happiness, I conclude, Sir,

Your obliged friend and servant,
M. Catesby

P.S. I must inform you that part of my book I send you is in a more contracted manner, and smaller paper, than that you have seen of Mr. Penn's, but in other respects the same.[4]

1 Historical Society of Pennsylvania, Philadelphia, Bartram Family Papers; the original not located in 2014; letter published in Darlington, W., 1967, p. 320.

2 Catesby's precaution of sending a copy of his earlier letter underlines the ongoing threat of Spanish attacks on British ships, amongst the other uncertainties of sea voyages.

3 Possibly a species of *Hudsonia* (Cistaceae).

4 For this smaller format copy of the *NH*, see Chapter 3, p. 79.

42 John Bartram, Philadelphia, undated (probably 1742)[1]

Dear Friend,
I am much obliged to you for two kind Letters one of them in the 20 of July 1741, the other of the 15 October following[.] The first [? *word charred*] contained a very accurate account and dissection of the Chamae[rhododendron] which gives me so good an idea of it's form and colours that [are an] assistance of the specimens you sent, when occasion requires I'll be enabled to give a tolerable figure of it which will be so [much?] the more necessary as there being little probability of ever [finding – *charred edge*] it in Blossom here: Those plants you have already sent us plainly Shew the avertion they have to our Soyl & climate by their slow progress & stunted appearance.[2]

In answer to your conjecture of their growing here as well [as with? *charred*] you in the like moist land, I say that plants which in America grow in moist land, are generally killed when planted in such like [soil? *charred*] here. It is by experience found that a dry warm Soyl is most agreable to American plants even Aquaticks. This I concieve [is] not from our too great cold in Winter more than with yours but from a difficiency of heat in our Summers, wherefore [a?] situation by being warmer may compensate for that difference in heat in a wet Situation.[3] It can hardly be imagined [so?] in the agrement of American plants with our Climate. [To?] some growing here as well as if they were Native of England others will not with all the assistance of Art.

The R[hododendron? *rest of word charred*] is apparently a cousin German to the Chamerhod: and can no [more] than that be prevailed on to grow with us.[4] Yet after many years I have one plant that has produced some tufts of its beautiful [blossoms?] these two years past, and yet the plant diminishes [gradually *crossed out*] yearly.

I am now to make gratefull acknowledgments of [the] other Letter of October 1741 accompanying a Case of Plants [which?] seemed to be alive and in good order but those sent before [with?] Capt Dent as you foretold miscarryed[.] Yet I am nothing the less obliged to you. Such accidents must be expected. When I tell you they are plants of ornament I most desire, I must leave it to you what to send next tho' a few plants of Sassafras and Laurel will be acceptable[,] as coming from a Colder Country than Carolina I hope they will agree better with our Climate.[5]

Sassafras Plants taken out of the Woods are so bare of roots th[ey] seldom arrive alive in England, whereas if they are transplanted in a Garden and there remain a year their ffibers will increas and endure a voyage much better if [*gap in sentence*]. If the plants you send were somewhat larger it would be better and if it could be those with several stems arising from the root are better enabled to end[ure the] voyage.

[*top line of side 2 charred*] … her beauties with such reluctancy and difficulty we must treat her with that regard her Eminence seem to claims, and as she scorns to be familiar with as we must be content with

her niggardly florid favours. So that instead of many plants for increase we desire only one large bearing plant with all the mould about the roots which may attract annually some Devotees who can no other ways admire its beauties. This is also the Opinion of our Friend P: Collinson who desired me to mention it to you.

Mr Clayton mentions a plant in the remote parts of Virg: called Leather Wood. It is a Thymelaea or Spurge Laurel perhaps the same of your Leather Wood?[6]

Among the Shell Animals of New England one is called the Signoe. Its eyes are placed under a Covert of thick Shell but so ordered that the part above the Eyes is transparent that the creature can see its way, tho' otherwise it is blinded[.] These are somwhat like the Eyes of a Mole which are covered with a thin Skin, to fit it for Working underground.

In New England is also The Monkfish having a hood like a ffryers cowl. In Bakers Cave in New England are Scarlet Mussels yielding a juice of a purple colour that gives so deep a dye that no water can wash out. I am told of an animal in Pensilvanea called a Monax and by Some a Ground hog[.] It lives and burrows under ground, and Sleeps much[;] is about the Size of a Rabbit. I shall be glad of what you know concerning it. Have you observed any other of the Deer kind, besides the Moose, Elk, and Common Deer? Do you think that the black Fox, common in North America is a different Species, or only varying in Colour from the common gray Fox? There is a Bird in Virginia and Carolina and I suppose in Pensilvania that at night calls Whipper Will & sometimes Whipwill's widow by which names they are called (as the Bird clinketh, the fool thinketh). I have omitted to describe it & therefore should be glad of it[;] I believe it is a kind of Cuckow[.][7] Your House Swallow is different from ours & singular in it's tail & nest which is artfully made with Small Sticks and cemented together with a kind of glue[.] The Bird with the nest would be acceptable[.]

With what I now send of my Book you have all the American Small Birds that I have figured except 7 or 8[,] by which you may gues what other Birds your Country affords. But such observations may be too troublesome without a strong inclination. New Animals of any Kind are always acceptable. Birds are best preserved (if not too large) by drying them gradually in an Oven and when sent[,] cover them with Tobacco dust. There is no other way in preserving Fish and Reptiles than in Spirits or Rum which method will also do for Birds.[8]

I present you Now the Second and third Parts of [my Book: *words missing where leaf was repaired*][9] in retaliation for your Kindness.[10] Think not my good ffriend that I expect your compliance [with?] all I mention, or any thing more than what sutes with your convenience, for tho' my method is to make a memorand of what will be acceptable, it is with no other intent than some things may offer or com in your way when others may [not].[11]

I am Mr Bertram
with all sincerity
Your obliged Friend
and Servt
M. Catesby

 (A large plant of Roe[dodendron?]
 (Sassafrass
Plants (Laurel
 (Wood Hony suckes white [and red?]
Different kinds of Tur[tles?]
Fish &c.

'To/ Mr John Bertram/in Philadelphia'[12]

1 Historical Society of Pennsylvania, Bartram Family Papers, Coll. 36, Box 1, no. 96, 1 leaf, folded; written on sides 1, 2 and 3, address on side 4, with calligraphy trial probably by William Bartram; edges of letter charred from a fire in the Bartram home and some words obliterated or difficult to read. Darlington noted 'London [year obliterated]' although no sign of the word 'London' remains along the partially destroyed upper edge of sheet (letter published in part in Darlington, W., 1967, pp. 321–3). The date is calculated from the fact that this is Catesby's reply to John Bartram's letters of 20 July and 15 October 1741.

2 The plant was the great laurel, *Rhododendron maximum*, from which Ehret produced a watercolour from a dried specimen and a description of its colours sent by Bartram (see fig. 173).

3 Darlington omits the next part of the letter up to the paragraph beginning 'Mr Clayton'.

4 This was probably the sheep laurel, *Kalmia angustifolia*.

5 Catesby is specific about his desire for ornamental rather than medicinal plants or those useful for agriculture, etc.

6 There are further mentions of Catesby's exchanges with the Virginia botanist John Clayton in letters 39 and 43.

The 'Leather Wood' is probably *Cyrilla racemiflora*, of which a specimen is in Du Bois's herbarium (no. 00095682U). I thank Stephen Harris for this identification.

7 Catesby asks Bartram about a number of animals here, not all of which of which he describes in the *NH*. The identification of the 'signoe' is uncertain but it may be a reference to the Atlantic blue crab, *Callinectes sapidus*; the ground hog is the woodchuck, *Marmota monax*; the moose, *Alces alces*; the elk, *Cervus canadensis*; and the common deer, the white-tailed deer, *Odocoileus virginianus* (I thank Aaron Bauer for these identifications). Catesby had sent a skin of the 'black fox' (melanistic fox, *Vulpes Vulpes*) from South Carolina to Hans Sloane (letter 23). He illustrated the 'Whip-poor-Will' (common nighthawk, *Chordeiles minor*) from two specimens sent by John Clayton (RCIN 926085, *NH*, Appendix, 16).

8 For the techniques Catesby used to preserve animals, see Chapter 2, p. 46; Chapter 6, p. 193.

9 This top line is only partially visible in the letter as it exists today; it seems more existed when Darlington transcribed it.

10 Parts 2 and 3 of the *NH* included pages/plates 21–60.

11 This sentence, and the list of plants at end of letter are omitted by Darlington.

12 Catesby's flourished 'To' has been copied awkwardly on the left of the sheet; very similar pen exercises, including a flourished 'To' and 'John' and 'JB' (fol. 57) and 'Periclym' and 'Bartram' (fol. 65), are found in the SIL Bartram copy of *NH*.

43 *John Bartram, Philadelphia, undated (April 1744)*[1]

Dear Friend,

I heartily thank you for yours of the 1st of December 1743 with the contents[.] Of what your letter mentions which seem to be alive, the most acceptable of them are the Laurel, Sassafras and Tupelo, the other three we had before particularly the Viburnum or Sheep turds or black Haw, as they are called in Virginia[.] The Witch Hasel I received from Mr Clayton one Christmas day full in blossom.

As ornamental plants are most my tast I cannot but observe to you how difficient your part of America is in Specious plants to what places in the same latitude are in the Old World; the like disparity is in beneficial production as oranges, Limons, Wine, Oyl, figs &c. which abound on this Side of the Atlantic in the same latitude you live in.

I have always observed animals as well as vegitables to increase gradually in number of species and beauty in approaching to the South, so Caro-lina tho' but five degrees or about 300 miles from Pensilvania yet is imbellished with [*long dash*] a far greater number of Excelling plants. Such influence has the sun at so small a distance yet so prevalent is novelty that the diminutive plants of Nova Zemble if there be any at all would be acceptable tho' as miserable in appearance as the Country in which they grow.[2]

At my going to Carolina I procured from Smyrna a Turkish Town in Asia, some seeds of Jesamum[,] a plant much esteem'd in the Eastern parts of the World for its medicinal and culinary uses. It is I suppose not unknown to your Pensilvanian Negroes as well as to those of most of our plantations who have long introduced it from Africa tho' I think they make no other use of it than to enrich and fatten their broth with by casting a handful of the seed into it[,] it yielding much Oyl[,] tho' the African sort is much inferior sort being a smaller grain [than] that from Smyrna.

I distributed this seed to many not doubting but my intention of introducing so usefull and beneficial a thing wold succeed. But so little inclination have they to any thing out of the common rode that except my friend Mr Skene none of them I gave it to gave themselves any trouble about it. Yet some of these very negligent persons with all others that eat of Mr Skene[']s Oyl commended it and desired to know where to buy some of the same. It is an annual; our summers want heat enough to ripen the seed. See more of this plant Hist. Jam. Vol. I, p. 161[.][3] [Y]our new discovered Magnolia is a noble tree indeed![4] The hopes of getting some good seeds of it delights me more than the possession of the last Cargo you were so kind to send me. Mr Clayton six years past sent me ample specimens of this same tree by the name of Magnolia maxima precox, and this year Dr Mitchel did the same to Mr Collinson and added some of its cones, tho' the seeds were not good and withal sent this Account of it[:]

> The Magnolia maxima precox grows only on the plantation of Nicholas Smith in Essex County on the head of Piscatoway – Rappahannock river in his pasture where it is well known to him & to all his neighbours[.] There is but one tree and a fine one it is left there by the Slaves in clearing the Woods for it's singularity & beauty, visited by all Travellers[.] There is never another such tree known, in Virginia nay in the World I believe[.] It as 25 miles from me.

Thus far Dr Mitchel. In another Letter he assumes to himself the honour of the first discovery of it. Yet as you have it more in your power I hope you will not fail to Eclips his vain pretences by a Superior honour of this August tree a Denison of Britain.[5]

Tho' as I have before observed Nature has in general adorned the more southern latitudes with her greatest beauties yet the plants of more Northern Countries as being more adapted to our climate will by reasonable conjecture do better with us and with these pleasing thoughts I flatter myself with the hopes of possessing it with a probability of its prospering here better than the rest of that Eligant Tribe.

In the next Cargo you send 20 or 30 seeds for me will be acceptable because our good ffriend Mr Collinson is somewhat tenacious of his, he having Customers enough besides, any will to [blank] that sutes most your convenience to get but the more Specimens the better. These are to oblige some forein Friends who set a value on all American productions.

As the last part of my Work concludes the whole it has been more than ordinary laborious and has taken up more time than any of the preceeding parts which has made it impossible to send you now a part but you may depend on my supplying this difficiency the first opportunity.[6]

If not so remote but that a Guinea or two would defray the expences of procuring a quantity of ripe seeds of the new Magnolia I would willingly be at that charge.

I am my dear Mr Bartram/ most unfainedly yours/M. Catesby

The things first set down are most desired as opportunity offers
Seeds of the new Magnolia with other seeds
A whipper Will
A cock humming bird
A Marsh Hen
Cypress and Popler seed a quantity
The different kinds of Turtle or
any kind of Fish in Spirits

	(Candleberry
	(Tupelo
Plants of	(Sassafras
	(Chinkapin
	(Leather Wood
	(Hony Suckle red & white

If your plants were sent somewhat bigger they would do better

'To/ Mr John Bartram'

1 Historical Society of Pennsylvania, Philadelphia, Gratz MSS, Case 12, Box 6, 1 leaf, folded; written on sides 1 and 2, side 3 pen trials, side 4 address. Undated but sent April 1744 (as mentioned in letter 45). Not published in Darlington, W., 1967.

2 Catesby refers to Nova Zembla Island in northern Canada.

3 Alexander Skene's experiments in extracting oil from the flowers of *Jasminum officinale* are described in letter 6. Catesby's reference to the plant in 'Hist. Jam.' is to Hans Sloane's *A Voyage to the Islands Madera, Barbados, Nieves, S. Christophers and Jamaica*, 1707–25, 2 vols, London.

4 This is 'The Magnolia of Pennsylvania', cucumber tree, *Magnolia acuminata*, which Catesby published in the appendix to his book (*NH*, Appendix, 15) (see also letter 22).

5 John Mitchell (1711–1768), a Virginian physician and botanist with whom Catesby had contact at the end of his life after Mitchell moved to London in 1746. Mitchell provided Catesby with accounts of North American species, some of which Catesby included in the *NH* (see also letter 44).

6 This is Part 5 of Volume I of the *NH*, consisting of plates 80–100, which he was to send on 15 April 1746 (see letter 45).

44 *Carl Linnaeus, Uppsala, 26 March 1745*[1]

London 26 March 1745

Sir

On board the Assurance, Capt Fisher[,] is a Case of American Plants in Earth, They are a present to you from my good ffriend Dr Lawson.[2]

I knowing this his intention, by his consulting me to know what plants I thought would be acceptable, I selected these as being hardy and naturallised to our Climate & consequently somwhat better adapted to endure your colder Air, yet I wish they do not require as much protection from the severity of your Winters, as plants from between the Tropicks do with us – possibly you have already some of them, yet if but a few of them be acceptable, I shall be much pleased. And whatever other American Plants in this inclosed Catalogue will be acceptable, you may freely command any that I am possessed of.[3]

In regard of that Esteem your merit claims

I am Sr
Your most Obedient
Humble Servant
M Catesby

PS This case of plants were intended to be sent last May and they were sent to the ship with the consent of the Skipper yet they were refused to be taken on board.

Cypressus Americana	Lychnidea flore purpurea
Arbor Tulipifera	Stirax Aceris folio
Cornus Americ:	Bignonia – Catalpa
Populus Nigra Carol:	Angelica Spinosa
Periclymenum	Pseudo Acacia
Barba jovis Arborescens	Anopodophÿllon Canadense
Phaseoloides	Phaseoloides frutescens
Arbor Virg: Citriæ folio	Rubus Americanus
Eunonimus Americ:	
Aster Americ: frutescens	

1 Linnean Society, 1 leaf (19.5 × 31 cm), folded; written on side 1 (see fig. 250). Watermark type J (fig. A11).

2 It seems that Catesby did not receive acknowledgement of this consignment from Linnaeus; John Mitchell wrote to Linnaeus on 20 September 1748, 'Mr Catesby desires his compliments, and wishes to know whether the plants he sent you by our friend Lawson are alive and flourishing' (Smith, J. E., 1821, *A Selection of the Correspondence of Linnaeus and other Naturalists from the Original Manuscripts*, London, I, p. 447).

 Catesby evidently enclosed a copy of his broadside 'Catalogue of American Trees and Shrubs', published *c*.1742 (see Chapter 3, pp. 95–8).

45 *John Bartram, Philadelphia,. 15 April 1746*[1]

April 15th, 1746

Dear Friend,

I own my self your Debtor, not from design or inclination, but I have really been discouraged by my ill fortune of loosing not only what I sent to America but also the two last years cargoes you intended me which loss the deprivation of time doubles[.][2] Yet nevertheless your kind intentions equally obliges

me as if attended with success, and requires a retaliation which I shall endeavour the first opportunity to acquit myself off[.] In the mean time accept of this Book of birds:[3]

As Mr Collison gives me the pleasure reading your entertaining Letters, I find you have sent me a plant of your Anona, some seed of your tall Magnolia, &c. for which I heartily thank you:

In a letter to you in Aprile 1744 I have mentioned in general what will be acceptable which I mention because I don't remember any of your succeding Letters take any notice of your receiving it. In it was an account of the [*deleted word*] jesamum etc.[4]

I am sincerely
Your obliged Friend and Servant
M. Catesby
Ap: 15: 1746

To Mr John Bartrum

1 Historical Society of Pennsylvania, Philadelphia, Bartram Family Papers, Coll 36, Box 1, no. 97, 1 leaf; written on side 1, addressed on side 2; published in Darlington, W., 1967, pp. 323–4.

2 It is not recorded what the accidents were that prevented the arrival of Catesby's consignment to Philadephia, or of two to him from Bartram.

3 This was Part 5 of his *NH* (see letter 43).

4 This was letter 43.

46 *John Bartram, Philadelphia, 17 November 1748*[1]

Dear Sir

The date of your very kind letter of May last upbraids me with neglect, tho' I assure you with no abatement of that esteem and affection I always bear you[.] I will not vindicate my silence but pray attribute it to the indolence of 60, and a diffidence of being superceeded by your numerous Friends.[2]

How much greater occurrencies must a few Villages afford among which you reside, than our grand Metropolis, which tho' the most opulent on the Globe is but a member of those mighty powers by which the late Catastrophe has been brought about, which I pray God may answer all good ends[.][3]

I wish Dr [Dear] Sir the gallantry of the good Company you keep don't stagger your philosophy for no doubt but they think it a much more Elegable work to collect gold by its parent light than in searching the dreary recesses of Pluto. But you who are born to enlighten those gloomy Regions may by sublimer motives think otherwise. However it may be[,] I wish you all imaginable success in your undertakings.[4]

Our Friend Dr Parsons & Mr Bell has had a kind of ren'counter but no Blood paper Wars (since the Cudgells have been laid aside with you) [*dash*] are pretty frequent here particularly amongst the Brethren of the Pill[5] whose profession is to mend and not maim.[6]

I am Dear
Most Sincerely yours
M Catesby
Nov: 17th – 1748

1 Historical Society of Pennsylvania, Philadelphia, Gratz MSS, Case 12, Box 6, 1 leaf; written on side 1. Inscribed by Bartram in top right-hand corner, 'I never answer'd it', and in another hand, 'Nov 19th 1749'. Not published in Darlington, W., 1967.

2 Catesby was in fact 65 at this date. The letter is untypical of him in its cares about the state of the world and lack of mention of the natural world.

3 He seems to have been referring to the end of the War of Austrian Succession, including its related military operations in North America (known as King George's War, 1744–8).

4 We do not know who the 'good Company' were of which Bartram had informed Catesby, but it would seem that Catesby was urging Bartram not to abandon his work as a plant collector ('in searching the dreary recesses of Pluto').

5 Catesby is clearly not impressed by whatever these disputes were amongst members of the medical profession 'whose profession is to mend and not maim'.

6 Just over a year after writing this letter Catesby died on 23 December 1749. Bartram seems to have annotated the letter 'I never answer'd it' after hearing of Catesby's death.

47 *William Sherard to Hans Sloane, London, 7 February, 1724*[1]

Feb. 7. 1723/4

Honered Sr.
By ye Bearer I send yr Box from Mr. Catesby, I hope 'tis in much better condition than ye last yo recd from him.[2] 'Twas opened by ye Customs house officers, but I beleive nothing taken out.

I have a large Gourd wth. seeds for Mr. Rand, wch please to give him notice of if you see him today, if not I'le write to him by penny post to morrow morning, having several forrain letters to dispatch to night by ye Holland post.[3] I am

Sr
Yr most humble servt.
W. Sherard

To Sr Hans Sloane/near/Bloomsbury Square

1 BL, Sloane MS 4047, fol. 126, 1 leaf; written on side 1, addressed on side 2.

2 Sherard refers to the consignment Catesby sent Sloane on 10 May 1723 on Captain Robinson's ship, the Dolphin, which was damaged by pirates (letters 10, 13, 14 and 15). The box from Catesby that Sherard informs Sloane he is delivering is that described in Catesby's letter to Sherard of 13 November 1723, 'With yours comes a Box with 2 Books of Plants for Sr Hans Sloan' (letter 14).

3 Catesby usually sent seeds to Isaac Rand for the Chelsea Physic Garden together with his consignments to Sherard; here Sherard asks Sloane to inform Rand of the arrival of a 'large Gourd wth. seeds'.

48 *George Rutherford to Elizabeth Jones, London, 27 June 1728*[1]

Dear Neice
Your Aunt is very much indisposed, & so I must give you an answer to your Lettr wch came to us on Munday last. And must tell you yt we are sorry to hear of your ill state of Health, but are glad yt you are arrived once more safe to yor Native Country. And we are very desirous to do wt we can, whereby you may perfect your Health, & shall be glad to see you att Bulmor, but we are not in a capacity to receive you att

present, for I have been a repairing my house, & so are all in dirt & confusion, but in a month's time we shall be capable to receive you for by yt time or beds will be put in order, & we hope yt you will bring yor little Boy, and neice Rachel with you.[2] As for your Uncle Mr Mark Catesby is now in London, but I cant tell you where he lodges.[3] Your Uncle John is in Scotland and not long since I heard by his Capt: yt is in a good state of Health.[4] Your Uncle Mr Jekyl together wth Mr Bruce, & your aunt are removed from Hedingham to his house at Lammarsh.[5] But we have had no acquaintance wth ym lately by reason of your Aunt[']s indisposition so I can give you no further acct of ym[.] I shld be glad if you or yor Uncle Mr Prat coud convey a Letter for me into Virginia to your Brothr Catesby & let me know when; for I woud give him some acct abt his Estate, & my advice in respect to it.[6] We all joyn in or Services to you & Neice Rachel, & a Letter will be acceptable to

Your affectionate friend
June 27 1728 Geo: Rutherford

For/Mrs Elizabeth Jones at Mr Randals in Man [*cut off*] Street in Chelsea, in Middlesex sign [sent?] by way of a London [*illeg.*]. 3. Brent. Geo Rutherforth.

1 Letter published in Jones, L. H., 1891, *Captain Roger Jones of London and Virginia*, Albany, NY, p. 217. The letter is from Catesby's brother-in-law, George Rutherford, husband of Catesby's younger sister Ann, to his niece Elizabeth (married to her second husband, Thomas Jones) (see fig. 43). Elizabeth with at least one of her children and her younger sister Rachel have come over from Virginia and are staying in London; she has written to her aunt and uncle (Ann and George Rutherford) hoping to be in contact with them as well as other members of the Catesby and Jekyll families.

2 This was probably Thomas, b. 1726, Elizabeth's first child with Thomas Jones. Elizabeth may have been pregnant with their second child, Dorothea, born in 1728.

3 Catesby was living at Hoxton at this date (see Chapter 2, p. 60) and working on Part 1 of the *NH*, the 'Proposals' for which were published that year (see Chapter 3).

4 Catesby's younger brother John, who was in the army (see Chapter 6, n. 156).

5 Elizabeth's 'Uncle Mr Jekyl[l]' would seem to be her uncle on her mother's side. Castle Hedingham had been the home of her mother's brother Nicholas Jekyll, who may have died by this time.

6 The reference may have been to Elizabeth's late husband William Pratt's uncle, or possibly father. Catesby Cocke was the oldest of Elizabeth's three younger brothers. George Rutherford was evidently advising family members with their affairs.

49 *John Bartram to Mark Catesby, London, undated but c.1741*[1]

Friend Mark Catesby,

I received thy kind letter of the 29th of November, but thee not having inserted when or where it was writ, I am at a loss to know where to direct my answer, otherwise than to thee, and to the care of our well-beloved and trusty friend, Peter Collinson, who merits the esteem and friendship of most of the curious. The reading of thy acceptable letter incited in me the different passions of joy, in receiving a letter of friendship and request from one so much esteemed, and sorrow in considering what time we have lost, when we might have obliged each other. It's a pity thee had not wrote to me ten years ago.[2] I should by this time have furnished thee with many different species of plants, and, perhaps some animals; but the time past can't be recalled, therefore, pray, write often to me, and inform me in every particular what thee wishes of me, and wherein I can oblige thee; for when I am travelling on the mountains, or in the valleys, the most desolate, craggy, dismal places I can find, where no mortal ever trod, I chiefly search out. Not that I naturally delight in such solitudes, but entirely to observe the wonderful productions in nature.[3]

Before Doctor Dillenius gave me a hint of it, I took no particular notice of Mosses, but looked upon them as a cow looks at a pair of new barn doors; yet now he is pleased to say, I have made a good progress in that branch of Botany, which really is a very curious part of vegetation.[4]

I am exceedingly pleased with thy proposals, and shall do what I can, conveniently, to comply with them.[5] I have a great value for thy books, and esteem them as an excellent performance, and an ornament for the finest library in the world.

1 Letter published in Darlington, W., 1967, p. 321, undated; whereabouts of original unknown.

2 Collinson was first introduced to John Bartram in the early 1730s. Catesby and Bartram were in correspondence from

*c.*1740. In this letter, which seems to have been a response to a missing letter from Catesby to Bartram of 29 November 1740, Bartram laments that Catesby and he had not known each other much earlier.

3 Darlington omits section of letter.

4 In his book on mosses, *Historia muscorum*, Oxford, 1741, Dillenius introduced a new classification of the lower plants.

5 In his letter of 20 May 1740 (letter 40) Catesby proposed that he exchanged the parts of his book for consignments of plants and animals from Bartram, an arrangement with which Bartram is 'exceedingly pleased'.

BL: British Library, London

BM: British Museum, London

BM (P&D): British Museum Prints and Drawings Department

Catalogue: Catalogue of Catesby's Drawings and Related Natural History Specimens (co-authored with Stephen Harris), forthcoming

CPG: Chelsea Physic Garden, London

CUL: University Library, Cambridge

ERO: Essex Record Office, Chelmsford

HBA: Mark Catesby, *Hortus Britanno-Americanus*, London, 1763 (for this and a second issue entitled *Hortus Europae-Americanus*, London, 1767, see Bibliography, p. 331)

KH (Knowsley Hall, collection of the Earl of Derby, Knowsley Hall, Merseyside): copy of the *NH* which Catesby gave to Peter Collinson, inscribed on the title page by Collinson, 'This edition of this Noble Work is very valuable as it was highly Finished by the ingenious Author who in gratitude made me this Present for the considerable sums of money I lent Him without Interest to enable him to publish it' (see fig. 39). The copy was purchased from Collinson's grandson in 1834 by the botanist and founding fellow of the Linnean Society Aylmer Bourke Lambert, and subsequently by Edward Stanley Smith, 13th Earl of Derby, in 1842. It remained part of the Earl of Derby's collections at Knowsley Hall until it was sold to a dealer in America in 2020 (as this book was in production). The copy is heavily annotated by Peter Collinson and extra-illustrated with drawings and prints by Catesby, Ehret, Edwards, William Bartram and others.

LS: Linnean Society, London

MLM (Morgan Library & Museum, New York): copy of the *NH* which Catesby's nephew Jekyll Catesby inherited from Mark and Elizabeth Catesby (see pp. 64–5) (MLM 45708–9). It was bought from Jekyll Catesby by the naturalist Thomas Pennant, from whom it passed to Pennant's son David in 1798. Later acquired by Henry S. Morgan, it was given by him to the Pierpont Morgan Library, New York, in 1954. The copy was extra-illustrated with 14 drawings and a print by Catesby, David Pennant and others. These additions, together with some of Catesby's manuscript 'fair' copies for text pages of the Appendix, have been removed from the volumes and are now housed and catalogued separately (1961.6:1–15; and MA 6038).

NA, Kew: National Archives, Kew

NH: Mark Catesby, *The Natural History of Carolina, Florida and the Bahama Islands*, London, 2 volumes, 1731–43 [1729–47]. The title pages of the two volumes are dated 1731 and 1743 respectively, although the book was published in 11 parts with 20 plates in each between 1729 and 1747 (see Bibliography, pp. 328–9). The abbreviated references to *NH* include 'p.' as a prefix to page numbers, with no prefix used to indicate plate numbers: for example, '*NH*, I, p. 43' (for page 43) and *NH*, I, 43 (for plate 43).

NHM: Natural History Museum, London

ODNB: *Oxford Dictionary of National Biography*, 2004–present, gen. ed. D. Cannadine; https://www.oxforddnb.com

OUH: Oxford University Herbaria

RCIN: Royal Collection computerized inventory number

RL: Royal Library, Windsor

RS: Royal Society of London

SIL: Smithsonian Institution and Archives, Washington, DC

SRO: Suffolk Record Office, Bury St Edmunds

WSRO: West Sussex Record Office, Chichester

INTRODUCTION

1　Attenborough, D., 2017, 'Fifteen of the Naturalist's Best Quotes in Celebration of his 91st Birthday', *Independent*, 8 May.

2　The dates on the title pages of the two volumes of Catesby's book differ from the actual publication dates (1729–47). See Chapter 3.

3　*NH*, Preface, p. i.

4　Frick, G. F., 1960, 'Mark Catesby: The Discovery of a Naturalist', *Papers of the Bibliographical Society of America*, 54, pp. 163–75. More recently it has been observed that 'there is remarkably little information about Mark Catesby as an individual, and no portrait of him is known' (Nelson, E. C. & Elliott, D. J., eds, *The Curious Mister Catesby: A 'Truly Ingenious' Naturalist Explores New Worlds*, Athens, GA, & London, p. xi).

5　See Appendix 3, Catesby's Letters.

6　An undated letter from John Bartram to Catesby is published in Darlington, W., with intro. by Ewan, J., 1967, *Memorials of John Bartram and Humphrey Marshall*, New York & London, p. 321. Letters from Catesby's correspondents reporting natural curiosities or archaeological finds were read by him to the Royal Society and published in its *Philosophical Transactions* (see Chapter 1, pp. 31–2, and Chapter 6, p. 216).

7　In the same vein, David Attenborough speaks of 'the double demands of aesthetic delight and scientific accuracy' involved in natural history illustration (Attenborough, D., 2007, *Amazing Rare Things: The Art of Natural History in the Age of Discovery*, London, p. 37).

For a discussion of Catesby's personality, see Chapter 2.

8　Inscription in Collinson's extra-illustrated copy of the *Natural History* at KH. For Elizabeth Catesby's will, see Chapter 2, pp. 64–5.

9　Edwards to his friend, the naturalist Thomas Pennant, 5 December 1761, MLM, Literary and Historical MSS, MA 1550. This letter is also quoted in Frick, G. F., 1960, pp. 173–4.

10　Collinson had noted shortly after Catesby's death that his widow 'has a few copies of this noble work undisposed of' (inscription in copy at KH). The booksellers Richard Manby and H. Shute Cox appear to have been acting for Mrs Catesby, as they were advertised as selling complete copies of the book in March 1750, three months after Catesby's death (Nelson, E. C., 2019, 'Royal Library's Copy of Mark Catesby's *The Natural History of Carolina, Florida and the Bahama Islands* containing Original Watercolours', *Huntia*, 17, no. 2, pp. 57–66 [p. 62]).

11　See note 46 for costs cited in this book. The sum of £400 realized in 1751 for the copper plates, stocks of letterpress and original drawings may be compared to the sum of £120 paid seventeen years later by George III for a bound three-volume copy of the book containing the original drawings (note 25).

12　An advertisement in the *Whitehall Evening Post* noted 'the Author's original Drawings, now in the Hands of the Proprietors' – i.e. the booksellers who in other advertisements are identified as Marsh, Wilcox and Stichall (Nelson, E. C., 2019, p. 63).

13　*London Daily Advertiser*, 22 October 1753 (ibid., p. 62).

14　For Catesby's and Edwards's friendship and working relationship, see Chapters 2, 3 and 4. For evidence of Edwards's familiarity with Catesby's drawings, see Wright, R., 2019, 'How Many Buntings? Revisiting the Relationship between Linnaeus and Catesby', Biodiversity Heritage Library, Blog Reel, 5 December 2019, https://blog.biodiversitylibrary.org/2019/12/how-many-buntings.html.

15　Both title pages of the second edition are dated 1754.

16　Robson, J., 1776, *Some Memoirs of Life and Works of George Edwards*, London, p. 25. Edwards's copy of the *Natural History* is in the Newberry Library, Chicago. See also Chapters 2, p. 67 and 3, p. 93.

17　The approximate dating of the compilation has been made from the dating of the letterpress pages, which are a mixture of first and second edition text sheets (Nelson, E. C., 2019).

18　Signs that the drawings had been mounted at least once before the final arrangement suggest that Catesby may have kept them mounted in his studio (McBurney, H., 1997, *Mark Catesby's Natural History of America*, exh. cat., London, pp. 31–2, n. 6).

19　The binding tools indicate that the binding was done before the volumes arrived in the Royal Library (ibid., p. 32, n. 16).

20　The number 'I' was added to both the English and French versions of the title.

21 See, for example, Sayer, R. & Bennett, J., 1775, *Enlarged Catalogue of New and Valuable Prints in Sets or Single …*, London, p. 110. McBurney, H., 1997, pp. 29–31, nn. 6 and 10. McBurney, H., 1995, 'Painted from Nature', *Country Life*, 14 December, pp. 44–6, fig. 2.

22 In some instances, where the drawings had been pasted close to the gutter of the book, or to the edges of the mount sheet, the borders partially obscured the drawings (McBurney, H., 1997, p. 31, n. 10).

23 While the possibility has been suggested that the application and painting of the borders might have been done by one of George III's daughters after the drawings had arrived in the Royal Collection, no similar work by them exists, and the unskilled quality of the work would suggest another hand (ibid., p. 32, n. 14).

24 Thomas Cadell (1742–1802) ran his business from 1767 to 1793 (obituary in *Gentlemen's Magazine*, LXXII, 1802, p. 1173); Nichols, J., 1812–16, *Literary Anecdotes of the Eighteenth Century*, London, VI, pp. 441–3; Plomer, H. R., 1932, *A Dictionary of the Printers and Booksellers who were at work in England, Scotland, and Ireland from 1726 to 1775*, Oxford, pp. 41–2; Dille, C., 2004, 'Cadell, Thomas, the Elder (1742–1802), Bookseller', *ODNB*, Oxford.

25 The inscription was added by John Glover, Royal Librarian (1837–60), probably during the late 1830s or 1840s. An attempt according to the Bank of England inflation calculator to convert the sum of £120 in 1768 to today's money (£19,894) does not convey the true value accorded to the set. The price may be better seen in relation to the cost in 1768 of *The Complete Dictionary of Arts and Sciences* (1766–8, 3 vols, folio), one of the most expensive new publications in London at 4 guineas a set bound (*Monthly Review*, XL, 1769, p. 1); I am grateful to Robert Harding for this information. See note 46 below.

26 Russell, F., 2004, *John, 3rd Earl of Bute: Patron and Collector*, London.

27 For George III's scientific library, see Goldfinch, J., 2013, 'Royal Libraries in the King's Library', in Doyle, K. & McKendrick, S., eds, *1000 Years of Royal Books and Manuscripts*, London, pp. 213–36.

28 Partly as a result of their being protected from exposure to light within the volumes, the drawings have retained their colours. Funds were donated by Mrs Hiroko Usami. Following conservation, two exhibitions containing a total of 112 drawings were shown in various locations in America and Japan and at the Queen's Gallery, London (McBurney, H., 1997, *Mark Catesby's Natural History of America*, exh. cat., London, and McBurney, H., 1998, *Mark Catesby's Natural History of America*, exh. cat. (Japan), Tokyo). The mounted drawings are now kept in solander boxes in the Print Room at Windsor. McBurney, H., 1995, pp. 44–6.

29 See Chapter 4 and forthcoming Catalogue.

30 Three other deposits of drawings by Catesby are contained in two extra-illustrated copies of the *Natural History*: KH and MLM (see p. 280), and in the group of 'duplicate' drawings that Catesby made for Hans Sloane (see Chapter 2, p. 52, Letter 23, p. 258, and forthcoming Catalogue).

31 The study was replaced by an online catalogue of Catesby's watercolours in the Royal Library, https://www.rct.uk/collection/search (search for Mark Catesby).

32 See Appendix 1, Note on Catesby's Plant and Animal Specimens.

33 Harris, S. A., 2015a, 'The Plant Collections of Mark Catesby in Oxford', in Nelson, E. C. & Elliott, D. J., eds, *The Curious Mister Catesby: A 'Truly Ingenious' Naturalist Explores New Worlds*, Athens, GA, & London, pp. 173–88, and the Sherard Herbarium, Oxford University website, https://herbaria.plants.ox.ac.uk/bol/catesby.

34 See forthcoming Catalogue.

35 See Appendix 1.

36 Meyers, A. R. W. & Pritchard, M. B., eds, 1998, *Empire's Nature: Mark Catesby's New World Vision*, Chapel Hill, NC, & London.

37 Ibid., p. 1.

38 Schiebinger, L. & Swan, C., eds, 2005, *Colonial Botany: Science, Commerce, and Politics in the Early Modern World*, Philadelphia, p. 3.

39 Ibid.; Edwards, E., 2006, 'Colonial Botany: Science, Commerce, and Politics in the Early Modern World', *Reviews in History*, 512, 1 April, https://reviews.history.ac.uk/review/512, accessed 20 September 2020.

40 Miller, D. P. & Reill, P. H., eds, 2010, *Visions of Empire: Voyages, Botany and Representations of Nature*, Cambridge, pp. 38–57, 109.

41 Batsaki, Y., Cahalan, S. B. and Tchikine, A., 2016, *The Botany of Empire in the Long Eighteenth Century*, Washington, DC, p. 4.

42 Ibid., pp. 235–53.

43 Bleichmar, D., 2012, *Visible Empire: Botanical Expeditions and Visual Culture in the Hispanic Enlightenment*, Chicago, p. 8.

44 Batsaki, Y., Cahalan, S. B. & Tchikine, A., 2016, p. 4.

45 Ibid., p. 9.

46 A study of the economics which necessarily forms part of this culture is beyond the scope of the present book. A fundamental problem is that measures vary greatly according to the perceived level of income of the average middle-class earner (one measurement, based on an estimated average wage of *c*.£12 p.a., is given in Floud, R., 2019, *An Economic History of the English Garden*, London). Further problems arise from the shifting value systems (aesthetic and practical) that existed in the hierarchical and status-ridden society of the first half of the eighteenth century. Rather than attempt to provide modern equivalents of the various contemporary costs quoted in the book, some comparative costs are given to help indicate relative values at the time.

47 Pulteney, R., 1790, *Historical and Biographical Sketches of the Progress of Botany in England from its Origin to the Introduction of the Linnaean System*, London, II, p. 226.

48 Egmond, F., 2017, *Eye for Detail: Images of Plants and Animals in Science, 1500–1630*, London, p. 12. Although Egmond speaks of the sixteenth century, the comment could equally be applied to the early eighteenth century.

49 Fox, C., 2010, *The Arts of Industry in the Age of Enlightenment*, New Haven & London, p. 5.

50 McClellan, J. E., 1985, *Science Reorganized: Scientific Societies in the Eighteenth Century*, New York. And see Chapter 6.

51 Rousseau, G. S. & Porter, R., 1980, *The Ferment of Knowledge: Studies in the Historiography of Eighteenth-Century Science*, Cambridge, p. 5.

52 Frick, G. P. & Stearns, R. P., 1961, *Mark Catesby: The Colonial Audubon*, Urbana, IL.

53 See forthcoming Catalogue.

CHAPTER 1 • CATESBY'S WORLD

1 Entry for Dr Richard Mead, *Biographica Britannia*, 1747–66, p. 3085.

2 Catesby's baptism entry (30 March 1682/3) in St Nicholas Church, Castle Hedingham; see fig. 46.

3 Linnaeus's student Pehr Kalm was to observe in his diary of his visit to England in 1748: 'It was curious that a large number of the leading men in natural history came from Essex – Mr Ray, Dale, Mortimer and his son, and Catesby' (Mead, W. R., 2016, *Pehr Kalm: His London Diary*, Aston Clinton, p. 44).

4 Raven, C., 1950, *John Ray, Naturalist: His Life and Works*, Cambridge. Ray's refusal to sign the 1662 Oath of Uniformity (requiring him to give unconditional consent to the Book of Common Prayer) necessitated giving up his academic appointments.

5 Ray, J., 1660, *Catalogus plantarum circa Cantabrigiam nascentium*, London.

6 Another example is Thomas Martyn's *Plantae Cantabrigiensis* (London, 1763), which credits 'the Diligence of the excellent Mr Ray and his Followers'.

7 Raven, C., 1950, p. 271.

8 Dale, S., 1722–38, 'Iter Cantabrigiense' (Diary of journeys between Braintree and Cambridge), CUL, MS Add 3466.

9 Raven, C., 1950, p. 272.

10 ERO, D/Y/1/1/111, letter 116, 2 December 1712.

11 Ibid., letter 182, 19 June 1730.

12 NHM, Dale Herbarium, specimen 57/9, labelled in Dale's hand: 'In horto D[omi]ni Jekyll apud Hedingham ad Castrum collegi. Anno 1711'.

13 Appendix 3, Catesby's Letters, letter 35, 10 January 1725: 'In a parcel to my Unkle I have sent you all the Sena Seed I could procure and some Seed of a Wild Marjoram not before sent and of Rattle Snake Root all which I received from a remote part of the Country[.] The Rattle Snake Seed is I think what I have before sent. At my Unkles request for Mr Mortimer I have sent Ceder Berries, which the beginning of this month I by accident found on an old Tree, except which amongst many Thousands I could not see one that had any. I have desired my Unkle to send you some if desired tho' I fear they will be too late to sow this spring.' Unless stated otherwise, all references to Catesby's letters are in Appendix 3.

14 Frick, G. F. & Stearns, R. P., 1961, *Mark Catesby: The Colonial Audubon*, Urbana, IL, p. 8, noting Courtman's contribution of seven specimens to Ray's *Historia insectorum*, 1710; Considine, J., 2017, *Small Dictionaries and Curiosity*, Oxford, p. 109.

15 Frick, G. F. & Stearns, R. P., 1961, p. 8, n. 45.

16 Ibid., p. 7; Sperling, C. F. D. (compiled from materials collected by W. W. Hodson), 1896, *A Short History of the Borough of Sudbury in the County of Suffolk*, Sudbury, p. 53.

17 RS, *Philosophical Transactions*, 21, 1699, pp. 108–9.

18 See Chapter 2, pp. 39–40.

19 Nichols, J., 1812–16, *Literary Anecdotes of the Eighteenth Century*, London, VI. Nichols stated that the Spalding Gentlemen's Society considered itself 'not subordinate to the other [two learned societies], but corresponding with them': ibid., p. 2.

20 Honeybone, D., 2010, *The Correspondence of the Spalding Gentlemen's Society, 1710–1761*, Woodbridge.

21 Nichols, J., 1812–16, VI, p. 78.

22 Owen, D., 1981, *The Minute-Books of The Spalding Gentlemen's Society 1712–1755*, Lincoln Record Society, vol. 73, Lincoln, p. 21.

23 RS, *Letter Book*, XXIV, 20 July 1737 and 15 August 1737. For an indication of the wide range of topics discussed by the society, see Honeybone, D., 2010.

24 Johnson, S., 1755, *A Dictionary of the English Language in which the words are deduced from their originals …*, London.

25 Eamon, W., 1994, *Science and the Secrets of Nature: Books on Secrets in Medieval and Early Modern Culture*, Princeton, who discusses the different meanings of 'curiosity' and the allied term 'virtuosity' (p. 316 and ch. 9).

26 *NH*, Preface, pp. i and v.

27 For the generally held opinion of the superiority of London society with its accompanying civility, as against regional provincialism, see Hoppit, J., 2000, *A Land of Liberty? England 1689–1727*, Oxford.

28 Sprat, T., 1667, *The History of the Royal-Society of London for the Improving of Natural Knowledge*, London; Tinniswood, A., 2019, *The Royal Society and the Invention of Modern Science*, London.

29 Sambrook, J., 1993, *The Eighteenth Century: The Intellectual and Cultural Context of English Literature 1700–1789*, 2nd edn, Harlow, pp. 60–64, 125.

30 Ibid., pp. 34–8.

31 Ray, J., 1677, *Catalogus plantarum Angliae*, London, p. 275.

32 Ray's 'delight in the worth of the world as aesthetically satisfying, intellectually educative and spiritually significant, reflects the best Hebrew, Greek and Christian thought, but is in strong and striking contrast to the philosophy and religion both of the Catholic and Protestant traditions' (Raven, C., 1950, pp. 275, 466–7).

33 See, for example, Catesby, *NH*, Account, p. xxxvi, in discussing the behaviour of insects, 'nothing excites more admiration of the wisdom of God our great Creator'; Edwards, G., 1743–51, *A Natural History of Uncommon Birds*, London, IV, dedication to 'God … the Almighty Creator of All Things that exist'.

34 For the urge to produce exhaustive compilations (such as encyclopaedias and catalogues) during earlier periods, see Blair, A., 2006, *Too Much to Know*, New Haven & London.

35 Such phrases were used in the Royal Society's *Philosophical Transactions* (e.g. *Phil. Trans.*, 1, 1665/6, p. 141; quoted by Frantz, R. W., 1968, *The English Traveller and the Movement of Ideas, 1660–1732*, New York, p. 16).

36 Stearns, R. P., 1970, *Science in the British Colonies of America*, Urbana, IL, pp. 101ff. As Wayne Hanley puts it, 'In that period, the wealthy were the equivalent of foundations or government agencies in supporting naturalists. In effect they were men with a deep interest in a subject who were sending out servants to get information for them from the library. But in this era, the Library was the world and their information was unrecorded. So they had to choose the servant wisely, for the information they received would depend totally on his wisdom' (Hanley, W., 1977, *Natural History in America: From Mark Catesby to Rachel Carson*, New York, p. 5).

37 Boyle, R., 1692, *General Heads for the Natural History of a Country …*, London.

38 Petiver, J., 1695, *Musei Petiveriani …*, London, p. 32.

39 Sprat, T., 1667, p. 113.

40 For the *Philosophical Transactions* see p. 31 and Tinniswood, A., 2019, pp. 63–73.

41 Ewan, J. & N., 1970, *John Banister and his Natural History of Virginia, 1678–1692*, Urbana, IL; Reeds, K., 2015, 'Mark Catesby's Botanical Forerunners in Virginia', in Nelson, E. C. & Elliott, D. J., eds, *The Curious Mister Catesby: A 'Truly Ingenious' Naturalist Explores New Worlds*, Athens, GA, & London, pp. 27–38.

42 Compton was to 'collect a greater variety of Green-house rarities, and to plant a greater variety of hardy Exotic Trees, and Shrubs, than had been seen in any garden before in England' (Pulteney, R., 1790, *Historical and Biographical Sketches of the Progress of Botany in England*, London, II, pp. 105–7). For Compton's botanical interests, see Desmond, R., 1977, *Dictionary of British and Irish Botanists and Horticulturists, including Plant Collectors and Botanical Artists*, London, p. 144.

43 Raven, C., 1950.

44 See letter 14, 13 November 1723.

45 Later, however, James Petiver was to attempt the task of illustrating Ray's *Historia plantarum*, publishing a partial attempt in his *Catalogue of Mr Ray's English herbal illustrated with figures on folio copper plates* (1713) (Henrey, B., 1975, *British Botanical and Horticultural Literature before 1800*, II: *The Eighteenth Century*, Oxford, pp. 80ff).

46 Ewan, J. & N., 1970, p. xv.

47 Lawson, J., 1709, *A New Voyage to Carolina; containing the Exact Description and Natural History of that Country, together with the Present State thereof. And a Journal of a Thousand Miles, Travel'd thro' several Nations of Indians, giving a particular Account of their Customs, Manners, &c.*, London.

48 Lefler, H. T., ed., 1967, *A New Voyage to Carolina by John Lawson*, Chapel Hill, NC, p. xv.

49 Immediately popular, Lawson's book was published in several editions, including German and French, and attracted many immigrant settlers to the colony of North Carolina. It was reissued in 1714 under the title of *The History of Carolina*.

50 *NH*, Account, p. viii.

51 Clokie, H. N., 1964, *An Account of the Herbaria of the Department of Botany in the University of Oxford*, Oxford, pp. 17–30.

52 For a biography of Sherard, see Riley, M., 2011, '"Procurers of plants and encouragers of gardening": William and James Sherard, and Charles du Bois, Case Studies in Late 17th and Early 18th-Century Botanical and Horticultural Patronage', DPhil thesis, University of Buckingham.

53 Brian Ogilvie notes that known plant species had grown from 500 described by Dioscorides to 6,000 listed by Caspar Bauhin (Ogilvie, B., 2006, *The Science of Describing: Natural History in Renaissance Europe*, Chicago & London, p. 203). Stephen Harris (pers. comm.) notes that it is impossible to estimate how many

thousands of extra plants Sherard added to Bauhin, as in addition to the closely written main volumes of the 'Pinax' there are hundreds of pages of apparently unsorted polynomials.

54 Sherard's 'Pinax' consists of an interleaved and annotated copy of the 1671 reprint of Bauhin's work (MSS Sherard 176–7) together with an unpublished manuscript catalogue (MSS Sherard 44–173) in the Sherardian Library of Plant Taxonomy, University of Oxford. Sherard's aim was only to be realized with the binomial system of nomenclature introduced by Linnaeus. For an account of the 'Pinax', see Harris, S. A., 2015b, 'William Sherard: His Herbarium and his *Pinax*', *Oxford Plant Systematics*, 21, September, pp. 13–15.

55 Frick, G. F. & Stearns, R. P., 1961.

56 Harris, S. A., 2015a, 'The Plant Collections of Mark Catesby in Oxford', in Nelson, E. C. & Elliott, D. J., eds, *The Curious Mister Catesby: A 'Truly Ingenious' Naturalist Explores New Worlds*, Athens, GA, & London, pp. 173–88 [p. 173]. For the several herbaria discussed in this volume, see Appendix 1.

57 Ogilvie cites the example of the sixteenth-century naturalists Conrad Gessner and Carolus Clusius transplanting Alpine plants into their gardens for study (Ogilvie, B., 2006, p. 160).

58 Le Rougetel, H., 1990, *The Chelsea Gardener: Philip Miller 1691–1771*, London, p. 9.

59 Society of Gardeners, 1730, *Catalogus plantarum*, London, p. iv. Also see Wulf, A., 2008, *The Brother Gardeners: Botany, Empire and the Birth of an Obsession*, London.

60 Stearn, W. T., 1961, 'Botanical Gardens and Botanical Literature in the Eighteenth Century', in Stevenson, A., *Catalogue of Botanical Books in the Collection of Rachel McMasters Miller Hunt*, Pittsburgh, PA, vol. II, pt I, pp. lxiv–lxviii; Riley, M., 2011.

61 Stearn, W. T., 1961, p. lxv. Riley, M., 2011.

62 For example, letters 1, 5 May 1722; 2, 20 June 1722; 11, 10 May 1723; 18, 16 January 1724; 35, 10 January 1725.

63 Letter 15, 15 November 1723.

64 Dillenius, J. J., 1732, *Hortus Elthamensis, sive, Plantarum rariorum quas in horto suo Elthami in Cantio collegit … Jacobus Sherard, M.D … Catalogus*, London.

65 Stearn, W., 1961, p. lxvi.

66 O'Neill, J., 1983, 'The Stove House and the Duchess', *Country Life*, 20 January, pp. 142–3;

Munroe, J., 2011, '"My innocent diversion of gardening": Mary Somerset's Plants', *Renaissance Studies*, 25, no. 1, pp. 111–23; Laird, M., 2015a, *A Natural History of English Gardening, 1650–1800*, New Haven & London, ch. 2.

67 Chambers, D., 1997, '"Storys of Plants": The Assembling of Mary Capel Somerset's Botanical Collection at Badminton', *Journal of the History of Collections*, 9, no. 1, pp. 49–60, who notes that Mary Somerset's plant collecting 'enterprise as a whole puts her on an equal footing with some of the greatest botanists and horticulturists of her age, many of whom were her friends and correspondents' (p. 49).

68 Riley, M., 2011.

69 Cottesloe, G. & Hunt, D., 1983, *The Duchess of Beaufort's Flowers*, Exeter; Laird, M., 2015a, pp. 89–97. For Kick, see p. 301, n. 118.

70 Numerous specimens sent by Mary Beaufort to Sloane are recorded in Sloane's manuscript catalogues of 'Vegetable Substances' (NHM, Department of Life Sciences, Algae, Fungi & Plants Division).

71 For Collinson see Armstrong, A. W., ed., 2002, *'Forget Not Mee & My Garden …': Selected Letters, 1725–1768 of Peter Collinson, F.R.S.*, Philadelphia; Swem, E. G., 1949, 'Brothers of the Spade: Correspondence of Peter Collinson of London and of John Custis of Williamsburg, Virginia, 1734–1746', *Proceedings of the American Antiquarian Society*, 58, pt I, pp. 17–190; O'Neill, J. & McLean, E., 2008, *Peter Collinson and the Eighteenth-Century Natural History Exchange*, Philadelphia, Laird, M., 2015a.

72 Dillwyn, L. W., 1843, *Hortus Collinsonianus: An account of the plants cultivated by … Peter Collinson … arranged alphabetically according to their modern names, from the catalogue of his garden, and other manuscripts*, Swansea (privately printed).

73 Lambert, A. B., 1811, 'Notes relating to Botany, collected from the Manuscripts of the late Peter Collinson, Esq., FRS, and communicated by Aylmer Bourke Lambert, Esq.', *Transactions of the Linnean Society of London*, X, pp. 270–82.

74 Memorandum of 1763 (Dillwyn, L. W., 1843, p. viii, who noted that 'considering his long-continued exertions … it is understandable that so high an opinion of his own success was entertained by this distinguished Patron of Horticulture').

75 This copy (KH) which Collinson extra-illustrated with watercolours by Catesby and

others, was bought by the 13th Earl of Derby, and remained in the library at Knowsley Hall until its recent sale.

76 Butt, J., ed., 1975, *The Poems of Alexander Pope*, London. For a discussion of Pope's influence, see Hoppit, J., 2002. For discussions of the movement, see Chambers, C., 1993, *The Planters of the English Landscape Garden: Botany, Trees, and the Georgics*, New Haven & London, chs 4 and 5; Hadfield, M., 1996, *A History of British Gardening*, London & New York; Crowe, S., 2003, *Garden Design*, 3rd edn, Woodbridge, pp. 52ff; Hunter, J. M., 1985, *Land into Landscape*, London & New York, ch. 5.

77 Laird, M., 1999, *The Flowering of the Landscape Garden: English Pleasure Grounds, 1720–1800*, Philadelphia, ch. 2, pp. 61–98.

78 Jellicoe, G. & S., 2001, *The Oxford Companion to Gardens*, Oxford & New York, pp. 554–5. Chambers, D., 1993, ch. 7.

79 In 1736 Lord Petre, the most generous of Bartram's subscribers, proposed an 'annual allowance' to Bartram of ten guineas, while other subscribers paid lesser amounts; eventually the cost of a box containing 100 plant species was to be set at five guineas (Stearns, R. P., 1970, pp. 579–80, and n. 173). These sums may be compared with the annual stipend of £20 Colonel Nicholson paid to Catesby to collect in South Carolina in 1722–5 (see pp. 8, 33). See also O'Neill, J. & McLean, E. P., 2008, chs 5 & 6.

80 Linnean Society of London, Collinson Commonplace Book, MS 323a, p. 65, undated note.

81 Lambert, A. B., 1811, p. 274.

82 Smith, J. E., 1821, *A Selection of the Correspondence of Linnaeus …*, London, I, pp. 9–10.

83 Campbell, C., 1725, *Vitruvius Britannicus*, London, III, p. 9. The annotated copy of Philip Miller's *Gardeners' Dictionary* (3rd edn, 1737) at Goodwood records dates of important plantings, including evergreens planted on the bowling green in the 1730s, tulip trees (*Liliodendron tulipifera*) and 'Virginia Oakes' (*Quercus virginiana*), planted in 1739.

84 Grigson, C., 2016, *Menagerie: The History of Exotic Animals in England, 1100–1837*, Oxford, ch. 3. Baird, R., 2007, *Goodwood: Art and Architecture, Sport and Family*, London, ch. 5, pp. 60–73.

85 Edwards, G., 1758, *Gleanings of Natural History …*, London, I, Preface, p. ii. For Edwards's work for the Duke of Richmond,

see Selborne, J., 1998, 'Dedicated to a Duke: Goodwood's Uncommon Birds', *Country Life*, 12 March, pp. 86–9. For the birds and other animals Edwards painted from models in the Duke of Richmond's extensive aviary at Whitehall and his menagerie at Goodwood, see MacGregor, A., 2014, 'Patrons and Collectors: Contributors of Zoological Subjects to the Works of George Edwards (1694–1773)', *Journal of the History of Collections*, 26, no. 1, pp. 35–44, and online appendix, http://jhc.oxfordjournals.org/.

86 *NH*, Appendix, p.18.

87 O'Neill, J. & McLean, E. P., 2008, p. 79.

88 Henrey, B., 1975, pp. 317–61.

89 Lambert, A. B., 1811, pp. 271–2.

90 *NH*, Preface, p. i.

91 See Chapters 2 and 5.

92 Among the private collections of rarities was that of Peter Collinson, of which he wrote to Linnaeus: 'You may remember my repository, in which I have a collection of all sorts of natural productions that I can procure from my distant friends' (Smith, J. E., 1821, *A Selection of the Correspondence of Linnaeus and other Naturalists from the Original Manuscripts*, London, I, p. 11).

93 In 1710, the contents of the Repository were summed up in Beeverell, J., 1710, *Les Delices de L'Angleterre*, London, as 'un Cabinet de raretez, où l'on ramassé mille choses curieuses, de toutes les parties du Monde, comme divers animaux rares de toute espêce, des momies d'Egypte, & autres choses semblables' (IV, pp. 922–3).

94 RS, *Council Minutes*, III, pp. 47–8.

95 RS, *Journal Book*, XIII, 12 December 1723.

96 Quarrell, W. H. & Mare, M., 1934, *London in 1710 from the Travels of Zacharias Conrad von Uffenbach*, London, p. 97, quoted in MacGregor, A., ed., 1994, *Sir Hans Sloane: Collector, Scientist, Antiquary, Founding Father of the British Museum*, London, p. 20.

97 MacGregor, A., ed., 1994, p. 20. In 1752, however, Emmanuel Mendes da Costa, the society's librarian and keeper of the Repository, noted it was in a 'ruinous, forlorn condition', and ten years later the animal and vegetable specimens were reported to be in an advanced state of decay. In the late 1770s, the society's council transferred the Repository to the newly formed British Museum where it joined Sloane's collections (Tinniswood, A., 2019, pp. 86–7).

98 RS, *Committee Minute Book* (CMB 63), January 1729/30–October 1733. See Chapter 2.

99 Ibid., unfoliated.

100 Sloane, H., 1707–25, *A Voyage to the Islands Madera, Barbados, Nieves, S. Christophers and Jamaica: with the Natural History … of the last of those Islands*, London, I, Preface, unpaginated [p. 1].

101 De Beer, G. R., 1953, *Sir Hans Sloane and the British Museum*, Oxford, pp. 59–62; MacGregor, A., 1994, p. 17, fig. 3; Caygill, M. L., 2003, 'From Private Collection to Public Museum: The Sloane Collection at Chelsea and the British Museum at Montagu House', in Anderson, R. G. W., Caygill, M. L., MacGregor, A. & Syson, L., eds, *Enlightening the British: Knowledge, Discovery and the Museum in the Eighteenth Century*, London, pp. 18–28.

102 Birch, T., 'Memoirs relating to the Life of Sr Hans Sloane Bart. Formerly President of the Royal Society', BL, Add MS 4241, quoted by MacGregor, A., 1994, p. 27.

103 Sloan, K., 2012, '"Sloane's Pictures and Drawings in Frames" and "Books of Miniature & Painting, Designs, &c."', in Walker, A., MacGregor, A. and Hunter, M., eds, 2012, *From Books to Bezoars: Sir Hans Sloane and his Collections*, London, pp. 168–89; McBurney, H., 1997, *Mark Catesby's 'Natural History' of America*, exh. cat., London, p. 33. For Sloane's related collection of prints, see Griffiths, A., ed., 1996a, *Landmarks in Print Collecting: Connoisseurs and Donors at the British Museum since 1753*, London, pp. 21–42.

104 Approximately 243 drawings by Edwards can be found in Sloane's albums (information kindly supplied by Felicity Roberts, March 2018).

105 Edwards, G., 1743–51, *A Natural History of Uncommon Birds*, 4 Parts, London, Pt 2, Dedication, p. iii. MacGregor, A., 2014.

106 Sloane was to subscribe to five copies of the *Natural History*.

107 MacGregor, A., 1994, p. 34.

108 Linnaeus in *Hortus Cliffortianus* quoted in Calmann, G., 1977, *Ehret: Painter Extraordinary*, Oxford, p. 47: 'Everlasting among Botanists is the memory of those Men of Wealth who have lent a helping hand to our art, who have been lovers of the Science of Botany, enthusiasts, supporters, patrons.'

109 *Biographia Britannica*, 1747–66, London, V (L–S), pp. 3077–85 [p. 3077]. For Mead's medical work, including his being 'credited with laying the foundations of a public health system in his outline proposals for quarantine and

other preventative measures' and his collecting activities, see Jenkins, I., 2003, 'Dr Richard Mead (1673–1754) and his Circle', in Anderson, R. G. W., Caygill, M. L., MacGregor, A., & Syson, L., eds, *Enlightening the British: Knowledge, Discovery and the Museum in the Eighteenth Century*, London, pp. 127–35 [p. 127].

110　See Chapter 6, p. 207. 'Catalogue of Gems' including lists of 'Animals preserved in spirits', bound with some copies of *Bibliotheca Meadiana*, London, 1755 (the copy in the CUL, shelfmark 7460.c.15, contains an example of this rare printed catalogue).

111　*Bibliotheca Meadiana*, 1755: the art collections, auctioned over fifty-six days, are listed in the 'Catalogue of Gems', 'Catalogue of Prints', 'Catalogue of Pictures' and 'Museum Meadiana'; the books and manuscripts are listed under the section 'Bibliotheca Meadiana'.

112　*Biographica Britannica*, 1747–66, V, p. 3085.

113　*NH*, Preface, p. viii.

114　Defoe, D., 1983, *A Tour through the Whole Island of Great Britain, 1724–1727*, letter VI, 'Containing a description of the counties of Middlesex …', London (Folio Society), II, p. 140.

115　Chandos to Sloane, 4 December 1721, BL, Sloane MS 4046.152–3.

116　While Handel, who had been musician in residence at Cannons between 1717 and 1719, had left the duke's employment by then, Catesby could have met him later in Goupy's house (see Chapter 2).

117　Goupy was born in London, nephew of the French-born artist Louis Goupy (*c.*1674/7–1747): see Simon, J., 1994, 'New Light on Joseph Goupy', *Apollo*, February, pp. 15–18; Sloan, K., 2000, *A Noble Art: Amateur Artists and Drawing Masters, c.1600–1800*, London.

118　Item 160 in sale of the Duke of Chandos's 'Catalogue of Pictures': Robinson, J. R., 1893, *The Princely Chandos: A Memoir*, London, p. 219. Chandos paid £50 for each of the copies: Sloan, K., 2000, p. 213.

119　See Robertson, B., 1988, 'Joseph Goupy and the Art of the Copy', *Bulletin of the Cleveland Museum of Art*, LXXV, no. 10, December, pp. 354–75. See also Harris, E. T., 2008, 'Joseph Goupy and George Frideric Handel: From Professional Triumphs to Personal Estrangement', *Huntington Library Quarterly*, 71, no. 3, pp. 397–452.

120　Johnson, J., 2004, rev. 2010, 'Brydges, James, First Duke of Chandos (1674–1744)', *ODNB*, Oxford; Brigham, D., 1998, 'Mark

Catesby and the Patronage of Natural History in the First Half of the Eighteenth Century', in Meyers, A. R. W. & Pritchard, M. B., eds, 1998, *Empire's Nature: Mark Catesby's New World Vision*, Chapel Hill, NC, pp. 91–146; Hammelmann, H. A. & Boase, T. S. R., 1975, *Book Illustrators in Eighteenth-Century England*, New Haven & London, pp. 86–8.

121　*NH*, Preface, p. vi.

122　Founded in 1711, the academy of 'Eminent Artists and Lovers of Art in this Nation' split in 1720 and collapsed in 1724. Whitely, W. T., 1928, *Artists and their Friends in England, 1700–1799*, 2 vols, London & Boston; Hoppit, J., 2000, pp. 451–5. For Goupy's address see Simon, R., 1994, pp. 15–18.

123　West, S., 1996, 'Vandergucht Family: English Family of Artists of Flemish Origin', in Turner, J., ed., *The Dictionary of Art*, London, vol. 31.

124　For Richardson senior, see note 138.

125　Turner, D., ed., 1835, *Extracts from the Literary and Scientific Correspondence of Richard Richardson …*, Yarmouth, pp. 398–9.

126　See Chapter 3.

127　BL, Sloane MS 4036.185, quoted by MacGregor, A., 1995, 'The Natural History Correspondence of Sir Hans Sloane', *Archives of Natural History*, 22, p. 86.

128　I am grateful to Lisa Smith for this information; the digitization of the letters is still in progress: http://sloaneletters.com.

129　See the online database, n. 128 above; also MacGregor, A., 1995, pp. 70–90.

130　For a listing of Sloane's manuscript catalogues, see MacGregor, A., 1994, pp. 291–4. See also Appendix 1, pp. 221–3.

131　Amongst these was Benjamin Franklin whose work on electricity he encouraged. More than 750 of Collinson's letters survive to more than seventy-five correspondents (Swem, E. G., 1949; Armstrong, A., 2002).

132　Armstrong, A., 2002, p. 15.

133　See Chapter 2.

134　These – numbering 106 volumes of his plant collection – were bought for £4,000 at his death in 1718 by Hans Sloane (Dandy, J. E., 1958, *The Sloane Herbarium …*, London, pp. 175–82).

135　Linder Hurley, S., 2015, 'Mark Catesby's Carolina adventure', Nelson & Elliott, pp. 109–26 [119].

136　Catesby's letter to Sherard, 16 January 1724, pp. 252–3.

137　Turner, D., 1835, p. iii.

138　For Richardson, see Courtney, W. P., rev. Davis, P., 2004, 'Richardson, Richard (1663–1741), Physician and Botanist', *ODNB*, Oxford; for selections of his letters, see Nichols, J., 1812–16; Smith, J. E., 1821; Turner, D., 1835. For Knowlton, see Henrey, B., 1986, *No Ordinary Gardener: Thomas Knowlton, 1691–1781*, London; Pulteney, R., 1790, II, pp. 239–41.

139　Tinniswood, A., 2019, pp. 63–73.

140　Pulteney, R., 1790, II, p. 240.

141　Bradley, R., 1724, *A General Treatise of Husbandry and Gardening*, London, III, pt II, pp. 75–6.

142　Letter 16, undated but before 1724.

143　Stearns, R. P., 1970, p. 260. For the herborizing tradition, see Walters, S. M., 1981, *The Shaping of Cambridge Botany*, Cambridge, ch. 2; Allen, D. E., 2000, 'Walking the Swards: Medical Education and the Rise and Spread of the Botanical Field Class', *Archives of Natural History*, 27, no. 3, pp. 335–67.

144　Henrey, B., 1975, p. 78; Laird, M., 2008, 'The Congenial Climate of Coffeehouse Horticulture …' and Riley, M., 2008, 'The Club at the Temple Coffee House', in O'Malley, T. and Meyers, A. R. W., eds, 2008, *The Art of Natural History: Illustrated Treatises and Botanical Paintings, 1400–1850*, New Haven & London, pp. 227–52 and 253–9; Riley, M., 2006, 'The Club at the Temple Coffee House Revisited', *Archives of Natural History*, 33, no. 1, pp. 90–100. Riley, M., 2011, pt 1, pp. 61–78.

145　Gorham, C., 1830, *Memoirs of John Martyn …*, London, p. 20.

146　Thomas Fairchild and Christopher Gray were amongst their number.

147　Some of these were published in the Society of Gardeners' *Catalogus plantarum*, 1730, a book which contained a high proportion of trees and shrubs from the American colonies (Henrey, B., 1975, p. 212).

148　Blair was the author of *Pharmaco-botanologia* (1723–8), consisting of a list and discussion of plants used in the 'new London Dispensatory' (ibid., p. 49).

149　Gorham, C., 1830, p. 15.

150　Schiebinger, L. & Swan, C., eds, 2005, *Colonial Botany: Science, Commerce, and Politics in the Early Modern World*, Philadelphia.

151　Stearns, R. P., 1970, pp. 101ff. See also MacGregor, A., 2018a, *Company Curiosities: Nature, Culture and the East India Company, 1600–1874*, London.

152 Sprat, T., 1667, p. 86.

153 Stearns, R. P., 1970, p. 106.

154 Johnson, J., 2004.

155 RS, *Council Minutes*, 20 October 1720.

156 *NH*, I, Dedication, unpaginated.

157 See Chapters 2 and 6.

158 Johnson, S., 1755. The 'liberal arts' covered grammar, logic, rhetoric, arithmetic, geometry, music and astronomy. Sambrook, J., 1993, especially ch. 1.

159 Fox, C., 2010, p. 1., who provides an extended discussion of this theme.

160 It was not until the second half of the nineteenth century that the notions of amateur and professional were reversed – with amateur acquiring its contemporary pejorative definition of someone whose approach is the opposite of professional: that is, not of a professional standard. For discussions of this topic, see Sloan, K., 2000; Fox, C., 2010.

Chapter 2 • Catesby's Life and Character

1 *NH*, Appendix, p. 20.

2 KH. George Edwards similarly recorded that Catesby was born of 'a gentiel Family' although he cited Castle Hedingham as his place of birth. His memories, were, however, recorded twelve years after Catesby's death, when Edwards excused himself from 'slowness of age' (letter to Thomas Pennant, 5 December 1761, MLM, MA 1550).

3 For the origins of the Catesby family, see Allen, E. G., 1937, 'New Light on Mark Catesby', *Auk*, LIV, July, pp. 349–63.

4 Sudbury Museum Trust, http://virtualmuseum.sudburysuffolk.co.uk (under Sudbury virtual museum, 17th and 18th century).

5 Sperling, C. F. D. (compiled from materials collected by W. W. Hodson), 1896, *A Short History of the Borough of Sudbury in the County of Suffolk*, Sudbury, pp. 73–4, 78.

6 SRO, EE 501/1/11 26, cited by Nelson, E. C., 2015, '"The truly honest, ingenious, and modest Mr Mark Catesby, F.R.S.": Documenting his Life (1682/83–1749)', in Nelson, E. C. & Elliott D. J., eds, 2015, *The Curious Mister Catesby: A 'Truly Ingenious' Naturalist Explores New Worlds*, Athens, GA, and London, pp. 1–20

[pp. 3–4]. John Catesby's possible forebears in Northamptonshire and Warwickshire, and his connection with Robert Catesby, known for his part in the Gunpowder Plot, are discussed in Frick, G. F. & Stearns, R. P., 1961, *Mark Catesby: The Colonial Audubon*, Urbana, IL, pp. 3–5.

7 The reference to 'Hedingham Castle' is to the village of Castle Hedingham, not the medieval castle within it which is on the grounds of a substantial eighteenth-century house now itself known as Hedingham Castle. There appears to be no support for the suggestion that a seventeenth-century house named 'Sheepcote' in Castle Hedingham was the house occupied by the Jekyll family (Allen, E. G., 1937, p. 350). Allen's further suggestion that Mark Catesby was born in that house was taken up in the blue plaque erected on it, but no evidence is cited.

8 Jekyll was described in 1627 as a 'Lover of Antiquities … and the Mathematical Sciences … acquainted with Camden and other famous Antiquaries of that time' (Reynolds, J. S., 2004, 'Jekyll, Thomas (1570–1652), antiquary', *ODNB*, Oxford).

9 Frick, G. F. & Stearns, R. P., 1961, p. 3; Allen, E. G., 1937, pp. 350–51; Nelson, E. C., 2015, p. 1.

10 ERO, D/P48/1/1/71. The difference in year is accounted for by the use of the Old and New Style calendars, the new year beginning on 25 March according to the Old Style.

11 Frick, G. F. & Stearns, R. P., 1961, p. 4.

12 Ibid., p. 14. For Jekyll's and Spotswood's acquaintance, see Brock, R. A., ed., 1882–5, 'The Official Letters of Governor Alexander Spotswood', *Collections of the Virginia Historical Society*, Richmond, letter, 16 November 1713, II, pp. 44–5.

13 See Chapter 6. For the part Latin and French played as international languages of discourse, see Hoppit, J., 2000, *A Land of Liberty? England 1689–1727*, Oxford, p. 172.

14 Elsa Allen suggested Sudbury Grammar School as a possibility and other writers have followed her (Allen, E. G., 1937, p. 351). For John Catesby as a natural history collector, see Chapter 6, p. 210 and nn. 155, 156.

15 The information is included in a list of 'The Scholars belonging unto Felsted-School, w[he]n they broke up before Xtmas last Dec: 16: 1710', CUL, MS Add 33, fol. 249. Christopher Dawkin, Archivist, Felsted School, notes: 'We have no internal documentation on curriculum or pupils before 1852. All our pupil information

before then (768 names out of 14,900) is derived from external sources' (pers. comm.); I am grateful for his help with Felsted School records.

16 Lockridge, K. A., 1987, *The Diary and Life of William Byrd II of Virginia, 1674–1744*, Chapel Hill, NC, & London, pp. 11–25.

17 Craze, M., 1955, *A History of Felsted School, 1564–1947*, Ipswich, pp. 68–9; Page, W. & Round, J. H., 1907, *Victoria History of the County of Essex*, London, II, p. 535.

18 *Spicilegium*, dedicated to the school's patron, Daniel Finch, Earl of Nottingham (Craze, M., 1955, pp. 78–9). Page & Round record the 'Oxford man, Simon Lydiatt, M.A., of Christ Church then [on his appointment] about thirty years of age … Though beset with financial difficulties Lydiatt had the school very near his heart' (1907, II, p. 535).

19 Curtis, S. J., 1953, *History of Education in Great Britain*, London, pp. 112–15. In *Thoughts concerning Education* (1692), John Locke criticized rigid classical education and advocated the teaching of French, arithmetic, chronology, history, geometry, astronomy, ethics, civil and common law and natural philosophy, as well as accomplishments such as riding, fencing, wrestling and dancing, and familiarity with at least one trade.

20 Lockridge, K. A., 1987, pp. 11–25; Hayes, K. J., 1997, *The Library of William Byrd of Westover*, Madison, WI.

21 Hoppit, J., 2000, p. 83.

22 John was admitted to Clifford's Inn in 1686, enrolled as a pensioner at Queens' College, Cambridge, in 1687, and admitted to the Inner Temple in 1690; Jekyll was admitted to the Inner Temple in 1692 (Venn, J. & J. A., 1922, *Alumni Cantabrigienses*, pt 1, I, Cambridge; Nelson, E. C., 2013, 'The Catesby Brothers and the Early Eighteenth-Century Natural History of Gibraltar', *Archives of Natural History*, 40, pt 2, October, pp. 357–60). The next two brothers, twins Samuel and Henry, died in infancy (see fig. 43). See also Frick, G. F. & Stearns, R. P., 1961, p. 7.

23 Hoppit, J., 2000, pp. 174ff.

24 Swem, E. G., 1949, 'Brothers of the Spade: Correspondence of Peter Collinson of London, and of John Custis, of Williamsburg, Virginia, 1734–1746', *Proceedings of the American Antiquarian Society*, 58, pt 1, 21 April, pp. 17–190.

25 ERO, D/Y/1/1/111/1–226. In letter 180 (6 February 1729/30) Jekyll describes himself as being like a 'Father to [Mark], and to his sister'.

26 RS, MS 253, letter 231, undated, but inscribed by Sherard on verso, 'Rec'd, Apr. 19. 1723'. From this it would appear that Dale also served as a conduit of information to Jekyll.

27 Diary entry for 24 May 1748: Mead, W. R., 2013, *Pehr Kalm: His London Diary*, Aston Clinton (privately printed), p. 44.

28 Edwards to Thomas Pennant, 5 December 1761, MLM, MA 1550.

29 See, for example, Jekyll writing to Holman about Dale wanting to borrow Dugdale's history of St Paul's which he thinks he lent to Holman: ERO, D/Y/1/1/111/144 (9 October 1729).

30 Le Rougetel, H., 1990, *The Chelsea Gardener: Philip Miller 1691–1771*, London, notes that Dale's garden of curiosities prompted a visit from Petiver and James Sherard when on a tour of East Anglia (p. 19). For Petiver's and Sherard's expedition around Essex, Suffolk and Norfolk, see Riley, M., 2011, 'Procurers of Plants and Encouragers of Gardening: William and James Sherard, and Charles du Bois, Case Studies in Late Seventeenth- and Early Eighteenth-Century Botanical and Horticultural Patronage', DPhil thesis, University of Buckingham, p. 20.

31 Raven, C., 1942, *John Ray, Naturalist: His Life and Works*, Cambridge, p. 205; Dale, S., 1722–38, 'Iter Cantabrigiense' ('Diary of journeys between Braintree and Cambridge'), CUL, MS Add 3466, fol. 31v. The plants were Chinese aster, *Callistephus chinensis*, and a double white cultivar of *Campanula persicifolia*. The reference to 'Hort. Elthamen' is to Dillenius, J. J., 1732, *Hortus Elthamensis seu plantarum rariorum quas in horto suo Elthami in Cantio coluit … Jacobus Sherard*, London. See Chapters 1 and 5.

32 Boulger, G. S., 1883, 'Samuel Dale', *Journal of Botany, British and Foreign*, XXI, quoting William Derham's 'Life of Ray': 'all [Ray's] collections of natural curiosities he bestowed on his friend and neighbour Mr Samuel Dale, author of the *Pharmacologia*, to whom they were delivered about a week before his death' (p. 197). Ray also gave Dale a number of his books (Broadhurst, S. & Kemp, D., 2012, 'A Survey of the Library Collection of Chelsea Physic Garden up to 1750', unpublished research paper). I am grateful to Sue Medway for showing me this paper.

33 RS, MS 253, letter 198, 17 August 1718. Petiver's copy of Jacob Theodorus (known as Tabernaemontanus), *Neuw Kreuterbuch* (Frankfurt am Main, 1588–91), ended up in Sloane's library instead (BL, classmark 444.k.1,2, 'E libris Jac Petiver'); I am grateful to Arnold Hunt for this information.

34 RS, MS 253, letter 210, 29 May 1719.

35 Dale, S., 1722–38, fol. 33v.

36 It is likely that an incomplete, uncoloured copy of Catesby's *Natural History* in the Chelsea Physic Garden library collections was part of the Dale Bequest and was therefore given by Catesby to Dale (Broadhurst, S. & Kemp, D., 2012, and Sue Medway, pers. comm., 25 June 2019); see Chapter 3, pp. 79–80.

37 NA, Kew, PROB/11/480 (quoted by Nelson, E. C., 2015, p. 3, n. 8). Pulteney, R., 1790, *Historical and Biographical Sketches of the Progress of Botany*, London, II, p. 220.

38 See Chapter 6. For the suggestion that Catesby worked with Fairchild before his first trip to America, see Leapman, M., 2000, *The Ingenious Mr Fairchild: The Forgotten Father of the Flower Garden*, London, p. 139.

39 NHM, Department of Life Sciences, Algae, Fungi & Plants Division, Dale Herbarium, no. 66.

40 Sloan, K., 1986, 'The Teaching of Non-Professional Artists in Eighteenth-Century England', PhD thesis, Westfield College, London, p. 27; and Sloan, K., 2000, *A Noble Art: Amateur Artists and Drawing Masters, c.1600–1800*, London.

41 Keith William Pratt's schoolmaster in Chelsea to Catesby's niece, Elizabeth Pratt (Jones, L. H., 1891, *Captain Roger Jones of London and Virginia*, Albany, NY, p. 127). For Keith Pratt see fig. 43 above.

42 See Chapter 4.

43 The work of the seventeenth-century botanical artist Alexander Marshal provides an example of an amateur training himself in foreshortening by copying figure studies from engravings after Rubens (Leith-Ross, P. & McBurney, H., 2000, *The Florilegium of Alexander Marshal in the Collection of Her Majesty The Queen at Windsor Castle*, London, p. 350, cat. 156).

44 See p. 16.

45 See Chapter 4.

46 Pulteney, R., 1790, II, p. 219.

47 Elizabeth Catesby, John's widow, was buried beside her husband on 7 September 1708 at St Nicholas Church, Castle Hedingham (Nelson, E. C., 2015, p. 5).

48 SRO, deed ref. 1674/4; reproduced in Nelson, E. C., 2015, p. 5, fig. 1-4.

49 For the marriage of Elizabeth Catesby, see Frick, G. F. & Stearns, R. P., 1961, p.11; Nelson, E. C., 2015, p. 5. For Spotswood, see Martin, P., 1991, *The Pleasure Gardens of Virginia: From Jamestown to Jefferson*, Princeton & Oxford.

50 The reason for the delay is not recorded but could have been to do with illness or the young age of the children.

51 *NH*, Preface, p. v.

52 Wright, L. B. & Tinling, M., 1941, *The Secret Diary of William Byrd of Westover, 1709–1712*, Richmond, VA, pp. 518–19. Two days later Byrd notes that he 'went to wait on Mrs. Cocke who is a pretty sort of woman' (p. 520).

53 For the design of the town and its gardens, see Martin, P., 1991, ch. 2.

54 William Cocke in *Dictionary of Virginia Biography* (online edition, https://www.lva.virginia.gov/public/dvb). For their children, see Nelson, E. C., 2015, n. 15.

55 Elizabeth Cocke was to marry William Pratt c.1720, by whom she had three children; after her husband's death in 1725 she married Thomas Jones, by whom she had ten children (see fig. 43). Catesby was close to his niece, who shared his natural history interests; three letters by Catesby to her survive, as Elizabeth Pratt (letter 3, 22 June 1722) and as Elizabeth Jones (letters 36, 1 March 1730, and 37, 30 December 1731). She is referred to in this book by her maiden or current married name according to the date.

56 Frick, G. F. & Stearns, R. P., 1961, p. 16.

57 An unidentified ailment. ERO, D/Y/1/1/111, letter 11, 20 September 1712.

58 *NH*, Preface, p. i.

59 See Chapters 5 and 6.

60 Lockridge, K. A., 1987.

61 The diplomat and virtuoso Southwell acted as Byrd's guardian during his education in England. He was president of the Royal Society 1690–96 (ibid., pp. 12–17). Southwell remained a mentor to Byrd.

62 Tinling, M., ed., 1977, *The Correspondence of the Three William Byrds of Westover, Virginia, 1684–1776*, Charlottesville, VA, I, pp. 195–202; Wenger, M., ed., 1989, *The English Travels of Sir John Percival and William Byrd II: The Percival Diary of 1701*, Columbia, SC; Hayes, K. J., 1997, pp. 19–22.

63 In a letter to Sloane, Byrd lamented the lack of 'people of skil and curiosity' in natural history (20 April 1706, see Chapter 6, p. 183).

Byrd's agricultural and horticultural interests are evident from his diaries, which show him 'constantly superintending the planting of crops, orchards and gardens', as well as sometimes 'taking a hand himself in setting out fruit trees' (Wright, L.B. & Tinling, M., 1941, p. xiii).

64 Byrd's diaries survive for the years 1709–12, 1717–21 and 1739–41. While Catesby's visits to Westover are recorded by Byrd in his diary for 1712, the diaries for the years 1713–16 are missing. Byrd was to leave for London early in 1715, and by 1717, the date of the next surviving diary, he was in London, only returning to Virginia in 1719, the year that Catesby returned to England (Lockridge, K. A., 1987, p. 1).

65 Wenger comments that 'Byrd solicited the likenesses of powerful and respected friends, which he drew together and displayed to advantage amidst the splendid holdings of the Westover library' (Wenger, M., 1989, pp. 38–9).

66 Hayes, K. J., 1997, pp. 37ff. Reeds, K., 2015, 'Mark Catesby's Botanical Forerunners in Virginia', in Nelson, E. C. & Elliott, D. J., eds, *The Curious Mister Catesby: A 'Truly Ingenious' Naturalist Explores New Worlds*, Athens, GA, & London, pp. 34–5.

67 Byrd's library contained a copy of *Albert Durer Revived: Or, a Book of Drawing …* (1652), which he may have acquired in London during this time (Hayes, K. J., 1997, pp. 50, 457). His art books, numbering fourteen European art treatises (not including volumes of prints), were shelved together with his gardening books (ibid., pp. 86–7).

68 Lucy was the daughter of Daniel Parke, a wealthy Virginian who served as governor of the Leeward Islands and as aide-de-camp to the Duke of Marlborough; he became a member of the governor's Council in 1708 (Tinling, M., 1977, I, pp. 195–6). The village of Gestingthorpe is just three miles from Castle Hedingham (see fig. 11).

69 ERO, D/Y/1/1/111, letter 12, October 1712 (no day given).

70 The last entry for Catesby's visit is 15 June 1712.

71 Tinling, M., 1977, I, p. 41. Elizabeth Cocke was eleven at this date; she was to marry William Pratt c.1720, by whom she had three children, and after her husband's death in 1725 she married Thomas Jones, by whom she had ten children (see fig. 43). Catesby was close to his niece, who shared his natural history interests; three letters by Catesby to her survive,

as Elizabeth Pratt (letter 3, 22 June 1722) and as Elizabeth Jones (letters 36, 1 March 1730, and 37, 30 December 1731). She is referred to in this book by her maiden or current married name according to the date.

72 Wright, L. B. & Tinling, M., 1941, p. 535.

73 This was the same ship in which Catesby and his sister had sailed to Virginia. Byrd mentions it several times in his diaries; he was friendly with its captain, no doubt from its being part of the fleet of merchantmen in regular use for the transatlantic journeys to Williamsburg.

74 Wright, L. B. & Tinling, M., 1941, p. 588. Colonel William Bassett (1671–1725) owned a plantation in New Kent County, Virginia; his house was named 'Eltham', after the Bassett family home in England.

75 Ibid., p. 590. Byrd's remedy for most ailments was a swim in the river.

76 Ibid., p. 591. Catesby was later to record that 'a young bear fed with autumn's plenty is a most exquisite dish' (*NH*, Account, p. xxvi).

77 *NH*, Preface, p. v.

78 See Chapter 6.

79 See Chapter 5.

80 Hayes, K. J., 1997, p. 3.

81 Boyd, W. K. & Adams, P. G., eds, 1967, *William Byrd's Histories of the Dividing Line betwixt Virginia and North Carolina*, New York. See, for example, Byrd's description of the wild scenery through which he travelled in 1728: 'the bottom [of the stream] is gravel spangled every where very thick with small flakes of mother of pearl'; he also speaks of 'ranging ten weeks in wild and uninhabited woods. In our progress we forded several times the most beautiful river I ever saw' (Tinling, M., 1977, I, p. 395).

82 *NH*, Account, pp. v–vi.

83 Ibid., p. vi.

84 Sloane, H., 1707–25, *A Voyage to the Islands Madera, Barbados, Nieves, S. Christophers and Jamaica … with the Natural History … of the last of those Islands*, London, I. The fine engraved illustrations were done partly from drawings made on the spot by a clergyman, Reverend Garrett Moore, and partly by Everard Kick from the herbarium specimens Sloane brought back with him; see MacGregor, A., 1994, *Sir Hans Sloane: Collector, Scientist, Antiquary, Founding Father of the British Museum*, London, pp. 13ff.; drawings made of the plants by Kick can be found in Sloane's herbarium volumes, NHM,

Department of Life Sciences, Algae, Fungi & Plants Division, Sloane HS 1–8 (see Dandy, J. E., 1958, *The Sloane Herbarium …*, London, p. 204).

85 Sloane, H., 1707–25, I, Preface, unpaginated.

86 See Bibliography, p. 333.

87 Jekyll's will, written in 1709, was proved in 1717 (SRO, IC500/1/171/90). He was buried on 21 September 1717: Nelson, E. C., 2013, fig. 1; Nelson, E. C., 2015, p. 9.

88 RS, MS 253, letter 211, 15 October 1719. The Virginian plants Catesby collected for Dale are now in the NHM, Department of Life Sciences, Algae, Fungi & Plants Division, Dale Herbarium, while some given by Dale to Petiver can be found in that department in HS 159 and 162.

89 RS, MS 253, letter 213, 23 December 1719.

90 Ibid., letter 215, 11 May 1720.

91 Ibid., letters 220, 221, 224, 225, 227.

92 Sherard to Richardson, MS Radcliffe Trust, C. IV, fol. 23, published in Turner, D., ed., 1835, *Extracts from the Literary and Scientific Correspondence of Richard Richardson*, Yarmouth, pp. 157–8; Nichols, J., 1812–16, *Literary Anecdotes of the Eighteenth Century*, London, I, pp. 278–9.

93 RCIN 925880, 925902, 925905b (etched in *NH*, I, 48, 67 and 70); see forthcoming Catalogue.

94 RCIN 926007 (*NH*, II, 57). Bauer, A. M., 2015, 'Catesby's Animals (other than birds) in *The Natural History of Carolina, Florida and the Bahama Islands*', in Nelson, E. C. & Elliott, D. J., eds, *The Curious Mister Catesby: A 'Truly Ingenious' Naturalist Explores New Worlds*, Athens, GA, & London, pp. 231–50 [p. 248]. Bauer suggests Catesby may have encountered the snake during his trip to the lower reaches of the Appalachian Mountains.

95 *NH*, Preface, p. i.

96 Gorham, G., 1830, *Memoirs of John Martyn FRS and of Thomas Martyn, BD, FRS, FLS, Professors of Botany in the University of Cambridge*, London, p. 11. For Blair see Pulteney, R., 1790, II, pp. 134–40.

97 See Chapter 3.

98 The exact dates of Catesby's return from Williamsburg in the autumn of 1719, and his departure for Charleston early in 1722, are not known.

99 Letter 3, 22 June 1722, written after his arrival in Charleston to his niece Elizabeth Pratt in Virginia, records: 'I came [to Charleston] from

London the beginning of Feb: last and left all well in Essex and Suff[olk] as I did Mr Pratt who I often saw in London.'

100 Letter 14, 13 November 1723: 'You desire some more of the Horschesnut and say it is new to you[.] Its' growing at fairchilds where I have seen it 4 or 5 years since with its' scarlet flowers'; and letter 6, 4 January 1723, where he notes: 'Cassena or Yapon I think not the same that I have seen at Fairchilds'.

101 Letter 6, 4 January 1723: 'I have seen a Tree of it [the Black Walnut] in Chelsey Garden and I think of the Hickory Nut'.

102 Nelson, E. C., 2015, p. 10. Catesby's copy was sold at auction by PBA Galleries, San Francisco (sale no. 303, lot 1), 24 February 2005, and is now in private ownership in America.

103 See Chapter 4.

104 Turner, D., 1835, p. 156, n. 1, quoted in Frick, G. F. & Stearns, R. P., 1961, p. 18: 'On completion of [his *Book of Insects*], proposals had been made to Albin, as Dr. Sherard states … "to go out to Carolina, there to paint Natural History in the summer months, and in the winter to paint the Caribee Isles"'.

105 RS, *Council Minutes*, 20 October 1720. The amount of Catesby's 'pension' may be compared with the price Catesby paid to purchase an African slave to accompany him on his collecting trips; see Chapter 6, p. 198 and letter 4.

106 *NH*, Preface, p. ii; Sherard, who was last in the list, noted that Catesby's 'obligations are more to me than to all the rest' (Nichols, J., 1812–16, I, p. 377).

107 Turner, D., 1835, 165, cited by Frick, G. F. & Stearns, R. P., 1961, p. 20.

108 Nichols, J., 1812–16, I, p. 378, cited by Frick, G. F. & Stearns, R. P., 1961, p. 20.

109 Letter 25, 20 August 1724.

110 The bird was probably a ruddy turnstone, *Arenaria interpres*, *NH*, I, 72; see forthcoming Catalogue.

111 Frick, G. F. & Stearns, R. P., 1961, p. 16.

112 Letter 1, 5 May 1722.

113 *NH*, Preface, p. xxiii.

114 Macmillan, P. D., Blackwell, A. H., Blackwell, C. & Spencer, M. A., 2013, 'The Vascular Plants in the Mark Catesby Collection at the Sloane Herbarium, with Notes on their Taxonomic and Ecological Significance', *Phytoneuron*, 7, pp. 1–37.

115 Linder Hurley, S., 2015, 'Mark Catesby's Carolina Adventure', in Nelson, E. C. & Elliott, D. J., eds, *The Curious Mister Catesby: A 'Truly Ingenious' Naturalist Explores New Worlds*, Athens, GA, & London, pp. 109–26.

116 See p. 66.

117 See Chapter 6 and Appendix 1. These numbers are based on surviving specimens, and in the case of the zoological specimens, in Sloane's manuscript catalogues; of course, many more were collected, some lost in transit and others after their arrival and subsequent rearrangement or destruction.

118 For duplicate watercolours made for Sloane, see Chapter 6, fig. 237 and forthcoming Catalogue. It is, however, possible that some of the duplicates were done on Catesby's return from America.

119 Letter 21, 6 April 1724.

120 Foster, J., 1888, *Alumni Oxonienses, 1715–1886*, Oxford, I, p. 294; Gardiner, R. G., 1889, *The Registers of Wadham College, Oxford*, pt I, 1613–1719, London, p. 460. Bequests of some of the books from Cooper's library are itemized in Moore, C. T. & Simmons, A. A., eds, 1960, *Abstracts of the Wills of the State of South Carolina, 1670–1740*, Charleston, SC, I, pp. 200–1. For information on Cooper's life in Charleston after Catesby's time there, see Shore, S. K., 2017, 'A Note on the Lives of Mark Catesby and Thomas Cooper', unpublished paper (for Applied Anthropology Internship, Catesby Commemorative Trust), spring.

121 Letter 24, 16 August 1724.

122 Letters 23, 15 August 1724; 24; 33, 5 January 1725; 35, 10 January 1725.

123 See Chapter 5.

124 Letters 4, 9 December 1722; 27, 30 October 1724.

125 Letters 4; 10, 10 May 1723; 14, 13 November 1723.

126 *NH*, Preface, p. xxiii.

127 Linder Hurley, S., 2015, pp. 115–16.

128 Webber, M. L., 1937, 'Sir Nathaniel Johnson and his Son Robert, Governors of South Carolina', *South Carolina Historical and Genealogical Magazine*, XXXVIII, no. 4, pp. 109–15.

129 See Chapter 6, n. 219.

130 A successful planter, during the Revolution of 1719 Waring had served under Governor James Moore on the Royal Council

of South Carolina. He inherited Pine Hill from his father, Benjamin, in 1711, where by 1726 he owned forty-one slaves (Edgar, W. B. & Bailey, N. L., 1977, *Biographical Directory of the South Carolina House of Representatives*, II: *The Commons House of Assembly, 1692–1775*, Columbia, SC, pp. 700–1). For Waring's part in the building of St George's Church, Dorchester, see Linder, S., 2000, *Anglican Churches in Colonial South Carolina*, Charleston, SC, pp. 73–5.

131 Catesby followed the eighteenth-century convention of applying the name 'acacia' to spiny, pod-bearing trees with pinnate or bipinnate compound leaves in the modern family Fabaceae.

132 *NH*, I, p. 43, and *HBA*, no. 29, p. 16: 'I never saw these trees growing but near the little town of Dorchester.' Pine Hill was burned down during the Revolution and 'scarcely anything [remains] of the old residence save a few bricks and nothing of … the garden and grounds around the site' (Smith, H. A. M., 1988, *The Baronies of South Carolina*, Spartanburg, SC, III, pp. 223–6).

133 Bull, K., Jr, 1991, *The Oligarchs in Colonial and Revolutionary Charleston: Lieutenant Governor William Bull and his Family*, Columbia, SC, p. 231. Fraser, C., 1940, *A Charleston Sketchbook*, Carolina Art Association, Charleston, SC, p. 26.

134 RCIN 924844, *NH*, I, 31.

135 For Blake see Smith, H. A. M., 1988, III, pp. 213–15.

136 *NH*, II, 41; see letter 18 to Sherard, 16 January 1724.

137 ERO, D/Y/1/1/111/3, 19 November 1723.

138 *NH*, II, p. 69.

139 Edgar, W. B. & Bailey, N. L., 1977, pp. 618–19. Skene, together with Thomas Waring, was among the group of plantation owners who oversaw the building of St George's Church, Dorchester; see note 130 above.

140 *HBA*, no. 4, p. 4.

141 Letter 7, 5 January 1723. See Chapter 5.

142 Bull, K., Jr, 1991, p. 231. For the furnishing of South Carolina plantation houses at this period, see Hudgins, C. C., 2011, 'The Material World of John Drayton: International Connections to Wealth, Intellect, and Taste', *Antiques and Fine Art*, X, no. 1, January, pp. 258–64.

143 *NH*, I, 44. For the use of 'loblolly bay', *Gordonia lasianthus*, in furniture making, see Bowett, A., 2012, *Woods in British Furniture-*

Making, 1400–1900: An Illustrated Dictionary, Wetherby, pp. 23–4.

144 *NH*, I, 67. Black or American walnut, *Juglans nigra*: Bowett, A., 2012, pp. 258–62.

145 *NH*, II, 95. 'Mancaneel' or manchineel, *Hippomane mancinella*, grown in the West Indies: Bowett, A., 2012, pp. 148–9.

146 In addition, unrest following the Yamasee War (1715–16), during which the Yamasee and their Spanish allies had massacred several hundred colonists, was to continue throughout Catesby's stay in South Carolina until 1727. The Cherokee and Chickasaw nations, however, remained on the side of the colonists (Linder Hurley, S., 2015, pp. 109–26 [pp. 111–12]; Edgar, W., 1998, *South Carolina: A History*, Columbia, SC, chs 6 and 7).

147 Catesby, in common with other natural history and travel writers of the time, included an account of Native Americans in the *Natural History* entitled 'Of the Aborigines of America' (*NH*, II, Account, pp. xvii–xvi). While he drew on John Lawson's account of 'Several Nations of Indians' in *The History of Carolina* (1714), Catesby emphasized that he 'chose to confine myself to what I learn'd by a personal knowledge of them'. His concern to learn about the uses of plants in medicine and food by Native Americans was typical of his practical, empirical approach as a naturalist.

148 *NH*, Account, p. xii.

149 Ibid., p. xvi. He seems mainly to have had relations with the Cherokee (https://web.archive.org/web/20120119115031/http://nc-cherokee.com) and Chickasaw nations.

150 *NH*, Account, p. xvi.

151 Ibid., p. viii. In a description 'Of the Habitations of the Indians', Catesby noted: 'The Wigwams, or cabbins of the Indians are generally either circular or oval, having but one floor, but of various dimensions, some containing a single family, others four or five families, but of the same kindred' (ibid., pp. x–xi).

152 Ibid., p. xxv.

153 Ibid., p. x.

154 *NH*, II, p. 63.

155 Ibid., Account, p. x.

156 Ibid., p. xi.

157 Ibid., p. viii; see Chapter 6, pp. 211–12, and letters 14, 27 and 31.

158 Ibid., p. xv.

159 Ibid., p. xiv.

160 Ibid., p. viii.

161 Ibid., pp. xiii–xiv.

162 Frick, G. F. & Stearns, R. P., 1961, pp. 114–19. See Chapter 6, p. 187.

163 Writing to Collinson, Bartram speaks of his 'laborious work' collecting acorns for him, accusing him of 'not [being] sensible of the 4th part of the pains I take'; on his journey through Maryland and Virginia he travelled more than 1,100 miles in five weeks, 'having rested one day in all that time'; collecting pine cones 'I had a grievous bad time … I climbed trees in the rain … then must stand up to the knees in snow to pluck off the cones' (Darlington, W., 1967, *Memorials of John Bartram and Humphrey Marshall*, New York & London, pp. 190, 120, 161).

164 *NH*, II, p. 95.

165 Ibid., Account, p. xxxviii.

166 Ibid., p. xxxv.

167 Ibid., p. xlii; see also Catesby's comment, *NH*, Preface, pp. v–vi.

168 See Chapter 6; see also Appendix 1, pp. 221–3.

169 *NH*, Account, p. xl.

170 All Catesby's immediate family had died apart from his younger brother, John, who was in the army abroad. There is no mention of his uncle Nicholas's death in the Castle Hedingham church register, but it is likely that he had died by this time. See 'Castle Hedingham: The Great and the Good', in *Disentangling My Family Tree*, www.familytreesurgeon.blogspot.com.

171 See Chapter 1, pp. 11, 15.

172 Wright, L. B. & Tinling, M., eds, 1958, *William Byrd of Virginia: The London Diary (1717–1721) and other Writings*, New York.

173 Letter 48, 27 June 1728.

174 Pulteney records: 'On his return to England, in the year 1726 … Mr. Catesby … retiring to Hoxton, employed himself in carrying on his great work' (Pulteney, R., 1790, II, p. 222). For a contemporary description of Hoxton, see Chapter 1, pp. 24–5.

175 Letter 36, 1 March 1730.

176 See Chapter 3; Overstreet, K. O., 2015, 'The Publication of Mark Catesby's *The Natural History of Carolina, Florida and the Bahama Islands*', in Nelson, E. C. & Elliott, D. J., eds, *The Curious Mister Catesby: A 'Truly Ingenious' Naturalist*

Explores New Worlds, Athens, GA, and London, pp. 155–72.

177 Several authors have suggested that Catesby lived in Fulham for some years. Pulteney, for example, notes: 'Before his death, he removed from Hoxton to Fulham, and afterwards to London, to a house behind St Luke's church in Old Street [Islington]' (Pulteney, R., 1790, II, pp. 229–30).

178 Its location was noted by Collinson in 1760: Dillwyn, L. W., 1843, p. 15. Daniel Lysons in the second edition of his *Environs of London* recorded that 'Catesby, the naturalist, had a botanic garden within the site of the nursery grounds, lately occupied by Mr Birchall' (Lysons, D., 1811, *The Environs of London*, 2nd edn, II, pt 2, p. 829); William Burchall (or Burchell) was Gray's successor at the Fulham nursery (Henrey, B., 1975, *British Botanical and Horticultural Literature before 1800*, II: *The Eighteenth Century*, London, New York & Toronto, p. 276).

179 *NH*, Appendix, p. 20.

180 See Chapters 1 and 4.

181 The day is not recorded, but it is likely that it was shortly before Catesby's presentation of Part 1 to the Royal Society on 22 May 1729.

182 He records that Queen Caroline had 'condescended to over-look and approve my Drawings' (*NH*, II, Dedication to Princess Augusta). For Caroline's and Augusta's horticultural interests, see Desmond, R., 1995, *A History of the Royal Botanic Gardens*, London, chs 1–3; Longstaffe-Gowan, T., 2017, 'Hankering after Horticulture', in Marschner, J., ed., *Enlightened Princesses: Caroline, Augusta, Charlotte …*, exh. cat., New Haven & London, pp. 349–52; and Griffith, T. & Meyers, A. R. W., 2017, 'The Natures of Britain and Empire', in Marschner, J., pp. 475–514 [pp. 475–6].

183 Nelson, E. C., 2015, p. 14.

184 *NH*, I, Dedication.

185 ERO, D/Y/1/1/111, letter 178, 29 May 1729.

186 The dates of Catesby's visits to the Royal Society are recorded in the RS *Journal Books*, 1729–50; there is no record of whose guest he was on his first visit.

187 For the dates of Catesby's presentation of the parts of the *Natural History* to the Royal Society, see fig. 93.

188 'Mr Catesby was put up as Candidate for Election, in pursuance of the following

Certificate. [Inset:] Mark Catesby, a Gentleman well skilled in Botany and Natural History, who travelled for several years in various parts of America, where he collected the Materials for a Natural History of Carolina and the Bahama Islands: which curious and magnificent Work he has presented to the Royal Society: is desirous of being a Member thereof, and is proposed by us: Hans Sloane, Roger Gale, Robert Paul, John Martyn, Peter Collinson. February 1, 1732/3' (RS, *Journal Books*, 1729–50, p. 15).

189 For the location of the Royal Society at Crane Court, see Tinniswood, A., 2019, *The Royal Society and the Invention of Modern Science*, London, pp. 76–80.

190 For accounts of these activities, see Chapter 6.

191 RS, *Journal Books*, 1729–50. Among these was the physician Thomas Stack, who was elected a fellow on 26 January 1738. Stack remained a friend of Catesby and was one of the doctors who attended him during his final illness.

192 Henrey, B., 1986, *No Ordinary Gardener: Thomas Knowlton, 1691–1781*, London, pp. 135–6.

193 Catesby was to correspond with Clayton, received plants from him, and cited the *Flora Virginica* in Volume II of the *Natural History*: see Bibliography, p. 321.

194 Knowlton himself, perhaps partly inspired by Catesby's descriptions, was to develop a similar desire 'to see Holland … where there is such a Variety of curious Gardens & Plants in them which we have not in this Kingdom'; he was able to make a trip there in 1751 when he saw 'Gronovius often who made enquirey after al his frainds & remember ym over a glasse of wine' (Henrey, B., 1986, pp. 213–14, 217).

195 See n. 182 above.

196 *NH*, II, Dedication, unpaginated.

197 For the dates of completion of the parts of the book, see fig. 93; Overstreet, L. K., 2014, 'The Dates of the Parts of Mark Catesby's *The Natural History of Carolina* … (London, 1731–1743 [1729–1747])', *Archives of Natural History*, 41, pt 2, Short Notes, pp. 362–4; and Overstreet, L. K., 2015.

198 For the society, see Owen, D. M., ed., 1981, *The Minute-Books of The Spalding Gentlemen's Society 1712–1755*, Lincoln Record Society, vol. 73, Lincoln.

199 Nichols, J., 1812–16, VI, p. 9. There is no record of the Spalding Gentlemen's Society having acquired a copy of the *Natural History*.

200 Allen, E. G., 1937, p. 352.

201 Mark, baptised 15 April 1731, died by 1740; John, born 6 March 1732, baptised 30 March, buried on 25 August 1732; Caroline, baptised 27 May 1733, buried 9 August 1733: Nelson, E. C., 2015, p. 15.

202 Mark's baptism in St Luke's is recorded in 'England Births & Baptisms 1538–1975', https://www.findmypast.co.uk/transcript?id=R_950224211, accessed 18 November 2019 (I thank Charles Nelson for this information).

203 Nelson, E. C., 2015, p. 15, suggests on the basis of the date of the elder Mark's baptism that 'Before July 1730' Catesby and Elizabeth Rowland had 'set up home … in the parish of St. Giles-without-Cripplegate'.

204 Mead, W. R., 2013, p. 44. Catesby was, however, 65 at this date; several other authors give Catesby's age incorrectly at the end of his life (see n. 208 below).

205 Knowlton to Richardson, letter CLVIII, 18 July 1749, in Turner, D., 1835, p. 400. Frick suggests: 'Catesby's dropsy [oedema] was symptomatic of conditions which caused his final seizure' (Frick, G. F., 1960, 'Mark Catesby: The Discovery of a Naturalist', *Papers of the Bibliographical Society of America*, 54, p. 172). However, it is likely that the head injury resulting from his fall was the actual cause of death.

206 Edwards to Pennant, 5 December 1761, MLM, MA 1550. Nelson, E. C., 2015, p. 19.

207 Edwards to Pennant, MLM, MA 1550. Nelson reproduces the church register entry for Catesby's burial, which gives the cause of death as 'age' (Nelson, E. C., 2015, p. 19, figs I–II).

208 *Caledonian Mercury*, 2 January 1750: Nelson, E. C., 2015, pp. 17–18. The announcement in the *Gentleman's Magazine* was printed in vol. 19, p. 573, with Catesby's age at death (66) also given incorrectly: 'Mr Mark Catesby, F.S.A., aged 70, author of the Natural History of Carolina, a large and curious work which is the chief support of his widow and two children' (cited by Allen, E. G., 1937, p. 351).

209 The total number of plates in the *Natural History* was 220.

210 Inscription in KH copy. Quoted, for example, in Turner, D., 1835, p. 401; Frick, G. F. & Stearns, R. P., 1961, p. 50.

211 Henrey, B., 1986, p. 292: 'Entry 422 [of Thomas Knowlton junior's library *Catalogue*]: Linnaeus's *Hortus Cliffortianus* … fol. 1757.

George Clifford gave this book to Mark Catesby, and he at his death will'd it to Thos. Knowlton.'

212 This was the copy sold by Catesby's nephew, Jekyll Catesby (referred to by Elizabeth Catesby as her 'cousin'), to the antiquary and naturalist Thomas Pennant, now in the Morgan Library & Museum, New York (Frick, G. F., 1960); for the drawings by Catesby which were contained in it, see forthcoming Catalogue.

213 NA, Kew, PROB/11/803. A transcription of the will is given by Allen, E. G., 1937, p. 353. Elizabeth died of consumption six weeks after making her will and was buried on 18 February 1753: Nelson, E. C., 2015, p. 20.

214 Edwards to Pennant, 5 December 1761, MLM, MA 1550.

215 Frick, G. F. & Stearns, R. P., 1961, p. 86.

216 As discussed above, many variables (including shifting notional values) make attempts at suggesting a modern equivalent of the value of Catesby's estate problematic. However, Collinson's comment that Elizabeth Catesby and her two young children were able to '[subsist] on the sale [of copies of the *Natural History*] for about 2 years' before the remaining copies of the book, copper plates and drawings were sold for £400 indicates there were sufficient funds for her family to live on (see Introduction).

217 *NH*, Appendix, p. 20.

218 See note 185.

219 Edwards to Pennant, 5 December 1661, MLM, MA 1550.

220 Hughes, I. D., 2004, 'Pulteney, Richard (1730–1801), botanist and physician', *ODNB*, Oxford.

221 Pulteney, R., 1790, II, p. 229. While Pulteney was only nineteen when Catesby died, and probably never met him, his information came from first-hand sources amongst Catesby's friends.

222 Mead, R. W., 2013, p. 44, who does not translate the Swedish word 'omgänge' [umgänge], which in this context approximates to (social) pretension. I am grateful to Judy Quinn and Mats Malm for their help with the translation.

223 By contrast, portraits exist of many of his friends, including Collinson (fig. 80), Dale (fig. 49), Edwards (fig. 81), Fairchild (fig. 72) and Sherard (fig. 18).

224 'Notices and Anecdotes of Literati, Collectors, etc. from a MS by the late Mendes

de Costa, and collected between 1747 and 1788' (item no. 30), *Gentleman's Magazine*, March 1812, p. 206 (quoted by Frick, G. F. & Stearns, R. P., 1961, p. 46).

225 Tinling, M., 1977, p. 498, letter to Captain Thomas Posford, *c.*August 1736.

226 Catesby was also one of the three witnesses to Fairchild's will on 20 February 1729 (Nelson, E. C., 2015, pp. 14–15). Leapman, M., 2000, pp. 191–2.

227 Armstrong, A. W., ed., 2002, '*Forget not Mee & My Garden …*': *Selected Letters 1725–1768 of Peter Collinson, F.R.S.*, Philadelphia.

228 Letter 7, 5 January 1723.

229 Recorded on title page of KH (see fig. 39).

230 It was these that Collinson mounted into the copy of the *Natural History* that Catesby gave him in return for the loan (KH); see forthcoming Catalogue.

231 As witnessed in his acting as signatory to Elizabeth Catesby's will. See above.

232 Knowlton writing to Richard Richardson, 8 March 1721, 'I hope that beloved botany will still share more and more of your favour' (Turner, D., 1835, p. 411).

233 See Chapter 5.

234 In 1729 Knowlton wrote to Sloane, 'My old aqu[tain]ance Mr Catesby has sent me down a part of his ffine History of Caralina having become a subscriber to it & hope shall procure him some more' (quoted by Henrey, B., 1986, p. 114).

235 Pulteney, R., 1790, II, p. 148.

236 Allen, D. E., 2004, 'Sherard, William (1659–1728), botanist', *ODNB*, Oxford. 'His affluence, joined to his learning, and agreeable qualities, rendered him… a liberal and zealous patron of the science [of botany]' (Pulteney, R., 1790, II, p. 149).

237 Letter 23, 15 August, 1724.

238 Letter 34, 10 January 1725.

239 Chapter 5, p. 164. A similar tribute was made to one of his noble subscribers, John Stuart, 3rd Earl of Bute, by Catesby naming the silky camellia 'Steuartia', which suggests that a closer acquaintance between the two men might have existed.

240 See Chapter 3, pp. 140–41.

241 See Chapter 3, pp. 93 and 295, n. 100.

242 The drawing Catesby copied from Sloane's album 'Of Quadrupeds' was of a Brazilian agouti (BM (P&D), Sloane 5261.119). The drawing Edwards gave Catesby was of a smooth-billed ani, *Crotophaga ani*, from Jamaica, which may have been in Sloane's collection; Catesby included it as Plate 3 in his Appendix.

243 Frick, G. F., 1960, p. 167; Chapter 3, p. 93. Wright, R., 2019, describes Edwards as serving 'as his friend and mentor's [Catesby's] literary and artistic executor': 'How Many Buntings? Revisiting the Relationship between Linnaeus and Catesby', https://blog.biodiversitylibrary. org/2019/12/how-many-buntings-html.

244 For example, Edwards, G., 1743–51, *A Natural History of Uncommon Birds*, London, pt 4, p. 218.

245 For their working relationship, see Chapter 4.

246 Letter 3, 22 June 1722.

247 ERO, D/Y/1/1/111, letter 82, 14 December 1722.

248 *NH*, Appendix, p. 20.

Chapter 3 • Catesby's Publications

1 Pehr Kalm, after his visit to Catesby, 23 May 1748: Mead, W. R., 2013, *Pehr Kalm: His London Diary*, Aston Clinton (privately printed).

2 *NH*, Preface, pp. vi–vii. A similar belief in the importance of images was expressed by Réaumur in his *Histoire des insects* (1737): see Chapter 6, pp. 216–17.

3 *NH*, Preface, p. xi.

4 The plates are signed 'Fr. C. Plumier Minimus Botanicus Regius delineavit' (or an abbreviation of this), with the engravings by 'I. Lud. Rollet'.

5 For the work of J. and M. Moninckx, see Quinby, J., 1958, *Catalogue of Botanical Books in the Collection of Rachel McMasters Miller Hunt*, I: *Printed Books 1477–1700 …*, Pittsburgh, PA, cat. 399.

6 All these were amongst works Catesby cited as his authorities: see Bibliography: Catesby's Authorities.

7 Stevenson, A., 1961b, *Catalogue of Botanical Books in the Collection of Rachel McMasters Miller Hunt*, II, pt 2: *Printed Books 1701–1800*, Pittsburgh, PA, pp. 116–22; Wiles, R. M., 1957, *Serial Publication in England before 1750*, Cambridge, pp. 90–91, 274.

8 Gorham, G. C., 1830, *Memoirs of John Martyn F.R.S. and of Thomas Martyn, B.D., F.R.S., F.L.S., Professors of Botany in the University of Cambridge*, London, p. 36. The cost of one guinea per part of ten plates of Martyn's book equates to Catesby's two guineas per part of twenty plates. A comparison with art prices of the period may be made with the fashionable artist Joseph Goupy's charge of twenty guineas for his gouache copies of paintings 'less than two feet in length' or forty or fifty guineas for 'larger gouaches' (Robertson, B., 1988, 'Joseph Goupy and the Art of the Copy', *Bulletin of the Cleveland Museum of Art*, LXXV, no. 10, December, p. 365). The sum of two guineas was also what Hogarth paid for a subscription to the new St Martin's Lane Academy in October 1720, 'a bold and expensive move' (Uglow, J., *Hogarth, A Life and a World*, London 1997, p. 65).

9 'we also propos'd to subjoin about 30 Plates of different Plants and Flowers … which were also to be painted in their natural Colours from the original Drawings: but upon our advancing in this Work, we found … the Charge of painting the Plates … would be a very expensive Undertaking' (Society of Gardeners, 1730, *Catalogus plantarum*, London, p. ix).

10 Although he later published a separate two-volume work of illustrations to his *Dictionary*, entitled *Figures of the most Beautiful, Useful and Uncommon Plants described in the Gardener's Dictionary*, with the etched and engraved plates made after watercolours painted by several artists including Georg Ehret (Stevenson, A., 1961b, cat. 566).

11 Heller, J. L., 1976, 'Linnaeus on Sumptuous Books', *Taxon*, 25, no.1, February, pp. 33–52 [pp. 33–5], translating Linnaeus's *Incrementa botanices*, Stockholm, 1753. Linnaeus mentioned Catesby, Ehret and Martyn's publications among authors of such high-priced illustrated natural history books.

12 *NH*, Preface, p. xi.

13 For Catesby's further use of professional letter engravers, see p. 95.

14 Gordon Dunthorne suggested a significant reason that Catesby learned to etch was 'because he was afraid that his drawings in the hands of another might suffer in translation' (Dunthorne, G., 1961, 'Eighteenth-Century Botanical Prints in Color', in Stevenson, A., *Catalogue of Botanical Books in the Collection of Rachel McMasters Miller Hunt*, II, pt 1: *Introduction to Printed Books 1701–1800*, Pittsburgh, PA, pp. xxi–xxxi [p. xxiii]).

15 Ray, J., 1678, *The Ornithology of Francis Willughby*, London, Preface, unpaginated [p. vi]. Authors' apologia for the quality of the plates in their books were not uncommon, however.

16 George Edwards, who learned etching from Catesby, describes its technical requirements in 'Some Brief Instructions for Etching or Engraving on Copper-Plates with Aqua Fortis', in *Essays upon Natural History and other Miscellaneous Subjects …*, London, 1770, pp. 158–71. For a modern account, see Griffiths, A., 1996b, *Prints and Printmaking: An Introduction to the History and Techniques*, London, pp. 56–71. The matter of the length of time required to leave copper plates in the acid bath to achieve the right density of line, for example, could only be learned through experience.

17 *NH*, Appendix, p. 20.

18 Ibid.

19 Gaskell, R., 2004, 'Printing House and Engraving Shop: A Mysterious Collaboration', *Book Collector*, 53, pp. 213–51, and Gaskell, R., 2018, 'Printing House and Engraving Shop, Part II: Further Thoughts on "Printing and Engraving Shop: A Mysterious Collaboration"', *Book Collector*, 67, pp. 788–97.

20 Henrey, B., 1975, *British Botanical and Horticultural Literature before 1800*, II: *The Eighteenth Century*, London, New York & Toronto, p. 52, n. 4. For subscription publishing, see Wallis, P. J., 1974, 'Book Subscription Lists', *Library*, 5th series, XXIX, pp. 255–86; Gaskell, P., 1972, *A New Introduction to Bibliography*, Oxford, p. 181; and Brewer, J., 1997, *The Pleasures of Imagination*, London, p. 164, who notes that the number of subscription volumes rose rapidly between the late seventeenth century and the 1730s.

21 Stevenson published a transcription of Martyn's Latin proposals, noting that 'so important is this document in the history of subscription books and books issued in parts that I give it entire' (Stevenson, A., 1961b, p. 120). John Martyn published an English translation of his proposals at the end of his translation of Tournefort, J. P. de, 1732, *History of Plants growing about Paris …*, Paris, I, p. 312; this is also reproduced in Henrey, B., 1975, p. 665.

22 Robertson, B., 1988, 'Joseph Goupy and the Art of the Copy', *Bulletin of the Cleveland Museum of Art*, LXXV, no. 10, December, pp. 355–77.

23 Society of Gardeners, 1730, p. ix.

24 See Bibliography, p. 328.

25 Letter 40, 20 May 1740. Catesby wrote this before he had decided on writing an Appendix of a further twenty plates, thus making a total of eleven parts.

26 William Innys (active 1711–32), one of the leading booksellers in London during the first quarter of the eighteenth century. Together with John Innys, he published many of Isaac Newton's works (Plomer, H. R., 1932, *A Dictionary of the Printers & Booksellers who were at work in England … from 1726 to 1775*, Oxford). Catesby referred to his 'Proposals' himself in a letter to his niece of 30 December 1731: letter 37. Nicholas Jekyll also referred to them in a letter to Holman of 6 February 1730: ERO, D/Y/1/1/111, letter 180, 6 February 1730.

27 Friends Library, London, Gibson MSS 4, p. 33. It would seem, however, that neither Thomas Story nor Lord Lonsdale became subscribers, as they are not included in Catesby's 'List of Encouragers'.

28 Letter from Peter Collinson to John Martyn, undated (but *c.*1727), Banksian MSS 103 (letters presented by Thomas Martyn to Joseph Banks, 14 March 1817), Department of Plant Sciences, University of Cambridge.

29 Overstreet, L. K., 2015, discusses in detail the different typesettings of the 'Proposals' (p. 156). Stevenson, A., 1961b, p. 145, suggests that the 'Proposals' was distributed together with twelve sample coloured etchings from evidence of copies in the Bodleian Library in Oxford, Peabody Institute in Baltimore, and Wagner Free Institute of Science in Philadelphia. However, this seems intrinsically unlikely, not only because of the significant expense and labour involved in distributing that many samples, but because the 'Proposals' mentions specifically that 'the Author's … Original Paintings' could be viewed by way of examples.

30 Philip Miller, by contrast, in his Proposals for his *Gardeners' Dictionary* of 1731, stated that the price for subscribers was 'one pound five shillings in sheets, the whole to be paid at the time of subscribing' (Henrey, B., 1975, pp. 214–15). For a useful summary of subscription publishing at this period, see ibid., pp. 659–65.

31 Inscription in Collinson's copy of the *Natural History* (KH).

32 James Raven notes that during the eighteenth century, 'Paper remained the single most expensive capital outlay' in the production of books: Raven, J., 2007, *The Business of Books: Booksellers and the English Book Trade, 1450–1850*, New Haven & London, pp. 308–9.

33 Overstreet, L. K., 2015, pp. 160–62.

34 The 'List of Encouragers' (subscribers) exists in two versions; in the second version an extra name, 'Earl of Iley' (Archibald Campbell, 1st Earl of Islay, later 3rd Duke of Argyll), possibly a late subscriber, is added at the bottom of the first page (ibid., p. 159).

35 Ten subscribers are indicated by a dash after their name, but apart from William Innys, who bought four copies, the quantities they bought are not specified. Overstreet calculates that around 200 copies were printed, of which an estimated 100 copies survive (ibid., p. 165, and Overstreet, L. K., 'A Census of Surviving Copies of Catesby's *Natural History of Carolina* [1731–1743]', work in progress).

36 See Introduction, p. 1.

37 See Chapter 4.

38 'Advertisement' for the Appendix (see fig. 112). For a discussion of this and other ephemera found in her survey of the first editions of the *Natural History*, see Overstreet, L. K., 2015, pp. 163–5.

39 For Ray's classification, see Raven, C., 1950, *John Ray, Naturalist: His Life and Works*, Cambridge, pp. 324–5. For Catesby's use of Ray, see Krech, S., III, 2018, 'Catesby's Birds', in MacGregor, A., ed., *Naturalists in the Field: Collecting, Recording and Preserving the Natural World from the Fifteenth to the Twentqy-First Century*, Leiden & Boston, pp. 279–331.

40 See Chapter 4. For an example of Catesby's influence in this respect on J. J. Audubon's *Birds of America* (London, 1827–38) see McBurney, H., 1997, *Mark Catesby's Natural History of America*, London p. 56.

41 *NH*, Preface, p. vi.

42 Ibid., p. ix.

43 *NH*, I, p. 11.

44 University of Virginia, Tracy W. McGregor Library accession no. 4530 (Albert and Shirley Small Special Collections Library). The manuscript was purchased from Richard S. Wormer Books, New York, 31 October 1953, identified as an 'Autograph Manuscript Signed [by Mark Catesby] with changes and comments by Cromwell Mortimer … Endorsed on last page, 'Feb. 18, 1747-8'.

45 MLM, MA 6038 (1–6). These neat versions are for the Appendix, pp. 4, 10, 11, 16 and 19.

46 For the dates of Catesby's presentation of parts to Royal Society, see Overstreet, L. K.,

2014, 'The Dates of the Parts of Mark Catesby's *The Natural History of Carolina* … (London, 1731–1743 [1729–1747])', *Archives of Natural History*, 41, pt 2, short notes, pp. 362–4, and Overstreet, L. K., 2015, pp. 158ff.

47 *London Evening Post*, 5–7 February 1730; *Country Journal*, 21 February 1730.

48 For these quantities see note 71 below.

49 'As to the French translation I am oblig'd to a very ingenious Gentleman, a Doctor of Physick, and a Frenchman born, whose Modesty would not permit me to mention his Name' (*NH*, Preface, p. xii). It is possible that Catesby met this French doctor through the London immigrant community to which Godfrey Smith, his printer as well as one of his subscribers, also belonged. For the French translation of his *Natural History of Uncommon Birds*, George Edwards used the services of Monsieur Durand, a fellow of the Royal Society and a Protestant minister serving in the French church in London. Durand disguised his name on the title page as 'MD de la SR'.

50 As is evident from the dating evidence of the 'Proposals' and the multiple settings of Parts 1–4 (see notes 29 and 56).

51 Overstreet, L. K., 2015, p. 160.

52 For paper sizes and terms used to refer to different quality papers, see Appendix 2, pp. 224, 229.

53 Jones, L. H., 1891, *Captain Roger Jones of London and Virginia*, Albany, NY, pp. 120–21.

54 Ibid.; letter 41 to John Bartram, 25 February 1741. This copy has now been identified with the coloured 'variant copy' at the Smithsonian: SIL, Sfcuncat, catalogue record, bib. no. 54245; see p. 81 and fig. 97, and Overstreet, L. K. & McBurney, H., forthcoming, 'A Variant Version of Catesby's *Natural History of Carolina* given to John Bartram'.

55 Stevenson, writing of the 'Proposals': 'the work [was] intended to be produced in two formats, presumably royal and certainly imperial, the first with black-and-white plates, at half the large-paper price' (Stevenson, A., 1961b, p. 146). A puzzle, however, is that not only from all copies checked it would seem the 'Proposals' was printed on (trimmed) imperial-size paper, but, according to the watermarks found on them, the same quality paper was used as for the 'finest Imperial' coloured copies: see Bibliography, pp. 328–9, and Appendix 2.

56 The few uncoloured copies located would appear to be early copies from the fact that they are all of the first typesetting (for the different typesettings of the first four parts of the book, see Overstreet, L. K., 2015, pp. 160–61). Of the approximately eighty-five copies examined by Overstreet, only four (partial) uncoloured sets have been found: NHM (Ealing copy); Bibliothèque Nationale, Paris (Tolbiac copy); CPG (possibly Samuel Dale's copy, B6/17); Duke of Richmond ('Birds': library classmark S.B.1, plates only).

57 For Queen Caroline's copy, see McBurney, H., 1997, *Mark Catesby's 'Natural History' of America: The Watercolours from the Royal Library, Windsor Castle*, exh. cat., London, p. 32, n. 17. The copy has not been identified.

58 KH copy, inscription in Collinson's hand, Volume I, title page.

59 RS, *Journal Book*, XX, p. 351, 'for which thanks were returned to Mr Catesby, as well as for his very valuable book itself, which is now compleat, with all the cuts'. Other copies which contain contemporary inscriptions claiming the colouring was done by Catesby include Jekyll Catesby's (MLM, inscribed, 'These books colored by the author I bought from his nephew Mr Catesby Haberdasher in Henrietta Street Covent Garden April 1766, together with some of the original drawings'); the copy in Dr Mead's book sale described as 'Catesby's Natural History of Carolina, cuts most beautifully coloured, by himself' (23 November 1754, p. 26, probably now identifiable with the copy bought by George III [King's Library: BL, shelfmark 44.k. 7, 8]); and the copy at King's College, Cambridge, inscribed, 'This copy was color'd by Catesby himself expressly for Mr Willett, and may be considered matchless').

60 Miller, E., 1987, *Hand-Coloured British Prints*, exh. cat., Victoria and Albert Museum, London, p. 6. Nickelsen, K., 2006a, 'The Challenge of Colour: Eighteenth-Century Botanists and the Hand-Colouring of Illustrations', *Annals of Science*, 63, no. 1, January, pp. 2–23; Jackson, C. E., 2011, 'The Painting of Hand-Coloured Zoological Illustrations', *Archives of Natural History*, 38, no. 1, pp. 36–52. The title page of Albin's *Natural History of Birds* states that it was 'Illustrated with a Hundred and one Copper Plates, Engraven from the Life, Published by the Author … and carefully colour'd by his Daughter and Himself'. For a general discussion of the hand colouring of prints, see Griffiths, A., 2016, *The Print before Photography: An Introduction to European Printmaking, 1550–1820*, London, ch. 9.

61 University of Virginia, Tracy W. McGregor Library accession no. 4530. The statement is included also in Mortimer's review of the Appendix published in *Philosophical Transactions*, 45, no. 486, 1748, p. 173.

62 For the need of the botanist/artist to supervise colouring of natural history prints, see Nickelsen, K., 2006b, *Draughtsmen, Botanists and Nature: The Construction of Eighteenth-Century Botanical Illustrations*, Dordrecht, pp. 68–70, and Nickelsen, K., 2006a.

63 CUL, classmark Syn.4.74.4. A further inscription notes that six other retouched copies were 'designed as standards to discover any bad Colour coppyes that may chans to be published after my death'. These other copies were presented to the University of Oxford, the Royal College of Physicians, the Royal Society, the Society of Antiquaries, the British Museum and the 'Academy Royal of Paris'.

64 See, however, p. 71 for Catesby's need for external professional input.

65 Such damage happened regularly, including to Ehret's original watercolours used as the patterns for colourists (Nickelsen, K., 2006b, pp. 63–4).

66 SIL, Sfcuncat; for further discussions of this copy (including graphite marks and doodles and calligraphic trials in pen and ink, which would appear to have been made by both John and William Bartram), see Overstreet, L. K. & McBurney, H., forthcoming. Very few, if any, early pattern plates survive, both because they would have been heavily used and also because there would have been no reason to keep them. A later example is provided by the plates for Sowerby, J., 1820–34, *Genera of Recent Fossil Shells* …, London, where there are numerous paint daubs and written colour annotations in the plate margins (NHM, Sowerby Collection, DF601/45, C46, folder A92); I thank Roger Gaskell for bringing this to my attention.

67 Copies of the plates are likely only to have been printed and coloured when ordered; for example, Part 1 for a different subscriber may have been coloured much later according to the date of the purchase (Overstreet, pers. comm.). A preliminary study has been made of the following first edition copies: Trinity College, Cambridge (Walker and Rothschild copies); King's College, Cambridge (Thackeray copy); Royal Society, London (Catesby's presentation copy); KH (Collinson copy); SIL (Mortimer and Bartram copies); and the NHM, London.

68 Part 4 was published 4 November 1731, and Part 5 on 23 November 1732 (fig. 93).

69 Letter 36, 1 March 1730.

70 ERO, D/Y/1/1/111, letter 187.

71 This figure is based on the existence of multiple typesettings of Part 1 (Plates 1–20): extrapolating from Overstreet's census of 85 copies examined, in which 30 per cent were the first typesetting, we may calculate that as many as 54+ copies were produced from it of the estimated 180 total (Overstreet, L. K., 2015, and pers. comm. March 2020).

72 *NH*, II, p. 82.

73 Catesby, 'Proposals', *c*.1728.

74 See fig. 93 above.

75 The preliminary material seems to have been printed in 1731 in anticipation of the completion of Part 5: Overstreet, L. K., 2015, p. 163.

76 The reference to the 'Preface' in the Note seems to refer rather to the Account, as an eight page Preface had already been sent out with Part 5 (Leslie Overstreet, pers. comm.).

77 For a discussion of the variations in different copies of the order of binding the Preface, map, Account and Appendix, see Overstreet, L. K., 2015.

78 Volume II, Plate 13, Catesby's 'Sea-Feather', Gorgoniidae (unidentified), is a soft coral, a member of the subclass of octocorals.

79 These are also octocorals.

80 Presented 15 January 1736.

81 Nineteen snakes and one legless lizard (eastern glass lizard, *Ophisaurus ventralis*, *NH*, II, 59).

82 Presented 7 April 1736.

83 Presented 7 June 1739.

84 Evidently Catesby changed the order at a late stage after the plates had been engraved with their numbers (but before printing the text which proceeds in the revised order); several copies of the *Natural History* show his correcting the engraved numbers in ink (examples of these are found at the RS, SIL and Boughton House, Northamptonshire). Both plates were later corrected in the copper plate to reflect this renumbering. The reasons for Catesby's making this change are discussed in Chapter 4.

85 Presented on 15 December 1743. Catesby stated the reason for not including more insects in his work in the Account, p. xxxvii.

86 While Catesby's papers have not survived, in the Account he mentions his earlier records several times, for instance, p. v: 'As some remarks I made then may serve to illustrate what I have now said, I hope it may not be amiss to recite so much of them as may serve for that purpose.'

87 Copies of the 'Advertisement', through which Catesby also informed his subscribers that both volumes could now be bound, are found in sets of the *Natural History* in SIL and at Trinity College, Cambridge: Overstreet, L. K., 2015, pp. 164–5.

88 See Chapter 4 and forthcoming Catalogue.

89 *NH*, Appendix, p. 20.

90 The completed volume, together with Appendix, was advertised on 21/23 April 1748 in the *General Evening Post* (issue 2275), with the notice that it was 'To be sold by W. Innys in Paternoster Row, and R. Manby & H. S. Cox on Ludgate Hill, and at the Auction House, near St Luke's Church', and a further comment: 'N.B. Single Parts to complete Sets will be had at the above-mentioned Places for twelve Months from the Date hereof, and no longer, the Author undertaking after that to dispose of none but complete Sets.'

91 Edwards, G., 1743–51, *Natural History of Uncommon Birds* …, London, I, p. 49.

92 *NH*, Appendix, p. 20.

93 Ibid.

94 For full bibliographic references to the works included in this section, see Bibliography, p. 329–30.

95 Although Frick and Stearns minimize Edwards's involvement in the second and third editions (Frick, G. F. & Stearns, R. P., 1961, *Mark Catesby: The Colonial Audubon*, Urbana, IL, pp. 100–1), and other authors have followed suit, the present author believes from other evidence cited here that he was more involved than he is generally given credit for.

96 Plomer, H. R., 1932: Charles Marsh (1730?–1767), who was also a publisher and author.

97 Overstreet notes that the second edition was made up with 'at least some (and in one copy, entirely with) printed sheets of text from the first edition, identifiable by their large pictorial initials' (Overstreet, L. K., 2015, p. 166). For minor textual changes – such as sections of pagination – see Frick, G. F. & Stearns, R. P., 1961, p. 100.

98 An example is the removal of the pentimento of the tongue of the pygmy rattlesnake, *Sistrurus miliarius* (*NH*, II, 42).

99 *London Daily Advertiser* (22 October 1753), meanwhile, stated that Edwards would 'in regard to [Catesby's] Memory … inspect every colour'd Plate that shall be exhib'ted to the Publick'. Examples of the correcting of colours are *NH*, I, 17, and Appendix, 20. The second edition 'Proposals' was published on 25 October 1753; an advertisement for it was carried in the *Whitehall Evening Post or London Intelligencer* for 3 January – 1 April 1756. For a transcription of the wording of the second edition 'Proposals', see Bibliography, p. 329.

100 The copy that Edwards coloured himself, in the Newberry Library, Chicago, contains his hand-drawn bookplate lettered: 'This Volume was coloured by Geo. Edwards, FRS. Author of a natural History of Birds & Gleanings of Natural History, from the original Drawings of the Author Mark Catesby, FRS.'

101 Benjamin White (1725?–1794), bookseller at Horace's Head, Fleet Street, specialized in books on natural history (Plomer, H. R., 1932); see also Nichols, J., 1817–58, *Illustrations of the Literary History of the Eighteenth Century*, London, III, p. 127.

102 Overstreet, L. K., 2015, pp. 168–71; Bibliography, pp. 329–30.

103 Jarvis, C. E., 2015, 'Carl Linnaeus and the Influence of Mark Catesby's Botanical Work', in Nelson, C. E. & Elliott, D. J., eds, *The Curious Mister Catesby: A 'Truly Ingenious' Naturalist Explores New Worlds*, Athens, GA, & London, pp. 189–204.

104 Overstreet, L. K., 2015, p. 117. She further notes: 'White seems simply and cannily to have printed a large number of copies of the text when it was set in type in 1771 and drawn on that stock as needed. He printed and coloured sets of the plates in smaller batches as the market required over the years, evidenced by the fact that some copies of the edition contain plates on either laid or wove Whatman paper with watermark dates ranging from 1794 to 1816'.

105 Examples of rearrangement of Catesby's subjects are Seligmann, J. M., 1749–76, *Sammlung verschiedener auslandischer und seltener Vogel* …, Nuremberg, II, tab. XVI and XVIII.

106 Frick, G. F. & Stearns, R. P., 1961, pp. 102–3.

107 Most of the plates are signed J. Cave.

108 *Gentleman's Magazine*, XXII, 1752, p. 300.

109 For a list of these, see Bibliography, p. 329. See also Nelson, E. C., 2020, 'Catesby's North American Images in *The Gentleman's Magazine*, 1750–1755', *Archives of Natural History*, 47, pt 1, short note, April, pp. 186–9.

110 Nelson, E. C., 2014b, 'Georg Dionysius Ehret, Mark Catesby and Sir Charles Wager's Magnolia Grandiflora: An Early Eighteenth-Century Picture Puzzle Resolved', *Rhododendrons, Camellias and Magnolias*, 65, pp. 36–51, describes and illustrates a number of watercolours and prints that Ehret made of this flower: fig. 2 shows Ehret's print and fig. 3 the field-sketch (in the NHM) used as the model for the flower head in the composite print.

111 Ehret to Trew, 26 July 1738, quoted in Raphael, S., 1989, *An Oak Spring Sylva: A Selection of the Rare Books on Trees in the Oak Spring Garden Library*, Upperville, VA, cat. no. 14, pp. 49–52 (p. 52).

112 The tepal is rather flat. Ehret himself included a different 'repaired' version of the tepal in what is likely to have been a later composite watercolour on vellum, now in the Oak Spring Garden Foundation collection (see fig. 5 in Nelson, E. C., 2014b).

113 A variation of the detail of the fruiting head shown with the seed follicles closed is included in Catesby's unpublished watercolour of *Magnolia tripetala* (RCIN 926041), see forthcoming Catalogue.

114 I am grateful to David Alexander and Roger Gaskell for their advice on this point.

115 A separate catalogue by Gray dated 1755, also mentioned by Henrey, B., 1975, p. 349, is in the Lindley Library of the Royal Horticultural Society, London (Harvey, J. H., 1973, *Early Horticultural Catalogues*, Bath, p. 10).

116 See, for example, Henrey, B., 1975, p. 348, and Raphael, S., 1989, cat. no. 14, pp. 49–52 (p. 49), who suggests '*circa* 1737'. Mark Laird believes that because of a very cold winter in 1739/40 when all *Magnolia grandiflora* would have been killed off in London, the 'Catalogue' may have been in preparation earlier, i.e. between 1737 and 1739, but was not published until 1742 when Gray's nursery stock had recovered (pers. comm.). For information on the magnolia in cultivation, see Laird, M., 2015b, 'Mark Catesby's Plant Introductions and English Gardens of the Eighteenth Century', in Nelson, E. C. & Elliott, D. J., eds, *The Curious*

Mister Catesby: A 'Truly Ingenious' Naturalist Explores New Worlds, Athens, GA, & London, pp. 265–80.

117 Nelson, E. C., 2014b, pp. 36–51.

118 Letter 44, 26 March 1745.

119 Cited as the *Natural History of Florida* and abbreviated to 'H.F.' Of the other references, five are to the Society of Gardeners' *Catalogus plantarum* (1730) and one to the *Hortus Elthamensis* (1732). The single abbreviated reference to 'Hort. Paris' may not be to a 'Book of Naturall History' as are the other references, but rather to the royal garden in Paris where the plant was grown (I thank Charles Nelson for this suggestion).

120 Stevenson proposed that as much of Gray's 'list [of shrubs in his 'Catalogue' of *c.*1742] corresponds to the contents of the *Hortus Britanno-Americanus … [it] may have suggested to Catesby the idea of this later publication' (Stevenson, A., 1961b, p. 291).

121 *HBA*, Preface, p. i.

122 See, for example, entry for 'The Catalpa-tree', no. 47, pp. 24–5, and 'The Cockspur Thorn', no. 77, p. 37.

123 Henrey, B., 1975, p. 339, n. 10.

124 Ibid., 1975, p. 275.

125 *HBA*, no. 47, pp. 24–5.

126 As pointed out by Stevenson, A., 1961b, p. 291.

127 *HBA*, p. iii. Although Catesby's claim of reproducing the details life-size is mainly true, in a few instances they are necessarily reduced to fit into the respective quarter of the square plate (see, for example, nos 4, 'The Umbrella Tree', and 3, 'The Sweet Flowering Bay').

128 For a discussion of this concept, see O'Malley, T., 1998, 'Mark Catesby and the Culture of Gardens', in Meyers, A. R. W. & Pritchard, M. B., eds, *Empire's Nature: Mark Catesby's New World Vision*, Chapel Hill, NC, & London, pp. 147–83.

129 The term 'quarto' is used here in its bibliographic sense to refer to the format rather than the size (Stevenson, A., 1961b, cat. 578, correctly designates it as 'a quarto in 2s', and Raphael, S., 1989, cat. 15, pp. 52–6 [p. 53], as a 'large Imperial Quarto').

130 The cost of the *Hortus-Britannno Americanus* in 1764 was 2 guineas, the same as the original cost of one coloured part of the *Natural History*.

131 The two plates with a single plant are no. 1, *Magnolia grandiflora*, and no. 84, *Sabal palmetto*. For a cross-reference to the equivalent plates in the *Natural History* (although no. 70, relating to *NH*, I, 28, is lacking), and a list of the plates with the Linnaean names provided in the 1771 edition of the *Natural History*, see Stevenson, A., 1961b, pp. 288–92.

132 The images are not 'miniatures' as they have been described (Frick, G. F. and Stearns, R. P., 1961, p. 69; Meyers, A. R. W. & Pritchard, M. B., 1998, 'Introduction: Toward an Understanding of Catesby', in Meyers, A. R. W. & Pritchard, M. B., eds, *Empire's Nature: Mark Catesby's New World Vision*, Chapel Hill, NC, & London, pp. 1–33 [p. 11, n. 2]).

133 *NH*, I, 38.

134 While the images for nos 4, 18 and 34 appear to be by Catesby, no. 84 is unusually stylized and may be by another hand (see fig. 121).

135 For a discussion of the new plants, see Chapter 5.

136 *HBA*, nos 17–20, 31–4, 43–6.

137 Ibid., nos 27–30, 47–50.

138 Ibid., for example, nos 65, 66, 67.

139 Ibid., for example, 'the locust tree', no. 68, and 'the red flowering maple', no. 63.

140 Frick, G. F. & Stearns, R. P., 1961, p. 68.

141 *HBA*, no. 29, p. 16.

142 Ibid., no. 25, p. 14.

143 Ibid., no. 4, p. 4.

144 Ibid., no. 72, pp. 35–6. The 'person of probity and curiosity' may have been Alexander Skene (see Chapter 2, p. 55, and Chapter 3, pp. 156–7).

145 Frick, G. F. & Stearns, R. P., 1961, for example, describe the plates by comparison with those in the *Natural History* as 'hardly better than hack work' (p. 43).

146 An example is no. 24, 'The Fringe Tree', where the features of the much denser bunch of flowers and the new addition of the berries (not included in *NH*, I, 68) indicate that the plates were not simply adaptations of those in the *Natural History*.

147 Rather than, for instance, being added by the editor, as the figure numbers must have been. The monogram appears on nos 1, 2, 5, 14

(on its side), 25, 30 (on its side), 33, 37, 41, 43 (upside down), 53, 55, 56, 81.

148 *HBA*, Preface, p. ii.

149 Ibid., no. 70, the 'clustered black cherry'; and no. 84, the 'Palmeto-tree'.

150 *NH*, Account, p. xli.

151 Although this does not explain why Gray, who died a year after *HBA* was published, should have delayed so long before publishing it.

152 Other than the title page, no other changes were made in this reissue, which was published by the London bookseller John Millan, using the same printed texts with the plates reprinted on wove paper: Bibliography: Catesby's Published Works; Henrey, B., 1975, p. 277.

153 It is discussed more fully in Chapter 6 together with the other papers Catesby presented to the Royal Society; all were published in shortened versions in the Account in the *Natural History*.

154 RS, *Journal Book*, 5 March 1747.

155 RS, *Philosophical Transactions*, 44, no. 483, 1747, pp. 435–44. See Bibliography, p. 331.

156 'Extract from a Paper … written by Mark Catesby, F.R.S. in *Phil. Trans.* No. 483', *Gentleman's Magazine*, 18, October 1748, pp. 447–8. See Bibliography, p. 331.

Chapter 4 • Catesby as Artist

1 *NH*, Preface, p. vi.

2 Eleazar Albin, for example, employed professional engravers to reproduce his drawings with less successful results (see below).

3 *NH*, Preface, p. vi.

4 Sloan, K., 2000, *A Noble Art: Amateur Artists and Drawing Masters, c.1600–1800*, London, p. 40, who gives the origin of the words 'limn', 'illuminate' and 'miniature'.

5 A 'limner' referred to any 'painter; a picture maker': Johnson, S., 1755, *A Dictionary of the English Language in which the words are deduced from their originals …*, London. Sloan points out that 'commentators on the place of limning in British art in general have regarded it as a forerunner to watercolours' (Sloan, K., 2000, p. 43). Henry Gyles, a seventeenth-century glass painter wrote in 1664: 'Limning is an art of Curious Working in Water Colours. I may well say of Curious working for there is no Art wherein Curiosity can be more

expressed than in the Art of Limning' (quoted in Hardie, M., ed., 1919, *Miniatura or the Art of Limning, by Edward Norgate …*, Oxford, p. xxi).

6 *NH*, Preface, pp. vi–vii.

7 See Sloan, K., 2000; Sloan, K., 1986, 'The Teaching of Non-Professional Artists in Eighteenth-Century England', PhD thesis, Westfield College, London, p. 13.

8 See Sloan, K., 2000, p. 44. Peacham, self-taught himself, wrote the manual for the benefit of his Greek and Latin pupils.

9 The long explanatory subtitle reads: *Or an exquisite practise, as well for drawing all manner of Beasts in their true Portraitures: as also the making of all kinds of colours, to be used in Lymning, Painting, Tricking, and Blason of Coates, and Armes … for all young Gentlemen and others …*

10 Byrd had inherited it from his father, William Byrd I (Hayes, K. J., 1997, *The Library of William Byrd of Westover*, Madison, WI, p. 4 and cat. no. 248).

11 Blome, R., 1686, *The Gentlemans Recreation, in two parts, the first being an Enclopedy of the arts and sciences …*, London, pp. 214ff. Much of this was taken from Henry Peacham as well as from a manual by Thomas Jenner, 1666, *A Book of drawing, limning, washing or colouring of maps and prints and the art of painting with the names and mixtures of colours used by the picture-drawers*, London.

12 See Sloan, K., 2000, p. 58, figs 35(a) and (b), who notes that Hans Sloane collected copies of these compilations of natural history prints.

13 Bowles, C., 1782, *New and Englarged Catalogue … of Elegant Drawing Books*, London, p. 46, item 13, and p. 165, item 19. Hodnett, E., 1978, *Francis Barlow: First Master of English Book Illustration*, London, p. 11.

14 Both Greek and Latin versions of *Aesop's Fables* were still part of a boy's classical education during the eighteenth century, as well as being considered suitable moralistic teaching for children. John Locke advocated their use for children, especially if they were illustrated, in *Some Thoughts concerning Education* (1693); he produced an interlinear version in 1703, published by Awnsham Churchill. *Aesop* was also a staple of gentleman's libraries; William Byrd, for instance, owned one edition in French and two in Latin and Greek (Hayes, K. J., 1997, cat. nos 1411, 1579 and 1593).

15 The education of the naturalist and physician Martin Lister (1639–1712) included practice in penmanship so that he could learn

to 'lean softly upon his pen' (Roos, A. M., 2019, *Martin Lister and his Remarkable Daughters: The Art of Science in the Seventeenth Century*, Oxford, p. 18).

16 A copy of this was in Pepys's collection; see McKitterick, D., et al., 1989, *Catalogue of the Pepys Library at Magdalene College, Cambridge*, IV: *Music, Maps and Calligraphy*, Woodbridge, pp. 131–63. Similar skills of fluency of line and layout of objects on the page are seen in the inscribed drawings of plants made by Richard Waller for the Royal Society, whose work Catesby may have known (Kusukawa, S., 2011, 'Picturing Knowledge in the Early Royal Society: The Examples of Richard Waller and Henry Hunt', *Notes and Records*, 65, no. 3, September, pp. 273–94).

17 Bickham, G., 1733, *Penmanship made easy, Or the Young Clerk's Assistant*, London, reprinted New York, 1997, pp. 12, 31, 32.

18 *NH*, Preface, p. xi.

19 See Chapter 3.

20 The Walther volume is now in BL, Add MSS 6485, 8486. See Birkhead, T., 2008, *The Wisdom of Birds: An Illustrated History of Ornithology*, London, pp. 28, 35, 147, 191, 254–5; Flis, N., 2015, 'Francis Barlow, the King's Birds, and the Ornithology of Francis Willughby and John Ray', in Henderson, F., Kusukawa, S. & Marr, A., eds, 'Curiously Drawn: Early Modern Science as a Visual Pursuit', *Huntingdon Library Quarterly*, 78, no. 2, summer, pp. 266–7. For Walther, best known for his florilegium, see Blunt, W. & Stearn, W. T., 1994, *The Art of Botanical Illustration*, Woodbridge, pp. 138–9, and Saunders, G., 1995, *Picturing Plants: An Analytical History of Botanical Illustration*, London, esp. pp. 41ff.

21 See Chapter 2.

22 Sloane's 'Books of Miniature' numbered 136 volumes in 1725: Sloan, K., 2012, 'Sloane's "Pictures and Drawings in Frames" and "Books of Miniature & Painting, Designs, &c."', in Walker, A., MacGregor, A. & Hunter, M., eds, 2012, *From Books to Bezoars: Sir Hans Sloane and his Collections*, London, pp. 168–89.

23 *NH*, Preface, p. iv.

24 Ibid., Appendix, p. 20. See figs 69 and 113.

25 See Introduction., p. 5. McBurney, H., 2001b, 'Catesby's Techniques as a Draftsman and Printmaker', in O'Connor, M. & Fradkin, A., eds, *Opening the Door to a New World: Mark Catesby's Travels in La Florida 1722–1726*, exh. cat., Boca Raton, FL, pp. 16–17.

26 The versos are reproduced in the forthcoming Catalogue.

27 In the case of the bison, however, it was not until he returned to England that he was able to find an illustration (by Everard Kick in Sloane's albums – see p. 130) to serve as an adequate model for a 'perfect likeness'. He adapted the prototype to make two different images (see figs 69 and 113).

28 Letter 6, 4 January 1723.

29 The annotated drawing of a tulip tree is on the verso of what is Catesby's only surviving drawing on vellum, originally mounted with other drawings in a copy of the *Natural History* belonging to Catesby's nephew Jekyll Catesby, which later passed into the collection of the naturalist Thomas Pennant (MLM, 1961.6:2v; see forthcoming Catalogue).

30 Brogert's chart contains 800 pages of colour samples with descriptive text (I am grateful to Michael Suarez for bringing it to my attention). A later colour chart created by Ferdinand Bauer used for the illustrations of the *Flora Graeca* (1806–40) is well known (Mabberley, D. J., 2017, *Painting by Numbers: The Life and Art of Ferdinand Bauer*, Sydney).

31 Overlays made of some of the outlines and final watercolours have shown that Catesby both traced and copied these compositional sketches. For example, a pen and ink outline of the swallowtail kite, *Elanoides forficatus* (RCIN 925875v) was copied and in the process changed slightly in the final composition (RCIN 924817), whereas a sketch of the laughing gull, *Larus atricilla* (RCIN 926031v), was traced for the final composition (RCIN 925924). An outline in graphite of a white fox found on the verso of RCIN 925986 was traced from a drawing in one of Sloane's albums (BM (P&D), Sloane 5261.164), although this image was not used in the *Natural History*. See forthcoming Catalogue for these images.

32 Sanderson, W., 1658, *Graphice, the use of the Pen and Pensil, or the most Excellent Art of Painting*, p. 11.

33 Jackson, C. E., 2011, 'The Painting of Hand-Coloured Zoological Illustrations', *Archives of Natural History*, 38, no. 1, pp. 36–52. Jackson notes that the different sizes were referred to by birds' names in suppliers lists of artists' materials.

34 McBurney, H., 2001b, pp. 16–17.

35 *NH*, Preface, p. vi. He admits, however, 'I do not pretend to have had this advantage in all, for some kinds I saw not plenty of, and of others I never saw above one or two.'

36 Amphibians and reptiles were not classified as distinct groups in Catesby's time.

37 *NH*, Preface, p. vii.

38 Ibid.

39 Ochs, K. H., 1985, 'The Royal Society of London's History of Trades Programme: An Early Episode in Applied Science', *Notes and Records*, 39, no. 2, 1 April, pp. 129–58.

40 Marshal to Povey, 30 November 1667 (Leith-Ross, P. & McBurney, H., 2000, *The Florilegium of Alexander Marshal in the Collection of Her Majesty The Queen at Windsor Castle*, London, pp. 12–13). For discussions of how such information was treated as 'secret', see Niekrasz, C. & Swan, C., 2006, 'Art', in Park, K. and Daston, L., eds, *The Cambridge History of Science*, III: *Early Modern Science*, Cambridge, pp. 773–96, and Eamon, W., 1994, *Science and the Secrets of Nature: Books of Secrets in Medieval and Early Modern Culture*, Princeton.

41 Waller's chart had itself been inspired by Elias Brenner's list of 'simple' or 'primary' colour samples 'which the masters of miniature paintings have especially used': Kusukawa, S., 2015, 'Richard Waller's Table of Colours (1686)', in Bushart, M. & Steinle, F., eds, *Colour Histories: Science, Art and Technology in the Seventeenth and Eighteenth Centuries*, Berlin, pp. 3–21 (p. 5).

42 Boutet, C., 1729, *The Art of Painting in Miniature*, London, p. 11.

43 Miller, E., 1987, *Hand-Coloured British Prints*, exh. cat., Victoria and Albert Museum, London, p. 8.

44 BL, Sloane MS 3338, fols 9–16; the note is dated 25 March 1712 (see Salmon, M., 2000, *The Aurelian Legacy: British Butterflies and their Collectors*, Colchester). 'Pinck' (or pink) referred to an organic yellow pigment generally extracted from unripe buckthorn berries which could be made into different hues (Harley, R. D., 2001, *Artists' Pigments, c.1600–1835: A Study in English Documentary Sources*, 2nd edn, London, pp. 107–14); it is listed as one of four greens by Sanderson: 'Sap-green, Pinck, Bise-green, Cedar-green' (1658, p. 53).

45 Edwards, G., 1743–51, *A Natural History of Uncommon Birds*, London, IV, pp. 212–17. He notes: 'Though all Colours may be compounded from three of the principal Colours, yet as the Colour-Shops produce a long List of Colours, wherein are Variety of Reds, Blues and Yellows, of different Shades and Casts, as well as Browns of many different Sorts, it will be convenient for those who set out in Paintings or Colouring, to be furnished with all of them, which may have some Trouble in Compounding' (p. 214).

46 *NH*, Account, p. xli: 'in South Carolina grows a kind of Opuntia, which are frequently three or four feet high, from which I have often picked cochineal in small quantities.'

47 Harley, R. D., 2001, p. 136.

48 KH (drawing DL 000 0981); the inscription is in Collinson's hand.

49 Berkeley, E. & D. S., 1992, *The Correspondence of John Bartram, 1734–1777*, Gainesville, FL, p. 194: Bartram hopes that 'tho' Clumsily done [his drawings] might give [Catesby] some ideas of [the] natural perfections' of the black and red fox, black squirrel and whip-poor-will.

50 *NH*, Preface, p. vii.

51 I am grateful to Alan Donnithorne, who conducted an examination of Catesby's drawings at the Royal Library under UV and high magnification (up to ×100) during September–October 2014 (see nn. 55 and 56 below).

52 An important contributory factor is that the watercolours have been very little exposed to light: see Introduction, p. 5.

53 See pp. 103–4. Blome, R., 1686, for example, has a section, 'Rules for laying on your Colours', pt 1, p. 222.

54 Edwards, G., 1743–51, IV, p. 215, following earlier authors.

55 Alan Donnithorne's investigation of Catesby's inks found that he most commonly used iron gall ink for both drawing and writing; this would originally have appeared black-brown but fades to brown over time. However, some of Catesby's drawings were executed in a carbon-based ink, which appears greyish-black rather than brown (for example, RCIN 925887 [yellow jessamine]); see forthcoming Catalogue. He may also have sometimes used a mixture.

56 These different techniques were identified by Alan Donnithorne under high magnification. The colour wash applied over lead white seems to be the cause of the flaking that has occurred in a few of the watercolours, most evidently in parts of the 'Parrot of Cuba', RCIN 924823 (see forthcoming Catalogue).

57 Sanderson, W., 1658, p. 91.

58 Edwards, G., 1743–51, IV, p. 217.

59 See Appendix 2.

60 *NH*, Appendix, p. 20.

61 As Kusukawa explains in her discussion of the evolution of *ad vivum*, the phrase did not necessarily mean direct observation but rather that an image so described could be accepted as authoritative: Kusukawa, S., 2019, '*Ad vivum* Images and the Knowledge of Nature in Early Modern Europe', in Balfe, T., Woodall, J. & Zittel, C., eds, *Ad Vivum: Visual Materials and the Vocabulary of Life-Likeness in Europe before 1800*, Leiden, pp. 89–121.

62 Egmond, F., 2017, *Eye for Detail: Images of Plants and Animals in Science, 1500–1630*, London.

63 Among numerous examples of 'time lapse' are *NH*, I, 26, 27, 44, 61; ibid., II, 28, 35, 43, 99, 100. 'Zoomed' images and insets include ibid., I, 10, 25, 38, 41, 55.

64 See also RCIN 924843 where the red-legged thrush, *Turdus plumbeus*, is shown by a stem of gum elemi, *Bursera simaruba*, springing from a curtailed trunk growing from the soil.

65 See Chapter 6.

66 See Appendix 2.

67 Sherard Herbarium, Sher-1090c, Department of Plant Sciences, Oxford.

68 Catesby did in fact report seeing coral in the Bahamas that grew 'above six feet high, and branch[ed] into various forms' (*NH*, Account, p. xlii).

69 As only a fragment of the dorsal fins fitted on to the page, Catesby drew them in full on the verso of the sheet, while showing them actual size in outline in the etched plate (see forthcoming Catalogue).

70 Eastern fox squirrel, *Sciurus niger* (*NH*, II, 73); southern flying squirrel, *Glaucomys volans* (ibid., 76); eastern chipmunk, *Tamias striatus* (ibid., 75). Shephard Krech III identifies examples of birds shown in characteristic postures and movement: 'Catesby's Birds', in MacGregor, A., ed., 2018b, *Naturalists in the Field: Collecting, Recording and Preserving the Natural World from the Fifteenth to the Twenty-First Century*, Leiden & Boston, pp. 279–331.

71 His precursor in this respect was Maria Sibylla Merian; see below.

72 See Chapter 6.

73 *NH*, Preface, p. iv.

74 Ibid., p. v.

75 Ibid.; *NH*, Appendix, p. 20.

76 See Chapter 6.

77 *NH*, I, p. 46. It is interesting to note that Catesby originally painted the indigo bunting on the sweet shrub (RCIN 925877 – see forthcoming Catalogue), replacing it at the etching stage with the cedar waxwing specifically to bring out the colour comparison.

78 *NH*, I, 48 (RCIN 925880), see forthcoming Catalogue.

79 *NH*, I, p. 59.

80 For the practice of artists' using different sorts of 'information sources' for botanical illustrations, see Nickelsen, K., 2006b, *Draughtsmen, Botanists and Nature: The Construction of Eighteenth-Century Botanical Illustrations*, Dordrecht, p. 69; Egmond, F., 2015; Kusukawa, S., 2019.

81 Sloane had acquired the albums of watercolours from the collector William Courten in 1702 and listed them in his 'Books in Miniature, Painting & Design' as 'Drawings of Insects, Plants, some Quadrupeds, and Birds by M.S. Merian', and 'Another volume of original drawings of Mrs Merian: chiefly of European Plants and Insects' (BL, Sloane MS 3972 C, vols IV and VI; see Sloan, K., 2012, p. 189). For a description of their contents, see Rucker, E. & Stearn, W. T., 1982, *Maria Sibylla Merian in Surinam: Commentary to the Facsimile Edition of Metamorphosis insectorum surinamensium (Amsterdam 1705) based on Original Watercolours in the Royal Library, Windsor Castle*, London, pp. 42–3. The albums are now in the BM (P&D), Sloane 5275 and 5276; the printed volume of the *Metamorphosis* included in Sloane's library list with his catalogue number, Pr XXXXIX, is now in the Royal Society, RCN 552555 (https://www.bl.uk/catalogues/sloane/BriefDisplay.aspx). McBurney, H., forthcoming, 'The Influence of Maria Sibylla Merian's Work on the Art and Science of Mark Catesby', in Etheridge, K., et al., eds, *Changing the Nature of Art and Science: Intersections with Maria Sibylla Merian*, Leiden.

82 He makes two specific references to her book in his Appendix, p. 9, and Account, p. xxix: see Bibliography: Catesby's Authorities.

83 Rucker identifies the influence on Merian's work of Dutch still-life painting, via her stepfather Joseph Marell, 'evident in her ability to create a composition, to think in terms of pictorial structure. It is precisely this quality … which led to the unique integration of art with science in her Surinam works' (Rucker, E. & Stearn, W. T., 1982, p. 41).

84 Frick, G. F. & Stearns, R. P., 1961, *Mark Catesby: The Colonial Audubon*, Urbana, IL, p. 60.

85 *NH*, Preface, p. vi. For a fuller discussion of this aspect of Catesby's work, see Chapter 6.

86 McBurney, H., 2015, 'Mark Catesby's Preparatory Drawings for *The Natural History of Carolina, Florida and the Bahama Islands*', in Nelson, E. C. & Elliott, D. J., eds, *The Curious Mister Catesby: A 'Truly Ingenious' Naturalist Explores New Worlds*, Athens, GA, & London, pp. 148–9. Further examples are Catesby's guana, *Cyclura cyclura*, clinging with its front toes on the plant stem of the pond-apple, *Annona glabra*, and its back legs spread out on a leaf and fruit of the plant (*NH*, II, 64), and Merian's lizard likewise clutching the stem of the manihot plant with its front toes, with its back legs spread out on the stalk and stem below (Merian, M. S., 1705, *Metamorphosis insectorum surinamensium*, Amsterdam, pl. 4); Catesby's ribbonsnake, *Thamnophis sauritus*, cut out of another sheet of studies and placed curled up at the base of the wild cinnamon, *Canella winterana* (RCIN 925998); and Merian's garden tree-boa similarly shown elegantly coiled at the base of the royal jasmine (Merian, M. S., 1705, pl. 46). See also Meyers, A. R. W., 1997, '"The perfecting of natural history": Mark Catesby's Drawings of American Flora and Fauna in the Royal Library, Windsor Castle', in McBurney, H., *Mark Catesby's 'Natural History' of America: The Watercolours from the Royal Library, Windsor Castle*, exh. cat., London, pp. 11–25 [pp. 21–2].

87 *NH*, I, 1 (RCIN 924814), fig. 162.

88 Other examples include: ibid., 35: *Spitzella passerina*; ibid., 55: *Tyrannus tyrannus* & insect; ibid., Appendix, 5, *Icterus icterus* & *Chalybion californicum*; ibid., 10, *Ardea herodias* with spotted salamander, *Ambystoma maculatum*, in bill; ibid., II, 45: *Heterodon platirhinos* and mole salamander, *Ambystoma talpoideum*; ibid., I, 69: *Megaceryle alcyon* with fish in bill; ibid., 39: *Passerina caerulea* pecking at seeds of *Magnolia virginiana*; ibid., 65: *Archilochus colubris* extracting sap from *Campsis radicans*; ibid., II, 76: *Glaucomys volans* clutching fruit of *Diospyrus virginiana*.

89 Catesby cites Plumier as an authority for a number of his plant names: see Bibliography: Catesby's Authorities.

90 His illustrations have been somewhat dismissed as 'made from his own clear, but rather crude drawings … engraved on a large scale and in outline. They serve their purpose of making West Indian plants known botanically but are not of much interest artistically' (Blunt, W. & Stearn, W. T., 1994, *The Art of Botanical Illustration*, Woodbridge, p. 143, n. 16).

91 Plumier, C., 1693, *Descriptions des plantes de l'Amérique*, Paris.

92 Ibid., pl. XLI.

93 Although he did not have them engraved, White's images became widely known in Europe through printed and adapted versions in Theodor de Bry's engravings in an illustrated edition of Thomas Harriot's *Brief and true report of the new found land of Virginia* (1590); Sloan, K., 2007, *A New World: England's First View of America*, London, ch. 6.

94 BL, Sloane Add MS 5270, acquired *c.*1717 from descendants of the White family. The seventeenth-century copies of White's originals, containing 113 folios of drawings of Native Americans of Virginia and of fauna and flora, were considered to be his originals: Sloan, K., 2007, who gives the large bibliography on these drawings and the complicated history of versions made after them. For a listing of the different sets of White-related drawings, see Griffiths, A. & Williams, R., 1987, *The Department of Prints and Drawings in the British Museum: Users' Guide*, London.

95 *NH*, II, 97, cited in the title for the 'Mamankanois' (tiger swallowtail, *Papilio glaucus*). This is the only one of the 'White' prototypes for which Catesby acknowledges his source. It is one of two images of swallowtail butterflies Catesby includes; he believed that the other (with its tails, ibid., 83) was a different species (for which he gives the authority as Petiver, J., 1695, *Musei Petiveriani …*, London, no. 505).

96 His comment would seem to contradict Sloan's observation that 'Catesby apparently did not see the volume itself [the seventeenth-century 'White' volume, which Sloane eventually acquired sometime around 1717]' (Sloan, K., 2007, pp. 224–5).

97 White catfish: RCIN 925967, after BM (P&D), Sloane 5270.107v, BL, Add MS 5267.33; remora: RCIN 925970, after BM (P&D), Sloane 5270.20; checkered puffer: RCIN 925973, after BM (P&D), Sloane 5270.14, BL, Add. MS 5267.42; Florida gar: RCIN 925975, BM (P&D), Sloane 5270.134, BL, Sloane Add MS 5267.96; purple landcrab: RCIN 925977, BM (P&D), Sloane 5270.21, BL, Add MS 5262.10; guana: RCIN 926015, BM (P&D), Sloane 5270.13r, BL, Add MS 5272.22; tiger swallowtail: RCIN 926044–5, BM (P&D), Sloane 5270.14, BL, Add MS 5289.167.

98 As, for example, land crab and blackwood (RCIN 25977); loggerhead sea turtle, *Caretta caretta*, and cinnecard, *Vachellia choriophylla* (RCIN 25986); and guana and pond-apple (RCIN 926015).

99 David Wilson chose the land crab as an exemplum of how Catesby's borrowings from White were 'integrated … into a new composition thoroughly original in effect' through his 'artistically link[ing] the crab and the plant by opening the crab's smaller claw so that it pinched a berry of the plant' (Wilson, D. S., 1970–71, 'The Iconography of Mark Catesby', *Eighteenth Century Studies*, 4, pp. 169–83). Meyers follows Wilson in her discussion of this plate (Meyers, A. R. W., 1997, p. 21).

100 McBurney, H., 1997, cat. no. 23.

101 This was unlike his own technique, in which, as we have seen, he built up images in layers of watercolour. For White's watercolour technique, see Hulton, P., 1984, *America 1585: The Complete Drawings of John White*, London. In two other instances, Catesby's drawings of fishes appear close to the John White copies but differ in a number of details, implying that the images may have been taken from an intermediary source. These are his turbot, *Balistes vetula* (RCIN 925966; BM (P&D), Sloane 5270.19v; BL, Add MS 5267.51) and longspine squirrelfish, *Holocentrus rufus* (RCIN 925940; BM (P&D), Sloane 5270.22r) (Sloan, K., 2007, p. 198, fig. 131; p. 192, fig. 126).

102 BM (P&D), Sloane 5277–8; listed as item no. 2 in Sloane's 'Books of Miniature and Painting': 'A book of the beasts, birds etc. at Versailles and of Shells, insects, petrefaction etc. done at Paris by Mr. Robert for Mr Courten'. Sloane acquired the volumes in 1702 from William Courten, who had commissioned many of the drawings directly from Robert.

103 Blunt, W. & Stearn, W. T., 1994, pp. 118–21. Stevenson, A., 1961b, *Catalogue of Botanical Books in the Collection of Rachel McMasters Miller Hunt*, II, pt 2: *Printed Books 1701–1800*, Pittsburgh, PA, p. 305.

104 Merian was also influenced by Robert's work, incorporating several flowers and some overall designs from his *Variae ac multiformes florum species: Diverses fleurs* (1660) into the illustrations for her *Histoire des insectes de l'Europe* (1730): see Stevenson, A., 1961b, p. 305.

105 16 December 1686 (de Beer, E. S., ed., 1955, *The Diary of John Evelyn*, Oxford, p. 108). Evelyn's description reflects the contemporary interest in the accuracy as well as beauty and quality of the drawings.

106 McBurney, H., 1997, cat. nos 33–4. For Catesby's tracing of the leaf from the recto of his sheet in RCIN 926022, see p. 108, fig. 129.

107 *NH*, II, 70. The carnivorous nature of pitcherplants was not known at this date; John Bartram's son William, the naturalist and artist, was to hint at the possibility when he wrote that 'the latent waters [caught in the hollow leaves] undoubtedly contribute to the support and refreshment of the plant; perhaps designed as a reservoir … but whether the insects caught in their leaves, and which dissolve and mix with the fluid, serve for aliment or support to these kind of plants, is doubtful' (see Ewan, J., 1968, *William Bartram: Botanical and Zoological Drawings, 1756–1788*, Philadelphia, p. 61).

108 The series of compositions which originated with the Robert image provided further inspiration to Catesby for his studies of the hooded and yellow pitcherplants, *Sarracenia minor* and *S. flava* (see fig. 234).

109 Robert: BM (P&D), Sloane 5277.7; Catesby: RCIN 925987, *NH*, II, 41 (for both artists' images, see forthcoming Catalogue). Catesby's copy is so close the outlines may have been traced.

110 Grew, N., 1681, *Musaeum Regalis Societatis*, London, pl. 4.

111 Robert and Aubriet were described as 'men of genius' by Blunt, W. & Stearn, W. T., 1994, p. 123. Catesby was familiar with Aubriet's illustrations in Tournefort's publications: see Bibliography: Catesby's Authorities.

112 Spanish jasmine, RCIN 926055, etched as *NH*, II, 92; cacao, RCIN 926071, etched as ibid., Appendix, 6; vanilla, RCIN 926072, etched as ibid., Appendix, 7; cashew, RCIN 926076, etched as ibid., Appendix, 9.

113 Sherard wrote to Richardson in 1717/18 that he needed English plants to send to 'three foreign correspondents', including 'Mr Aubriet, the King's Painter … [who] is the most accurate Botanist I ever knew and the most cordial' (Turner, D., ed., 1835, *Extracts from the Literary and Scientific Correspondence of Richard Richardson*, Yarmouth, letter LXIV, pp. 130–33).

114 None of the vellums were published by Aubriet. They appear to have been part of a larger group, another example from which, showing a specimen of vanilla at a later stage of development, is in the collection of the Lindley Library, London (Blunt, W. & Stearn, W. T., 1994, col. pl. 29); the provenance of that drawing is equally unknown.

115 Tournefort trained Aubriet to employ 'that scientific exactness which was to be one of the characteristics of his talent' (Calmann, G., 1977, *Ehret: Flower Painter Extraordinary*, Oxford, p. 35).

116 Brent Elliott notes that 'Aubriet pioneered the use of dissections to convey additional information about fine structure' (Elliott, B., 1994, *Treasures of the Royal Horticultural Society*, London, p. 17).

117 Catesby added his identifications in pen and ink directly on to two of Aubriet's vellums (Spanish jasmine and cashew), while in the others the inscriptions appeared only in the engraved titles in the etched plates.

118 Kick (or Kik), who often Latinized his name to Kickius, and who later described himself as 'bred in Germany', came to London from Holland in the mid-1660s. After a period of working in London and in Scotland painting interiors, he acted as a draughtsman for David Loggan's *Oxonia illustrata* (1675), *Cantabrigia illustrata* (1690), and for John Slezer's *Theatrum Scotiae* (1693). By 1700, when he was recorded in London as a 'limner', he was working for Sloane, and from 1703 to 1705 for the Duchess of Beaufort at Badminton (see fig. 25). I am grateful to Sachiko Kusukawa for sharing her unpublished research on Kick with me. In addition to his many coloured drawings made for Sloane's drawings albums, he executed a series of monochrome drawings of plants and other specimens for Sloane's *Natural History of Jamaica* (NHM, Department of Life Sciences, Algae, Fungi & Plants Division, Sloane HS 6, 7).

119 Bauer describes this image as 'truly striking and may be the most lifelike of any of the vertebrates' in the *Natural History* (Bauer, A. M., 2015, 'Catesby's Animals (other than birds) in *The Natural History of Carolina, Florida and the Bahama Islands*', in Nelson, E. C. & Elliott, D. J., *The Curious Mister Catesby: A 'Truly Ingenious' Naturalist Explores New Worlds*, Athens, GA, and London, pp. 231–50 [p. 245]).

120 For copies Catesby made of other drawings by Kick, see forthcoming Catalogue. Catesby's drawing of a spotted skunk (fig. 239) was made after Kick's drawing, BM (P&D) Sloane 5261,136.

121 Barlow, F., 1703, *Aesop's Fables*, London, fable XVI, p. 33; ibid., XXXV, p. 71. Catesby's hovering osprey is shown in the same sense in which it appears in the *Aesop's* plate; Barlow's swooping hawk, however, is reversed in Catesby's watercolour. Both images of birds

were, of course, then reversed in Catesby's etching (*NH*, I, 1).

122 *NH*, I, 13 (RCIN 924826).

123 McBurney, H., 1997, cat. no. 27. For Catesby's use of Barlow, see also Seltzer, A., 2015, 'Catesby's Conundrums: Mixing Representation and Metaphor', *British Art Journal*, 16, pp. 82–92, and Seltzer, A., 2019, 'Catesby's Eclecticism and the Origin of his Style', *1650–1850: Ideas, Aesthetics and Inquiries in the Early Modern World*, 24, pp. 263–86. The present author's observations were made independently.

124 *NH*, II, p. 45.

125 Edwards remained a friend of Sloane's until the end of the latter's life, recording, 'After his retirement to Chelsea, he requested as a favour to him … that I would visit him every week, in order to divert him, for an hour or two, with the common news of the town, and with any thing particular that should happen amongst his acquaintance of the Royal Society, and other ingenious Gentlemen, many of whom I was weekly conversant with; and I seldom missed drinking coffee with him on a Saturday, during the whole of his retirement at Chelsea' (de Beer, G. R., 1953, *Sir Hans Sloane and the British Museum*, Oxford, p. 139).

126 See Chapter 2, p. 67.

127 The agouti (RCIN 926087; *NH*, Appendix, 18) was kept as a pet at Goodwood by the Duke of Richmond, for whom Edwards was also employed to draw animals.

128 McBurney, H., 1997, cat. no. 16.

129 Blunt, W., 2001, *The Compleat Naturalist: A Life of Linnaeus*, London, pp. 104, 107.

130 Henrey, B., 1975, *British Botanical and Horticultural Literature before 1800*, II: *The Eighteenth Century*, London, New York & Toronto, pp. 62–4; Calmann, G., 1977.

131 A volume of plant drawings by Ehret and Van Huysum in the Royal Society, acquired via Philip Miller in 1737, contains a drawing by Ehret of a pulmonaria inscribed 'Flower'd in the Garden of Peter Collinson at Peckham in Aprill 1735' (RS, Ehret MS 668, fol. 1). To the end of his life, Collinson remained a friend of Ehret's, sending reports and news of him to Dr Trew (Calmann, G., 1977, p. 63).

132 The results of their combined work on this group of drawings and etchings were published between 1739 and 1747, in Parts 9, 10 and 11 (the Appendix) of the *Natural History*. See forthcoming Catalogue and note 133 below.

133 Calmann, G., 1977, pp. 52 and 67, who notes: 'Patronage by rich collectors was essential for Ehret's survival; since the demand was great, he made hundreds of coloured drawings in the 1740s, his most productive period. Almost all his clients were Fellows of the Royal Society.'

134 Calmann suggests that Catesby 'probably did not actually commission Ehret to do the three [*sic*] drawings which he incorporated [into the *Natural History*]' (Calmann, G., 1977, p. 67). Ehret contributed ten drawings to the *Natural History*, and two etchings as follows: pawpaw, *Asimina triloba*, RCIN 926047 (*NH*, II, 85); pride-of-Ohio, *Primula meadia*, RCIN 926065 (ibid., Appendix, 1); witch-hazel, *Hamamelis virginiana*, RCIN 926066 (ibid., 2); smooth sumac, *Rhus glabra*, RCIN 926071 (ibid., 5); Canada lily, *lilium canadense*, RCIN 926079 (ibid., 11); silky camellia, *Stewartia malacodendron*, RCIN 926082 (ibid., 13); cucumber-tree, *Magnolia acuminata*, RCIN 926084 (ibid., 15); American ginseng, *Panax quinquefolius*, RCIN 926085 (ibid., 16); and great laurel, *Rhododendron maximum*, RCIN 926086 (ibid., 17). His two etchings are: *Magnolia grandiflora* (ibid., II, 61) after his own drawing (not extant); and sea-grape, *Coccoloba uvifera* (ibid., II, 96) after Catesby's drawing, RCIN 926059. Ehret signed one of his drawings (the silky camellia) and both of his etchings. Catesby published his own drawing of the mountain laurel (RCIN 926061) rather than Ehret's (RCIN 926062) as Plate 98 in Volume II of the *Natural History*.

135 See Chapter 5, p. 165.

136 Nelson, E. C., 2014b, 'Georg Dionysius Ehret, Mark Catesby and Sir Charles Wager's Magnolia Grandiflora: An Early Eighteenth-Century Picture Puzzle Resolved', *Rhododendrons, Camellias and Magnolias*, 65, pp. 36–51, fig. 2 [p. 39]. Collinson pasted an impression of this print into his copy of the *Natural History* (KH).

137 The technique of using black or dark backgrounds to set off white or pale subjects had been used by natural history artists at least since the seventeenth century, notably by Dutch still-life painters. Numerous striking examples of the technique can be found among drawings of plants and animals in Cassiano dal Pozzo's Paper Museum (Haskell, F., MacGregor, A. & Montagu, J., eds, 2001–, *The Paper Museum of Cassiano dal Pozzo: A Catalogue Raisonné*, London, series B, part VII: Elliott, B., et al., 2015, *Flora: Federico Cesi's Botanical Manuscripts*; and series B, part IV: McBurney, H., et al., 2017, *Birds, Other Animals and Natural Curiosities*. In the eighteenth

century, works by the Dietzsch family of botanical artists in Nuremberg, as well as Ehret, inspired Mrs Delany's use of black backgrounds for her paper collages of plants (Laird, M. & Weisberg-Roberts, A., eds, 2009, *Mrs Delany and her Circle*, New Haven & London, p. 160).

138 For an unpublished variant of the image, see fig. 66.

139 For the physical evidence of this late change, see Chapter 3, n. 84.

140 Catesby completed one of the leaves which Ehret had shown only in part, as well as attaching the separate stem with two flowers to the main stalk bearing the fruit.

141 Ehret added three details of the flower head in different stages of development and repositioned the moth.

142 *NH*, II, 98.

143 For a discussion and illustrations of the drawings, see McBurney, H., 1997, cat. nos 46–7. A comparison of the two drawings in the Royal Library using overlays revealed that the central section of leaves below the stem bearing the flowers in Ehret's drawing was traced by Catesby.

144 *Panax cinquefolius* appears as *NH*, Appendix, 16. Dillwyn, L. W., 1843, *Hortus Collinsonianus: An Account of the Plants cultivated by the late Peter Collinson, Esq., FRS, arranged alphabetically according to their modern names, from the catalogue of his garden and other manuscripts*, Swansea, p. 37.

145 *NH*, Appendix, 17.

146 McBurney, H., 1997, cat. no. 52, where Catesby's original drawing of the stem of sheep laurel (MLM, 1961.6:4) was attributed to Ehret.

147 In the way that most of the watercolours Ehret sold to individual collectors bear his signature (Calmann, G., 1977).

148 *NH*, Appendix, 13 (RCIN 926082).

149 The only one of Ehret's drawings to which Catesby did not add an image of his own was the pawpaw (ibid., II, 85), which he adapted in other ways.

150 Examples of animals shown as still-life elements are RCIN 926077 (see fig. 227) and RCIN 926020 (see fig. 219); for analytic parts, see *NH*, II, 81 (see fig. 216) and ibid., 99 (see fig. 210).

151 Griffiths, A., 1996b, *Prints and Printmaking: An Introduction to the History and Techniques*, London, pp. 56–71.

152 Gilpin, W., 1768, *An Essay on Prints: Containing remarks upon … the different kinds of prints, and the characters of the most noted masters …*, London, p. 47.

153 *NH*, Preface, p. vi.

154 He did, however, have horticultural interests, and was employed by the Prince of Wales to help with developing the gardens at Kew: Harris, E. T., 2008, 'Joseph Goupy and George Frideric Handel: From Professional Triumphs to Personal Estrangement', *Huntington Library Quarterly*, 71, no. 3, pp. 397–452.

155 Gilpin, W., 1768, p. 161.

156 *NH*, Preface, p. vi. See Chapter 3.

157 Barlow's etchings managed to show 'the way fur lies and wings and feathers are attached, beaks curl and claws clutch, characteristic postures and expressions, and all of the precise factual data that are the starting points of scientific observation' (Hodnett, E., 1978, p. 182).

158 Catesby did not reverse his images before transferring them to the etching plate, possibly to save time. This meant that his printed compositions were always in a different sense from his original ones. While on the whole this did not affect his images adversely, it did in some cases mean that the observations made correctly in his drawings about the direction in which some climbing plants grow were not realized in the reversed prints (Stearn, W. T., 1958b, 'The Publication of Catesby's "Natural History of Carolina"', *Journal of the Society for the Bibliography of Natural History*, 3, p. 328).

159 David Knight speaks of the disadvantages of 'a craftsman [coming] between the artist and the printed illustration', noting: 'Some of the finest work was done when the naturalist was his or her own artist and etcher or graver: as for example Mark Catesby had to be for his superb *Natural History of Carolina*, for he could not afford to pay for the engraving to be done by someone else, and did the etching himself' (Knight, D. S., 1977, *Zoological Illustration: An Essay towards a History of Zoological Pictures*, Folkestone, p. 53).

160 Albin, E., 1731–8, *A Natural History of Birds, illustrated with … copper plates, curiously engraven from the life*, 3 vols, London. The names of two of the etchers, Henry Fletcher and G. Thornton, appear amongst the plates.

161 Edwards, G., 1743–51, I, p. xvii.

162 Sitwell and Blunt note: 'Some artists were admirably served by their engravers and

printers (e.g. Audubon's *Birds of America*, despite his immense skill as bird artist, would be less of a masterpiece were it not for the skills of Robert Havell). Other artists were treated less well than they deserved. Catesby avoided this possibility by etching his own work' (Sitwell, S., and Blunt, W., 1990, *Great Flower Books 1700–1900: A Bibliographical Record of Two Centuries of Finely-Illustrated Flower Books*, London, p. 3).

163 Edwards, G., 1743–51, II, p. 112.

164 McBurney, H., 2001b, pp. 16–17.

165 Other examples include the starfish and cockle shell on the seashore in the flamingo plate (*NH*, I, 73), from *Aesop's* 'The Dolphin and Tunis' (pl. 207); the foreground vegetation with a broken fish trap on the verge of the stream by which the green heron, *Butorides virescens*, perches (ibid., 80), from *Aesop's* 'The Oak and Reed' (pl. 67); and the bulrushes which appear in the plate for the little blue heron, *Egretta caerulea* (ibid., 76), from *Aesop's* 'The Hunted Beaver' (pl. 39).

166 Sloane owned a copy of Harriot's (sometimes spelt Hariot) work; although it has not been found, it is listed in one of the manuscript catalogues of his printed books with his classmark E 167 (https://www.bl.uk/catalogues/sloane/BriefDisplay.aspx).

167 See Sloan, K., 2007, fig. 86.

168 The text reads: 'They hang before them the skin of some beast very finely dressed in such a way that the tail hangs down behind.'

169 *NH*, II, 2. Further examples are ibid., Appendix, 6 and 20, where it hangs off a leaf of the cacao and the acacia, and ibid., II, 34, in which it sits on top of a broken-off stump of a branch of coral. See Meyers, A. R. W., 1997, p. 23.

170 The practice of borrowing was common in other areas of the arts, especially music. Jonathan Keates in his discussion of Handel's borrowing and adapting from other composers, as well as his own work, notes: 'An age which extolled imitation could permit and encourage adaptation' (Keates, J., 1985, *Handel: The Man and his Music*, London, pp. 224–6).

171 Lindsay, J., 1977, *Hogarth: His Art and his World*, London; Knight, D. S., 1977, p. 83; Simon, R., 1993, *Hogarth, France & British Art: The Rise of the Arts in Eighteenth-Century England*, New Haven & London; Uglow, J., 1997, *Hogarth: A Life and a World*, London, pp. 267–71.

172 He did not sign, however, one of Aubriet's designs (*NH*, II, 92: *Plumeria rubra*),

although he made subtle changes to the original composition, as he did with the other three works by Aubriet that he signed.

173 Wilson, D., 1970–71, p. 174.

174 Albin recorded: 'Teaching to Draw and Painting in Water-Colours, being my Profession, first led me to observing of Flowers and Insects, with whose various Forms and beautiful Colours I was very much delighted, especially the latter, several of which I painted after the Life, for my own Pleasure' (Albin, E., 1720, *A Natural History of Insects*, London, preface, unpaginated).

175 *NH*, Appendix, p. 20.

CHAPTER 5 • CATESBY AS HORTICULTURIST

1 Knowlton to Richardson, letter of 18 July 1749, as quoted in Turner, D., ed., *Extracts from the Literary and Scientific Correspondence of Richard Richardson*, Yarmouth, 1835, p. 402.

2 Cooper, A. A., 3rd Earl of Shaftesbury, 1714, 'The Moralists', in *Characteristicks of Men, Manners, Opinions, Times*, London, II, pp. 393–4. 'Horrid', meaning 'rough' or 'savage', originated in the Latin 'horridus' ('shaggy', 'bristly', 'unpolished': Lewis, C. T. & Short, C., 1969, *A Latin Dictionary*, Oxford, s.v. 'horridus').

3 Blanche Henrey speaks of a 'revolution in England in garden design when … the formal style of gardening with its rigid geometrical layout gradually went out of fashion' (Henrey, B., 1975, *British Botanical and Horticultural Literature before 1800*, II: *The Eighteenth Century*, London, New York & Toronto, pp. 495–8. Chambers, D., 1993, *The Planters of the English Landscape Garden: Botany, Trees and the Georgics*, New Haven & London, chs 4–5. Crowe, S., 2003, *Garden Design*, 3rd edn, Woodbridge, pp. 52ff.

4 Switzer, S., 1718, *Ichnographia rustica*, London, I, pp. xxxv–xxxvi.

5 See note 2 above.

6 Although Philip Miller is not stated as its author, John Martyn in his review of the *Catalogus* read to the Royal Society on 11 February 1730 cited him as such (RS, *Register Book*, XV, p. 274).

7 Society of Gardeners, 1730, *Catalogus plantarum*, London, pp. vi and viii, where the 'Patriots of Horticulture' are glossed as those 'who have either added to our Collections from abroad, or have assisted in tracing out the various Operations of vegetative Nature thro' her many intricate Mazes, where by discovering her various

Footsteps, the Business of Gardening is daily reduced to a much greater Certainty'.

8 See Laird, M., 1998, 'From Callicarpa to Catalpa: The Impact of Mark Catesby's Plant Introductions on English Gardens of the Eighteenth Century', in Meyers, A. R. W. & Pritchard, W. B., eds, *Empire's Nature: Mark Catesby's New World Vision*, Chapel Hill, NC, & London, pp. 184–228; Laird, M., 1999, *The Flowering of the Landscape Garden: English Pleasure Grounds 1720–1800*, Philadelphia, especially ch. 2; Laird, M., 2015b, 'Mark Catesby's Plant Introductions and English Gardens of the Eighteenth Century', in Nelson, E. C. & Elliott, D. J., eds, *The Curious Mister Catesby: A 'Truly Ingenious' Naturalist Explores New Worlds*, Athens, GA, & London, pp. 265–80; and Laird, M., 2015a, *A Natural History of English Gardening, 1650–1800*, New Haven & London, especially ch. 3.

9 McBurney, H., 2001a, 'Catesby, Mark, 1682–1749: English Collector, Artist, Author, and Horticulturist', in Shoemaker, C. A., ed., *Encyclopedia of Gardens: History and Design*, 3 vols, London, I, pp. 244–45.

10 Alice Coats sums up the inseparable nature of horticulture and botany at this period: 'It is impossible to make any firm distinction between the "horticultural" collectors of ornamental plants, and the "botanical" ones whose primary aim was the enlargement of the science; for the botanists introduced plants and the gardeners botanized' (Coats, A. M., 1969, *The Quest for Plants: A History of the Horticultural Explorers*, London, p. 7).

11 See Chapter 1, p. 25, Chapter 2, p. 40.

12 *NH*, Preface, p. i.

13 See Chapter 2. Hoxton, Fulham, Peckham and Eltham were all villages 'about London' at this date: see Pehr Kalm's descriptions in Mead, W. R., 2016, *Pehr Kalm: His London Diary*, Aston Clinton. Only part of Hoxton can be seen in John Rocque's 1737 'Plan of the Cities of London and Westminster and Borough of Southwark' (Hyde, R., 1982, *The A–Z of Georgian London*, Lympne Castle). See figs 194 and 195.

14 Martin, P., 1991, *The Pleasure Gardens of Virginia: From Jamestown to Jefferson*, Princeton & Oxford, especially ch. 2.

15 Ibid.

16 The botanical collectors John Banister and John Clayton before him also had gardens of their own: ibid., pp. 16–17.

17 Wright, L. B., ed., 1947, *The History and Present State of Virginia by Robert Beverley*, Chapel Hill, NC, p. 140.

18 NHM, Dale Herbarium, no. 40. The plant was not included in the *Natural History*. The specimen is accompanied by a note in Dale's hand: 'This was shewn to me in Chelsea Garden anno 1686 for the Cortex tree. Mr Catesby saith that the leaf is clammy and of a pleasant scent and therefore its properly a Conyza.'

19 *NH*, I, 27.

20 Collinson to Custis, 20 February 1737/8 (Swem, E. G., 1949, 'Brothers of the Spade: The Correspondence of Peter Collinson of London, and of John Custis of Williamsburg, Virginia, 1734–1746', *Proceedings of the American Antiquarian Society*, 58, pt 1, pp. 17–190). See also Nelson, E. C., 2019a, 'Brethren of the Spade', *Hortus: A Gardening Journal*, no. 120, pp. 81–4.

21 A specimen of the white variant in the Sherardian Herbarium (OUH, Sher-231), labelled in Dillenius's hand 'from Carolina', includes the comment 'this differs only in colour from ye red.'

22 *NH*, I, p. 27.

23 The information is recorded on the label accompanying the preserved specimen which Catesby sent to Dale (NHM, Dale Herbarium, no. 63).

24 Label to NHM, Dale Herbarium, no. 71.

25 As Collinson recounted to Custis, 15 December 1735 (Swem, E. G., 1949, p. 48).

26 *NH*, I, p. 29.

27 See Chapter 2. Wright, L. B. & Tinling, M., eds, 1941, *The Secret Diary of William Byrd of Westover, 1707–12*, Richmond, VA, 5 June 1712, p. 540.

28 Martin, P., 1991, pp. 26–7, who notes that the plan 'is enormously important because the subsequent architectural history of the main house and its flanking kitchen and library invites the conclusion that this early axial landscape may have remained unaltered throughout the lifetimes of Byrd II and his son Byrd III'.

29 Wright, L. B., 1947, pp. 298–9.

30 *NH*, I, p. 65.

31 Martin, P., 1991, p. 54, who describes Byrd as 'among the boldest and most scientifically curious promoters of Virginia gardening and horticulture before 1750'. Byrd was familiar with many English gardens, including Pope's at

Twickenham and others belonging to his friends. Together with Lord Perceval during their tour around England in 1701, he had made a point of inspecting the gardens of noble estates (Wenger, M., ed., 1989, *The English Travels of Sir John Percival and William Byrd II: The Percival Diary of 1701*, Columbia, SC).

32 Among the books on gardening and horticulture at Westover were several on the cultivation of fruit trees, such as Cook, M., 1679, *The Manner of raising Fruit Trees*, London (Hayes, K. J., 1997, *The Library of William Byrd of Westover*, Madison, WI, cat. nos 1051–77).

33 *NH*, Account, pp. xx–xxi.

34 Byrd mentioned the fruits grown at Westover frequently in his diaries (Wright, L. B. & Tinling, M., 1941).

35 *NH*, Account, p. xxii.

36 NHM, Dale Herbarium, no. 30. Dale's note on the specimen label that he received it from Catesby in 1714 is confirmed in James Petiver's list of 'Seeds from Virginia sent by Mr Catesby to Mr Dale' (Nelson, E. C., 2015, '"The truly honest, ingenious, and modest Mr Mark Catesby, F.R.S.": Documenting his Life (1682/83–1749)', in Nelson, E. C. & Elliott, D. J., *The Curious Mister Catesby: A 'Truly Ingenious' Naturalist Explores New Worlds*, Athens, GA, & London, pp. 1–20 [p. 352, n. 18]).

37 It was situated on a site later occupied by an ice-house, on the same east–west axis as the house (Woods, M. and Swartz Warren, A., 1988, *Glass Houses: A History of Greenhouses, Orangeries and Conservatories*, London, p. 68). I am grateful to Joel Fry for information on greenhouses in American gardens; see also his 'Plants for Winter's Diversion: Greenhouse History and Greenhouse Plants at Historic Bartram's Garden', John Bartram Association, Philadelphia, 1995.

38 Darlington, W., 1967, *Memorials of John Bartram and Humphrey Marshall*, New York & London, p. 113.

39 Bartram to Collinson, 18 July 1739 (Berkeley, E. & D. S., 1992, *The Correspondence of John Bartram, 1734–1777*, Gainesville, FL, p. 121).

40 *NH*, I, p. 29. Perhaps significantly, Catesby shows the snakeroot in conjunction with a dead specimen of 'The Fieldfare of Carolina', the American robin (*Turdus migratorius*).

41 See Chapter 6, p. 216.

42 RS, *Journal Book*, 16, 201–2.

43 *NH*, Account, p. xxii.

44 See Chapter 2. Collinson was later to encourage Byrd with his vineyard, suggesting that he 'make the experiment of a quarter of an acre with the best & choicest of your country['s] grapes' (Collinson to Byrd, *c*.1730: Armstrong, A. W., ed., 2002, *'Forget not Mee & My Garden': Selected Letters, 1725–1768 of Peter Collinson, F.R.S.*, Philadelphia, pp. 4–5).

45 Custis was married to Frances Parke, sister of Lucy Parke, Byrd's wife. Byrd often mentioned visits to and from Custis in his diaries for 1712, the period when Catesby was staying with him (Wright, L. B. & Tinling, M., 1941).

46 Much information about Custis's gardening activities at a later period is contained in his correspondence with Collinson, published in Swem, E. G., 1949.

47 Custis's garden was later to be commemorated in Custis Square (see fig. 52).

48 *NH*, I, p. 27; Collinson to Custis, 20 February 1737/8 (Swem, E. G., 1949, p. 67).

49 Martin, P., 1991, p. 56. The sum of £5 that Custis spent on evergreens in 1717 may be compared with the cost of Bartram's 5 guinea boxes of seeds sent via Collinson to garden owners in England in the 1740s.

50 Swem, E. G., 1949, p. 49. Martin notes that the changes in taste affecting English gardening at this time were slower to take hold in America (Martin, P., 1991, p. xxi).

51 Martin, P., 1991, p. 56.

52 *NH*, Preface, p. viii.

53 Letter 21, 6 April 1724. Frick, G. F. & Stearns, R. P., 1961, *Mark Catesby: The Colonial Audubon*, Urbana, IL, p. 29.

54 Letter 24, 16 August 1724.

55 Letter 5, 10 December 1722. The 'kind of perriwinkle' may have been partridgeberry, *Mitchella repens*, as illustrated by Catesby in *NH*, I, 20, and the 'purple seed', American beautyberry, *Callicarpa americana*, as illustrated ibid., II, 47. I thank Charles Nelson for these suggestions.

56 A similar concern was expressed in the early days of the American Republic and at the start of the nineteenth century by botanists who were starting to catalogue the US flora systematically (Stephen Harris, pers. comm.).

57 Lawson, J., 1714, *The History of Carolina*, London, quoted by Martin, P., 1991, p. 17.

58 *NH*, I, p. 49. From this it would seem that Catesby sent seeds to Fairchild, whose successor, Bacon, raised them successfully.

59 Letter 38, postmarked 3 February, 1736.

60 Letter 7, 5 January 1723.

61 Ibid.

62 Letter 44, undated, April 1744. *Jasminum officinale* is found wild in North America. John Gerard, in his *Herball* (1597), describes the various medicinal properties of jasmine oil (pp. 893–4).

63 Spatches was a member of the Council of the Bahamas: Malcolm, H. G., 1921, *A History of the Bahamas House of Assembly*, Nassau, pp. 21, 25, 39, 44, 82 – cited by Frick, G. F. & Stearns, R. P., 1961, p. 33, who note the reference might have been to either William Spatches, senior or junior.

64 *NH*, II, p. 66.

65 Miller, P., 1733, *The Gardeners' Dictionary*, 2nd edn, London, Preface, Preface, p. ix. See Chapter 1.

66 Richmond to Collinson, 22 November 1741 (WSRO, MS 28726, fol. 108).

67 Richardson, T., 1997, 'The Good Wood of Goodwood', *Country Life*, 25 September, pp. 88–9. See Chapter 1.

68 Letters 25, 20 August 1724, and 28, 15 November 1724.

69 *NH*, Preface, p. ix.

70 See Chapter 1, p. 24, for Collinson's description of Hoxton.

71 See Chapter 2, n. 177, for the location of Gray's garden.

72 Mead, W. R., 2016, pp. 24–5.

73 Letter 42, undated, probably 1742.

74 *NH*, II, 98. See Chapter 4, and fig. 211.

75 The plants were sent by John Bartram to Collinson, who gave one to Catesby.

76 *NH*, Appendix, p. 13.

77 Ibid., 13. McBurney, H., 1998, *Mark Catesby's Natural History of America*, exh. cat. (Japan), Tokyo, cat. no. 60. Ehret produced several other versions of the watercolour, including two now in the collections at Knowsley Hall (NH12E6, fol. 3, signed and dated 1743, and NH12E6, fol. 2, dated 1744); one now at the NHM (Botany Library, Special Collections, Drawings, 65 original watercolour drawings of plants from the collection of Sir R. More,

1740–41), and many years later a more elaborate version of the composition, signed and dated 1764, at the Royal Botanic Gardens, Kew (Library, Art and Archives, Church collection, Ch. 70).

78 Catesby wrote: 'it arrived at Christmas [in the year 1743], and was then full of blossoms, as it has annually been about the same time ever since' (*NH*, Appendix, p. 2; *HBA*, no. 56).

79 *NH*, Appendix, p. 17. It was not yet known that rhododendrons needed a lime-free soil.

80 See Chapter 4, p. 138.

81 Letter 42. The shrub may have been one of the rhododendron/azalea group.

82 *NH*, Appendix, p. 15.

83 Ibid., I, p. 22. These were willow oak (*Quercus phellos*), live oak (*Q. virginiana*), swamp chestnut oak (*Q. michauxii*), blackjack oak (*Q. marilandica*), water oak (*Q. nigra*), white oak (*Q. alba*), southern red oak (*Q. falcata*) and bluejack oak (*Q. incana*).

84 Ibid., p. 39.

85 Henrey, B., 1986, *No Ordinary Gardener: Thomas Knowlton, 1691–1781*, London, p. 118.

86 *NH*, I, p. 57. However, it had already been recorded growing in Fairchild's garden in 1724 (Bradley, R., 1724, *A General Treatise of Husbandry & Gardening*, London, letter from Fairchild to Bradley, III, pp. 181–8. Fairchild's monthly letters were published in a second edition of the book in 1726 as 'A Catalogue of Plants flowering in Mr. Fairchild's Garden at Hoxton in every month of the year', pp. 458–73). The yellow jasmine was also included in *HBA* (no. 56, p. 30) and in Catesby and Gray's 'Catalogue'.

87 *NH*, I, p. 55; *HBA*, no. 30, p. 17.

88 *NH*, I, 57, 62, 66.

89 Bradley, R., 1724, pp. 184–5; in the entries for November and December it is called 'Mr. Catesby's fine blue Starwort'. See also Leapman, M., 2000, *The Ingenious Mr Fairchild: The Forgotten Father of the Flower Garden*, London, p. 141. Catesby did not include this plant in his *Natural History*.

90 Martyn, J., 1728–32, *A History of Rare Plants*, London, translated from his *Historia plantarum rariorum*, London, 1728–37. Originally published with Latin text, the first three decades were republished with an English text and without plates in 1728, 1729 and 1732.

91 *NH*, Appendix, 4 and p. 4.

92 Ibid., I, 57.

93 Ibid., II, p. 78.

94 Ibid., II, 70. Thomas Walter (*c.*1741–1789) published his *Flora caroliniana* in 1788.

95 Lettsom, J. C., 1783, *Some account of … John Fothergill, M.D.*, London, quoted in Henrey, B., 1975, pp. 349–50.

96 Catesby cited Collinson's Peckham garden in the *Natural History* more than any other private garden, with thirteen mentions from Part 2 of the book onwards. It was only in the last year of Catesby's life that Collinson moved to his house at Mill Hill, near Hendon, Middlesex, of which he records that for 'two years [I] was transplanting my garden to my house at Mill Hill, called Ridgeway House' (Dillwyn, L. W., 1843, p. iii).

97 See Chapter 1, p. 23.

98 Collinson's manuscript catalogue was later, however, printed as Dillwyn, L. W., 1843.

99 Mead, W. R., 2016, p. 76. Collinson's later garden at Mill Hill was described by William Stukeley as offering 'an infinite sight of rare flowers' (10 July 1752, note in Stukeley, W., 1882, *The Family Memoirs of the Rev. William Stukeley …*, Durham, p. 83).

100 *NH*, II, p. 56.

101 Ibid., Appendix, pp. 8 and 11.

102 Ibid., Appendix, p. 3, and II, p. 73.

103 Ibid., Appendix, p. 1.

104 Ibid., II, 71.

105 See Chapter 4, p. 137.

106 *NH*, II, 98, and Appendix, p. 17.

107 Dillwyn, L. W., 1843, Preface, p. iii. These probably included cypresses, pines and cedars.

108 Baugh, D. A., 2000, 'Sir Charles Wager, 1666–1743', in le Fevre, P. & Harding, R., eds, *Precursors of Nelson: British Admirals of the Eighteenth Century*, London, pp. 101–26, who describes Wager as 'one of the most remarkable and admired admirals of the eighteenth century'.

109 Baugh notes that Wager was often at Hollybush and 'seems to have loved the place' (ibid., p. 125).

110 He was often mentioned in the correspondence of the horticultural circle; he was included amongst 'the many curious Gentlemen which are at present carrying [the]

Spirit of Gardening to a considerable Height by introducing many new Kinds of Plants, Flowers, Trees and Fruits and in making many curious Experiments concerning their Culture and Uses' (Society of Gardeners, *Catalogus plantarum*, 1730, Preface, p. vii).

111 Dillwyn, L. W., 1843, pp. 30, 54, 16.

112 Among the plants Collinson raised in Wager's greenhouses was the pine pink orchid, *Bletia purpurea*, from a bulb sent to Collinson from the island of Providence in 1731: Dillwyn, L. W., 1843, p. 7, as *Bletia verecunda*.

113 *NH*, II, p. 61.

114 See *NH*, II, 61 (Ehret's print after his own watercolour) and fig. 117 (Catesby and Gray's 'Catalogue' with Catesby's print adapted from Ehret). For a full account of the events surrounding the flowering and depicting of Wager's magnolia, see Nelson, E. C., 2014b, 'Georg Dionysius Ehret, Mark Catesby and Sir Charles Wager's *Magnolia grandiflora*: An Early Eighteenth-Century Picture Puzzle Resolved', *Rhododendrons, Camellias and Magnolias*, 65, pp. 36–51.

115 Dillwyn, L. W., 1843, pp. 30–31.

116 *NH*, I, p. 62, where he records 'many large ones in the garden of Mr Bacon at Hoxton'.

117 The name 'Sir Charles Wager's Maple' could also, however, be applied to the silver maple, *Acer saccharinum* (Laird, M., 2015b, p. 267).

118 James bought the estate at Eltham *c.*1719–20 from wealth he had acquired as a successful apothecary: Webb, W. W., rev. Mandelbrote, S., 2008, 'Sherard, James (1666–1738)', *ODNB*, Oxford.

119 Riley, M., '"Procurers of plants and encouragers of gardening": William and James Sherard, and Charles du Bois, Case Studies in late 17th and early 18th-Century Botanical and Horticultural Patronage', DPhil thesis, University of Buckingham, 2011, pp. 403–4.

120 Turner, D., 1835, p. 393.

121 Stevenson notes that Sherard's garden was made famous through Dillenius's engraved plates, which were accurate enough for Linnaeus to make use of (Stevenson, A., 1961b, *Catalogue of Botanical Books in the Collection of Rachel McMasters Miller Hunt*, II, pt 2: *Printed Books 1701–1800*, Pittsburgh, PA, cat. 637). For a recent discussion of the value of the *Hortus Eltamensis* plates, see Wood, J. R. I., Marner, S. K., Scotland, R. W. and Harris, S. A., 2018, 'Specimens of

Convolvulaceae linked to the Plates of Dillenius's *Hortus Elthamensis*', *Taxon*, 67, pp. 1014–19.

122 Dillenius, J. J., 1732, *Hortus Elthamensis, seu plantarum rariorum in horto suo Elthami*, London, I, pp. 1, 122; II, p. 207. Eleven labels identifying plants sent by Catesby were recorded by Druce (Druce, G. C., 1907, 'The Plants of the Hortus Elthamensis', in *The Dillenian Herbaria: An Account of the Dillenian Collections in the Herbarium of the University of Oxford, together with a Biographical Sketch of Dillenius, Selections from his Correspondence, Notes, &c.*, Oxford, pp. 158–84).

123 Dandy, J. E., 1958, *The Sloane Herbarium: An Annotated List of the Horti Sicci composing it …*, London, pp. 128–9.

124 For Du Bois's collecting activities and his garden, see Riley, M., 2011, chs 2 and 5.

125 Letter 35, 10 January 1725.

126 Henrey, B., 1986; Denman Kingsbury, P., 2004, 'Boyle, Richard, Third Earl of Burlington and Fourth Earl of Cork (1694–1753), Architect, Collector, and Patron of the Arts', ODNB, Oxford.

127 *NH*, II, p. 61. Nelson notes that although 'Catesby never claimed credit for being the original introducer [of *Magnolia grandiflora*] he was closely associated with the tree during its earliest decades as a garden plant in Britain' (Nelson, E. C., 2014b, p. 37). For additional information on *Magnolia grandiflora* in cultivation, see Laird, M., 2015a and 2015b.

128 *NH*, Appendix, p. 20; *HBA*, no. 40, p. 21. Philip Miller's reference to *Robinia hispida* being 'at present scarce in the gardens about London, but in Devonshire it is in greater plenty' would seem to be to Sir John Colleton's success with the plant (1768 edn, *The Gardeners' Dictionary*, sv '3: Robinia [*hispida*]'); Laird, M., 1998, p. 215. As pointed out by Laird (2015a, p. 151), Colleton could have brought a plant of *Magnolia grandiflora* from Carolina himself, as he lived there for a short period after 1714.

129 Chambers, D. D. C., 1983, ch. 6.

130 Anonymous, 1984, '*Blest Retreats*': *A History of Private Gardens in Richmond upon Thames*, exh. cat., Orleans House Gallery, Chiswick. For the Duke of Argyle, see Chambers, D. D. C., 1993, ch. 4.

131 *HBA*, p. 21. Catesby recorded in the *Natural History*: 'These Trees usually grow in low shady swamps, and in a very fat soil', noting also that the fruit is not 'relished but by very few, except Negroes' (*NH*, II, p. 85).

132 Blathwayt was the son of the politician William Blathwayt (*c*.1649–1717), who had redesigned his gardens along Dutch lines between 1693 and 1698, and naturalized them by introducing exotic Virginian flora, including tulip trees, yuccas, Virginia pine, sassafras and flowering oaks (Jacobsen, G., 1932, *William Blathwayt, a Late Seventeenth-Century English Administrator*, New Haven, p. 61; Martin, P., 1991, p. 19).

133 *NH*, II, p. 100.

134 Dillwyn, L. W., 1843, p. 10. In 1726 Collinson noted that Guava trees were also raised successfully by Powers in the heated greenhouses at Dyrham Park; they 'bear as plentifully as our Apple trees; the ripe fruit dropping on the pots have rotted, and the seed come up in plenty; one fruit measured six inches round … the plants were raised and kept without bark in a dry stove.'

135 Ibid., p. 42. The architect was William Talman; a glazed roof was added *c*.1800 by Humphrey Repton.

136 *HBA*, Preface, p. ii.

137 Miller, P., *The Gardeners' Dictionary*, quoted in Le Rougetel, H., 1990, *The Chelsea Gardener: Philip Miller 1691–1771*, London, p. 105.

138 Pulteney, R., 1790, *Historical and Biographical Sketches of the Progress of Botany …*, London, II, p. 224.

139 Loudon, J. C., 1854, *Arboretum et fruticetum Britannicum*, 2nd edn, London, I, 80–88. Quoted by Kenneth Lemmon, who adds that 'subsequent history proved just that' (Lemmon, K., 1968, *The Golden Age of Plant Hunters*, London, p. 10).

140 His library also included several editions of Miller's *Dictionary*. I am grateful to Crispin Powell, librarian at Boughton House, Northamptonshire, for showing me this material.

141 Crispin Powell noted that there are many itemized bills for seeds, plants and trees in the archives at Boughton (pers. comm., September 2018).

142 Hunter, J. M., 1985, *Land into Landscape*, London & New York, pp. 101–2.

143 Letter 42.

144 *NH*, II, p. 97.

145 Ibid., Appendix, p. 20.

146 Ibid., II, p. 61.

147 Ibid., p. 99.

148 NHM, Sloane 'Vegetable Substances', no. 8412.

149 *NH*, II, p. 98.

150 Ibid., p. 76.

151 Ibid., I, p. 52; I, p. 28 (black cherry).

152 Ibid., II, p. 46.

153 Ibid., I, p. 24.

154 Ibid., II, p. 78.

155 Ibid., p. 57.

156 Ibid., p. 79.

157 Ibid., I, p. 41.

158 Ibid., p. 63. See Chapter 2, p. 55.

159 Ibid., II, 65.

160 Ibid., Appendix, p. 15.

161 Ibid., Account: 'Of the air of Carolina', pp. i–iii, and 'Of the soil of Carolina', pp. iii–vi, passages which also include observations on the Bahamas and Virginia.

162 Ibid., p. xxi, xxii.

163 Ibid., p. iii.

164 Ibid., p. iv.

165 Ibid.

166 Ibid., p. v.

167 Ibid., p. iv.

168 Ibid.

169 Ibid., p. v.

170 Letter 43, undated April 1744.

171 The main contemporary sources are the texts of the *Natural History* and *Hortus Britanno-Americanus*, Catesby's own letters and those of his contemporaries, Collinson in the *Hortus Collinsonianus*, John Martyn in his *Historia plantarum rariorum* (1728–37), the Society of Gardeners in the *Catalogus plantarum* (1730) and the various editions of Philip Miller's *Gardeners' Dictionary*. While the *Hortus Kewensis* (1789) of William Aiton, Royal Gardener at Kew, has been cited as the main authority on when and how plants came into English gardens, it seems he did not have access to all the contemporary sources.

172 See, however, Laird, commenting on Aiton, that Aiton listed seven outdoor species and nine indoor, 'although later literature has qualified this list, and added [five] more', making a total of twenty-one new species for which

Catesby was responsible (Laird, M., 1998, pp. 186–7). See also Laird, M., 2015b, and Nelson, E. C., 2014a, 'Catalpah – Called so by the Indians', *Hortus: A Gardening Journal*, no. 112, pp. 78–85.

173 *NH*, II, p. 100.

174 Le Rougetel, H., 1990, p. 53.

175 *NH*, I, p. 49.

176 Sherard's specimen: OUH, Sher-1249; Sloane's: NHM, Sloane HS 212, fol. 61; Dale's: NHM, Dale Herbarium, no. 57. All three specimens retain their original labels (see Chapter 6, p. 201).

177 Miller, P., 1733, *The Gardeners' Dictionary*, under *Bignonia*; Aiton, W., 1789, *Hortus Kewensis*, London, III, p. 346.

178 Miller, P., 1733. Miller had previously noted in the *Catalogus plantarum* (1730) that it was 'at present very little known in England'.

179 Letter 44. Isaac Lawson was a Scots doctor who got to know Linnaeus in Leiden and became one of his patrons (Blunt, W., 2001, *The Compleat Naturalist*, London, pp. 98, 110).

180 *NH*, I, p. 49; *HBA*, pp. 24–5.

181 Miller, P., 1752, *The Gardeners Dictionary*, 6th edn, London, under 'Bignonia'.

182 Miller, P., 1768, *The Gardeners Dictionary*, 8th edn, London. See Laird, M., 1998, pp. 219–24; Laird, M., 2015b, pp. 265–80; and Nelson, E. C., 2014a.

183 *NH*, II, p. 98.

184 Ibid. See Chapter 4, p. 137.

185 Laird writes that *Kalmia latifolia* was one of the shrubs of which Catesby 'played an indirect role in promoting the introduction' (Laird, M., 1998, pp. 216–19).

186 As quoted by Coats, A. M., 1963, *Garden Shrubs and their Histories*, London, pp. 186–9.

187 *NH*, I, 27; *HBA*, no. 23.

188 Letter 5, 10 December 1722.

189 Aiton, W., 1810, *Hortus Kewensis*, 2nd edn, London, I, p. 261, no. 3, as 'Cornus arborea'.

190 Letter 6, 4 January 1723; letter 7. By 1727, the shrub was listed in Robert Furber's catalogue.

191 'Notes relating to Botany, collected from the Manuscripts of the late Peter Collinson by Lambert, A. B., 1809', Linnean Society, London, MS SP 235A, pp. 30–31; as quoted by Laird, M., 1998, p. 188.

192 *NH*, I, p. 46. Coats, A. M., 1963, p. 48.

193 Aiton, W., 1789, II, p. 220.

194 *NH*, II, p. 47.

195 Miller, P., 1768, under the name of 'Johnsonia Americana', commemorating the seventeenth-century botanist Thomas Johnson. Following Miller, Aiton recorded that it was 'introduced 1724, by Mr. Mark Catesby' (Aiton, W., 1789, I, p. 148). Laird suggests 'the Doctor' was Samuel Dale, but as he had died five years before (in 1739) it cannot be him (Laird, M., 1998, p. 190).

196 Letter 22, undated list, connected with letter 21, 6 April 1724.

197 Letter 2, 20 June 1722.

198 *NH*, II, p. 61.

199 Nelson, E. C., 2014b, p. 37.

200 Inscription in Collinson's hand on the verso of Plate 61, *Natural History*, Volume II, in the Goodwood library.

201 *NH*, II, p. 80; *HBA*, p. 4.

202 *HBA*, p. 4.

203 Letter 24.

204 Ray, J., 1686–1704, *Historia plantarum*, II, p. 1798.

205 Letters 21, 22 and 24.

206 *NH*, Appendix, p. 15.

207 *HBA*, p. 3, 'The Magnolia of Pennsylvania'.

208 *NH*, II, p. 81.

209 Ibid.

210 Importations of mahogany into England (and excluding those to Scotland, which were recorded separately) reached 525 tons per annum by 1740, 3,688 tons by 1750, and more than 30,000 tons in 1788, the peak year of the eighteenth-century trade (Bowett, A., 1994, 'The Commercial Introduction of Mahogany and the Naval Stores Act of 1721', *Furniture History*, 30, pp. 43–56). Charles Nelson notes, however, that not all so-called 'mahogany' was *Swietenia mahogoni*, so these import figures may be 'botanically imprecise' (pers. comm., December 2019).

211 Henrey, B., 1986, p. 167.

212 *HBA*, Preface, p. i.

213 Martyn, J., 1728–37, 'Aster Virginianus' (opp. p. 19); 'Brunella Caroliniana' (opp. p. 5: selfheal, *Prunella vulgaris*); the other six plants

are 'Corona Solis Caroliniana' (opp. p. 20: false sunflower, *Heliopsis helianthoides*); 'Cassia Bahamensis' (opp. p. 21: privet senna, *Senna ligustrina*); 'Bidens Caroliniana' (opp. p. 26: lance-leaved coreopsis, *Coreopsis lanceolata*); 'Abutilon Carolinanum' (opp. p. 34: bristly fruited mallow, *Modiola caroliniana*); 'Granadilla Americana' (opp. p. 37: passion flower, *Passiflora cuprea*) and 'Anonis Caroliniana' (opp. p. 44: white wild indigo, *Baptisia leucantha*).

214 Martyn, J., 1728–32, pp. 10–11.

215 Society of Gardeners, 1730, p. 13. Catesby had presented Part 3 of the *Natural History* to the Royal Society on 19 November 1730: see fig. 93. The other trees and shrubs included by Miller were 'The Scarlet-flowering Acacia' and 'Water Acacia', 'Bastard Indigo Tree', 'Carolina Ash' (swamp ash, *Fraxinus caroliniana*), 'Carolina Kidney Bean Tree' (*Lablab purpureus*), 'Carolina Lime Tree' and 'Yellow-berried Carolina Hawthorn'.

216 See Chapter 1. Hoppit notes that sixty-one new species of trees and ninety-one new species of shrubs were introduced between 1700 and 1751 (Hoppit, J., 2000, *A Land of Liberty? England 1689–1727*, Oxford, pp. 373–4). These quantities (and date range) correspond to those reported by Aiton in the *Hortus Kewensis* (1789); it is likely, however, that there were many more examples of trees and shrubs being grown in British gardens other than Kew, and that these numbers, therefore, underestimate the totals for the period.

217 See Chapter 6.

218 Laird, M., 1998, p. 189, discusses 'the correspondence of image and actuality' in Catesby's plates and the plants themselves.

Chapter 6 · Catesby as Naturalist

1 Letter of 20 April 1706 (Tinling, M., 1977, *The Correspondence of the Three William Byrds of Westover, Virginia, 1684–1776*, Charlottesville, I, p. 259).

2 Harris, S. A., 2015a, 'The Plant Collections of Mark Catesby in Oxford', in Nelson, E. C. & Elliott, D. J., eds, *The Curious Mister Catesby: A 'Truly Ingenious' Naturalist Explores New Worlds*, Athens, GA, & London, pp. 173–88 [pp. 173–4].

3 The process of the 'professionalization' of the scientist was to carry on into the next century (the first instance of the word 'scientist' occurred only in the 1830s). For a discussion of

this subject, see McClellan, J. E., 1985, *Science Reorganized: Scientific Societies in the Eighteenth Century*, New York, and Cannon, S. F., 1978, *Science in Culture: The Early Victorian Period*, New York, ch. 5, 'Professionalization'.

4 See Chapter 2, p. 62, and this chapter, p. 217.

5 Linnaeus's so-called 'sexual system' of classifying plants was based on the number and arrangement of a plant's floral parts; this classification, however, was more or less rejected by academic botanists in the early years of the nineteenth century, although his zoological classification has remained in use. His more important legacy was his binomial system for naming plants and animals, which is still in use today: Stearn, W. T., ed., 1957, *Linnaeus, Species Plantarum: Facsimile Edition of First Edition, 1753*, London. See also Jarvis, C. E., 2015, 'Carl Linnaeus and the Influence of Mark Catesby's Botanical Work', in Nelson, E. C. & Elliott, D. J., eds, *The Curious Mister Catesby: A 'Truly Ingenious' Naturalist Explores New Worlds*, Athens, GA, & London, pp. 189–204.

6 Frick, G. F. & Stearns, R. P., 1961, *Mark Catesby: The Colonial Audubon*, Urbana, IL, p. 50.

7 Frick & Stearns point out that while Catesby's Latin designations were 'rendered obsolete' by Linnaeus's system of binomial nomenclature, 'traces of Catesby's names live on in the Linnaean system' (ibid., p. 58).

8 Jarvis, C. E., 2007, *Order Out of Chaos: Linnaean Plant Names and their Types*, London, p. 116; Jarvis, C. E., 2015.

9 For fifty-two subjects Catesby was Linnaeus's sole reference: Adler, K., 2015, 'Catesby's Fundamental Contributions to Linnaeus's Binomial Catalog of North American Animals', in Nelson, E. C. & Elliott, D. J., eds, *The Curious Mister Catesby: A 'Truly Ingenious' Naturalist Explores New Worlds*, Athens, GA, & London, pp. 251–64. For Linnaeus's use of Catesby's herpetological images, see Bauer, A. M., 2012, 'Linnaean Names and Pre-Linnaean Sources in Herpetology', in Bell, C. J., ed., *The Herpetological Legacy of Linnaeus: A Celebration of the Linnaean Tercentenary*, *Bibliotheca Herpetologica*, 9, nos 1–2, pp. 53–79. Recently, Rick Wright has observed that much of what Linnaeus attributed to Catesby in the *Systema natura* in respect of his birds was taken second-hand from Edwards's *Natural History of Uncommon Birds*, which for some reason Linnaeus relied on initially rather than directly on the *Natural History* (Wright, R., 2019, 'How Many Buntings? Revisiting the

Relationship between Linnaeus and Catesby', https://blog.biodiversitylibrary.org/2019/12/how-many-buntings-html.

10 Stearn, W. T., 1957, p. 44. For the *Hortus Cliffortianus*, see Stevenson, A., 1961b, *Catalogue of Botanical Books in the Collection of Rachel McMasters Miller Hunt*, II, pt 2: *Printed Books 1701–1800*, Pittsburgh, PA, cat. no. 504. Jarvis points out that as only Parts 1–7 of Catesby's book were published by this date, not all his plates featuring plants were yet available to Linnaeus; however, of those that were, twenty-six were cited in the *Hortus Cliffortianus* (Jarvis, C., 2015, pp. 192–3).

11 Eight plant species have been named for Catesby, seven of which are still in use: *Calystegia catesbeiana* Pursh (Convolvulaceae) (*NH*, II, 60); *Clematis catesbyana* Pursh (Ranunculaceae) (not represented in the *Natural History* but named after Catesby by Frederick Traugott Pursh, based on a specimen in William Sherard's Herbarium (OUH, Sher-1135-2a); *Gentiana catesbaei* Walter (Gentianaceae) (*NH*, I, 70); *Lilium catesbaei* Walter (Liliaceae) (*NH*, II, 58); *Prunus catesbaei* Belval ex Colla (Rosaceae) (*NH*, I, 28); *Sarracenia × catesbaei* Ellis (Sarraceniaceae) (*NH*, II, 69); and *Trillium catesbaei* Elliott (Trilliaceae) (*NH*, I, 45). An eighth, *Silene catesbaei* Walter (Caryophyllaceae) (*NH*, II, 54), is now regarded as a synonym of *S. virginica* L.

12 *NH*, II, 100, later to be followed by the Appendix of twenty more plates. The name was adopted by Linnaeus and Catesby's image serves as the type (Jarvis, C., 2015, p. 198).

13 Two of the names of snakes recognizing Catesby are still valid: *Dipsas catesbyi* and *Uromacer catesbyi*; although the names of the remaining three, *Dryiophis catesbyi*, *Heterodon catesbyi* and *Crotalus catesbaei*, have not been retained, as synonyms they remain part of the history of the species' identification (Adler, K., 2015, who notes that 'herpetologists have accorded Catesby more honor than have ornithologists, for I can find no birds that were named for him' (p. 378, n. 23).

14 Forster cited Catesby for 172 species: ibid., p. 255.

15 Among modern publications are Simpson, G., 1943, 'The Discovery of Fossil Vertebrates in North America', *Journal of Paleontology*, 17, no. 1, p. 27; Ray, C., 1983, 'Geology and Paleontology of the Lee Creek Mine, North Carolina', *Smithsonian Contributions to Paleobiology*, I, no. 53, p. 5; Kirkbride, J. H. & Olsen, R. T., 2011, 'Neotypification of *Catalpa speciosa* (Bignoniaceae)', *Taxon*, 60, pp. 1760–63;

Macmillan, P. D., Blackwell, A. H., Blackwell, C. & Spencer, M. A., 2013, 'The Vascular Plants in the Mark Catesby Collection at the Sloane Herbarium, with Notes on their Taxonomic and Ecological Significance', *Phytoneuron*, 7, pp. 1–37; Austin, D. F., 2014, 'Salt Marsh Morning Glory (*Ipomoea sagittata*, Convolvulaceae) – An Amphi-Atlantic Species', *Economic Botany*, 68, pp. 203–19.

16 See Chapter 2. Catesby's extensive knowledge of botanical literature is evident in the authorities he cited; see this chapter, pp. 212–13, and Bibliography, pp. 332–4.

17 Stearn, W. T., 1958a, 'Botanical Exploration to the Time of Linnaeus', *Proceedings of the Linnean Society of London*, 169, pp. 173–96 (p. 176).

18 More wrote to Sherard that being 'without a horse and fatigue in travel … excuses me from methodizing and laying [dried plants] curiously' (Frick, G. F. & Stearns, R. P., 1961, pp. 114, 123); his attitude is reflected in the poor quality of his specimens which survive in Sherard's Herbarium (Stephen Harris, pers. comm.). Other collectors sent to the New World who disappointed their English patrons were William Vernon in Maryland and Hugh Jones in Virginia (Stearns, R. P., 1952, 'James Petiver, Promoter of Natural Science, c. 1663–1718', *Proceedings of American Antiquarian Society*, 62, pt 2, October, pp. 244–365 [pp. 292–310]). For More and Vernon, see Clokie, H. N., 1964, *An Account of the Herbaria of the Department of Botany in the University of Oxford*, Oxford, pp. 78, 214, 259. See also p. 291, n. 163.

19 *NH*, Preface, p. i.

20 Woodward, J., 1696, 'Directions …', London (privately printed); a transcription is published in MacGregor, A., ed., 2018b, *Naturalists in the Field: Collecting, Recording and Preserving the Natural World from the Fifteenth to the Twenty-First Century*, Leiden & Boston, Appendix V; and reprinted for the Society for the History of Natural History, Sherborn Fund, facsimile no. 4, Appendix, pp. 10–16.

21 For the many different versions of Petiver's 'Directions', see Jarvis, C. E., 2018, '"Take with you a small Spudd or Trowell": James Petiver's Directions for Collecting Natural Curiosities', in MacGregor, A., ed., *Naturalists in the Field: Collecting, Recording and Preserving the Natural World from the Fifteenth to the Twenty-First Century*, Leiden & Boston, pp. 212–39.

22 Chapter 1, p. 16.

23 Reeds, K., 2015, 'Mark Catesby's Botanical Forerunners in Virginia', in Nelson, E.

C. & Elliott, D. J., eds, *The Curious Mister Catesby: A 'Truly Ingenious' Naturalist Explores New Worlds*, Athens, GA, & London, pp. 27–38.

24 The group included Edmund Bohun of Archdale plantation, a Charleston apothecary George Franklin, Hannah Williams, wife of a planter William Williams, and Joseph Lord, the pastor at Dorchester (Sanders, A.E. & Anderson, W. D., 1999, *Natural History Investigations in South Carolina from Colonial Times to the Present*, Columbia, SC, pp. 8–10). See also Stearns, R.P., 1970, *Science in the British Colonies of America*, Urbana, IL, for an account of collecting in the Carolinas at this period (pp. 293ff.).

25 *Philosophical Transactions*, 24, 1705, pp. 1952–60.

26 See Chapter 1, p. 17. Stearns, R. P., 1970, p. 314; Simpson, M. B., Jr, 2015, 'John Lawson's *A new voyage to Carolina* and his "Compleat History": The Mark Catesby Connection', in Nelson, E. C. & Elliott, D. J., eds, *The Curious Mister Catesby: A 'Truly Ingenious' Naturalist Explores New Worlds*, Athens, GA, & London, pp. 71–84.

27 Woodward, J., 1696, item 2.

28 Catesby was to use this variation of the Royal Society's phrase 'occular inspection' in his paper on bird migration delivered to the Royal Society in 1747 (see below). For the use of ocular inspection in the early years of the Royal Society, see Tinniswood, A., 2019, *The Royal Society and the Invention of Modern Society*, London, p. 15.

29 *NH*, Appendix, p. 14.

30 His comment on Réaumur: see p. 217.

31 See p. 216.

32 *NH*, Appendix, p. 5.

33 Ibid., II, 32.

34 Ibid., II, 38. Bauer, A. M., 2015, comments on Catesby's accuracy in his reports of 'mating and egg laying' among sea turtles in 'Catesby's Animals (other than Birds) in *The Natural History of Carolina, Florida and the Bahama Islands*', in Nelson, E. C., & Elliott, D. J., eds, *The Curious Mister Catesby: A 'Truly Ingenious' Naturalist Explores New Worlds*, Athens, GA, & London, pp. 231–50 [p. 248].

35 *NH*, II, p. 1.

36 Ibid., II, p. 10.

37 Ibid., Account, p. xxix.

38 Ibid., II, p. 43.

39 As there is no record of Catesby having had any medical training, he may have learned how to dissect from his medical friends, and no doubt also observed how the Native Americans dissected animals.

40 *NH*, II, p. 63.

41 Ibid., I, p. 85.

42 Ibid., I, p. 8.

43 Ibid., I, p. 82. For his misidentification of the juvenile as a separate species, see 'The Brown Curlew', ibid., I, 83.

44 Ibid., I, p. 14.

45 He did, however, depict both the male and female of the blue-winged teal but believed them to be different species (ibid., 99 and 100).

46 For a study of Catesby's illustrations of the ecological and environmental relationships between birds and plants, see Krech, S., III, 2018, 'Catesby's Birds', in MacGregor, A., ed., *Naturalists in the Field: Collecting, Recording and Preserving the Natural World from the Fifteenth to the Twenty-First Century*, Leiden & Boston, pp. 279–331. For the influence of Maria Sibylla Merian on Catesby's study and depiction of environmental relationships, see Etheridge, K. and Pieters, F. J. M., 2015, 'Maria Sibylla Merian (1647–1717): Pioneering Naturalist, Artist, and Inspiration for Catesby', in Nelson, E. C. & Elliott, D. J., eds, *The Curious Mister Catesby: A 'Truly Ingenious' Naturalist Explores New Worlds*, Athens, GA, & London, pp. 39–56, especially pp. 53–6.

47 *NH*, II, p. 63.

48 Ibid., II, p. 65.

49 Ibid., II, p. 66. Bauer, A. M., 2015, notes that Catesby's hypothesis of this signalling mechanism was correct (p. 240).

50 *NH*, II, p. 33.

51 Stephen Harris notes that 'the junipers are both variable and diverse and it would be impossible to place a reliable species ID with the information given' (pers. comm.).

52 Letter 38, postmarked 3 February, 1736.

53 *NH*, Account, p. xli. See Eshbaugh, W. H., 2015, 'The Economic Botany and Ethnobotany of Mark Catesby', in Nelson, E. C. & Elliott, D. J., eds, *The Curious Mister Catesby: A 'Truly Ingenious' Naturalist Explores New Worlds*, Athens, GA, & London, pp. 205–18 [p. 218].

54 NHM, Dale Herbarium, label to no. 26a.

55 *NH*, Account, p. xliv.

56 Ibid., I, p. 65.

57 Tinniswood, A., 2019; Hall, M. B., 1991, *Promoting Experimental Learning: Experiment and the Royal Society, 1660–1727*, Cambridge; Espinasse, M., 1956, *Robert Hooke*, London. As well as Hooke's *Micrographia* (London, 1665), Catesby would have been familiar with illustrations of objects under magnification published in the *Philosophical Transactions*.

58 Henry Baker, letter book, I, 1722–48, letter 16, 1743 (Beinecke Library, Yale University, New Haven, Osborn FC 109/1/2). Baker's *The Microscope made Easy* (London, 1742) went through five editions in his lifetime and was translated into Dutch and French.

59 Smallwood, W. M., 1941, *Natural History and the American Mind*, New York, pp. 198–200, who describes John Bartram's use of the microscope in 1729 (mentioned by Bartram in a letter to William Byrd), as 'one of earliest contributions of the microscope to the development of natural history in America'. Microscopes were acquired by Harvard in 1732 and Yale in 1734 (I thank Robert Peck for this information).

60 *NH*, Appendix, p. 10. While it is difficult to calculate the exact degree of magnification, the flea would appear to be shown approximately 45-fold while the flea egg and the unidentified beetle appear approximately 25-fold magnified. By 1725 three-legged Culpeper-type compound microscopes, housed in oak chests, were available, as well as popular more compact Wilson-type screw barrel microscopes. I am grateful to Michael Korey and Tiemen Cocquyt for their advice on this matter.

61 Baker described how different objects should be inserted into the 'sliders' (a 'flat slip of ivory with four round Holes through it, wherein to place Objects between two Glasses'), and advised which glasses were suitable for which objects: 'Make use of the third or fourth Magnifier for Frogs, or Fishes; but for the Tails of Water-Newts, the fifth or sixth will do' (Baker, H., 1742, p. 13).

62 As a fellow of the Royal Society, Catesby would have had access to the 'Cabinet of Microscopes' which had been bequeathed to it by the Dutch physician Antonie van Leeuwenhoek in 1723 (RS, CLP/2/17).

63 *NH*, Account, p. xxx.

64 Edwards, G., 1743–51, *A Natural History of Uncommon Birds ...*, London, I, p. 52.

65 *NH*, Appendix, p. 4.

66 Ibid., 5.

67 Botanical specimens were also, of course, the most easily preserved.

68 See Appendix 1, Note on Catesby's Plant and Animal Specimens.

69 Letter 1, 5 May 1722. For one of the fossils Catesby collected, see fig. 246, and Appendix 1.

70 Letter 18. Catesby did, however, deviate from this programme on occasion, as for instance in his returning to an unspecified location 'Near Rivers tho' very remote from the Settlements' to collect specimens of the Indian bean tree (Harris, S. A., 2015a, p. 176).

71 Letter 2, 20 June 1722.

72 Letter 18, 16 January 1724.

73 Letter 24, 16 August 1724.

74 Letter 26, 30 October 1724.

75 Nichols, J., 1817–58, *Illustrations of the Literary History of the Eighteenth Century*, London, I, pp. 381–2; Turner, D., ed., 1835, *Extracts from the Literary and Scientific Correspondence of Richard Richardson*, Yarmouth, p. 188.

76 See Chapter 5, pp. 201–2 and letter 11, 10 May 1723.

77 Letter 2.

78 Letter 21, 6 April 1724.

79 For methods of travelling in South Carolina at the period, see Linder Hurley, S., 2015, 'Mark Catesby's Carolina Adventure', in Nelson, E. C. & Elliott, D. J., eds, *The Curious Mister Catesby: A 'Truly Ingenious' Naturalist Explores New Worlds*, Athens, GA, & London, pp. 109–26. Amongst 'collecting kit' needed by a plant collector, were 'Presses, paper, notebooks and rations' as well as a hand lens or field microscope, a compass, a knife, 'and for personal protection, swords and/or pistols': Harris, S. A., 2018, 'Snapshot of Tropical Diversity: Collecting Plants in Colonial and Imperial Brazil', in MacGregor, A., ed., *Naturalists in the Field: Collecting, Recording and Preserving the Natural World from the Fifteenth to the Twenty-First Century*, Leiden & Boston, pp. 550–76 [p. 570].

80 Letter 4, 9 December 1722.

81 Letter 6, 4 January 1723. The patrons of Hugh Jones, collecting in Maryland, recognized that in his 'greatest drudgery, as carrying the box, basket &c.' he needed help (Stearns, R. P., 1952, p. 299). Harris, citing John Woodward in his 'Directions …' (1696), notes: 'To ease the burden, physical collection and preservation of

objects could always be delegated to the "Hands of Servants"' (Harris, S. A., 2018, p. 557).

82 Catesby specified the cost in letter 4; see also letter 6 and Chapter 2, n. 104. In the 1720s African slavery was well established as a source of labour in South Carolina and large numbers of captives from the west coast of Africa were being traded through Charleston. For an extensive discussion of the African slave trade in South Carolina during this period, see Wood, P., 1974, *Black Majority*, New York.

83 Letter 18.

84 Letter 5, 10 December 1722.

85 Letters 4; 11, 10 May 1723; 21.

86 *NH*, Preface, p. iv. The 'box' was perhaps a chest. Catesby's statement that he put into it 'dry'd Specimens of Plants, Seeds, &c. as I gathered them' inferred that he was inserting his fresh specimens straight away into a collecting book so that they would be kept flat and dry.

87 A 'quire' usually meant 24 folios (Glaister, G. A., 1960, *Glossary of the Book: Terms used in Paper-making, Printing, Bookbinding and Publishing …*, London, reprinted 1996 as *Encylopedia of the Book*, London, p. 339). Later in the eighteenth century the 'botanical book' was replaced by the 'botanical box' (known as a vasculum): Harris, S. A., 2015a, pp. 182–8.

88 Letter 21. Pasteboard, commonly used in bookbinding, was stiff board formed from layers of paper or pulp pasted together (Krill, J., 2001, *English Artists' Paper: Renaissance to Regency*, New Castle, DE, p. 60).

89 Petiver stipulated 'In Collecting of Plants': 'these must be put into a Book or into a Quire of Brown Paper (which you must take with you) as soon as gathered, and once a Week shift them to a fresh place, to prevent either rotting themselves or Paper' ('Advertisement', in Petiver, J., 1695, *Musei Petiveriani centuria prima, rariora naturae …*, unpaginated; a different version of this 'Advertisement' notes the quire of brown paper should be 'stich'd').

90 In Catesby's letter to Dillenius he mentions his later use of the 'written observations I made' in the field (letter 38).

91 Petiver's directions to George Harris, apprentice to Edmund Halley, included the injunction: 'Take always your pencil booke with you & never fail to write down anything observable as soon as you see it which transcribe into your Observatory booke as soon as you can' (quoted in Stearns, R. P., 1952, p. 280).

92 Letter 2.

93 Harris, S. A., 2015a, p. 176.

94 Ibid., p. 179.

95 See Appendix 1; Harris, S. A., 2015a, pp. 182–8, for an account of later rearrangements of Sherard's herbarium.

96 NHM, Dale Herbarium, no. 86. Catesby was to note in the *Natural History*: 'Many or most part of the Trees and Shrubs in Carolina retain their verdure all winter' (*NH*, Account, p. iii).

97 NHM, Sloane HS 212, fol. 16. A similar sketch is found on the label to the specimen of *Calycanthus floridus* he sent Sherard (NHM, Dale Herbarium, folder 1, fol. 1).

98 NHM, Dale Herbarium, no. 27a; it has so far not been possible to see whether infrared imaging might show up the drawing on the back of the leaf.

99 Ibid., no. 29.

100 Ibid., no. 57.

101 Petiver, J., undated(a), 'Brief Directions for the easie making, and preserving collections of all natural curiosities', broadside (not before 1713), London.

102 Letter 10, 10 May 1723.

103 Letter 24, 16 August 1724.

104 Letter 2. One of Catesby's specimens of *Sarracenia flava* does indeed show a pitcher 'spatchcocked' in this way (Du Bois Herbarium: 00087312L, Oxford Plant Sciences).

105 Letter 24.

106 See Appendix 2.

107 Harris, S. A., 2015a, p. 179, notes it is not surprising that with the mass of material Catesby was collecting he occasionally attached the wrong label to the wrong specimen.

108 Petiver also advised such a system in his undated broadside 'Directions for the Gathering of Plants' (see fig. 231).

109 Letter 11.

110 Forty-five of the plants in the watercolours at Windsor still bear numbers.

111 Catesby prioritized accordingly his 'account of the Method I have observed in giving the Natural History of these Countries' in the Preface to his *Natural History*, beginning with plants and following with birds before describing other categories (*NH*, Preface, pp. iv–v).

112 In 109 plates with birds, he illustrated 110 North American and Caribbean/West Indian species (Krech, S., III, 2018).

113 *NH*, Preface, p. vi. Adler notes: 'When compared to illustrations drawn by other artists of the eighteenth century, Catesby's [snakes] were among the best in terms of their accuracy' (Adler, K., 2015, p. 256). It is interesting to note that as early as 1758 Catesby's description and image of the tree frog was cited in von Rosenhof, R., 1758, *Historia naturalis ranarum nostratium*, Nuremberg, p. 38, tab. IX.

114 *NH*, Preface, p. x. He noted that he identified 'eighteen or nineteen Sorts of Serpents: whereof four are of the Viper kind, the others of the Snake kind' (ibid., II, p. 41). Bauer notes that Catesby's statement 'very few escaped me' was 'rather optimistic' as around twenty-three other snakes occur in the areas Catesby was exploring. However, he concedes that 'many of the snakes missed by Catesby are either inconspicuous or similar in appearance to those he did illustrate' (Bauer, A. M., 2015, p. 248).

115 Several of the other categories of fauna indicate that Catesby kept numbered tallies of the different species he saw within different groups.

116 In Catesby's day mammals (along with many reptiles and amphibians) were described as 'quadrupeds' following Aristotle's use of the term *quadrupedia*; it was not until Linnaeus's classificatory system in 1758 that mammals were identified as a class (Wilson, D. E., 2009, 'Class Mammalia', in Wilson, D. E. & Mittermeier, R. A., eds, *Handbook of the Mammals of the World*, Barcelona, I, pp. 17–47).

117 *NH*, Preface, p. v. Aaron Bauer points out, however, that it was mostly amongst mammals that 'Catesby often erroneously considered North American species to be conspecific with their European counterparts and as such did not illustrate them or provide information on their biology' (Bauer, A. M., 2015, pp. 243–5).

118 For Catesby's use of other artists' sources, see Chapter 4 and forthcoming Catalogue.

119 *NH*, Preface, p. v. See note 136 below.

120 Caygill, M., 2012, 'Sloane's Catalogues and the Arrangement of his Collections', in Walker, A., MacGregor, A. & Hunter, M., eds, *From Books to Bezoars: Sir Hans Sloane and his Collections*, London, pp. 120–36. For a list of Sloane's manuscript catalogues, see MacGregor, A., ed., 1994, *Sir Hans Sloane: Collector, Scientist, Antiquary, Founding Father of the British Museum*, London, pp. 291–4.

121 Purges of the historic collections in the Natural History Museum have taken place over the years for several reasons: items had lost their accompanying labels; they were duplicates; or they were in too poor condition. The plight of the fossil collections gives an idea of how much has been lost: out of 15,250 fossil specimens in Sloane's collection, only 150 survive (one of which was sent by Catesby). No insect, echinoderm, mammal or ornithological material has survived, while only eight shells and one fish are extant (for the surviving specimens, see Appendix 1). For a survey of Sloane's zoological collections, see Clutton-Brock, J., 1994, 'Vertebrate Collections', in MacGregor, A., ed., *Sir Hans Sloane: Collector, Scientist, Antiquary, Founding Father of the British Museum*, London, pp. 77–92.

122 Letters 11; 20, 12 March 1724; 23, 15 August 1724.

123 Letter 20: 'With one I sent before I now send 7 kinds of wood peckers which is all the kinds except one I have discovered in this Country[.]' For the different species, see letter 10.

124 Letters 10 and 20.

125 Letters 20 and 23. Sloane's catalogue entry for the 'great booby' reads, 'The head of a bird from Mr Catesby from Carolina called by him the Fisher' (NHM, Sloane 'Fossils V', no. 575) (see McBurney, H., 2019, 'Mark Catesby's Plate "The Great Booby"', in Droth, M., Flis, N. and Hatt, M., eds, *Britain in the World: Treasures from the Yale Center for British Art*, New Haven and London, pp. 40–43).

126 Letter 20. Judging by the duplicates of his watercolours of birds that Catesby made for Sloane, the latter's principal interest was in the more spectacular birds. (For Catesby's watercolours made for Sloane, see forthcoming Catalogue and fig. 237.)

127 It is possible that some of Catesby's letters did not survive; equally he may not have been precise about the total quantity sent in each cargo.

128 Of these, two specimens of the ivory-billed woodpecker feature in NHM, Sloane 'Fossils V', nos 537 and 538 (head only with bill).

129 *NH*, I, p. 16. It was, however, the destruction of their forest habitat over more than a century that caused the decline of the species: Fuller, E., 1987, *Extinct Birds*, Oxford, pp. 267–74, the last bird being recorded in 1944, although both Fuller and more recently Attenborough (Attenborough, D., 2015, *Amazing Rare Things: The Art of Natural History in the Age of Discovery*, London) leave open the possibility that 'a few individuals [might] linger in rarely-trodden parts of the southern United States or north-east Cuba' (Fuller, E., 1987, p. 268). Brush and Brush note that it was the primal forest, 'dominated by oaks (*Quercus*), gum (*Nyssa*), and cypress (*Taxodium*)', susceptible to insect infestations, which supported ivory-billed woodpeckers. Those swamp lands, so familiar to Catesby, barely exist today (Brush, M. J. and Brush, A. H., 2018, *Mark Catesby's Legacy: Natural History Then and Now*, Charleston, SC, pp. 27–30).

130 *NH*, I, p. 11. Fuller, E., 1987, pp. 239–43, notes that the last caged individual died at the Cincinnati Zoological Gardens in 1918.

131 *NH*, I, p. 23. Fuller, E., 1987, pp. 188–94. Martha, the last bird to remain in captivity, was found dead on the floor of her cage in Cincinnati Zoo in 1914 (she was stuffed and can be seen in the National Museum of Natural History, Smithsonian Institution). In its heyday the species had accounted for between 25 and 40 per cent of the total land bird population of America.

132 Letter 23. NHM, Sloane 'Fossils II', no. 1198, records: 'The skin of a black fox from Carolina where they are very rare and found on the mountains.' The animal may have been the so-called 'silver fox', a melanistic fox, *Vulpes vulpes*, which is mostly black and was in high demand for its pelt, even among Native Americans (I am grateful to Aaron Bauer for this information).

133 Letter 23. The skunk was recorded in NHM, Sloane 'Fossils V', no. 1198, as 'The skin of a pole catt, they all vary in their marks.' Catesby was later to present another specimen of the skunk to the Royal Society: see p. 216.

134 Letter 10.

135 Sloane's manuscript catalogues, NHM, Sloane 'Insects I–II', include wasps, butterflies, moths, chrysalises and fireflies collected by Catesby in both Virginia and South Carolina.

136 Letter 10. Glass bottles were very expensive, as they continued to be over a century later. In 1838 the botanist and explorer Allan Cunningham in Sydney wrote that he had purchased glass bottles from chemists at 'a dear cost (3/6 per lb!)' (Endersby, J., 2008, *Imperial Nature: Joseph Hooker and the Practices of Victorian Science*, Chicago, p. 72). I am grateful to Stephen Harris for this information.

137 Letter 20.

138 Letter 23.

139 A specimen included in the 'Serpents' section of NHM, Sloane 'Fossils I', no. 299, sent by Catesby's brother John from Gibraltar and labelled 'Cocilia dorso fusco ventro candido minima', can be identified as a worm lizard, *Blanus cinereus*, a legless reptilian found in Morocco, Portugal and Spain (I am grateful to Carlo Violani for this identification).

140 NHM, Sloane 'Fossils V', no. 1182 (tortoise shell).

141 Letter 34, 10 January 1725. The 'large Bottle' may have been among those listed under 'Animals preserved in spirits' in the sale catalogue of Mead's collection, 'A Catalogue of the Genuine and Entire Collection of Valuable Gems, Bronzes, Marble and other Busts and Antiquities of the late Doctor Mead, sold by auction by Mr Langford on 11th March 1755 and 4 following days. March 1755', London, pp. 3, 5, 8.

142 Letters 10 and 20.

143 *NH*, Preface, pp. v–vi.

144 NHM, Sloane 'Fossils II'. The fact that no letters from Catesby to any of his sponsors survive from his Bahamian stay suggests he may have decided to keep hold of the collections he made there so that he could bring them back himself on his return to England.

145 See Appendix 1.

146 NHM, Sloane HS 232, fol. 18.

147 *NH*, II, p. 15. NHM, Sloane 'Fossils V', nos 1559–60.

148 NHM, Sloane 'Fossils V', no. 1562.

149 Ibid., no. 994.

150 Ibid., no. 1561. As was usual at this period, sharks were classified as fish. This specimen might have been any one of around ten species that occur in nearshore waters off the Carolinas.

151 For methods of 'skinning' and 'stuffing' at this period, see Morris, P., 2012, *A History of Taxidermy: Art, Science and Bad Taste*, Ascot.

152 Mead, W. R., 2013, *Pehr Kalm: His London Diary*, Aston Clinton, p. 45.

153 Simmons, J. E., 2014, *Fluid Preservation: A Comprehensive Reference*, Lanham, MD; Bauer, A. M. & Wahlgren, R., 2013, 'On the Linck Collection and Specimens of Snakes Figured by Johann Jakob Scheuchzer (1735) – The Oldest

Fluid Preserved Herpetological Collection in the World?', *Bonn Zoological Bulletin*, 62, no. 2, December, pp. 220–52.

154 Oliver Crimmen notes that many animals preserved in spirits in the centuries following this have not survived in such good condition (pers. comm.).

155 John was commissioned in Grove's Regiment of Foot (10th Foot): Nelson, C. E., 2013, 'The Catesby Brothers and the Early Eighteenth-Century Natural History of Gibraltar', *Archives of Natural History*, 40, pt 2, pp. 357–9.

156 These can be found in Sloane's manuscript catalogues (NHM). Further specimens collected by John were given to George Edwards and Johann Amman; see MacGregor, A., 2014, 'Patrons and Collectors: Contributors of Zoological Subjects to the Works of George Edwards (1694–1773)', *Journal of the History of Collections*, 26, no.1, pp. 35–44, Appendix, 'Alphabetical List of Collectors etc. credited in Edwards's texts'; this lists six different species of birds sent from Gibraltar to Catesby, given by him to Edwards. See also Nelson, E. C., 2013.

157 In a similar way, Eleazar Albin recorded making a drawing from a kingfisher caught in Smyrna which William Sherard sent him preserved in spirits of wine: 'This Bird was shot by Consul Sherrard in a River of Smirna, and brought over by him preserved in Spirits of Wine, from which I made a drawing exactly like the Bird' (Albin, E., 1731–8, *A Natural History of Birds*, London, III, p. 26).

158 BL, Sloane Add MS 5267, fol. 67 (see forthcoming Catalogue).

159 *NH*, Appendix, p. 19. NHM, Sloane 'Fossils V', no. 1432.

160 *NH*, Account, p. vii. Influential writings on the subject with which Catesby would have been familiar were John Woodward's *Essay towards a Natural History of the Earth* (1695) and Thomas Burnet's *Theory of the Earth* (1684). He could have discussed marine fossils with Samuel Dale, who published his *History and Antiquities of Harwich* in 1737 (see fig. 13).

161 NHM, Sloane 'Fossils V', no. 1142. For Robert Johnson's natural history interests, see Chapter 2.

162 Woodward, J., 1696, item 14.

163 For the basket of this type collected for Sloane by Francis Nicholson, see fig. 68

(BM, Department of Africa, Oceania and the Americas, Sloane 'Miscellanies', no. 1218).

164 King, J. C. H., 1994, 'Ethnographic Collections: Collecting in the Context of Sloane's Catalogue of "Miscellanies"', in MacGregor, A., ed., *Sir Hans Sloane: Collector, Scientist, Antiquary, Founding Father of the British Museum*, London, pp. 228–44.

165 Letter 27, 27 November 1724.

166 BM, Department of Africa, Oceania and the Americas, Sloane 'Miscellanies', no. 1203.

167 Letter 14, 13 November 1723. As by this date both Catesby's older brothers, John and Jekyll, had died (Nelson, E. C., 2013), the waistcoat must have been destined for Catesby's younger brother John.

168 *NH*, Account, p. viii.

169 The pipe bowl of the calumet depicted by Catesby is similar to one listed in Sloane's catalogue with a 'square piece cutt in the shape of the butt end of a gunn' (BM, Department of Africa, Oceania and the Americas, Sloane 'Miscellanies', no. 1214). I am grateful to Jonathan King for this information.

170 The impressive list of around eighty published works he cited included books in Latin, French, German and Dutch; see Bibliography, pp. 332–4.

171 Of earlier authors, he cited Gessner most frequently. His use of predominantly contemporary authors is indicative of the fact that he worked in the field, unlike academic naturalists who depended on secondary sources in libraries.

172 Catesby cited Sloane more frequently than any other author – see Bibliography, p. 333. He only had use of the first volume of the *Natural History of Jamaica* (1707) while he was in America; he would have been able to consult the second volume (1725) after his return to London, together with other new scientific works being published.

173 It was the revised edition, *The History of Carolina* (1714), of Lawson's original *New Voyage to Carolina* (1709) that Catesby used (Simpson, M. B., Jr, 2015, p. 72).

174 One of the books from Byrd's library which recently came to light is John Parkinson's *Theatrum botanicum* (1640), which previously belonged to John Banister (pers. comm., Karen Reeds, June 2012). For Mattioli, see Catesby to Sherard (letter 22); *Hortus Malabaricus*: label on specimens of *Catalpa bignonioides* sent to Sherard

(OUH, Sher-1249) and Sloane (NHM, HS 212, fol. 61]), quoted above p. 200; Clusius: label on specimen of *Nelumbo lutea* (OUH, Sher-1090).

175 *NH*, Preface, p. xii.

176 Pulteney recorded that 'Dr Sherard was in a particular manner, the patron of Mr Mark Catesby; and himself affixed the Latin names to the plants of "The Natural History of Carolina"' (Pulteney, R., 1790, *Historical and Biographical Sketches of the Progress of Botany in England from its Origin to the Introduction of the Linnaean System*, London, II, p. 148).

177 As Sherard's letters to Catesby do not survive, there are only indications of his replies to Catesby in Catesby's letters to him, and in Catesby's plant labels.

178 Letter 17, 16 January 1724.

179 Smith, J. E., 1821, *A Selection of the Correspondence of Linnaeus and other Naturalists from the Original Manuscripts*, London, II, p. 107, letter 39a, 28 November 1737.

180 Frick, G. F. & Stearns, R. P., 1961, p. 58. Among published authors apart from Ray and Sloane, Catesby made reference to the works of James Petiver and Martin Lister: Bibliography, pp. 332–4.

181 Letter 16, before 1724.

182 Letter 4. Linnaeus developed a different method using glass bottles instead of gourds; he wrote to the London merchant John Ellis: 'Seeds may be brought from abroad in a growing state if we attend to the following method. Put your seeds into a cylindrical glass bottle and fill up the interstices with dry sand to prevent their lying too close together and they may perspire freely thro the sand. Then cork the bottle or tie a bladder over the mouth of it' (Ellis, J., 1759, 'An Account of some Experiments …', *Philosophical Transactions*, 51, pp. 206–15).

183 Letter 5.

184 Over 8,000 specimens from Sloane's 'Vegetable Substances' collection survive in the NHM, of which *c.*215 are specimens sent from Catesby (see Appendix 1). For descriptions of the collection, see Cannon, J. F. M., 1994, 'Botanical Collections', in MacGregor, A., ed., *Sir Hans Sloane: Collector, Scientist, Antiquary, Founding Father of the British Museum*, London, pp. 145–6; Pickering, V., 2017, 'Putting Nature in a Box: Hans Sloane's Vegetable Substances Collection' (PhD thesis, Queen Mary College, University of London), and Ogborn, M. & Pickering, V., 2018, 'The World in a Nicknackatory: Encounters

and Exchanges in Hans Sloane's Collection', in Craciun, A. & Terrall, M., eds, *Curious Encounters: Voyaging, Collecting, and Making Knowledge in the Long Eighteenth Century*, Toronto, pp. 113–37.

185 While Catesby's labels have not survived, the wording of the 'Vegetable Substances' catalogue entries bears the hallmark of his style. For example, the entry for no. 8289 reads, 'This kind of Alkanet was in great esteem wt. the Indians (of Carolina) for painting themselves with befor the English supplied them wt. vermilion. It is yet precious amongst them they using it with bears oil for painting & preserving their hair. It seems to be not [dissimilar?] in colour to Cochineel. The acorns are as I had them from the Indians wch. they use wt. the root to fix the colour. Mr Catesby.'

186 John Evelyn advised using barrels to transport trees from New England: 'The trees in barrils their rootes wraped about mosse; the smaller the plants and trees the better; or they will do well packed up in matts; but the barril is best, and a small vessel will contain enough of all kinds, labels of paper tyed to every sort with ye name' (quoted in Lemmon, K., 1968, *The Golden Age of Plant Hunters*, London, p. 7). Later, in his *Directions for Bringing over Seeds and Plants from the East-Indies and other Distant Countries, in a State of Vegetation*, London, 1770, frontispiece, John Ellis illustrated barrels with 'windows', and boxes with partitions to keep specimens separate. See also Bridgman, K. and Laird, M., 2014, 'American Roots: Techniques of Plant Transportation and Cultivation in the Early Atlantic World', in Smith, P. H., Meyers, A. R. W. & Cook, H. J., eds, *Ways of Making and Knowing: The Material Culture of Empirical Knowledge*, Ann Arbor, MI, pp. 164–93.

187 Letter 8, 7 February 1723.

188 Letter 5.

189 Letter 4, where the cost of a wooden box can be seen to be double that of a bottle of English beer (10d or 2d sterling).

190 Letter 2. In his book on mosses, *Historia muscorum* (Oxford, 1741), Dillenius introduced a new classification of the lower plants, some of which is still in use today.

191 Letter 4.

192 And dormant plants would remain so while in temperate (winter) conditions until they were unpacked on arrival.

193 Letter 4.

194 Letter 26. Catesby's letters contain mention of the names of at least ten ships' masters, and six different ships (sometimes the ships are referred to only by their masters' names) in connection with the transport of his consignments to London (see Appendix 3). Several of these ships are listed as entering and leaving Charleston harbour in the port's naval officer records: see the papers for an unfinished book by T. J. Tobias on the history of Charleston, SC, as a port, *c.*1670–*c.*1865 (Thomas J. Tobias papers, *c.*1716–1968 [1106.00], South Carolina Historical Society, Charleston, SC).

195 Letter 8.

196 Letters 1 and 14, 13 November 1723. On 26 June 1723, Catesby wrote: 'I dread the mischief the Pirates have done to the things I sent[.] I had not the opertunity of seing and putting them up in the best manner again tho Capt Robinson has promised if they are wet to … preserve this and most of my Letters, but Capt Robinson's acct of the plants is so imperfect that I am wholly ignorant of the damage' (letter 13).

197 Letter 24; it is not clear if this was the same pirate raid he referred to eighteen months earlier.

198 Letters 8, 21, 31, 27 November 1724, and 35, 10 January 1725.

199 Tinling, M., 1977, p. 550: letter of 10 July 1740.

200 As well as the significant quantities of live and preserved plants and animals he had successfully sent back during his time in America, he brought back with him collections of live plants, seeds (amongst which were *Catesbaea spinosa*), many of the molluscs and crustacea he had collected in the Bahamas, and various live animals, including painted finches (*NH*, I, 44). The large numbers of molluscs and crustacea he brought back are listed in NHM, Sloane 'Fossils V', 'Corals, Sponges, & some other submarines', and three volumes of 'Shells'; see Appendix 1.

201 Pulteney, R., 1790, II, p. 229. An instance of Catesby's ornithological reputation is revealed in a letter from William Sherard to Richard Richardson: 'I shewed [Catesby] your Sparrow: he is of opinion it is the Reed Sparrow, which he says varies much in colour' (Turner, D., 1835, p. 373).

202 It should be remembered that during this period he was also assisting his nursery garden friends with raising North American plants for commercial use by garden owners (see Chapter 5).

203 See Chapter 2. His visits are recorded in the Royal Society *Journal Books*, beginning on 22 May 1729.

204 See fig. 93.

205 10 November 1732: RS, *Council Minutes*, III, p. 118.

206 It is puzzling that no drawings by Catesby have been found in the Register Books, or even gaps where they might have been. As there are none by Catesby in the one surviving album of drawings (MS 131) which contains a miscellany of images of antiquarian and natural objects, a possible explanation is that they were added to what was described in 1708 as the Society's 'Book of Drawings', an album that has not survived.

207 'The rates which the artist demanded were reasonable: only that his bond for future payments to the Society be given to him' (RS, *Journal Books*, III, p. 142). The 'bond' or annual subscription to the society was 2 guineas, the cost of just one coloured part of Catesby's *Natural History*.

208 RS, *Committee Minute Book* (CMB 63). On 30 October the committee finished examining 'the artificiall curiosities … with which they ended their review of all the Curiosities from the Repository'. For the state of the Repository at this time, see Chapter 1.

209 RS, *Journal Book*, 15, 2 May 1734, p. 42. Ten years earlier he had sent Sloane a stuffed skunk, very likely of the same species (see letter 23, 15 August 1724, pp. 258–9).

210 Ibid., 5 May 1743. A shortened version was published in *NH*, Account, pp. vii–xvi.

211 Ibid., 19 May 1743. Published in a shortened version in *NH*, Account, pp. xxii–xxiv.

212 To which was added 'Receipts … from his Excellency Mr Johnson late Governor of South Carolina; one for the Pickle of Sturgeon; the other for making Caviair [*sic*]' in a shortened version in *NH*, Account, pp. xxxiii–xxxiv.

213 RS, *Journal Book*, 20, 5 March 1747, pp. 218–23. Published in 1747 as 'Of Birds of Passage', *Philosophical Transactions*, 44, no. 483, pp. 435–44; and in *NH*, Account, pp. xxxv–xxxvii. A two-page extract was also published in the *Gentleman's Magazine*, 18 October 1748, pp. 447–8: see Bibliography, p. 330.

214 The importance of Catesby's theories are discussed fully in Krech, S., III, 2015, '"Of birds of passage": Mark Catesby and Contemporary Theories on Bird Migration and Torpor', in Nelson, E. C. & Elliott, D. J., eds, *The Curious*

Mister Catesby: A 'Truly Ingenious' Naturalist Explores New Worlds, Athens, GA, & London, pp. 219–30. See also Birkhead, T., 2008, *The Wisdom of Birds: An Illustrated History of Ornithology*, London; Birkhead provides a chart of 'Authors who give torpor or submersion as possible reason for disappearance of swallows, vs migration' (pp. 154–5). Frick & Stearns suggest that while some of Catesby's theories were 'flawed' by contemporary thinking about climatology, as well as a 'passion for uniformity and symmetry', some, such as his observations on bird migration, were 'ahead of much of the best opinion of his time, including … the great Linnaeus himself' (Frick, G. F. & Stearns, R. P., 1961, pp. 63–4).

215 RS, *Journal Book*, 16, 23 October 1735, p. 173; 27 November 1725, p. 201; Frick & Stearns note that Amman's Russian explorations 'in ways paralleled [Catesby's] own work in America' (1961, p. 40).

216 RS, *Journal Book*, 20, 6 March 1746, p. 70: 'One in sand bed of River Derwent, different from any now known in England[,] it is supposed that they have lain buried for at least seven or eight hundred years … the other of extraordinary size from a peat-moss, still in velvet, six feet between the tips'.

217 RS, *Journal Book*, 17, 12 January 1738, p. 172, and *Letter Book*, XXIV, pp. 115–18 (letter from Byrd to Catesby, 27 June 1737); Frick & Stearns (1961) discuss Byrd's conventional ideas as opposed to modern thinking of the time (including Catesby's), p. 41. See also Tinling, M., 1977, pp. 518–20.

218 Presented to the Royal Society at six meetings on 25 March, 10 June, 1 July and 18 Nov. 1736, and on 31 March and 21 April 1737.

219 RS, RBO/20/27, 1737, p. 62.

220 Most of Réaumur's illustrations are on fold-out sheets by professional engravers such as Charles and Louis Simoneau, Claude Lucas, Jean-Baptiste Haussard and others.

221 *NH*, Preface, pp. xi–xii.

222 RS, RBO/20/27, 1737, p. 31. Réaumur's references are to entomological works by Ray, J., 1705, *Method and History of Insects*, London; Merian, M. S., 1705, *Metamorphosis insectorum surinamensium*, Amsterdam; Albin, E., 1720, *Natural History of English Insects*, London; and Goedaert, J., 1662–9, *Metamorphosis et historia insectorum naturalis*, Middleburg.

223 A rare work (a dissertation on mosquitoes), published in Regensburg by Joh. Leopold Montag.

224 RS, *Journal Book*, XVII, 10 November 1737: 'John-Matthew Barthius's "De culice dissertatio" in 4to rec'd & referred to Catesby'.

225 RS, *Journal Book*, XVI, 18 December 1735, 'A copy of Dr Charles Linnaeus' Systema Naturae … was presented and shewn to the Society, being sent from Dr. Gronovius in a Letter to Mr Catesby … [;] it was referr'd to Mr. Catesby to give an account of its contents.'

226 RS, *Journal Book*, XVII, 8 June 1738, 'Dr. Stack gave an account of Linnaeus's *Systema Naturae* in folio printed at Leyden in 1735.'

227 The RS *Journal Books* record Catesby's readings of his reviews of four of the volumes of Réaumur's *Insectes* during 1736, 1737, 1738 and 1740 (beginning with RS, *Journal Book*, XVI, 25 March 1736).

228 Frick & Stearns comment that Catesby 'was not a systematist, nor … even a consistent follower of a system' (1961, p. 40).

229 Wilfrid Blunt noted that 'Sloane was too set in his opinions to approve of the new system of classification' (Blunt, W. T., 2001, *The Compleat Naturalist: A Life of Linnaeus*, rev. edn, London, p. 109). For Sloane's classification methods, see MacGregor, A., ed., 1994, and Delbourgo, J., 2017, *Collecting the World: The Life and Curiosity of Hans Sloane*, London. Linnaeus was later to comment that Sloane's museum was in a state of chaos (Blunt, W. T., 2001, p. 110).

230 Pulteney, R., 1790, II, p. 345.

231 As Linnaeus's visit was very brief, it would appear that he lacked the time to study either Sloane's or Sherard's herbarium collections adequately.

232 Jarvis, C. E., 2015, p. 196.

233 Blunt, W. T., 2001, p. 112.

234 Ibid., p. 110.

235 Ibid, p. 113.

236 Pulteney, R., 1790, II, p. 345. While it is likely Linnaeus saw Sherard's herbarium as well as the 'Pinax', just as with the Sloane herbarium, he did not refer to Catesby's specimens in Sherard's collections in his citations of Catesby.

237 Blunt, W. T., 2001, p. 112. Several of Collinson's letters to Linnaeus, however, reveal his frustration at Linnaeus's failure to reply; on 27 March 1748, he wrote: 'It is a General Complaint that Dr Linnaeus Receives all & Returns nothing. This I tell you as a Friend, and as Such I hope you'l receive It in Great Friendship. As I love and Admire you, I must tell

you Honestly what the World sayes' (Smith, J. E., 1821, I, pp. 17–18; Armstrong, A. W., ed., 2002, *'Forget not Mee & My Garden …': Selected Letters 1725–1768 of Peter Collinson, F.R.S.*, Philadelphia, p. 144).

238 Blunt, W. T., 2001, p. 112.

239 Linnaeus recorded that he had met Catesby amongst other botanists in a letter to Johannes Burman in Amsterdam written after his return from London in August 1736 (Linnaeus to Burman, Hartecamp, 15 August 1736: Linnaean correspondence, Uppsala University Library, Carolina Rediviva, Dag Hammarskjölds väg 1, Box 510, SE 751 20).

240 Smith, J. E., 1821, II, p. 102 (18 August 1737).

241 Ibid., I, pp. 18–23 (3 October 1748), and passim.

242 Letter 44, 26 March 1745.

243 See Chapter 3, pp. 95–8, for Catesby's 'Catalogue'.

244 Jarvis, C., 2007, passim. In a similar way, in 1756 Linnaeus was to criticize Sloane's *Natural History of Jamaica* as inaccurate and outmoded while citing it extensively in his *Species plantarum* (1753): Delbourgo, J., 2017, p. 112.

245 For a discussion of the eighteenth century as a 'distinct historical stage' in the process, and the importance of the part of learned scientific societies, see McClellan, J. E., 1985, especially the Introduction and ch. 7, 'Scientific Societies and the Making of the Scientist'. See also Shapin, S., 2006, 'The Man of Science', in Park, K. & Daston, L., eds, *Early Modern Science*, Cambridge, pp. 179–91.

246 Frick, G. F. & Stearns, R. P., 1961, p. 35.

247 Letter 21.

248 See Appendix 1.

249 Frick, G. F. & Stearns, R. P., 1961, p. 50. Dandy gives a list of botanical monographs referencing Catesby's specimens (Dandy, J. E., 1958, *The Sloane Herbarium*, London, p. 112). See also Macmillan, P. D., Blackwell, A. H., Blackwell, C. & Spencer, M. A., 2013, p. 1, who note 'the insight [Catesby's collections] provide into the flora of the Carolinas and Georgia prior to extensive modification by European immigrants', and as 'reference for assessing native ranges of several problematic taxa'. Research into Catesby's herbarium specimens at Oxford (OUH) has been undertaken by Stephen Harris, and images, raw data and label transcriptions of all OUH specimens can be found on https://herbaria.plants.ox.ac.uk/bol/Catesby. The lack of survival of Catesby's zoological specimens means it is not possible to assess the contribution his substantial collections might have made to zoological studies.

250 *NH*, Appendix, p. 20.

Adler, K., 2015, 'Catesby's Fundamental Contributions to Linnaeus's Binomial Catalog of North American Animals', in Nelson, E. C. & Elliott, D. J., eds, *The Curious Mister Catesby: A 'Truly Ingenious' Naturalist Explores New Worlds*, Athens, GA, & London, pp. 251–64

Aiton, W., 1789, *Hortus Kewensis*, 3 vols, London (2nd edn, 1810)

Albin, E., 1720, *A Natural History of English Insects*, London

—, 1731–8, *A Natural History of Birds, illustrated with … copper plates, curiously engraven from the life*, 3 vols, London

Allen, D. E, 1993, 'Natural History in Britain in the Eighteenth Century', *Archives of Natural History*, 20, no. 3, pp. 333–47

—, 2000, 'Walking the Swards: Medical Education and the Rise and Spread of the Botanical Field Class', *Archives of Natural History*, 27, no. 3, pp. 335–67

Allen, E. G., 1937, 'New Light on Mark Catesby', *Auk*, LIV, pp. 349–63

—, 1951, 'History of American Ornithology before Audubon', *Transactions of the American Philosophical Society*, 61, no. 3, pp. 385–591

Amman, J., 1739, *Stirpium rariorum in Imperio Rutheno*, Saint Petersburg

Anderson, R. G. W., Caygill, M. L., MacGregor, A. & Syson, L., eds, 2003, *Enlightening the British: Knowledge, Discovery and the Museum in the Eighteenth Century*, London

Andrade, E.N. da C., 1960, *A Brief History of the Royal Society*, London

Anonymous, 1652, *Albert Durer Revived, or, A Book of Drawing …*, London

Anonymous, 1984, *'Blest Retreats': A History of Private Gardens in Richmond upon Thames*, exh. cat., Orleans House Gallery, Chiswick

Armstrong, A. W., ed., 2002, *'Forget not Mee & My Garden …': Selected Letters 1725–1768 of Peter Collinson, F.R.S.*, Philadelphia

Attenborough, D., 2007, *Amazing Rare Things: The Art of Natural History in the Age of Discovery*, London

—, 2017, 'Fifteen of the Naturalist's Best Quotes in Celebration of his 91st Birthday', *Independent*, 8 May

Audubon, J. J., 1827–38, *The Birds of America*, London

Austin, D. F., 2014, 'Salt Marsh Morning Glory (*Ipomoea sagittata*, Convolvulaceae) – An Amphi-Atlantic Species', *Economic Botany*, 68, pp. 203–19

Baird, R., 2007, *Goodwood: Art and Architecture, Sport and Family*, London

Baker, H., 1742, *The Microscope made Easy*, London

Barlow, F., 1703, *Aesop's Fables*, London

Barth, J. M., 1737, *De culice dissertation*, Regensburg

Basset, J. S., ed., 1901, *The Writings of Colonel William Byrd*, New York

Batsaki, Y., Cahalan, S. B. and Tchikine, A., eds, 2016, *The Botany of Empire in the Long Eighteenth Century*, Washington, DC

Bauer, A. M., 2012, 'Linnaean Names and Pre-Linnaean Sources in Herpetology', in Bell, C. J., ed., *The Herpetological Legacy of Linnaeus: A Celebration of the Linnaean Tercentenary, Bibliotheca Herpetologica*, 9, nos 1–2, pp. 53–79

—, 2015, 'Catesby's Animals (other than Birds) in *The Natural History of Carolina, Florida and the Bahama Islands*', in Nelson, E. C. & Elliott, D. J., eds, *The Curious Mister Catesby: A 'Truly Ingenious' Naturalist Explores New Worlds*, Athens, GA, & London, pp. 231–50

— & Wahlgren, R., 2013, 'On the Linck Collection and Specimens of Snakes Figured by Johann Jakob Scheuchzer (1735) – The Oldest Fluid Preserved Herpetological Collection in the World?', *Bonn Zoological Bulletin*, 62, no. 2, December, pp. 220–52

Baugh, D. A., 2000, 'Sir Charles Wager, 1666–1743', in Le Fevre, P. & Harding, R., eds, *Precursors of Nelson: British Admirals of the Eighteenth Century*, London, pp. 101–26

Bauhin, C., 1623, *Pinax theatri botanici … sive, Index in Theophrasti, Dioscoridis, Plinii et botanicorum qui a seculo scripserunt opera*, Basel (2nd edn, 1671)

Baxter, W., 1847, *Specimen of a Catalogue of the Sherardian Herbarium in the Botanic Garden*, Oxford

Beeverell, J., 1710, *Les Delices de L'Angleterre*, London

Berkeley, E. & D. S., 1963, *John Clayton: Pioneer of American Botany*, Chapel Hill, NC

—, 1974, *Dr John Mitchell: The Man Who Made the Map of North America*, Chapel Hill, NC

—, 1982, *The Life and Travels of John Bartram…*, Tallahassee, TN

—, 1992, *Correspondence of John Bartram, 1734–1777*, Gainesville, FL

Biographia Britannica, 1747–66, 7 vols, London

Bibliotheca Meadiana, 1755, London

Bickham, G., 1733, *Penmanship made easy, Or the Young Clerk's Assistant*, London (repr. New York, 1997)

Binyon, L., 1924–5, 'The Drawings of John White', *Walpole Society*, XIII, pp. 19–30

Birkhead, T., 2008, *The Wisdom of Birds: An Illustrated History of Ornithology*, London

Blair, A., 2006, *Too Much to Know*, New Haven & London

Bleichmar, D., 2012, *Visible Empire: Botanical Expeditions and Visual Culture in the Hispanic Enlightenment*, Chicago

Blome, R., 1686, *The Gentlemans Recreation, in two parts, the first being an Enclopedy of the arts and sciences …*, London

Blunt, W., 2001, *The Compleat Naturalist: A Life of Linnaeus*, rev. edn, with intro. by Stearn, W. T., London

— & Stearn, W. T., 1994, *The Art of Botanical Illustration*, rev. and enlarged edn, Woodbridge

Boas Hall, M., 1991, *Promoting Experimental Learning: Experiment and the Royal Society, 1660–1727*, Cambridge

Boulger, G. S., 1883, 'Samuel Dale', *Journal of Botany, British and Foreign*, XXI, pp. 193–230

Boutet, C., 1729, *The Art of Painting in Miniature*, London

Bower, P., 2018, 'The Papers used for Watercolour Designs for Silks by James Leman (1688–1745) in the Collections of the Victoria & Albert Museum', *The Quarterly*, 108, October, pp. 1–20

Bowett, A., 1994, 'The Commercial Introduction of Mahogany and the Naval Stores Act of 1721', *Furniture History*, 30, pp. 43–56

—, 2012, *Woods in British Furniture-Making, 1400–1900: An Illustrated Dictionary*, Wetherby

Bowles, C., 1782, *New and Englarged Catalogue … of Elegant Drawing Books*, London

Boyd, W. K. & Adams, P. G., eds, 1967, *William Byrd's Histories of the Dividing Line betwixt Virginia and North Carolina*, New York

Boyle, R., 1664, *Experiments and Considerations touching Colours*, London

—, 1692, *General Heads for the Natural History of a Country, Great or Small; drawn out for the use of Travellers and Navigators*, London

Bradley, R., 1724, *A General Treatise of Husbandry and Gardening*, 3 vols, London

Brewer, J., 1997, *The Pleasures of Imagination*, London

Bridgman, K. and Laird, M., 2014, 'American Roots: Techniques of Plant Transportation and Cultivation in the Early Atlantic World', in Smith, P. H., Meyers, A. R. W. & Cook, H. J., eds, *Ways of Making and Knowing: The Material Culture of Empirical Knowledge*, Ann Arbor, MI, pp. 164–93

Bridson, G. D. R., 1976, 'The Treatment of Plates in Bibliographical Description', *Journal of the Society for the Bibliography of Natural History*, 7, pp. 469–88

Brigham, D., 1998, 'Mark Catesby and the Patronage of Natural History in the First Half of the Eighteenth Century', in Meyers, A. R. W. & Pritchard, M. B., eds, *Empire's Nature: Mark Catesby's New World Vision*, Chapel Hill, NC, pp. 91–146

Broadhurst, S. & Kemp, D., 2012, 'A Survey of the Library Collection of Chelsea Physic Garden up to 1750', unpublished research paper for the Chelsea Physic Garden

Brock, R. A., ed., 1882–5, 'The Official Letters of Governor Alexander Spotswood', *Collections of the Virginia Historical Society*, 2 vols, Richmond

Brogert, 1692, *Traité des couleurs servant a la peinture à l'eau*, Delft

Brush, M. J. & Brush, A. H., 2018, *Mark Catesby's Legacy: Natural History Then and Now*, Charleston, SC

Bull, K., Jr, 1991, *The Oligarchs in Colonial and Revolutionary Charleston: Lieutenant Governor William Bull and his Family*, Columbia, SC

Butt, J., ed., 1975, *The Poems of Alexander Pope*, London

Calmann, G., 1977, *Ehret: Painter Extraordinary*, Oxford

Campbell, C., 1725, *Vitruvius Britannicus*, 3 vols, London

Cannon, J. F. M., 1994, 'Botanical Collections', in MacGregor, A., ed., *Sir Hans Sloane: Collector, Scientist, Antiquary, Founding Father of the British Museum*, London, pp. 136–49

Cannon, S. F., 1978, *Science in Culture: The Early Victorian Period*, New York

Catesby, M., for works by Catesby and their derivatives, see pp. 328–32 below

Caygill, M. L., 2003, 'From Private Collection to Public Museum: The Sloane Collection at Chelsea and the British Museum at Montagu House', in Anderson, R. G. W., Caygill, M. L., MacGregor, A. & Syson, L., eds, *Enlightening the British: Knowledge, Discovery and the Museum in the Eighteenth Century*, London, pp. 18–28

—, 2012, 'Sloane's Catalogues and the Arrangement of his Collections', in Walker, A., MacGregor, A. & Hunter, M., eds, *From Books to Bezoars: Sir Hans Sloane and his Collections*, London, pp. 120–36

Chambers, D., 1993, *The Planters of the English Landscape Garden: Botany, Trees and the Georgics*, New Haven & London

—, 1997, '"Storys of Plants": The Assembling of Mary Capel Somerset's Botanical Collection at Badminton', *Journal of the History of Collections*, 9, no. 1, pp. 49–60

Clokie, H. N., 1964, *An Account of the Herbaria of the Department of Botany in the University of Oxford*, Oxford

Clutton-Brock, J., 1994, 'Vertebrate Collections', in MacGregor, A., ed., *Sir Hans Sloane: Collector, Scientist, Antiquary, Founding Father of the British Museum*, London, pp. 77–92

Coats, A. M., 1963, *Garden Shrubs and their Histories*, London

—, 1969, *The Quest for Plants: A History of the Horticultural Explorers*, London

Commelin, J. & C., 1701, *Horti Medici Amstelodamensis*, Amsterdam

Considine, J., 2017, *Small Dictionaries and Curiosity*, Oxford

Cook, M., 1679, *The Manner of raising Fruit Trees*, London

Cooper, A. A., 3rd Earl of Shaftesbury, 1714, 'The Moralists', in *Characteristicks of Men, Manners, Opinions, Times*, 3 vols, London

Cottesloe, G. & Hunt, D., 1983, *The Duchess of Beaufort's Flowers*, Exeter

Craze, M., 1955, *A History of Felsted School, 1564–1947*, Ipswich

Croft-Murray, E., 1970, *Decorative Painting in England, 1537–1837*, II, London

— & Hulton, P., 1960, *Catalogue of British Drawings in the British Museum*, I: *XVI and XVII Centuries*, London

Croker, T. H., Williams, T. & Clark, S., 1766, *The Complete Dictionary of Arts and Sciences*, London

Crowe, S., 2003, *Garden Design*, 3rd edn, Woodbridge

Curtis, S. J., 1953, *History of Education in Great Britain*, London

Dale, S., 1693, *Pharmacologia seu manuductio ad materiam medicam*, London (later edns 1705, 1710, 1738)

—, 1730, *The History and Antiquities of Harwich and Dovercourt in the County of Essex*, London

Dandy, J. E., 1958, *The Sloane Herbarium: An Annotated List of the Horti Sicci composing It …*, London

Daniel, R. & Cocker, E., 1664, *Daniel's Copy-Book, or A Compendium of the Usuall Hands of England, Netherlands, France, Spain and Italie … With sundry Figures of Men, Beasts, and Birds, done Alavolee, Written and Invented by Richard Daniel Gent. and Engraven by Edward Cocker Philomath*, London

Darlington, W., 1967, with intro. by Ewan, J., *Memorials of John Bartram and Humphrey Marshall*, New York & London

De Beer, E. S., ed., 1955, *The Diary of John Evelyn*, Oxford

De Beer, G. R., 1953, *Sir Hans Sloane and the British Museum*, Oxford

De Costa, M. de, 1812, 'Notes and Anecdotes of Literati, Collectors, &c. from a MS by the late Mendes de Costa and collected between 1747 and 1788', *Gentleman's Magazine*, LXXXII, pt I, January–July, pp. 206–7

Defoe, D., 1983, *A Tour through the Whole Island of Great Britain, 1724–1727*, II, London

Delbourgo, J., 2017, *Collecting the World: The Life and Curiosity of Hans Sloane*, London

Desmond, R., 1977, *Dictionary of British and Irish Botanists and Horticulturists, including Plant Collectors and Botanical Artists*, London

—, 1995, *A History of the Royal Botanic Gardens*, London

Dickenson, V., 1998, *Drawn from Life: Science and Art in the Portrayal of the New World*, Toronto

Dillenius, J. J., 1732, *Hortus Elthamensis, sive Plantarum rariorum quas in horto suo Elthami in Cantio collegit … Jacobus Sherard*, London

—, 1741, *Historia muscorum*, Oxford

Dillwyn, L. W., 1843, *Hortus Collinsonianus: An account of the plants cultivated by the late Peter Collinson, Esq., FRS, arranged alphabetically according to their modern names, from the catalogue of his garden and other manuscripts*, Swansea

Dodart, D., Robert, N. & Bosse, A., 1701, *Recueil des plantes dessinées et gravées par ordre du roi Louis XIV*, Paris

Dossie, R., 1758, *Handmaid of the Arts*, London

Druce, G. C., 1907, 'The Plants of the Hortus Elthamensis', in Druce, G. C. & Vines, S. H., *The Dillenian Herbaria: An Account of the Dillenian Collections in the Herbarium of the University of Oxford, together with a Biographical Sketch of Dillenius, Selections from his Correspondence, Notes, &c.*, Oxford, pp. 158–84

—, 1928, 'British Plants contained in the Du Bois Herbarium in Oxford', *Botanical Exchange Club Report 1727*, pp. 463–93

— & Vines, S. H., 1907, *The Dillenian Herbaria: An Account of the Dillenian Collections in the Herbarium of the University of Oxford, together with a Biographical Sketch of Dillenius, Selections from his Correspondence, Notes, &c.*, Oxford

Dunthorne, G., 1961, 'Eighteenth-Century Botanical Prints in Color', in Stevenson, A., *Catalogue of Botanical Books in the Collection of Rachel McMasters Miller Hunt*, II, pt 1: *Introduction to Printed Books 1701–1800*, Pittsburgh, PA, pp. xxi–xxxi

Eamon, W., 1994, *Science and the Secrets of Nature: Books on Secrets in Medieval and Early Modern Culture*, Princeton

Edgar, W. B. & Bailey, N. L., 1977, *Biographical Directory of the South Carolina House of Representatives*, II: *The Commons House of Assembly, 1692–1775*, Columbia, SC

Edwards, E., 2006, 'Colonial Botany: Science, Commerce, and Politics in the Early Modern World', *Reviews in History*, review no. 512, April, https://reviews.history.ac.uk/review/512, accessed 21 September 2020

Edwards, G., 1743–51, *A Natural History of Uncommon Birds and of some other Rare and Undescribed Animals … to which is added, a brief and general idea of drawing and painting in watercolours; with instructions for etching on copper with Aqua Fortis …*, 4 parts, London

—, 1758–64 *Gleanings of Natural History exhibiting figures of quadrupeds, birds, insects, plants …*, 3 parts, London

—, 1770, *Essays upon Natural History and other Miscellaneous Subjects, to which is added, a catalogue of the birds, beasts, fishes,*

insects, plants, etc. Contained in Mr Edwards' 'Natural History',
London

Egmond, F., 2017, *Eye for Detail: Images of Plants and Animals
in Science, 1500–1630*, London

Elliott, B., 1994, *Treasures of the Royal Horticultural Society*,
London

Ellis, J., 1759, 'An Account of some Experiments …',
Philosophical Transactions of the Royal Society, 51, pp. 206–15

—, 1770, *Directions for Bringing over Seeds and Plants from the
East-Indies and other Distant Countries, in a State of Vegetation*,
London

Endersby, J., 2008, *Imperial Nature: Joseph Hooker and the
Practices of Victorian Science*, Chicago

Eshbaugh, W. H., 2015, 'The Economic Botany and
Ethnobotany of Mark Catesby', in Nelson, E.C. & Elliott,
D. J., eds, *The Curious Mister Catesby: A 'Truly Ingenious'
Naturalist Explores New Worlds*, Athens, GA, & London,
pp. 205–18

Espinasse, M., 1956, *Robert Hooke*, London

Etheridge, K., & Pieters, F. J. M., 2015, 'Maria Sibylla
Merian (1647–1717): Pioneering Naturalist, Artist, and
Inspiration for Catesby', in Nelson, E. C. & Elliott, D. J.,
eds, *The Curious Mister Catesby: A 'Truly Ingenious' Naturalist
Explores New Worlds*, Athens, GA, & London, pp. 39–56

Evelyn, J., 1664, *Sylva, or a Discourse of Forest-Trees and the
Propagation of Timber in His Majestie's Dominions*, London

Ewan, J., 1968, *William Bartram: Botanical and Zoological
Drawings, 1756–1788*, Philadelphia

— & Ewan, N. 1970, *John Banister and his Natural History of
Virginia, 1678–1692*, Urbana, IL

Fairchild, T., 1722, *The City Gardener*, London

Faithorne, W., 1662, *The Art of Graveing and Etching: Wherein is
exprest the true way of Graveing in Copper; Allso the manner and
method of that famous Callot & Mr Bosse in their several ways of
etching*, London

Feduccia, A., ed., 1985, *Catesby's Birds of Colonial America*,
Chapel Hill, NC, & London

Flis, N., 2015, 'Francis Barlow, the King's Birds, and the
Ornithology of Francis Willughby and John Ray', in
Henderson, F., Kusukawa, S. & Marr, A., eds, *Curiously
Drawn: Early Modern Science as a Visual Pursuit*, special edn
of *Huntingdon Library Quarterly*, 78, no. 2, summer, pp.
263–300

Floud, R., 2019, *An Economic History of the English Garden*,
London

Ford, B. F., 2003, 'Scientific Illustration in the Eighteenth
Century', in Porter, R., ed., *The Cambridge History of Science*,
IV: *Eighteenth-Century Science*, Cambridge

Foster, J., 1888, *Alumni Oxonienses, 1715–1886*, I, Oxford

Fox, C., 2010, *The Arts of Industry in the Age of Enlightenment*,
New Haven & London

Frantz, R. W., 1968, *The English Traveller and the Movement of
Ideas, 1660–1732*, New York

Fraser, C., 1940, *A Charleston Sketchbook*, Charleston, SC

Fraser, W. J., Jr, 1989, *Charleston! Charleston! The History of a
Southern City*, Columbia, SC

Frick, G. F., 1960, 'Mark Catesby: The Discovery of a
Naturalist', *Papers of the Bibliographical Society of America*,
54, pp. 163–75

— & Stearns, R. P., 1961, *Mark Catesby: The Colonial Audubon*,
Urbana, IL

Fry, J., 1995, 'Plants for Winter's Diversion: Greenhouse
History and Greenhouse Plants at Historic Bartram's
Garden', privately circulated for the John Bartram
Association, Philadelphia

Fuller, E., 1987, *Extinct Birds*, Oxford

Galpine, J. K., 1983, with intro. by Harvey, J., *The Georgian
Garden: An Eighteenth-Century Nurseryman's Catalogue*,
Stanbridge

Gardiner, R. G., 1889, *The Registers of Wadham College, Oxford*,
pt I, 1613–1719, London

Gaskell, P., 1972, *A New Introduction to Bibliography*, Oxford

Gaskell, R., 2004, 'Printing House and Engraving Shop:
A Mysterious Collaboration', *Book Collector*, 53, pp. 213–51

—, 2018: 'Printing House and Engraving Shop, Part II:
Further Thoughts on "Printing House and Engraving
Shop: A Mysterious Collaboration"', *Book Collector*, 67,
pp. 788–97

Gerard, J., 1597, *The Herball, or Generall historie of plantes*,
London

Gilpin, W., 1768, *An Essay on Prints: Containing remarks upon
… the different kinds of prints, and the characters of the most
noted masters …*, London

Glaister, G. A., 1960, *Glossary of the Book: Terms used in Paper-
making, Printing, Bookbinding and Publishing …*, London
(repr. 1996 as *Encylopedia of the Book*)

Goedaert, J., 1662–9, *Metamorphosis et historia insectorum
naturalis*, 3 vols, Middleburg

Goldfinch, J., 2013, 'Royal Libraries in the King's Library', in
Doyle, K. & McKendrick, S., eds, *1000 Years of Royal Books
and Manuscripts*, London, pp. 213–36

Goodwin, P., 1988, *The 20-gun ship Blandford*, London

Gorer, R., 1978, *The Growth of Gardens*, London

Gorham, G. C., 1830, *Memoirs of John Martyn F.R.S. and of
Thomas Martyn, B.D., F.R.S., F.L.S., Professors of Botany in
the University of Cambridge*, London

Grew, N., 1681, *Musaeum Regalis Societatis*, London

Griffith, T. & Meyers, A. R. W., 2017, 'The Natures of Britain
and Empire', in Marschner, J., ed., *Enlightened Princesses:
Caroline, Augusta, Charlotte and the Shaping of the Modern
World*, exh. cat., New Haven & London, pp. 475–514

Griffiths, A., ed., 1996a, *Landmarks in Print Collecting:
Connoisseurs and Donors at the British Museum since 1753*,
London

Griffiths, A., 1996b, *Prints and Printmaking: An Introduction to
the History and Techniques*, London

—, 1998, *The Print in Stuart Britain, 1603–1689*, exh. cat.,
British Museum, 8 May–20 September, London

—, 2016, *The Print before Photography: An Introduction to European Printmaking, 1550–1820*, London

— & Williams, R., 1987, *The Department of Prints and Drawings in the British Museum: User's Guide*, London

Grigson, C., 2016, *Menagerie: The History of Exotic Animals in England, 1100–1837*, Oxford

Gronovius, J. F., *c.*1739–43, *Flora Virginica, exhibens plantas quas …Johannes Claytonus in Virginia crescens observavit atque collegit*, 2 parts, Leiden

Hadfield, M., 1996, *A History of British Gardening*, London & New York

Hall, M. B., 1991, *Promoting Experimental Learning: Experiment and the Royal Society, 1660–1727*, Cambridge

Hamilton, W., 1796, 'A Short Account of Several Gardens near London, with remarks on some particulars wherein they excel, or are deficient, upon a view of them in December 1691; communicated to the Society by the Reverend Dr. Hamilton, Vice President, from an original Manuscript in his possession', *Archaeologia*, 12, pp. 181–92

Hammelmann, H. A. & Boase, T. S. R., 1975, *Book Illustrators in Eighteenth-Century England*, New Haven & London

Hanley, W., 1977, *Natural History in America: From Mark Catesby to Rachel Carson*, New York

Hardie, M., ed., 1919, *Miniatura or the Art of Limning, by Edward Norgate; edited from the manuscript in the Bodleian Library and collaged with other manuscripts*, Oxford

Harley, R. D., 2001, *Artists' Pigments, c. 1600–1835: A Study in English Documentary Sources*, 2nd edn, London

Harriot, T., 1590, *A brief and true report of the new found land of Virginia*, London

Harris, E. T., 2008, 'Joseph Goupy and George Frideric Handel: From Professional Triumphs to Personal Estrangement', *Huntington Library Quarterly*, 71, no. 3, pp. 397–452

Harris, S. A., 2015a, 'The Plant Collections of Mark Catesby in Oxford', in Nelson, E. C. & Elliott, D. J., eds, *The Curious Mister Catesby: A 'Truly Ingenious' Naturalist Explores New Worlds*, Athens, GA, & London, pp. 173–88

—, 2015b, 'William Sherard: His Herbarium and his *Pinax*', *Oxford Plant Systematics*, 21, September, pp. 13–15

—, 2018, 'Snapshot of Tropical Diversity: Collecting Plants in Colonial and Imperial Brazil', in MacGregor, A., ed., *Naturalists in the Field: Collecting, Recording and Preserving the Natural World from the Fifteenth to the Twenty-First Century*, Leiden & Boston, pp. 550–76

Harvey, J. H., 1973, *Early Horticultural Catalogues: A Checklist of Trade Catalogues issued by firms of Nurserymen and Seedsmen in Great Britain and Ireland down to the Year 1850*, Bath

—, 1988, *The Availability of Hardy Plants of the Late Eighteenth Century*, London

Haskell, F., MacGregor, A. & Montagu, J., eds, 2001–, *The Paper Museum of Cassiano dal Pozzo: A Catalogue Raisonné*, London, series B, part VII: Elliott, B., et al., 2015, *Flora: Federico Cesi's Botanical Manuscripts*; and series B, part IV:

McBurney, H., et al., 2017, *Birds, Other Animals and Natural Curiosities*

Hayes, K. J., 1997, *The Library of William Byrd of Westover*, Madison, WI

Hedrick, U. P., 1950, *A History of Horticulture in America to 1860*, Oxford

Heller, J. L., 1976, 'Linnaeus on Sumptuous Books', *Taxon*, 25, no. 1, February, pp. 33–52

Henderson, F., Kusukawa, S., & Marr, A., eds, 'Curiously Drawn: Early Modern Science as a Visual Pursuit', *Huntingdon Library Quarterly*, vol. 78, no. 2, Summer

Henrey, B., 1975, *British Botanical and Horticultural Literature before 1800*, II: *The Eighteenth Century*, London, New York & Toronto

—, 1986, *No Ordinary Gardener: Thomas Knowlton 1691–1781*, London

Hills, R. L., 1988, *Papermaking in Britain, 1488–1988*, London

Hind, A. M., 1931, *Catalogue of Drawings by Dutch and Flemish Artists … in the British Museum*; IV: *Dutch Drawings of the XVII Century*, London

Hodnett, E., 1978, *Francis Barlow: First Master of English Book Illustration*, London

Honeybone, D., 2010, *The Correspondence of the Spalding Gentlemen's Society, 1710–1761*, Woodbridge

Honour, H., 1975, *The European Vision of America*, exh. cat., Cleveland Museum of Art, Cleveland, OH

Hooke, R., 1665, *Micrographia*, London

Hoppit, J., 2000, *A Land of Liberty? England 1689–1727*, Oxford

Hudgins, C. C., 2011, 'The Material World of John Drayton: International Connections to Wealth, Intellect, and Taste', *Antiques and Fine Art*, X, no. 1, January, pp. 258–64

Hulton, P., 1984, *America 1585: The Complete Drawings of John White*, London

— & Quinn, D. B., 1964, *The American Drawings of John White 1577–1590, with Drawings of European and Oriental Subjects*, London & Chapel Hill, NC

Hunter, J. M., 1985, *Land into Landscape*, London & New York

Hunter, M., 1981, *Science and Society in Restoration England*, Cambridge

—, 1989, *Establishing the New Science: The Experience of the Early Royal Society*, Woodbridge

—, 2015, Introduction to Henderson, F., Kusukawa, S., & Marr, A., eds, 'Curiously Drawn: Early Modern Science as a Visual Pursuit', *Huntingdon Library Quarterly*, vol. 78, no. 2, Summer, pp. 141–55

Hyde, R., 1982, *The A–Z of Georgian London*, Lympne Castle

Jackson, C. E., 1985, *Bird Etchings: The Illustrators and their Books, 1655–1855*, Ithaca & London

—, 2011, 'The Painting of Hand-Coloured Zoological Illustrations', *Archives of Natural History*, 38, no. 1, pp. 36–52

Jacobsen, G. 1932, *William Blathwayt, a Late Seventeenth-Century English Administrator*, New Haven

Jarvis, C. E., 2007, *Order Out of Chaos: Linnaean Plant Names and their Types*, London

—, 2015, 'Carl Linnaeus and the Influence of Mark Catesby's Botanical Work', in Nelson, E. C. & Elliott, D. J., eds, *The Curious Mister Catesby: A 'Truly Ingenious' Naturalist Explores New Worlds*, Athens, GA & London, pp. 189–204

—, 2018, '"Take with you a small Spudd or Trowell": James Petiver's Directions for Collecting Natural Curiosities', in MacGregor, A., ed., *Naturalists in the Field: Collecting, Recording and Preserving the Natural World from the Fifteenth to the Twenty-First Century*, Leiden & Boston, pp. 212–39

—, 2019, '"The most common grass, rush, moss, fern, thistles, thorns or vilest weeds you can find": James Petiver's Plants', *Notes and Records*, online article, 27 November, https://doi.org/10.1098/rsnr.2019.0012

Jefferson, T., 1785, *Notes on the State of Virginia*, Paris

Jellicoe, G. & S., 2001, *The Oxford Companion to Gardens*, Oxford & New York

Jenkins, I., 2003, 'Dr Richard Mead (1673–1754) and his Circle', in Anderson, R. G. W., Caygill, M. L., MacGregor, A., & Syson, L., eds, *Enlightening the British: Knowledge, Discovery and the Museum in the Eighteenth Century*, London, pp. 127–35

Jenner, T., 1666, *A Book of drawing, limning, washing or colouring of maps and prints and the art of painting with the names and mixtures of colours used by the picture-drawers*, London

Johnson, Captain J. [Daniel Defoe], 1724, *A History of the Robberies and Murders of the most notorious Pyrates … from their first Rise and Settlement in the Island of Providence, in 1717, to the present Year 1724*, London

Johnson, J., 2004, rev. 2010, 'Brydges, James, First Duke of Chandos 1674–1744)', *ODNB*, Oxford

Johnson, S., 1755, *A Dictionary of the English Language in which the words are deduced from their originals …*, London

Johnson, T., 1658, *A Booke of Beasts, Birds, Flowers, Fruits, Flies and Wormes …*, London

Jones, L. H., 1891, *Captain Roger Jones of London and Virginia*, Albany, NY

Kastner, J., 1977, *Species of Eternity*, New York

Keates, J., 1985, *Handel: The Man and his Music*, London

King, J. C. H., 1994, 'Ethnographic Collections: Collecting in the Context of Sloane's Catalogue of "Miscellanies"', in MacGregor, A., ed., *Sir Hans Sloane: Collector, Scientist, Antiquary, Founding Father of the British Museum*, London, pp. 228–44

Kirkbride, J. H. & Olsen, R. T., 2011, 'Neotypification of Catalpa speciosa (Bignoniaceae)', *Taxon*, 60, pp. 1760–63

Knight, D. S., 1977, *Zoological Illustration: An Essay towards a History of Zoological Pictures*, Folkestone

Krech, S., III, 2015, '"Of birds of passage": Mark Catesby and Contemporary Theories on Bird Migration and Torpor', in Nelson, E. C. & Elliott, D. J., eds, *The Curious Mister Catesby: A 'Truly Ingenious' Naturalist Explores New Worlds*, Athens, GA, & London, pp. 219–30

—, 2018, 'Catesby's Birds', in MacGregor, A., ed., *Naturalists in the Field: Collecting, Recording and Preserving the Natural World from the Fifteenth to the Twenty-First Century*, Leiden & Boston, pp. 279–331

Krill, J., 2001, *English Artists' Paper: Renaissance to Regency*, 2nd edn, New Castle, DE

Kusukawa, S., 2011, 'Picturing Knowledge in the Early Royal Society: The Examples of Richard Waller and Henry Hunt', *Notes and Records*, 65, pp. 273–94

—, 2015, 'Richard Waller's Table of Colours (1686)', in Bushart, M. & Steinle, F., eds, *Colour Histories: Science, Art and Technology in the Seventeenth and Eighteenth Centuries*, Berlin, pp. 3–21

—, 2019, '*Ad vivum* Images and the Knowledge of Nature in Early Modern Europe', in Balfe, T., Woodall, J. & Zittel, C., eds, *Ad Vivum: Visual Materials and the Vocabulary of Life-Likeness in Europe before 1800*, Leiden, pp. 89–121

Labarre, E. J., 1952, *Dictionary and Encyclopaedia of Paper and Papermaking*, Amsterdam

Laird, M., 1998, 'From Callicarpa to Catalpa: The Impact of Mark Catesby's Plant Introductions on English Gardens of the Eighteenth Century', in Meyers, A. R. W. & Pritchard, M. B., eds, *Empire's Nature: Mark Catesby's New World Vision*, Chapel Hill, NC, pp. 184–227

—, 1999, *The Flowering of the Landscape Garden: English Pleasure Grounds, 1720–1800*, Philadelphia

—, 2008, 'The Congenial Climate of Coffeehouse Horticulture …', in O'Malley, T. & Meyers, A. R. W., eds, *The Art of Natural History: Illustrated Treatises and Botanical Paintings, 1400–1850*, New Haven & London, pp. 227–52

—, 2015a, *A Natural History of English Gardening, 1650–1800*, New Haven & London

—, 2015b, 'Mark Catesby's Plant Introductions and English Gardens of the Eighteenth Century', in Nelson, E. C. & Elliott, D. J., eds, *The Curious Mister Catesby: A 'Truly Ingenious' Naturalist Explores New Worlds*, Athens, GA, & London, pp. 265–80

—, & Weisberg-Roberts, A., eds, 2009, *Mrs Delany and her Circle*, New Haven & London

Lambert, A. B., 1811, 'Notes relating to Botany, collected from the Manuscripts of the late Peter Collinson, Esq., FRS, and communicated by Aylmer Bourke Lambert, Esq. 1809', *Transactions of the Linnean Society of London*, X, pp. 270–82

Lawson, J., 1709, *A New Voyage to Carolina; containing the Exact Description and Natural History of that Country: together with the Present State thereof. And a Journal of a Thousand Miles, Traval'd thro' several Nations of Indians, giving a particular Account of their Customs, Manners, &c.*, London (reissued in 1714 and 1718 as *The History of Carolina …*, London)

Leapman, M., 2000, *The Ingenious Mr Fairchild: The Forgotten Father of the Flower Garden*, London

Lefler, H. T., ed., 1967, *A New Voyage to Carolina by John Lawson*, Chapel Hill, NC

Leith-Ross, P. & McBurney, H., 2000, *The Florilegium of Alexander Marshal in the Collection of Her Majesty The Queen at Windsor Castle*, London

Lemay, J. A. L., 2006, *The Life of Benjamin Franklin*, 2 vols, Philadelphia

Lemmon, K., 1968, *The Golden Age of Plant Hunters*, London

Le Rougetel, H., 1990, *The Chelsea Gardener: Philip Miller 1691–1771*, London

Lettsom, J. C., 1783, *Some Account of … John Fothergill, M.D.*, London

Lewis, C. T. & Short, C., 1969, *A Latin Dictionary*, Oxford

Linder, S., 2000, *Anglican Churches in Colonial South Carolina*, Charleston, SC

Linder Hurley, S., 2015, 'Mark Catesby's Carolina Adventure', in Nelson, E. C. & Elliott, D. J., eds, *The Curious Mister Catesby: A 'Truly Ingenious' Naturalist Explores New Worlds*, Athens, GA, & London, pp. 109–26

Lindsay, J., 1977, *Hogarth: His Art and his World*, London

Linnaeus, C., 1735, *Systema naturae, sive regna tria naturae systematice proposita per Classes, Ordines, Genera, et Species*, Leiden

—, 1737, *Hortus Cliffortianus …*, Amsterdam

—, 1753, *Species plantarum*, Stockholm, 2 vols

—, 1758, *Systema naturae, sive regna tria naturae secundum Classes, Ordines, Genera, Species, cum characteribus, differentiis, synonymis, locis*, 10th edn, Stockholm

Locke, J., 1693, *Some Thoughts concerning Education*, London

Lockridge, K. A., 1987, *The Diary and Life of William Byrd II of Virginia, 1674–1744*, Chapel Hill, NC, & London

Longstaffe-Gowan, T., 2017, 'Hankering after Horticulture', in Marschner J., ed., *Enlightened Princesses: Caroline, Augusta, Charlotte and the Shaping of the Modern World*, New Haven & London, pp. 349–52

Loudon, J. C., 1854, *Arboretum et fruticetum Britannicum*, 2nd edn, 8 vols, London

Lucas, J. L., trans., 1892, *Kalm's Account of his Visit to England on his way to America in 1748*, London

Lysons, D., 1811, *The Environs of London*, 2nd edn, II, pt 2, London

Mabberley, D. J., 2017, *Painting by Numbers: The Life and Art of Ferdinand Bauer*, Sydney

McBurney, H., 1995, 'Painted from Nature', *Country Life*, 14 December, pp. 44–6

—, 1997, with intro. by Meyers, A. R. W., *Mark Catesby's 'Natural History' of America: The Watercolours from the Royal Library, Windsor Castle*, exh. cat. (containing 52 catalogue entries), London

—, 1998, with intro. by Meyers, A. R. W., *Mark Catesby's 'Natural History' of America*, exh. cat. (Japan, text in Japanese, containing 60 catalogue entries), Tokyo

—, 2001a, 'Catesby, Mark, 1682–1749: English Collector, Artist, Author, and Horticulturist', in Shoemaker, C. A.,

ed., *Encyclopedia of Gardens: History and Design*, 3 vols, London, I, pp. 244–5

—, 2001b, 'Catesby's Techniques as a Draftsman and Printmaker', in O'Connor, M. & Fradkin, A., eds, *Opening the Door to a New World: Mark Catesby's Travels in La Florida 1722–1726*, exh. cat., Boca Raton, FL, pp. 16–17

—, 2015, 'Mark Catesby's Preparatory Drawings for *The natural history of Carolina, Florida and the Bahama Islands*', in Nelson, E. C. & Elliott, D. J., eds, *The Curious Mister Catesby: A 'Truly Ingenious' Naturalist Explores New Worlds*, Athens, GA, & London, pp. 141–54

—, 2019, 'Mark Catesby's Plate "The Great Booby"', in Droth, M., Flis, N. and Hatt, M., eds, *Britain in the World: Treasures from the Yale Center for British Art*, New Haven & London, pp. 40–43

—, forthcoming, 'The Influence of Maria Sibylla Merian's Work on the Art and Science of Mark Catesby', in Etheridge, K., et al., eds, *Changing the Nature of Art and Science: Intersections with Maria Sibylla Merian*, Leiden

McClellan, J. E., 1985, *Science Reorganized: Scientific Societies in the Eighteenth Century*, New York

McKitterick, D. et al., 1989, *Catalogue of the Pepys Library at Magdalene College, Cambridge*, IV: *Music, Maps and Calligraphy*, Woodbridge

MacGregor, A., ed., 1994, *Sir Hans Sloane: Collector, Scientist, Antiquary, Founding Father of the British Museum*, London

—, 1994, 'The Life, Character and Career of Sir Hans Sloane', in MacGregor, A., ed., *Sir Hans Sloane: Collector, Scientist, Antiquary, Founding Father of the British Museum*, London

—, 1995, 'The Natural History Correspondence of Sir Hans Sloane', *Archives of Natural History*, 22, pp. 70–90

—, 2007, 'Forming an Identity: The Early Society and its Context, 1707–51', in Pearce, S., ed., *Visions of Antiquity. The Society of Antiquaries of London, 1707–2007*, London, pp. 45–74

—, 2014, 'Patrons and Collectors: Contributors of Zoological Subjects to the Works of George Edwards (1694–1773)', *Journal of the History of Collections*, 26, no. 1, pp. 35–44; with online appendix, http://jhc.oxford journals.org

—, 2018a, *Company Curiosities: Nature, Culture and the East India Company, 1600–1874*, London

—, ed., 2018b, *Naturalists in the Field: Collecting, Recording and Preserving the Natural World from the Fifteenth to the Twenty-First Century*, Leiden & Boston

Macmillan, P. D., Blackwell, A. H., Blackwell, C. & Spencer, M. A., 2013, 'The Vascular Plants in the Mark Catesby Collection at the Sloane Herbarium, with Notes on their Taxonomic and Ecological Significance', *Phytoneuron*, 7, pp. 1–37

Malcolm, H. G., 1921, *A History of the Bahamas House of Assembly*, Nassau

Marschner, J., ed., 2017, *Enlightened Princesses: Caroline, Augusta, Charlotte and the Shaping of the Modern World*, exh. cat., New Haven & London

Martin, P., 1991, *The Pleasure Gardens of Virginia: From Jamestown to Jefferson*, Princeton & Oxford

Martyn, J., 1728–37, *Historia plantarum rariorum*, London

—, 1728–32, *A History of Rare Plants*, London

Martyn, T., 1763, *Plantae Cantabrigiensis, or A catalogue of the plants which grow wild in the county of Cambridge*, London

Mason, A., 1992, *George Edwards: The Bedell and his Birds*, London

Mead, W. R., 2013, *Pehr Kalm: His London Diary*, Aston Clinton

Merian, M. S., 1705, *Metamorphosis insectorum surinamensium*, Amsterdam; later edition Amsterdam, 1719

Meyers, A. R. W., 1997, 'The Perfecting of Natural History: Mark Catesby's Drawings of American Flora and Fauna in the Royal Library, Windsor Castle', in McBurney, H., *Mark Catesby's 'Natural History' of America: The Watercolours from the Royal Library, Windsor Castle*, exh. cat. (containing 52 catalogue entries), London, pp. 11–25

— & Pritchard, M. B., 1998, 'Introduction: Toward an Understanding of Catesby', in Meyers, A. R. W. & Pritchard, M. B., eds, *Empire's Nature: Mark Catesby's New World Vision*, Chapel Hill, NC, & London, pp. 1–33

—, ed., 2011, *Knowing Nature: Art and Science in Philadelphia, 1740–1840*, New Haven & London

Miller, D. P. & Reill, P. H., eds, 2010, *Visions of Empire: Voyages, Botany and Representations of Nature*, Cambridge

Miller, E., 1987, *Hand-Coloured British Prints*, exh. cat., Victoria and Albert Museum, London

Miller, P., 1730, *Catalogus plantarum officialium quae in horto botanico Chelseyano aluntur*, London

—, 1731, *The Gardeners' Dictionary*, London (and later editions)

—, 1755–60, *Figures of the most Beautiful, Useful and Uncommon Plants described in the Gardener's Dictionary*, London

Moore, C. T. & Simmons, A. A., eds, 1960, *Abstracts of the Wills of the State of South Carolina, 1670–1740*, I, Charleston, SC

Morison, R., 1680–99, *Plantarum historiae universalis Oxoniensis*, Oxford

Morris, P., 2012, *A History of Taxidermy: Art, Science and Bad Taste*, Ascot

Munroe, J., 2011, '"My innocent diversion of gardening": Mary Somerset's Plants', *Renaissance Studies*, 25, no. 1, pp. 111–23

Nelson, E. C., 2013, 'The Catesby Brothers and the Early Eighteenth-Century Natural History of Gibraltar', *Archives of Natural History*, 40, pt 2, pp. 357–60

—, 2014a, 'Catalpah – Called so by the Indians', *Hortus: A Gardening Journal*, no. 112, pp. 78–85

—, 2014b, 'Georg Dionysius Ehret, Mark Catesby and Sir Charles Wager's Magnolia Grandiflora: An Early Eighteenth-Century Picture Puzzle Resolved', *Rhododendrons, Camellias and Magnolias*, 65, pp. 36–51

—, 2015, '"The truly honest, ingenious, and modest Mr Mark Catesby, F.R.S.": Documenting his Life (1682/83–1749)', in Nelson, E. C. & Elliott, D. J., eds, *The Curious Mister Catesby: A 'Truly Ingenious' Naturalist Explores New Worlds*, Athens, GA, & London, pp. 1–20

—, 2019a, 'Brethren of the Spade', *Hortus: A Gardening Journal*, no. 120, pp. 81–4

—, 2019b, 'Royal Library's Copy of Mark Catesby's *The Natural History of Carolina, Florida and the Bahama Islands* containing Original Watercolours', *Huntia*, 17, no. 2, pp. 57–66

—, 2020, 'Catesby's North American Images in *The Gentleman's Magazine*, 1750–1755', *Archives of Natural History*, 47, pt 1, short note, April, pp. 186–9

— & Elliott, D. J., eds, 2015, *The Curious Mister Catesby: A 'Truly Ingenious' Naturalist Explores New Worlds*, Athens, GA, & London

Nichols, J., 1812–16, *Literary Anecdotes of the Eighteenth Century …*, 9 vols, London

—, 1817–58, *Illustrations of the Literary History of the Eighteenth Century …*, 8 vols, London

Nickelsen, K., 2006a, 'The Challenge of Colour: Eighteenth-Century Botanists and the Hand-Colouring of Illustrations', *Annals of Science*, 63, no. 1, January, pp. 2–23

Nickelsen, K., 2006b, *Draughtsmen, Botanists and Nature: The Construction of Eighteenth-Century Botanical Illustrations*, Dordrecht

Niekrasz, C. & Swan, C., 2006, 'Art', in Park, K. & Daston, L., eds, *The Cambridge History of Science*, III: *Early Modern Science*, Cambridge, pp. 773–96

Ochs, K. H., 1985, 'The Royal Society of London's History of Trades Programme: An Early Episode in Applied Science', *Notes and Records*, 39, no. 2, pp. 129–58

Ogborn, M., & Pickering, V., 2018, 'The World in a Nicknackatory: Encounters and Exchanges in Hans Sloane's Collection', in Craciun, A. & Terrall, M., eds, *Curious Encounters: Voyaging, Collecting, and Making Knowledge in the Long Eighteenth Century*, Toronto, pp. 113–37

Ogilvie, B., 2006, *The Science of Describing: Natural History in Renaissance Europe*, Chicago & London

O'Malley, T., 1998, 'Mark Catesby and the Culture of Gardens', in Meyers A. R. W. & Pritchard, M. B., eds, *Empire's Nature: Mark Catesby's New World Vision*, Chapel Hill, NC, & London, pp. 147–83

O'Neill, J., 1983, 'The Stove House and the Duchess', *Country Life*, 20 January, pp. 142–3

— & McLean, E. P., 2008, *Peter Collinson and the Eighteenth-Century Natural History Exchange*, Philadelphia

Overstreet, L. K., 2014, 'The Dates of the Parts of Mark Catesby's *The natural history of Carolina …* (London, 1731–1743 [1729–1747])', *Archives of Natural History*, 41, pt 2, pp. 362–4

—, 2015, 'The Publication of Mark Catesby's *The natural history of Carolina, Florida and the Bahama Islands*', in Nelson, E. C., & Elliott, D. J., eds, *The Curious Mister Catesby: A 'Truly Ingenious' Naturalist Explores New Worlds*, Athens, GA, & London, pp. 155–72

— & McBurney, H., forthcoming, 'A Variant Version of Catesby's *Natural History of Carolina* given to John Bartram'

Owen, D. M., 1981, *The Minute-Books of the Spalding Gentlemen's Society 1712–1755*, Lincoln Record Society, vol. 73, Lincoln

Page, W. & Round, J. H., 1907, *Victoria History of the County of Essex*, 2 vols, London

Panofsky, E., 1983, *Meaning in the Visual Arts*, New York

Park, K. & Daston, L., eds, 2006, *The Cambridge History of Science*, III: *Early Modern Science*, Cambridge

Parkinson, J., 1640, *Theatrum botanicum: The Theater of Plants*, London

Peacham, H., 1661, *The Compleat Gentleman*, London

Peck, R. McC., 2003, 'Preserving Nature for Study and Display' and 'Alcohol, Arsensic, Pepper and Pitch: Brief Histories of Preservation Techniques', in Prince, A. A., ed., *Stuffing Birds, Pressing Plants, Shaping Knowledge: Natural History in North America, 1730–1860*, Philadelphia, pp. 11–53

Petiver, J., 1695, *Musei Petiveriani centuria prima, rariora naturae …*, London

—, 1713, *Catalogue of Mr Ray's English herbal illustrated with figures on folio copper plates*, London

—, 1764–7, *Jacobi Petiveri opera*, London

—, undated(a), 'Brief Directions for the easie making, and preserving collections of all natural curiosities', broadside (not before 1713), London

—, undated(b), 'Directions for the gathering of Plants', broadside, London

Pickering, V., 2017, 'Putting Nature in a Box: Hans Sloane's Vegetable Substances Collection', PhD thesis, Queen Mary College, University of London

Plomer, H. R., 1932, *A Dictionary of the Printers and Booksellers who were at work in England, Scotland, and Ireland from 1726 to 1775*, Oxford

Plukenet, L., 1691–2, *Phytographia sive stirpium illustriorum*, London

Plumier, C., 1693, *Description des plantes de l'Amérique*, Paris

—, 1703, *Nova plantarum Americanum genera*, Paris

—, 1705, *Traité de fougères*, Paris

Pope, A., 1711, *An Essay on Criticism*, London

Pritchard, M. B., 1993, *William Byrd II and his Lost History*, Williamsburg, VA

Pulteney, R., 1790, *Historical and Biographical Sketches of the Progress of Botany in England from its Origin to the Introduction of the Linnaean System*, 2 vols, London

Pursh, F., 1816, *Flora Americae septentrionalis, or, A systematic arrangement of the plants of North America*, London

Quarrel, W. H. & Mare, M., 1934, *London in 1710 from the Travels of Zacharias Conrad von Uffenbach*, London

Quinby, J., 1958, *Catalogue of Botanical Books in the Collection of Rachel McMasters Miller Hunt*, I, Pittsburgh, PA

Raphael, S., 1989, *An Oak Spring Sylva: A Selection of the Rare Books on Trees in the Oak Springs Garden Library*, Upperville, VA

Raven, C., 1942, *John Ray, Naturalist: His Life and Works*, Cambridge

Raven, J., 2007, *The Business of Books: Booksellers and the English Book Trade, 1450–1850*, New Haven & London

Ray, C., 1983, 'Geology and Paleontology of the Lee Creek Mine, North Carolina', *Smithsonian Contributions to Paleobiology*, I, no. 53, pp. 1–529

Ray, J., 1660, *Catalogus plantarum circa Cantabrigiam nascentium*, London

—, 1677, *Catalogus plantarum Angliae*, London

—, 1678, *The Ornithology of Francis Willughby*, London (Latin edn, 1676)

—, 1686–1704, *Historia plantarum*, 3 vols, London

—, 1705, *Method and History of Insects*, London

—, 1710, *Historia insectorum*, London

— & Willughby, F., 1686, *De historia piscium*, London

Réaumur, A. F., de 1737, *Memoires pour server a l'histoire des insects*, Paris

Reeds, K., 'Don't Eat, Don't Touch: Roanoke Colonists, Natural Knowledge, European Newcomers and Dangerous Plants of North America', in Sloan, K., ed., 2009, *European Visions: American Voices*, exh. cat., London, pp. 51–7

Reeds, K., 2015, 'Mark Catesby's Botanical Forerunners in Virginia', in Nelson, E. C. & Elliott, D. J., eds, *The Curious Mister Catesby: A 'Truly Ingenious' Naturalist Explores New Worlds*, Athens, GA, & London, pp. 27–38

Richardson, E. P., 1956, *Painting in America*, London

Richardson, T., 1997, 'The Good Wood of Goodwood', *Country Life*, 25 September, pp. 88–9

Riley, M., 2006, 'The Club at the Temple Coffee House Revisited', *Archives of Natural History*, 33, no. 1, pp. 90–100

—, 2008, 'The Club at the Temple Coffee House', in O'Malley, T. & Meyers, A. R. W., eds, *Art of Natural History: Illustrated Treatises and Botanical Paintings, 1400–1850*, New Haven & London, pp. 253–9

—, 2011, '"Procurers of plants and encouragers of gardening": William and James Sherard, and Charles du Bois, Case Studies in Late 17th and Early 18th-Century Botanical and Horticultural Patronage', DPhil thesis, University of Buckingham

Rix, M., 1981, *The Art of the Botanist*, Guildford & London

Robert, N., 1701, *Recueil des plantes gravées par order du Roi Louis XIV*, Paris

Robertson, B., 1988, 'Joseph Goupy and the Art of the Copy', *Bulletin of the Cleveland Museum of Art*, LXXV, no. 10, December, pp. 345–82

Robertson, R., 2015, 'Mark Catesby's Bahamian Natural History (observed in 1725–1726)', in Nelson, E. C. & Elliott, D. J., eds, *The Curious Mister Catesby: A 'Truly Ingenious' Naturalist Explores New Worlds*, Athens, GA, & London, pp. 127–40

Robinson, J. R., 1893, *The Princely Chandos: A Memoir*, London

Robson, J., 1776, *Some Memoirs of the Life and Works of George Edwards*, London

Roos, A. M., 2019, *Martin Lister and his Remarkable Daughters: The Art of Science in the Seventeenth Century*, Oxford

Rousseau, G. S. & Porter, R., 1980, *The Ferment of Knowledge: Studies in the Historiography of Eighteenth-Century Science*, Cambridge

Rucker, E. & Stearn, W. T., 1982, *Maria Sibylla Merian in Surinam: Commentary to the Facsimile Edition of 'Metamorphosis Insectorum Surinamensium' (Amsterdam 1705), based on Original Watercolours in the Royal Library, Windsor Castle*, London

Russell, F., 2004, *John, 3rd Earl of Bute: Patron and Collector*, London

Salmon, M., 2000, *The Aurelian Legacy: British Butterflies and their Collectors*, Colchester

Salmon, N., 1740, *The History and Antiquities of Essex from the Collections of Thomas Jekyll of Bocking, Esqr … and from the Papers of Mr. Holman of Halstead*, London

Salmon, W., 1685, *Polygraphice, or The arts of drawing, engraving, etching, limning, painting, washing, varnishing, gilding, colouring, dying, beautifying and perfuming …*, London

Sambrook, J., 1993, *The Eighteenth Century: The Intellectual and Cultural Context of English Literature, 1700–1789*, 2nd edn, Harlow

Sanders, A. E. & Anderson, W. D., 1999, *Natural History Investigations in South Carolina from Colonial Times to the Present*, Columbia, SC

Sanderson, W., 1658, *Graphice, the use of the Pen and Pensil, or the most Excellent Art of Painting*, London

Saunders, G., 1995, *Picturing Plants: An Analytical History of Botanical Illustration*, London

Savage, S., 1945, *A Catalogue of the Linnaean Herbarium*, London

Sayer, R. & Bennett, J., 1775, *Enlarged Catalogue of New and Valuable Prints in Sets or Single …*, London

Schiebinger, L., & Swan, C., eds, 2005, *Colonial Botany: Science, Commerce, and Politics in the Early Modern World*, Philadelphia

Selborne, J., 1998, 'Dedicated to a Duke: Goodwood's Uncommon Birds', *Country Life*, 12 March, pp. 86–9

Selzer, A., 2015, 'Catesby's Conundrums: Mixing Representation and Metaphor', *British Art Journal*, 16, pp. 82–92

—, 2019, 'Catesby's Eclecticism and the Origin of his Style', *1650–1850*, 24, pp. 263–86

Shapin, S., 2006, 'The Man of Science', in Park, K. & Daston, L., eds, *The Cambridge History of Science*, III: *Early Modern Science*, Cambridge, pp. 179–91

Sendino, C., 2016, 'The Hans Sloane Fossil Collection at the Natural History Museum, London', *Deposits Magazine*, 47, pp. 13–17

Shore, S. K., 2017, 'A Note on the Lives of Mark Catesby and Thomas Cooper', unpublished paper (for Applied Anthropology Internship, Catesby Commemorative Trust), spring

Simmons, J. E., 2014, *Fluid Preservation: A Comprehensive Reference*, Lanham, MD

Simon, J., 1994, 'New light on Joseph Goupy', *Apollo*, February, pp. 15–18

Simon, R., 1993, *Hogarth, France & British Art: The Rise of the Arts in Eighteenth-Century England*, New Haven & London

Simpson, G., 1943, 'The Discovery of Fossil Vertebrates in North America', *Journal of Paleontology*, 17, no. 1, pp. 26–38

Simpson, M. B., Jr, 2015, 'John Lawson's *A new voyage to Carolina* and his "Compleat History": The Mark Catesby Connection', in Nelson, E. C. & Elliott, D. J., eds, *The Curious Mister Catesby: A 'Truly Ingenious' Naturalist Explores New Worlds*, Athens, GA, & London, pp. 71–84.

Sitwell, S. & Blunt, W., 1990, *Great Flower Books 1700–1900: A Bibliographical Record of Two Centuries of Finely-Illustrated Flower Books*, London

— & Buchanan, H., 1990, *Fine Bird Books 1700–1900*, London

Sloan, K., 1986, 'The Teaching of Non-Professional Artists in Eighteenth-Century England', PhD thesis, Westfield College, London

—, 2000, *A Noble Art: Amateur Artists and Drawing Masters, c.1600–1800*, London

—, 2007, *A New World: England's First View of America*, London

—, ed., 2009, *European Visions: American Voices*, exh. cat., British Museum, London

—, 2012, 'Sir Hans Sloane's "Pictures and Drawings in Frames" and "Books of Miniature & painting, designs, &c'', in Walker, A., MacGregor, A. & Hunter, M., eds, *From Books to Bezoars: Sir Hans Sloane and his Collections*, London, pp. 168–89

Sloane, H., 1707–25, *A Voyage to the Islands Madera, Barbados, Nieves, S. Christophers and Jamaica: with the Natural History of the herbs and trees, four-footed beasts, fishes, birds, insects, reptiles, &c. of the last of those Islands*, 2 vols, London

Smallwood, W. M., 1941, *Natural History and the American Mind*, New York

Smith, H. A. M., 1988, *The Baronies of South Carolina*, III, Spartenburg, SC

Smith, J. E., 1821, *A Selection of the Correspondence of Linnaeus and other Naturalists from the Original Manuscripts*, 2 vols, London

Smith, T.-A. & Hann, K., 2012, 'Sloane, Slavery and Science', in Walker, A., MacGregor, A., & Hunter, M., *From Books to Bezoars. Sir Hans Sloane and his Collections*, London, pp. 227–35.

Society of Gardeners, 1730, *Catalogus plantarum, or A Catalogue of Trees, Shrubs, Plants, and Flowers both Exotic*

and Domestic which are propagated for Sale in the Gardens near London, London

Sowerby, J. 1820–34, *Genera of Recent Fossil Shells ...*, London

Sperling, C. F. D. (compiled from materials collected by W. W. Hodson), 1896, *A Short History of the Borough of Sudbury in the County of Suffolk*, Sudbury

Sprat, T., 1667, *The History of the Royal-Society of London for the Improving of Natural Knowledge*, London

Stearn, W. T., 1957, *Linnaeus, Species Plantarum: A Facsimile of the First Edition, 1753*, London

—, 1958a, 'Botanical Exploration to the Time of Linnaeus', *Proceedings of the Linnean Society of London*, 169, pp. 173–96

—, 1958b, 'The Publication of Catesby's *Natural History of Carolina*', *Journal of the Society for the Bibliography of Natural History*, 3, p. 328

—, 1961, 'Botanical Gardens and Botanical Literature in the Eighteenth Century', in Stevenson, A., *Catalogue of Botanical Books in the Collection of Rachel McMasters Miller Hunt*, II, pt 1: *Introduction to Printed Books, 1701–1800*, Pittsburgh, PA, pp. xli–cxl

Stearns, R. P., 1952, 'James Petiver, Promoter of Natural Science, c. 1663–1718', *Proceedings of American Antiquarian Society*, 62, pt 2, pp. 244–365

—, 1970, *Science in the British Colonies of America*, Urbana, IL

Stevenson, A., 1961a, *Catalogue of Botanical Books in the Collection of Rachel McMasters Miller Hunt*, II, pt 1: *Introduction to Printed Books 1701–1800*, Pittsburgh, PA

—, 1961b, *Catalogue of Botanical Books in the Collection of Rachel McMasters Miller Hunt*, II, pt 2: *Printed Books 1701–1800*, Pittsburgh, PA

St John Brooks, E., 1954, *Sir Hans Sloane: The Great Collector and his Circle*, London

Stukeley, W., 1882, *The Family Memoirs of the Rev. William Stukeley ...*, Durham

Swem, E. G., 1949, 'Brothers of the Spade: The Correspondence of Peter Collinson of London, and of John Custis of Williamsburg, Virginia, 1734–1746', *Proceedings of the American Antiquarian Society*, 58, pt 1, pp. 17–190

Switzer, S., 1718, *Ichnographia rustica*, 3 vols, London

Theodorus, J. [Tabernaemontanus], 1588–91, *Neuw Kreuterbuch*, Frankfurt am Main

Tinling, M., ed., 1977, *The Correspondence of the Three William Byrds of Westover, Virginia, 1684–1776*, I, Charlottesville, VA

Tinniswood, A., 2019, *The Royal Society and the Invention of Modern Science*, London

Tournefort, J. P. de, 1698, *Histoire des Plantes qui naissent aux environs de Paris, avec leur usage dans la Medicine*, Paris

—, 1700–3, *Institutiones rei herbariae*, 3 vols, Paris

—, 1732, *History of plants growing about Paris ...*, I, trans. John Martyn, Paris

Turner, D., ed., 1835, *Extracts from the Literary and Scientific Correspondence of Richard Richardson*, Yarmouth

Turner, J., ed., 1996, *The Dictionary of Art*, 24 vols, London

Uglow, J., 1997, *Hogarth: A Life and a World*, London

Van de Passe, C., 1614, *Hortus floridus ...*, London

Venn, J. & J. A., 1922, *Alumni Cantabrigienses*, pt 1: *From the earliest times to 1751*, I, Cambridge

Von Rosenhof, R., 1758, *Historia naturalis ranarum nostratium*, Nuremberg

Walker, A., MacGregor, A. & Hunter, M., eds, 2012, *From Books to Bezoars: Sir Hans Sloane and his Collections*, London

Wallis, P. J., 1974, 'Book Subscription Lists', *Library*, 5th ser., XXIX, pp. 255–86

Walter, T., 1788, *Flora caroliniana*, London

Walters, S. M., 1981, *The Shaping of Cambridge Botany*, Cambridge

Waring, J. I., 1964, *A History of Medicine in South Carolina, 1670–1825*, Columbia, SC

Webber, M. L., 1937, 'Sir Nathaniel Johnson and his Son Robert, Governors of South Carolina', *South Carolina Historical and Genealogical Magazine*, XXXVIII, no. 4, pp. 109–15

Wenger, M., ed., 1989, *The English Travels of Sir John Percival and William Byrd II: The Percival Diary of 1701*, Columbia, SC

West, S., 1996, 'Vandergucht Family: English Family of Artists of Flemish Origin', in Turner, J., ed., *The Dictionary of Art*, London, vol. 31

Wettengl, K., 1998, *Maria Sibylla Merian: Artist and Naturalist*, Frankfurt am Main

Whitely, W. T., 1928, *Artists and their Friends in England, 1700–1799*, 2 vols, London & Boston

Wiles, R. M., 1957, *Serial Publication in England before 1750*, Cambridge

Wilkins, G. L., 1953, *A Catalogue and Historical Account of Sloane's Shell Collection*, London

Wilson, D. E., 2009, 'Class Mammalia', in Wilson, D. E. & Mittermeier, R. A., eds, *Handbook of the Mammals of the World*, I, Barcelona, pp. 17–47

Wilson, D. S., 1970–71, 'The Iconography of Mark Catesby', *Eighteenth Century Studies*, 4, pp. 169–83

—, 1978, *In the presence of Nature*, Amherst, MA

Willson, E. J., 1982, *West London Nursery Gardens*, London

Wood, J. R. I., Marner, S. K., Scotland, R. W. & Harris, S. A., 2018, 'Specimens of Convolvulaceae linked to the Plates of Dillenius's *Hortus Elthamensis*', *Taxon*, 67, pp. 1014–19

Wood, P., 1974, *Black Majority*, New York

Woods, M. & Swartz Warren, A., 1988, *Glass Houses: A History of Greenhouses, Orangeries and Conservatories*, London

Woodward, J., 1696, 'Directions for the Collecting, Preserving and Sending over Natural things from foreign countries', London (privately printed); transcribed in MacGregor, A., ed., 2018, *Naturalists in the Field: Collecting, Recording and Preserving the Natural World from the Fifteenth to the Twenty-First Century*, Leiden & Boston, Appendix V

Wright, L. B., ed., 1947, *The History and Present State of Virginia by Robert Beverley*, Chapel Hill, NC

— & Tinling, M., eds, 1941, *The Secret Diary of William Byrd of Westover, 1707–12*, Richmond, VA

—, 1958, *William Byrd of Virginia: The London Diary (1717–1721) and other Writings*, New York

Wulf, A., 2008, *The Brother Gardeners: Botany, Empire and the Birth of an Obsession*, London

Catesby's Published Works and their Derivatives

Compiled by Roger Gaskell[1]

A note on dimensions: the size of a book is determined by the size of the sheet of printing paper and its format, that is the number of times the sheet is folded: once for folio, twice for quarto, three times for octavo. As part of the binding process, the rough deckle edges of the hand-made paper are trimmed. If a book is rebound, further trimming may occur. The resulting page dimensions therefore vary from copy to copy. In the descriptions that follow, we have given the format followed by the dimensions of typical copies. For a discussion of the paper used in Catesby's publications, see Appendix 2, pp. 224–32.

THE NATURAL HISTORY OF CAROLINA
'Proposals' for the first edition, c.1728

'Proposals, for printing an essay towards a natural history of Florida, Carolina and the Bahama islands … By Mark Catesby …'

At the foot of the page: 'Gentlemens Names will be enter'd by W. Innys, at the West End of St. Pauls; John Brindley, Book-Binder to Her Majesty and to His Royal Highness the Prince of Wales, at the Kings Armes, New Bond-Street; and by the author at Mr. Fairchild's, in Hoxton; where may be seen the original paintings.'

Later editions: 'These Books are to be had, At W. Innys's, at the West End of St. Pauls; and at the author's at Mr. Bacon's late Mr. Fairchild's in Hoxton; where may be seen the original paintings.'

Single-sheet broadside, 20 × 13¾ in./51 × 35 cm.

Notes: there are several editions, the earliest c.1728; the information at the foot of the page was changed after the death of Thomas Fairchild on 10 October 1729, when the business passed to his nephew Stephen Bacon.

Parts issue

The *Natural History* was originally published in 11 parts with 20 plates in each between 1729 and 1747. The parts were presented to the Royal Society as they were issued, and an account of each part was written by Cromwell Mortimer (1693–1752) and published in the *Philosophical Transactions of the Royal Society* in a series of papers between 1730 and 1748. In his first paper, 'An Account of Mr. Mark Catesby's Essay towards the Natural History of Carolina and the Bahama Islands, with some extracts out of the first three sets' (*Philosophical Transactions*, 36, 1730, pp. 425–34), Mortimer dealt with the first three parts (containing Plates 1–60). Thereafter, he discussed a single part in each contribution, with titles beginning 'A continuation of an account of an essay'. Mortimer's 'Accounts' each begin with a brief preamble and then a listing of all the plates with paraphrases of Catesby's texts, sometimes including direct quotations. He signs off with the often quoted remark: 'Thus ends the most magnificent Work I know of, since the Art of Printing has been discover'd.'

See fig. 93 for a list of the parts with the dates of presentation to the Royal Society and the appearance of Mortimer's 'Accounts' in the *Philosophical Transactions*.

First edition as bound in two volumes dated 1731–43

The Natural History of Carolina, Florida and the Bahama Islands: containing the figures of birds, beasts, fishes, serpents, insects, and plants: particularly, the forest-trees, shrubs, and other plants, not hitherto described, or very incorrectly figured by authors: together with their descriptions in English and French: to which, are added observations on the air, soil, and waters: with remarks upon agriculture, grain, pulse, roots, &c. To the whole, is prefixed a new and correct map of the countries treated of. By Mark Catesby. Vol. I, [II]. Histoire naturelle de la Caroline, la Floride, & les Isles Bahama [etc].

Volume I: London, 'Printed at the expense of the author: and sold by W. Innys and R. Manby, at the West End of St. Paul's, by Mr. Hauksbee at the Royal Society House, and by the Author, at Mr. Bacon's in Hoxton. MDCCXXXI. [1731]'

Volume II: London, 'Printed at the expense of the author: and sold by W. Innys, at the West End of St. Paul's; R. Manby, on Ludgate-Hill; Mr. Hauksbee, at the Royal Society House, and by the Author, MDCCXLIII. [1743]'

2 volumes, folio, 20 × 13¾ in./51 × 35 cm.

Contents:

Volume I: title page dated 1731, double-page map; dedication to Queen Caroline; 'List of the encouragers of this work'; 'The Preface'; 'An Account of Carolina, and the Bahama Islands'; Plates 1–100 with facing page of text for each plate.

Volume II: title page dated 1743; dedication to the Princess of Wales; Plates 1–100 with facing page of text for each plate; 'Appendix' Plates 1–20 with facing page of text for each plate; index to Appendix; index to Volumes I and II.

Apart from the dedications, the text is in English and French in double columns, the index in English, Latin and French.

The map and the etched plates are hand-coloured in the great majority of copies, the few known uncoloured copies being incomplete (for these see Chapter 3, n. 56).

Notes: the title page to Volume I was probably sent with Part 5 in November 1732. With Part 10 in December 1743 probably came the title page to Volume II, dedication to that volume, and the list of subscribers, preface and index to the whole work as well as the map and 'An Account of Carolina, and the Bahama Islands'. As a result, copies vary in binding sequence: for example, though the map and 'Account' were intended for Volume I (the map is called for on the title page), they are often bound in Volume II. The copy formerly owned by Cromwell Mortimer, secretary of the Royal Society and a subscriber, now in the Smithsonian Libraries and Archives (CH41.C35 1731, digitized for the Biodiversity Heritage Library, http://biodiversitylibrary.org/bibliography/62015), is in the order that Catesby probably intended and contains all the paratexts and, in addition, a copy of the 'Proposals' and other ephemera.[2]

The parts were advertised in the 'Proposals' at one guinea plain 'on the same paper as these Proposals' and two guineas coloured 'on the finest Imperial Paper'. See Appendix 2 (pp. 224–32 above) for a discussion of paper and watermarks.

The quality of the colouring varies from copy to copy; see Chapter 3, pp. 77–90.

Parts 1–4 exist in different typesettings, three of Part 1 and two each of Parts 2, 3 and 4, indicating that more copies were printed as the subscription list increased.

About 100 copies are estimated to survive of an estimated 200 produced.

Short extracts or summaries with woodcut or etched copies of several plates (some coloured) appeared in the *Gentleman's Magazine*, XXI (1751), pp. 10, 11; XXII (1752), pp. 276, 300, 364, 412, 474, 572; XIII (1753), pp. 29, 128, 180, 268, 324, 512, 609.

'Proposals' for the second edition, 1753

'Proposals for re-publishing by subscription a Natural History of Carolina, Florida, and the Bahama Islands … By Mark Catesby, F.R.S.'

At the foot of the page: 'Subscriptions are taken in, and Books delivered by the Proprietors, Charles Marsh, Bookseller, in Round-Court in the Strand; Thomas Wilcox, Bookseller, opposite the New-Church in the Strand; and Benjamin Stichall in Clare-Court. Subscriptions are likewise taken in by all the eminent Booksellers in Great-Britain, Ireland, and all other Parts of Europe.'

Dated at top right: 'London, Oct. 25, 1753.'

Docket title on verso: 'Proposals for Re-publishing by Subscription Catesby's Natural History of Carolina Florida, and the Bahama Islands.'

Single-sheet broadside, docket title on verso for folding in four, 17 × 11 in./43 × 28 cm.

Notes: the only copy so far located is tipped in to the endleaves of a copy of the second edition in the Houghton Library, Harvard University, Cambridge, MA (NH 1557.54).

Second edition, 1754

The Natural History of Carolina, Florida and the Bahama Islands … Revis'd by Mr. Edwards, of the Royal College of Physicians

London: 'Printed for Charles Marsh, in Round Court in the Strand; Thomas Wilcox, over-against the New Church, in the Strand; and Benjamin Stichall in Clare-Court, MDCCLIV. [1754]'

2 volumes, folio, 20¾ × 13¾ in./53 × 35 cm, with a map and 220 hand-coloured etched plates.

Notes: although stated on the title page to be revised by George Edwards (1694–1773), the text is unchanged, and copies are made up randomly of sheets left over from the first edition and reset sheets with some changes to orthography and spelling. Minor changes have, however, been made to a few of the plates, presumably instigated by Edwards, and in addition the 'Proposals' (see above) state that the colouring is to be done under Edwards's supervision.

The 'Proposals' show that the work was to be issued in smaller parts than the first edition, 8 plates and accompanying letter-press at 10s. 6d., compared with 20 plates and text at 2 guineas for the first edition, the first part available on New Year's Day 1754. Complete copies could be purchased in sheets (the purchaser paid for the binding in addition) at 14 guineas: the same price as a complete set of 28 parts.

Third edition, 1771

The Natural History of Carolina, Florida and the Bahama Islands … By the late Mark Catesby, F.R.S. Revised by Mr. Edwards, of the Royal College of Physicians, London. To the whole is now added a Linnaean index of the animals and plants.

London: 'Printed for Benjamin White, at Horace's Head, in Fleetstreet, MDCCLXXI. [1771]'

2 volumes, folio, 20¾ × 13¾ in./53 × 35 cm, with a map and 220 hand-coloured etched plates.

Notes: although stated on the title page to have been revised by George Edwards, the text is reset but unchanged, apart from the addition of an index of Linnaean binomials, probably by Edwards.

Copies continued to be issued as demand arose, some with plates printed on Whatman paper watermarked from 1794 to 1816. The Linnaean index seems to have been made avail-

able on its own and is sometimes found bound into copies of the first edition: for example, the Hunt Botanical Library copy (Stevenson, A., 1961b, *Catalogue of Botanical Books in the Collection of Rachel McMasters Miller Hunt*, II, pt 2: *Printed Books 1701–1800*, Pittsburgh, PA, cat. 486) and a copy in the BL (74/C.113.i.1).

EUROPEAN TRANSLATIONS AND ADAPTATIONS OF THE *NATURAL HISTORY*

Seligmann's *Sammlung*, 1749–76

Sammlung verschiedener auslaendischer und seltener Vögel, worinnen ein Jeder dererselben nicht nur auf das Genaueste beschrieben, sondern auch in einer richtigen und sauber illuminirten Abbildung vorgestellet wird

Nuremberg: J. J. Fleischmann, 1749–76

9 parts (bound in 2 or 4 volumes), folio, 16½ × 9½ in./42 × 24 cm, with a map and 114 hand-coloured etched plates.

Notes: a translation by Johann Michael Seligmann (1720–1762) and Georg Leonhart Huth (1705–1761) of parts of George Edwards's *A Natural History of Uncommon Birds* (1743–51) and *Gleanings of Natural History* (1758–64) and Catesby's *Natural History*. The plates are copies of the originals by Seligmann, reduced in size and with backgrounds in the style of Edwards added to many of Catesby's images (see fig. 115). The Edwards and Catesby material is intermingled. From Part 7, additionally described on the title page 'als eine Nachlese zu G. Edwards Werken', the material is all from Edwards.

Die Beschreibung von Carolina, Florida und den Bahamischen Inseln

Nuremberg, [1755]

Notes: a separate issue of the translation of 'An Account of Carolina, and the Bahama Islands', including the map, from Part 3 of the *Sammlung*.[3]

Seligmann's *Sammlung*, French, 1768–76

Recueil de divers oiseaux étrangers et peu communs qui se trouvent dans les ouvrages de messieurs Edwards et Catesby; représentés en taille douce et exactement coloriés par J.M. Seligmann.

Nuremberg: heirs of Seligmann, 1768–76

9 parts in 8 volumes, folio, 16 × 10 in./41 × 25 cm, with a map and 521 hand-coloured etched plates.

Notes: republication of Seligmann's *Sammlung* plates with French text. The German preliminaries are omitted and replaced by a translation of Edwards's Preface, 'faite par un Ami sous la révision & l'approbation de l'auteur'.[4]

Histoire naturelle de la Caroline, la Floride et les isles Bahama

Nuremberg, 1770

Notes: a separate issue of the translation of 'An Account of Carolina, and the Bahama Islands', including the map, from Part 3 of the *Recueil*.

Seligmann's *Sammlung*, Dutch, 1772–81

Verzameling van uitlandsche en zeldzaame vogelen, benevens eenige vreemde dieren en plantgewassen, in 't engelsch naauwkeurig beschreeven en naar 't leven met kleuren afgebeeld

Amsterdam: Jan Christiaan Sepp, 1772–81

9 parts in 5 volumes, folio, 17½ × 10½ in./45 × 27cm, with 473 hand-coloured etched plates.

Notes: republication of Seligmann's *Sammlung* plates with a new introduction by Martinus Houttuyn (1720–1798) and his translations of the text from Huth's German, verified against the English originals.[5]

Piscium (Volume II and Appendix), 1750–68, 1777

Piscium, serpentum, insectorum, aliorumque nonnullorum animalium nec non plantarum quarundam imagines quas Marcus Catesby posteriore parte splendidi illius operis quo Carolinae, Floridae et Bahamensium insularum tradidit historiam naturalem eiusque appendice descripsit. Additis vero imaginibus piscium tam nostratium quam aliarum regionum auxerunt vivisque coloribus pictas ediderunt Nicolaus Fridericus Eisenberger et Georgius Lichtensteger … Die Abbildungen verschiedener Fische, Schlangen, Insekten, einiger andern Thiere und Pflanzen …

Nuremberg: Typis Ioannis Iosephi Fleischmanni, 1750–68

Second issue: Typis Pauli Jonathae Felsackeri, 1777

Folio, 20½ × 13 in./52 × 33cm, with 109 hand-coloured etched plates.

Notes: full-sized copies of all the plates of Volume II of the *Natural History* and 9 plates from the Appendix; the texts in Latin and German are translations from Catesby's entries. The etched plates by Nikolaus Friedrich Eisenberger (1707–1771), Georg Lichtensteger (1700–1781) and Georg Wolfgang Knorr (1705–1761) and his heirs are unsigned.

The work was issued in parts from 1750 to 1768, when a dedication to Catherine the Great was issued. Subscribers must have fallen away as the majority of copies lack the full complement of plates. A new title page was issued with the complete work in 1777, adding Knorr's name.

'Catalogue of American Trees and Shrubs'

Mark Catesby, 'A Catalogue of American Trees and Shrubs that will endure the climate of England ... These trees with the rest of the Catalogue are to be had of Christopher Gray Nursery man at Fulham near London. Where also may be had fruit trees, forest trees, shrubs and flowers' [*c*.1742]

Bottom right: 'N.B. The Publisher, conceiving it a satisfaction to the Curious has added Marginal references of those Plants in this Catalogue that are delineated in a few Books of Naturall History, where may be seen an ample description and figure of them.

'G.C. Gardiners Catalogue
H.F. Nat. Hist. of Florida.
H.E. Hortus Elthamensis.'

Broadside, 12½ × 13½ in./32 × 34 cm, central etched image of magnolia with monogram 'MC', catalogue and engraved text on three sides in English and French.

Notes: see Chapter 3, pp. 94–8.

Hortus Britanno-Americanus
First issue, 1763

Mark Catesby, *Hortus Britanno-Americanus: or, A curious collection of trees and shrubs, the produce of the British colonies of North America; adapted to the soil and climate of England, with observations on their constitution, growth, and culture: and directions how they are to be collected, packed up, and secured during their passage. Embellished with copper plates neatly engraved.*

London: 'Printed by W. Richardson and S. Clark, for John Ryall, at Hogarth's Head, in Fleet-Street. M DCC LXIII. [1763]'

Quarto, 15 × 12 in./38 × 30 cm, with 16 etched plates containing 62 images of plants.

Notes: See Chapter 3, pp. 98–101. The plates are usually hand-coloured.

Second issue, 1767

Mark Catesby, *Hortus Europae-Americanus: or, A collection of 85 curious trees and shrubs, the produce of North America; adapted to the climates and soils of Great-Britain, Ireland, and most parts of Europe, etc. Together with their blossoms, fruits and seeds; observations on their culture, growth, constitution and virtues. With directions how to collect, pack up, and secure them in their passage. Adorn'd with 63 figures on 17 [sic] copper-plates, large imperial quarto.*

London: 'Printed for J. Millan, near Whitehall, MDCCLXVII [1767]. Price color'd 1l. 11s. 6d.'

Quarto, 15 × 12 in./38 × 30 cm, with 16 etched plates containing 62 images of plants.

Notes: see Chapter 3, p. 101.

A reissue of the sheets of the *Hortus Britanno-Americanus* with the original title page cancelled and the new title page attached to the remaining stub.

In the Linnean Society copy (F 917/918: 582.4) the plates were probably printed later than the date on the title page on blue-tinged wove paper.

'Of Birds of Passage', 1747
'Of Birds of Passage', *Philosophical Transactions*, 1747

'Of Birds of Passage, by Mr. Mark Catesby, F.R.S. Read at a Meeting of the Royal Society, March 5. 1746–7.'

Philosophical Transactions of the Royal Society, 44, no. 483, March–May 1747, pp. 435–44.

Notes: see Chapter 3, p. 101.

'Of Birds of Passage', *Gentleman's Magazine*, 1748

'Extract from a Paper on the Same Subject written by Mark Catesby, F.R.S. in *Phil. Trans.* No. 483.'

Gentleman's Magazine, 18, October 1748, pp. 447–8.

Note: this follows an unsigned article, 'Some Remarks on a Printed Paper concerning Birds of Passage', pp. 445–7, unsigned but written in the first person.

1 The bibliography of the first edition of Catesby's *Natural History* has been studied in depth by Leslie Overstreet and I thank her also for a number of helpful discussions; I have drawn heavily on Overstreet, L. K., 2015, 'The Publication of Mark Catesby's *The Natural History of Carolina, Florida and the Bahama Islands*', in Nelson, E. C. and Elliott, D. J., eds, *The Curious Mister Catesby: A 'Truly Ingenious' Naturalist Explores New Worlds*, Athens, GA, & London, pp. 155–72. Catesby's works and Continental derivatives are discussed in Frick, G. F. & Stearns, R. P., 1961, *Mark Catesby: The Colonial Audubon*, Urbana, IL, ch. 9, with a checklist on pp. 109–11.

2 These are a 'Note' with Part 5 saying the frontispiece (which never materialized), preface and maps (plural) were still to come, so subscribers should wait before binding their copy of this volume; and an 'Advertisement' announcing the forthcoming 'Appendix' and suggesting the binder is instructed to bind in guards to which the text and plates could be attached when they are received. The Trinity College, Cambridge, copy is indeed bound in this way. See Overstreet, L., 2015, pp. 163–5.

3 I am grateful to Leslie Overstreet for help in establishing the relationship of *Die Beschreibung* with the *Sammlung* and for examining the Smithsonian Libraries and Archives copy of the latter, QL674.E26 G1749.

4　　I am grateful to Gretchen Ring, Diana Duncan and Robin Secco for examining the Field Museum of Natural History, Chicago, copy, bound with the *Recueil*, Ayer add.1 1768.1*.

5　　Boesman, M. and de Ligny, W., 2004, 'Martinus Houttuyn (1720–1798) and his Contributions to the Natural Sciences, with Emphasis on Zoology', *Zoologische verhandelingen*, 349, p. 100.

Catesby's Authorities
Compiled by Leslie K. Overstreet

The following is a list of the authors and their works cited by Catesby in his publications, his letters and his plant labels. A fuller listing, giving his exact citations and the corresponding pages to the authors' works, is in preparation for separate publication.

Note: multiple editions are given when it is not known which Catesby used.

Alpini, Prosper (1553–1617), *De plantis Aegypti liber*, Venice, 1592. Also as *Historia naturalis Aegypti, pars secunda …*, Leiden, 1735. Also collected works: *De plantis exoticis libri duo*, Venice, 1627, and further editions 1629, 1656, etc.

Aristotle, *Historia animalium* [edition unknown, surviving in manuscript from ancient Greece, first printed in Venice, 1476]

Bauhin, Caspar (1560–1624), *Pinax theatri botanici … sive, Index in Theophrasti, Dioscoridis, Plinii et botanicorum qui a seculo scripserunt opera*, Basel, 1623; 2nd edn, Basel, 1671

Browne, Thomas, Sir (1605–1682), *Pseudodoxia epidemica; or, Enquiries into very many received tenents [sic] and commonly presumed truths*, London, 1646; 2nd edn, London, 1650; 3rd edn, London, 1658; 'last ed. by author', London, 1659

Bruyn, Cornelis de (1652–1727) (Cornelius Le Brun), *Voyage de Corneille le Brun par la Muscovie, en Perse, et aux Indes Orientales*, Amsterdam, 1718. First published in Dutch in 1711; in English as *Travels into Muscovy, Persia, and part of the East Indies*, London, 1737

Buonanni, Filippo (1638–1725) [general reference to his illustrations of shells; possibly his *Ricreatione dell'occhio e della mente nell'osservation delle Chiocciole*, Rome, 1681, or *Receatio mentis, et oculi: in observatione animalium testaceorum*, Rome, 1684]

Clusius, Carolus (1526–1609) (Charles de l'Ecluse), *Exoticorum libri decem: Quibus animalium, plantarum, aromatum, aliorumque peregrinorum fructuum historiae describuntur*, Leiden, 1605

Collinson, Peter (1694–1768), 'An Account of some very curious Wasps Nests made of Clay in Pensilvania [sic]; by Mr. John Bartram: communicated by Mr. Peter Collinson, F.R.S.', *Philosophical Transactions of the Royal Society*, 43, 1745, pp. 363–6, and 1 plate

Colonna, Fabio (1567–1650), *Minus cognitarum stirpium aliquot, ac etiam rariourum nostro coelo orientium ekphrasis*, Rome, 1616

Commelin, Johannes (1629–1692), *Horti Medici Amstelodamensis rariorum tam Orientalis, quam Occidentalis Indiae, aliarumque peregrinarum plantarum … descriptio et icones ad vivum aeri incisae*, Amsterdam, 1697

Cowper, William (1666–1709), 'A Letter to Dr Edward Tyson. Giving an Acconnt [sic] of the Anatomy of those parts of a Male Opossum that differ from the Female, by William Cowper, F.R.S.', *Philosophical Transactions of the Royal Society*, 24, 1704, pp. 1576–90, and 2 plates

Dale, Samuel (c.1659–1739), 'A Letter from Samuel Dale, M.L. to Sir Hans Sloane … containing the Descriptions of the Moose-Deer of New England, and a Sort of Stag in Virginia …', *Philosophical Transactions of the Royal Society*, 39, 1736, pp. 384–9, and 1 plate

Dampier, William (1652–1715) [*Voyages*, I:] *A new voyage round the world*, London, 1697. [*Voyages*, II:] *Voyages and descriptions*, London, 1699. [*Voyages*, III:] *A voyage to New Holland &c. in the year 1699*, London, 1703. All with later editions

Dillenius, Johann Jakob (1687–1747), *Hortus Elthamensis, seu, Plantarum rariorum in horto suo Elthami in Cantio coluit … Jacobus Sherard*, London, 1732

Douglas, James (1675–1742), 'The Natural History and Description of the Phoenicopterus or Flamingo; with two views of the Head, and three of the Tongue, of that beautiful and uncommon Bird', *Philosophical Transactions of the Royal Society*, 29, 1716, pp. 523–41, and 1 plate

Edwards, George (1694–1773), *A Natural History of Uncommon Birds and of some other Rare and Undescribed Animals … to which is added, a brief and general idea of drawing and painting in watercolours; with instructions for etching on copper with Aqua Fortis …*, 4 parts, London, 1743–51

Gessner, Conrad (1516–65), *Historiae animalium liber III: Qui est de avium natura*, Zurich, 1555; subsequent editions Frankfurt, 1585 and 1604

—, *Historiae animalium liber IIII: Qui est de piscium & aquatilium animantium natura*, Zurich, 1558; subsequent editions Frankfurt, 1604 and 1620

Grew, Nehemiah (1641–1712), *Musaeum Regalis Societatis; or, A catalogue & description of the natural and artificial rarities belonging to the Royal Society*, London, 1681; reissued London, 1694

Gronovius, Johannes Fredericus (1686–1762), *Flora Virginica, exhibens plantas quas … Johannes Clayton in Virginia observavit atque collegit*, 2 parts, Leiden, c.1739–43

Hernandez, Francisco (1517–1587), *Quatro libros: De la naturaleza, y virtudes de las plantas, y animales que estan recevidos en el uso de medicina en la Nueva España … Traduzido … por fr. Francisco Ximenez*, Mexico [City], 1615; also as *Plantas y animales de la Nueva España, y sus*

virtudes por Francisco Hernandez, y de Latin en Romance por fr. Francisco Ximenez, Mexico [City], 1615

—, *Rerum medicarum Novae Hispaniae thesaurus, seu plantarum, animalium, mineralium mexicanorum*, Rome, 1628, and another edition, Rome, 1651

Herrera y Tordesillas, Antonio de (1549–1626), *Historia general de los hechos de los Castellanos en las islas i tierra firme del mar oceano.* [Vol./Pt 5] *Descripcion d[e] las Indias Occidentales*, Madrid, 1601. Translated as *The general history of the vast continent and islands of America, commonly call'd the West Indies …*, London, 1725–6; reissued London, 1740

Jartoux, Pierre, [Probably], 'Sur le gin-seng' *Histoire de l'Académie Royale des Sciences avec les mémoires*, 1718, 41–5. Related articles include 'Lettre du pere Jartoux … touchant la plante de ginseng' in *Lettres édifiantes et curieuses écrites des missions étrangèrs par queleues missionnaires de la Compagnie de Jesus*, 10e recueil, 1713, 159–85; translated as 'The description of a tartarian plant, call'd gin-seng', *Philosophical Transactions of the Royal Society*, 28, 1713, 237–47.

Joncquet, Denis (d.1671), *Hortus, sive Index onomasticus plantarum, quas excolebat Parisiis annis 1658 & 1659*, Paris, 1659

Josselyn, John (1630–1675), *New-England's rarities discovered*, London, 1672; 2nd edn, London, 1675

Klein, Jacob (1685–1759), 'De Sciuro volante, sive Muro Pontico, aut Scythico Gesneri, & Vespertilione admirabile Bontij, Dissertatio, Dr. Hans Sloane … à Jacobo Theodoro Klein … à Secret. R.S.S. commnicata', *Philosophical Transactions of the Royal Society*, 38, 1733, pp. 32–8, and 1 plate

Laet, Johannes de (1593–1649), *Novus orbis, seu, Descriptionis Indiae Occidentalis libri XVIII*, Leiden, 1633

Lafitau, Joseph–François, Père (1681–1746), *Mémoire présenté à Son Altesse Royale Monseigneur Le Duc d'Orléans, Regent du Royaume de France; concernant la precieuse plante du gin-seng de Tartarie, découverte en Canada par le P. Joseph François Lafitau, de la Compagnie de Jesus, missionaire des Iroquois du Sault Saint Louis*, Paris, 1718

Lawson, John (1674–1711), *A New Voyage to Carolina*, London, 1709; reissued as *The History of Carolina …*, London, 1714 and 1718

Léry, Jean de (1534–c.1613), *Histoire d'un voyage faict en la terre du Bresil, autrement dite Amerique*, La Rochelle, 1578. Various later editions, and in Latin, *Historia navigationis in Brasiliam, quae et America dicitur*, Geneva, 1586

Linné, Carl von (Linnaeus) (1707–1778), 'Decem nova plantarum genera', *Acta Societatis Regiae Scientiarum Upsaliensis*, ser. 1, v. 2 for 1741, pp. 77–84, Uppsala, 1746

Lister, Martin (c.1638–1712), *Historiae sive synopsis methodicae conchyliorum*, London, 1685–92

Marggraf, Georg (1610–1644), in Piso, Willem (1611–1678), *Historia rerum naturalium Brasiliae*, Leiden, 1648. Subsequent edition entitled *De Indiae utriuque re naturali et medica*, Amsterdam, 1658

Mattioli, P. A. (1501–1577), *Commentarii in libros sex Pedacii Dioscoridis Anazarbei, De material medica*, Venice, 1554; and numerous subsequent editions

Mentzel, Christian (1622–1701), *Index nominum plantarum universalis*, Berlin, 1682

Merian, Maria Sibylla (1647–1717), *Metamorphosis insectorum surinamensium*, Amsterdam, 1705. Later editions 1719, 1730, etc., in Dutch, French and Latin with various title changes and additional plates

Moffet, Thomas (1553–1604), *Insectorum sive minimorum animalium theatrum*, London, 1634

Morison, Robert (1620–1683), *Plantarum historiae universalis Oxoniensis*, Oxford, 1680–99. Reissued, London, 1715

Mortimer, Cromwell (d.1752), 'The Anatomy of a Female Beaver, and an Account of Castor found in her', *Philosophical Transactions of the Royal Society*, 38, 1733, pp. 172–83, and 1 plate

Munting, Abraham (1626–1683), *Naauwkeurige beschryving der aardgewassen*, Leiden, 1696

Nieremberg, Juan Eusebio (1595–1658), *Historia naturae … In quibus rarissima naturae arcana, etiam astronomica, & ignota indiarum animalia, quadrupedes, aves, pisces … describuntur*, Antwerp, 1635

Parkinson, John (1567–1650), *Theatrum botanicum: The Theater of Plants*, London, 1640

Petiver, James (c.1663–1718), *Musei Petiveriani centuria prima, rariora naturae*, London, 1695; subsequent editions London, 1703, and in *Opera*, 1764–7

—, *Gazophylacii naturae & artis decas sexta*, London, 1702; subsequent editions London, 1711, and in *Opera*, 1764–7

Pliny the Elder, *Naturalis historiae*, edited by Jean Hardouin (1646–1729), Paris, 1685; subsequent edition 1723

Plukenet, Leonard (1642–1706), *Phytographia sive Stirpium illustriorum*, London, 1691–2

—, *Almagestum botanicum*, London, 1696

—, *Almagesti botanici mantissa*, London, 1700

—, *Amaltheum botanicum*, London, 1705
 All four titles collectively reissued as *Opera omnia botanica*, London, 1720

Plumier, Charles (1646–1704), *Nova plantarum americanarum genera*, Paris, 1703; specifically its 'Catalogus plantarum americanarum' (21 pages)

Ray, John (1627–1705), *Historia plantarum*, 3 vols, London, 1686–1704

—, *Synopsis methodica animalium quadrupedum et serpentini generis*, London, 1693; section entitled 'Synopsis animalium quadrupedum'

—, *Historia insectorum*, London, 1710

—, *Synopsis methodica avium & piscium*, London, 1713

Reede tot Drakestein, Hendrik von (c.1637–1691), *Hortus Indicus Malabaricus*, Amsterdam, 1686 [1678]–1703 (1686 on title page, published 1678)

Rochefort, Charles (1605–1683), *Histoire naturelle et morale des iles Antilles de l'Amerique*, Rotterdam, 1658; 2nd edn,

Rotterdam, 1665; English edn, *The history of the Caribby-islands*, London, 1666

Sloane, Hans, Sir (1660–1753), *Catalogus plantarum quae in Insula Jamaica sponte proveniunt*, London, 1696

—, *A voyage to the islands Madera, Barbados, Nieves, S. Christophers and Jamaica, with a natural history of the herbs and trees, four-footed beasts, fishes, birds, insects, reptiles, &c. of the last of those islands*, London, 1707–25

Solis, Antonio de (1610–1686) (Solis y Ribadeneyra), *Historia de la conquista de Mexico, poblacion, y progressos de la America Septentrional, conocida por el nombre de Nueva España*, Madrid, 1584. Numerous subsequent editions and translations; in English, *The history of the conquest of Mexico by the Spaniards*, London, 1724; also Dublin, 1727; London, 1738

Strabo, *Geographia* [edition unknown, surviving in manuscript from ancient Greece, first printed Tarvisii [Treviso] per Bartholomaeum Confalonerium de Salodio, 1483]

Theophrastus, *De historia plantarum* [edition unknown, surviving in manuscript from ancient Greece, first printed in Rome, 1469]

Thevet, André (*c.*1516–1592), *Les Singularités de la France antarctique, autrement nommée Amérique*, Paris, 1557; and later editions

Tournefort, Joseph Pitton de (1656–1708), *Intitutiones rei herbariae*, 2 vols, Paris, 1700–3. First published in French, *Elements de botanique, ou Methode pour reconnaitre les plantes*, Paris, 1694

Tyson, Edward (1650–1708), 'Carigueya, seu Marsupiale Americanum, or, The anatomy of an Opossum, dissected at Gresham-College', *Philosophical Transactions of the Royal Society*, 20, 1698, pp. 105–64, and 2 plates

—, 'Carigueya, seu Marsupiale Americanum Masculum. Or, the Anatomy of a Male Opossum: In a Letter to Dr Edward Tyson from Mr William Cowper, Chirurgeon, and Fellow of the Royal Society, London. To which are premised some further Observations on the Opossum … by Edward Tyson', *Philosophical Transactions of the Royal Society*, 24, 1704, pp. 1565–75

Warren, George (active 17th century), *An impartial description of Surinam upon the continent of Guiana in America with a history of several strange beasts, birds, fishes, serpents, insects, and customs of that colony, etc.*, London, 1667

White, John (active 1585–1593), 'M.S. Dni Gualteri Raleigh penes D. Hans Sloane', BM (P&D), Sloane 5270

Willughby, Francis (1635–1672) & Ray, John (1627–1705), *Ornithologiae libri tres*, London, 1676. Catesby cites the English edn: *The Ornithology of Francis Willughby*, London, 1678

—, & Ray, John (1627–1705), *De historia piscium*, Oxford, 1686; reissued 1743

Not yet determined

Acad. R. Par. [=Académie Royale, Paris]

Hist. R. H.

Offic: [= *Officinarum* (a pharmacopeia)?]

Q. Curtius [= Curtius Rufus, Quintus]

The following rights holders have generously granted permission for photographs of works in their care to be reproduced:

Royal Collection Trust / © Her Majesty Queen Elizabeth II 2021: 1, 2, 3, 4, 6, 7, 8, 9, 58, 64, 66, 69, 70, 71, 73, 77, 90, 100, 127, 128, 129, 132, 133, 134, 135, 140, 141, 142, 143, 145, 146, 153, 155, 156, 158, 160, 162, 166, 168, 170, 173, 184, 189, 191, 196, 197, 200, 201, 202, 203, 204, 209, 211, 214, 216, 219, 222, 224, 225, 226, 227, 230, 235, 236, 238, 239, 240, 241, 245; © The Royal Society, London: 4, 5, 20, 28, 33, 37, 74, 75, 76, 91, 113, 148, 150, 152, 157, 161, 167, 171, 175, 177, 180, 185, 192, 210, 220, 221, 223, 249, A3, A4, A5, A6, A12; Reproduced by kind permission of the Syndics of Cambridge University Library: 11, 12, 13, 14, 17, 21, 22, 32, 40, 49, 50, 55, 56, 57, 81, 83, 85, 86, 95, 96, 115, 116, 123, 124, 163, 164, 165, 174, 176, 194, 195, 199, 218, 228, 229, 231, 247; © The Trustees of the Natural History Museum: 15, 26, 38, 109, 119, 120, 121, 136, 138, 183, 186, 190, 198, 212, 213, 215, 232, 233, 242, 243, 244, 246, A7, A10; © The British Library Board: 16, 237; University of Oxford, Department of Plant Sciences: 18, 19, 23, 72, 125, 137, 139, 205, 206, 234; © Albright-Knox Art Gallery, NY: 24; By kind permission of His Grace the Duke of Beaufort, Badminton House, Gloucestershire: 25; West Sussex Record Office. Trustees of the Goodwood Collection: 27; © National Portrait Gallery, London: 29, 31, 34; © City of London Metropolitan Archives: 30, 79; © The Trustees of the British Museum: 35, 68, 151, 154, 169; Christie's Images Limited: 36, 39, 118, 131; © Sudbury Museum Trust: 42; Suffolk Record Office, Bury St Edmunds: 44, 51; © Sudbury Town Council: 45; Essex County Record Office: 46, 193; Felsted School Archives, Felsted, Essex: 47; Master and Fellows of Trinity College, Cambridge: 48, 84, 94, 98, 99, 101, 102, 103, 104, 105, 106, 107, 108, 111, 178, 179; Colonial Williamsburg Foundation (Special Collections Research Center, William & Mary Libraries): 52, 182; © Virginia Museum of History and Culture, Richmond, VA: 53, 54, 187, 188; Anonymous private collection: 59; Gibbes Museum of Art, Charleston, SC: 60, 63, 130; Maryland State Archives: 61; Jane Waring: 62; University of South Carolina, Columbia, SC: 65; Corie Hipp: 67; Spalding Gentlemen's Society, Lincolnshire: 78; Mill Hill School, London: 80; Smithsonian Libraries and Archives, Washington, DC: 87, 97, 110, 112, 114, A8; Artis Library, University of Amsterdam: 88, 89, 147; Morgan Library & Museum, New York: 92, 159, 172, A13; © Oak Spring Garden Foundation, Upperville, VA: 117; © The Metropolitan Museum of Art, NY: 126; Brian Gratwicke: 144; Bibliothèque Nationale de France, Paris: 149; © Orleans House Gallery, Twickenham: 207; National Trust Images: 208; © Bridgeman Images: 248; Linnean Society of London: 250, A2, A9, A11; Peter Bower: A1

expense of etching and engraving 69, 71
 risk of using outside engravers 71–2
 tools and techniques 72, 138, 140, *140*
 see also Catesby: career as artist and artistic
 training
enslaved African peoples 54, 253, 255
 Catesby's purchase of boy assistant 198, 239,
 242
 knowledge of plants and uses 244, 274,
 307*n*.131
'Erect Bay' 213, 240, 244, 255, 257*n*.5
 see also 'Umbrella Tree' (*Magnolia tripetala*)
Essex: natural history circles 11, *12*
ethnographic objects 56, *56*, *178*, 211–12, 222,
 250, 262, 264, 266
'Eunonimus Americ:' 276
Evelyn, John 125, 148, 314*n*.186
everlasting pea (*Lathyrus latifolius*) 13, *14*
exotic plants
 in gardens in Virginia 153
 supply and cultivation in Britain 170, 175–81
 heated greenhouses 23, 165, 169
 in London nurseries and gardens 24–5, 49,
 98, 148, 158–68
 Catesby's cultivation in own garden
 157–63, 170, 175–6, 179–80, 271, 271–3,
 272–3, 274–5
 Collinson's garden 163–5, 271, 272, 273,
 274
 successful propagation for sale 180–81
 Thorndon Park 23

Fairchild, Thomas 25, 32, 60, *60*, 98, 180, 213
 friendship with Catesby and support for 65–6
 garden at Hoxton and exotic plants 24, 40,
 148, 157, 158, 162–3, 241, 248, *270*
 Catesby's sends plants and seeds to 149, 177,
 243, 249
 display of Catesby's watercolours at 328
 horse chestnut in flower 49, 249
 letter from Catesby 233, 234, 251
Faithorne, William: *The Art of Graveing and
 Etching* 72, 138, 140, *140*
Felsted School, Essex 36, 38, *38*, 42
'Fiddle wood' 264
'Fieldfare of Carolina' (American robin, *Turdus
 migratorius*) 149, *155*
'Fig tree' and figs 153, 265, 274
 see also 'Prickly Pear of Virginia'
finches 53, 81, 84–5, *113*, 203, 245
'Fir' or 'Spruce pine' 240, 252, 255, 256, 259, 261
fish 58, *59*, 67, 87, 90, *120*, 212
 drawing on sources for unseen fish 124–5, *126*
 painting from life for fresh colours 108, 121
 preservation in alcohol in glass jars 208, 210,
 210, 273
 specimens sent by Bartram 273, 275
 specimens sent to Sloane 208, 210–11, 222

viperfish (*Chauliodus sloani*) 92, 210–11, *210–11*,
 222
 see also individual species
'Fish-root tree' 265
Fisher, Captain 275
'Five finger' 265
flamingo ('Flamingo', *Phoenicopterus ruber*) 88,
 114–15, *117*, 145
fleas *see* 'Chego' (chigoe flea, *Tunga penetrans*)
Fleur-de-lis watermark 225–6, *225*, 229, *231*
'Flos passionis' 92
flower books and quality of illustrations 105
flowering dogwood ('Dogwood Tree'/'Cornus
 Americ:', *Cornus florida*) 149, *150–51*, 219
 Catesby sends plants and seeds to England 177,
 240, 241, 242, 243, 244, 245, 255, 263, 265,
 267, 276
 rose-coloured variant (*Cornus florida* f. *rubra*)
 149, *150*, 154, 177
fly-catcher *see* great crested fly-catcher
'Flying Squirrel' (southern flying squirrel,
 Glaucomys volans) 115, 129–30, *130–31*
'Forrest wood' 264
Forster, Johann Reinhold: *Catalogue of the Animals
 of North America* 184
fossil collecting 196, 211, *212*, 222, 235
foxes *see* 'black Fox'; 'Gray Fox'; melanistic fox
France: paper from 224–5, 226, 227–8, *231*, 232
Franklin, Benjamin, 286*n*.131
Frederick, Prince of Wales 26, 28–9, 62
Frick, G. P. 9
frogs 54–5, 108, 115, *125*, 127, 128–9, *129*, 186
'Frutex baccifer' *see* American beautyberry
'Frutex corni foliis conjugatis' *see* Carolina allspice
'Frutex Spinosus Buxi foliis' *see* lily thorn
Fulham, London
 Gray's nursery 24–5, 98, 101, *159*, 162, 176
 and Catesby's garden at 60, 138, 157–8, 180
fungi 240
Furber, Robert 24–5
furniture: production from native American
 trees 55, 174

G or C MT monogram watermark *229*, 229, *232*
gannet *see* 'great booby'
Garden, Revd Alexander (c.1685–1756) 246, 256
Garden, Alexander (1730–1791) 247*n*.7
gardens and horticulture 19–25
 in America
 Carolina 53–5, 175–6
 Virginia 148–55
 botanical gardens 18–20, 23
 Catesby's gardens in London 25, 60, 137, 138,
 157–8, 271–3
 Catesby's interest and *Hortus Britanno-
 Americanus* 98–101, 179–80, 181
 Catesby's introduction of British plants to
 America 156–7, 236, 243, 251, 252

Catesby's introductions from America 46, 147,
 156, 170, 175–81
 Catesby's cultivation and observations 149,
 157, 158–63, 170, 179–80, 181, 271, 272–3,
 274–5
 Catesby's enquiries after success of planting
 263
 tree planting on estates 147, 157, 168–9, 170,
 177, 263
 Catesby's visits to London gardens 40
 Dale's garden 39
 Eltham garden of James Sherard 19, 98, 165,
 168
 formal style of gardens 23, 147, 154, 181
 'natural' style of landscaped gardens 23–4, 28,
 53–5, 147, 168–9, 175
 nurseries and nursery trade
 cultivation of American plants 158–63, 176,
 180–81
 Gray and advertising in Catesby's catalogue
 98
 supply of exotic plants 24–5, 98, 176,
 180–81
 private gardens as source of illustrations for
 Appendix 92, 230
 see also Chelsea Physic Garden, London; exotic
 plants; Hoxton, London; menageries
 and exotic animals; plant collecting and
 collectors
garganey ('Anas Fera vulgo Ein Kernel', *Anas
 querquedula*) *106*
'Garlick' wood 265
'Gentiana Virginiana' (Elliott's gentian, *Gentiana
 catesbaei*) 163, *163*
Gentleman's Magazine
 announcement of Catesby's death 64,
 292*n*.208
 images after Catesby's *Natural History* 94, *95*,
 329
 'Of Birds of Passage' in 101, 331
George III, king of Great Britain: three-volume
 copy of *Natural History* 2–5, *2–6*
George, Claude de 226
Gerrevinck, Lubertus van and family 225–6, 228
Gessner, Conrad 284*n*.57
Gibraltar: specimens from Catesby's brother 92,
 210, 211
Gilpin, William 140
ginger 249
'Ginseng or Ninsin of the Chinese' (American
 ginseng, *Panax cinquefolius*) 7, *93*, 137, 164, *166*
Glascock, Christopher 38
'Glass' berry 265
glass jars for specimens 66, 207, 208, 210, *210*,
 245–6, 254, 258, 266
'Globe Fish' *see* checkered puffer
Glover, John 5
'goat-sucker' (*Caprimulgus caroliniensis*, *C. vociferus*
 or *Chordeiles minor*) 191

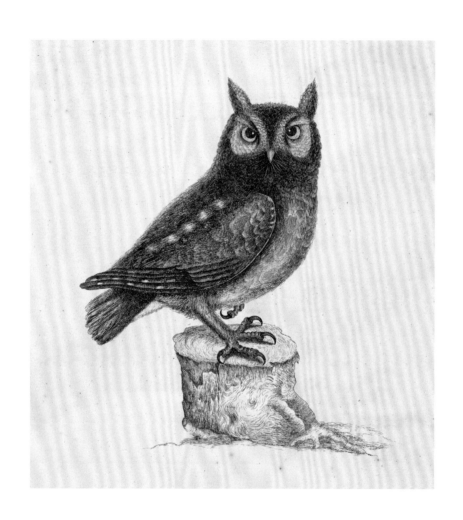

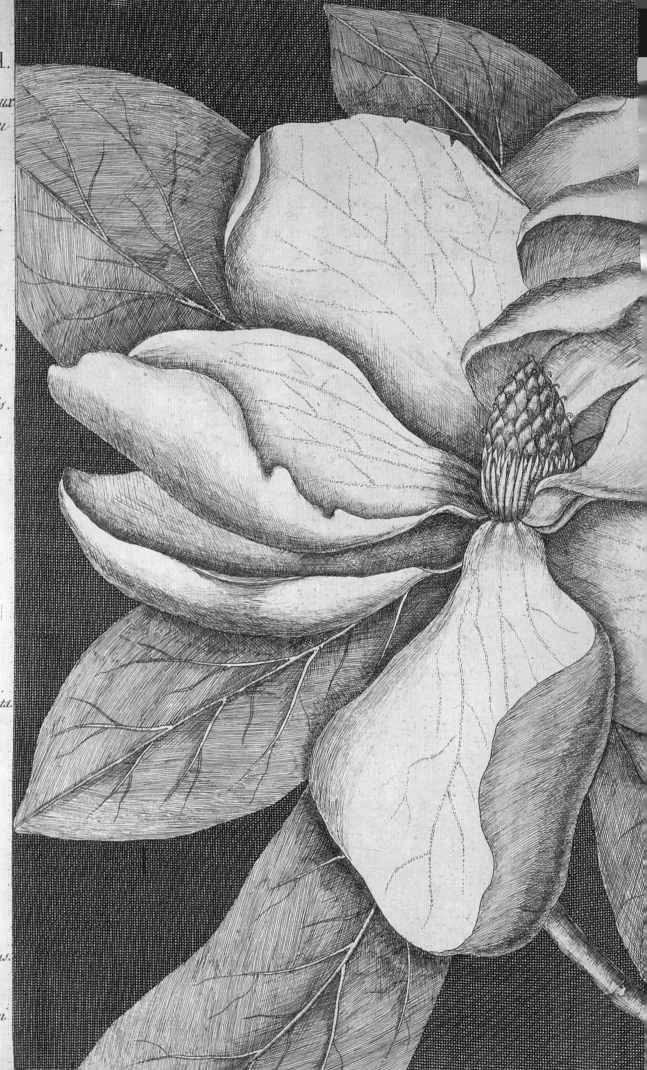

A Catalogue of American Trees and Shrubs that will endure the Climate of England.

Catalogue d'Arbres et Arbrisseaux Americains qui s'accomodent du Climat d'Angleterre.

A

G.C. Acacia Abruæ folijs triacanthos &c.
 Acacia with triple thorns.

H.F. Acacia Abruæ folijs. capsula Ovali.
 The water Acacia.

H.F. Acacia pseudo.
 Locust Tree.

Angelica Spinosa.
 The Angelica Tree.

H.F. Althea Floridana.
 The Loblolly Bay.

Arbor Virg: Citriæ vel Limoniæ folio.
 Benjamin Tree.

Amelanchier Virginiana.
 The Fringe tree.

H.F. Acer Virginianum floribus coccineis.
 Red flowering Maple.

Acer Americanum floribus multis.
 Red Maple with larger bunches.

Acer Maximum folijs trifidis.
 Ash leaved Maple.

H.F. Arbor Tulipifera.
 The Tulip-tree.

H.F. Arbor in aqua nascens.
 The Tupelo Tree.

H.F. Arbor in aqua nascens folijs latis.
 Water Tupelo.

B

G.C. Barba Jovis.
 Bastard Indigo.

Bignonia Fraxini folijs.
 Scarlet Trumpet flower.

Bignonia Coccineo flore majore.
 Trumpet flower with larger flowers.

H:ri Pari. Bignonia Americana capreolis donata.
 Trumpet flower four leav'd.

H.F. Bignonia Urucu folijs &c.
 Catalpa Tree.

C

Carpinus Virginiana florescens.
 The flowering Hornbeam.

H.F. Cassina vera Floridanorum.

Cerasus Carolinensis.
 The Cluster Cherry.

Castanea Pumila Virg.
 Chinkapin.

Cupressus Americana.
 The American Cypress.

Cornus mas. Virg.
 The Dogwood of Virginia.

Cornus Carolinensis folijs minoribus.
 The Narrow leav'd Dogwood tree.

Cornus mas odorata.
 The Sassafras Tree.

Cistus Virg: flore & odore periclymeni.

H.F. Cistus.
 The poyson Ivy of America.

Crataegus Virginiana folijs Arbuti.